WARHOL

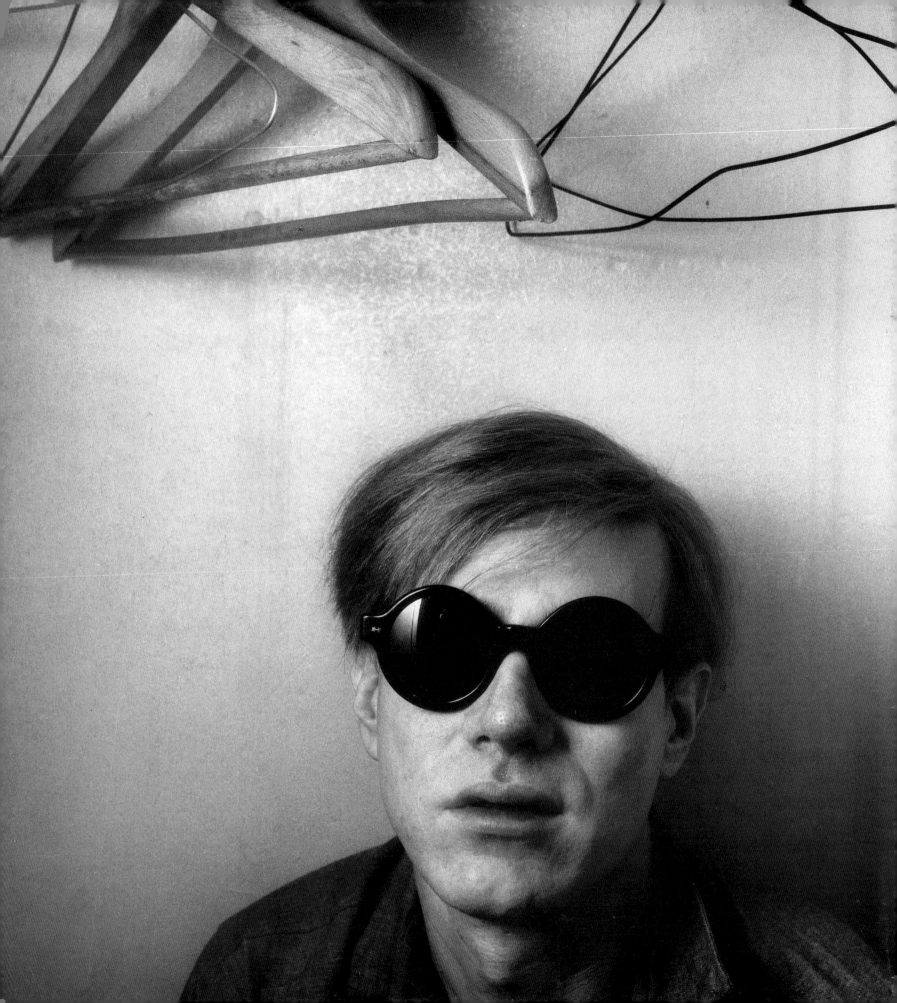

WARHOL

DAVID BOURDON

HARRY N. ABRAMS, INC., PUBLISHERS, NEW YORK

Project Director: Andreas Landshoff
Editor: Beverly Fazio
Designer: Dana Sloan
Photo Editor: Barbara Lyons

Frontispiece: Warhol in Paris, May 1, 1965. Photograph ©
 Harry Shunk

Library of Congress Cataloging-in-Publication Data
Bourdon, David.
 Warhol / David Bourdon.
 p. cm.
 Bibliography: p. 419
 Includes index.
 ISBN 0–8109–1761–0
 1. Warhol, Andy, 1928–1987. 2. Artists—United
 States—Biography.
I. Title.
N6537.W28B68 1989
700'.92'4
[B] 89–436

CONTENTS

PREFACE

Andy Warhol was the brightest ornament at a festive Christmas party on Manhattan's Upper East Side, where I first laid eyes on him in the late 1950s. I had settled in near the buffet, swilling champagne punch and gorging on marzipan strawberries, when I noticed everybody near the door snap to attention upon his arrival. I knew Andy had to be somebody special. Even in those pre-Pop days, Andy was something of a celebrity—an award-winning, widely admired illustrator with a distinctive drawing style. He was spiffily dressed in a close-fitting suit with a loud red paisley lining. His restless blue eyes periodically scanned the room as he chatted animatedly with a circle of admirers. He was not handsome, but boyishly or, rather, puckishly cute, with high, shiny pink Slavic cheeks, and a tendency to throw his chin back when he emitted a pale, bubbly laugh. He struck me as being supremely foppish, but in a lighthearted, self-deprecating way. He appeared simultaneously shy and self-assured, reticent in talking about himself but confident of who he was and not at all hesitant to put himself forward.

Somewhat later I attended a party at his midtown apartment on Lexington Avenue. The place was jammed with smartly dressed young men—the "pretties," as Andy called them—from the worlds of fashion, advertising, publishing, and decorating. There were one or two drag queens—of the glamorous 1950s showgirl variety, not like the deliberately tacky later 1960s travesties, who went around with smeared lipstick and runs in their stockings. What impressed me most about that apartment was its sophisticated, campy conglomeration of folk sculptures, hand-painted store signs, penny-arcade machines, carousel horses, and even a stuffed peacock. The most exuberant window trimmer couldn't have dreamed up a better prop room.

About 1960, with the money he earned as a commercial artist, Andy bought the town house on Lexington Avenue in the Eighties, where he turned the rear parlor-floor room into a studio. There he made his first Pop paintings and drawings—the comic strips, dollar bills, and soup cans. I resisted the small soup-can paintings, which

he was willing to let go for a hundred dollars apiece, but he succeeded in talking me into a drawing for thirty-five dollars. Andy excelled at separating collectors from their money, and many of them became richer for it.

His metamorphosis into a Pop persona was calculated and deliberate. The foppery was left behind as he gradually evolved from a sophisticate, who held subscription tickets to the Metropolitan Opera, into a sort of gum-chewing, seemingly naive teenybopper, addicted to the lowest forms of pop culture. When he expected important visitors from the art world, influential advocates of new art like Ivan Karp or Henry Geldzahler, Andy replaced a classical recording with a pop song that he deliberately played over and over again.

One Sunday afternoon in 1963, when his regular assistant, Gerard Malanga, was not around, Andy pressed me into service, helping him silkscreen a batch of the silver Elvis Presley paintings. They were made on the top floor of an old firehouse on East 87th Street that he was renting as a studio. I was inexperienced at dragging the heavy squeegee across the screen, so my sections of the full-length portraits were not as crisp and mechanical-looking as he wanted. Andy complained that I was making them too arty, and perhaps I was doing it on purpose, because I preferred the "imperfect" silkscreenings with overlapping edges and expressionist smudges. Our aesthetic differences were resolved one rainy night when a heavy downpour leaked through the roof and destroyed all the paintings. Andy redid them his way.

In 1964, Andy sat me down on one of his Heinz grocery-carton sculptures and told me to eat a banana as slowly as I could, while he filmed me in profile with his 16mm Bolex movie camera. I was one of several people he filmed eating bananas, and I was apparently the worst because I always managed to consume the entire fruit long before the three-minute reel was through. Because the camera was on a tripod, Andy could read magazines while the film was turning. Every once in a while he looked up to complain that I was

overacting. At that time in his movie career, he confused blinking with acting.

Andy's public fame and notoriety slipped up on me. I was astonished by—and nearly trampled in—the melee that constituted the opening of his one-man show at the Institute of Contemporary Art in Philadelphia in October 1965. Many had come to jeer, while others had brought their books of S & H Green Stamps or cans of Campbell's Soup for him to sign, but everybody wanted to gape at Andy and his Girl of the Year, Edie Sedgwick, in the flesh.

Andy loved nothing better than being recognized and asked for his autograph. From that year on, it was often difficult to be with him in public situations. Strangers in restaurants interrupted dinner to obtain his signature on a scrap of paper, apologetically explaining that they were doing so on behalf of a child who was not with them at the moment. If we were shopping in Bloomingdale's, I'd overhear individuals stage-whispering to their companions, "Look, over there, it's Andy Warhol," evoking the disdainful response, "Oh, I see him everywhere!" When Andy strolled along Madison Avenue, Deco dealers would run out of their storefronts onto the sidewalks to tout their wares. The most intimate moments I had with Andy were on the telephone, especially when he called me late at night from home, but even then I had to compete for attention with his TV set.

In the late 1960s, when I sometimes followed Andy around the country on his so-called lecture tours, I occasionally shared motel rooms with him in places such as Arizona, Texas, and Wisconsin (but still never saw him without his wig). At bedtime, he reminded me of a wide-awake teenager whose energy required that he talk in the dark until exhaustion overtook him. Between the repeated "Goodnights," always planning ahead, he'd wonder aloud about his next project: Should he film a sunset? Should he devise a vending machine that, for fifty cents, would dispense a plastic sculpture that was made before the buyer's eyes?

On June 3, 1968, the day a deranged woman gunned him down at the Factory, I was among the dozens of people who, upon hearing the awful news, rushed to Columbus Hospital, where he underwent an operation that lasted nearly five hours. In the room where we all waited, the telephones rang ceaselessly and Viva, Ultra Violet, and the other superstars gave enough interviews to fill every newspaper in town. At the end of the evening, the doctors announced that Andy's chances of survival were "fifty-fifty." For days after the operation, his existence teetered between survival and the void. I called the hospital every morning to inquire whether he had made it through the night. A couple of weeks later, when he telephoned me from his hospital bed, I was so startled and overcome with joy that I collapsed in a fit of choking sobs, and it was he who had to comfort me. In a voice that sounded weaker than ripping facial tissue, he lamented that the attempted assassination had not been recorded on film. "If only she had done it while the camera was on!"

It seemed nothing short of a miracle that Andy survived the shooting. The years that followed were, in effect, a magnificent added gift of life, a second chance to fulfill his destiny in the world. Andy, although he was a regular churchgoer, never struck me as an especially spiritual person, but I think the experience made him more religious and put him into more frequent communion with God.

The last time I saw Andy was in January 1987 at the Robert Miller Gallery, where he showed new photographic works, each consisting of several identical black-and-white prints sewn together in grids. The opening was jammed, and the shoulder-to-shoulder crowd extended all the way to the elevator bank. Andy stood behind the counter, patiently autographing copies of the catalogue. He was thinner than I had ever seen him, but he looked terrifically healthy, and that nervous little smile still darted about his lips.

Andy's "magic"—I don't know what else to call his inimitable sensibility and his bewitching effect upon people—made a dramatic impact upon his world. His spirit and influence will be with us for many years to come.

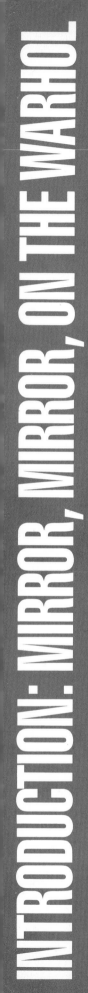

INTRODUCTION: MIRROR, MIRROR, ON THE WARHOL

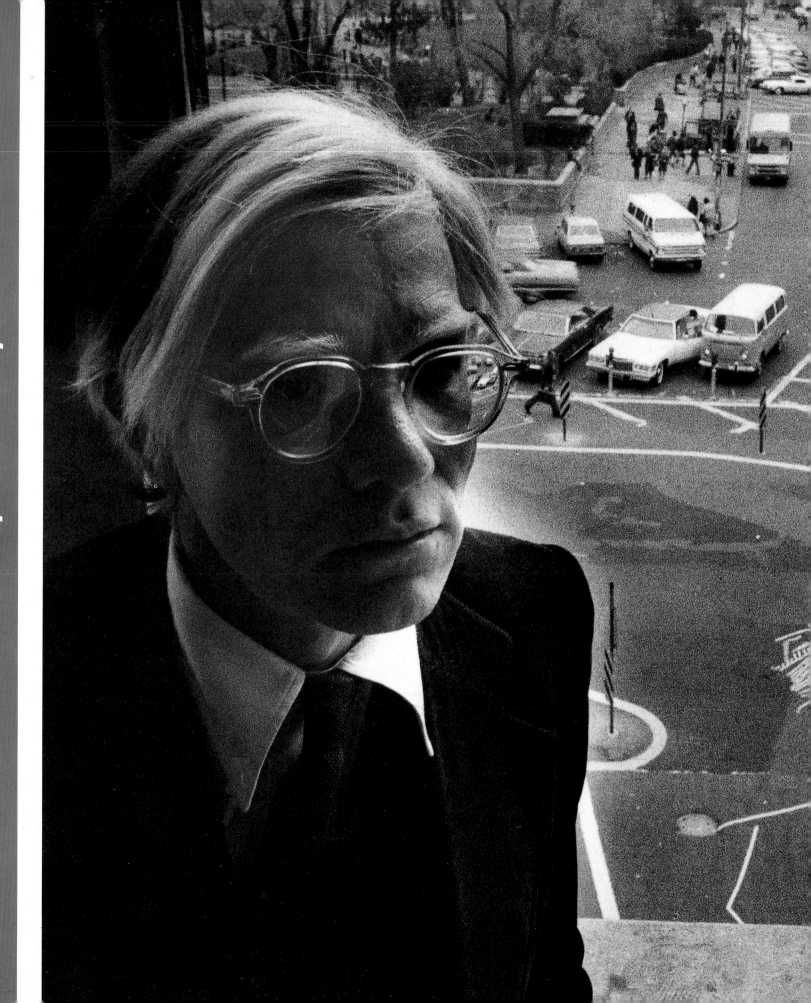

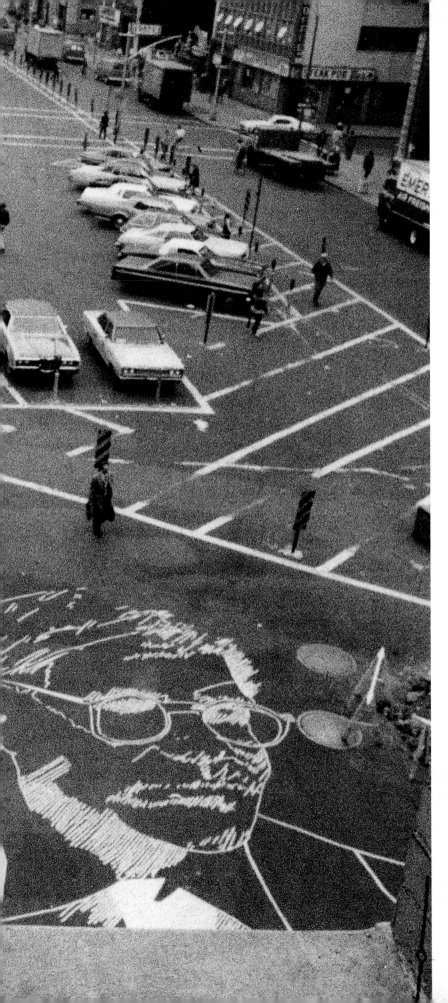

A mirror of his age: that's what many people called Andy Warhol. Why is it, then, that when people peer at the silvery surface he offered, they glimpse indistinct, elusive, and contradictory reflections?

His admirers venerate Warhol as a great artist, the apotheosis of the Pop sensibility, an arbiter of New York social and cultural taste, and an expert on everything smart and trendy. To them, he was a genius, whose brash, provocative paintings and movies epitomized the prevailing cultural and moral spirit of his time. His detractors see him as a flagrant self-promoter, a cynical opportunist, and a heartless manipulator who degraded the seriousness of art through relentless commercialism. Yet throughout his life, Warhol represented a startling mixture of guile and naivete. No conventional intellectual, he possessed a quick and ready insight that enabled him to size up aesthetic and social trends. He extracted amorphous ideas that were in the air and distilled them into provocative artworks with crystalline clarity.

Warhol made a career out of appropriating famous images and products in order to promote his own reputation. By preempting the celebrity of his subjects—from Campbell's Soup and Coca-Cola to Marilyn Monroe and Elvis Presley—he parlayed his own name and face into commercial commodities that became recognized—and valued—around the world. His paintings of brand-name products reflect the essential materialism of American culture, with its entrenched devotion to consumerism, advertising, packaging, promotion, and the processing of just about everything, from guided missiles to Miss America, into economic entities. In other paintings based on news photographs, he makes us look anew at some of the distressingly familiar violence that mars the American scene: the racial conflicts that periodically erupt in our cities and the chronic mayhem of automobile collisions. His food tins, pretty faces, and mangled cars—all metaphors of contemporary life style—imply that our era is relatively devoid of intellectual and spiritual values.

An idea man, Warhol was forever scheming about future art

1. The artist as mythic figure. One day in May 1976, Warhol, arriving at his studio on Union Square, discovered that an admiring art student, Chip Duyck, assisted by a couple of friends, had spent most of the previous night creating a street drawing of him in masking tape. Photograph by Jack Manning, NYT Pictures

projects, performing his own informal marketing research as he tested out ideas on friends, wanting to be assured that nothing similar had been done before. He could be merciless when it came to badgering his friends for ideas, constantly beseeching them for far-out and "nutty" (to borrow one of his favorite words) ideas. He brazenly stole creative material from other artists: "You look around and see what the second-rate artists are doing, and then you do the same thing, but better."[1]

His art was an intentional provocation, of course, as almost everything he did was calculated to win attention. He reveled in controversy and possessed an unerring instinct for what would elicit press coverage and generate shock waves. With an insatiable appetite for fame, he needed to be talked about and to see his name dropped in the gossip columns. The immediacy of fame is what mattered to him; he appeared indifferent to the judgment of posterity. Having worked as an illustrator on numerous advertising campaigns, he instinctively knew which ideas and subjects would "sell." His unflagging desire to create outrageous art often led him to pure sensationalism. "Oh, I've got to do my *Come Book*," he told a friend in 1971. "You've got to find somebody that I could photograph jerking off." Some years later, he created a series of small abstract "come" paintings whose design was formed by ejaculated semen. He also talked of selling his own semen for a limited edition of twenty-five artificially inseminated babies. "Isn't that a good idea?"[2]

Warhol strove to be a jack-of-all-arts. It wasn't enough for him to be recognized as merely an artist, filmmaker, and show-business entrepreneur. He fantasized about having a hit movie playing at Radio City Music Hall, a Broadway show at the Winter Garden, a television special, a book on the best-seller list, a Top-40 record, and the cover of *Life*. He truly believed he could keep several careers going simultaneously, winning acclaim in all of them.

Warhol never expressed any self-doubts about his importance as an artist, but he also never claimed any particular importance of any of his works. "If you want to know all about Andy Warhol, just look at the surface: of my paintings and films and me, and there I am. There's nothing behind it."[3] His disarmingly unpretentious assertion suggested there were no ulterior meanings, no hidden depths, no hint of anything that would indicate more significance.

But he was determined to make the art world accept him on his terms. Many people would find those terms unacceptable. He repudiated claim to artistic invention by copying grocery labels and cartons, thereby undermining some traditional notions about what constitutes originality in art. He negated the uniqueness of art objects by "manufacturing" virtually identical paintings and sculptures in quantity. He even called his studio a "Factory," implying that he was primarily concerned with mass-production, commerce, and the business of making money.

One of the reasons Warhol remained a charismatic figure for more than three decades was his quirky way of looking at things. He had a lively and resourceful imagination, a restless curiosity, and a skewed sense of humor. He was a journalist's dream, seldom failing to come up with a ridiculous *pensée,* an oddball observation, or a glib, self-mocking put-down. He captures the public imagination with his ready quips such as his widely quoted observation: "In the future, everybody will be world famous for fifteen minutes."

The public Warhol differed considerably from the private one. Though constantly in the public eye, he remained something of an enigma, aloof despite his accessibility. His "official" persona was to a large extent a deliberate fabrication. Many reporters made the mistake of portraying him as a simpleton who talked in a childlike, "gee-whiz" manner that called for cartoon balloons. But Warhol was not as simple as some writers wanted to believe. He clammed up around interviewers, manipulating the session in such a way that he could answer every question with a simple "yes" or "no." From experience he knew that journalists' stories reflected their particular slants and biases. But no matter how inaccurate the reportage, he made no effort to clarify. It was as if he realized all along that legends are based on a cloud of rumors, faulty perceptions, and factual errors.

Warhol practiced at being a mystery. He was always reluctant to divulge any truthful information about himself, perhaps because the actual facts of his life never seemed glamorous enough to him. In public, Warhol projected an easy-going tolerance and an almost saintly willingness to forgive people their worst transgressions. He displayed a nonjudgmental, passive attitude. In the company of others, he was good at concealing his anger, becoming aloof and

2. The artist as alter ego. Christopher Makos's 1981 photograph refers to Man Ray's 1921 portrait of Marcel Duchamp in the guise of Rrose Sélavy.

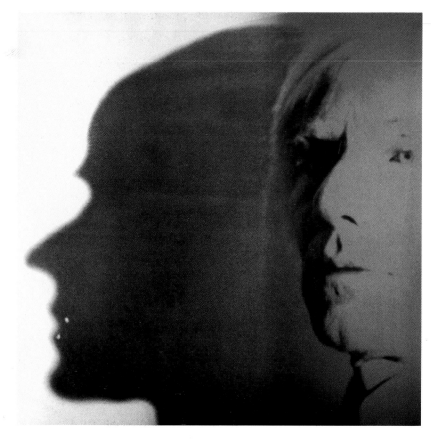

3. The artist as voyeur. *The Shadow.* 1981. Screenprint with diamond dust on paper (edition of 200), 38 x 38″. Courtesy Ronald Feldman Fine Arts, New York

cold. In private, by contrast, he could excoriate "awful" people, condemning their actions and expressing deep, lasting hostility. He was quick to criticize anyone or anything that struck him as "corny," "tacky," or "trashy."

Warhol had an elephantine memory for faces, names, places, and other people's needs and desires. He always remembered the price of things. He was a chronic gossip, spending many hours of each day on the telephone in marathon conversations with friends, but he could also remain as silent and noncommittal as a priest hearing confessions or an analyst, a trait that has led some of his more neurotic hangers-on to "transfer" to him.

He possessed a playful sense of artifice, made most noticeable in his series of hairpieces in various shades of gray, silver, and white, always parted on the left, usually skimming the top of his right eyebrow, and contrasting with the dark fringe of real hair that still flourished around the back and sides of his head. His toupees were fairly naturalistic in the 1950s, increasingly sleek and platinum in the 1960s, and suggested mops of fuzzy plastic yarn by the 1980s. (Had he been born into the eighteenth century, he would have delighted in wearing powdered perukes, which made no pretense of imitating natural locks.) Although some people maintain he was an albino, he lacked the necessary pink eyes; his were a medium gray-blue. In contrast to the rest of his pale face, his fleshy, bulbous nose looked inflamed for many years, because of extensive broken blood vessels. He wore touches of gloss on his face and sometimes eye makeup. He also liked to wear perfume: Chanel No. 5 and Shalimar were among his favorites. In other people's bathrooms, he sampled whatever new or expensive scents were within reach.

Warhol was an advocate of dandyism, though his own wardrobe precluded his being a dandy. His attire was a study in casual eccentricity. In the 1960s, he wore paint-spattered shoes and pants with a leather jacket or, if the occasion was formal, a tuxedo jacket and yellow sunglasses. Because he was sensitive to cold and often worked in drafty places, he wore bright-colored leotards—chartreuse, cerise, and yellow—which showed through the tiny tears in his pants. He also wore panty hose and, after he was shot in the torso, surgical corsets dyed in bright hues. But his outer layer—black pants and turtlenecks—contradicted his florid underpinnings.

Warhol was a galvanizing presence wherever he went. When he arrived at a party, the noise level went up because his entry marked an important climax, signaling to the other guests that this was the "in" place of the moment. He was not voluble and did not "work" the room, but the people who spoke to him always felt they had his undivided attention and access to his witty insights. He regarded most of his social outings as work—command performances for collectors, dealers, and old friends as well as opportunities to hustle new commissions. "Keeping busy, " he said. "I think that's the best thing in life: keeping busy."[4]

During the 1970s and 1980s, he outgrew his raffish entourage, preferring the companionship of the conservative rich, whose wealth dazzled him. "Oh, the Swiss are so rich," he once remarked in a rejoicing tone. "We met the young rich, the young Swiss rich, and they were so sweet. I mean, they were all just so rich and not knowing what to do. Really, really rich and beautiful."[5] Andy was an optimist, indoctrinated with the all-American belief that equal opportunity and hard work provided him with the inalienable right to become rich and famous. He had a fantasy about his own personal wealth: he wanted to walk down the street and hear someone whisper, "There goes the richest person in the world."[6]

Warhol expended tremendous energy in remaining topical, a name in the news. He was obsessed with social dynamics—the ups and downs of who was "in" and "out." Power fascinated him— not the boring diplomatic variety wielded by heads of state, but the petty tyranny exemplified by the strong, silent doormen of Manhattan's hottest discos, who let the elite in without delay while making everyone else wait outside indefinitely. Always alert to new trends and social patterns, he constantly read magazines, movie-star biographies, and the gossip columns in the tabloids.

By redefining the public's perception of what a successful artist could be, Warhol became a role model for younger painters who craved publicity more than the respect of their peers. Success in the post-Warhol art world meant not just feverish acclaim and high prices, but also a fame so pervasive that one's name appears in gossip columns, fashion magazines, and television game shows. These were hardly lofty standards of achievement, but they affected the aspirations of subsequent generations of art students who were less interested in creating serious art than in getting their faces published n the fashion press and living it up in style.

In time, every aspect of Warhol—his personality, his art, his significance—is bound to be reevaluated, but he will still be held up as a mirror of his age. It is entirely possible that no two people will ever perceive the same reflection—he was far too elusive and multifaceted to pin down. Andy himself fretted that one day he would gaze into a looking glass and be as bewildered as anyone else. "If a mirror looks into a mirror," he wondered, "what is there to see?"[7]

Notes

1. David Bourdon, "Plastic Man Meets Plastic Man," *New York*, February 10, 1969, pp. 44–46.
2. Telephone conversation with Andy Warhol, September 26, 1971.
3. Gretchen Berg, "Nothing to Lose/Interview with Andy Warhol," *Cahiers du Cinema in English*, May 1967, p. 40.
4. Berg, "Nothing to Lose," p. 42.
5. Telephone conversation with Andy Warhol, December 7, 1971.
6. Andy Warhol, *The Philosophy of Andy Warhol: From A to B and Back Again* (New York: Harcourt Brace Jovanovich, 1975), p. 135.
7. Warhol, *Philosophy*, p. 7.

"I'd prefer to remain a mystery. I never like to give my background and, anyway, I make it all up different every time I'm asked."

—Andy Warhol[1]

Andy Warhol spent much of his life deliberately obscuring and mystifying his origins in Pittsburgh, yet it was his early years in that city, from 1928 to 1949 and encompassing the Depression and World War II, that helped to shape his values and to influence his later art. He rarely mentioned anything relating to his childhood, and he encouraged confusion about the date and place of his birth. What little evidence now remains suggests a drab youth that was marred by hardship, illness, feelings of inferiority, and perhaps worst of all, at least in his view, a total lack of the glamour that meant so much to him in adult life. Depending on how many years he thought he could erase from the record, he led interviewers to believe that the year of his birth was as early as 1929 or as late as 1933. He acknowledged that he was a native Pennsylvanian, but left it murky as to whether the exact location was Pittsburgh, a nearby industrial town named McKeesport, or even Philadelphia. In any case, according to family members and school records, he was born in Pittsburgh on August 6, 1928.[2] Christened Andrew Warhola, he was the youngest of three sons of Ondrej [Andrew] (1888–1942) and Julia Zavacky Warhola (1892–1972).

Both parents were Czechoslovakian immigrants who came from farming families in Miková, a Carpatho-Rusyn mountain village in the Prešov region of northeastern Slovakia near the Polish border. Ondrej Warhola was one of four children, and the oldest of three brothers. His family owned a large farm and was considered wealthy by local standards. The Zavackys were not so well off; Julia had eight siblings who survived into adulthood and an unknown number who died during infancy. Three of her brothers and two of her sisters emigrated to the United States before her, settling in western Pennsylvania.

Ondrej and Julia were respectively about twenty and sixteen years old when they first met, in either 1908 or 1909. He had already made a couple of trips to the United States, each time to work for an extended period and then to return home with his savings as well as bolts of fine fabric that enabled his female relatives to make dirndls that were the envy of other women in the village.

Julia was carrying a load of wheat in from the fields when she first laid eyes on Ondrej, who was passing the Zavacky house. Mrs. Zavacky called out to him, asking him if he had seen her sons in

4. *Dancers.* c. 1948. Oil on paperboard, 24 1/4 x 24 1/4".
Collection Paul Warhola Family, Pittsburgh

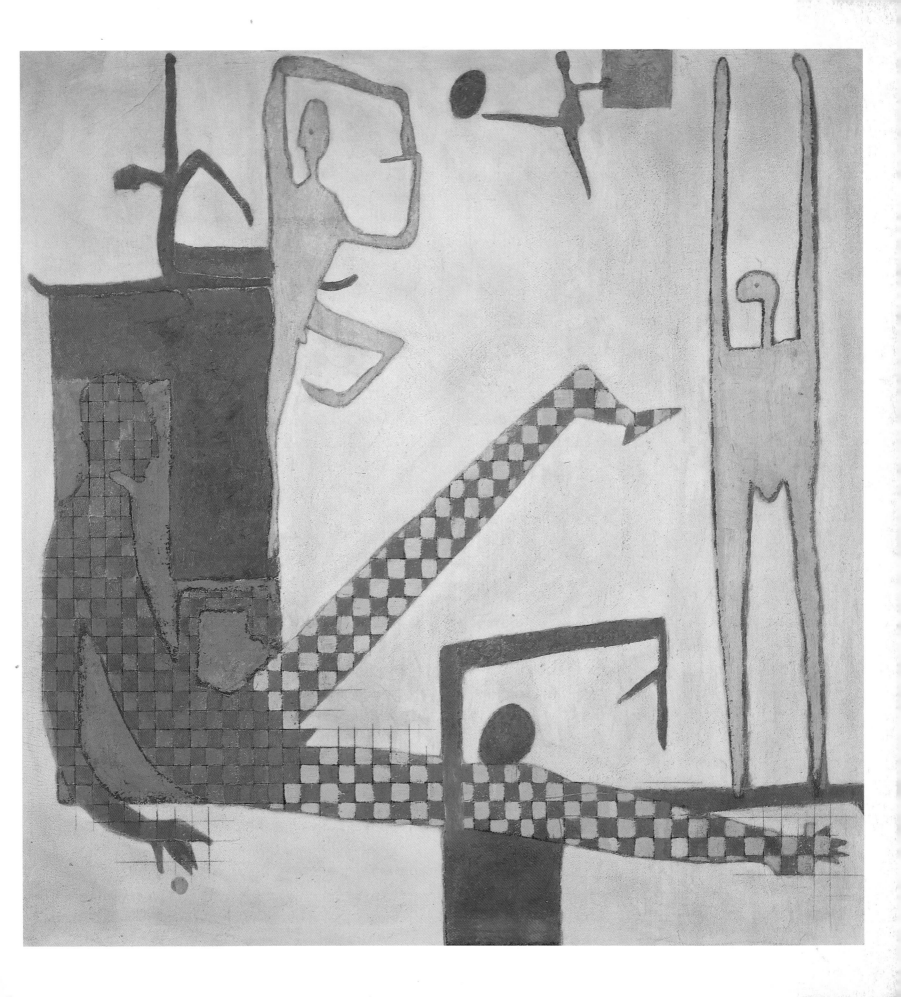

America. Ondrej said yes and, in fact, had been best man at her son John's wedding. Who is this pretty girl? he wanted to know. Mrs. Zavacky laughed and said, "She's going to be your wife." Julia thought him very handsome, with his blond, wavy hair. Every unattached young woman in the village was reportedly after Ondrej, because of both his wealth and good looks.

Ondrej and Julia married in 1909; the wedding festivities lasted three days. Two years later, they had their first child, a daughter whom they christened Josephine. The infant was only a couple of months old when she caught a bad cold. There was no doctor in the village and Julia watched helplessly as her baby grew weaker and finally died.

The growing hostilities in Europe clouded the future of young Ondrej Warhola and his family. Fearing that he would have to serve in the Austro-Hungarian army, one night in 1912, with about one hundred sixty dollars in his pocket, he bade farewell to Julia—they would not see each other again for nine years—and ran the few miles to the Polish border. From there, he made his way to western Pennsylvania, where his younger brother, Joseph, had also settled. Ondrej intended to save enough money to send for his wife as soon as possible. For two years he worked as a coal miner and succeeded in amassing the money, but he was unable to get it transmitted to Miková.

For Julia, the war years brought many hardships. She was then living with Ondrej's parents on the Warhola farm, where she worked long days in the fields, carrying sacks of potatoes on her back. After the death of her father-in-law, her mother-in-law no longer needed her help, so Julia, whose own parents had died, went to work for the parish priest, which enabled her to take care of her two younger sisters. Finally, in 1921, she placed her sisters in the care of relatives, borrowed about one hundred eighty dollars from her priest, and sailed for America to rejoin her husband.

In Pittsburgh, Julia and Ondrej Warhola started a new family, raising three sons—Paul, born on June 26, 1922; John, born on May 31, 1925; and Andrew, born in 1928. The youngest son inherited his mother's looks, while Paul and John more closely resembled their father. Mrs. Warhola characterized Andy as "a wild baby," but "a very, very bright boy" who talked early—"it was a sunny day and he

started to talk, and said, 'Oh, what's that?, what's that?' and I said, 'that's sun'; . . . he loved the sun."[3] The Warhol family resided on Orr Street in the Soho district of the city. Ondrej spoke and wrote very little English; he never signed his name "Ondrej" (pronounced like the French André) but instead Americanized it to Andrew. He made a decent living as a construction worker, employed for nearly thirty years by the Eichleay Corporation as a laborer and rigger on industrial installation jobs in the Pittsburgh area and throughout the eastern United States.

According to his brother Paul, Andy was four years old when he was enrolled very briefly at Soho Elementary School. On his first day there, a girl hit him, upsetting him so much that he refused to go back. In 1934, when Andy was six years old, the family moved across town to a brick row house at 3252 Dawson Street in the South Oakland section of Pittsburgh. As both Ondrej and Julia were thrifty by nature, they were able to buy the house outright with cash. That same year Andy caught scarlet fever, which typically inflames the nose and mouth. (One can't help wondering if this illness somehow contributed to the red-nosed look that afflicted him into adulthood.) Andy started school again, after an emotional protest involving much kicking and screaming, this time as a second grader at Holmes Elementary School. Skipping a year of grade school was not uncommon in those years. In fact, Andy later also skipped the fourth grade.[4]

As a little boy, Andy liked to make pictures, often doing them with his mother's assistance. The youngest Warhola, again according to his brother Paul, was handy with a crayon by age six and displayed considerable talent at sketching by the time he was nine. The brothers often sat at the kitchen table, where they entertained themselves by drawing.[5] Later, like many children, Andy developed a passion for comic books and coloring books. But it was beyond the imagination of anyone in the family that the uncommonly shy boy might one day become a professional artist.

Carpatho-Rusyn, in its Prešov region dialectical variant, was the official language at home. For Mrs. Warhola, English was a fiendishly difficult second language whose grammatical subtleties constantly eluded her. Andy goaded his mother to read the comics to him in English, but her thick accent so mangled the words that he

often couldn't follow the story. (He fully understood his parents' Rusyn dialect but preferred to communicate with them in English.[6])

Religion was a top priority for the Warholas, who raised their children in the Byzantine Catholic faith. Mrs. Warhola was an especially pious woman, who went to mass daily, often sang in church, and regularly took her boys to St. John Chrysostom Church in Pittsburgh's *Ruska dolina* (Rusyn Valley). She instructed the children in their religion and made sure they said their prayers upon arising and before going to bed.

During the early 1930s, Mrs. Warhola supplemented the family income by making fanciful bouquets out of empty tin cans and crepe paper. After removing the lid, she cut the sides of the can into linear patterns that could be bent into stemlike shapes. She then fashioned rounded blossoms out of bright-colored crepe paper and affixed them to the stems. There was no market for such handcraft in the immediate neighborhood, so she walked to the more affluent Oakland area a few miles away, taking two or three of her tin-and-paper creations at a time, and offered them door-to-door for twenty-five cents apiece. (It is an irresistible temptation to consider that Mrs. Warhola's imaginative treatment of food tins and flowers was an artistic influence on her youngest son.) From about 1937 to 1940, Mrs. Warhola did domestic work a couple of times a week for two dollars a day.

At age eight, Andy suffered what he called a "nervous breakdown"—actually Saint Vitus's dance, a disorder marked by uncontrollable spasms. Around this same time his skin underwent a curious loss of pigment, becoming so pale that people would sometimes wonder if he was an albino. Andy spent all summer lying in bed, amusing himself with his comics and coloring books, making paper cut-outs and drawings. Years later, he would say that his mother gave him a Hershey bar every time he finished a page in his coloring book—though this sounds suspiciously like an alibi for his lifelong passion for chocolate.

Even before the age of ten, Andy was showing signs of becoming a movie fan, his first major infatuation being with Hollywood's great song-and-dance child star Shirley Temple, to whom he sent a fan letter. It was a momentous day for the Warhola family when the postman delivered an envelope containing an autographed photograph. The picture was proudly displayed on the living room mantel and remained one of Andy's favorite treasures for years to come. He later became a zealous moviegoer, immersing himself in movie magazines and following the careers of many of his favorite stars.

In 1941, Mr. Warhola's job took him to a West Virginia mine. While there, his wife would later maintain, he drank poisonous water. After his return home, he became jaundiced. His health continued to worsen for about six months. About a week before he was to go into the hospital, he took his son John to the back porch and told him that he probably would not be coming home again. He predicted that Paul, who was then twenty, would get married within a year and that John, who still had one more year of high school to complete, might have to take care of his mother and Andy. He also believed that Andy, because he was so bright, should go to college; to help make this happen, the father had bought postal bonds to cover Andy's tuition for two years.[7] Five days later, on May 15, 1942, Mr. Warhola died, apparently from peritonitis.

For Julia Warhola and her three sons, the hardships of life varied in their detail but never disappeared. Frugal and hardworking, they knew how to stretch a dollar. Fortunately, there was money in the bank. But they owned no car and had to walk to church, school, and stores. Paul, who was still living at home, had been working in a steel mill since 1941 and now became the family's primary wage earner. He married the following year and went into the navy for the duration of World War II. John continued to live at home, working full-time to support his mother and younger brother.[8]

In 1942, Andy enrolled in Schenley High School, about four or five miles from home. He was a good student, considered highly imaginative. His teachers thought him "quiet," "retiring," "very polite," and "colorless and washed out" in appearance. Andy was never an outdoors type, displayed no aptitude for athletics, and was a favored target for the class bullies. He excelled at drawing and, through most of his junior and senior high school years, attended free Saturday-afternoon art classes at the Carnegie Museum of Art. At a school fund-raising benefit for an arts and crafts center, Andy sketched portraits for a dollar each. Even then, his approach was unusual: sometimes he drew faces not with continuous lines but

with a series of dots and dashes. His high school yearbook noted that he was "as genuine as a fingerprint." He graduated a few months short of his seventeenth birthday in 1945, ranked 51 in a class of 278.

One of Andy's high school artworks is a 1942 self-portrait (plate 6), a carefully detailed pencil drawing made when he was about fourteen and signed "Andrew Warhola." Evidently done while scrutinizing himself in a mirror, the drawing presents a sensitive face with large, intently focused eyes, a long nose with a bulbous tip, and fleshy lips. The eyebrows are uncommonly shaggy for someone so young, and the chin is cleft. He was always self-conscious about his looks, especially his pale skin and his excessively reddish nose. Over the years the face would become more angular; the eyes would recede behind prescription lenses, the tip of the nose would straighten out, the lips would thin, and the brow would largely disappear behind a shaggy mass of gray hair. (The seemingly colorless pigment, however, remained the same; he always had to be wary of sunburn because he had the kind of skin that never tans but only turns boiled-lobster red.) Still, the youthful, wide-eyed face in the drawing is recognizably Andy's, and the work—which he gave to his art teacher, Mary Adeline McKibbin—demonstrates that the fledgling artist was a remarkably assured draftsman who possessed an early gift for portraiture. McKibbin, even after she retired as director of art for the Pittsburgh schools, would clearly remember Andy. "His work was unusually sensitive and his line drawings always delicate," she said. "He was quiet, sensitive, intense. In my classes, he seemed to pal with no one, but to become immersed in his work. He was in no way a problem, but hard to know personally."[9]

A few years later, probably in 1945 or 1946, Andy painted a watercolor of the Warhola living room (plate 7). He depicted it as a comfortable, if rather dowdy, interior, conventionally furnished with a sofa, an upholstered chair, and a rocker. The two focal points of the

5. Paul Warhola. *Description How Mother Made Flowers*. 1987. Ink on paper, 11 x 8½″

6. *Self-Portrait*. 1942. Pencil on paper, 19 x 13⅜″. Collection Mary Adeline McKibbin, Pittsburgh

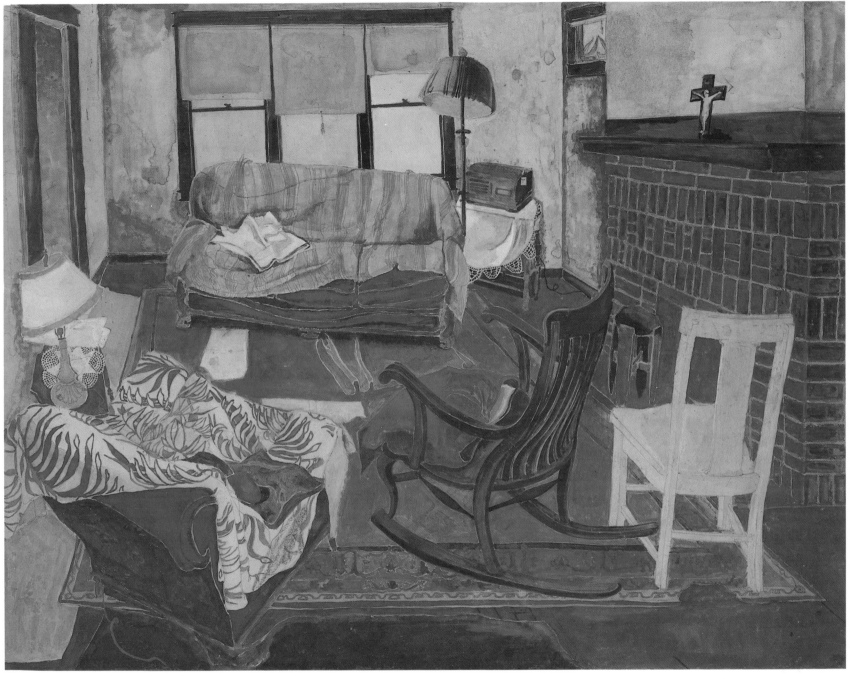

7. *Living Room.* c. 1946–47. Watercolor and tempera on illustration board, 15 x 20″. Collection Paul Warhola Family, Pittsburgh



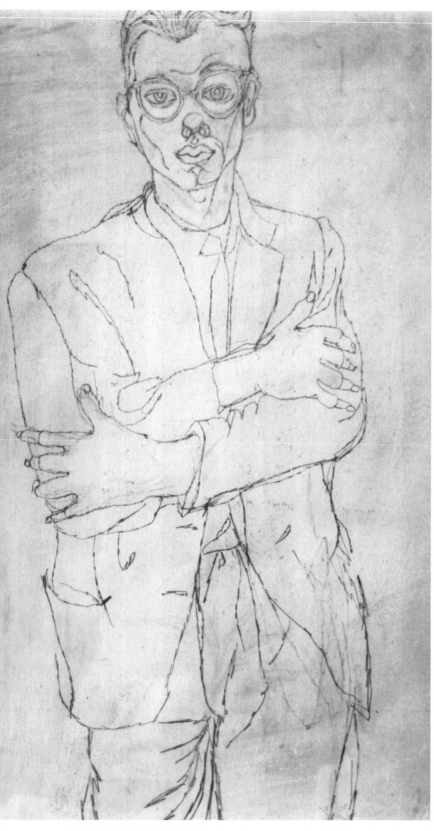

8. *Self-Portrait.* 1948. Pencil and watercolor on paper, 16 x 8⅝″. Collection Ethel and Leonard Kessler, New City, New York

room are the crucifix on the mantel and the table radio in the corner. (The family didn't own a radio until 1939, by which time Andy was eleven.) Andy and his brothers and their mother gathered there, listening to Jack Benny, Baby Snooks, Edgar Bergen and Charlie McCarthy, Dick Tracy, and other broadcasting favorites.

Andy entered the nearby Carnegie Institute of Technology (now Carnegie-Mellon University) in September 1945, his tuition paid for out of his father's savings. Many of the students in his freshman class were returning war veterans, four or five years older than he, attending school on the G.I. Bill. In the eyes of one instructor, the seventeen-year-old freshman "seemed almost like the baby of the class." Andy impressed other students as "quiet" and "nonverbal," and one of his teachers remembered him as a "small, thin boy who had a great talent for avoiding personal contact." But it appears his older classmates, particularly the women, looked after him and helped write his English papers.

Andy majored in painting and design, but most of the courses he took prepared him for a career in commercial, rather than fine, art. The "Carnegie Plan" method of teaching placed great emphasis upon solving specific problems. All the students' completed assignments were hung in a large gallery and evaluated through a process called "judgment," in which members of the faculty moved from one piece of work to another as the teacher explained the assignment. The group then voted on the individual's contribution. "It was always predictable that Andy's work would stir up a row," according to instructor Howard Worner, who had Andy as a student in a course in pictorial design from 1945 to 1946. "Usually, a compromise grade was arrived at, not having enough votes to flunk him, nor enough to give him an 'A.'"[10] Andy came dangerously close to expulsion on more than one occasion. "They were going to flunk me after the first year," Warhol said, "but I created a big scene and cried."

Andy did poorly in academic subjects, and his manner of executing assignments infuriated the instructors. "I was always confronted with the challenge of liking what Andy did," Worner said, "but coping with his inability or refusal to cope with the assignment as presented." On one occasion, Andy allegedly cut a painting into four parts and submitted it as four different assignments. Another

instructor, Robert Lepper, who taught a course in pictorial design, recalled that Andy's work was always provocative and controversial, continually prompting the question, "Should Andy stay or go?" "If anyone would have asked me who was least likely to succeed, I would've said Andy Warhola."[11]

One of Andy's fellow students, Sidney Simon, later an art-history professor, claimed Warhol left Carnegie Tech "the same as he entered. They couldn't teach him anything and he couldn't learn anything. He had his own style and direction from the beginning."[12]

According to classmate Imilda Tuttle, "In his freshman year at Carnegie Tech, Andy painted the way he wanted, and they flunked him. So he went to summer school and painted the way they wanted. In his senior year, he went back to painting his own way and they called him a genius. In a room full of senior paintings, his always stood out. He couldn't put a stamp on an envelope without a developed, individual sense of design. Now his teachers say they always knew he was a genius."[13]

During the summer of 1946, between his freshman and sophomore years, Andy worked with Paul, who was then trucking produce into various Pittsburgh neighborhoods and nearby milltowns. Andy peddled fruits and vegetables from the tailgate of the truck and occasionally sketched neighborhood scenes and portraits, which he sometimes sold to the same customers. His drawings helped win him a scholarship award that covered his tuition at Carnegie Tech for his second year. Afterward, Andy was able to renew his scholarships until graduation.

During Andy's second year at Carnegie Tech, he became friendly with classmate Philip Pearlstein, another Pittsburgh-born artist, who was four years older than Andy. Pearlstein had already completed his freshman year at Carnegie Tech when, in 1943, at age nineteen, he was drafted into the army and sent overseas to Italy. He returned to Carnegie Tech in 1946, when he and Andy were both embarking on their sophomore-year courses. Because of his museum going in Italy, Pearlstein was far more knowledgeable than Andy about art history. But one of the things about Pearlstein that most impressed Andy was that the older artist had had his paintings published in *Life* magazine in 1941. By their senior year, Andy would refer jokingly to Pearlstein as a "has-been."

9. Andy Warhol as a student at the Carnegie Institute of Technology in Pittsburgh. c. 1947. Photograph by Philip Pearlstein. Collection George Klauber, Brooklyn

According to Pearlstein, Andy "would come over to my house to work, because he didn't have enough room at home. There were some nieces and nephews who wouldn't let him work in peace, and they'd destroy his work."[14] Andy and Philip and two of their fellow students, Arthur Elias and Dorothy Cantor, shared a barn-studio on an old estate during the summer of 1947.

If Andy was asked what he intended to do after graduation, he sometimes replied that he wanted to be an art teacher in the public school system. But he began to consider other career possibilities during his third and fourth years at Carnegie Tech, when he worked part-time at the Joseph Horne Department Store. For about fifty cents an hour, he trimmed the store's windows, dressed the mannequins, and discovered that he loved to read women's fashion magazines. They sharpened his sense of style and awakened his lifelong, extravagant admiration for fashion.

Andy's plainly dressed mother, who typically wore a babushka, enthusiastically supported his efforts to earn good grades and money. Her faith in his ability to make something of himself never wavered. "He asks thousands of questions," she would recall at a later date; "he asks here and he asks there, and he asks me... 'Mom, what shall I do, what shall I do now?' and I tell him, 'Andy, just believe in destiny, you will get it in a dream and then you will go off and you will do something, you will do something great, crazy, terrific.'"[15]

During his senior year at Carnegie Tech, Andy joined the Modern Dance Club. He appreciated the fact that ideas, emotions, and stories could be conveyed through body gestures, and his lithe figure was ideal for a dancer. His handmade 1948 Christmas card to a former classmate, George Klauber, portrays five girls in various ballet positions, standing atop small pedestals that carry the words: "Merry Christmas and Happy New Year from André"—his nickname among friends. The humor is typically fey, lighthearted, and whimsical. In a painting made about the same time, *Dancers* (plate 4), he depicted six ultramodern dancers in elongated and unnaturally angular poses, deployed against a monochrome background. Andy displayed the picture in a juried exhibition of the Associated Artists of Pittsburgh. (Someone offered him seventy-five dollars for the painting, but he turned it down.) The exaggerated

10

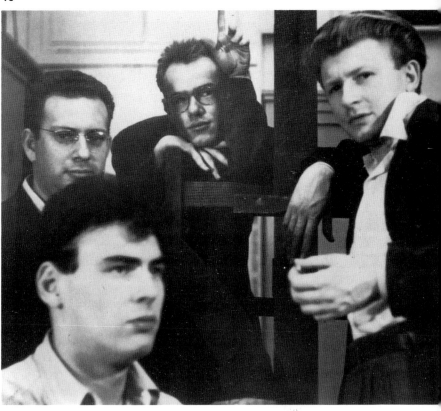

11

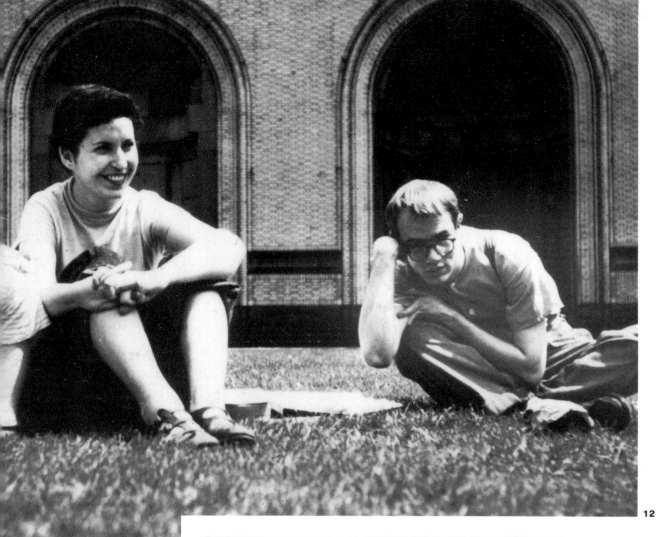

10. Classmates at Carnegie Tech (clockwise from top center): Warhol, Leonard Kessler, Arthur Elias, Philip Pearlstein. c. 1948–49. Courtesy James Warhola, Rhinebeck, New York

11. Andy as a member of Carnegie Tech's Modern Dance Club. c. 1948–49. Courtesy James Warhola, Rhinebeck, New York

12. Dorothy Cantor and Andy on Carnegie Tech campus. c. 1948–49. Warhol's stylized, angular poses reflect his interest in modern dance movement and his determination to draw attention to himself. Courtesy James Warhola, Rhinebeck, New York

13. *Christmas Card.* 1948. Tempera on folded paper, 10⅜ x 20¼". Collection George Klauber, Brooklyn

12

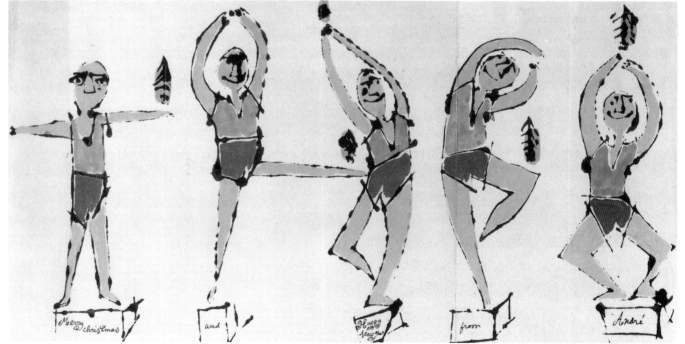

13

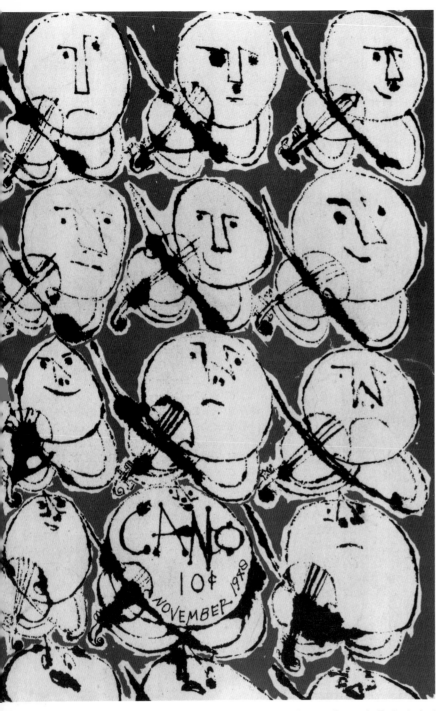

14. Cover illustration for November 1948 issue of *Cano,* a Carnegie Tech student publication. 9 x 6″. Collection George Klauber, Brooklyn

poses correspond to some of Andy's own dancelike contortions in photographs of him taken during that period (plate 12). He knew even then how to steal a scene by assuming attention-getting postures.

Andy's originality and stylishness as a draftsman led, during his senior year, to his appointment as art editor of *Cano,* the undergraduate creative-writing magazine; the position prophesied his future success as a magazine illustrator. His cover design for the November 1948 issue (plate 14) consists of more than a dozen round-faced violinists, arranged in a grid with the collectively raised bows creating an insistent pattern of diagonal lines. The grid format anticipated much of the commercial art he produced in the 1950s and the multiple portraits of Marilyn Monroe that he made in the 1960s.

The *Cano* cover typifies Andy's already distinctive drawing style, which would lead to his early success as a commercial artist in New York. The look, but not the technique, of his ink drawings was evidently influenced by Ben Shahn, a widely renowned artist of politico-social themes throughout the 1940s and 1950s. Shahn's ink drawings, made with a small and narrow brush rather than a pen, were noted for their jumpy, energetic quality, looking as if the rather dry bristles had encountered resistance as they were dragged across the paper. His inked lines are constantly varied in width, occasionally blurred, and often discontinuous, breaking down into serial dots. Andy apparently modified Shahn's nubby line and may even have taken a cue from the latter artist's tendency to portray people with oversize heads and expressionistically distorted anatomy. It is highly unlikely that Andy was unaware of Shahn: New York's Museum of Modern Art mounted a Shahn retrospective in the autumn of 1947 and *Look* magazine selected him as one of America's leading painters in 1948.

As Andy and Philip approached graduation, one of their teachers, painter Balcomb Greene, encouraged them to pursue art careers in New York. The young artists were aware that other Carnegie Tech students had made the same move with success, among them, George Klauber, who had completed his studies at Brooklyn's Pratt Institute and was then working as an assistant to the art director of *Fortune* magazine. In the summer of 1947, Andy and

Philip visited New York and stayed several days at Klauber's apartment in Brooklyn. During spring recess in 1948, the two made a second investigative foray into New York. It was probably inevitable that both of them would soon leave Pittsburgh for good. But Andy, being extremely shy and always dependent upon others, rarely went anywhere on his own and might not have moved to New York if he had not been accompanied by Pearlstein.

Balcomb Greene, through his New York contacts, located a small apartment on St. Mark's Place near Avenue A that the pair could sublet for the summer of 1949. Andy and Philip, each carrying a couple of hundred dollars, boarded a train late one evening to make the overnight trip, arriving at Pennsylvania Station in New York around dawn. As they carried their luggage through the vast terminal, searching for the right exit, they shivered with anticipation at the adventures that awaited them, wondering if they could truly survive as artists in the demanding city.

NOTES

1. Gretchen Berg, "Nothing to Lose/Interview with Andy Warhol," *Cahiers du Cinéma in English*, May 1967, p. 39.

2. Warhol's contradictory birth dates are most frequently given as 1930, 1931, 1932, and 1933. Jean Stein's *Edie: An American Biography* (New York: Alfred A. Knopf, 1982, edited with George Plimpton) reproduces a questionable birth certificate on page 190 that offers the information that Warhol was born on October 28, 1930, in Forest City, Pennsylvania, a date that is reiterated in the Warhol monographs by Carter Ratcliff and Patrick S. Smith. *Pop Art Redefined*, a 1969 catalogue to a London exhibition, claims the artist was born in Philadelphia in 1930. In one of Warhol's own books, *The Philosophy of Andy Warhol: From A to B and Back Again* (New York: Harcourt Brace Jovanovich, 1975), he implies on page 22 that he grew up in McKeesport, Pennsylvania. The artist's two older brothers, however, maintain the family never lived in McKeesport. Records at Carnegie Tech, which Warhol attended from the fall of 1945 through the spring of 1949, show his birth date as August 6, 1928. The artist's brothers concur that this is the correct date.

3. David Bailey, *Andy Warhol, Transcript of David Bailey's ATV Documentary* (London: Bailey Litchfield/Mathews Miller Dunbar Ltd., 1972), n.p.

4. Interview with Paul Warhola, September 24, 1987.

5. Interview with Paul Warhola, September 24, 1987.

6. In the 1960s, when the author frequently telephoned Warhol at home, overheard snippets of conversation indicated that Mrs. Warhola almost always spoke to her son in her native tongue while he replied in English.

7. Interview with John Warhola, September 1987.

8. Paul Warhola eventually became the proprietor of a scrap metal business, while John became an electronics serviceman and then a parts clerk at a Sears Roebuck store. Both brothers remained in Pittsburgh, where they married and raised their own families.

9. Mary Adeline McKibbin had her doubts, however, about her former student's later accomplishments. "His reliance on sensationalism disappoints me," she said in 1972, "but perhaps he is awakening us to the monotonous standardization, mechanical repetition, and garish crudeness of today's life, calling attention to our gods, the products of the supermarket and Hollywood." Margie Carlin, "Andy Warhol...Is He for Real?," *The Pittsburgh Press Roto*, October 22, 1972, p. 18.

10. Kathryn M. King, "Warhol Remembered by Former Teacher," *The Sandpiper* (Long Beach Island, New Jersey), March 4, 1987.

11. Robert D. Tomsho, "Looking for Mr. Warhol," *Pittsburgher Magazine*, May 1980, p. 59.

12. Interview with Sidney Simon, February 1968.

13. Interview with Imilda Tuttle, April 1, 1968.

14. Stein, *Edie*, pp. 185–87.

15. Bailey, *Warhol*, n.p.

"He seemed one of those hopeless people that you just know *nothing's* ever going to happen to. Just a hopeless, born loser."—*Truman Capote* [1]

Almost immediately after their arrival in New York, in the summer of 1949, Andrew Warhola and Philip Pearlstein began making the rounds of advertising agencies and magazines, showing their portfolios in the hope of getting free-lance illustration and design work. Their friend George Klauber had supplied them with the names of several art directors who might be interested in giving them a job. The process of soliciting work was often an excruciating ordeal for shy Andy, who was easily intimidated by impatient art directors and their staffs. But by the end of their first week, Andy, "whose portfolio was stunning and geared towards illustration," according to Pearlstein, "was getting major assignments," while Pearlstein himself "got nowhere as a free-lance artist." [2]

Glamour provided Andy with one of his first magazine jobs. Tina S. Fredericks, the publication's art editor, liked his portfolio so much that she not only gave him an assignment, but also purchased one of his works for herself—*Orchestra* (plate 16), a blotted-line drawing of dozens of string and wind musicians, similar in style to the round-faced violinists he had done for the cover of *Cano*. (It is signed "André Warhola," one of the few surviving works bearing that signature.) Andy's first drawings for *Glamour,* showing shoes and young women upon ladders, were published in the September 1949 issue, accompanying an article titled "Success Is a Job in New York" (plates 18, 19). The full-page opening illustration showed five shoes, positioned randomly on the rungs of two ladders; this was followed on subsequent pages by several drawings of jubilant young women, each perched high on a "ladder of success," including one aerialist/ballerina holding a parasol and balancing *en pointe*. During the next decade, Andy would become New York's most famous illustrator of footwear.

Warhola's name shrunk in his debut appearance in *Glamour,* his shoe-and-ladder illustrations credited: "Drawings by Warhol." While Andy at that time signed most of his name legibly, he let the final "a" trail off as a horizontal line. Someone on the magazine's staff could easily have misconstrued the "a" as a decorative dash and inadvertently omitted it. In any case, the artist decided to retain the truncated name. (By the time he published some illustrations in the February 1950 issue of *Mademoiselle,* he had also dropped the "Andrew" in favor of "Andy" and thus became Andy Warhol.)

15. *Butterflies.* 1955. Hand-colored photo-offset print, 13¾ x 10". Collection Nathan Gluck, New York

26

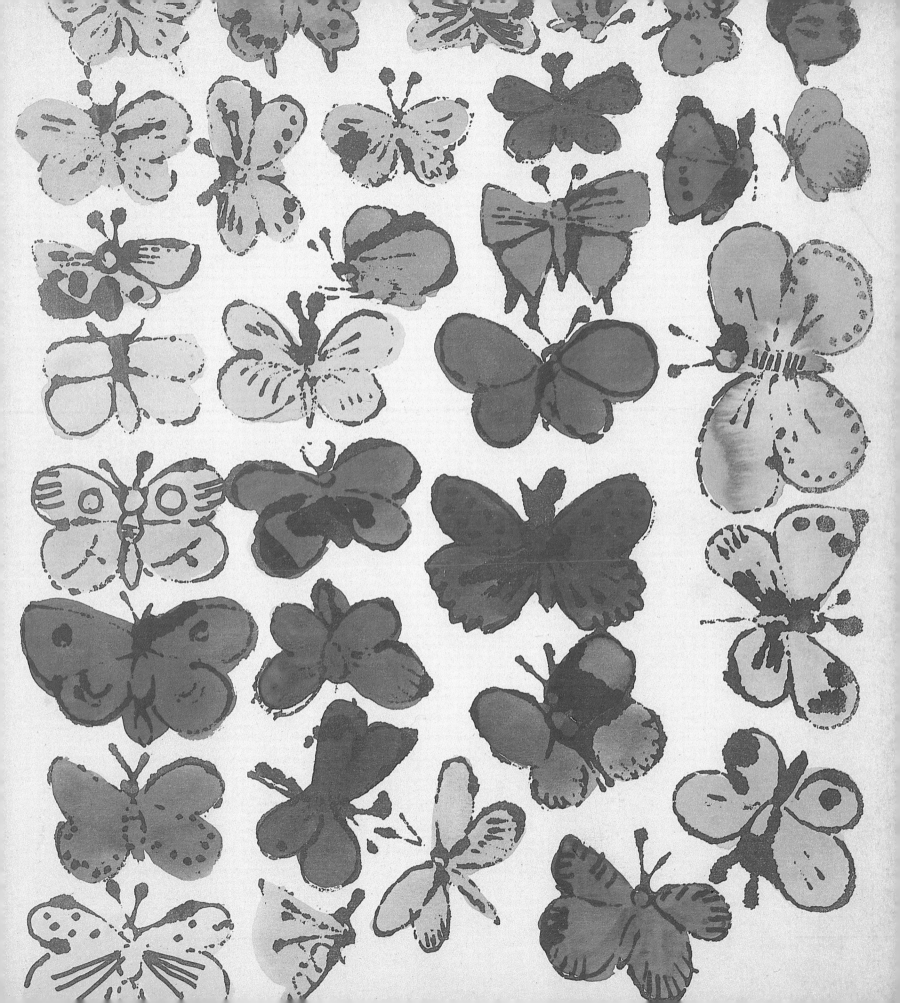

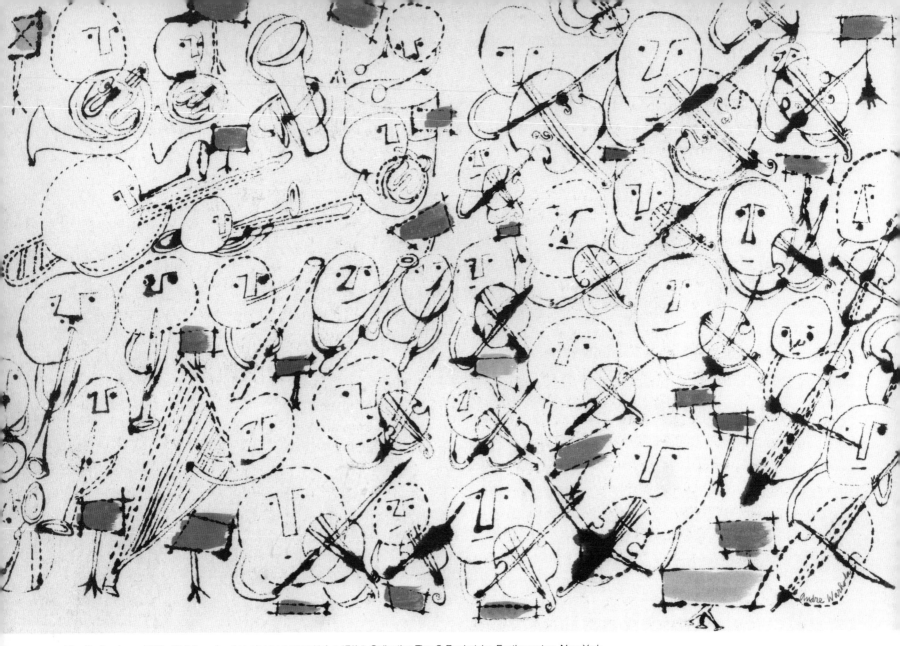

16. *Orchestra.* c. 1948–49. Ink and watercolor on paper, 11¼ x 17¾". Collection Tina S. Fredericks, Easthampton, New York

Andy and Philip spent those early months in New York in a walk-up, cold-water flat with three small rooms just off Tompkins Square Park in a drab, blue-collar neighborhood inhabited mainly by Ukrainians. At the end of summer, when they had to vacate that apartment, they answered an ad in the *New York Times* that led them to a large second-floor front room in a four-story building at 323 West 21st Street in the Chelsea area. The room was amply proportioned, about twenty-five by fifteen feet, with three windows overlooking the street. They sublet the space from Franziska Boas, a modern dancer who lived elsewhere on the premises with an Old

English sheepdog. Boas had turned the rear area of the floor into a theater and studio, where she conducted dance classes. She often rented out the studio to other performers for use as rehearsal space. Technically, no one was supposed to be living on the second floor because it was zoned as commercial space. Therefore, the two artists had to make do without a refrigerator or stove, though they had a hot plate, and share a bath with the dance studio.

Andy set up a table at one end of the room and worked quietly all day and often late into the night on his many commissions, mainly for women's fashion magazines such as *Charm* and

Seventeen. Andy's early success in New York was due in good measure to the originality and expressiveness of the blotted-line drawing technique he had developed in Pittsburgh. His blotted lines appeared to skip and stutter across the sheet in irregular dots and blips, conveying a lively, pulsating energy. The style was at once casual and childlike, lighthearted and droll. Art directors reacted as if they had never seen anything like it.

Warhol achieved the blotted-line effect through a simple technique. He took a penciled drawing and hinged it with tape to a piece of smooth Strathmore board. He then traced several lines of the drawing in ink. While the ink was still wet, he flipped the sheet of drawing paper onto the Strathmore and pressed the design onto it, causing the ink to blot and thereby creating the illusion of spontaneity. Then he would lift the drawing up and continue the process until the whole image had been transferred. (He couldn't blot the whole drawing at one time because the ink dried too quickly.) He never made any corrections or changes along the way, always accepting the "accidents" of his chancy technique. The Strathmore became the final artwork—the "original." If he wished, he could reink the initial drawing and reblot it several times to reiterate the image with variations in the thickness and continuity of the line.

According to Pearlstein, Andy "did several versions of each of his assignments, showing all of them to the art directors, who loved him for that. He studied the printed results carefully for the effectiveness of his work and applied the results of those self-critiques to his next assignments."[3] Andy never sought a full-time office job, being sufficiently confident of his abilities to survive as a free-lance illustrator, even though it meant subjecting himself to the endless whims, indecisions, and rejections of art directors. Pearlstein, by contrast, decided to take a full-time graphic design job, doing layouts and mechanicals for catalogues of plumbing fixtures and ventilators. He spent his evenings at the other end of the room, working on his "serious" paintings, including a small oil portrait of his roommate. (Pearlstein's importance as a realist painter was generally not recognized until the 1960s.)

In their free time, Andy and Philip often went to the movies, catching mostly reruns on 42nd Street, and they bought standing-

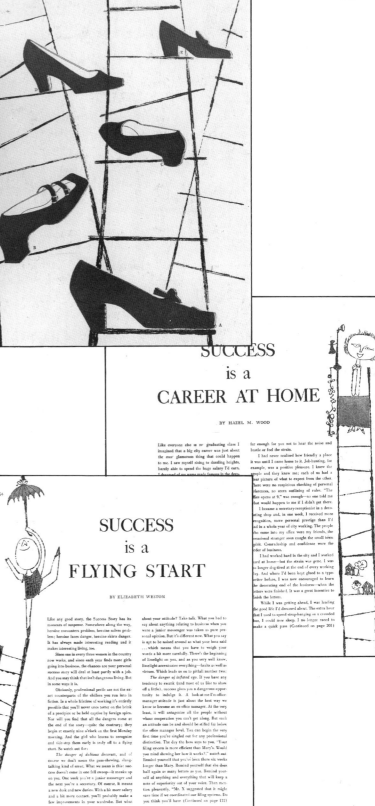

17. Shoe illustration from *Glamour* magazine, September 1949.

18. *Success Is a Career at Home* from *Glamour* magazine, September 1949

19. *Success Is a Flying Start* from *Glamour* magazine, September 1949

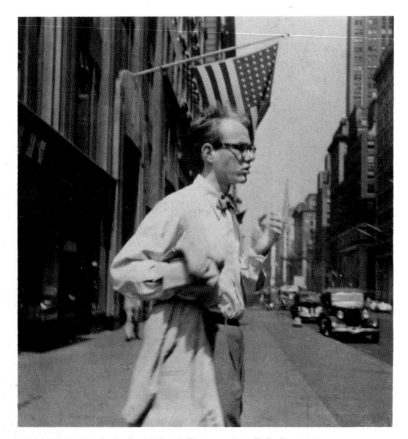

20. Warhol in Manhattan. c. 1948–49. Photograph by Philip Pearlstein

room tickets for several Broadway shows. They went to museums on Sundays. At home, they often listened to Pearlstein's phonograph records, Andy's favorite being William Walton's *Facade* with Edith Sitwell reciting her witty, rhythmically clever poetry.

Andy, despite his sophistication in cultural matters, was still very naive sexually. But he lost some of his innocence after meeting a man who frequented the West 21st Street premises. Conflicting stories portray the man as black and either a building superintendent, who came in twice a week, or a light-fingered dancer who left behind him a trail of missing jewelry. Whoever he was, this man could hardly wait to get his hands on Andy, furtively tickling him all over and trying to maneuver him toward a bed. Later, Andy would claim that he didn't have any idea what it was all about,

but at the time he was clearly upset. On one occasion, he even fled the building and ran to a pay phone to telephone Philip at work—though what he expected Pearlstein to do about the situation is anybody's guess.

In the spring of 1950, just after Boas's sheepdog gave birth to eight puppies in Andy and Philip's room, the two artists, the dancer, and all her dogs were evicted. Andy and Philip went their separate ways. In August, Warhol attended Pearlstein's wedding to their former Carnegie Tech classmate Dorothy Cantor.

By then, Warhol had moved into a large ground-floor apartment at 74 West 103rd Street. Though the telephone was listed under his name ("Warhol Andy artist"), he later maintained that the apartment actually belonged to Victor Reilly, a dancer who split the $125 rent with a constantly rotating cast of young men and women, including several ballet dancers who used the place as a stopover. Andy had once seen Reilly—whom he described as "a beauty, like Tyrone Power"—in a Pittsburgh dance performance. "He needed someone to pay rent," Warhol explained, "so I moved in with him. It was the hardest time to get an apartment." Andy impressed his roommates as a simple, ingenuous young man who needed to be shielded from emotional injury. But his shyness and reticence may have concealed his growing sophistication about affairs of the heart. He was certainly aware that many of the girls and some of the boys who passed through the apartment had a crush on Reilly. Andy particularly noticed one young man, who was desperately in love with Victor—"he had a look in his eye that ate you up." Broken hearts must have fallen right and left when Reilly ended up marrying one of the young women who lived there.

Warhol's communal home life came to an end sometime during the 1950–51 season. According to numerous but unconfirmed rumors, he eluded an enormous phone bill, which probably included costs for calls made by the cast of rotating roommates. By June 1951, he resurfaced at 218 East 75th Street near Third Avenue, where his telephone was listed under Victor Reilly's name. (The dancer apparently lived elsewhere.)[4]

In 1952, Warhol, though still listed in the telephone book as Victor Reilly with the same number, was living next door at 216 East 75th Street in a depressing, mouse-infested, cold-water flat. It was

one of the rare times in his life when he lived alone, and it lasted only briefly. He soon adopted a Siamese cat, to keep the mice on the run and to provide companionship while he worked on his art. Then Mrs. Warhola came to visit and, apparently distressed by the squalor of his setting, decided to stay and keep house for him. Andy thought his mother would miss Pittsburgh, where her other two sons and their families remained, but she adapted surprisingly well to New York. She kept in touch with the rest of her family by making biannual trips home, usually traveling by Greyhound bus.

By the time his mother came to live with him, Andy was getting a wide variety of assignments. Though he had plenty of tasks to keep him busy, he was always on the lookout for new work. According to Imilda Tuttle, who lived in New York during the early 1950s, Andy could be determinedly assertive, developing what she called an "aggressive shyness." She recalled a visit with him to a Doubleday bookstore on Fifth Avenue: "He just stood there and went through every record album, looking for record jackets he liked and jotting down the names of the companies that produced them. Then he went home, called up the companies, and said, 'I'm Andy Warhol, I'd like to do a record jacket for you.' His name meant nothing at that time. But out of the fifteen companies he called, he got maybe six appointments, and out of those, he got to do four or five jackets. He always did things that expressed himself. He did just what he wanted to do."[5]

One way in which Warhol sought to express himself was by illustrating the short stories of Truman Capote, the precocious, award-winning young writer (only four years older than Andy) whose *Other Voices, Other Rooms* had created a literary sensation in the late 1940s. As Capote exemplified a type of celebrity that Andy himself craved, he began to display a most peculiar obsession with the writer. According to Capote, Warhol sent him daily "fan letters," sometimes enclosing drawings. When Capote did not respond, Warhol took to hanging around the author's apartment building and stalking him on the street. A couple of Andy's friends once bumped into him as he loitered outside the Stork Club, and the visibly agitated artist told them he was waiting for Capote to come out. Capote felt ambushed at every turn.

One day Capote came home and was startled to find Warhol

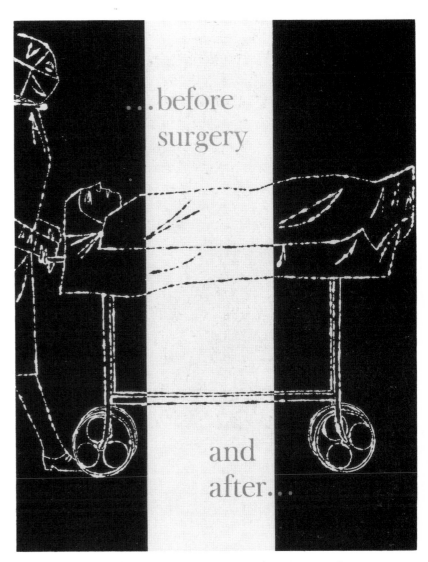

21. *Before Surgery and After.* 1952. Promotional brochure for The Upjohn Company, Kalamazoo, Mich., 10⅞ x 8⅝". Collection George Klauber, Brooklyn

inside his apartment, talking to the author's intoxicated mother. Warhol apparently had approached her on the street and she had invited him in. Andy proceeded to make small talk about himself, his mother, and all their cats. Capote thought his visitor was "the loneliest, most friendless person I'd ever seen in my life." Afterward, Warhol started telephoning Capote every day. Then one day Capote's mother answered and ordered him not to call anymore. "Like all alcoholics, she had Jekyll-and-Hyde qualities," Capote said, "and although she was a basically sympathetic person and thought he was very sweet, she lit into him. So suddenly he stopped writing

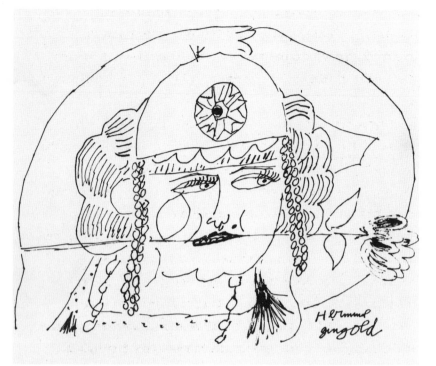

22. *Hermione Gingold.* c. 1953. Ink and brass paper fastener on paper, 8⅞ x 11¾".
Collection James Warhola, Rhinebeck, New York

or calling me." With typically gleeful malice, Capote later observed, "I'm not saying that Andy Warhol doesn't have any talent....But I can't put my finger on exactly *what* it is that he's talented at, except that he's a genius as a self-publicist."[6]

On his own initiative, Warhol went ahead and drew illustrations inspired by Capote's fiction, evidently hoping to get a future commission from the author or his publisher. In May 1952, Warhol brought his "Capote drawings" into the Hugo Gallery on East 55th Street and showed them to the flamboyant proprietor, Alexandre Iolas, a former ballet dancer in his mid-forties who dressed and carried himself as if he were still on center stage. After his retirement from *la danse,* Iolas became an art dealer who championed the European Surrealists, eventually making a fortune in their art, which enabled him to open galleries in several European cities. He liked Warhol's drawings, but was making plans to go to Europe for the summer, so he telephoned David Mann, who worked in the

bookshop upstairs, and asked if he would be willing to keep the gallery open an extra three weeks.[7] Ironically, Iolas would turn out to be the dealer responsible for Warhol's first and last one-man gallery shows during the artist's lifetime.

David Mann also liked the drawings but perceived no hint of future glamour in the thin, disheveled-looking artist. "Andy was one of the plainest boys I've ever seen in my life," Mann said, "a pimply-faced adolescent with a deformed, bulbous nose that was always inflamed. He looked right off the boat. He was very poorly dressed and carried a torn portfolio under his arm." At a later date, Mann would meet Andy's mother, whom he described as "one of the strangest creatures I've ever seen. She's like a domestic, but very nice."[8]

Warhol's exhibition—his first in New York—opened on June 16, 1952, at the tail end of the spring season; the announcement read, "Andy Warhol: Fifteen Drawings Based on the Writings of Truman Capote." During the show, Capote and his nettlesome mother—the latter brought along, perhaps, to fend off the tenacious artist—went to see the work, managing to slip in and out without encountering Warhol. Capote indicated to Mann that he thought the drawings suited his short stories, but he didn't offer to buy any of them. And neither did anybody else.

The drawings reminded critic James Fitzsimmons, who reviewed the show for *Art Digest,* of Aubrey Beardsley, Balthus, Jean Cocteau, Charles Demuth, and Toulouse-Lautrec. "The work," Fitzsimmons wrote, "has an air of preciosity, of carefully studied perversity. Boys, tomboys and butterflies are drawn in pale outline with magenta or violet splashed here and there—rather arbitrarily it seems."[9] Fitzsimmons was right on target in defining elements that would characterize Warhol's works for the remainder of his career. The suggestive subject matter and off-register colors were staples of Warhol's art and became even more evident ten years later in the artist's Pop works.

With his career as an illustrator progressing so well, Warhol began searching for larger living quarters. In 1953, he happily discovered that he could take possession of a floor-through apartment in a four-story building at 242 Lexington Avenue, between 33rd and 34th streets. The apartment belonged to

Leonard Kessler, one of Warhol's former classmates at Carnegie Tech and now an author and illustrator of children's books. Warhol sublet Kessler's top-floor apartment for about a year and then signed a new lease with the landlord. The apartment had two big rooms—one in front, one in the back—a kitchen in the middle, and a bathroom in the rear. Andy set up his drafting table in the front room and shared the back bedroom with his mother. Large stacks of white drawing paper began to pile up everywhere. Much of it was used, but none of it was ever thrown out. Visitors seldom found any place to sit because of the piles of paper. Warhol's work space was limited to a small corner of his table and, under such cramped conditions, he often overturned a bottle of ink. Kessler stopped by one day and helped shift some papers around, unearthing a check for seven hundred dollars that somebody had sent Warhol about six months earlier. Andy was so busy with commercial assignments that he couldn't keep track of his finances.

Before long, Warhol's first pair of Siamese cats, Hester and Sam, had multiplied. With the exception of Hester, all the cats were named Sam. Were there eight, seventeen, or twenty-five cats in the apartment? None of Warhol's friends agrees on the number, but all of them remember the artist and his mother constantly giving away kittens. The cats left messes everywhere, from the drafting table to the bathtub, and soiled Andy's drawings and his mail. The beds were kept covered with plastic sheets. Mrs. Warhola, who providently kept a mop and a bucket of water in the kitchen, was always rushing into action, cleaning up the feline "accidents" as well as the spilled ink. Andy never got angry at the situation. He just accepted it.

Warhol based many of his drawings on published photographs and illustrations, which he used as compositional shortcuts. It was easier to trace human figures from existing images such as photographs in *Life* magazine or to make freehand drawings after nineteenth-century engravings than it was to invent new pictures from scratch. He conducted many of his illustration searches in the New York Public Library's Picture Collection, where he met and befriended Carlton Willers, who then worked there. "Andy came in all the time," Willers said. "He practically lived there, because he was always looking for material and ideas that he could use in his

commercial art." (In fact, Andy was notorious at the Picture Collection for "losing" many of the illustrations he borrowed, preferring to pay the small fine rather than return them.) "Once or twice he said, 'Hello.' Then one day, he said, 'Do you want to go on a picnic?' "[10]

The picnic took place in Central Park—at night. Several of Warhol's friends, including Imilda Tuttle, were in attendance, and the whole affair impressed Willers as very elegant. He liked Andy because "he was tremendously childlike and playful. Then I got to know him better, and I went to his apartment. I was there every single evening after that." Like many of Warhol's friends, Willers often posed for the artist and was given chores that ranged from stretching canvases to hand-coloring drawings. "Perhaps Andy thought his visitors would feel self-conscious unless they had something to do," Willers speculated.[11] Warhol himself maintained that he assigned tasks to his visitors because it kept them out of trouble, preventing them from brooding about their problems.

Warhol's commercial jobs continued to pour in. He was contributing illustrations to practically all of the fashion magazines, including *Mademoiselle, Glamour, Vogue,* and *Harper's Bazaar,* as well as doing covers for *Dance Magazine* and *Interiors.* His work could also be seen in many of the city's fanciest stores: he designed greeting cards for Tiffany & Co., stationery for Bergdorf Goodman, and place mats for the Bird Cage restaurant at Lord & Taylor. He whipped up sketches for album covers for RCA Victor and Columbia records and dust jackets for New Directions, including one with a typically Warholian composition of rows and rows of faces (plate 24) and a suggestively impish cupid with arrow for the cover of *Three More Novels* by Ronald Firbank, the outré English writer and a pillar of camp sensibility. Warhol also devised illustrations for the corporate image-building campaigns of the Upjohn (plate 21) and Rexall companies. He drew newspaper ads for the National Broadcasting Company and created title cards for the prestigious television show "Studio One." For a while, he was even the "hands" on an early morning television weather report, drawing clouds, raindrops, and whatever else the meteorologists predicted.

Art directors showered Warhol with assignments because he

worked fast, met deadlines, and displayed a properly submissive attitude when they demanded revisions. "If they told me to draw a shoe," he said, "I'd do it, and if they told me to correct it, I would—I'd do anything they told me to do, correct it and do it right. After all that 'correction,' those commercial drawings would have feelings, they would have a style. The attitude of those who hired me had feeling or something to it; they knew what they wanted, they insisted; sometimes they got very emotional. The process of doing work in commercial art was machine-like, but the attitude had feeling to it."[12]

Andy cleverly ingratiated himself with almost anyone who was in a position to give him work. He made and gave away numerous personalized artworks, including hand-colored wrapping paper (plate 25), ornately decorated Easter eggs, and whimsical drawings of butterflies (plate 15). This endeared him to art directors, many of whom treasured every drawing he sent their way.

The most noteworthy of Warhol's self-promotional works were the numerous picture books and portfolios that he produced and self-published, often in collaboration with friends. Among the first of these portfolios were *A Is an Alphabet, Love Is a Pink Cake,* and *There Was Snow in the Street,* all made in partnership with writer Ralph Thomas ("Corkie") Ward and published about 1953. *A Is an Alphabet,* "by Corkie and Andy," contains twenty-six loose-leaf pages, each printed with one of Warhol's blotted-line drawings of a young boy or girl and a humorous, three-line poem by Ward about animals ("A was an albatross," "B was a bat," "C was a cricket," and so forth). Most of the pictures show heads in profile or full face and are an early sign of the artist's characteristic style of portraiture, which even then emphasized eyes and mouth (see plates 28, 29).[13]

Love Is a Pink Cake, printed on light-blue paper, celebrates famous star-crossed couples in history and myth, including Samson and Delilah, Anthony and Cleopatra, and Napoleon and Josephine. Ward's accompanying verses are humorously irreverent: "Eurydice loved Orpheus and when she died he raised a fuss, he played his harp and went to hell—it didn't work out very well." Warhol's line drawings are rendered not in his customary blotted technique, but in a neat, evenly inked manner that suggests a stilted neoclassicism. He based his images, as usual, on preexisting printed sources, using an 1846 Currier & Ives lithograph,

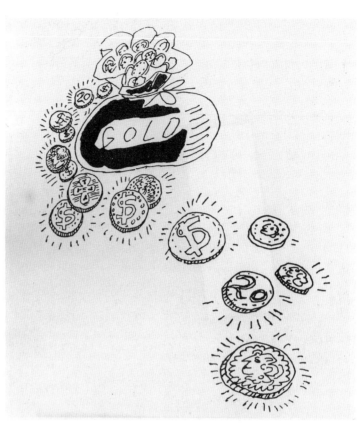

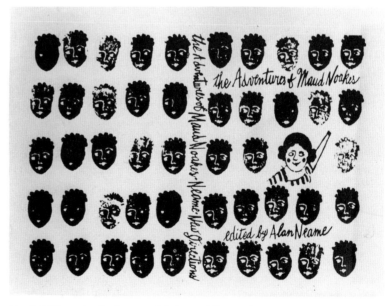

23. *Gold* (illustration for January 1954 issue of *Dance Magazine*). 1953. Ink on paper

24. *The Adventures of Maud Noakes* (dust jacket design). 1961. 8¼ x 12″. Book published by New Directions, New York

25. *Wrapping Paper.* c. 1959. Hand-colored photo-offset print, 28¾ x 22¾″. Collection David Bourdon, New York

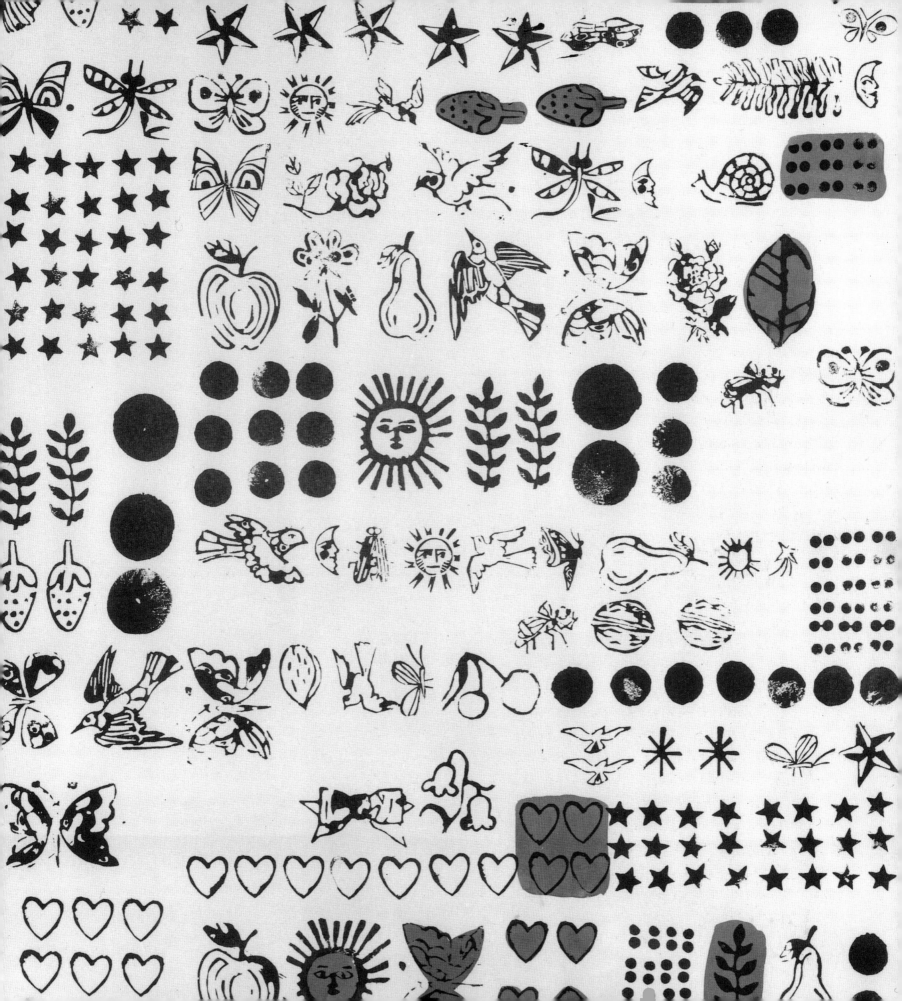

The Lovers' Reconciliation, as the model for his portrait of Frédéric François Chopin and George Sand (plate 30). The bearded young man in another 1846 Currier & Ives print, *The Lovers' Quarrel,* served as Warhol's prototype for the dandy, who was, in Ward's words, "beguiled when he was a little child by the author Oscar Wilde." Instead of slavishly tracing the original compositions, Warhol apparently redrew them freehand, and what he chose to leave out is as illuminating as what he included. In both cases, he totally eliminated the backgrounds and any suggestion of tonal modeling.[14]

Through Vito Giallo, one of his friends in the commercial art world, Warhol was invited to join the Loft Gallery, a modest showroom that existed for a couple of years in the front part of Jack Wolfgang Beck's advertising studio at 302 East 45th Street. Beck, a commercial artist who did a booming business in annual reports and corporate brochures, and Giallo, who worked as his assistant, turned their unneeded work space into a showcase for themselves and their friends. The gallery opened in April 1954 with a group show of eight artists, including Warhol. The following October, Andy had the first of two solo exhibitions there of works on paper. One of those shows consisted of sheets of white Strathmore paper that he had sliced with various straight lines, folding the cut portions outward to create three-dimensional geometric shapes; he had then dipped the projecting parts of the paper into an oil-and-water solution to create a marbleized effect, and finally had drawn a number of boys' faces in pencil. The sheets of paper cut-outs, mounted directly to the walls with pushpins, revealed his playful approach to formal experimentation.[15]

A year or so after Andy and his mother moved to 242 Lexington Avenue, the parlor floor in the same building became available, so he leased it in order to have a place to live and entertain. While the doubled space could be described as a duplex apartment, the two areas were actually separated by the floor in between, occupied by other tenants, so that Warhol and his mother had to use the communal stairway to get from one level of their quarters to the other. The top floor remained the workplace and the domain of Mrs. Warhola and all the cats.

Andy's friends doted on Mrs. Warhola, with her folksy

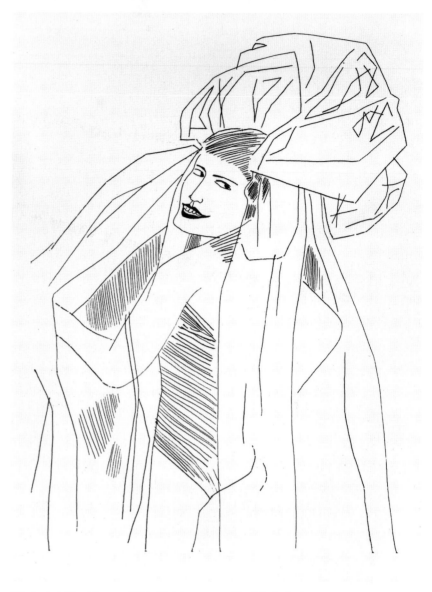

26. *Lady in Headdress.* c. 1954–55. Ink on paper, 17 x 14″. Collection James Warhola, Rhinebeck, New York

babushka, her ever-cheerful smile, her Old-Country manners, her muddled English, and her innocence of all things fashionable. She was almost always looking after her Andy, doing his shopping, making his sandwiches, sorting and mending his clothes, and reminding him to go to church. She seemed to be forever sewing, sending "care" packages to relatives, pouring milk for the cats, and admonishing him and his visitors to "work, work, work." She put up with Andy's food faddisms, sometimes muttering darkly in her native dialect about her son's passion for mashed avocados and chocolates. Her own cooking tended toward mushroom and barley soup and stuffed cabbage. She literally burst into joyous song when

27. *I Love You Clipper.* c. 1954–55. Ink on paper, 17 x 14″. Collection James Warhola, Rhinebeck, New York

28. *X* (detail) from *A Is an Alphabet* by Corkie (Ralph T. Ward) and Andy (Warhol). 1953. Photo-offset print from portfolio of 26 unbound pages, each 9⁹/₁₆ x 5¹⁵/₁₆"

29. *Y* (detail) from *A Is an Alphabet* by Corkie (Ralph T. Ward) and Andy (Warhol). 1953. Photo-offset print, 9⁹/₁₆ x 5¹⁵/₁₆"

30. *Chopin and George Sand* from *Love Is a Pink Cake* by Corkie (Ralph T. Ward) and Andy (Warhol). 1953. Photo-offset print on light blue paper from portfolio of 25 unbound pages, each 10¾ x 8⅜"

CHOPIN SOME SAY LOVED GEORGE SAND,
HE TRIED BUT ONCE TO HOLD HER HAND,
FOR ONCE WAS ENOUGH; THIS LESSON HE LEARNED
IF YOUR GIRL SMOKES CIGARS YOU'RE APT TO BE BURNED

Andy gave her a tape recorder. Inspired by the pop musical team of Les Paul and Mary Ford, whose rich sound was achieved through multitrack recordings of his guitar and her vocals, Mrs. Warhola recorded Czechoslovakian folk songs, then played them back and sang duets with herself.

Mrs. Warhola was an intensely devout woman who kept crucifixes in the kitchen and bedroom and regularly attended mass at St. Mary's Catholic Church of the Byzantine Rite on East 15th Street. Andy's friends, whom he quietly requested never to swear in his mother's presence, seldom saw him going to church, but they noticed that he wore a cross on a chain around his neck and had his own pocket missal and rosary.

They also thought he went out of his way to look sloppy. "The look was early thrift shop," declared Nathan Gluck, a free-lance artist who met Andy in the early 1950s. "He stamped around in deliberately dirty clothes that always looked like he didn't care much about them."[16] "Andy had an innate sense of style and taste," according to Carlton Willers, "but he wanted to appear shabby, like a prince who could afford expensive shoes but couldn't care less and treated them as worthless." Willers insisted that Andy wore only

expensive Brooks Brothers shoes, "but before wearing them out in public, he would spill paint on them, soak them in water, let the cats pee on them. When the patina was right, he'd wear them." His ties, Willers added, were deliberately askew, one end down to his knees, the other end up to his chin.[17] Imilda Tuttle contradicted this story, maintaining that Andy never learned how to knot a tie. "When he couldn't make the ends match up," she said, "he just cut them off. And he always saved them. Eventually he had a whole box of tie ends."[18] As Warhol became more successful, he came under the influence of some of his more dandified friends and splurged on custom-made shirts and suits and Italian shoes.

"Andy felt very insecure about the way he looked," Tuttle said. "He had a pigmentation problem—some complicated thing. He had all kinds of treatments, and he still felt unattractive. He also took eye exercises, so he wouldn't have to wear glasses."[19]

Warhol's increasing baldness was a constant bother. "He had

absolutely no hair on the top of his head," Willers said, "and he was extremely self-conscious about this. He took to wearing a hat everywhere, indoors and out, in theaters and at dinner parties. I told him, 'Andy, this is insane. Other people are confused by this. They think it's either phony or rude. Why don't you buy a wig?' "[20] Warhol eventually bought himself a costly hairpiece in a relatively naturalistic hue and conventional style. But being a connoisseur of artifice, he soon switched to gray hair, which he parted on his left side. It was perverse of course, for a young man to deliberately affect the lanky colorless locks ordinarily associated with old age, but Andy was determined to re-create himself in order to attract maximum attention. Over the years he acquired a great many wigs, all in a spectrum of cool grays that ranged from off-white to light silver. The shy, pale boy from blue-collar Pittsburgh was now conspicuous in any crowd.

NOTES

1. Jean Stein, *Edie, an American Biography,* edited with George Plimpton (New York: Alfred A. Knopf, 1982), pp. 196–97.

2. Philip Pearlstein and others, "Andy Warhol 1928–87," *Art in America,* May 1987, p. 138.

3. Pearlstein and others, "Warhol 1928–87," p. 138.

4. The June 1951 New York Telephone book listed Victor Reilly at 218 East 75th Street. The 1952–53 phone book showed Reilly with the same telephone number, but at 216 East 75th Street. Neither Warhol nor Reilly was listed in the 1953–54 book.

5. Interview with Imilda Tuttle, April 1968.

6. Stein, *Edie,* pp. 196–97.

7. Interview with David Mann, March 1968.

8. Interview with David Mann, March 1968.

9. James Fitzsimmons, *Art Digest,* July 1952, p. 19. A few years later, Fitzsimmons became the owner, editor, and publisher of the Swiss-based periodical *Art International.*

10. Interview with Carlton Willers, March 1968. Willers later became a private art dealer. The library's purloined pictures turned up in the artist's effects more than a year after his death.

11. Interview with Carlton Willers, March 1968.

12. G. R. Swenson, "What Is Pop Art?: Answers from 8 Painters, Part I," *Art News,* November 1963, p. 26.

13. Patrick S. Smith, *Andy Warhol's Art and Films* (Ann Arbor, Mich.: UMI Research Press, 1986, 1981), pp. 44–48, has pointed out that Warhol derived many of the figures from photographs published in *Life,* which, among magazines, was the artist's favorite picture source. The "C" figure, for instance, derives from a tearful young boy pictured in a Curity bandage advertisement in the May 19, 1952, issue, p. 88. The profiled head of "K" is modeled, amazingly enough, after the "last photograph" of President Franklin Delano Roosevelt, published in the November 16, 1953, *Life,* p. 93. The "U" figure is based on a "faltering" tightrope acrobat practicing a drunken-clown routine, as photographed from below in the magazine's March 31, 1952, issue, p. 110. All twenty-six illustrations are reproduced in Andreas Brown, *Andy Warhol, His Early Works 1947–1959* (New York: Gotham BookMart, 1971), pp. 16–19, and Rainer Crone, *Andy Warhol: A Picture Show by the Artist* (New York: Rizzoli International Publications, 1987), pp. 156–61.

14. Both Currier & Ives prints are reproduced in Smith, *Warhol,* pp. 51–52.

15. Interview with Vito Giallo, September 21, 1988.

16. Interview with Nathan Gluck, March 1968.

17. Interview with Carlton Willers, March 1968.

18. Interview with Imilda Tuttle, April 1968.

19. Interview with Imilda Tuttle, April 1968.

20. Interview with Carlton Willers, March 1968.

"**Andy's going to be broke someday. You better be ready to take him in and treat him like one of your own kids."—Andy Warhol's mother, speaking to her other two sons.**[1]

Warhol's easy stride into the top rank of New York illustrators was facilitated by women's shoes. By 1955 he was free-lancing on a regular basis for the I. Miller shoe company, which published his drawings almost weekly in horizontal, half-page ads on the fashion pages of the *New York Times*. I. Miller's in-house art director, Peter Palazzo, was trying to establish a crisp black-and-white graphic style that would give the company "a strong, identifiable image." He had determined that "the art technique should be gutsy," almost like a woodcut. Palazzo's strengths were in design concepts and the overall layout of the ad. "I was able," the art director said, "to add an element in an area where Andy wasn't too strong—composition. Andy and I would discuss the ideas to make sure they were compatible. I would then make design and composition suggestions in rough form and Andy would go off and interpret them in his blotting technique. There were times when Andy would draw the raw elements and I would then compose them by photostatically resizing and rearranging them in the ad space to make a good decorative composition."[2]

Some of Warhol's early I. Miller drawings illustrated actual products. But as time went by, his drawings increasingly became whimsical caricatures of shoes, their stylish swagger exaggerated by gaudy buckles, flamboyant bows, or outlandish ankle straps. He became widely known in the advertising world for these droll interpretations. A 1955 ad, for example, showed portions of three shoes in an ambiguous, disorienting space: the rear half of a high-heeled shoe in left profile ran off the left side of the sheet; the front half of a shoe, also in profile, descended from the top center; and the front half of the same shoe, this time shown in aerial view, cut in from the right side of the page. The three fragments, presented from varying vantage points, were calculated to arrest a page-turner's attention. Even the overall shape of the ads could be eye-catching. On one memorable occasion, I. Miller ran an L-shaped ad so that Warhol's drawing of a woman's calf extended along the full length of the page while her shoe ranged across the full width (plate 33).

"There was a lot *not* to like about these ads," Palazzo said. "The entire shoe industry, as well as the I. Miller sales people, initially hated them because they were used to literal renderings of shoes. But when the ads began to get recognition in the graphics,

31. *Za Za Gabor Shoe.* 1956. Collage of gold foil, embossed silver trim, and ink on paper, 10⅞ x 10⅞".
Collection Suzie Frankfurt, New York

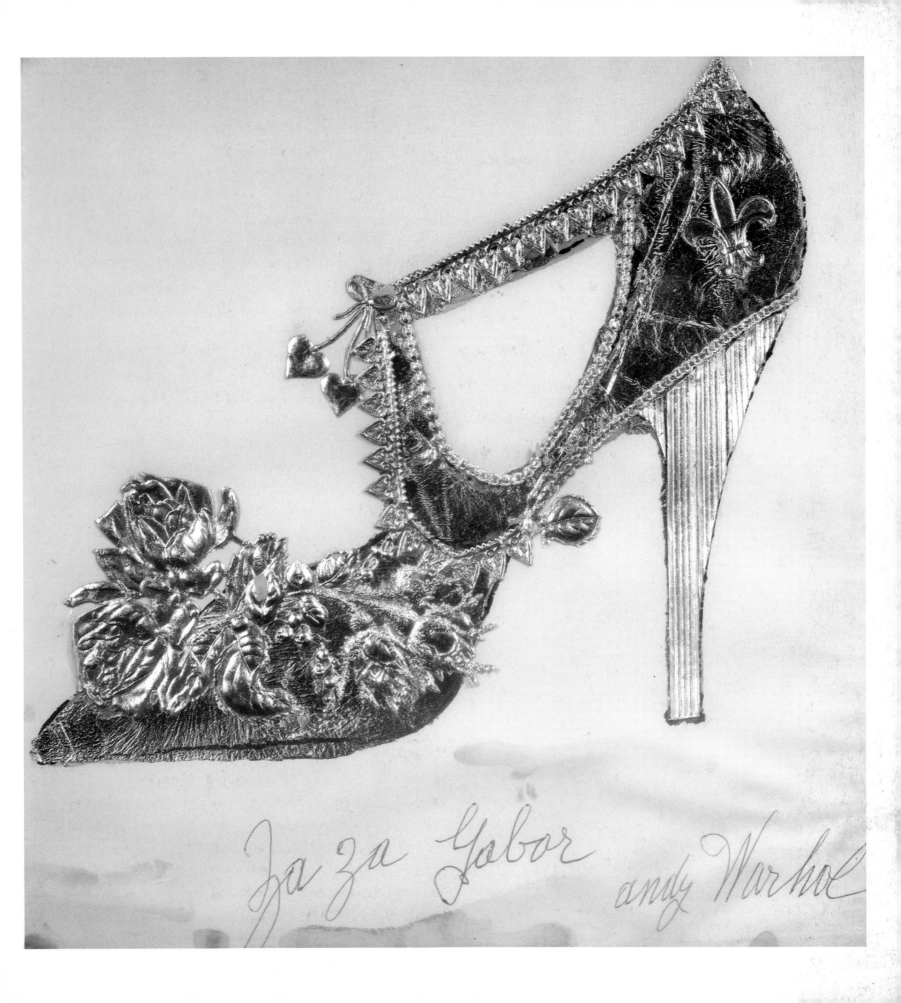

Zsa Zsa Gabor

andy Warhol

New brilliance from our evening glossary: fabulous shoe buckles to light up the perfectionist pump. Just one facet of our glittering collection of dinner shoes and dancing sandals, all as gala as this most festive season. The buckles, on elastic bracelets, jewelled with rhinestones and colored brilliants, from $3.00 to $18.00. Exclusive, of course. I.Miller

New York · Washington · Philadelphia · Baltimore · White Plains · Rochester · Atlantic City · Salons at Abraham & Straus, Brooklyn; L. Bamberger, Newark

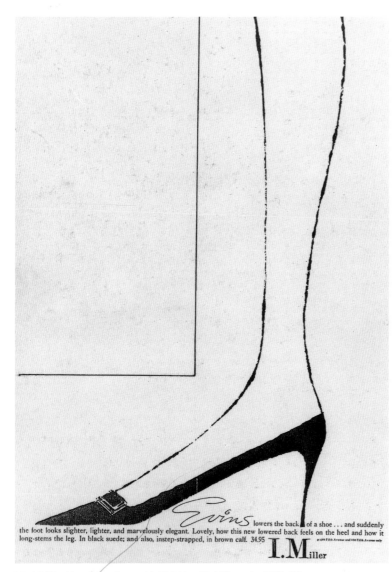

lowers the back of a shoe ... and suddenly the foot looks slighter, lighter, and marvelously elegant. Lovely, how this new lowered back feels on the heel and how it long-stems the leg. In black suede; and also, instep-strapped, in brown calf. 34.95 I.Miller

at 498 Fifth Avenue and 450 Fifth Avenue only

32. I. Miller shoe advertisement, *The New York Times.* c. 1955–56

33. I. Miller shoe advertisement, *The New York Times.* c. 1955–56. The company bought an L-shaped space to insinuate their product amid editorial matter.

advertising, and fashion communities—and customers still came into the store—then management deemed the campaign a success."[3]

Warhol's I. Miller shoe illustrations brought him much attention, propelled him on his route to fame, and won him annual awards from the Art Directors Club—for "distinctive merit" in 1956 and 1957, and a medal, the society's highest honor, also in 1957. *Women's Wear Daily* reportedly dubbed him "the Leonardo da Vinci of the shoe trade." The I. Miller account became Warhol's principal source of income. For several years Andy was on an annual retainer of twenty thousand dollars, earning more after he reached a minimum number of drawings.

Warhol always preferred to be assigned a specific task rather than to be given the freedom to dream up ideas of his own. It was as if his imagination operated most freely within limitations. "I loved working when I worked at commercial art and they told you what to do and how to do it and all you had to do was correct it and they'd say yes or no," Warhol said. "When I think about what sort of person I would most like to have on a retainer, I think it would be a boss. A boss who could tell me what to do, because that makes everything easy when you're working."[4]

Warhol soon became New York's most distinctive and sought-after illustrator of ladies' accessories. His instantly recognizable work appeared in virtually every New York fashion magazine, the *New York Times,* and even the 1954 debut issue of *Sports Illustrated.* An endless procession of shoes, gloves, scarves, hats, handbags, belts, and jewelry passed through the apartment. Andy was so inundated with commissions that he hired a part-time assistant to make some of the preliminary drawings, which he would then amend.

Nathan Gluck came in a few times a week for $2.50 an hour to assist him with his commercial work. Half of the job, as Gluck discovered, was keeping the cats from playing with the accessories. "Andy would tell me whether to draw the objects full face or profile," Gluck said. "I would draw them and Andy would corrèct them and then we would trace them onto a piece of paper that he would ink and blot them onto another piece of paper. That was his technique —the broken dotted line."[5]

Warhol never volunteered information about his use of assistants, preferring to let clients think he was uncommonly prolific. One of his earliest helpers, perhaps the very first, was Vito Giallo, who came in for six to ten hours a week to assist Andy on editorial "spot" drawings, usually rush jobs for magazines. Unlike Gluck, who specialized in the shoes and accessories, Giallo worked only on human figures. After Warhol penciled a drawing on the left side of a sheet of Strathmore, Giallo traced the drawing in ink, then folded the paper to get the blotted final version on the right side. Andy always accepted the blotting, however it turned out.[6]

Giallo helped out for only a brief period in 1955, but Gluck assisted Warhol for nearly ten years. During that time they improvised a number of primitive printing techniques involving hand-carved art-gum erasers and blocks of balsa wood, which they designed with traditionally pleasing images, such as birds, butterflies, stars, sun faces, hearts, strawberries, cherries, and pears. Once carved, the images could be inked and stamped repeatedly for a variety of uses. Part of the appeal of Warhol's work was its seemingly naive, handcrafted look, reminiscent of American folk art.

The favorable response to Warhol's quirky illustrations of I. Miller footgear prompted him to create a series of even more outlandish— as well as brightly colored—shoe drawings for a promotional portfolio titled *A la Recherche du Shoe Perdu* (plate 34). By now, he could find something to satirize in any shoe, and the understated humor that marked his commercial drawings became uninhibited parody in drawings that he did for himself. The portfolio contained thirteen plates within a folded paper wrapper that was illustrated on the front and back covers with dozens of boots and pumps. The drawings, printed one to a sheet and watercolored by hand, profile some stunningly fancy shoes, ornamented with bows, filigree, or floral patterns. Each picture is accompanied by a "shoe poem" by Ralph Pomeroy, another of Warhol's friends, who supplied jokey, one-line takeoffs on famous phrases—"Twenty-three Shoe-do"; "Beauty is shoe, shoe beauty"; "Shoe of the evening, beautiful shoe"; and "Uncle Sam wants shoe!"

All of Pomeroy's shoe poems were painstakingly written out by Mrs. Warhola, who contributed importantly to her son's artistic

34. Cover of *A la Recherche du Shoe Perdu*. 1955. Hand-colored photo-offset print; portfolio with cover (25 x 19"), inside cover, and 14 pages, each 9¾ x 13¾". Collection George Klauber, Brooklyn

success by lettering the words in his drawings, and even signing his name to the finished works in her ornate, Old-Country calligraphy. She wrote a quaint, loopy script, full of flourishes and spiraling serifs. "He always liked his mother's 'Middle Europa' penmanship," Gluck said, "so whenever he was finished with a drawing, he would give it to her and indicate where she was to sign it. When Andy wanted a sentence written, we would write out the words, and then his mother—whose English was not the greatest—would copy it letter for letter. If you wrote, 'the,' and the 'h' looked like a 'b,' she would

make a 'b.'" When Mrs. Warhola's health became too frail in the early 1960s, Gluck started forging her distinctive calligraphy.[7]

To expedite his production of books, portfolios, and other promotional artwork, Warhol had his original drawings reproduced by offset printing. Then he corralled his friends for evening "coloring parties," where everyone helped out by brushing Dr. Martin's dyes onto the printed sheets of paper. Part of Warhol's considerable talent was his never-failing ability to get others to work for free by turning a project into a "fun" occasion.

Andy provided a few guidelines but almost always accepted his associates' improvisations as the sheets were circulated around the table. (He did not like the colors to be filled in too precisely, and he also shunned flat, unmodulated brushwork, preferring a flowing wash that was deeper in some areas than in others; the uneven saturation gave a richness and depth to the color.) Each individual was usually assigned a particular hue—one person, for instance, brushed on the pink, the second filled in the magenta, while the third added the yellow. If the assembly line were interrupted, the proportions and sequencing of the colors might change. The more hues involved, the less likely it was that every version of the same hand-colored drawing would be identical. Andy watercolored some sheets entirely by himself, but it did not bother him if he did not put his own hand to each finished work.

During the mid-1950s, Warhol began frequenting a chic restaurant–general store named Serendipity 3 on Manhattan's East Side. He liked the extravagant desserts and he got along famously with the three smart young men who owned the place. Andy often dropped by in the afternoon, after making the rounds at the ad agencies, and sometimes he'd show the I. Miller shoe drawings that had been rejected. Stephen Bruce, one of Serendipity's co-owners, thought the rejects were often better than the ones chosen for publication and suggested that Warhol sell them through the store,

35. *Paisley Pink Shoe on Red-Stockinged Leg.* c. 1955. Hand-colored photo-offset print, 13 1/2 x 9 3/4". Collection George Klauber, Brooklyn

36. A composite of Warhol's hand-colored offset prints for *A la Recherche du Shoe Perdu.* 1955. In the original portfolio, each illustration is centered on its own page.

The autobiography of alice B. shoe.

Any one for shoes ?

Sunset and evening shoe

Dial M for shoe.

Shoe of the evening, beautiful shoe.

37. Portrait of Stephen Bruce from sketchbook *Playbook of You S Bruce from 2:30 to 4:00.* c. 1955. Ink on paper, 17⅞ x 11¹³/₁₆". Collection Stephen Bruce, New York

which had a style-conscious clientele. Andy thought that was a great idea, so Serendipity had a batch of the drawings framed, priced them between twenty-five and fifty dollars, and sold them off the walls. Before long, the store became known as a showcase for Warholiana, while the artist himself spent so much time there that many people suspected he was a part owner.

One day Andy swept into Serendipity 3 with five or six companions equipped with a stack of the artist's printed butterfly drawings and jars of Dr. Martin's dyes and commandeered a table for an impromptu "coloring party." The group drank cappuccino while hand-coloring the butterflies. "He'd accept every idea that was offered, digest it, and use the best of the suggestions for his benefit," Bruce said. "He was like an ink pad that absorbed everything."[8]

Andy spent the better part of one afternoon in about 1955 filling an entire pad of drawing paper with ink sketches of the store co-owner (plate 37), inscribing the front cover, *Playbook of You S Bruce from 2:30 to 4:00 Andy W.* All the portraits were sketched freehand without corrections, one right after the other. They exemplify Warhol's skill at conveying thoughts and emotions through extremely simple, direct, and clear-cut images—the thoughts and emotions in this case being playfully amorous, doubtless affected by the fact that Bruce was zealously promoting and selling his works.

Bruce observed that Warhol surrounded himself with the most attractive people possible, while at the same time maintaining secrecy about his private life. "If he said he was in love with someone," Bruce said, "he never told you who it was. If he was having an affair, it may have been an affair of the mind. He might have adored the person from afar, truly may have been in love with the person. I don't know if anything was ever consummated, quite honestly, because he was so private, but he did speak of being in love, or going with someone, or being fond of someone."[9]

Warhol never became immune to teenlike infatuations with slim, soft-spoken, clean-cut young men. Although he was far from handsome, he could lay on the charm, and the initially flustered objects of his attention were usually captivated by his oddball personality, droll humor, and skewed imagination. Most of Andy's

romantic longings, however, were directed at unattainable "pretties."

One of Warhol's major crushes in the mid-1950s was Charles Lisanby, a young Kentucky gentleman who worked as a set designer and art director at CBS-TV. They met at a party in 1954 and instantly became fast friends. Andy conducted a public flirtation that Lisanby found intensely flattering. One day he opened the Sunday *New York Times* to discover that Warhol's I. Miller illustration contained lots of little "cl"s. On another occasion, Lisanby passed one of Andy's window displays at the Bonwit Teller department store and saw dozens of "cl"s drawn in poster paint on the inside of the glass.[10]

In the late 1950s, Warhol, in addition to his other design tasks, created occasional displays for a number of stores, including Bonwit's, Tiffany & Co., and I. Miller. The topicality and ephemerality of window trimming held an enormous appeal for him. For a 1955 window display at Bonwit's, Warhol applied his own brand of graffiti to the store's set of specially constructed wood fences (plate 41), which were placed close to the glass so the back walls of the showcases could be painted. (The fences contained cut-out, illuminated niches in which various cosmetics and perfumes were displayed.) Andy embellished the fences with childlike crayon drawings of his usual subjects, including cupids, lips, flowers, butterflies, and a "Happy Bug Day" greeting. But being someone who loved to tease his friends, he added pairs of initials that referred to actual romantic involvements in his circle and also threw in a few telephone numbers of those who might not object to a call from a horny passerby.

Warhol and Lisanby saw each other almost daily and frequently sketched together. Though Andy clearly wanted the relationship to be a little more physical, Lisanby was attracted only to Andy's mind. Warhol firmed up their friendship by making Lisanby his "collaborator" on a hand-colored picture book of cats, published in a hardbound, limited edition.

Andy had produced a couple of dozen blotted-line drawings of cats that he wanted to turn into a book if only he could think of a catchy title. (Although he had an ample number of feline models at home, he based his images on photographs of other people's cats.[11]) Lisanby suggested that Andy call the last drawing in the sequence "One Blue Pussy," and title the book *25 Cats Named Sam and One Blue Pussy.* (There are, in fact, only sixteen Sams in the book.) Warhol declared that was a great idea and credited Lisanby on the title page with having "written" the text. Mrs. Warhola provided the calligraphy, inscribing the names of all the cats. But she inadvertently omitted the "d" on "Named," thereby calling the work, *25 Cats Name Sam and One Blue Pussy.* All the plates, including the one pasted down on the cover, were individually watercolored by Andy and his friends in vivid, fanciful colors—for instance, a green cat with red eyes or a coral face with purple eyes (see plates 38, 39, 40). The *25 Cats* was the first of Warhol's books to be bound, and it remains among the most brightly colored of all his printed works. It was supposedly published in a numbered edition of 190 copies, but Andy was as inattentive to correctly sequenced numerals as he was to the exact quantity of cats named Sam. He inscribed low numbers in copies he gave to people he wanted to impress; several of his most special friends received copies that he identically—and salaciously—numbered "69."

Warhol continued his public flirtation with Lisanby by including several portraits of him in a one-man drawing show that took place at the Bodley Gallery, directed by David Mann and by then located at 223 East 60th Street. The exhibition was titled "Drawings for a Boy-Book by Andy Warhol," and it opened, appropriately, on February 14, 1956—St. Valentine's Day. ("He was always an idea man; every show was an idea show," Mann said.[12]) Warhol's eroticism was fairly explicit in his portraits of good-looking young men. In some cases he had sketched his models as they lay on a bed, usually with their eyes and lips closed. Because their heads rested on pillows, their necks tended to arch backward, exposing their throats. Warhol then turned the finished drawings by ninety degrees, making it appear that his models were upright with their heads tilting backward, as if in a rapturous swoon. He further emphasized their narcissistic sensuality by inserting obvious symbolic devices such as strings of inverted hearts and disembodied lips suspended in space. The "boy-book" drawings differ from Warhol's standard portraiture, which generally turned faces into schematic masks, by suggesting that his sitters possess an inner life. The show was a big success

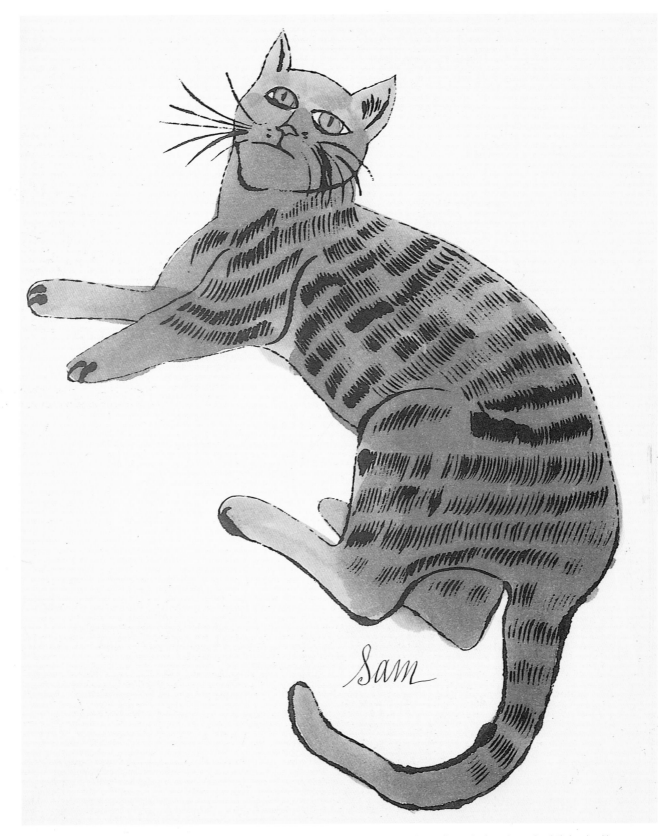

38. *Lavender Sam* from *25 Cats Name Sam and One Blue Pussy.* c. 1955. Hand-colored photo-offset print from bound artist's book with 18 illustrations in an edition of 190, each page 9¹⁄₈ × 6″

Sam

40. *Blue Pussy* from *25 Cats Name Sam and One Blue Pussy.* c. 1955. Hand-colored photo-offset print, 9⅛ x 6″

39. *Pink Sam* from *25 Cats Name Sam and One Blue Pussy.* c. 1955. Hand-colored photo-offset print, 9⅛ x 6″

41. Warhol added droll graffiti to Bonwit Teller's wood fence for a window display of perfume. July 1955

among Andy's friends, but, for reasons unknown, the drawings were not reproduced in book form.

Some observers detected a touch of Jean Cocteau in the "boy-book" drawings, but the implied influence is questionable. Warhol was indeed familiar with the Frenchman's sleek, erotic drawings of narcissistic male nudes and reportedly admired them. The similarities in their draftsmanship consist mainly of spareness, simplicity, and the omission of unnecessary detail. But Cocteau's more fluent line was essentially neoclassical, evoking ancient Greek vase-painting (as well as Picasso and Matisse), while Warhol's draftsmanship aspired to be "naive" and idiosyncratic. Cocteau's main importance for Warhol was probably as a role model. Though the two never met, Andy was certainly aware of Cocteau's reputation as a sometimes scandalous, always glamorous

celebrity-artist who excelled in several creative fields, most notably literature and filmmaking.

Another of Warhol's role models was Cecil Beaton, the ultrachic English portrait and fashion photographer, writer/diarist, and costume and set designer. Beaton, like Cocteau and Truman Capote, had made his debut as a cultural celebrity at an uncommonly early age. All three were dandies in an age of mass culture. They were also diligent snobs, social climbers, and self-promoters with a shrewd sense of just how far to parade their affectations. As aesthetes for whom style was nearly all, they deliberately set out to amuse, innovate, and provoke, and they succeeded in appearing outré while simultaneously finding acceptance among the most conservative elements of society.

Warhol admired and envied this multitalented trio and modeled himself to varying degrees upon them. Like Cocteau and Beaton, Andy eventually would establish himself as a versatile "jack-of-all-arts" whose interests ranged from painting and photography to theater and film and to fashion and high society. Beaton's celebrity portraits and Capote's literary profiles of the "in" crowd helped inspire Warhol to exploit his own skills as a portraitist in order to infiltrate the lives of the rich and famous.

Because Andy felt a kinship with Beaton and eagerly wanted to meet him, he was thrilled to discover that his dear friend Charles Lisanby was suddenly seeing a lot of "Cecil." Beaton, then in great demand as a theatrical designer because of his work on the Broadway musical *My Fair Lady*, had engaged Lisanby to assist him on the scenery for a couple of productions, *The Little Glass Clock*, a flop play of 1956, and Samuel Barber's opera *Vanessa*, which had its premiere at the Metropolitan Opera in January 1958. "Andy was after me for a long time to introduce him to Cecil," Lisanby explained, "but when you work for people like Cecil, you protect them—even from your own friends."[13] Lisanby made Warhol wait nearly two years before he finally relented and brought Andy to one of Beaton's cocktail parties. Warhol established a cordial relationship with the celebrated Englishman, maintained mostly at other people's parties.

Warhol's prestige as an artist went up a notch in April 1956, when one of his shoe pictures was included in a large survey

exhibition, "Recent Drawings U.S.A.," at The Museum of Modern Art. This was the first time any of his works had been exhibited in a New York museum. The experience apparently emboldened him to try joining the Tanager Gallery, one of the most prestigious of several artists' cooperatives on East 10th Street, then a hotbed of emerging talents. He approached his old friend Philip Pearlstein, a member of the Tanager, and sought his help in gaining acceptance in the co-op. But his subject matter backfired. "He submitted a group of boys kissing boys which the other members of the gallery hated and refused to show," Pearlstein said. "He felt hurt and he didn't understand. I told him I thought the subject matter was treated too... too aggressively, too importantly, that it should be sort of matter-of-fact and self-explanatory. That was probably the last time we were in touch."[14]

Andy survived his humiliating rejection from the Tanager and, with his substantial income from I. Miller shoe drawings, was so well-heeled that he could afford to tag along on Lisanby's around-the-world trip in the summer of 1956.[15] In June, the two flew from San Francisco to Japan (where they ordered custom-made kimonos), Taiwan, Hong Kong, Indonesia, Cambodia, Thailand, and India. Andy, though only twenty-seven, was so secretive about his age that he never let Lisanby hold his passport, which identified him as "Warhola."[16] In Calcutta, Lisanby came down with a fever, so they flew directly to Rome. After Lisanby recuperated, they headed north for Florence. Charles prodded Andy through virtually every church and museum, and the latter made a determined effort to appear thrilled by all the great art and architecture. But confronted with a Botticelli or a Michelangelo, Andy's stock response, "Wow" or "Great," was articulated without much conviction. Warhol and Lisanby went on to Amsterdam, Paris, London, and Dublin, arriving back in New York a week or two earlier than planned.

After his return home, Warhol prepared a set of whimsical shoe drawings for his second show that year at the Bodley Gallery. The exhibition, which opened on December 3, 1956, was titled "Andy Warhol: The Golden Slipper Show or Shoes Shoe in America," and it contained a series of works on paper in which he fantasized extravagant footgear for celebrities. (The drawings ranged in price from $35 to $150.) Although his flamboyant designs continued in

the zany vein of *A la Recherche du Shoe Perdu*, he created the new works in Dutch metal, an imitation gold leaf, and trimmed them with a variety of commercially produced, embossed gold-foil cut-outs in the shape of stars, grape clusters, cupids, and hearts.

The drawings included an oversized, sensibly low-heeled pump for Kate Smith, whose stalwart calf extends across two sheets of separately framed paper; a buccaneer's boot for Elvis Presley; a long, sleek slipper for Julie Andrews; a plant-sprouting shoe for Truman Capote; a Western boot with spur for James Dean; and a spike-heeled, ankle-strapped shoe bedecked with frilly hearts and flowers for Zsa Zsa Gabor (plate 31). These six drawings were reproduced in the January 21, 1957, issue of *Life* magazine, which published an article on two facing pages, titled "Crazy Golden Slippers."[17] The tone of the piece was light and humorous and made no special claims for Warhol's art. The subtitle was "Famous people inspire fanciful footwear." In fact, the opposite was true. Warhol designed the shoes first, then chose the celebrity who seemed most appropriate. If the shoe fitted, the name wore it.

Gold, real or ersatz, fascinated Warhol for the wealth that it represented as well as for its glitz. During 1957, he self-published still another promotional item, this one with the alluring title *A Gold Book*. It was a forty-page bound volume, published in an edition of one hundred, and dedicated to "Boys/Filles/fruits/and flowers/Shoes/and tc [Ted Carey] and e.W. [Edward Wallowitch]." Most of the nineteen plates were printed on gold paper, but six were on white paper, a number of them hand-tinted and overlaid with colored tissue. According to Lisanby, Warhol got the idea of printing black ink over metallic gold paper in Bangkok, where he saw gold-leafed furniture that had been lacquered with black designs. Although this book was a more opulent production than *A la Recherche du Shoe Perdu* and *Twenty-five Cats*, the drawings were relatively insipid. Among the strongest images are a portrait of James Dean (plate 45), a young man's face with a long-stemmed rose between his lips, and a rear view detail of a male nude. That December, Warhol exhibited the illustrations for the book and related drawings in his third exhibition at Bodley, "A Show of Golden Pictures by Andy Warhol." His striking full-length portrait of a youth in underwear, *Golden Boy* (plate 43), probably dates from this period.

42. *Lady on a Rooster.* 1957. Gold foil, watercolor, and ink, 24¾ x 18¾". Collection John Rombola, New York

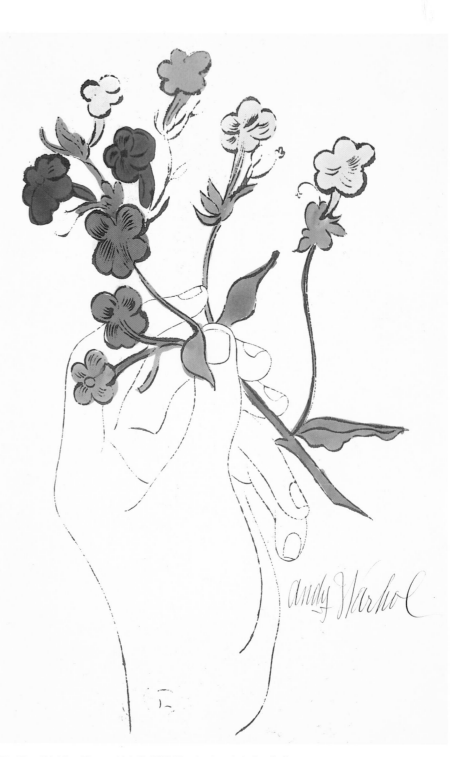

44. *Hand Holding Flowers* (detail). 1957. Hand-colored photo-offset print, 20⅝ x 14¾". Collection Nathan Gluck, New York

43. *Golden Boy* (detail). 1957. Ink and gold leaf on paper, 97 x 35⅝". Collection Erich Marx, Berlin

45. Jacket of *A Gold Book by Andy Warhol* (James Dean). 1957. Photo-offset print on gold paper from the artist's bound book with 18 pages, edition of 100, 14½ x 11½″

46. *Golden Nude.* 1957. Ink and gold leaf on paper, 20 x 16″ (51 x 41 cm). Courtesy Thomas Ammann Fine Arts, Zurich

Many of the *Gold Book*'s innocuous images of children were based on photographs by Edward Wallowitch, a sensitive and empathetic young man from South Philadelphia whom Warhol had met early in 1956 through Nathan Gluck. Andy and Edward became good and close friends and their intimacy soon blossomed into a passionate relationship. After going out together to movies and dinners, Andy often stayed overnight in Edward's apartment. Sometimes they made excursions to Philadelphia. As Andy liked to keep his favorites close to him by suggesting artistic collaborations, Edward inevitably ended up taking many photographs especially for him. In October 1958, Wallowitch, already an alcoholic at age twenty-six, suffered a full-blown breakdown. His brother John, with whom he shared an apartment, thought he needed to be hospitalized for a couple of weeks but could not afford the cost. John (who later would become a noted songwriter, pianist, and cabaret performer) approached Andy, who appeared to be doing so well financially, and asked for five hundred dollars so his brother could get some treatment. "I'll have to call you back," Warhol said; but when he did call back, it was to say: "My business manager won't let me do it." "I never told my brother that Andy refused to give me the money," John Wallowitch said, "because I didn't want to spoil their relationship."[18]

47. *Face with Foot.* c. 1956–57. Ink on paper, 17 x 14″. Collection James Warhola, Rhinebeck, New York

48. *Feet with Candlesticks.* c. 1956–57. Ink on paper, 17 x 14″. Collection James Warhola, Rhinebeck, New York

Warhol did not enjoy relationships that hindered his career, and he was in any case busy planning other shows and books. He wanted to follow up the success of his Golden Slippers exhibition with a book of drawings of celebrities' feet. He wrote to many notable people, seeking appointments, and reportedly succeeded in sketching the most pedestrian parts of Broadway legend Tallulah Bankhead and opera singer Leontyne Price, among others, but he apparently did not bag enough big names to bring the project to conclusion. He did succeed, however, in persuading Cecil Beaton to bare both feet and to pose with a long-stemmed rose between his toes.[19]

Meanwhile, Warhol parlayed his reputation as a sophisticated draftsman into a manipulative, but surefire way to get attractive young men to strip for him. He experienced little resistance in prodding several friends, including Carlton Willers, Charles Lisanby, and art director Reid Miles, into posing for full-length nude studies. Andy's approach could be both flattering and suggestive. Whenever he met a good-looking youth, he would say, "I could use you. I want to draw your feet." He filled whole sketch pads with foot drawings, often in erotic, if incongruous, juxtapositions with other anatomical parts. In one picture, *Face with Foot* (plate 47), a serious-looking young man casts an alert, sidelong glance in the direction of

49. Illustration from *In the Bottom of My Garden*. c. 1958. Photo-offset print from artist's bound book with 20 pages, some of them hand-colored, edition of 50?, pages 8⅝ x 11¼″.

a person to whom he studiously gives a sort of oral pedicure. In another suggestive drawing, *Feet with Candlesticks* (plate 48), a pair of bare feet is deliberately juxtaposed with animal-paw candle holders; in case anyone doubts that the atmosphere is charged with a combination of inebriation and satyriasis, the spent candle and wax dripping imply the successful resolution of a phallic enterprise.

Then, as Warhol became more brazen, he badgered his male acquaintances into baring their genitals, maintaining that he wanted to sketch them for a proposed book of "cock" drawings. He must have filled up a large series of sketch pads, because virtually all his pals claim to have posed for him. The drawings were prissy, rather than coarse, and distinguished by his arch humor. He occasionally delineated a neatly tied ribbon around the male member or accessorized it with free-floating hearts. While it may be amusing to picture him as a scholarly typologist, it is far more likely that Andy was essentially a voyeur who relished the delicious anticipation of getting an unobstructed view of other men's private parts.

In December 1958, Warhol favored Serendipity 3 with a show of drawings from his latest book, *In the Bottom of My Garden* (plates

49, 50).[20] (The restaurant-store had recently moved to 225 East 60th Street, right next door to the Bodley Gallery.) The title was inspired by a 1917 song, "There Are Fairies at the Bottom of Our Garden," which English music-hall star Beatrice Lillie frequently sang on her United States tours, to the delight of her fans. The book contains twenty-one plates, including the cover, mostly watercolored by hand, of mischievous cupids and elves in suggestive, compromising positions. Warhol based some of his drawings on *Les Jeux et Plaisirs de l'Enfance* (Paris, 1657), a set of seventeenth-century engravings by Jacques Stella, showing chubby naked boys innocently playing games. One of Stella's prints depicts a pair of boys playing *la charrue* ("the plow," or what Americans would call "wheelbarrow"), with one child walking on his hands while his legs are held by a playmate who walks behind. Another print has boys playing *le pet en gueule*, a curious game that appears to involve breaking wind in one another's face; three figures do handstands, supported by three standing playmates. In Warhol's version, the sportive children have become glad-eyed, small-winged cherubs; while the poses are close to those in the prints, there are now gleefully perverse innuendos of sexual acrobatics. Warhol derived other images from the flower-women of Jean-Ignace-Isidore

50. Illustration from *In the Bottom of My Garden*. c. 1958. Hand-colored photo-offset print, pages 8⅝ x 11¼″.

51. Three-panel screen. c. 1956–57. Paint on wood, 64½ x 51″. Collection Suzie Frankfurt, New York

Grandville, the nineteenth-century French illustrator of *Les Fleurs Animées* (Paris, 1846).[21] In addition, Lisanby claimed that some of Warhol's drawings were inspired by a British children's book—*Flower Fairies of the Autumn* by Cicely Mary Barker—that Andy bought during their stopover in Amsterdam. Despite his varied sources, Warhol clearly succeeded in giving his "fairy" book an exuberant and unified style, making it one of the sprightliest and "naughtiest" of his publications.

While assiduously advancing his own career, Andy also promoted his mother as a naive artist, a sort of calligraphic counterpart to Grandma Moses. Because Mrs. Warhola was frequently moved to make portraits of cats, he encouraged her to do a set of drawings in her own ingenuous style. She would complain later that he was a harsh taskmaster; she'd be "so tired," but he'd insist "you have to get up and do another pussycat." He published her drawings under the title *Holy Cats by Andy Warhol's Mother* (plates 52, 53). (Andy typically took top billing.) Warhol, whose early portfolios were inexpensively assembled, could now afford higher quality binding, and he had his mother's ink sketches reproduced on variously colored paper stock. The sewn-bound volume had a cover image of three handcolored angels over a dotted-line cat and a touching dedication within: "This little book is for my little Hester who left for pussy heaven." Many of Mrs. Warhola's celestial felines appear to be outfitted with tiaras rather than halos. Each drawing is captioned with a short sentence, such as "Some angels up there love her," followed on the next page by a retort such as, "Some don't."

Mrs. Warhola's ornate calligraphy inspired Reid Miles to commission her to design a record jacket for *The Story of Moondog* (Prestige Records) in 1958. (Moondog was a famous sidewalk character—and blind composer—who prominently positioned himself along the Avenue of the Americas and nobly accepted alms, while wearing an incredible getup consisting of a hooded robe and a twin-horned headpiece.) In fulfilling the task, Mrs. Warhola spent an entire evening writing and rewriting sixteen lines of copy, but her script tended to go uphill and get progressively smaller. "Instead of covering the whole space, she would write the text so that it took up only the top two inches," Nathan Gluck

52, 53. Julia Warhola. Two pages from *Holy Cats by Andy Warhol's Mother.* c. 1957. Limited-edition book with offset drawings on colored stock, 5½ x 8¾". Collection Betty Lou Davis, New York

Purr Purr Purrr... (repeated throughout)

Andy Warhols
Mather

54. Julia Warhola. *Cat Lying on Side.* c. 1956. Ink on paper, 16 x 20″. Collection Betty Lou Davis, New York

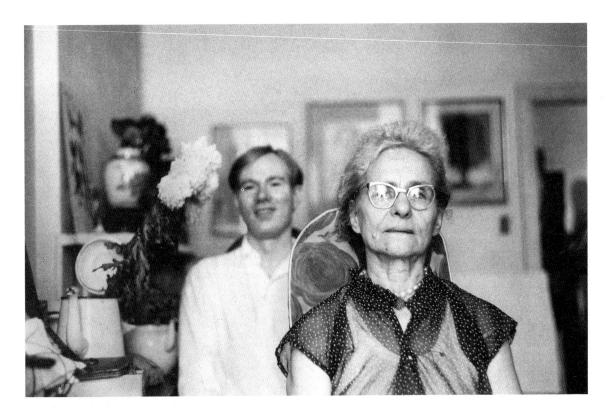

55. Andy Warhol and his mother in their apartment at 242 Lexington Avenue. 1958. Photograph by Duane Michals

recalled. "Andy finally convinced her to write it all out and then he cut it up and spread it out over the whole space."[22] For her efforts on the Moondog jacket, Mrs. Warhola won an Art Directors Club award—inscribed "Andy Warhol's Mother."

In his private life, Andy continued the overhaul of his personal appearance. Tired of being embarrassed by his nose, he consulted a doctor who reportedly advised him to do something about it quickly or it would get worse. Some of Andy's friends thought his nose looked so swollen and inflamed that it made him resemble a distant relative of W. C. Fields, and there was even talk that it might have been caused by too much drinking. In 1957, Andy checked into St. Luke's Hospital for a skin-planing operation that, by his own account, involved having "frozen stuff" sprayed all over his face. "Then they take a sandpaperer and spin it around all over your face. It's very painful afterwards. You stay in for two weeks waiting for the scab to fall off. I did all that and it actually made my pores bigger. I was really disappointed."[23] "Frankly," Nathan Gluck noted, "there was no change. And frankly, Andy's nose was not as bulbous or awful as everyone says. One sees worse noses."[24]

With his expanding income, Warhol indulged himself as a collector. He was chronically, almost neurotically acquisitive, and he possessed a knack for pursuing offbeat material before it became widely popular. He was forever searching for that mythical five-dollar find that would turn out to be worth $1 million.

Clutter was an indispensable element of Warhol's habitats, and his parlor-floor apartment came to resemble a scavenger's pleasure palace with an overall style that somebody characterized as "Victorian Surrealist." He amassed antique furniture, including a canopied brass bed with cupids, and decorative objects, as well as some pretty flamboyant curios, such as a nineteenth-century ceramic phrenology head, a chair made of animal horns, and a stuffed peacock he found in an Eighth Avenue taxidermy shop. (After keeping the bird awhile, he decided it would be the perfect gift for Charles Lisanby.)

The front room contained a table set for a children's birthday party that Warhol had created in about 1959 for a Tiffany & Co. display of designer table settings. It consisted of a bentwood table, high-back chairs slipcovered in a festive cabbage-rose chintz, plates

of fancifully iced cookies, and Coca-Cola bottles sprayed an iridescent golden orange. As originally installed at Tiffany's, the tableau included a stuffed cat that Warhol had rented from a taxidermist. But some of Tiffany's customers were so horror-struck by the lifeless animal on the table that the store asked Warhol to remove it.

Andy seldom entertained at home, preferring to take his friends to restaurant dinners. In the late 1950s, he dined two or three times a week at Serendipity 3, where he delighted in the hot-fudge sundaes, banana splits, and lemon icebox pies. His idea of a wonderful way to spend a Sunday afternoon was to have brunch at the Palm Court at the Plaza. One of his favorite haunts was Café Nicholson, when it was located on East 57th Street—he rejoiced in the chocolate soufflés. When the check came, he laboriously extracted crumpled bills from various pockets and even out of his shoes. Then, along with a cash tip, he left a cluster of Hershey's chocolate kisses.

Warhol brought a commanding sense of style and ceremony to almost every outing. Once in a while, craving fast food, he hired a limousine to round up his friends and whisk them to Nedick's on East 86th Street. The chauffeur would wait while Warhol and his party ate hot dogs.

Mrs. Warhola was convinced her extravagant son would die a pauper. But her worries were unfounded. Less than ten years after his arrival in New York, Andy was well on his way to financial security, earning more money than anyone in his family had ever dreamed possible.

Warhol was delighted to find himself mentioned in a 1958 novelty book titled *1000 Names and Where to Drop Them*. The slim paperback amusingly categorized prominent people under various headings, such as "Nescafé Society." But Andy had already transcended categories. He was listed not under "Artists" or "Fashion," but "Big Business."

NOTES

1. Interview with Mrs. Paul Warhola, August 10, 1987.
2. Interview with Peter Palazzo, January 19, 1988.
3. Interview with Peter Palazzo, January 19, 1988.
4. Andy Warhol, *The Philosophy of Andy Warhol: From A to B and Back Again* (New York and London: Harcourt Brace Jovanovich, 1975), p. 96.
5. Interview with Nathan Gluck, March 21, 1968.
6. Interview with Vito Giallo, September 21, 1988.
7. Interview with Nathan Gluck, March 21, 1968.
8. Interview with Stephen Bruce, September 30, 1987.
9. Bearegard Houston-Montgomery, compiler. "Andy Warhol Remembered," *Details*, May 1987, p. 71.
10. Interview with Charles Lisanby, August 7, 1987.
11. Charles Lisanby and Nathan Gluck cite *All Kinds of Cats*, a 1952 book of photographs by Walter Chandoha as a source for at least one of Warhol's drawings. [See Patrick S. Smith, *Andy Warhol's Art and Films* (Ann Arbor, Mich., UMI Research Press, 1986, 1981), pp. 70, 318.] Lisanby also noted that Warhol derived about four of the cat pictures from *The Book of Kittens*, edited by Brant House (New York: A. A. Wyn, 1951).
12. Interview with David Mann, March 1968.
13. Interview with Charles Lisanby, August 7, 1987.
14. Jean Stein, *Edie: An American Biography*, edited with George Plimpton (New York: Alfred A. Knopf, 1982), p. 188.
15. Their journey was probably sparked by the all-star hit movie *Around the World in Eighty Days*, which won that year's Academy Award for Best Picture. The film was based on Jules Verne's 1873 travel romance, which relates the fictional adventures of an English gentleman, Phileas Fogg, and his French valet, Passepartout. Warhol was probably unaware that Cocteau had "reenacted" Verne's trip in 1936, writing it up for the newspaper *Paris-Soir*.
16. Interview with Nathan Gluck, August 6, 1987.
17. "Crazy Golden Slippers," *Life*, January 21, 1957, pp. 12–13.
18. Interview with John Wallowitch, September 21, 1988.
19. The drawing is owned by the Philadelphia Museum of Art.
20. In their Warhol monographs, Andreas Brown and Rainer Crone dated *In the Bottom of My Garden*, respectively, to c. 1956 and 1955. But the drawings were exhibited at Serendipity 3 in a show that opened December 2, 1958, and it seems highly unlikely that Warhol would have displayed works that were two or three years old.
21. The two Jacques Stella prints are reproduced in Smith, *Warhol*, pp. 61, 63. The two Grandville illustrations are also in Smith, pp. 56–57.
22. Interview with Nathan Gluck, March 21, 1968.
23. Warhol, *Philosophy*, p. 64.
24. Interview with Nathan Gluck, August 6, 1987.

"Andy had a kind of facility which I think drove him to develop and even invent ways to make his art so as not to be cursed by that talented hand. His works are like monuments to his trying to free himself of his talent. Even his choice of subject matter is to get away from anything easy. Whether it's a chic decision or a disturbing decision about which objects he picks, it's not an aesthetic choice. And there's strength in that."—*Robert Rauschenberg*[1]

56. *Before and After 3*. 1962. Acrylic on canvas, 72 x 99⅝". Whitney Museum of American Art, New York. Purchase and gift from Charles Simon. 71.226

Between the autumn of 1959 and the spring of 1961, Andy Warhol's art underwent a dramatic, wholly unexpected, and largely inexplicable metamorphosis. During that period, he evolved from a stylish illustrator, noted for his playful and whimsical drawings, into a deadpan painter of comic strips and display ads, which he derived from newspapers and magazines and enlarged on canvas with a minimum of artistic transformation. Warhol based his paintings on commonplace subjects, displaying a preference for banal and ephemeral imagery with connotations of "low culture." The subjects were almost guaranteed to look incongruous when expanded on six-foot-high canvases. He correctly intuited that his vulgar subjects would attract considerable attention. In embarking on this new course, he leaped from the periphery of the art world to somewhere near dead center—though the enormity of the move would not become immediately apparent.

Warhol's art throughout the 1950s was entirely alien to the then-prevailing style of painting, Abstract Expressionism, a situation that caused him a certain amount of annoyance and distress. The Abstract Expressionist movement had triumphed in the museums, the press, and the marketplace. Several of its leading exponents—Willem de Kooning, Franz Kline, Jackson Pollock, Mark Rothko, and Clyfford Still, among others—were recognized internationally as modern masters. Warhol only grudgingly acknowledged the movement as important, and was never a great admirer of the style. As late as 1972, he said, "Oh, I wish I was an Abstract Expressionist. It's so easy, not drinking and painting up a storm."[2] Warhol had very little facility for composing abstractly; he almost always dealt with recognizable subjects, and he usually based his pictures on preexisting imagery. Therefore, he must have been expectantly intrigued by the early signs of a major stylistic shakeout in the art world.

About 1958, a major shift in aesthetic attitudes and sensibilities began to trigger massive changes throughout New York's artistic community. Abstract Expressionism's dominance was at its peak, but its continuing influence over the Manhattan art scene was undermined by the movement's slavishly imitative second generation. Many of these younger artists indulged themselves in glib, rhetorical, and formulaic imitations of De Kooning's and Kline's

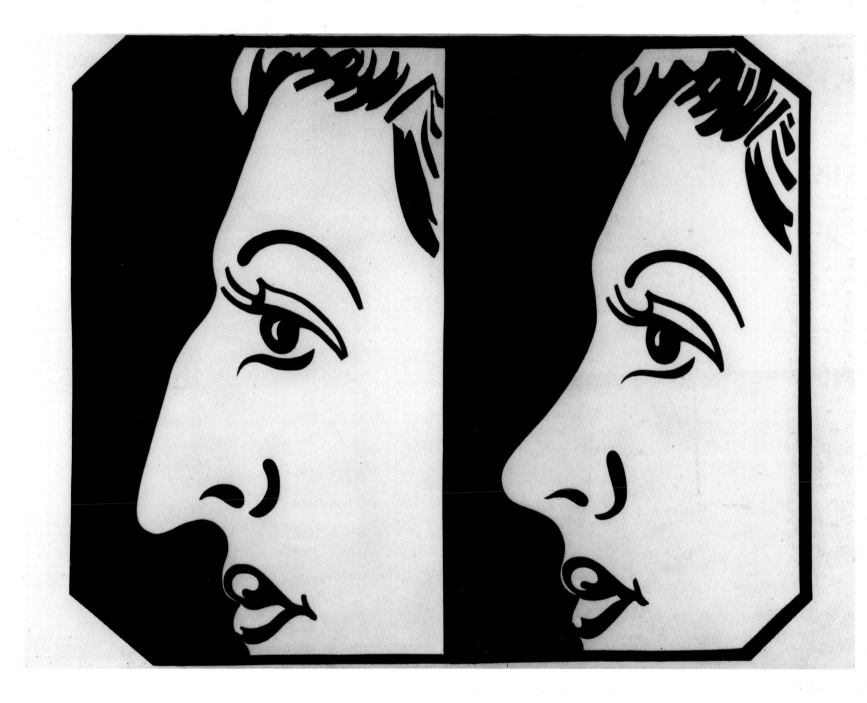

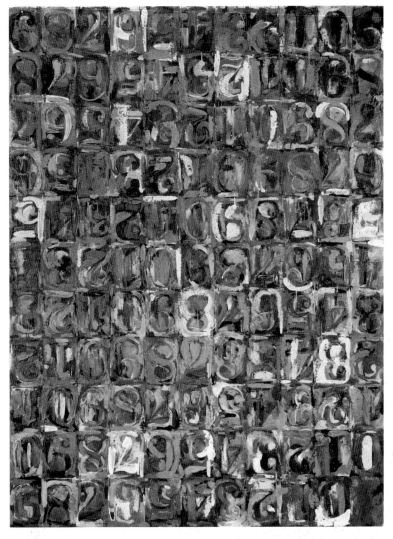

57. Jasper Johns. *Numbers in Color.* 1958–59. Encaustic and collage on canvas, 67 x 49½″. Albright-Knox Art Gallery, Buffalo, New York

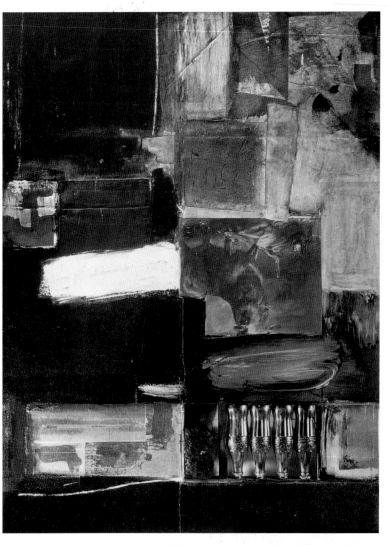

58. Robert Rauschenberg. *Curfew.* 1958. Combine-painting, 57 x 39″. Collection Ben Heller, New York

broad sweeps of brushwork. This in turn prompted other rising artists to rebel against Abstract Expressionism.

The new generation attempted to reinvigorate painting by incorporating images and materials that they found in their urban environment. Many artists began to use "found" objects in their assemblages and paintings, sometimes adding them in their unaltered state directly to the canvas. The city streets were full of debris, which many artists perceived as free art materials. These scavenged goods often ended up in three-dimensional constructions that were respectfully called "junk sculptures."

One of the great innovators in this technique was Robert

Rauschenberg, who belonged chronologically to the second-generation school of Abstract Expressionists and behaved as the enfant terrible of his class. An exuberant, outspoken, and extroverted young man from Port Arthur, Texas, Rauschenberg was easy to pick out in any crowd because of his spirited behavior and cackling laugh. Brashly talented, he loved to experiment with new materials and processes. He occasionally shocked viewers by the irreverence of his actions: once, having solicited a free drawing from De Kooning, he proceeded to erase most of it in large sweeping gestures, converting it into a "Rauschenberg."

In the mid-1950s, Rauschenberg started making what he called

"combine-paintings," works that started out as pictures, to which he then added various found objects, such as stuffed birds, a chair, or automobile tire. His famous 1955 painting *Bed* features an actual quilt and pillow that he daubed and splattered with paint. He juxtaposed passages of painterly brushwork with areas of collaged materials (typically printed fabric, doilies, ties, ribbed cloth salvaged from umbrellas, comic strips, and news photographs), as well as unorthodox relief elements, such as pails and ladders. The resulting compositions appeared semi-improvised, half "made" and half "found," providing a kaleidoscope of diverse visual information that suggested a blitz of urban images. Rauschenberg's art was like a cake mix into which he could fold the images and headlines of the day, making it topical without getting bogged down in reportage.

Rauschenberg's good and close friend Jasper Johns also retained the painterly brushwork of Abstract Expressionism but sidestepped the abstruseness of that style by introducing a new factuality in the form of familiar symbols and emblems—targets, American flags, and sequences of letters and numerals. Like Rauschenberg, Johns utilized preexisting or "ready-made" subjects, which he neither invented nor "interpreted." "Using the design of the American flag took care of a great deal for me because I didn't have to design it..." Johns said. "That gave me room to work on other levels."[3]

By selecting inherently flat subjects, Johns was able to create compositions in which the depicted image was totally congruent with the picture plane. His "preflattened" subjects virtually eliminated any illusion of three-dimensional depth, thereby conforming to the formal requirements of a flat painting style. To a large extent, Johns's art-historical importance is based on his discovery that representational images could be reconciled with the modernist aesthetic theory that decreed that painting should orient itself to flatness.

Because Johns and Rauschenberg frequently employed letters and numerals in their works, they implicitly demanded that viewers not only *look* at their pictures, but also *read* them. Rauschenberg seemed to relish a wide variety of "found" lettering as he zealously collaged everything from calendar pages and election flyers to license plates and "caution" signs. Johns, by contrast, based his

letters and numerals on stencils, shapes that he "didn't have to design" so that he could concentrate on the expressive quality of his brushstrokes or penciled lines.

Warhol became aware of Rauschenberg and Johns during the late 1950s, possibly encountering them for the first time in connection with display work at Bonwit Teller or Tiffany & Co.—all three artists trimmed windows for the same stores. Rauschenberg, who was a few years older than Warhol, and Johns, who was a couple of years younger, were "serious" fine artists who trimmed windows only in order to make ends meet. Both did their display work rather covertly under the joint pseudonym Matson Jones. (Johns, then an unknown artist, displayed two of his now famous early paintings, *Flag on Orange Field* and the small *White Flag*, in Bonwit Teller's windows, probably in 1957.)[4]

Warhol had several friends in common with Rauschenberg and Johns but never managed to become genuinely sociable with either artist. He often imagined that they looked down on him and even snubbed him. One of their mutual friends, according to Andy, told him that Rauschenberg and Johns disapproved of him for two reasons: his art was too commercial and his behavior "too swish."[5]

In 1957, Rauschenberg and Johns joined the Leo Castelli Gallery, an important new showcase for post–Abstract Expressionist art, located at 4 East 77th Street. Rauschenberg, being uncommonly prolific, had solo shows there just about every year from 1958 on. In January 1958, Johns had his first one-man show, in which he exhibited paintings of flags, targets, Arabic numerals, and letters. He attained "overnight" art-world celebrity when his *Target and Four Faces* appeared on the January 1958 cover of *Art News*—a rare instance of an art magazine conferring its cover upon an artist having his first one-man show. That *Target* and two other works— *White Numbers* (which anticipated all the minimalist grid paintings of the 1960s) and *Green Target*—were acquired during the year by The Museum of Modern Art, and exhibited there in October 1958. Again, it was extremely rare for a new artist, only twenty-eight years old and with just one solo show to his credit, to be so strongly endorsed by a major museum.

Johns's pictures were painted in encaustic (pigment mixed with melted beeswax) over a ground of collaged newsprint. The

layered strokes were irregular and sometimes transparent, like a colored scrim over the newsprint. *Green Target*, for instance, looked different from various vantage points. From a distance, the picture looked like a plain green square. At midrange, the viewer realized that it consisted of a centered disk, surrounded by four concentric rings. Up close, one could read some of the underlying newsprint, with its collage of department-store display ads and a photograph captioned, "Woman Hurt as Autos Crash." Johns's decision to leave many of the underlying news clippings legible introduced elements of journalistic topicality that prophesied Warhol's later portrayals of newspaper headlines, news photographs, and advertising illustrations.

Rauschenberg and Johns were two of the key figures in "Sixteen Americans," a watershed exhibition at The Museum of Modern Art in 1959 that signaled the end of the Abstract Expressionists' Sturm und Drang influence and the rise of a comparatively cool, impersonal, and ultrarational generation. The show also featured works by Ellsworth Kelly, Louise Nevelson, and Frank Stella. Rauschenberg's combine-paintings on view included *Curfew* (plate 58), a picture juxtaposing abstract painting and collaged images with a niche containing a row of four empty Coca-Cola bottles, as well as *Satellite*, a 1955 work with a horizontal band running across the midsection that was collaged with paint-splattered comic strips (including Popeye) from the *New York Journal-American*. Johns was represented by several works in encaustic on newspaper, including *Numbers in Color* (plate 57), a grid of rectangles, eleven high by eleven across, each containing an Arabic numeral from 0 to 9 in sequence; *Large White Flag*; and *Black Target*.

While the artists in "Sixteen Americans" were putting the public on notice that a new and more conceptual aesthetic was about to eclipse second-generation Abstract Expressionism, what was Warhol doing? He was still churning out clever shoe drawings for I. Miller, selling his handcolored picture books through Serendipity, and providing very little evidence that he wanted to be taken seriously in the art world. It must have been inconceivable to almost everyone who knew him that a day might dawn when he would be as controversial or famous an artist as Johns, Rauschenberg, or

59. *Omelet Greta Garbo*. 1959. Photo-offset illustration for *Wild Raspberries* by Andy Warhol and Suzie Frankfurt. Bound artist's book, edition of 100, half fully hand-colored, half partly hand-colored, pages 17 1/2 x 11 1/4"

Stella. Compared to that of the probing artists of the New York School, who prized "tough" and "authentic" abstract painting, Warhol's work was altogether too facile and ingratiating, unremittingly frivolous, and ultimately irrelevant.

In 1959 Warhol produced what would be the last of his privately printed, hand-colored picture books, *Wild Raspberries;* the title was a takeoff on Ingmar Bergman's film *Wild Strawberries*. Warhol collaborated on the mock cookbook with designer Suzie Frankfurt, who provided the arch recipes for dishes such as "A & P Surprise," "Oysters à la Harriman," and "Omelet Greta Garbo" (plate 59). This forty-page novelty book, bound in a brilliant fuchsia, contains Warhol's frothy illustrations, some of them inspired by florid engravings in nineteenth-century French cookbooks. Mrs. Warhola wrote out all the recipes in her curlicue script with her typical

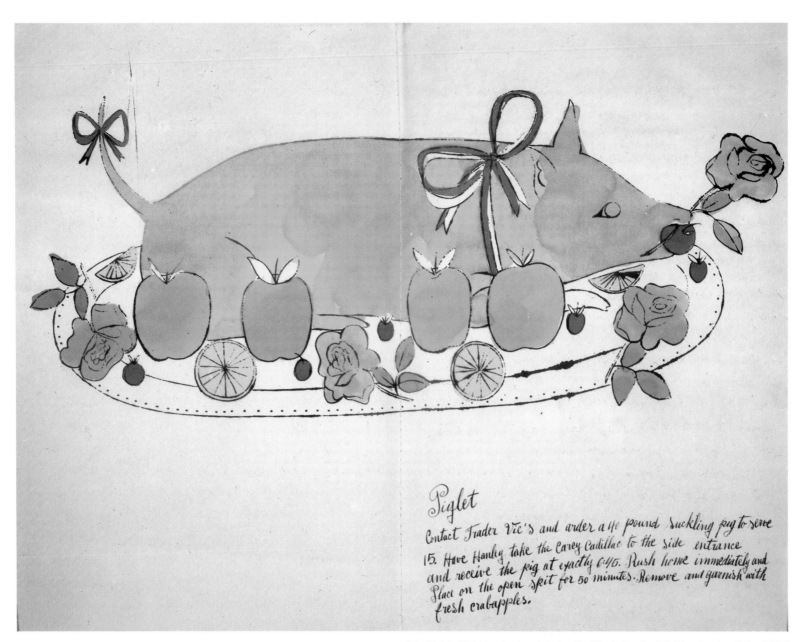

Piglet

Contact Trader Vic's and order a 40 pound suckling pig to serve 15. Have Hanley take the Carey Cadillac to the side entrance and receive the pig at exactly 6:45. Rush home immediately and place on the open spit for 50 minutes. Remove and garnish with fresh crabapples.

60. *Piglet.* 1959. Hand-colored photo-offset illustration for *Wild Raspberries,* 17 ½ x 22 ½"

misspellings, and Andy's friends helped color the eighteen plates, including a centerfold spread of a roast piglet (plate 60). The original drawings were displayed at the Bodley Gallery in December and received a favorable one-sentence review in *Arts Magazine.*[6] Warhol's gallery exhibitions in the 1950s were scarcely noted in the press, except for brief, often negative reviews buried in the back pages of *Art News* and *Arts Magazine,* the city's leading art journals.

During his first decade in New York, Warhol turned out a prodigious amount of work, almost all of it intentionally ephemeral. He seemed to thrive on the transitory context of his art, which often appeared as outmoded and disposable as last month's fashion magazines and show window displays. His drawings and books sold well, mainly to his friends in the clothing, antiques, and design trades, and he was famous in his circle but not to the art world at large. The Serendipity set loved his work for its playfulness and esprit, not because they thought he was going to become the next Jackson Pollock or Willem de Kooning.

Though Warhol was not esteemed as a serious artist, he was a huge success in materialistic terms. In 1960, he was able to buy a four-story town house at 1342 Lexington Avenue, near the southwest corner of 89th Street on Manhattan's Upper East Side, for

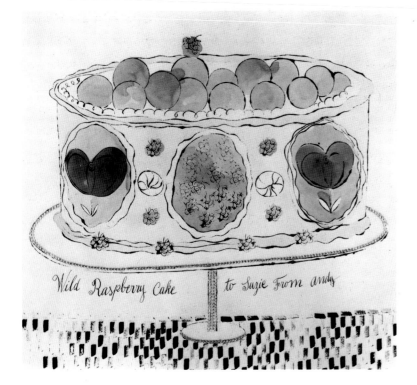

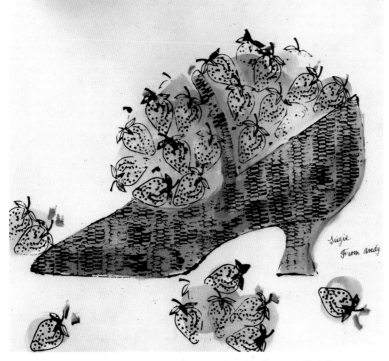

61. *Wild Raspberry Cake.* 1959. Ink and watercolor with silver metallic foil on paper, 22⅝ x 28½". Collection Suzie Frankfurt, New York

62. *Shoe with Strawberries.* 1959. Ink and watercolor on paper, 22¾ x 29". Collection Suzie Frankfurt, New York

$60,000.[7] He used the parlor floor for business and entertaining, and eventually turned the paneled rear room into his studio; the front room became a work space for Nathan Gluck, who came in a couple of times a week to assist on the commercial assignments. Andy slept in a dilapidated bed with a tattered canopy on the third floor and used the fourth floor mainly for storage.

Warhol installed his mother, who was then about sixty-eight years old, in the basement near the kitchen, so she would have fewer stairs to climb. She maintained her reputation as an assiduous housekeeper, arising before dawn to start her cleaning chores. Andy laughingly claimed that she went through a case of Cutty Sark scotch each week. Friends occasionally did see her down a large glass of straight scotch, but she never appeared tipsy, and when she answered the phone during the afternoon and evening hours, she sounded as spry and alert as ever. She sometimes complained that Andy was ashamed of her and did not want his friends to see her—and it is true that he rarely appeared in public with his mother. But he never objected to her ongoing attempts at matchmaking: if the visitor were a man, she would try to arrange a match with one of her nieces in Pittsburgh; and if the visitor were a woman, she would say something like, "You'd be a good wife for my Andy, but he's too busy."

The parlor furnishings were an eclectic mix of period furniture, American folk art, and kitsch curios. Some of the more striking objects on view were a pair of carved, painted, and gilded English carousel figures in the form of military centaurs, dating from about 1915; the upper halves represented helmeted men and the lower halves galloping horses. One of the most important artifacts was a seventy-two-inch-high painted wood statue of Punch, grotesquely humpbacked and wearing a tasseled cap and ruffled collar, possibly carved in the 1870s. The life-size human effigies made visitors feel that more people were present than could be accounted for. Warhol's taste for obsolete penny-arcade machines, relics of forgotten American midways, was evident in a "Perfume Your Handkerchief" device, originally equipped to dispense four fragrances, and a cast-iron "Test Your Strength" contraption that challenged spectators to "punch or hug me for only 1¢." There were also signs, literally, of an extensive collection of lithographed tin

advertising memorabilia, including a sign promoting Smith Brothers cough drops, a painted-wood shoe-shop sign from the early 1900s, several antique coffee containers, Coca-Cola drink trays, and Planters peanuts ashtrays. Warhol's campy sensibility manifested itself in the Carmen Miranda–type platform shoe with a ridiculously high heel that occupied a central position on the mantel; it was a gift from Nathan Gluck. Andy let visitors believe it actually had belonged to Carmen Miranda.

Warhol was already assembling what would become an extensive art collection. At first he bought mostly Surrealist-type art —works on paper by René Magritte, Pavel Tchelitchew, Paul Cadmus, Roberto Matta, Eugene Berman, and Leonore Fini. He also acquired lithographs by Henri de Toulouse-Lautrec, Pablo Picasso, and Joan Miró, among others. In the late 1950s, he began to accumulate works by the younger artists of the New York School, such as Larry Rivers, Grace Hartigan, Jane Wilson, and Robert Goodnough.

Warhol periodically made the rounds of the city's art galleries, usually on Saturday afternoons and often accompanied by his good friend Ted Carey, a fabric and textile designer. In 1960, Warhol and Carey commissioned Fairfield Porter to paint their portraits. They thought they could save money by requesting a double portrait, which they planned to cut in two, each taking his half. But Porter foiled their scheme by posing them so closely together that they could not divide the forty-inch-square oil painting without ruining it. Warhol ended up buying Carey's share and ultimately giving the portrait to the Whitney Museum of American Art in New York.

One day Warhol and Carey dropped into The Museum of Modern Art's Art Lending Service, where a large range of works were available for rental or purchase, and came across a small collage by Rauschenberg, containing a cut-off portion of a man's shirt sleeve. "Oh, that is fabulous," Carey said. Warhol retorted, "I think that's awful. Anyone can do that. I can do that." So why didn't he do it? Carey wanted to know. "Well, I've got to think of something different," Andy said.[8] Whatever his thoughts, he had the instinct to stay away from collage and assemblage, no doubt realizing that too many other artists had already made their names with those materials and formats.

Though he enjoyed a successful career as an illustrator, Warhol now set out to win fame as a painter. During his school years, after all, he had entertained dreams of becoming a widely admired, much-sought-after artist, aspirations that now came back to nag him. Ironically, his high reputation as a commercial artist made it even more difficult for him to make the leap into the world of "high" art. Moreover, he was not about to lower his standard of living or change of life-style. He had attained considerable prominence with his advertising work, was widely published in national magazines, owned a Manhattan town house, and had accumulated a good deal of money. But he couldn't help noting with envy that artists such as Rauschenberg and Johns were suddenly becoming bigger names than he was and commanding high prices as well.

Warhol's friends thought he was definitely influenced by Johns and Rauschenberg, by their perceived glamour and success, the fact that they were in the Castelli Gallery and acclaimed by The Museum of Modern Art. Andy had had one of his drawings displayed in a group show at that museum in 1956, but it hadn't created a ripple of interest compared to the big splash Rauschenberg and Johns made in "Sixteen Americans." And while Andy had been hired to create covers for various fashion and design magazines, he realized that it wasn't as prestigious as making a painting that editors thought was so significant and newsworthy in itself that it merited reproduction on the cover of an art magazine. What had Johns done to get on the cover of *Art News*? One imagines Warhol studying Johns's and Rauschenberg's work, wondering what made them so special. Warhol must have sensed that, as representational imagery was making a comeback, this was the right time for him, perhaps even the last chance, to make his entry into the art world. For clues as to what kinds of imagery he might paint, he looked to Johns and to a lesser extent Rauschenberg.

From Rauschenberg, Warhol may have adopted the idea that any subject is "fit" for art. Rauschenberg had demonstrated for years that ephemeral material from magazines and newspapers could be a fresh source of imagery for paintings. Although Warhol did not systematically or perhaps even consciously plunder Rauschenberg's subjects, it is somewhat astonishing how many

63. *Dick Tracy.* 1960. Acrylic on canvas, 79 x 45″. Collection Mr. and Mrs. S. I. Newhouse, Jr., New York

64. *Superman.* c. 1961. Acrylic and crayon on canvas, 67 x 52″. Collection Günter Sachs, Paris

themes identified with him first appeared in Rauschenberg's work. Comic strips, Coca-Cola bottles, an F.B.I. "most wanted man" poster, and cautionary signs all existed in Rauschenberg's art several years before Warhol got around to the same subjects.

Perhaps the main message Warhol received from Johns was that he did not have to invent images but, instead, could choose ones that already existed and use them as pretexts for paintings. This idea was extremely easy for Warhol to accept because he had been basing his own drawings on illustrations and photographs for years. Johns's grid compositions of numerals and letters doubtless encouraged Warhol to impersonally regiment his ready-made subjects in rows.

Seeking an equivalent to the commonplace imagery that

figured in Johns's and Rauschenberg's work, Andy quickly zeroed in on some throwaway products of daily culture with which he was particularly familiar. Newspapers and magazines, previously the *setting* for his commercial art, now became the *subject* of his serious painting.

The first inkling of Warhol's emerging style appeared in 1960, when he began painting a series of works based on cartoon-strip characters, such as Superman, Popeye, and the Little King. He concentrated on some of the most famous and recognizable faces to be found in the funnies, the "superstars" of their world.

In the front room on the top floor of his house, Warhol kept an opaque projector, which enabled him to enlarge clippings from newspapers and magazines. After fastening a sheet of drawing

65. *Popeye.* 1961. Acrylic on canvas, 68¼ x 58½″. Collection Mr. and Mrs. S. I. Newhouse, Jr., New York

66. *Strong Arms and Broads.* 1960. Acrylic on canvas, 54 x 72″. The Estate of Andy Warhol

67. *Bald?* 1960. Pencil and gouache, 28⅝ x 22½″. Collection Dia Art Foundation, New York

68. *U Spend $2 Your Hair.* 1960. Pencil and gouache, 28⅝ x 22½″. Collection Dia Art Foundation, New York

paper or a piece of canvas with a white gesso ground to the wall, he projected his "found image" on it, and rapidly traced the most important contours and any lettering that he wanted to keep. (Warhol employed a great deal of lettering in his early Pop works—from block letters enclosed in cartoon balloons to various typefaces used in ads and labels.) He sketched in the outlines with a pencil, then proceeded to paint the composition in a loose, casual manner, usually in black casein.

In *Dick Tracy* (plate 63), Warhol aggrandized two of cartoonist Chester Gould's most popular creations—the no-nonsense police detective hero and his amiable sidekick, Sam Ketchem. Tracy's right-angled jaw (not dissimilar to the squared-off chins that Warhol typically found so attractive in men) is thickly outlined in black, while his assistant's more rounded chin is less defined. Though Warhol's composition is apparently based on an actual comic-strip panel, the artist obviously chose which details to copy, omitting visual information that did not suit his purpose. He often left several areas in a sketchy state or blurred them with passages of freely brushed paint, which he applied thinly, letting it run and drip toward the bottom edge of the canvas. The wording in this painting's balloon is virtually whitewashed and illegible, discouraging a close reading of the text.

For *Superman* (plate 64), Warhol made a fairly literal copy of a panel in which the flying hero uses his powerful lungs to extinguish a forest fire, exhaling a mighty gust of radiating lines, accompanied by large block letters that spell out "PUFF!" To ensure that the picture was perceived as art, Warhol added some scribbled passages of colored crayon just above and below the balloon, energizing an otherwise plain ground.

Did Warhol intend his cartoon blowups to be satiric or ironic? If so, they appear curiously deadpan and devoid of sardonic humor. There is obviously something incongruous about monumentalizing an ephemeral example of journalistic "art" and preserving it on canvas. The original subject was intended to divert readers' attention and to entertain, but Warhol's capricious shift into a more durable medium and much larger scale, with an emphasis on a single cartoon frame rather than the narrative strip, is disorienting and therefore startling. In *Popeye* (plate 65), the silhouette of the hero

and a starburst shape, which symbolizes a wallop, are superimposed over fragments of a crossword puzzle, another newspaper feature that often appears on the same entertainment page as the funnies. The overlapping implies the barrage of visual information that confronts the reader.

Warhol also based several of his 1960 pictures on the small display ads—the ones promising wish fulfillment through self-improvement—in the back pages of tabloid newspapers and fan magazines. These include *U Spend $2 Your Hair* (plate 68), *Make Him Want You,* and *Strong Arms and Broads* (plate 66), the latter derived from a Charles Atlas ad offering strength and musculature to "ninety-seven pound weaklings." Some of the ads refer to baldness, hairpieces, and cosmetic surgery, no doubt reflecting the artist's interest in his own personal appearance. *Bald?* (plate 67), for instance, shows a man's head before and after hair treatments, and *Wigs* (plate 69) presents an array of women's hairpieces neatly displayed in three rows. Despite their abrasively tacky subjects, these early pictures often possess elegant, if erratically worked surfaces. In the end, Warhol succeeded in transforming bits of journalistic ephemera into aesthetically durable paintings and drawings.

Before and After 3 (plate 56) is a fairly outrageous example of the artist's perversely "aesthetic" subject matter—the reshaping of a human nose to conform to contemporary canons of beauty. The painting presents two side-by-side views of a woman's profile, the left half showing her natural aquiline nose, which on the right half has been deftly reshaped by cosmetic surgery to a snubby contour. Warhol derived the composition from a New York plastic surgeon's ad in the *National Enquirer,* offering "face lifting" and "skin planing," as well as "hair transplantation for baldness." Warhol copied the drawing fairly literally in his first painted version, including the letters "HAPED" from the headline, "NOSES RESHAPED." But in his next two versions, he eliminated the textual part of the ad and sharpened the contour lines. In transposing a small advertising illustration onto a one-hundred-inch-wide canvas in the last and largest of the "nose job" paintings, he monumentalized an unforgettable image that is simultaneously poignant and ludicrous.

Warhol painted several black-and-white pictures based on

69. *Wigs.* 1960. Ink, tempera, and wax crayon on canvas, 70⅛ x 40″. Collection Dia Art Foundation, New York

70. *Storm Door.* 1960. Acrylic on canvas, 46 x 42⅛″. Courtesy Thomas Ammann Fine Arts, Zurich

display ads of consumer products: a telephone, a typewriter, a well-stocked refrigerator (plate 74), a water heater, and a storm door (plate 70). Both *3-D Vacuum Cleaner* and *TV $199* (plate 75) contain fragments of advertising copy with many of the letters or words rendered sketchily or omitted entirely.

Warhol's early paintings of consumer products are painterly in a fairly conventional way, including the almost mandatory drips of the Abstract Expressionists. He deliberately imitated the smeared edges, runny paint, and the calculated "look" of accident that had become a cliché in the hands of many members of the New York School. Even Johns, Rauschenberg, and Larry Rivers, all important links between the Abstract Expressionist generation and the following Pop movement, left drips in their paintings.

Warhol equivocated in some of his early paintings between close imitations of advertising illustrations, such as *Before and After 3,* and expressionistic reworkings of those images. The Del Monte *Peach Halves* (plate 73) of c. 1960, for instance, is based on a commercial label, perhaps as represented in a supermarket's newspaper ad; the can is deployed to the left of center and floating in an amorphous space. Once again the lettering is sketchy, the Del Monte label almost obscured by runny paint. This fruit tin is the forerunner of the many Campbell's Soup can pictures that he began painting toward the end of 1961.

His uncertainty about his stylistic approach continued as he focused his attention on Coca-Cola, the ubiquitous American soft drink that is easily recognized by its distinctive glass bottle (designed by Raymond Loewy) and scripted brand name. In 1960, he made an expressionistic treatment, *Coca-Cola* (plate 77), with a full-length image of a Coke bottle along the left edge, the ghost of a bottle neck to its immediate right, and a large circular shape with part of the logo bleeding into a scribbled area along the right edge. The casually rendered image is in sharp contrast to the immaculately drawn *Large Coca-Cola* (plate 76) of 1962, with its carefully drawn lettering and more faithful imitation of the stylized shades and highlights in the advertising prototype.

Warhol's choice of subjects—from comic strips and newspaper ads to canned peaches and soda pop—generally celebrates his sincere belief in egalitarianism, the equal right of all Americans to

71. *Perfume Bottles.* 1962. Pencil and watercolor on paper, 29 x 23". Robert Miller Gallery, New York

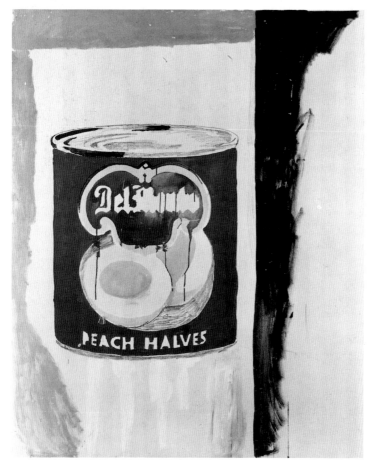

72. *Eight Point Program.* 1960. Acrylic on canvas, 54 x 72″. Whereabouts unknown

73. *Peach Halves.* 1960. Acrylic on canvas, 70 x 54″. Staatsgalerie Stuttgart

enjoy most of the same products. "What's great about this country," he asserted at a later date, "is that America started the tradition where the richest consumers buy essentially the same things as the poorest. You can be watching TV and see Coca-Cola, and you can know that the President drinks Coke, Liz Taylor drinks Coke, and just think, you can drink Coke, too. A Coke is a Coke and no amount of money can get you a better Coke."[9]

But a soft drink's popularity didn't necessarily make it a suitable or worthy subject for serious painting. Some critics deemed brand-name products to be too "low," "vulgar," and "commercial" to merit inclusion in fine art. These observers were perturbed by paintings of such subjects because they saw in them the insidious effects of advertising and marketing. They feared and loathed the advertising industry and viewed commercial illustrations and product designs as unwholesome evidence of the crass materialism of consumer culture. Literary intellectuals turned out a profusion of books deploring the manipulations of "hidden persuaders" and "hucksters" in "gray flannel suits" who twisted truth and debased public taste. The British historian Arnold Toynbee vigorously joined the fray, stating, "I cannot think of any circumstance in which advertising would not be an evil." "The destiny of our Western civilization," he declared in 1961, "turns on the issue of our struggle with all that Madison Avenue stands for more than it turns on the issue of our struggle with Communism."[10]

But brand-name product labels had cropped up from time to time throughout twentieth-century art. Actual labels were almost a stock commodity in Cubist, Futurist, and Dadaist collages by Picasso, Juan Gris, Carlo Carrà, Kurt Schwitters, and a host of other artists. In the United States, Stuart Davis created some marvelous cosmopolitan paintings, from the 1920s on, in which he wittily depicted packaging designs, as well as shop and street signs, using a highly individual Cubist syntax. Davis's *Lucky Strike* (1921) is one of several pictures inspired by the words and images that appeared on actual packages of cigarette papers and tobaccos. By the late 1950s, brand-name goods were once again appearing frequently in art. Rauschenberg, as mentioned earlier, outfitted many of his compositions with consumer products, incorporating actual Coca-Cola bottles in *Coca-Cola Plan* and *Curfew,* both 1958,

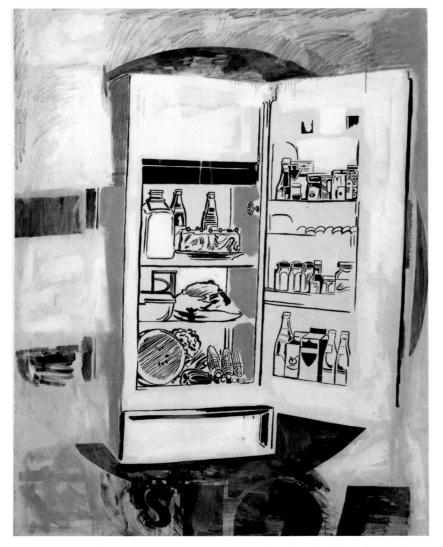

74. *Icebox*. 1960. Oil, ink, and graphite on canvas, 67 x 53⅛″. The Menil Collection, Houston

75. *TV $199*. 1960. Oil and wax crayon on canvas, 62¼ x 49½″. Collection John and Kimiko Powers. Courtesy Thomas Ammann Fine Arts, Zurich

76. *Large Coca-Cola.* 1960. Acrylic on canvas, 82 x 57″. Collection Elizabeth and Michael Rea

and Johns made painted-bronze replicas of a pair of Ballantine Ale cans and a Savarin coffee can in 1960.

As for Warhol, he obviously disagreed with intellectuals like Toynbee. "Buying is much more American than thinking," he later declared, "and I'm as American as they come"[11]

In April 1961, Warhol ended up exhibiting some of his comic-strip and display-ad paintings in the show windows of Bonwit Teller's, where they served as a backdrop for mannequins in summer dresses (plate 78). The pictures included a couple of black-and-white works, such as *Before and After I,* and three colored cartoons—*Little King* (a schematic representation of the red-robed, curly-bearded ruler), *Superman,* and *Saturday's Popeye.*

As Andy looked at his paintings in Bonwit Teller's windows, he must have been pleased at the thought that his work would be seen by tens of thousands of people near the fashionable intersection of Fifth Avenue and 57th Street, even though few of those passersby might recognize the pictures as his. But he could have had no premonition that, by the end of the following year, he would be whirled up into the crest of a new wave of art, or that his name was about to become a household word throughout the Western world.

77. *Coca-Cola.* 1960. Ink, tempera, and wax crayon on canvas, 72 x 54″. Collection Dia Art Foundation, New York

NOTES

1. Jean Stein, *Edie, an American Biography,* edited with George Plimpton (New York: Alfred A. Knopf, 1982), p. 189.
2. Telephone conversation with Andy Warhol, May 2, 1972. Warhol told the author that he had made twelve eight-foot paintings that day, and wondered if that figure set a record. He became more tolerant of Abstract Expressionism after his own success was established, and he acquired various works by De Kooning, Motherwell, and Pollock.
3. Leo Steinberg, *Other Criteria* (New York: Oxford University Press, 1975), p. 31.
4. Michael Crichton, *Jasper Johns* (New York: Harry N. Abrams, 1977), pp. 36, 67, note 31.
5. Andy Warhol and Pat Hackett, *POPism: The Warhol '60s* (New York: Harcourt Brace Jovanovich, 1980), p. 11.
6. Sidney Tillim, *Arts Magazine,* January 1960.
7. Interview with Paul Warhola, September 24, 1987.
8. Patrick S. Smith, *Andy Warhol's Art and Films,* (Ann Arbor, Mich.: UMI Research Press, 1986), pp. 253–54.
9. Andy Warhol, *The Philosophy of Andy Warhol: From A to B and Back Again* (New York: Harcourt Brace Jovanovich, 1975), pp. 100–101.
10. "The Mammoth Mirror," *Time,* October 12, 1962, p. 87.
11. Warhol, *Philosophy,* p. 229.

"When I first saw Warhol,

Lichtenstein, Rosenquist,

Oldenburg, and Wesselmann

within a four-month period, I had

a sitting-up-in-bed kind of thing,

thinking something very strange

was going on in the art world."

—*Ivan C. Karp* [1]

78. Warhol's Pop paintings on display in Bonwit Teller
windows, Fifth Avenue, New York, April 1961

One day in the late spring of 1961, Andy Warhol and Ted Carey ventured into the Leo Castelli Gallery and asked to see some drawings by Jasper Johns. Ivan C. Karp, the quick-witted, cigar-flourishing director of the gallery, recognized Carey, a frequent visitor, but did not know his companion, a shy and reticent man with "a singular physical presence." Karp showed them Johns's *Light Bulb* (plate 79), a 1958 pencil and graphite wash drawing of an incandescent lamp lying on its side atop a low base. The price, somewhere between $400 and $500, struck Warhol as shockingly high for a small work on paper by a contemporary artist, but this only added to its attraction, so he went ahead and bought it, after negotiating the cost down to $350.

Warhol asked Karp if there was anything else of particular interest in the storage racks. The dealer, brimming with enthusiasm, was only too happy to respond, pulling out several pictures in quick succession and making acute observations about each in what sounded like a rapid-fire patter. ("It's both a blessing and plague of nature that my mind hums as it does," Karp once observed.) [2]

Out of the racks came a painting that had arrived in the gallery only the week before—by a young artist named Roy Lichtenstein. The five-foot-high picture, *Girl with Ball,* showed the upper half of a young woman in a bathing suit, holding a beach ball high over her head. The work looked like a literal enlargement of a simplistic line drawing, suitable for a children's coloring book and filled in with flat, bright hues. (The picture, in fact, was based on an advertising illustration that regularly appeared in the Sunday edition of the *New York Times* as publicity for a resort hotel in the Pocono mountains.) "I think it's absolutely provocative, don't you?" Karp asked.

Warhol's eyes widened as he stared in astonishment and disbelief at the painting. Karp saw that his new client was not only incredulous, but also deeply distressed. Warhol said in an agitated voice, "Ohhh, I'm doing work just like that myself." Karp, intrigued, expressed curiosity about Warhol's work. Andy invited him to his studio, and they made an appointment for later that afternoon. (Karp typically visited a few artists' studios each week.)

As Warhol later would learn, Lichtenstein had had several one-man shows at various New York galleries since the early 1950s but was still, as of 1961, a little-known figure in the art world. He taught

painting at Rutgers University in New Brunswick, New Jersey, where he was an assistant professor. He had not begun to make paintings of advertising imagery and cartoon panels until earlier that year, leading Warhol to harbor the suspicion that Lichtenstein might have seen his paintings in the windows of Bonwit Teller that April. (Though Warhol's comic-strip paintings apparently preceded Lichtenstein's by almost a year, it was pure coincidence that both pursued similar subjects.)

Lichtenstein, according to Karp, showed up in the gallery one day, having driven into the city with four paintings strapped to the top of his station wagon. Karp had been sufficiently taken by the work to visit Lichtenstein's studio, returning with *Girl with Ball*. The Castelli Gallery was not yet officially representing Lichtenstein, but Leo Castelli and Karp kept a few of the artist's paintings in the back room for consideration and showed them to various people who might find them of interest.

Back at home, Warhol anticipated Karp's visit by hurriedly suppressing evidence of his commercial artwork, being apprehensive that it might interfere with the dealer's perception of his "serious" painting. But Andy felt a rapport with Karp the minute he walked through the door, because the dealer was so upbeat, enthusiastic, and supportive. Karp followed Warhol into the paneled room and saw dozens of stacked-up pictures amid an array of furnishings. "I remember the visit," Karp said, "because he was playing a rock 'n' roll record, 'I Saw Linda Yesterday,' and he played it ninety times at incredible volume." Warhol also impressed Karp by "keeping himself in the shadows so he couldn't physically be seen."[3]

Karp viewed several of Warhol's cartoon paintings. One that Karp particularly admired was inspired by Nancy, the sassy, bushy-haired child in Ernie Bushmiller's syndicated comic strip. Warhol's *Nancy* (plate 80) contains most of one panel, showing the snow-suited girl shivering outside her front door. Just below this image is a portion of another frame, containing a fragment of a second balloon that reads, "Brr...STILL." Karp relished the interrupted narrative sequence and its implication that Nancy remains out in the cold indefinitely.

Karp also looked at the mostly black-and-white works based on display ads, including the "nose job," Coca-Cola, and typewriter

79. Jasper Johns. *Light Bulb*. 1958. Pencil and graphite wash, 6½ x 8¾". Private Collection

pictures, and several that featured sale prices. Although Warhol was in command of his subject matter and headed in an original direction, it seemed to Karp that the artist hadn't quite resolved the treatment, which led him to deal with his images in contradictory ways—both painterly and nonpainterly. Some of the pictures contained sketchy passages and a lot of drips, as if he were paying homage to latter-day Abstract Expressionism. Other works were done in a more meticulous, crisply delineated manner. Warhol was clearly ambivalent about choosing between his two contrasting styles of representation.

Karp immediately decided that he preferred the pictures without the smudges and trails of runny paint, and he wasted no time and minced no words in telling Andy. (Though he was not a cruel man, Karp could sound insensitive and even brutal as he sorted out artists and their work, declaring which had a future and which were "finished.") "Anyway," Karp said, "I told him that the only works I thought of any consequence were these cold,

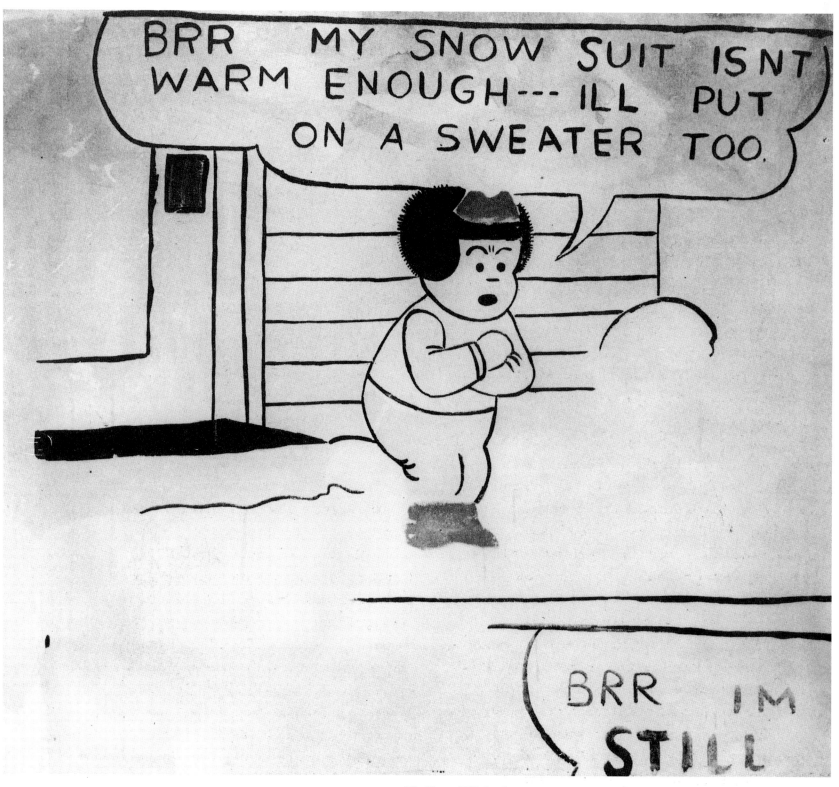

80. *Nancy.* 1961. Acrylic on canvas, 40 x 54". Collection Mr. and Mrs. S. I. Newhouse, Jr., New York

straightforward works."[4] It seemed somehow obvious to Karp that Warhol's paintings, given the subject matter (and Lichtenstein's example), should be "more blunt" and undramatic.

Warhol replied that he, in fact, would prefer to do them that way, but wondered if it were possible to reject all evidence of gestural paint handling without offending the art public. "You can't do a painting without a drip," he said. Karp reminded Warhol that Lichtenstein's pictures were devoid of runny paint. "Maybe you *can* make a painting in modern times without a drip," Karp concluded.[5]

Before leaving, Karp told Warhol that he would bring some people to look at the work. About an hour after he returned to the gallery, Karp received a package wrapped in white paper and tied with a red bow. It contained the *Nancy* painting.

Karp instantly became one of Warhol's most articulate champions. The very next day the dealer brought to the artist's studio some people he thought would be receptive to the art. He was astonished to discover a peculiar facet of Warhol's personality. "On my next two or three visits," Karp said, "he wore theatrical masks, the type you wear at a masked ball. They were fanciful, but never what you might call ornate. He had bunches of them, and he made other people wear them as well. I don't think he was comfortable with the way he looked, because he had a terrible complexion at the time. The mask gave him a more stylized look. There was one occasion with three people who were disconcerted about the mask business. I don't remember who they were; it was a collector of some kind, an imperious character who was forced to wear a mask."[6] Karp himself could not decide if the masks were an affectation, neurosis, or prank.

A few weeks later, Karp brought Leo Castelli, one of the most discerning dealers of his generation, with him to Warhol's town house. Castelli appeared rather perplexed as he scrutinized *Dick Tracy* and the "nose job" picture. Finally, he said, "Well, it's unfortunate, the timing, because I just took on Roy Lichtenstein, and the two of you in the same gallery would collide."[7]

Despite his cosmopolitanism, exquisite manners, and enormous tolerance for artistic temperament, Castelli, according to Karp, seemed very uneasy in Warhol's studio the whole time he was there. Perhaps the artist's character and environment were just

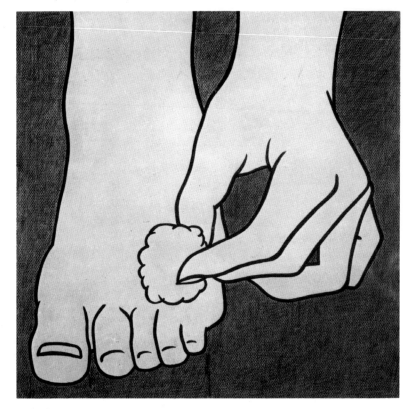

81. Roy Lichtenstein. *Foot Medication.* 1962. Pencil and frottage, 18½ x 18¾". Collection David Whitney, New York

too bizarre for him. "Leo was very uncomfortable with the situation and very likely with the art," Karp said, "but he did buy two little soup-can pictures for forty dollars and sixty dollars apiece—one individual soup and one double soup"[8] The purchases helped cushion the blow of rejection, no doubt, but Warhol was greatly disappointed. He hoped that Castelli might change his mind.

With the sharpened perception of hindsight, it is easy to spot some major differences between Warhol's and Lichtenstein's cartoon paintings. The latter usually imitated an entire panel, whereas Warhol tended to copy details of panels, or portions of adjoining frames. Warhol derived his comic-strip figures from specific and easily identifiable characters, usually humorous caricatures such as Popeye and the Little King. Lichtenstein, by contrast, painted cartoon *types*—idealized war heroes and teary-eyed heroines, inspired by the more realistic strips devoted to adventure and romance. His flat, uningratiating paint surface was a

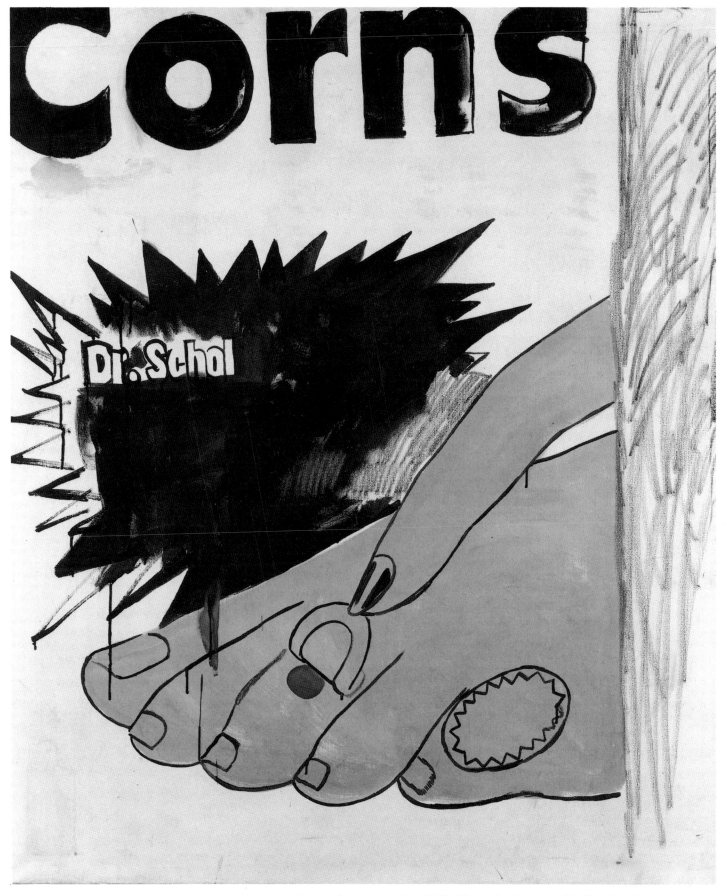

82. *Dr. Scholl.* 1960. Acrylic on canvas, 48 x 40″. The Metropolitan Museum of Art, New York. Gift of Halston, 1982

more brazen assault on conventional taste, while some of Warhol's pictures were still mired in the routine painterliness of Abstract Expressionism. But all their differences in subjects and techniques did not undo the fact that both artists shared a small piece of turf.

One of art history's little curiosities is that each artist based one of his pictures on Dr. Scholl's ads for foot comfort products. Warhol's *Dr. Scholl* (plate 82) shows a woman's elongated fingertip gingerly pulling back a corn pad, while Lichtenstein's immaculate drawing, *Foot Medication* (plate 81), portrays an entire hand daubing a foreshortened foot. Lichtenstein's treatment is consistently austere, dispassionate, and even neoclassical, whereas Warhol's version is comparatively "busy" because of the words, complicated starburst form, and expressionistic technique.

Karp's most zealous initiate into Warhol's circle was Henry Geldzahler, an ebullient young curatorial assistant in The Metropolitan Museum of Art's Department of American Painting and Sculpture, who frequently accompanied the dealer on studio visits to up-and-coming artists. Geldzahler was quite entranced by Andy's personality and vision, especially after spotting the Carmen Miranda shoe, his first clue to the artist's camp sensibility. (The curator felt at once that Warhol might be an admirer of the oddly sophisticated/naive paintings of American artist Florine Stettheimer and invited him to the museum the next day to see her works, then in storage. Henry was right—Andy did respond to her work.) Eventually, Geldzahler became one of Warhol's most frequent visitors, and perhaps the most prominent member of Warhol's kitchen cabinet, advising the artist on a range of artistic and social matters. For several years, the two were fast friends, palling around, going to parties, and spending hours each day on the phone.

Geldzahler, in turn, directed potential dealers to Warhol's studio. One of them was Irving Blum, a tall, lanky young man who was then of only marginal importance in a borderland area of the art world. Blum, a transplanted New Yorker, directed Los Angeles's Ferus Gallery, a highly regarded showcase for area talent, but virtually unknown beyond the city limits. He made infrequent trips to New York, where he tried to connect with young artists whom he might represent on the West Coast. Blum first visited Warhol during the fall of 1961, when he saw several of the cartoon paintings, including

Dick Tracy and *Superman*. According to Blum, he found these less than compelling and "conveyed support but not passionate interest, and left rather quickly."[9] Despite this false start, Blum soon became a loyal fan, as well as the first dealer courageous enough to give Warhol a one-man show of his "brand-name" paintings.

For nearly a year and a half, Karp moonlighted as Warhol's private agent and dealer, bringing or sending clients to the artist's studio. Many of Karp's "independent collectors" bought pictures, generally priced between one hundred dollars and four hundred dollars, and Warhol was very ethical about giving the dealer a commission on any sales he generated. Among the important collectors Karp steered to Warhol's house were Emily and Burton Tremaine, noted for their major holdings in twentieth-century art. Warhol made a dramatic first impression upon the Tremaines. "We thought he was naive, a new douanier Rousseau—how wrong we were," Mrs. Tremaine said.[10] "We made several visits to Andy's studio—Andy usually was playing two stereos simultaneously, one belting out Bach, the other blasting rock 'n' roll—and came to think of both Andy and his work as perhaps the most enigmatical and complex of any of the artists we were beginning to know."[11] During 1962, the Tremaines bought fifteen Warhols, including *A Boy for Meg, Campbell's Soup Can with Can Opener, 50 S & H Green Stamps, Do It Yourself (Violin with Numbers), Close Cover Before Striking,* and *Marilyn Diptych.*

Karp also did something most unusual for a dealer: he approached several other "advanced" galleries on Warhol's behalf, showing slides and photographs of his paintings and sometimes even carrying the pictures over personally, but none of the dealers was responsive. Karp would return to Andy and gently break the news, saying, "I'm afraid they don't perceive the larger element in your work."[12]

Warhol felt so discouraged about getting into a first-rate gallery that he considered showing his works once again at Bodley. Andy was desperate enough, according to Carey, that "he would have even *paid* the gallery" to show his new paintings.[13] What a shock awaited him, then, after he invited David Mann to see his new work. Mann dropped in for a look and was aghast to find himself confronted by large paintings of cartoon strips. As with many of the

people who had been charmed by Warhol's whimsical drawings of cats and cherubs, he was put off by the artist's vulgar new pictures of consumer products. "I thought they were terrible," Mann said. "I thought they were ridiculous."[14]

Warhol's feelings of rejection were compounded when I. Miller's new management decided to let him go, thereby cutting off what was probably his principal source of income. His work for the company had flourished under the art direction of Peter Palazzo, who left in about 1958, and his successor, Robert Fabian, who found Andy "easygoing and pleasant." His drawings, right up to the very end, continued to win awards. (Warhol received two Art Directors Club awards in 1960 for I. Miller shoe illustrations that appeared in the *New York Times* and another in 1961 for a shoe-ad drawing published in the *Chicago Tribune*.)

But I. Miller's incoming president, seeking to bolster sales, wanted a new and different kind of advertising, utilizing photographs of actual shoes. Warhol was no doubt very startled to walk into Fabian's office one day and to be told that his services were no longer needed, but he took the news stoically. "He thought I had dropped him because *I* wanted to use photographs," Fabian said, "but it was against my wishes that he was let go. I was obliged to do it. I didn't stay much longer myself."[15] After Fabian's departure in 1962, I. Miller's ads were done by an outside advertising agency.

Warhol, however, remained in demand, receiving plenty of assignments from women's fashion magazines.

While trying to keep his commercial career afloat, Warhol concentrated on his painting. He cast his friends in the role of consulting art directors, relentlessly nagging them for art ideas. Andy was never embarrassed about asking someone, "What should I paint?" He solicited suggestions from lots of people, then used the proposals as conversational gambits. If X came up with a provocative concept, Warhol immediately tested its potency by discussing it with Y. "That kind of thing," he said in 1980, "would go on for weeks whenever I started a new project—asking everyone I was with what they thought I should do. I still do it."[16]

Toward the end of 1961, Warhol was painting individual and group "portraits" of Campbell's Soup cans in every available flavor (plate 104)—there were then thirty-two. The pictures had shock value because they seemed to be mere copies of manufactured labels on consumer products, displaying no discernible imagination, expression, or originality. Although relatively few people actually saw the soup-can pictures in his studio, word of them spread quickly throughout the art world, generating widespread controversy and scandal long before they were publicly exhibited. The paintings did not have to be seen to create consternation.

NOTES

1. Interview with Ivan C. Karp, April 22, 1988.
2. Interview with Ivan C. Karp, April 22, 1988.
3. Interview with Ivan C. Karp, April 22, 1988.
4. John Wilcock, *The Autobiography & Sex Life of Andy Warhol* (New York: Other Scenes, 1971), n.p.
5. Patrick S. Smith, *Andy Warhol's Art and Films,* (Ann Arbor, Mich.: UMI Research Press, 1986, 1981), pp. 351–52.
6. Interview with Ivan C. Karp, April 22, 1988.
7. Andy Warhol and Pat Hackett, *POPism: The Warhol 60s* (New York: Harcourt Brace Jovanovich, 1980), p. 20.
8. Interview with Ivan C. Karp, April 22, 1988.
9. Interview with Irving Blum, October 2, 1987.
10. Emily Tremaine, "Emily Tremaine: Her Own Thoughts," *The Tremaine Collection: 20th Century Masters* (Hartford, Conn.: The Wadsworth Atheneum, 1984), p. 19.
11. Tremaine, *Tremaine Collection*, p. 29.
12. Warhol and Hackett, *POPism*, p. 22.
13. Smith, *Warhol's Art and Films*, p. 25.
14. Interview with David Mann, March 1968.
15. Interview with Robert Fabian, October 29, 1987.
16. Warhol and Hackett, *POPism*, p. 17.

"If you take a Campbell's Soup can and repeat it fifty times, you are not interested in the retinal image. What interests you is the concept that wants to put fifty Campbell's Soup cans on a canvas."— *Marcel Duchamp*[1]

Anyone who ever walked a supermarket aisle or thumbed through a magazine could easily recognize a can of Campbell's Soup. But until Andy Warhol came along, no artist had ever entertained the idea of painting a "full-face portrait" of a soup can and making it the sole subject of a work of art. The very idea was so ridiculous that people could argue the merits and even the ethics of the work without feeling any compelling need to actually see it. As a result of the artist's conceptual and stylistic strategies, his Campbell's Soup paintings made Andy Warhol a household name.

Warhol's red-and-white-labeled pictures signaled a cold-blooded rebellion against the centuries-long tradition of painterly still lifes. It was as if the artist had declared that packaged foods with recognizable brand names constituted contemporary reality, abruptly leading him to clear the table of outmoded visual feasts. His paintings implied that nobody should go on mimicking Caravaggio's sensual baskets of ripened fruits, Chardin's glowing copper vessels and mounds of plush peaches, or Cézanne's dynamic arrangements of energy-rich apples. It was also goodbye to all those extravagant banquets of seventeenth-century Dutch art and even the intellectual pleasures of Cubist tabletops. The joy of food was now exemplified by a humdrum can of condensed soup starkly isolated against a refrigerator-white ground. High-minded admirers of *belle peinture* felt a chill as they gazed at or thought about Warhol's soup-can paintings, which seemed only a shade more intellectual, cosmopolitan, and cultivated than a pantry shelf.

"Soup of the evening, beautiful soup!" Warhol's stark soup cans were a far cry from Lewis Carroll's evocative and often quoted line from *Alice's Adventures in Wonderland.*[2] (Warhol certainly knew this particular line—Ralph Pomeroy had paraphrased it earlier in their collaborative portfolio, *A la Recherche du Shoe Perdu.)* Once upon a time, Warhol's art had displayed a sympathetic relationship to Carroll's whimsical fantasies. But the artist's mind-set was taking him in the direction of absurdism and away from the merely fanciful. His pictures were going to prove bothersome on several counts, including subject matter, style, and artistic intention.

Warhol's earliest soup-can painting appears to be *Campbell's Soup Can (Tomato Rice),* a 1960 canvas rendered in a combination of ink, tempera, crayon, and oil. It is obviously related by subject and

83. *Big Campbell's Soup Can, 19¢.* 1962. Acrylic and pencil on canvas, 72 x 54½". The Menil Collection, Houston

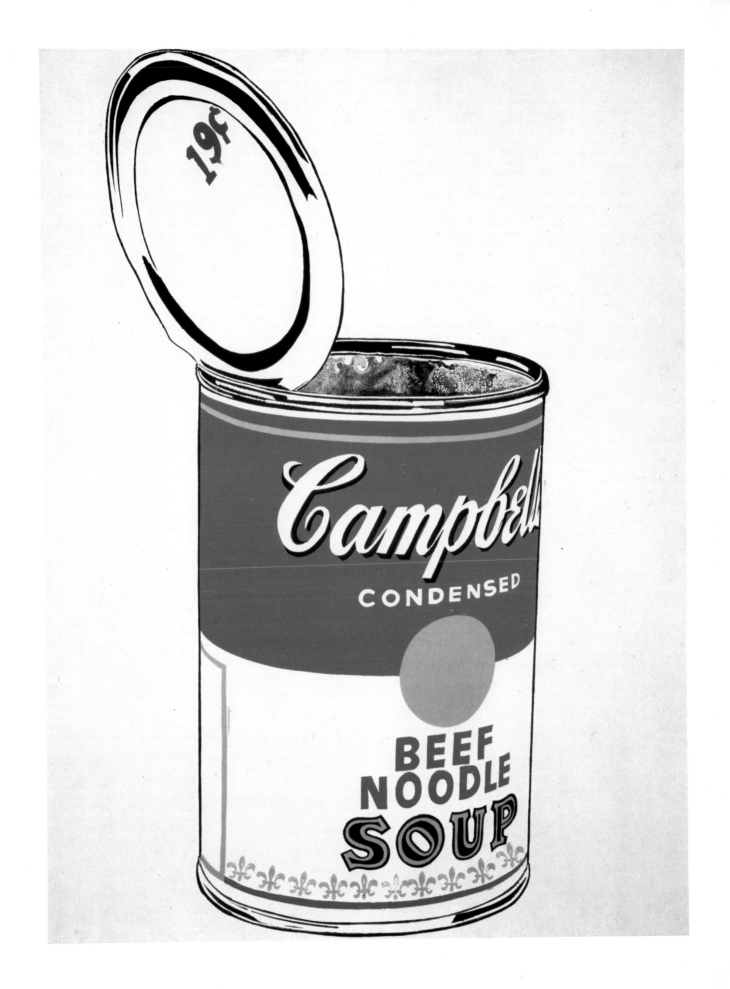

style to some of his other early images of products of the food-processing and beverage industries, specifically the Del Monte can and the paint-smeared Coca-Cola bottle, both dated 1960. Like those two larger and more complex pictures, *Tomato Rice* displays a vestigial expressionism in the form of runny paint that drips down the label.

Warhol polled many of his friends and acquaintances about what subjects to paint in order to avoid conflict with Roy Lichtenstein, who was scheduled to have his first show at the Castelli Gallery in February 1962. Anyone could have suggested or ratified the idea of painting Campbell's Soup. The product was not only commonplace but also in keeping with his other brand-name products—from General Electric television sets to Dr. Scholl's corn pads. Andy always zeroed in on the most familiar and instantly recognizable subjects. Just as he had chosen to paint Superman and Dick Tracy because they were headliners in their field, he decided to depict Coca-Cola and Campbell's Soup, the two leading products in their markets. At the time Warhol was producing his soup-can paintings, four out of every five cans of prepared soup sold in the United States were Campbell's. But he preferred that the Campbell Soup Company know nothing about his paintings "because the whole point would be lost with any kind of commercial tie-in."[3]

Processed soup impressed many people as an unworthy subject for fine art, too identified with mass production and commercial mediocrity. Asked what he really thought of tomato soup, Warhol usually responded with a limp statement, such as "I love it."[4] Once, when the spirit moved him to elaborate, he declared, "I just paint things I always thought were beautiful, things you use every day and never think about. I'm working on soups, and I've been doing some paintings of money. I just do it because I like it."[5] But Warhol's feelings about soup were nowhere evident in his noncommittal paintings.

Perplexed critics might have found Warhol's work more tolerable if they had been able to perceive an attitude toward his subject. Why did he think a commonplace supermarket item was worth painting? Was he a genuine fan of processed soups or was he making fun of them? Did he behold beauty in everyday food tins or was he satirizing the standardization and conformity of American

society? Was he for or against mass production, consumerism, and advertising? Were his provocative icons a comment on the decline of individualism? Viewers seemed to want some editorial comment, expecting the artist to take a position. (The critical response in Europe was particularly skewed. There, the artist's enthusiastic fans detected a subversive or Marxist slant to his work, seeing it as caustic satire on American capitalism.) But it was not Warhol's style to take positions, and it would be misleading to assert that he intended his soup-can paintings to signify either commendation or censure. This does not mean that the paintings are lacking in substance or significance, for they are burdened with a heavy freight of references and allusions that include the above questions. Still, there is a distinct possibility that Warhol's intended purpose in painting soup cans may not have amounted to much more than a calculated effort to rivet the art world's attention. "Tomato soup will never be just tomato soup again," Ivan Karp announced with great satisfaction, because it had become a "symbol that is universally recognized" as Warhol's own.[6]

While Warhol's intentions remained obscure, the manner in which he painted his soup cans definitely set viewers' teeth on edge. His unpainterly, inexpressive technique, virtually indistinguishable from the advertising art that served as his source, alienated much of the art world, which was already suspicious of him because of his commercial background.

Most of the pictures in this series were not conventional still lifes, showing a harmoniously arranged group of objects within a coherent three-dimensional space. Instead, they were precise, mechanical-looking renderings based on a commercial illustration of a soup can. Many of the paintings were essentially identical—only the flavors on the labels varied. He typically portrayed a single can, centered against a white ground and viewed slightly from above. His deadpan treatment emphasized Campbell's "packaging"—the familiar red-and-white label (first used on the product in 1898) with its several different typefaces. Warhol deliberately achieved the impersonal look by using stencils. The only part of the original composition that he drastically simplified was the gold medallion, which features a pair of allegorical figures; he converted it into a flat yellow disk. Otherwise, the paintings were literal copies of soup-can

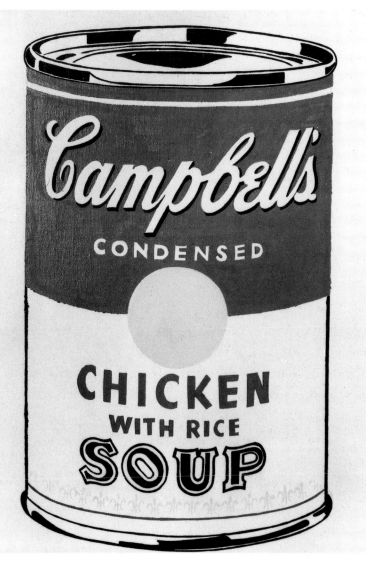

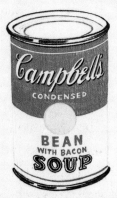

84. *Campbell's Soup Cans (Chicken with Rice, Bean with Bacon).* 1962. Acrylic on canvas, two panels, each 20 x 16″. Stadtisches Museum Abteiberg, Monchengladbach

illustrations, down to the schematic shading on the tin lid, the only hint of any three-dimensionality in an otherwise flattened image.

The issue of transformation became an overriding concern among critics who faulted Warhol for not inventing an image of his own. They perceived no evidence that he had aesthetically transformed his ready-made image in any way. How, they wondered, could anyone call himself an artist who merely copied labels? Where was the imagination, expression, and originality? In transposing a "found image" to canvas, Warhol underplayed his compositional strategy, but he was making critical decisions

regarding the size of the can, its scale in relation to the background, its positioning against a white field, and, of course, the stenciled flavor. His seeming lack of composition helped focus attention on his concept of image-making.

Some people were put off by the serial nature of Warhol's enterprise, believing that he repeated the same composition over and over as if his soup cans were tumbling off an assembly line with only the labels varying. But, in fact, he painted his subjects in varied sizes and formats. The paintings range in height from twenty inches to six feet. Warhol most often portrayed the cans in pristine

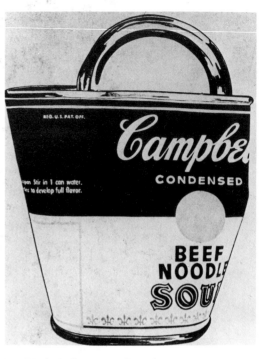

85. *Big Soup Can with Torn Label (Pepper Pot)*. 1962.
Acrylic on canvas, 72 x 54″. The Estate of Andy
Warhol

86. *Campbell's Soup Can with Peeling Label (Black
Bean)*. 1962. Acrylic on canvas, 72 x 54″.
Kunstsammlung Nordhein-Westfalen, Düsseldorf

87. *Big Open Campbell's Soup Can (Beef
Noodle)*. 1962. Acrylic on canvas, 70 x 54″. The Estate
of Andy Warhol

condition, but he sometimes painted them with opened lids or with torn and peeling labels.

In contrast to the immaculate cans, Warhol painted a smaller, comparatively morbid series of tins that had been violated or deformed. An otherwise intact can of vegetable soup is portrayed at the precise moment in which it is punctured by a can opener (plate 92), a somewhat menacing sight insofar as the gadget appears to be operating without any sign of human guidance. Then there is the "corpse" of a can of "beef noodle" (plate 87), shown in an uncharacteristic profile with its upper torso nearly flattened; the can's label is unviolated, but half of its decapitated lid is stuffed into its opened end.

Warhol's most eloquent and tragic soup cans are those with torn labels, among the most impressive of all his works. Like memento mori, they are metaphorical reminders that all living things must die; even packaged food, after all, has a limited shelf life. As intimations of mortality, these handpainted pictures are far more effective than the artist's 1976 series of silkscreened paintings of human skulls. A "pepper pot" label is ripped in several areas but still in place. The top half of a "vegetable beef" label (plate 88) is falling off, revealing the underlying tin, which is blotched to suggest shading.[7] In *Big Soup Can with Torn Label (Pepper Pot)* (plate 85), only the left side of the label remains, curling away from the can. All the torn-label paintings are uncommonly expressionistic for Warhol, conveying a preoccupation with degradation. One is tempted to read into these works all sorts of dark prophecies, ranging from the nation's decline as an industrial power to the coming apart of American society as a result of its military involvement in Vietnam. But it is seldom a good idea to plumb deeply for meaning in Warhol's art.

In addition to all the single cans, both pristine and battered, Warhol painted several pictures of multiple soup tins, regimented across the entire surface of the canvas, creating a formidable wall of labels that suggests a fully stocked aisle in a supermarket. He

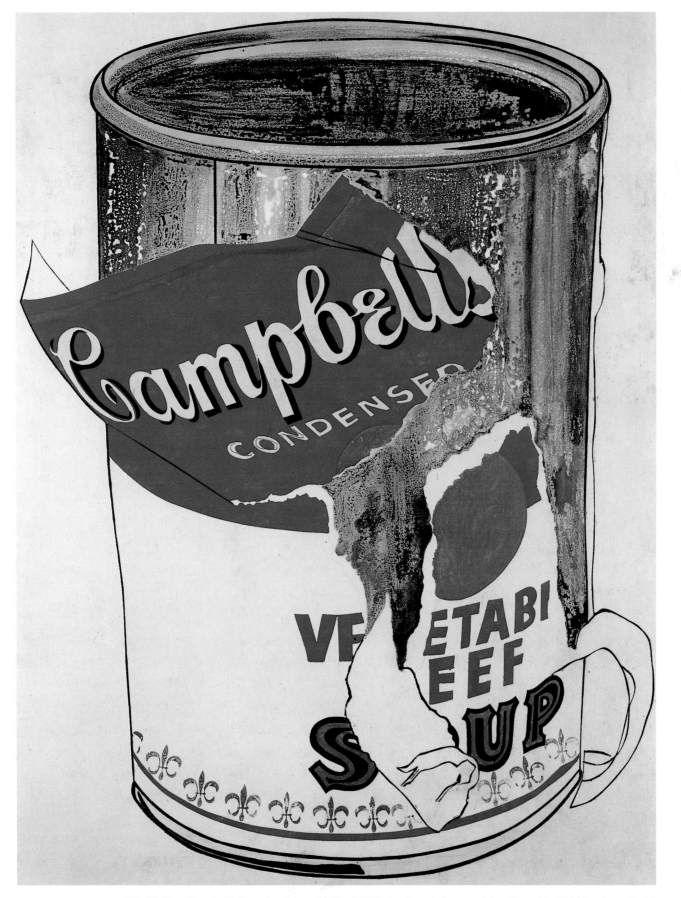

88. *Big Torn Campbell's Soup Can (Vegetable Beef).* 1962. Acrylic and silkscreen ink on linen, 72 x 54″. Kunsthaus, Zurich

94

89. *Soup Can.* 1961. Pencil and ink wash on paper, 39¾ x 29⅞″. Collection Jean Yves Mock, London

90. *Campbell's Soup Can with Ketchup Bottle.* 1962. Pencil on paper, 24 x 18″. Collection Robert and Meryl Meltzer

91. *Campbell's Soup Can and Dollar Bills.* 1962. Pencil and watercolor on paper, 24 x 18″. Collection Roy and Dorothy Lichtenstein, New York

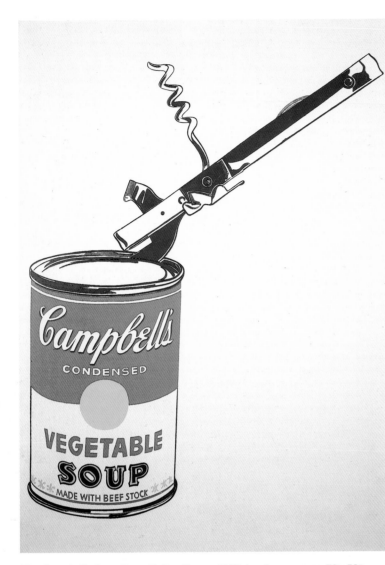

92. *Campbell's Soup Can with Can Opener.* 1962. Acrylic on canvas, 72 x 52″. Collection Windsor, Inc., St. Louis

created the illusion of stacked cans by simply eliminating the perspective view of the top lid. Stencils facilitated his ability to produce *100 Campbell's Soup Cans* (plate 94), all "beef noodle" and displayed in a ten-by-ten grid, and *200 Campbell's Soup Cans* (plate 93), a mixture of flavors, also arranged in ten rows; the latter is the largest of the soup-can paintings, measuring seventy-two by one hundred inches. The repetition resulted in an allover pattern that encourages viewers to scan the work as a whole, almost as if it were an abstraction, because visual incident is evenly dispersed across a grid. One's gaze may occasionally linger on a particular unit, but it is more likely to keep sweeping around the entire field in a vain quest for a focal point.

Warhol's use of repetition as a compositional device clearly separated his work from Lichtenstein's, enabling him to get out from under the other artist's lengthening shadow. The grid organization implied mass production and uniformity and also possessed commercial overtones that he welcomed. As a result, the repetition of unitary images became a central element of Warhol's aesthetic, and he went on to regiment shipping labels, airmail stamps, dollar bills, and Coca-Cola bottles.

During 1962, Warhol produced numerous pencil drawings of soup cans in conjunction with Coca-Cola and Heinz ketchup bottles, as well as dollar bills. As usual, he deliberately neglected to fill in all of the words and logos, leaving some of the letters blank. Many of the drawings are noteworthy for their incongruous, somewhat grotesque collisions of brand-name goods—a Coca-Cola bottle standing inside an empty tomato-soup can or an empty tomato-soup can set upside down on top of a Heinz ketchup bottle (plate 90). Some of the works hint at a kinky underworld of supermarket sodomy, while others prophesy the morbidity and violence that would pervade the artist's later paintings of car crashes. Several of the drawings, despite their jarring juxtapositions, are conventional still lifes in the sense that they present objects in relation to one another within a spatially coherent context. One of the most poignant is a can that has lost its label, standing alone in mute anonymity (plate 89).

In 1965, Warhol would return to the subject of Campbell's Soup cans, which he then silkscreened individually in "fauve" colors—any

93. *200 Campbell's Soup Cans*. 1962. Acrylic on canvas, 72 x 100″. Collection John and Kimiko Powers

94. *100 Campbell's Soup Cans.* 1962. Acrylic on canvas, 72 x 52″. Museum of Modern Art, Frankfurt a/M

arbitrary combination of hues but the original red and white (see plate 190). In the late 1970s, he would also incorporate inverted images of the soup cans in some of his Reversals series.

Warhol's early soup-can pictures created shock and controversy throughout the art world. In the spring of 1962, art critic Lawrence Alloway showed slides of Warhol's work to about sixty of his students at Bennington College in Vermont, igniting arguments that flared throughout the school. One of his students, Suzy Stanton, wrote a paper for the course, parodying various hypothetical theories and motives that ostensibly led to the paintings. She devised an imaginative scenario in which sixteen students visited Warhol's studio and recorded their interpretations of the man and his work.

In one of Stanton's fantasized versions, Warhol asks his visitor, "Won't you come and share my soup with me? I'm just about to have my lunch—or is it breakfast? or dinner? Oh, the time is not important, I always have soup no matter what the hour happens to be." As the two sit down, Warhol remarks: "I love soup, and I love it when other people love soup, too.... You know, when I was little, my mother always used to feed us this kind of soup. But now she's gone, and sometimes when I have soup I remember her and I feel like she's right here with me again."[8] There was a good measure of truth in this. According to Warhol's brother Paul, their mother habitually served Campbell's Soup at home, and Andy grew up on the product.[9]

In another of Stanton's scenes, "Warhol looked dismayed when we inquired into the significance the Campbell's soup can had for him. 'Soup!' he said, 'who really cares what the soup or the can or Campbell's means to me? The important thing is what each one of you thinks....I've already made my statement—right there.'"[10]

Andy himself couldn't have said it better.

NOTES

1. Rosalind Constable, "New York's Avant Garde and How It Got There," *New York Herald Tribune*, May 17, 1964, p. 10.
2. Lewis Carroll, *Alice's Adventures in Wonderland*, Chapter 10, Stanza 3.
3. Warhol, interviewed by the author, March 1962. The Campbell Soup Company soon became aware of Warhol's paintings but maintained a long silence. In 1965, Ivan Karp observed, "The Campbell people are a staid, conservative people. For three years after Mr. Warhol glorified tomato soup, they said nothing. But recently they gave their retiring president one of Andy's paintings as a going-away gift. And if I may judge by the expression on the old man's face in the newspaper, there is nothing he wanted less." ("The Contemporary Scene," *Arts Magazine*, May–June 1965, pp. 16–18.)
4. "The Contemporary Scene," p. 18.
5. "The Slice-of-Cake School," *Time*, May 11, 1962, p. 52.
6. "The Contemporary Scene," pp. 16–18. Karp was right: gift shops soon advertised "Pop art highball glasses" bearing "the famous Campbell's Soup label by Andy Warhol." The Campbell Soup Company adopted the red-and-white label in 1898, after one of its executives, Heberton L. Williams, attended a football game between the University of Pennsylvania and Cornell University and was taken by the Cornell team's red-and-white uniforms. The company's previous label had been orange and black. In 1900, Campbell won a gold medal for excellence at the Paris International Exposition and added a picture of the medallion to its label.
7. None of the artist's intimates knows how he achieved the blotchy effect. The paint appears to have been blotted or possibly sponged rather than brushed.
8. Suzy Stanton, "On Warhol's *Campbell's Soup Can*," manuscript (May 20, 1962), p. 2. Alloway sent a copy of Stanton's essay to Warhol, who was so enthusiastic about it that he had it photocopied and distributed as the announcement for his November 1962 exhibition at the Stable Gallery. Excerpts from Stanton's paper, titled "Warhol at Bennington," were later published in *Art Journal*, Summer 1963, pp. 237–38.
9. Interview with Paul Warhola, September 24, 1987.
10. Stanton, manuscript, p. 3.

"I'm using silkscreens now. I think somebody should be able to do all my paintings for me. I haven't been able to make every image clear and simple and the same as the first one. I think it would be so great if more people took up silkscreens so that no one would know whether my picture was mine or somebody else's."—*Andy Warhol*[1]

Although his paintings of Campbell's Soup cans were generating notoriety throughout the art world, Warhol was making little progress in his efforts to connect with a respected New York gallery. One of the more adventuresome dealers to visit him during the second half of 1961 was Allan Stone, who thought the pictures had "something," though he was put off by Warhol's flat, seemingly brushless technique. "His paintings had no surface life," said Stone, who favored the lushly textured pigments of Abstract Expressionism, "but I liked the bravura of the stacks of soup cans." Stone took several of the works on consignment, including a large grid of one hundred Campbell's Soup cans, and a big single soup can with a torn label, and stocked them in the back room of his gallery, then located at 18 East 82nd Street. He showed the pieces to potential buyers and possibly exhibited a small soup-can picture in a December 1961 group show.[2]

Stone offered to put Warhol into a three-man show that would have included two other newly emerging Pop painters, Robert Indiana and James Rosenquist, but all three artists balked, holding out for solo exhibitions. "They were all incensed," according to Stone, who ended up representing none of them. Meanwhile, Warhol and his friends continued to campaign for a one-man exhibition of his own. "I started getting an incredible number of phone calls from a lot of people I didn't know, like Philip Johnson, people like that, suggesting that I give Andy a show," Stone said.[3]

Warhol's inability to get an exhibition at a reputable gallery caused him tremendous frustration. Virtually every New York artist whose name was linked with what soon became known as Pop art was already lined up for a one-person show in the city during 1962, but Andy was making no progress in finding a dealer willing to represent him. The new art movement was erupting all around him, winning tremendous attention, and he was well aware that he had only a limited time in which to make a successful debut as part of the school. He anxiously made the rounds of his "competitors'" exhibitions—and worried that the bandwagon was departing without him.

Warhol, accompanied by his friend Ted Carey, started off the year by visiting Claes Oldenburg's Store, a dazzling installation of brightly painted plaster objects representing everyday clothing and

95. *Do It Yourself (Flowers)*. 1962. Acrylic and Prestype on canvas, 69 x 59″. Collection John and Kimiko Powers

96. *Handle with Care—Glass—Thank You.* 1962. Silkscreen ink on canvas, 82⅛ x 66⅛″. Collection Erich Marx, Berlin, on extended loan to the Stadtisches Museum Abteiberg, Monchengladbach

and the clever way in which Oldenburg blurred the distinction between studio, exhibition space, and marketplace. The experience was almost too much for Andy, who left muttering, "I'm so depressed."[4]

During January, he most probably saw Jim Dine's first solo exhibition at the Martha Jackson Gallery, a respected establishment that Warhol viewed as a desirable showcase for his own work. Dine's large, drastically stark paintings depicted or incorporated articles of clothing—hats, ties, coats, suspenders, and shoes. Like Oldenburg, Dine was a harbinger of Pop art, although he, too, employed an essentially expressionistic style. At the end of the month, James Rosenquist had his first show of large billboard-like paintings at the Green Gallery. Unlike Dine and Oldenburg, Rosenquist was an exponent of an emerging "anti-drip sensibility," shunning expressionistic brushwork in favor of neatly rendered images. His compositions resembled magnified collages of magazine and outdoor advertising illustrations, and they presented a distilled impression of contemporary American popular culture by juxtaposing details of human anatomy, food (canned spaghetti, large as fire hoses), and industrial commodities in extreme close-up and in garish colors. Ted Carey saw the show and telephoned Warhol to say that Rosenquist's paintings were "really wonderful" and that he was thinking of buying one. "If you buy one of those paintings," Andy told him, "I'll never speak to you again."[5]

But February was the cruelest month for Warhol because of Roy Lichtenstein's exhibition of cartoon pictures at the Leo Castelli Gallery. The mild-mannered assistant painting professor turned into the Clark Kent of Pop art, shaking up the art world with his controversial paintings (which sold out at prices ranging from $400 to $1,200, then respectable sums for "new" artists). Lichtenstein's show closed off any possibility of Warhol exhibiting his own cartoon paintings, because the public would have assumed he was imitating the other artist. (Although Pop artists were brazen copyists of mass-media images, none of them, ironically, wanted to be perceived as copyists of one another).

On April 17, Warhol attended the opening of Wayne Thiebaud's show at the Allan Stone Gallery. The California painter exhibited juicily painted all-American foods—hot dogs, ice cream cones, hard

food, displayed in the artist's storefront studio at 107 East 2nd Street; the inventory of expressionistically rendered goods included shoes, dresses, pants, cakes, and pies. Oldenburg's striking exhibition, which opened in December 1961 and continued through January 1962, received a good deal of attention for its flamboyant contents, its offbeat location on the Lower East Side, and its split personality (store? studio? gallery? environment?). Warhol, who was almost automatically attracted to any theme that involved merchandise and shopping, thought Oldenburg's show was "fabulous." He was overwhelmed by the abundance of work, its crowded installation,

97. *64 S&H Green Stamps.* 1962. Silkscreen ink on canvas, 20 x 16″. Collection Betty M. Asher, Los Angeles

98. *Red Airmail Stamps.* 1962. Silkscreen ink on canvas, 20 x 16″. Collection Thordis Moeller, Millerton, New York

candies, layer cakes, and meringue-topped pies. The opening itself qualified as a Pop art event because the owner of a nearby bakery was so flattered by the artist's choice of subject matter that he donated a plethora of gooey desserts. The show was a sellout, and, for a while, Thiebaud was the most widely admired artist of the new school.[6]

Warhol, having abandoned his comic-strip imagery because of Lichtenstein, was now agitated because so many other artists were dishing up images of food, thereby putting his soup-can paintings in jeopardy. Would his soup cans be crushed by Rosenquist's

colossal spaghetti, Oldenburg's eighty-four-inch-diameter *Floor-Burger* (exhibited at the Green Gallery the following September), or Thiebaud's frosted cakes?

As Warhol strove to establish a subject matter and style that were identifiably his own, he increasingly concentrated on two methods—one compositional, the other technical. His favored format became the grid, which he had used in his commercial illustrations throughout the 1950s. Warhol initially chose subjects that existed in actuality in mass-produced multiples. Postage and trading stamps, routinely produced in perforated sheets, were ideal

99. *Ten-Dollar Bill.* 1962. Pencil and watercolor on paper, 10 x 23″. Private Collection, New York

100. *Dollar Bill with Washington's Portrait.* 1962. Pencil on paper, 30 x 40″. Collection Roy and Dorothy Lichtenstein, New York

101. *Five-Dollar Bill, Incomplete.* 1962. Pencil on paper, 17¾ x 23⅝". Private Collection

102. *80 Two-Dollar Bills, Front and Rear.* 1962. Silkscreen ink on canvas, 83 x 38″.
Museum Ludwig, Cologne

candidates for unitary compositions. His decision to present these forms as an ongoing, seemingly endless succession of units conveys the impression that quantity and conformity are of crucial importance. It didn't really matter whether he repeated the image twenty, one hundred, or two hundred times; the implication was always that the potential sum is infinite.

His decision to repeat the same image over and over in a grid composition prompted him to employ stencils and rubber stamps. These techniques not only expedited his production by facilitating the rendering of typography, but also minimized personal touch, enabling him to make pictures that almost appeared as if they had been stamped out by a machine. Both in his blotted-line drawings and in his paintings, he had always liked a printed look.

Warhol, assisted by Gluck, carved art-gum erasers with larger-than-actual-size images of seven-cent airmail stamps and used them to imprint rows of identical red or blue images on canvas. (The technique was identical to the one Warhol and Gluck had used throughout the late 1950s.) The hand-carving is especially noticeable in the irregular contours of the lettering and the plane in *Red Airmail Stamps* (plate 98), and is also visible in *64 S & H Green Stamps* (plate 97); the latter image required two different stamps, one for each color. (Mrs. Warhola was a fervent collector of the popular Sperry & Hutchinson trading stamps, which many stores dispensed as a premium to their customers. She sometimes enlisted Andy to help her paste the S & H stamps into booklets, which she could later redeem for merchandise.)

In addition to postage and trading stamps, Warhol pictured a form of printed paper that he most definitely liked: dollar bills. This subject marked an important turning point in his art because it prompted him to take up silkscreening in the spring of 1962.

Many of Warhol's 1962 representations of dollar bills took the form of pencil drawings (plates 99, 100, 101), some with added watercolor. Several of the works on paper show full, flattened dollar bills, while others present them as a mass of crumpled planes or wadded into thick rolls in three-dimensional still-life arrangements. But when Warhol wanted to repeat the bills in grid compositions, as he had with the stamps, he realized that cutting a stencil or carving an eraser was too difficult for such a complicated, detailed image.

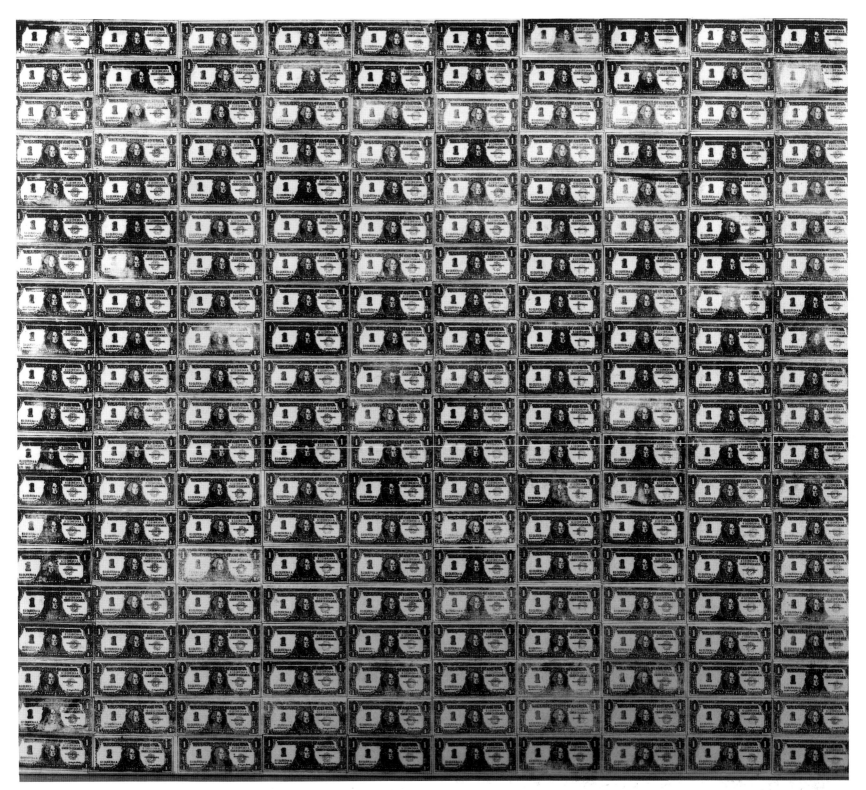

103. *200 One Dollar Bills*. 1962. Silkscreen ink on canvas, 82 x 92″. Private Collection

108

(The legal consequences of reproducing a dollar bill at actual size also may have deterred him.) Warhol first made drawings of both the front and back of a dollar bill, then took them to a printing shop, which converted the line drawings into hand-cut silkscreens. (Gluck recalled that Warhol asked the men who did his Christmas cards at the Tiber Press if they could make him a silkscreen of actual money. They reportedly told Warhol that if he provided them with a drawing, they could make a silkscreen of that.)

Silkscreening is a photomechanical stencil process utilizing a fabric screen that has been chemically treated so that certain areas are impervious to pigment, while other areas let the pigment pass through. The silkscreen functions like a fabric negative: what appears light on the screen comes out dark, and what is dark is not printed at all. To imprint the image, the canvas is spread out on the floor, and the silkscreen, stretched taut within a wood frame, is placed over it, in contact with the surface to be painted. The pigment is poured in a line along one inside edge of the frame and then swiped across the screen with a rubber squeegee, forcing the paint through the open meshes and onto the canvas below. Warhol's early silkscreens were approximately the same dimensions as the actual source pictures. As a result, the screens were small enough (about ten or twelve inches in either direction) that Warhol could do the squeegeeing by himself.

Warhol's paintings of dollar bills are the first works in which he employed that technique.[7] It is certain that he had already silkscreened one of the largest and most imposing of his money paintings, *200 One Dollar Bills* (plate 103), by the end of April 1962. (The currency in the painting is depicted larger than actual size, and the round Treasury Department seal on the right half of the bill is printed in blue, which probably required a separate silkscreen.) The approximate date of the painting is known because a portion of it shows up in a photograph published in the May 11, 1962, issue of *Time;* allowing for the time it took to prepare the article, as well as the advance dating of the magazine, the photograph could not have been taken any later than April.[8]

Warhol's paintings and drawings of flat dollar bills bring to mind the trompe l'oeil works created by several American painters in the closing decades of the nineteenth century, specifically William M.

Harnett and John Haberle, both of whom scrupulously copied paper money. (Warhol's pictures of postage stamps were also anticipated by Jefferson David Chalfant, who made a small painting in which he pasted an actual two-cent stamp alongside a painted one, drawing a simulated news clipping that challenged viewers to tell the difference.) Many fool-the-eye illusions depend for their success upon the actual flatness of the pictured subject. Like Haberle and Harnett, Warhol repeatedly chose to paint subjects that possessed very little three-dimensionality.

Warhol's subjects, however, like those of Jasper Johns, were not chosen entirely for their flatness. Many of his replications, including the postage and trading stamps and dollar bills, are based on printed paper with a specific financial value, and offer evidence of Warhol's persistent wish to achieve a sort of artistic alchemy, transforming ordinary paint into actual cash. Warhol loved few things better than to barter his art for objects that had more value, at least in his eyes. He earnestly yearned for the power to transmute virtually everything he touched into something of greater financial worth.

One of the few Warhol paintings that represents paper stamps *without* commercial value is *Handle with Care—Glass—Thank You* (plate 96). This red-and-white picture was also silkscreened, apparently with a hand-cut stencil, about the same time as the multiple dollar-bill paintings. Warhol demonstrated wit and irony in imprinting a warning label about the fragility of glass on a canvas surface, which traditionally functions as the so-called picture plane, the "window" through which spectators perceive a realist's illusionistic reconstruction of three-dimensional space. The reference to nonexistent glass and an ambiguous picture plane was reiterated a couple of years later by Johns.[9]

Throughout the spring, dealers and collectors continued to dart in and out of Warhol's parlor-floor studio to view and purchase his paintings. (Warhol was still earning most of his income through commercial art.) While some dealers put his work into group shows, none offered him a one-man exhibition. Sometime around April, Martha Jackson visited the studio, bought several paintings outright, and discussed the possibility of an exhibition. Consequently, he planned to abandon his rather one-sided relationship with Stone

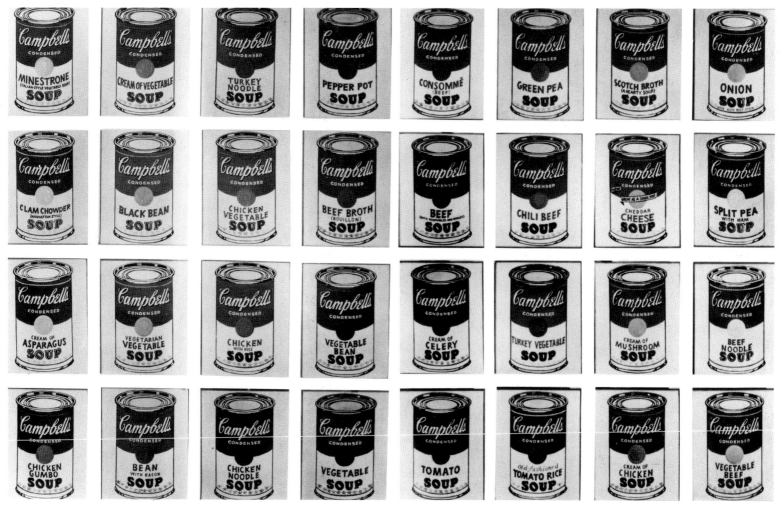

104. *Campbell's Soup Cans.* 1961–62. Acrylic on canvas, 32 panels, each 20 x 16″. Collection Irving Blum, New York

in order to transfer to Jackson, only to learn that she had changed her mind and did not want to represent him after all.

During the first week of May, Warhol attended the opening of a Philip Guston retrospective at The Solomon R. Guggenheim Museum and encountered Irving Blum, accompanied by the Los Angeles collector Betty Asher. Earlier that day, Asher had visited the Allan Stone Gallery and seen two of Warhol's small soup-can paintings, priced at one hundred dollars each, but had been unable to interest her husband in buying one. Warhol invited Blum and Asher to his house, which was only a few blocks from the museum.[10]

There, Blum was startled to see dozens of Campbell's Soup can paintings, including many individual portraits as well as one of the grids of one hundred Campbell's Soup cans. "What happened to the cartoons?" Blum wanted to know. Warhol explained that Lichtenstein was treating similar subjects "in a more finished way" than he had been doing them, so he was "doing these soup cans instead." Blum spent a long time looking at the paintings and decided he liked them. "I said, 'Has anybody expressed any interest in them?' and he said, 'Yes, Martha Jackson. But I have no gallery.' I said, 'Would you be interested in showing them in California?' He said, 'Wonderful.'" They decided on a July opening. Blum took a

couple of soup-can paintings with him, and Betty Asher bought *64 S & H Green Stamps*. Subsequently, Warhol shipped a set of twenty-by-sixteen-inch individual portraits of Campbell's Soup, each can labeled with one of the thirty-two different flavors.[11]

News of Pop art reached the general public about the same time that it was spreading through the art world. The novelty and vulgarity of the style fascinated newspaper and magazine editors. As a result, Pop art made an earlier and more dramatic impact in the general press than in the art press. *Time,* in its May 11, 1962, article titled "The Slice-of-Cake School," informed its readers that "a group of painters have come to the common conclusion that the most banal and even vulgar trappings of modern civilization can, when transposed to canvas, become Art." The article discussed the work of Thiebaud (whose *Bakery Counter* was reproduced), Lichtenstein, Rosenquist, and Warhol. An accompanying photograph showed Warhol, spoon in hand, pretending to eat from an opened can of actual Campbell's Soup as he stood in front of one of his six-foot-high paintings, *Campbell's Soup Can with Can Opener.* It is noteworthy that Warhol, though not yet represented by a New York gallery, happened to be the only artist to have a photograph of himself published in the *Time* article, an early hint of his amazing ability to commandeer press coverage by upstaging other artists and even his own art.[12]

Once the mass media started to be attentive to his new art, Warhol worked at developing and perfecting a Pop persona that complemented his paintings. He deliberately cultivated the manner and attitudes of an ostensibly mindless teenager, addicted to some of the more juvenile manifestations of popular culture, such as rock 'n' roll shows and fan magazines. As part of his calculated metamorphosis, he professed to like "monotony" and "repetition." While his mind had never been burdened with a plethora of academic knowledge, it now seemed like a tabula rasa. His verdict on just about everything was "terrific" or "fantastic" or "wow."

When visitors from the "serious" art world were due to arrive, Andy whisked Nathan Gluck to the basement and quickly concealed any evidence of commercial art activities. He made certain the floor was strewed with movie magazines and pop records, everything from Elvis Presley albums to copies of *Teen*

105. *Dance Diagram—Tango.* 1962. Acrylic on canvas, 72 x 54". Museum of Modern Art, Frankfurt a/M

Pinups. Then he turned on the portable 45 rpm record player that he had deliberately "fixed" to play the same tune over and over again, subjecting his callers to endless replays of current hit singles, such as "Teenager in Love" or "Teen-age Heaven." The monotonously repeated song seemed to underscore the unitary images that he often regimented across his canvases.

During the course of 1962, Warhol practiced three very different painting processes: the hand-painted, one-of-a-kind compositions; the pictures of multiplied images for which he used stencils and/or rubber stamps to simulate a machine-printed look; and the

106. *Close Cover Before Striking (Pepsi-Cola).* 1962. Acrylic and sandpaper on canvas, 72 x 54″. Museum Ludwig, Cologne

107. *Do It Yourself (Narcissus).* 1962. Pencil and crayon on paper, 23 x 18″.
Kunstmuseum, Basel

108. *Do It Yourself (Landscape).* 1962. Acrylic on canvas, 70 x 54″. Museum Ludwig,
Cologne

109. *Do It Yourself (Sailboats).* 1962. Acrylic and Prestype on canvas, 72 x 100″. Collection Celine and Heiner Bastian, Berlin

silkscreened paintings, which also feature repeated images. But Warhol's discovery of silkscreen printing did not mean the immediate end of his hand-painted works. While it would be convenient to assume that he made a clear-cut progression from one technique to another, he, in fact, went back and forth between them. There was not a decisive and irreversible shift from one technique to another, or from single into repeated images. The subject, in effect, determined the technique.

Throughout the first half of the year, Warhol continued to produce many unique hand-painted works, based on preexistent images that he copied with the aid of his opaque projector. The pictures are rendered in an impersonal, seemingly mechanical graphic style, as in his enlargements of matchbook covers, such as *Close Cover Before Striking (Pepsi-Cola)* (plate 106). He painted two six-foot-high matchbooks: the other one advertised Coca-Cola. His black-and-white "dance-step" paintings purport to show the movements of actual ballroom dances, such as the fox-trot and tango (plate 105). The special oddity of these latter paintings is that Warhol insisted they be shown parallel to the floor, usually on platforms a couple of feet high.

Warhol derived his Do It Yourself series from actual paint-by-number hobby kits that contained pigment and a small, outlined composition (landscape, seascape, flowers, sailboats, or still life) on canvasboard with numbered areas that the hobbyist was to fill in with specified colors (plates 95, 108). While he copied the entire compositions literally, he filled in only a portion of the colors and with hues of his own choice. He then used press-on type for the numbers, not always with regard to the actual numerals on the models. Only an artist as irreverent and ironic as Warhol could have dreamed up the idea of transposing these kitsch, mass-produced images into "originals" for an affluent audience, which prizes them for being among his wittiest and cheekiest artworks.[13]

Warhol also produced a large number of pencil drawings during the course of 1962. In addition to renderings of soup cans and ketchup bottles, he drew dance diagrams, *Do It Yourself (Narcissus)* (plate 107), and portraits of movie stars (Joan Crawford, Hedy Lamarr, Ginger Rogers). Interestingly, he chose to represent some of the leading ladies who shone more brilliantly in the 1930s

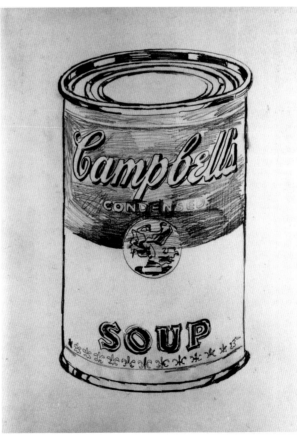

110. *Big Coffee Tin.* 1962. Pencil and watercolor on paper, 18 x 23¾". Kunstmuseum, Basel

111. *Campbell's Soup Can.* 1962. Pencil on paper, 22⅝ x 12¾". Ströher Collection, Darmstadt

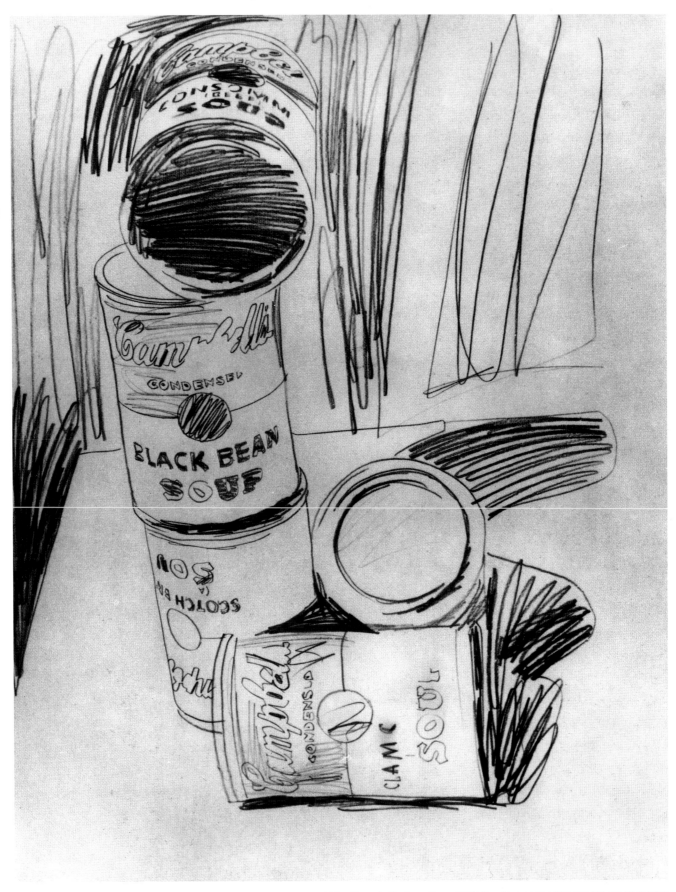

112. *Campbell's Soup Cans.* 1962. Pencil on paper, 23 x 18″. Private Collection

and 1940s, the period of his youth. Their names and faces were as familiar as any brand name or corporate logo in America, and Warhol probably chose them because they were so readily identifiable. (He could not help but notice how movie stars parlayed their celebrity and wealth through paid endorsements of consumer products. Years later, he would exploit the commercial value of his own name and face to earn extra money by promoting everything from airlines and stereo equipment to magazines and investment services.) Warhol copied his penciled portraits of Joan Crawford and Hedy Lamarr (plates 115, 116) from magazine ads in which the long-lashed movie queens endorsed Maybelline, an eye makeup that the latter luminary claimed she "would never be without." He derived Ginger Rogers's portrait (plate 117) from the front cover of *Movie Play*, a fan magazine popular in the 1940s; his literal copying of the entire cover, complete with headlines, corresponds to his related paintings of newspaper front pages.

While he was willing to use nostalgic source material for his movie-star drawings, Warhol preferred his paintings of newspaper front pages to be topical. *A Boy for Meg* (plate 113) is the first of three newspaper paintings made between November 1961 and June 1962, all of them hand-painted blowups of actual front pages of New York tabloids. (Warhol preferred the tabloids with their lively combination of local scandals, celebrity photographs, and gossip columns to the lofty overviews of world affairs offered by the *New York Times*.) The six-foot-high picture portrays the front page of the *New York Post*, and Warhol most likely painted it shortly after the actual date of the newspaper—November 3, 1961. The headline refers to Great Britain's Princess Margaret, who smiles toothily in an accompanying black-and-white portrait. Warhol made a halfhearted attempt to simulate a news photograph but couldn't be bothered with painting it realistically in tones of gray and, instead, treated it as a schematic black-and-white drawing. A smaller portrait of Frank Sinatra at the top of the page is similarly unconvincing as a newspaper photograph. Although Warhol had based many of his drawings over the years on printed photographs, these portraits are his first attempt to make a painting *look* like a photograph.

Aside from the simulated photographs of Sinatra and Princess Margaret, the layout consists largely of letters and numbers in a variety of typefaces. Words and numerals are key ingredients in nearly all of Warhol's early Pop paintings, from the letters in comic-strip balloons and price tags to the brand-name logos displayed on cans and bottles. In contrast to the often incomplete and impressionistic lettering in his freely painted cartoon panels, Warhol now painted sharp-edged headlines. The newspaper front pages, more than most other works, demand to be read, rather than merely looked at, in order to have a meaningful effect.

Warhol's second newspaper painting portrays both the front and back pages of the March 29, 1962, edition of the *Daily News*, showing them as if the paper were spread out flat on the wall. Headlined "EDDIE FISHER BREAKS DOWN/In Hospital Here; Liz in Rome," the front page bears the artist's hand-painted simulation of a photograph of the pop singer and his current wife, Elizabeth Taylor—her first appearance in Warhol's art.

Tabloid headlines epitomized for Warhol the pervasiveness and ephemerality of the mass media. In the long view, historians probably will place little importance on Eddie Fisher's mental state during his rocky marriage to Elizabeth Taylor; but for one spring day, that was the story that engaged the attention of virtually every New Yorker who passed a newsstand. It was precisely that sort of trivia that Warhol sought to preserve for posterity.

Warhol's first two newspaper paintings dealt with celebrity subjects—English royalty and Hollywood personalities, stellar topics that genuinely fascinated him. (Indeed, he would spend much of the 1970s and 1980s socializing with titled Europeans and movie stars.) By contrast, the third and last of his hand-painted newspaper pictures, *129 Die in Jet (Plane Crash)* (plate 114), introduced the subject of accidental and violent death, a morbid theme that was initially quite alien to his essentially optimistic sensibility, but which soon became central to his art.

The gloomy picture originated over lunch at Serendipity, where Warhol met with Henry Geldzahler on June 4. Andy was in a good mood because he was finally getting some recognition: the *Time* magazine article had recently appeared, and Irving Blum was about to show his soup-can pictures at the Ferus Gallery in Los Angeles. But Geldzahler was being peevish and a bit impatient. He thought there had been enough "affirmation of soups and Coke bottles" and

113. *A Boy for Meg.* 1961. Acrylic on canvas, 72 x 52″. National Gallery of Art, Washington, D.C. Gift of Mr. and Mrs. Burton G. Tremaine

114. *129 Die in Jet (Plane Crash).* 1962. Acrylic on canvas, 100 x 72″. Museum Ludwig, Cologne

115. *Joan Crawford.* 1962. Pencil on paper, 23⅝ x 17¾". Collection Dia Art Foundation, New York

116. *Hedy Lamarr.* 1962. Pencil on paper, 23⅝ x 17¾". Collection Dia Art Foundation, New York

"too much emphasis upon the consumerism aspect" of Pop art. "I wanted Andy to get serious," Geldzahler maintained. "I said, 'It's enough life. It's time for a little death.' He said, 'What do you mean?'" Geldzahler happened to be carrying a copy of that day's *New York Mirror,* headlined "129 DIE IN JET." (The story reported the crash of an Air France Boeing 707 on takeoff near Paris.) He handed it to Warhol, saying, "This is what's really happening."[14] (Geldzahler was certainly aware that Warhol had previously painted two pictures of newspaper front pages, but it was typical of Andy's friends to feed him images relating to subjects he had already admitted to his repertoire.)

Although *129 Die* is an important transitional work in Warhol's oeuvre, it is not one of his greatest paintings. None of his three newspaper pictures is really very successful as a work of art. All tend to be relatively overblown and vacuous, and deficient in surface detail. One reason that they don't altogether succeed, perhaps, is that he lacked the skill and/or patience to make hand-painted simulations of halftone photographs. Warhol was in too much of a rush to care about the subtleties of tonal modeling, so his portraits of "Eddie," "Liz," and "Meg" emerged as summary sketches.

Perhaps dissatisfied with the results of his newspaper pictures,

117. *Ginger Rogers.* 1962. Pencil on paper, 23¾ x 18″. Whitney Museum of American Art, New York. Purchase with funds from the Lauder Foundation—Drawing Fund 79.29

Warhol continued to work on soup cans and Coke bottles. In fact, he resumed the Coca-Cola imagery that he had initiated a year or two earlier, but now began to marshal multiple impressions of an actual-size bottle across the picture plane. He based his image on a schematic advertising illustration. It is unclear whether he stenciled or silkscreened the Coke bottles, or employed a combination of the two techniques. The uneven contours of the lettering on the bottles could be the result of either a stencil or hand-cut silkscreen. (According to Gluck, Warhol used a hand-carved balsa-wood stamp for the earliest multiple images of Coca-Cola bottles.)

Green Coca-Cola Bottles (plate 119) presents 112 bottles arranged in a grid seven rows high by sixteen across. All of the bottles are presented "full face." The regimented deployment of the bottles suggests mass production and machine-like uniformity, but closer inspection reveals individuality in both the containers and their contents. Warhol inconsistently filled in the glass-green silhouettes that he painted on the white ground prior to screening or stenciling the schematic image of the bottle. The density of the pigment, as well as the registration, varies considerably from one container to the next. Some of the bottles are evenly colored from spout to base, others possess blank white spots, and a few appear to be lacking the green hue altogether. Ironically, considering the artist's wish to duplicate identical images, these subtle and perhaps unintended (but obviously acceptable) variations give the bottles an expressive handmade quality.

The *210 Coca-Cola Bottles* (plate 120) is a much wider and more complex variant than its 112-bottle counterpart. It too has seven rows of glass containers, but these are marshaled thirty across. In contrast to the narrower picture, it presents three different views of the bottle: in addition to the frontal view, there is a profile view, in which the seam of the molded glass runs down the middle, flanked by "Cola" and "Coca," and a three-quarter profile view, in which the seam appears toward the left side of each bottle. Although the three views frequently occur in sequence, there seems to be no regularly repeated pattern. The beverage is printed in brown over bottle-green silhouettes on a white ground, while the contours of the containers are printed in black, indicating that he required at least four and possibly five stencils or silkscreens. The

118. *Coca-Cola Cap.* 1962. Pencil on paper, 24 x 17¾". Collection Ileana Sonnabend, New York

artist obviously wanted a great deal of diversity in the repeated images, because he varied not only the frontal and profile views of the bottles, but also the amounts of green and brown.

Warhol's soup-can exhibition opened at the Ferus Gallery on July 9 and continued through August 4. Blum hung the thirty-two soup-can portraits in a single, evenly spaced line along three of the gallery's white walls. (The show prompted a rival dealer on La Cienega Boulevard to fill his show window with several dozen Campbell's Soup cans, accompanied by a derisive sign that said, in effect, "Buy them cheaper here—five cans for a dollar.")

Blum found six collectors brave enough to buy an individual

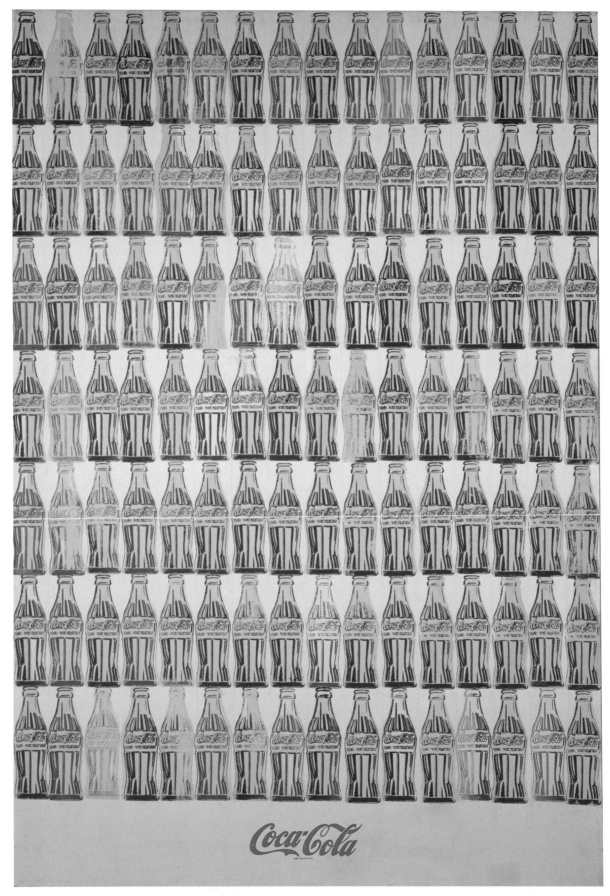

119. *Green Coca-Cola Bottles*. 1962. Acrylic on canvas, 82¼ x 57″. Whitney Museum of American Art, New York. Purchase with funds from the Friends of the Whitney Museum of American Art. 68.25

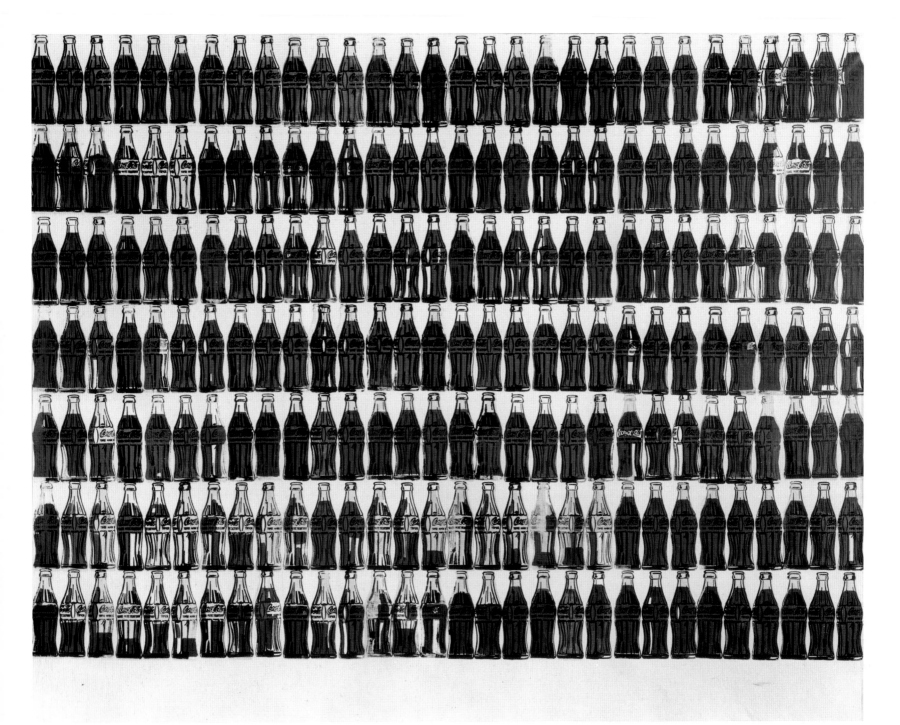

120. *210 Coca-Cola Bottles*. 1962. Acrylic on canvas, 82½ x 105″. Private Collection

painting for one hundred dollars each, then had second thoughts about breaking up the set. He phoned the would-be purchasers and told them he had to cancel the sales because the artist preferred to keep the set together. (Although Warhol, in fact, would have been willing to sell the canvases individually, he had conceived and displayed them as an ensemble, and it was providential that Blum kept the set intact.) The dealer then turned around and bought the entire series for himself. Warhol's asking price was fifty dollars a painting or fifteen hundred dollars for the entire set. Blum offered him a thousand and Andy accepted. "I paid him a hundred dollars a month for ten months," Blum said. "It was probably as much as I could put together at that time."[15]

Around the same time, most likely in June or July, Warhol discovered that he could have black-and-white photographs converted into silkscreens. The process is similar to that of photoengraving, requiring an intermediate stage in which the image is translated into a series of halftone dots. His decision to make silkscreened paintings based on actual photographs may have been prompted in part by *129 Die,* his last attempt to make a hand-painted copy of a photograph. His first painting made with a photograhic silkscreen was *Baseball,* featuring a repeated image of home-run champ Roger Maris (plate 128).[16]

Warhol's use of silkscreens further infuriated his detractors, who now complained that he not only lacked originality as an image-maker, but also produced his pictures mechanically. Yet it was his innovative use of the silkscreen technique on canvas, combined with his startling adaptation of commonplace imagery, that secured his position as one of the most important artists of his time.

NOTES

1. G. R. Swenson. "What Is Pop Art?" *Art News,* November 1963, p. 26.

2. Interview with Allan Stone, February 26, 1988.

3. Interview with Allan Stone, February 26, 1988.

4. Patrick S. Smith, *Andy Warhol's Art and Films* (Ann Arbor, Mich.: UMI Research Press, 1986, 1981) p. 255.

5. Smith, *Warhol's Art and Films,* p. 255.

6. Revisionist critics, such as Lawrence Alloway, would later point out that Thiebaud, aside from his lip-smacking subject matter, had little in common with Pop art. His painterly technique and use of traditional perspective set him apart from the "pure" Pop artists, who were essentially involved in schematic, two-dimensional representations of preexisting imagery.

7. This writer saw no silkscreened paintings when he first visited Warhol's studio at 1342 Lexington Avenue in March 1962. Among the paintings on view then were dozens of individual Campbell's Soup cans, mostly in the 20 x 16″ format and representing all the then-available flavors, and a 74 x 108″ image of two hundred cans (twenty across, ten down), and some 72″ high canvases of single cans, shown squashed or with their labels falling off. The studio also contained several black-and-white pictures, including a version of *Before and After, Rupture (8-Point Program), Dance Diagram (Fox Trot),* one or more of the large single images of a Coca-Cola bottle, a large stand-up telephone, and Royal typewriter. An earlier comic-strip painting of Batman was also present. The writer does not recall seeing any S & H Green Stamps or dollar bill paintings on that visit.

8. "The Slice-of-Cake School, " *Time,* May 11, 1962, p. 52. "In August '62 I started doing silkscreens," Warhol misleadingly stated in *POPism: The Warhol '60s* (New York: Harcourt Brace Jovanovich, 1980), p. 22. Actually, he had started silkscreening at least four months earlier.

9. Jasper Johns evidently expressed some interest in Warhol's painting *Handle With Care—Glass—Thank You.* The picture might have caught Johns's eye because of the stenciled letters and the grid composition, both elements so clearly derived from his own work. In any case, Warhol seized the opportunity to ingratiate himself with Johns and gladly offered to lend him the silkscreen. Johns accepted and later used it in his 1963–64 painting, *Arrive/Depart,* where a single gray impression of the label appears slightly below the center of the painting. Art historian Roberta Bernstein noted Johns's use of the silkscreen in her book *Jasper Johns' Paintings and Sculptures 1954–1974* (Ann Arbor, Mich.: UMI Research Press, 1985), pp. 111-12.

10. Interview with Betty Asher, April 20, 1988.

11. Interview with Irving Blum, October 2, 1987.

12. "The Slice-of-Cake School," p. 52.

13. The writer helped apply the press-on numbers to a few of the Do It Yourself canvases, probably during late spring or summer 1962.

14. Interview with Henry Geldzahler, October 4, 1987.

15. Interview with Irving Blum, October 2, 1987.

16. Barry Blinderman, "Modern 'Myths': An Interview with Andy Warhol," *Arts Magazine,* October 1981, p. 145.

MARILYN: DEIFIED AND MULTIPLIED

''I was lying on the grass, looking at the sky, and suddenly I was wondering what I was going to do about November and a voice said, 'Call up Andy Warhol.' ''—*Eleanor Ward*[1]

On August 5, the day after Warhol's soup-can show closed in Los Angeles, Marilyn Monroe died, sending shock waves around the world. For weeks, the press was filled with sensational stories chronicling the glamorous film star's extraordinary life and career and speculating on the factors that led to her tragic suicide by an overdose of sleeping pills. During the immediate aftermath of her death, the entire world seemed gripped by an unusually somber and morbid depression. Warhol, two years younger than Monroe, had met or at least seen her a couple of times[2] and had avidly followed her career. He, too, was shocked by her passing and noted with curiosity how it was sparking a wave of "sympathetic" suicides around the world. He also was impressed, needless to say, by the extraordinary amount of press coverage her death received.

Within a few days of Monroe's death, Warhol purchased a 1950s publicity photograph of her and, after cropping it below her chin, had it converted without any alteration into a silkscreen.[3] The silkscreen enabled him to imprint her portrait hundreds of times onto various canvases. He screened her face one time only on small, individual canvases, and repeated it—twice, four times, six times, twenty times—on larger canvases, positioning the heads in rows to create an allover pattern. Unlike the earlier serial images of stamps and dollar bills, which seemed to mimic sheets of printed paper, the multiple Marilyns, though also regimented in a grid format, evoked strips of motion-picture film, with each frame slightly different from its neighbor.

Although many of the Marilyns were screened in black on an off-white ground, the most visually striking of the series were screened in black on a multicolored ground that Warhol had previously prepared with hand-painted color-shapes corresponding to the actress's face, hair, eyelids, lips, and collar. Creating, in effect, a colored map of her face, he first laid down a yellow patch for hair, blue for eye shadow, red for lips, flesh tone for face, and green for collar, most often against an orange ground. To increase the likelihood of proper registration, Warhol deliberately made some of the color areas larger than the forms they were intended to describe; Monroe's red lips and blue eye shadow, for instance, are much larger than the actual areas of makeup. Then, after the paint had dried, he placed the silkscreen over the canvas and squeegeed

121. *Marilyn Monroe.* 1962. Acrylic on canvas, 20 x 16".
Collection Leo Castelli, New York

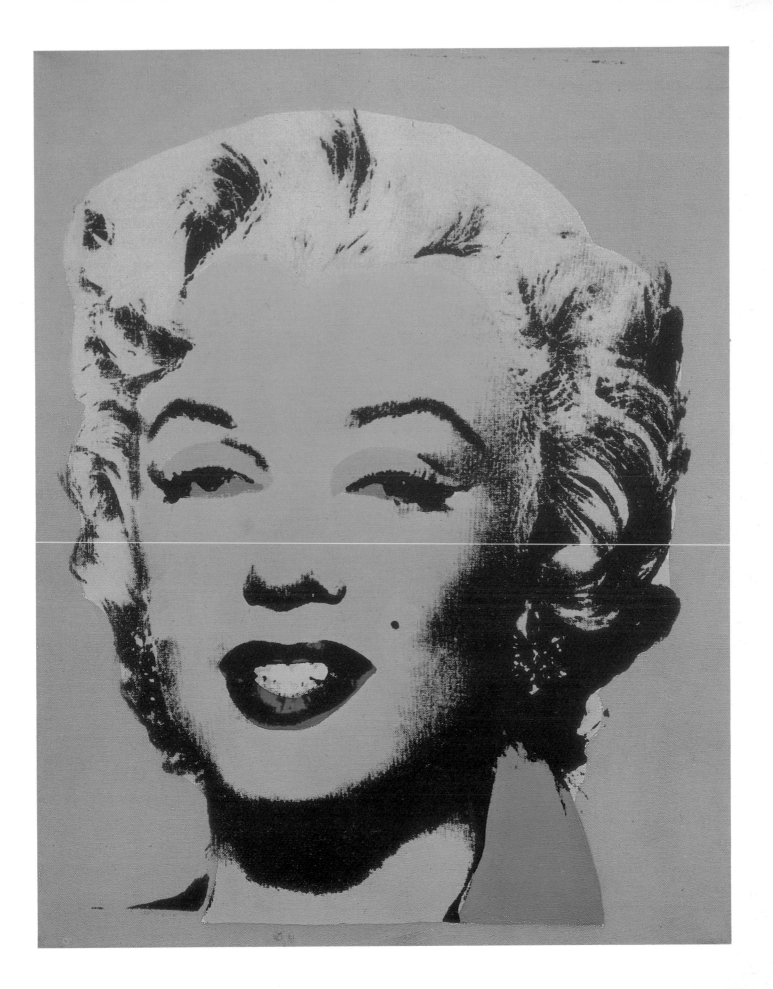

122. *Gold Marilyn Monroe.* 1962. Acrylic, silkscreen ink, and oil on canvas, 83¼ x 57". The Museum of Modern Art, New York. Gift of Philip Johnson

black pigment through the mesh, thereby superimposing the photographic image onto the colored ground. Nathan Gluck reminded Andy to mark the corners of each repeated image so that he could line up the screens and get Monroe's features in the exact place. But Andy liked to work quickly and couldn't be bothered with such niceties. "So, when he got through," Gluck said, "the lips were a little askew, the eye shadow went a little high, or the hair went a little over to the left." Gluck would find himself looking ruefully at the picture and saying, "Andy, it's a little off-register." The artist invariably responded, "I like it that way."[4]

For the *Marilyn Diptych,* also known as *100 Marilyns* (plate 125), Warhol painted fifty black-and-white faces of Monroe on one area of canvas and an equal number of colored faces on another. He was ambivalent about the relationship, if any, between the two versions. In the black-and-white section, Marilyn's face varies from a crisp photographic image to a black blur, suggesting smudged newsprint; the faces are either clotted with too much pigment or dryly rendered with too little pigment. In the brightly colored panel, which is relatively garish because of the intense hues, each face appears to be variously off-register. Initially, Warhol debated with himself whether to present the canvases as two separate pictures. But the visitors he polled liked the tension set up between the two contrasting versions, so he abutted the two panels.

Curiously, Warhol's semimechanical process resulted in a new kind of painterly technique, achieving, if only unintentionally, the look of autographic touch. His repetitions of the silkscreened image varied considerably, depending upon the amount of pigment placed on the screen, the degree of pressure with which it was manually squeegeed, and the seldom perfect registration. The screen had to be held stationary or the image would blur. An experienced eye could spot instantly an uneven swipe of the squeegee or a directional stroke or a too meager load of pigment. During the silkscreening process, Warhol benignly accepted and retained most of the accidents that occurred, as if to emphasize that the paint had a reality of its own, independent of the representational image it formed.

Admirers found such discrepancies to be a virtue, claiming these minor variations made his art subtly expressive. British-born

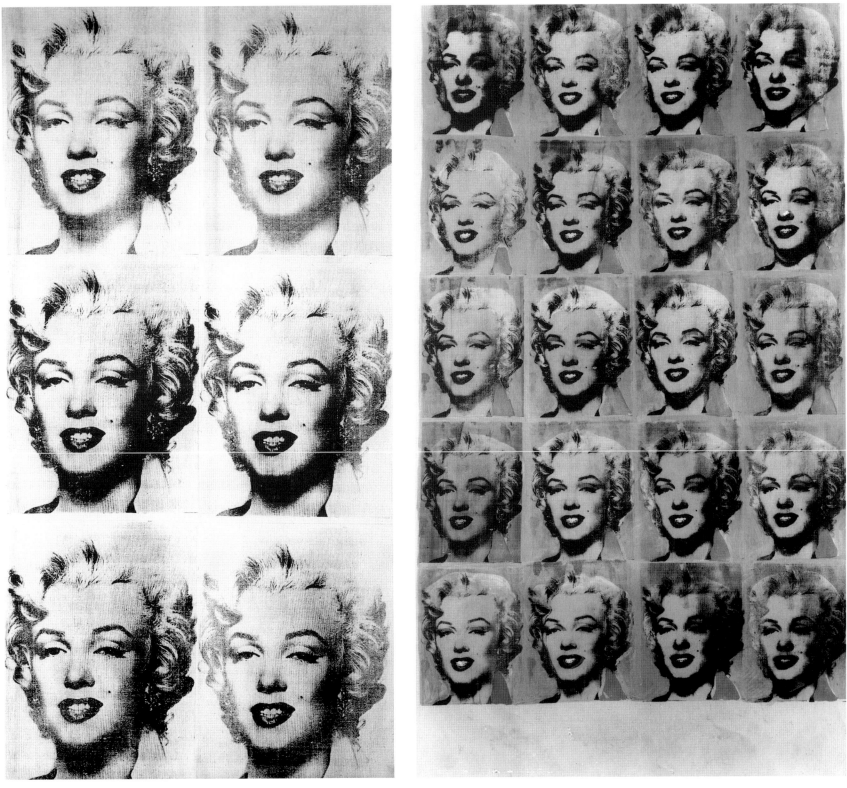

123. *Six Marilyns (Marilyn Six-Pack)*. 1962. Acrylic and silkscreen ink on canvas, 43 x 22¼". Collection Emily and Jerry Spiegel

124. *Marilyn Monroe Twenty Times*. 1962. Silkscreen ink on canvas, 84 x 46". Private Collection, Paris

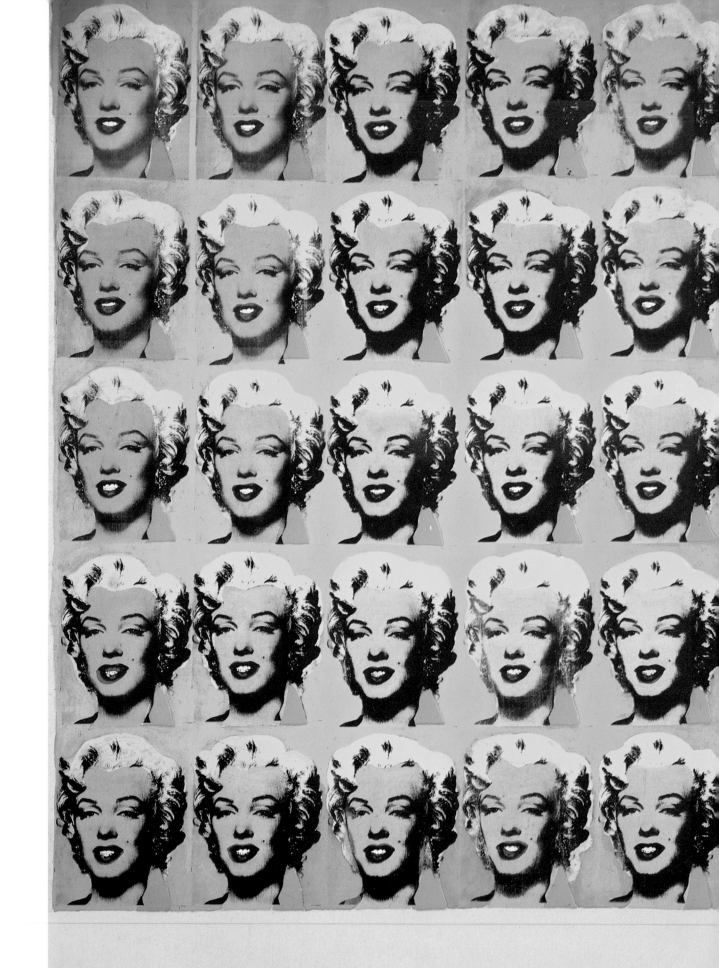

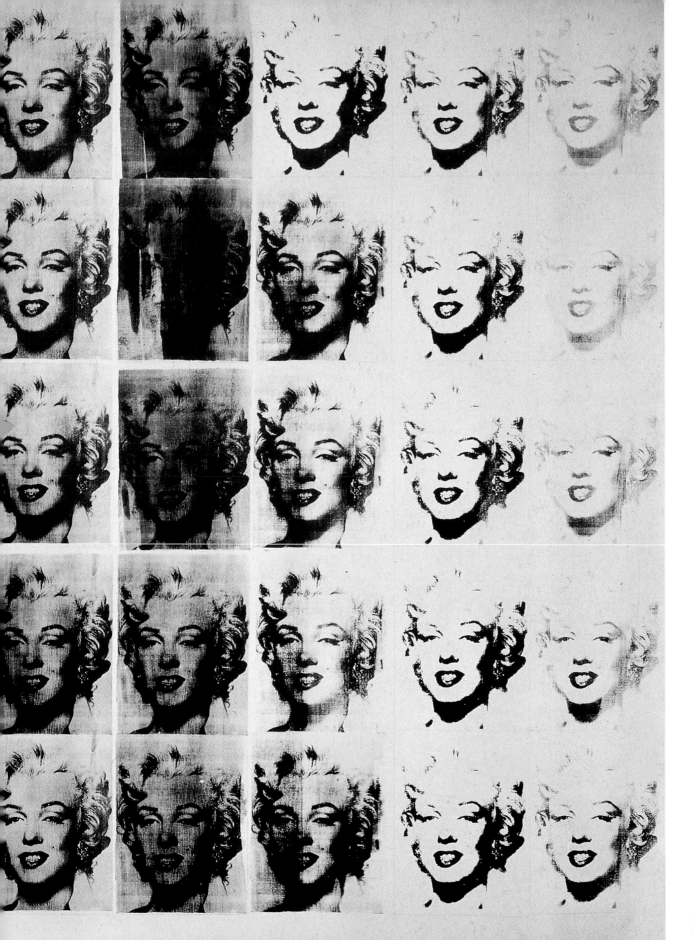

125. *Marilyn Diptych.* 1962. Acrylic and silkscreen ink on canvas, two panels, each 82 x 57". The Tate Gallery, London

art critic Lawrence Alloway praised Warhol's method for being simultaneously mechanical and autographic: "His serial images are like Japanese plastic toys, which have irregular joints where they are broken from the mold. In the context of painting, these failures of identical repetition take on gestural vitality; they become the reassurance of human touch or, at least, casualness."[5]

Warhol apparently intended all his portraits of Monroe as funereal and commemorative icons. In the *Gold Marilyn Monroe* (plate 122), Warhol deployed a single silkscreened image of the actress slightly above center on a relatively large expanse of spray-painted metallic gold ground. While his other pictures of her frequently contain multiple faces, aligned in rows to suggest her pervasiveness in the news media, this isolated visage, which floats in an unspecific and ethereal space, is a poignant reminder of Monroe's uniqueness—a radiant star in a gilded, Byzantine-style heaven. The gold ground is a consistent and logical follow-up, of course, to Warhol's Golden Slippers and *A Gold Book* of the 1950s. The tinselly treatment also harks back to Warhol's childhood memories of St. John Chrysostom Church in Pittsburgh, with its many icons of religious figures portrayed against rich gold backgrounds. Though Warhol's Marilyn is perhaps an unusually florid counterpart to the saints portrayed in ceiling mosaics in eastern Catholic churches, it is nonetheless clear that the artist symbolically canonized her.

According to the artist's own account in *POPism*, his not always reliable history of the 1960s, the earliest of his movie-star portraits were those of Troy Donahue and Warren Beatty, both derived from publicity photographs and screened sometime in August 1962.[6] Warhol made relatively few portraits of Donahue and perhaps only one or two of Beatty, which probably indicates that he found them less glamorous and less sensational subjects than Marilyn Monroe, who figured in dozens of his paintings. (Warhol generally found it much easier to make women look alluring because he could exaggerate the florid hues of their lipstick and eye shadow.) The *Troy Diptych* (plate 126) is unusual among the artist's icons of Hollywood faces because of the oval image, the asymmetrical format, and the hand-painted colors—the red jacket, gold-yellow hair, pink-toned face, and blue background. The two panels of the diptych are of

unequal width, leading one to believe that they were not originally intended to go together. The wider panel is black and white and contains an additional eighteen faces. One of Warhol's most successful homages to masculine glamour is *Red Elvis* (plate 127), containing three dozen repetitions of the singer's face—dark, brooding, and sexy—regimented in six rows, and silkscreened in black pigment on a smoldering red ground. The sultry portrait suggests the flammable passions ignited by Presley's music.

Warhol's movie-star subject matter and his use of photographic silkscreens helped separate him from the other emerging Pop artists, so many of whom were dealing with images of food, clothing, and display signs. This made him more attractive to certain dealers, especially those who learned from his own lips that his Los Angeles show of soup-can labels had been a sellout. But Andy still felt like an art-world outsider, until suddenly the New York dealer Eleanor Ward dropped into his life.

Eleanor Ward was a great and rather imperious beauty, a commanding woman with an air of glamorous hauteur. Always elegant, poised, and cool, she brought to mind a 1940s movie queen, a sort of composite of Bette Davis, flashing her eyes as she waved a cigarette, and Joan Crawford, casting a withering glare on whoever dared to oppose her. She had grown up on Manhattan's upper East Side, starting out with a career in advertising and promotion that she parlayed into a position as assistant to Christian Dior in Paris.

In 1953, Ward, having returned to New York, leased a former stable on Seventh Avenue, a couple of blocks south of Central Park, and opened the Stable Gallery. During its early years, the Stable's "stable" of New York artists included Joseph Cornell, Joan Mitchell, Isamu Noguchi, Robert Rauschenberg, Richard Stankiewicz, and Cy Twombly. In 1960 she moved the gallery to the ground floor of a town house at 33 East 74th Street, where she added new artists, such as the painters Alex Katz and Robert Indiana and the figurative sculptor Marisol.

Ward first met Warhol on one of his many visits to her gallery, probably in 1961 or early 1962. She immediately liked him and was intrigued by him personally as well as by his work. But she could not offer him a show, she said, because her exhibition schedule was all

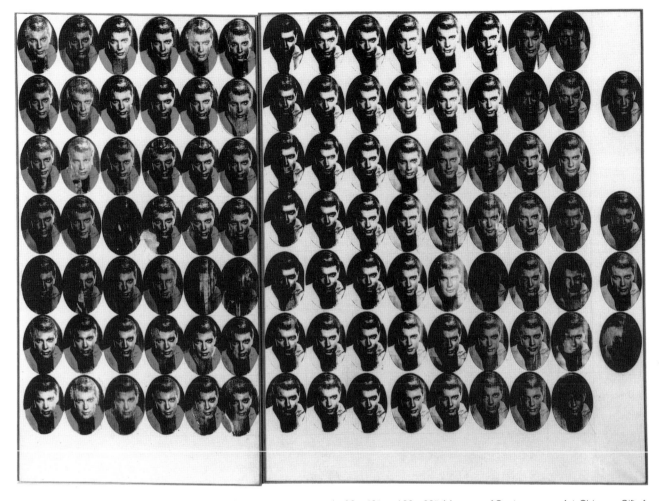

126. *Troy Diptych*. 1962. Acrylic and silkscreen ink on canvas, two panels, 82 x 43″ and 82 x 68″. Museum of Contemporary Art, Chicago. Gift of Mrs. Robert B. Mayer

booked up. During the summer, however, she had what she called "a difference of opinion" with Alex Katz and canceled his upcoming exhibition, which had been planned for November. (The dispute involved some painted wood cutouts that Katz had created as a set design for a production of Kenneth Koch's play *George Washington Crossing the Delaware*. Rival dealer Martha Jackson purchased the set outright for about $1,500 and mounted an exhibition of it at her gallery in June. Ward was infuriated and booted Katz out of the Stable.)[7]

While summering at her country place in Connecticut, Ward brooded about who to show in Katz's place. She was sunning herself on the lawn one afternoon when she suddenly thought of Andy. She looked up his telephone number, called for an

appointment, then drove into town to look at his work. "I didn't know how easy it was going to be to talk to somebody to whom all I ever said was hello," she said. "Andy was quite a bit self-conscious. However, it turned out to be an enchanting and easy visit."[8]

Ward viewed many of his paintings, including the large Campbell's Soup cans and the multiple Coca-Cola bottles, the Do It Yourself pictures, the *Marilyn Diptych,* and the *Red Elvis*. Then she told Andy that, by a miracle, she happened to have November free, the prime month of the year, and could give him a show at that time. His response was a simple "Wow!"

Andy's art career was going into high gear. On the evening of September 18, 1962, Ileana and Michael Sonnabend, accompanied by Robert Rauschenberg and the Swedish artist Carl Fredrik

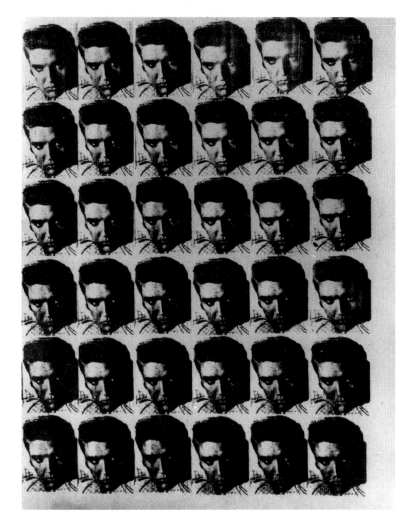

127. *Red Elvis.* 1962. Acrylic and silkscreen ink on canvas, 69 x 52″. Private Collection

Reuterswärd, paid Warhol a visit. The Sonnabends planned to open a gallery in Paris and offered Andy the opportunity to have a show there, which he gratefully accepted. Intent upon making a good impression, he unrolled many of his recent paintings, including portraits of Marilyn Monroe and the *210 Coca-Cola Bottles.* Because the canvases were unstretched, questions arose as to where Warhol planned to establish his framing edges. As usual, he took a poll, quizzing his visitors about their preferences.

Rauschenberg may well have wondered where Warhol got the idea to paint rows and rows of Coca-Cola bottles; understandably, the older artist might have been unable to think of a likelier source

than some of his own works, specifically his 1958 painting *Curfew,* which incorporates a row of four empty Coke bottles. In any case, Rauschenberg scrutinized *210 Coca-Cola Bottles* and volunteered the advice that Warhol should leave a strip of blank canvas along the right edge to show that he intended to paint only that many bottles and no more. Warhol was all smiles and expressed enthusiasm for the suggestion; later, however, he did not take Rauschenberg's advice and, instead, stretched the canvas so that the bottles continued to the edge, implying a continuum. The edge-to-edge repetition was consistent with his earlier images of multiple soup cans, sheets of S & H Green Stamps, and grids of dollar bills.

Warhol attempted to ingratiate himself with Rauschenberg by offering to make some silkscreened portraits of him. All Rauschenberg had to do, Andy said, was to provide him with some photographs. Rauschenberg was enthusiastic about the project and immediately began to discuss what kinds of photographs would be suitable. (At this point in his career, Rauschenberg, though he had been incorporating photographic imagery in his work for several years, was unfamiliar with silkscreens.) He innocently started to quiz Warhol for particulars on where and how one could get photographic images transferred into silkscreens.

Andy, still upset about his cartoon subjects being sideswiped by Roy Lichtenstein, felt mixed emotions, wanting to appear helpful to Rauschenberg but fearful of having his silkscreen technique whisked away from him by the more famous artist. His dread was justified, as Rauschenberg promptly adapted the silkscreening technique to his own paintings. Rauschenberg produced a substantial body of rather spectacular silkscreened pictures, several of which—including the majestic 389-inch-wide *Barge*—were included in his comprehensive one-man exhibition at New York's Jewish Museum the following spring. As Rauschenberg was perceived to be more inventive than Warhol, whose reputation was based on being a copyist, many people assumed that the latter artist "stole" the silkscreen technique from the former.

Fortunately for Warhol, his year-long struggle to get a one-man show in a reputable gallery finally resulted in his striking exhibition at the Stable, which opened on November 6. It was one of the rare

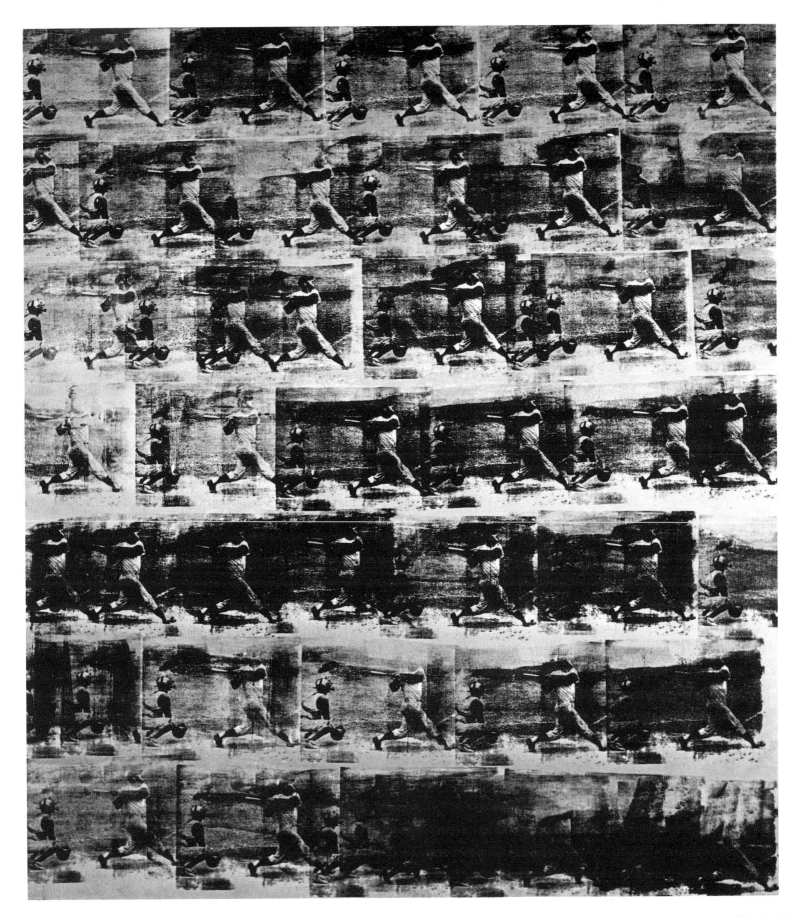

128. *Baseball.* 1962. Acrylic and silkscreen ink on canvas, 91½ x 82″. The Nelson-Atkins Museum of Art, Kansas City, Missouri. Gift of the Guild of Friends of Art and a group of friends of the gallery

occasions when he agreed to display a diverse batch of work. Most of his shows, both before and later, were devoted to a single theme or image. The exhibition contained eighteen works, including a *Do It Yourself, Baseball, Marilyn Diptych, Gold Marilyn Monroe, 129 Die, Close Cover Before Striking* (a matchbook with a "Drink Coca-Cola" ad), *Red Elvis, Troy Donahue* (a multiple portrait in colors), *Dance Diagram* (displayed horizontally on a low platform), and a couple of the large paintings of serial images of Campbell's Soup cans and Coca-Cola bottles.

Following Warhol's opening, Henry Geldzahler threw a party for him in his upper West Side apartment. Geldzahler invited many art-world notables as well as a few cultural celebrities such as Norman Mailer, but the attempt to integrate Andy into the art establishment was far from successful. The Abstract Expressionist crowd was hostile and shunned Warhol, who represented an alien and threatening sensibility. With few allies present, Andy stood timidly on the sidelines, a wallflower at his own party.

Shortly afterward, Geldzahler visited Warhol's parlor, bringing along with him Jasper Johns. The curator knew that Andy idolized and envied Jasper and, therefore, sought to establish some rapport between them by inducing the more famous artist to look at some of his "follower's" silkscreened work. But Johns appeared dismayed by Warhol's paintings and, instead, began to scrutinize a stack of Polaroid prints that had been left out on a nearby table. Warhol had recently acquired a Polaroid camera with a flash attachment, using it to importune his male visitors to stand up and bare their buttocks, which he quickly photographed in a forthright close-up. Similar to his earlier "cock" books, the assembled series of Polaroids could easily pass as typological studies of male rumps in all different sizes and shapes. Henry valiantly attempted to redirect Jasper's attention to Andy's paintings, but Johns would not shift his gaze from the Polaroids to the canvases, which he pointedly ignored. Warhol's relationship with Johns "never really worked," Geldzhaler would later admit. "Jasper may think highly of Andy now [in 1978], but he certainly didn't then. Andy was self-consciously anti-intellectual, and Jasper's whole Wittgenstein side reared up in horror at him. But another part of Jasper—the little boy—thought Andy was quite wonderful, so it was a divided reaction."[9]

Though Warhol was one of the last of the Pop artists to get a New York gallery, he actually benefited by his belated exposure, which coincided with a cresting wave of interest in the new art. Andy's work was, according to Ward, "accepted instantly with wild enthusiasm," and the show was a sellout.[10] The pleased dealer took to calling the artist "Andy Candy." His prices, in retrospect, were astonishingly low: an adventuresome collector could have picked up a twenty-by-sixteen-inch framed painting of a Campbell's Soup can with a torn "Pepper Pot" label for only $200.

Prior to his exhibition, the controversy surrounding Warhol had concentrated on the soup-can paintings. But the surprise of the show was the silkscreened movie-star portraits. Art critic Michael Fried wrote: "Of all the painters working today in the service—or thrall—of a popular iconography, Andy Warhol is probably the most single-minded and the most spectacular....An art like Warhol's is necessarily parasitic upon the myths of its time, and indirectly therefore upon the machinery of fame and publicity that market these myths; and it is not at all unlikely that the myths that move us will be unintelligible (or at best starkly dated) to generations that follow. This is said not to denigrate Warhol's work but to characterize it and the risks it runs—and, I admit, to register an advanced protest against the advent of a generation that will not be as moved by Warhol's beautiful, vulgar, heart-breaking icons of Marilyn Monroe as I am." Fried believed that the Marilyns were the most successful pieces in the show, although he was not convinced that "even the best of Warhol's work can much outlast the journalism on which it is forced to depend."[11]

Warhol was exceptionally fortunate insofar as his exhibition coincided with what appeared to be the apotheosis of the emerging Pop tendency, an international extravaganza at the Sidney Janis Gallery. The Janis show, titled "The New Realists," which ran throughout the month of November, was the most provocative art event of the season, marking one of the most divisive moments in the history of the New York art world. This was due in part to the stature of the gallery, which represented many of the major figures in the Abstract Expressionist movement, including Willem de Kooning, Adolph Gottlieb, Philip Guston, Robert Motherwell, and Mark Rothko.

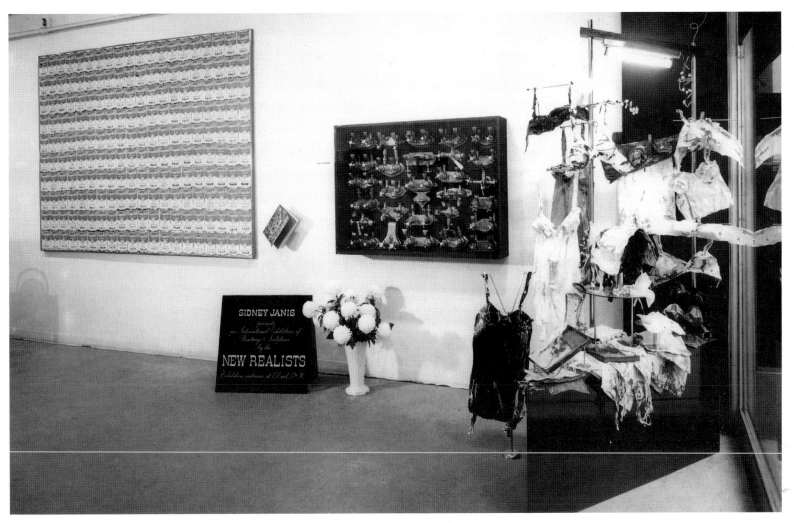

129. Installation view, "New Realists," Sidney Janis Gallery, New York, October 31–December 1, 1962

Janis's "New Realists" exhibition contained more than fifty works by twenty-nine "younger" European and American artists. French critic Pierre Restany claimed in the accompanying catalogue that the art dealt with a "contemporary nature" that is "mechanical, industrial, and flooded with advertisements." Janis's essay noted that the New Realist was "a kind of urban folk artist," who was "attracted to abundant everyday ideas and facts." The show was so comprehensive that two spaces were needed to contain it; in addition to his fifth-floor gallery at 15 East 57th Street, Janis rented a storefront space at 19 West 57th Street. As this part of the show was visible to passersby, who stopped to stare at the

display of Oldenburg's painted-plaster *Lingerie Counter* in the window and Warhol's painting of *200 Campbell's Soup Cans* on the side wall (plate 129), large crowds ended up visiting both parts of the exhibition. The show included two Swedes (Oyvind Fahlstrom and Per Olof Ultvedt), three English artists (Peter Blake, John Latham, and Peter Phillips), five Italians (Enrico Baj, Gianfranco Baruchello, Tano Festa, Mimmo Rotella, and Mario Schifano), and seven artists living in France (Arman, Christo, Raymond Hains, Yves Klein, Martial Raysse, Daniel Spoerri, and Jean Tinguely). The twelve Americans were Peter Agostini, Jim Dine, Robert Indiana, Roy Lichtenstein, Robert Moskowitz, Claes Oldenburg, James Rosenquist, George

Segal, Harold Stevenson, Wayne Thiebaud, Andy Warhol, and Tom Wesselmann. The last two especially benefitted by having simultaneous one-man shows at other galleries. (Wesselmann's "Great American Nudes," at the Green Gallery, featured large collage-paintings in which hand-painted, voluptuous Matissean nudes were played off against backdrops of domestic interiors that incorporated printed advertisements and actual three-dimensional objects.) At Janis, Warhol was represented by *Big Campbell's Soup Can, 19¢, Do It Yourself (Flowers),* and *Dance Diagram (Fox Trot)*, as well as *200 Campbell's Soup Cans.*

By now, many people had a good idea of the brash visual elements that typified the new art, but they still did not know what to call it. The artists were sometimes called Neo-Dadaists, New Realists, Commonists, Vulgarists, Sign Painters, New American Dreamers, Popular Realists, Factualists, and Kitsch-niks. (The Neo-Dadaist label, initially the most prevalent of the working titles, was perhaps the least suitable, because the Dadaists were nihilists and iconoclasts, while the Pop artists, even if they did not explicitly endorse American consumerism and materialism, were not at all alienated by their everyday, commercial subject matter.) The Italians in the exhibition had been known in their own country as Polymaterialists, while the French had been dubbed Nouveaux Réalistes. In England, Lawrence Alloway had already coined the term "Pop art" in the 1950s in reference to painters' use of "popular art sources" such as "movie stills, science fiction, advertisements, game boards, heroes of the mass media."[12]

Commonplace images and lowbrow ideas were anathema, of course, to the Abstract Expressionists, as earnest and disdainful of kitsch culture as any group of artists could be. Because the Janis Gallery had long served as the city's premier showcase for Abstract Expressionism, the "New Realists" show fanned the flames of art-world paranoia, and Sidney Janis himself came to be perceived by some of his own artists as a traitor. The old guard—which still thought of itself as avant-garde—could barely tolerate the fact that serious dealers such as Richard Bellamy, Leo Castelli, Allan Stone, and Eleanor Ward were showing the crass new art, but Janis's "defection" enraged them. Within a few days, all his Abstract Expressionists, with the exception of De Kooning, huffed their way out of the gallery. As the critic Harold Rosenberg reported in *The New Yorker,* the "New Realists" exhibition "hit the New York art world with the force of an earthquake. Within a week, tremors had spread to art centers throughout the country....Art politics sensed the buildup of a crisis. Was this the long-heralded dethronement of Abstract Expressionism? Conversation turned to speculation about treachery, secret motives, counterstrategies."[13]

The Janis Gallery's excellent reputation "added a certain adrenaline quality to the manifestation," noted the critic and editor Thomas B. Hess in *Art News.* A tireless promoter of the "scandalously neglected second generation" Abstract Expressionists, Hess declared that the "New Realists" show was "an implicit proclamation that the New had arrived and it was time for all the old fogies to pack." He cited an unidentified "leading modernist," still in his thirties, who said, "I feel a bit like a follower of Ingres looking at the first Monets."[14] Artist-critic Sidney Tillim wrote in *Arts Magazine* : "With the same business acumen and perfect timing that made him the Duveen of Abstract Expressionism, dealer Sidney Janis has moved in on the 'Pop' art craze at harvest time."[15]

Ten years later, critic Hilton Kramer was still fulminating about the exhibition: "Not since the Pyrrhic victories of the Pre-Raphaelites in Victorian England had the taste and standards of the professional art world been so radically debased. For a sizable portion of the art public, the whole notion of artistic seriousness was altered—altered downwards, it must be said, to a level where an insidious facetiousness and frivolity could pass muster as an attitude of high endeavor."[16]

"Pop" became the established name for the new movement on December 13, when The Museum of Modern Art held a public "Symposium on Pop Art." The auditorium was packed with partisans of various factions, including many of the controversial new artists such as Warhol, Lichtenstein, Rosenquist, and George Segal. The Pop clique included dealers (Castelli, Janis, Karp), critics (Restany, Gene R. Swenson), collectors (Robert C. Scull), and a figure whom many held responsible for this aesthetic development —Marcel Duchamp. But sympathizers in the restive audience were far outnumbered by all the hostile people who had come to hiss and jeer at the new art. Karp said he felt "surrounded by Apaches."[17]

The panel was put together and moderated by Peter Selz, the museum's curator of painting and sculpture exhibitions, and it featured five speakers: critics Dore Ashton and Hilton Kramer, poet Stanley Kunitz, art historian Leo Steinberg, and Geldzahler—who thought it ironic that he, as a curator at the Metropolitan Museum, should be summoned to the Modern to defend Pop art. Among the panelists, Steinberg was cautiously open-minded, noting that Pop art "pushed subject matter to such prominence that formal or aesthetic considerations are temporarily masked out." Kramer, the ever-articulate naysayer, declared that "Pop art derives its small, feeble victories from the juxtaposition of two clichés: a cliché of form superimposed on a cliché of image." Ashton lamented Pop art's absence of metaphor, which she claimed "is as natural to the imagination as saliva to the tongue," and Kunitz complained at length that Pop art was "a nine days' wonder."[18] The panelists' dialogue was entertainingly contentious and sarcastic, and by the time the overexcited, divisive audience was invited to join in the discussion, the event threatened to get out of hand.

While Pop art's significance was still being debated within the art world, its impact was already rippling through society, influencing the look of architecture, home furnishings, housewares, fashion, advertising, and graphic design. More than a mere leader of the Pop movement, Warhol was perceived as an oracle and tastemaker, whose every word demanded careful study. He had become what the press calls an "overnight sensation"; his challenge now was to hang on to his new celebrity.

NOTES

1. Les Levine, "The Golden Years: A Portrait of Eleanor Ward," *Arts Magazine*, April 1974, p. 42.

2. Patrick S. Smith, *Andy Warhol's Art and Films*, (Ann Arbor, Mich: UMI Research Press, 1986, 1981), p. 522.

3. Thomas Crow published a very similar publicity photograph of Marilyn Monroe, obviously taken at the same sitting, in *Art in America*, May 1987, p. 130. Because this is not the photograph that Warhol actually used, Crow erroneously concluded that the artist manipulated the image by transforming his source material.

4. Smith, *Warhol's Art and Films*, p. 316.

5. Lawrence Alloway, "Introduction," brochure accompanying "The Photographic Image" exhibition at The Solomon R. Guggenheim Museum, New York, January 1966.

6. Andy Warhol and Pat Hackett, *POPism: The Warhol '60s* (New York: Harcourt Brace Jovanovich, 1980), p. 22.

7. Interview with Alex Katz, December 9, 1987.

8. John Wilcock, *The Autobiography & Sex Life of Andy Warhol* (New York: Other Scenes Inc., 1971), n.p.

9. Interview with Henry Geldzahler, October 4, 1987.

10. Wilcock, *Autobiography*, n.p.

11. Michael Fried, "New York Letter," *Art International*, Zurich, vol. 6, no. 10, December 20, 1962, p. 57.

12. Lawrence Alloway, "Pop Art Since 1949," *The Listener*, London, vol. 67, no. 1761, December 27, 1962, p. 1085.

13. Harold Rosenberg, "The Art Galleries: The Game of Illusion," *The New Yorker*, November 24, 1962, pp. 162, 165; reprinted in *The Anxious Object* (New York: Horizon Press, 1964), pp. 63–64.

14. Thomas B. Hess, "New Realists," *Art News*, vol. 61, December 1962, p. 12.

15. Sidney Tillim, "The New Realists," *Arts Magazine*, vol. 37, December 1962, p. 43.

16. Hilton Kramer, "And Now...Pop Art: Phase II," *New York Times*, January 16, 1972.

17. Interview with Ivan Karp, April 22, 1988.

18. "A Symposium on Pop Art," *Arts Magazine*, April 1963, pp. 36–44.

"Andy wanted to keep the human element out of his art, and to avoid it he had to resort to silkscreens, stencils, and other kinds of automatic reproduction. But still the Art would always manage to find a way of creeping in. A smudge here, a bad silkscreening there, an unintended cropping. Andy was always antismudge. To smudge is human."

— *Gerard Malanga*[1]

130. *Suicide.* 1963. Silkscreen ink on paper, 40 x 30".
Collection Adelaide de Menil, New York

By the spring of 1963 every with-it museum in the nation seemed to be mounting a Pop art exhibition, and Warhol's work was considered mandatory in all of them. In mid-March he was one of a half-dozen artists (along with Robert Rauschenberg, Jasper Johns, Jim Dine, Roy Lichtenstein, and James Rosenquist) included in "Six Painters and the Object," at The Solomon R. Guggenheim Museum. The show was organized by the museum's curator, Lawrence Alloway, who made sure that Warhol was represented by a choice selection of works, including a cartoon blowup *(Dick Tracy),* a hand-painted ad *(Before and After 3),* silkscreened movie-star portraits of Marilyn Monroe *(Marilyn Diptych)* and Elizabeth Taylor *(The Men in Her Life),* and a canvas with a photographic image of a car crash repeated in two tiers *(Silver Disaster, No. 6).*

Alloway noted in his catalogue text that all six of his chosen artists dealt with "objects drawn from the communications network and the physical environment of the city. Some of these objects are: flags, magazines and newspaper photographs, mass-produced objects, comic strips, advertisements. Each artist selects his subject matter from what is known not only to himself, but also to others, before he begins work."[2]

The show prompted *Time* magazine to call Pop art "a mild, unrebellious comment on the commonplace made by picturing it without any pretense of taste or orthodox technical skill. It is nothing new to transform nonart materials into works of art; but seldom have artists been so willing to forgo the transforming. They may paint a soup can and enlarge or repeat it; but the can remains a can, designed by the Campbell Soup Co."[3]

Critic Barbara Rose claimed in her review of the show that Pop art "was made for the same exclusive and limited public as abstract art. That it has filtered down to the mass public, mostly by way of the mass media, and that it does have popular appeal, is irony to the third power." She went on to say, "I wish to disagree with the assumption that Pop art is an *art style.* It is not; these artists are linked only through subject matter, not through stylistic similarities. This makes it possible to talk of the iconography or attitudes of Pop art, but not of Pop art as an art style, as one would speak of Baroque or Cubism." She noted that Rauschenberg and Johns belonged to Abstract Expressionism, and that Lichtenstein was essentially a

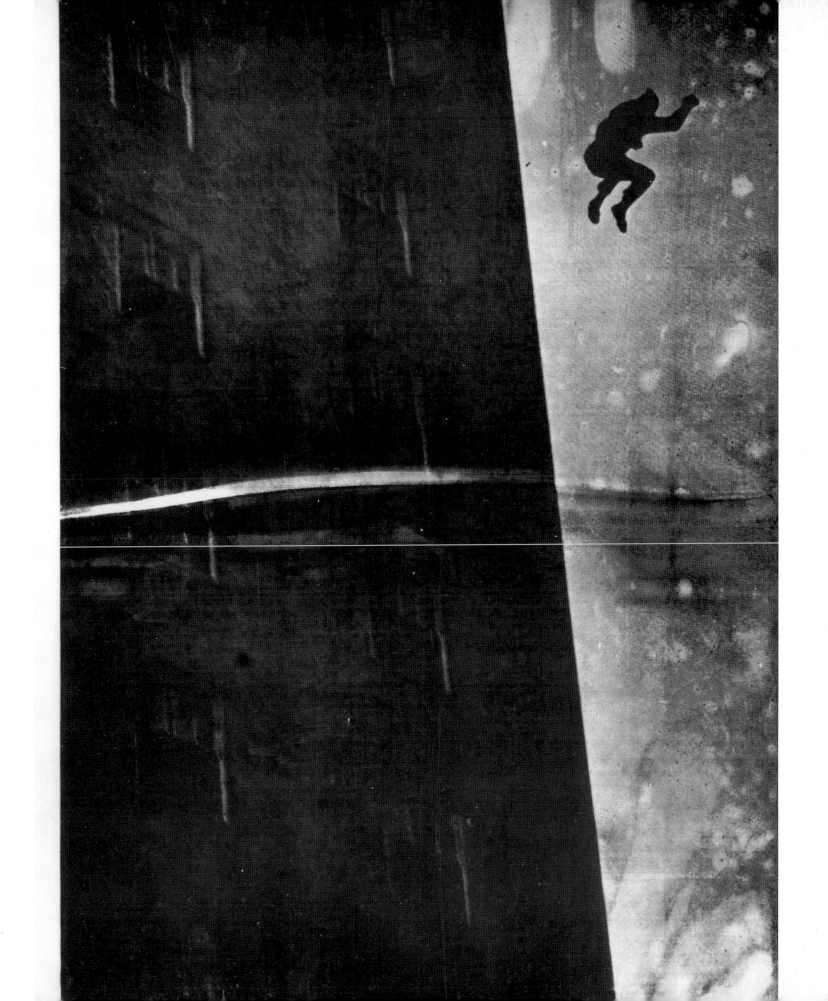

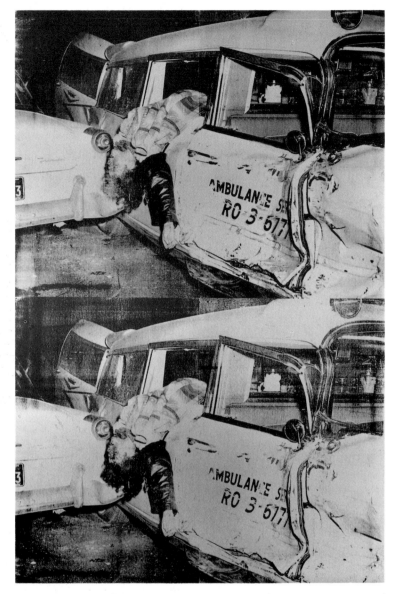

131. *Ambulance Disaster Two Times.* 1963. Acrylic and silkscreen ink on canvas, 124 x 80". Collection Erich Marx, Berlin

"hard-edge painter." "Only Andy Warhol has actually offered anything new in terms of technique, by adapting the commercial and purely mechanical process of silk screen to the purposes of painting on canvas."[4]

Warhol had made it clear from the outset that he adopted the silkscreen process because it enabled him to produce pictures easily and quickly. "Paintings are too hard," he told *Time.* "The things I want to show are mechanical. Machines have less problems. I'd like to be a machine, wouldn't you?"[5] He later elaborated these thoughts for the critic G. R. Swenson, who interviewed him for *Art News.* "The reason I'm painting this way is that I want to be a machine, and I feel that whatever I do and do machine-like is what I want to do."[6]

Warhol's avowed wish to be a machine was part of the new unemotional and uncommunicative public persona he had developed in order to complement his seemingly impersonal and noncommittal art. But in private, he loved to make hours-long phone calls to close friends and confidants, during which he gossiped and opinionated freely. Often, he would telephone a pal and urge him to attend a particular gallery opening or theatrical performance. The friend would go, only to find himself all but completely ignored by Warhol, who stood mute and aloof amid a swirl of people, his eyes scrutinizing every action and detail, his ears tuned in to nearby conversations. Much later, often after midnight, Warhol would telephone that same friend and rehash the noteworthy events of the evening. The depth of his reportage and analysis would leave his listener feeling they had attended two different events.

Warhol was constantly going out, propelled by his broad interests, which covered a diverse mix of high and low art, avant-garde and pop culture. New York's thriving culture scene was experiencing one shock wave after another as a result of the explosive creativity taking place in virtually all of the visual and performing arts. Andy, almost always accompanied by a friend or two, went to art gallery openings, Happenings, poetry readings, off-Broadway plays, innovative dance performances, and experimental films. During one six-week period in the spring of 1963, for example, he attended events as varied as a rock 'n' roll performance at the Brooklyn Fox Theatre; the fiftieth-anniversary recreation of the

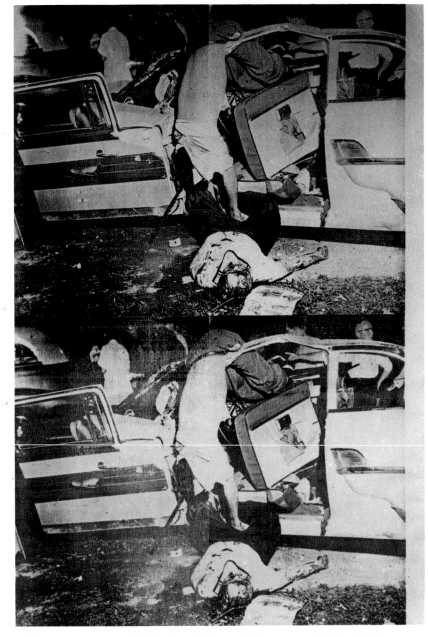

132. *Saturday Disaster.* 1964. Acrylic and silkscreen ink on canvas, 106⅞" x 81⅞".
Rose Art Museum, Brandeis University, Waltham, Mass. Gervitz-Mnuchin Purchase Fund,
by exchange

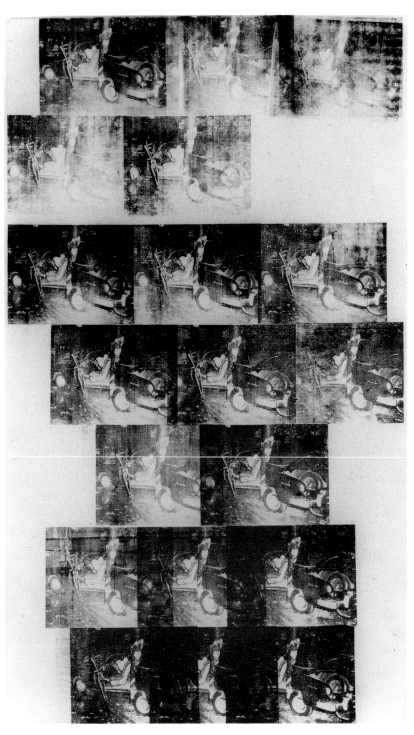

133. *White Car Crash Nineteen Times.* 1963. Acrylic and silkscreen ink on canvas,
144 x 83". Courtesy Thomas Ammann Fine Arts, Zurich

famous 1913 Armory Show, resurrected in its original setting at Lexington Avenue and 25th Street; dancer-choreographer Yvonne Rainer's *Terrain* at Judson Memorial Church (mainly to keep tabs on Rauschenberg, who had designed the lighting); a day-long Yam Festival of Happenings and performance art at George Segal's farm in New Jersey; and even a Mr. New York contest at the Brooklyn Academy of Music. Andy did not want to miss a thing.

At Warhol's Lexington Avenue home, the parlor floor was no longer large enough for the quantity of paintings he was now turning out. As the completed, rolled-up canvases and wood-framed silkscreens were leaned against the paneled walls in ever-greater numbers, he was left with less and less space in which to work. It sometimes seemed as if he spent most of his time unrolling canvases across the floor to show to visitors, who had to fit themselves into cramped corners and crane their necks. It was time to search for a larger studio.

Early in 1963, Warhol rented a two-story brick firehouse on East 87th Street, near Lexington Avenue—only two blocks from his house. The whole building cost him $150 a month. He brought his paints, canvases, and silkscreens to the former hook and ladder company and turned the top floor into his studio. Like many firehouses, the building had a metal pole running vertically through a large round hole in the second-story floor. Andy's visitors stepped gingerly around this aperture, not to mention several other hazardous gaps in the flooring. He left the ground floor empty except for occasions when he stretched his paintings and lined them up along the walls to show to visitors. He didn't like to leave finished works in the place, partly because the roof leaked, so he usually rolled up his completed canvases and carried them home, adding them to those already stacked against the parlor walls. The studio had no telephone or electricity, so Andy could work there only during daylight hours, but he did so without the distractions of incoming calls. As a result, he turned out a prodigious amount of paintings. Warhol kept the firehouse for less than a year, but during that period he silkscreened many of his most important paintings, including the Car Crashes, Electric Chairs, Race Riots, Suicides, Tunafish Disasters, and movie-star portraits of Elizabeth Taylor, Elvis Presley, and Marlon Brando.

Warhol devoted much of the year to images of unremitting morbidity. Starting with the newspaper painting *129 Die,* and the Marilyn Monroe portraits of the previous summer, death had become a dominating theme in his art. "I realized that everything I was doing must have been Death," he told G. R. Swenson. "It was Christmas or Labor Day—a holiday—and every time you turned on the radio they said something like, '4 million are going to die.' That started it." Warhol frequently remarked upon the news broadcasts that predicted how many hundreds of Americans would die in traffic accidents over the holiday weekends. The announcements were intended to make drivers more cautious, but Warhol interpreted the projected figures as goals to be met. He believed that the forecasted number of fatalities lured motorists into wanting to flesh out the statistics. "But when you see a gruesome picture over and over again," he told Swenson, "it doesn't really have any effect." Even the Elizabeth Taylor pictures, he added, had been started "when she was so sick and everybody said she was going to die."[7]

Warhol found many of the subjects for his paintings in movie magazines and lurid tabloids. He chose to screen some of the most morbid, distasteful scenes he could find—news photographs of horrendous automobile accidents in which lifeless human bodies were pinned under overturned cars or hanging out of smashed-up vehicles. Friends with access to news-agency and police photographs also provided him with images.

The grisly car-crash paintings are among Warhol's most powerful and disturbing pictures, presenting the mangled remains of vehicles and human bodies in several different variations. There is considerable irony, of course, in choosing loaded subject matter, then distancing it through photomechanical repetition and regimentation. In *Green Burning Car I, Nine Times* (plate 134), a man, hurled out of an overturned, flaming car, has been freakishly impaled on a climbing spike projecting from a utility pole. *White Car Crash Nineteen Times* (plate 133), showing a car wrapped around a tree with its sprawled driver visible through the flung-open door, is exceptionally high in format (twelve feet). Warhol lightly ruled some pencil markings to indicate the top and bottom edges of the screen, then printed the scene in seven tiers. He deliberately staggered the repetitions, which often overlap from left to right, eliciting the jolting

sensation that the images themselves are locked in eternal collisions with one another.

The paintings reflect Warhol's deep-seated horror of physical violence and his profound dread of accidental death. But at the same time he suggests through the numbing repetition of the images that one can develop indifference to the accidental and tragic loss of life. When death is multiplied, it becomes more abstract and therefore less painful to behold. In automobile collision pictures such as *Optical Car Crash* (plate 136), the scene is multiplied dozens of times and with such insistency that the repulsive particulars dissolve into a flamboyantly patterned abstraction ("like a dress fabric," Warhol said), though still conveying a ferocious energy. It requires an act of will to see through the abstraction in order to make it resolve once again into a discrete image filled with grisly details. The shrewdly balanced contradiction between the disagreeable subject and the cool, seemingly mechanical way in which it is regimented in rows accounts, of course, for the success of the picture.

Foot and Tire (plate 137) is a ghastly vignette of a traffic accident, the only sign of the victim being the sole of a shoe, barely visible under the double wheels of a tractor-trailer. Only the slight tilt of the axle implies that the shoe may still be on the foot of its owner. It is difficult to imagine a picture involving footgear that is more antithetical to Warhol's lighthearted I. Miller drawings.

Warhol did not feel sorry for the car-crash victims he portrayed, but he thought "people should think about them sometime." He viewed his death series as divided into two categories—famous and anonymous fatalities. "It's just that people go by and it doesn't really matter to them that someone unknown was killed, so I thought it would be nice for these unknown people to be remembered by those who ordinarily wouldn't think of them."[8]

As Warhol was now painting exclusively with silkscreens, often on a much larger scale than initially, he required help in swiping the squeegee across the screen, so he began to look for an assistant to help print the images and also clean the screens before they became clogged with dried ink. In June, he attended a poetry reading at the New School for Social Research in Greenwich Village, where a friend introduced him to Gerard Malanga, a stocky twenty-

year-old poet with a mane of curly hair that grazed his shoulders. The Bronx-born youth was a student at Wagner College on Staten Island and desperately in need of a job. Malanga ingratiated himself immediately by declaring that he was an "experienced silkscreen technician," who, three years earlier, had held an after-school job silkscreening ties for a textile designer. "Can you come tomorrow?" Warhol asked him. The poet showed up at the firehouse the next day and Andy immediately put him to work for $1.25 an hour, then the minimum wage.[9]

Malanga's first task was to help Warhol print some forty-inch-square portraits of Elizabeth Taylor on canvases that had been previously spray-painted with a coat of silver. (Warhol liked the lustrous, sensual look of a metallic ground, which gave off an elusive, mirror-like shimmer.[10] The silver background was also an homage, of course, to the "silver screen" of his moviegoing youth.)

Elizabeth Taylor, whose magnificent face was known to fans all over the world, was an ideal subject for Warhol. She was constantly in the news because of her extraordinary career, fragile health, and complicated romantic life. "Liz," as the tabloids headlined her, was the movie queen incarnate: beautiful, famous, rich, touched by tragedy, and one of the most wanted women in the world. At the time Warhol was painting her, the actress was earning an unprecedented acting fee of one million dollars to play the title role in the film *Cleopatra*. Her marriage to Eddie Fisher was fizzling as she became romantically involved with her costar, Richard Burton.

Warhol presented Taylor in a variety of poses—as a Hollywood beauty, as Cleopatra, and as a wife in the company of three of her husbands (not all at once). Despite the apparent topicality of his movie-star paintings, he derived many of his images from photographs that were several years old before he decided to use them. He based *The Men in Her Life* (plate 139), for instance, on a 1957 photograph published in the April 13, 1962, issue of *Life,* which included a ten-page cover story on her marital history, headlined "Blazing New Page in the Legend of Liz." The picture shows Taylor at an Epsom Downs horse race, walking alongside her third husband, producer Mike Todd, and smiling vivaciously at Eddie Fisher (soon to be husband Number Four), who is accompanied by his then-wife, Debbie Reynolds. In that same issue of *Life,* Warhol found a full-page

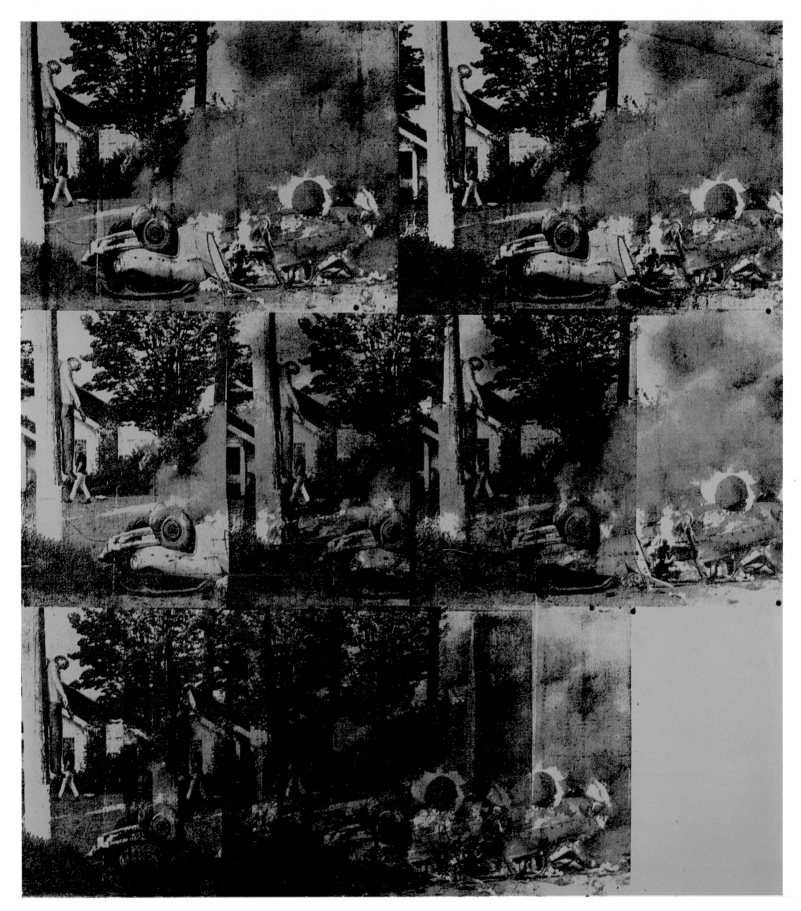

134. *Green Burning Car I, Nine Times.* 1963. Acrylic and silkscreen ink on canvas, 79⁷/₈ x 90¹/₈″. Galerie Bruno Bischofberger, Zurich

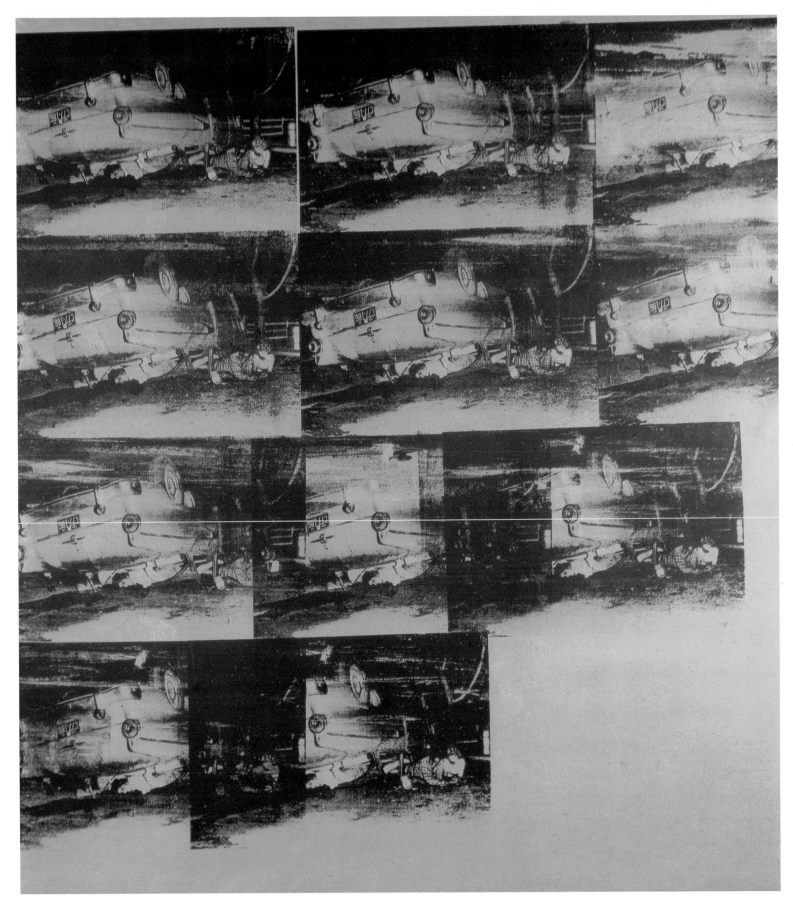

135. *Orange Car Crash Ten Times.* 1963. Acrylic and silkscreen ink on canvas, 106 x 82". Museum der Stadt, Cologne

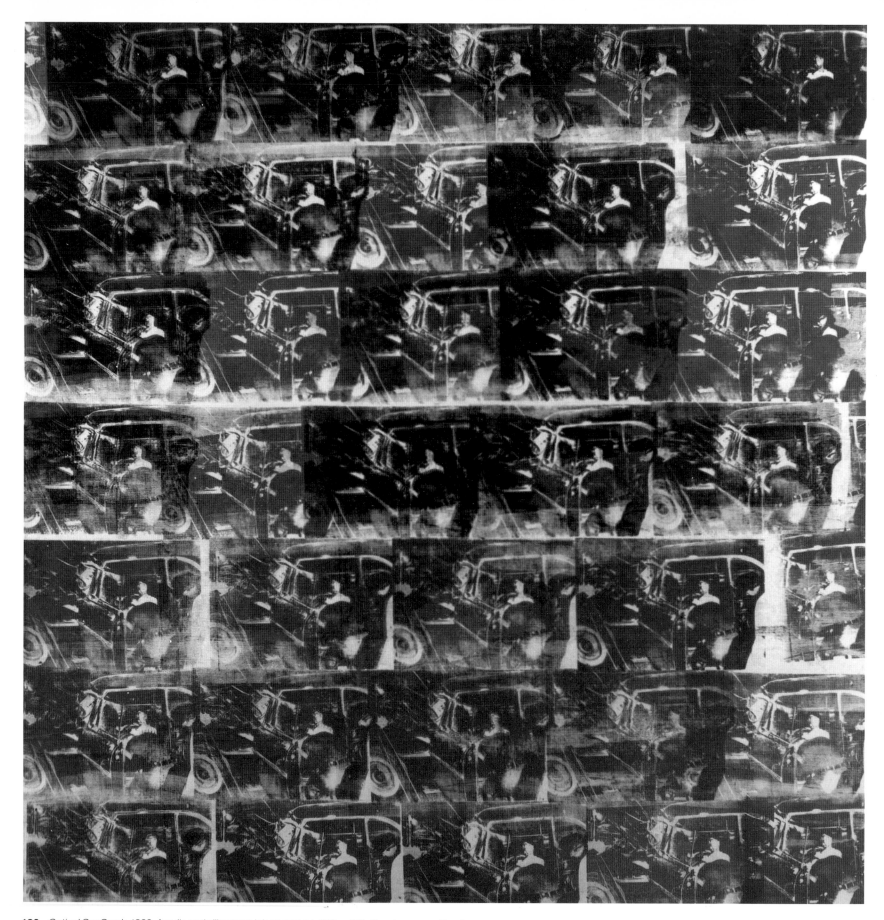

136. *Optical Car Crash.* 1962. Acrylic and silkscreen ink on canvas, 81⅞ x 82". Kunstmuseum, Basel

137. *Foot and Tire*. 1963. Acrylic and silkscreen ink on canvas, 80¼ x 144¾". Collection Dia Art Foundation, New York

photograph of Taylor, looking like a classic *femme fatale* with exaggerated eye makeup and a braided Cleopatra wig, that he converted into a silkscreen for *Blue Liz as Cleopatra* (plate 140).

Once again Warhol turned his attentions to Elvis Presley, whose face the artist had reiterated three dozen times in the previous year's *Red Elvis* (plate 127). This time Warhol silkscreened the rock 'n' roller as a full-length, almost life-size figure. Warhol derived his new portraits of Presley from a publicity still (for *Flaming Star,* a 1960 Western) that shows the star in cowboy garb, holding a gun instead of a guitar, with a holster and hunting knife parked on his notoriously undulating hips, and confronting the viewer in a shoot-out stance. Warhol had the photograph converted to a larger-than-life-size silkscreen and printed the image in black on canvases that he had previously sprayed with metallic silver. He and Malanga screened

Presley's figure, cropped through the hair and the feet, once, twice, or three or more times, sometimes slightly overlapping the images on the same canvas. One of the best in the series, the only one of its kind, is a diptych, *Elvis I and II* (plate 146), which features two pairs of side-by-side Presleys, one duo on a silver field, the other set on a hand-colored ground. Like the *Marilyn Diptych* and the *Troy Diptych, Elvis I and II* encourages spectators to search out the similarities and contrasts between the paired segments.

Warhol chose also to portray Marlon Brando, like Presley, in a rousing virile role, using a publicity still from *The Wild One* (1954), in which the actor played a leather-jacketed biker whose lawless gang terrorizes a small town. Though the original photograph is vertical in format, Warhol printed it—singly, doubled, or quadrupled—on mostly horizontal canvases, leaving bands of blank space along

the right or left edge (plate 145). The gun and the motorcycle respectively added overtones of aggression and violence to the macho portraits of Presley and Brando, and related them to the artist's 1962 painting of *Cagney* (plate 144), who brandishes a revolver in each hand. All three of these male stars, who exemplify different periods of Hollywood history, sharply contrast with the comparatively bland faces of Warren Beatty and Troy Donahue.

Warhol's steady trickle of visitors to the firehouse studio that spring included Irving Blum, who offered the artist another one-man show at the Ferus Gallery. Blum liked the car-crash paintings and bought one for himself, but he agreed with Warhol that an all-movie-star exhibition would be more appropriate for the Los Angeles setting. Andy wanted to capitalize on the notoriety caused by his soup-can paintings the previous year, and he probably believed he would have an even greater success with imagery that catered to Hollywood's film industry. They decided on a September show.

Andy's New York dealer, Eleanor Ward, found the car-crash paintings distasteful and refused to exhibit them, although she did sell some out of the racks of the Stable Gallery. In any case, Warhol was planning to have a one-man show at Ileana Sonnabend's gallery in Paris, and he had decided to show the car-crash paintings there. As usual, Andy had quizzed his friends for ideas and advice. The consensus seemed to be that the French would hate any imagery that seemed to advocate consumerism and "the American way of life." In a typically perverse turn of mind, Warhol chose as his theme "Death in America," concentrating on peculiarly contemporary and violent scenes that typified mortality *à l'américaine*.

Warhol savored the horror of meeting a premature death as the result of an innocent supermarket purchase, a sickening possibility that prompted him to paint a series of Tunafish Disasters (see plate 149). These paintings derive from news stories about two Detroit housewives who opened a can of A & P chunk light tuna, made themselves a couple of sandwiches for lunch, and died within hours of botulism. The repeated photographs of a single can of tuna, ominously marked with a code indicating it is part of a seized shipment, are a perverse and sardonic follow-up to the artist's earlier and comparatively benign cans of Campbell's Soup.

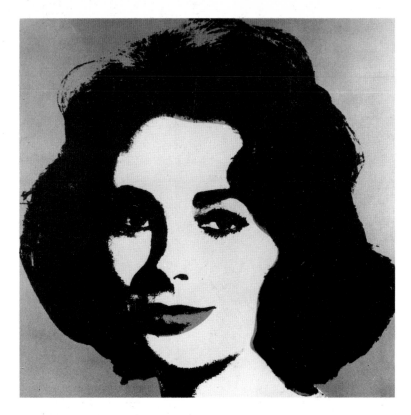

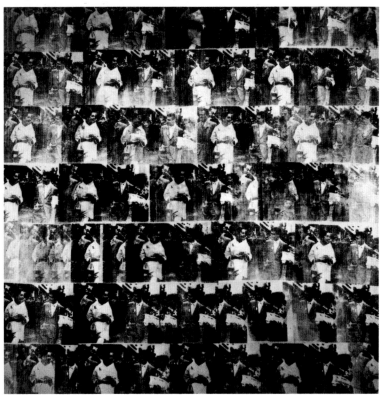

138. *Portrait of Liz*. c. 1963–64. Silkscreen ink on canvas, 40 x 40″. Collection Leo Castelli, New York

139. *The Men in Her Life (Mike Todd and Eddie Fisher)*. 1962. Acrylic and silkscreen ink on canvas, 82 x 82″. Morton G. Neumann Family Collection, Chicago

140. *Blue Liz as Cleopatra*. 1962. Acrylic and silkscreen ink on canvas, 82 x 65″. Collection Adrian and Robert Mnuchin, New York

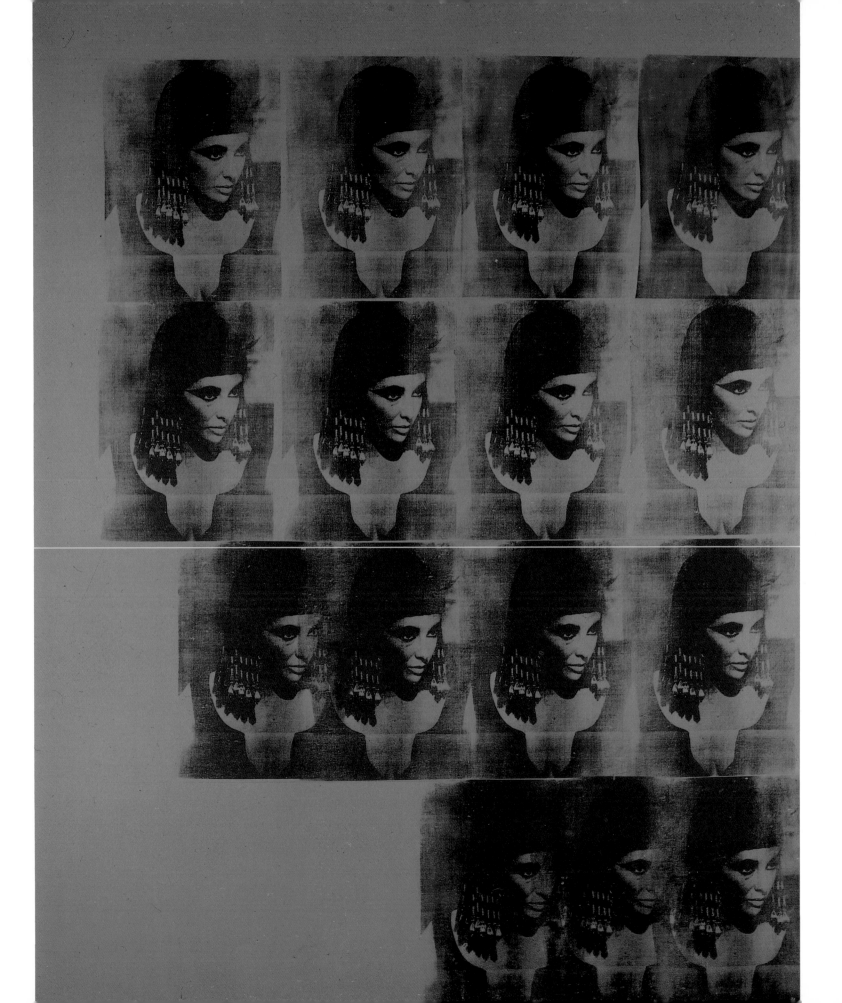

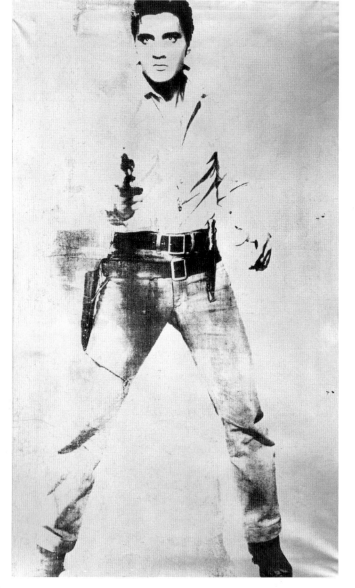

141. *Elvis*. 1963. Acrylic and silkscreen ink on canvas, 82 x 48″. Private Collection

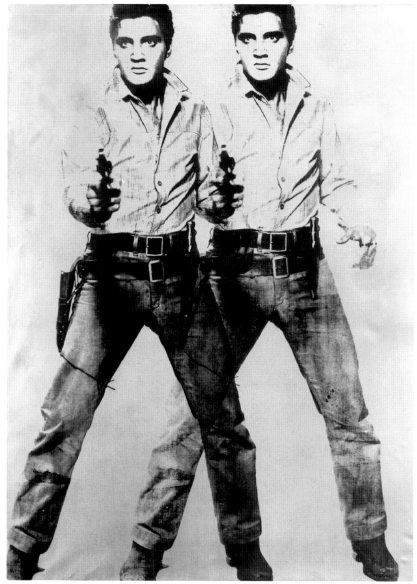

142. *Double Elvis*. 1963. Silkscreen ink on aluminum paint on canvas, 82 x 60″. Museum Ludwig, Cologne

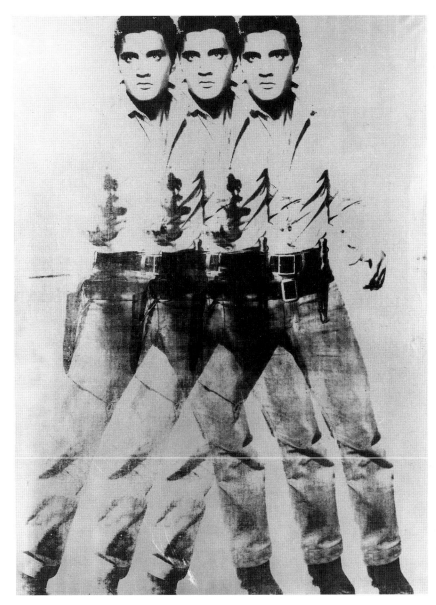

143. *Elvis (Triple Image).* 1964. Acrylic and silkscreen ink on canvas, 82 x 60″. Virginia Museum of Fine Arts, Richmond. Gift of Frances and Sydney Lewis

144. *Cagney.* 1963. Silkscreen ink on paper, 30 x 40″. Collection Peter Lofgren, New York

145. *Silver Marlon One Time.* 1963. Acrylic and silkscreen ink on canvas, 70 x 80″. Private Collection

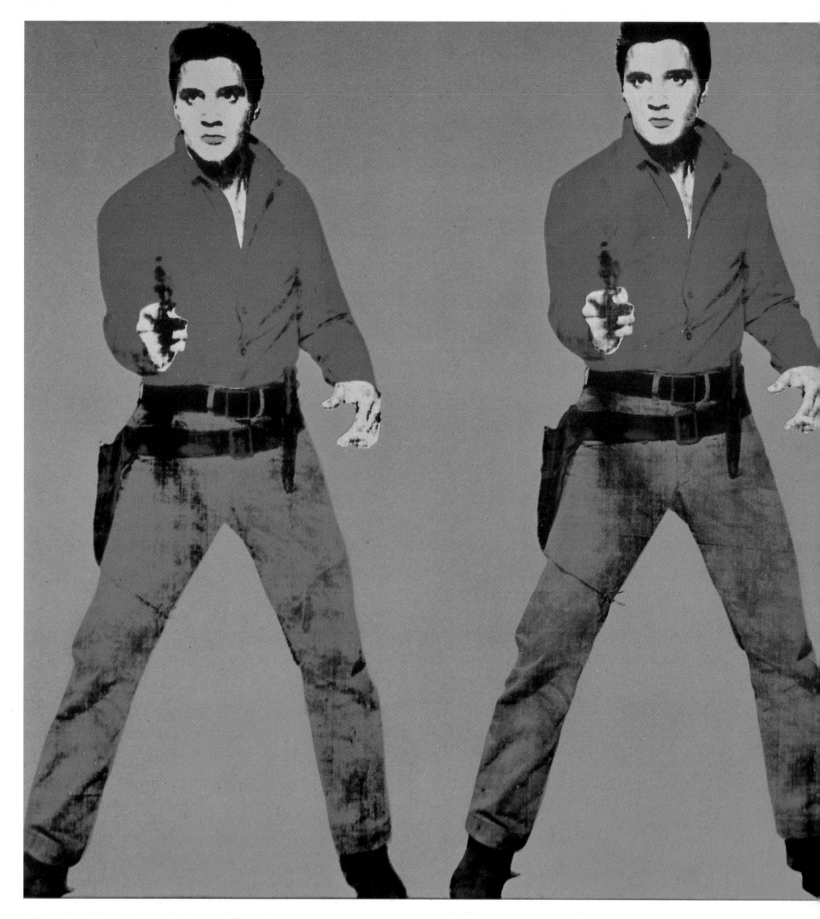

146. *Elvis I and II.* 1964. Acrylic, aluminum paint, and silkscreen ink on canvas, two panels, each 82 x 82″. Art Gallery of Ontario, Toronto

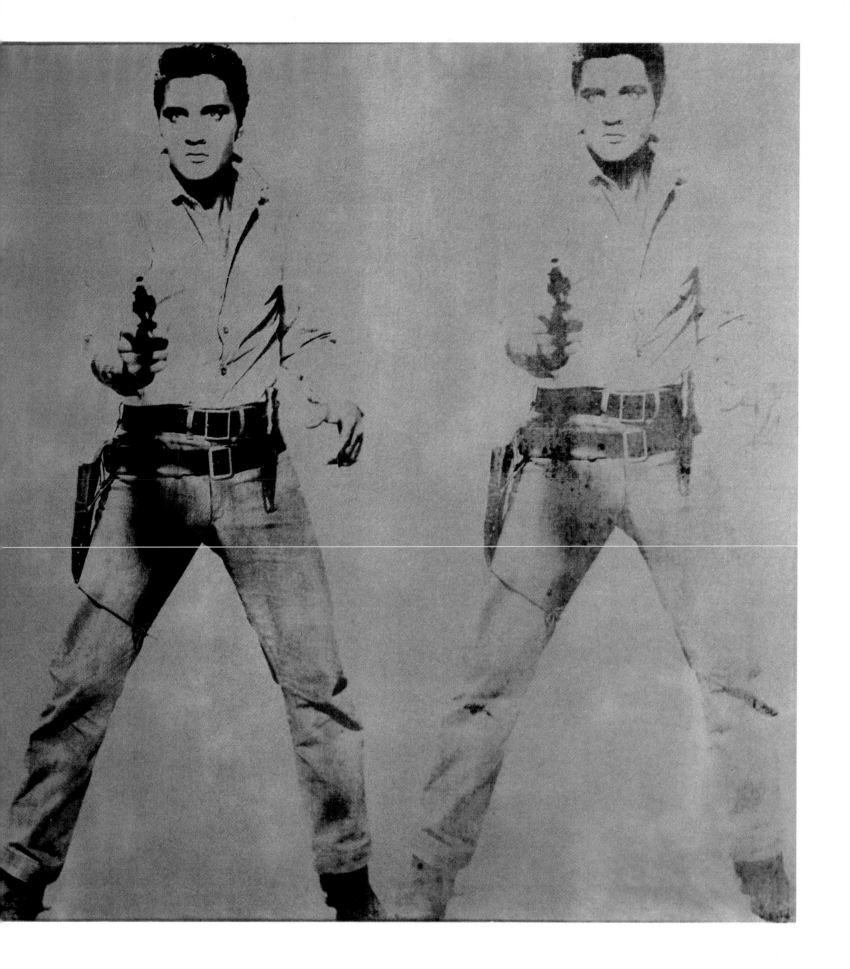

Death by suicide was another morbid theme that haunted Warhol, who now sought photographs of people in the act of or shortly after killing themselves. His friends scoured magazines and newspapers for him and came up with pictures that led to paintings such as *1947 White*. The image derives from a 1947 photograph of a young model who had jumped from the eighty-sixth floor of the Empire State Building, landing on a car. (The artist's source was a tearsheet from the January 18, 1963, New York regional edition of *Life,* which featured a brief history of the Empire State Building; the photograph had first appeared in the April 12, 1947, issue of the magazine.) She lies as if in repose atop the crumpled roof of the automobile, her gloved hands raised gracefully toward her unblemished face. Only the bunched stockings at her ankles provide a clue to the violence of her demise. Other desperate people who leapt to their deaths include the midair figure in *Suicide* (plate 130) and the grounded hospital patient in *Bellevue II* (plate 147).

Executions were a topical subject in New York State, where the electric chair in Sing Sing was used for the last two times in March and August of 1963. This "modern" form of legal electrocution impressed Warhol as a typically American way to go. He located a photograph of a vacant hot seat, starkly isolated in a large empty room with a wall sign that requests "SILENCE," and used it to produce a large number of paintings. Perversely, he silkscreened the image of lethal furniture against monochrome backgrounds in decorator colors, as in *Lavender Disaster* (plate 150).

For his Race Riot paintings (see plate 152), Warhol selected and screened news photographs of policemen siccing their dogs on civil-rights demonstrators who were participating in a nonviolent protest against racial segregation in Birmingham, Alabama. Once again, he turned to *Life* (in this case, the May 17, 1963, issue) as his picture source, appropriating photographs by Charles Moore of leashed German shepherds literally tearing the pants off a black man. Warhol conveyed the savagery of the police attack by presenting three successive moments in the man's struggle to flee the menacing canines. The artist mixed and staggered the images in such a way as to imply that escape was impossible. While some viewers interpreted Warhol's police-dog paintings as "liberal statements," others, such as Claes Oldenburg, saw them not as a

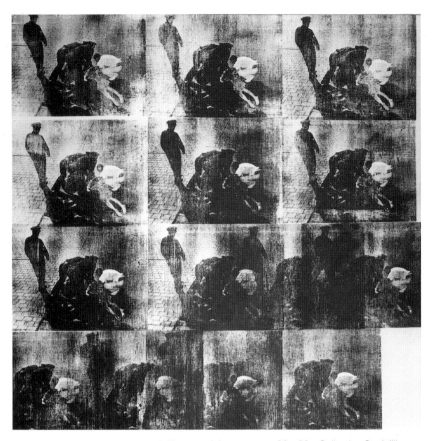

147. *Bellevue II.* 1963. Acrylic and silkscreen ink on canvas, 82 x 82″. Collection Stedelijk Museum, Amsterdam. Purchase, with support of the Vereniging "Rembrandt"

political comment but, instead, as an expression of the artist's indifference to his subject. "It is indifference," Warhol told Oldenburg. (Andy was essentially apolitical, never participated in a protest demonstration, and displayed little interest in the civil-rights or antiwar movements.) Asked if it wasn't significant that he deliberately chose that particular photograph of a "hot" subject, he replied, "It just caught my eye."[11]

Mass death by radiation, first made possible by American technology, is the implied subject of Warhol's painting of repeated mushroom clouds in *Atomic Bomb* (plate 151), probably painted in 1963.[12] On August 6, 1945, a United States B-29 plane dropped the first atomic bomb on Hiroshima; the date should have been easy for Andy to remember, as it coincided with his seventeenth birthday.

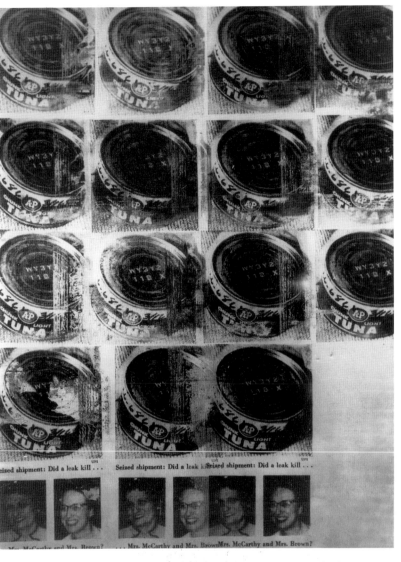

149. *Tunafish Disaster.* 1963. Acrylic and silkscreen ink on canvas, 112 x 82″. Collection Cy Twombly, Rome

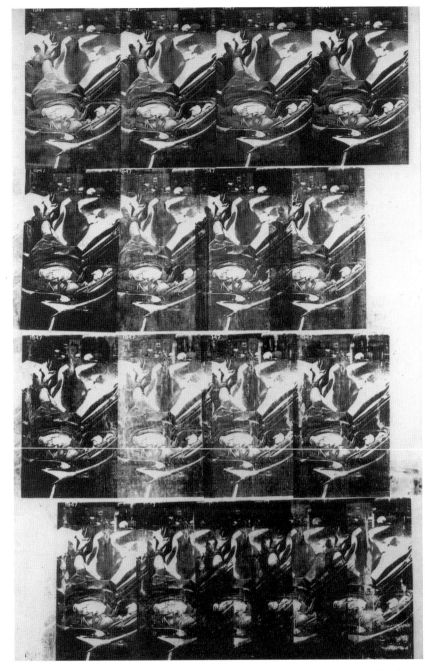

148. *Suicide.* 1963. Acrylic and silkscreen ink on canvas, 111½ x 80¼″. Collection Dia Art Foundation, New York

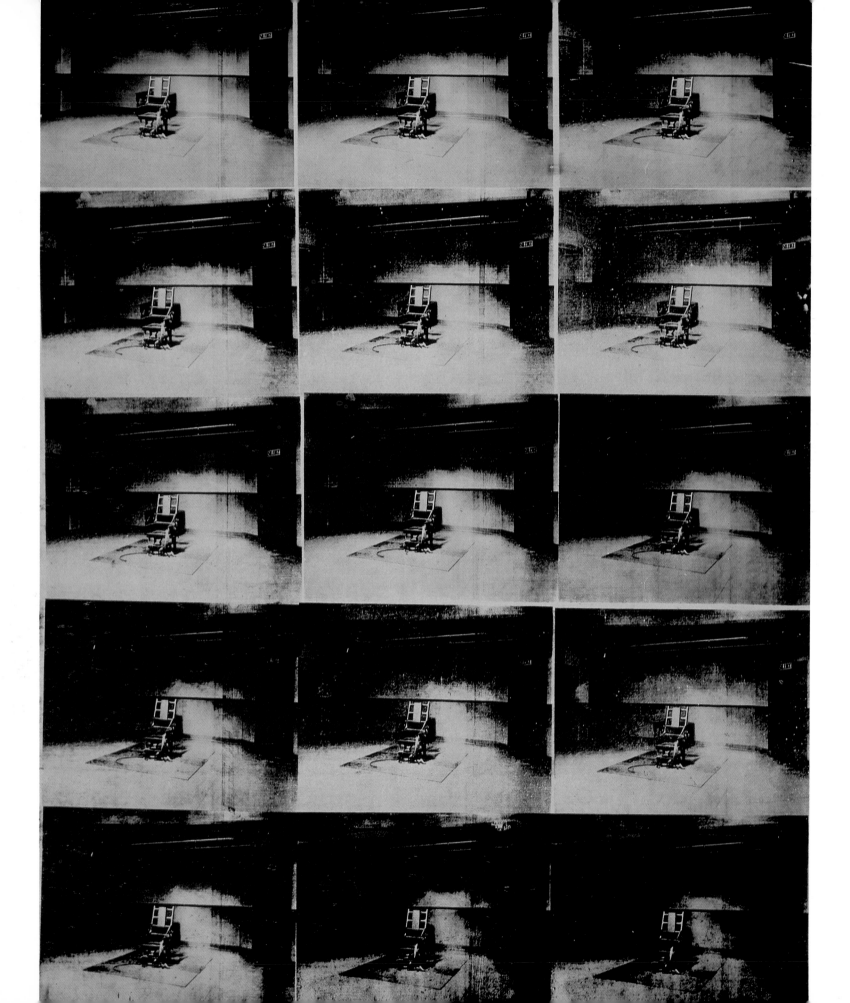

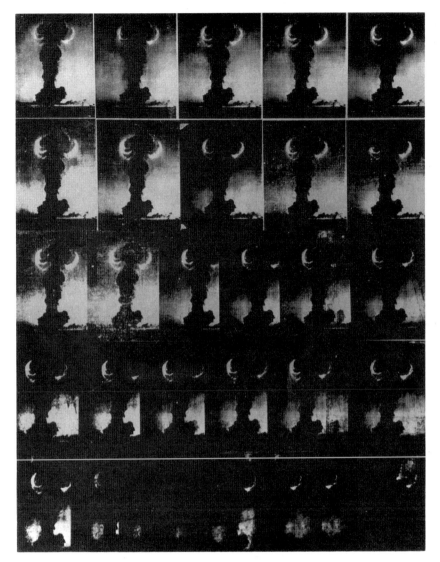

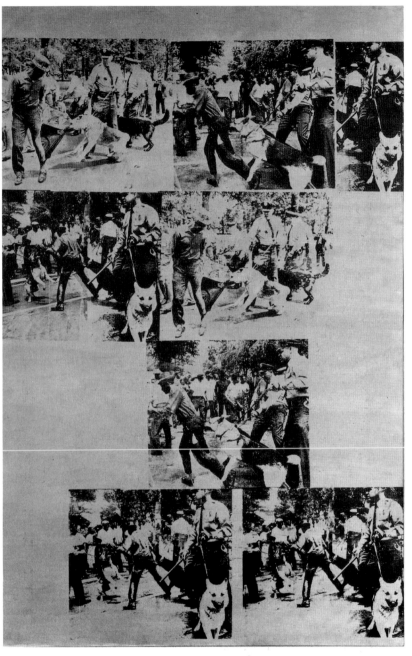

151. *Atomic Bomb.* c. 1963–64. Acrylic and silkscreen ink on canvas, 104 x 80½″. Saatchi Collection, London

150. *Lavender Disaster.* 1963. Acrylic and silkscreen ink on canvas, 106 x 81⅞″. The Menil Collection, Houston

152. *Red Race Riot.* 1963. Acrylic and silkscreen ink on canvas, 137 x 82½″. Museum Ludwig, Cologne

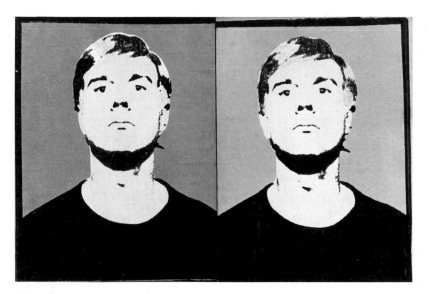

153. *Self-Portrait.* 1964. Acrylic and silkscreen ink on canvas, two panels, each 20 x 16" Collection Gerald S. Fineberg

Warhol radically altered the format of his paintings during the firehouse period. In the beginning, he was regimenting several repetitions of an image in rows across a single canvas. After 1963, he seldom silkscreened more than one solitary image on a canvas; the final size of a painting could expand or contract depending on how many panels were added or removed. Collectors, he reasoned, could buy as many units as they wanted and hang them in any order they chose. The final disposition of the panels did not much matter to him.

While at the firehouse, Warhol also started producing diptychs in which he first painted both panels with the same allover hue and then silkscreened only one section with a photographic image, leaving the other a plain monochrome. "Wouldn't it be a good idea to add a blank panel?" he asked his friends. "It would make the painting twice as big and twice as expensive." The amount of work involved in screening a second canvas was fairly negligible, of course, but Warhol's imagination was fired by the possibility that he could persuade collectors to buy an "empty" monochrome unit, a notion that appealed to the Rumpelstiltskin in him. If he could stencil pictures of dollar bills and convert them into actual cash, why

couldn't he sell blank canvases? He proceeded to pair an all-silver panel with an individual portrait of Elizabeth Taylor, and he similarly accessorized some of the Tunafish Disasters, Race Riots, and Car Crashes with blank appendages.

In addition to his prodigious output of movie-star and Death and Disaster paintings, Warhol emerged as a highly distinctive portraitist who exploited the potential of multiple silkscreened impressions to suggest various facets of a "sitter's" personality. His earliest silkscreened portraits of someone he actually knew appear to be those of Robert Rauschenberg, painted in late 1962 and early 1963 and based on family snapshots supplied by the older artist. *Let Us Now Praise Famous Men* is based on five different photographs laid out in six registers. It is, in effect, a narrative cycle, chronicling Rauschenberg's maturation from child to youth to adult. Another of the Rauschenberg pictures, *Texan* (plate 154), features a medium close-up of the artist repeated twenty-five times in four tiers. While only a single photographic image was used, each repetition is visibly unique, due to the numerous degrees of overlapping, differing amounts of pigment, and inconsistent swipes of the squeegee. Because each of *Texan*'s screened portraits reveals a varied amount of background color, the faces appear to be illuminated by a flickering light that suggests the passage of time.

The first—and one of the best—of Warhol's commissioned silkscreened portraits was *Ethel Scull Thirty-Six Times* (plate 155). This multipanel painting portrays the fashion-minded, fun-loving wife of New York taxi mogul Robert C. Scull, a flamboyant pioneer collector of Pop art who previously had purchased several of Warhol's works. In contrast to many of his earlier pictures, which consist of repetitions of a single image on one canvas, the Scull portrait offers a variety of poses, each printed on a separate piece of canvas and subsequently joined together. Instead of basing the portraits on preexisting "official" photographs supplied to him by the sitter, Warhol chose to make his own candid pictures, but he did not shoot them himself. He taxied with Mrs. Scull, who was ready to face posterity in an Yves Saint Laurent for Christian Dior suit, to a Times Square amusement arcade and installed her in an automatic, four-for-a-quarter photo-booth. "Now start smiling and talking, this is costing me money," he told her, as he dropped

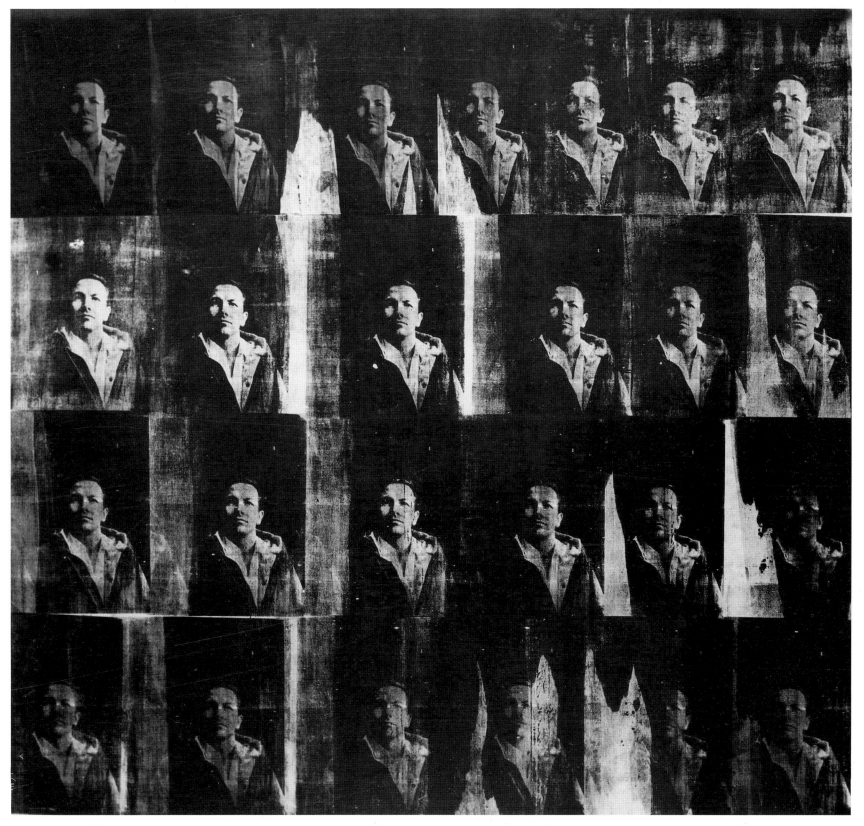

154. *Texan (Robert Rauschenberg).* 1962. Acrylic and silkscreen ink on canvas, 82 x 82″. Museum Ludwig, Cologne

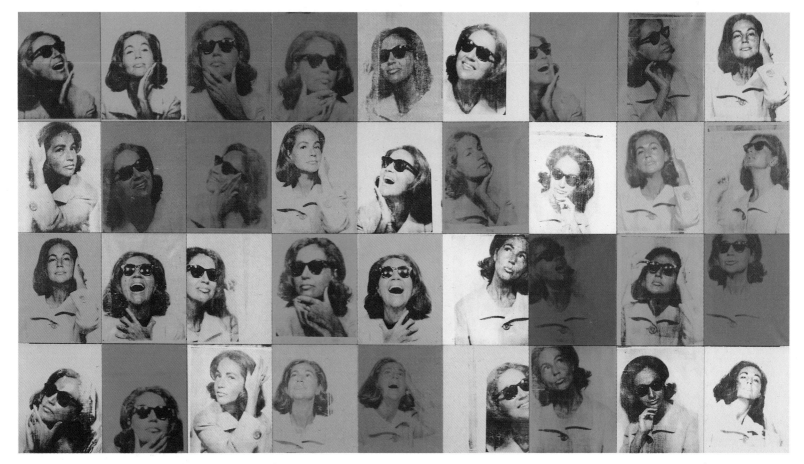

155. *Ethel Scull Thirty-Six Times.* 1963. Acrylic and silkscreen ink on canvas, thirty-six panels, each 19⅞ x 15⅞"; overall size 79¾ x 143". Whitney Museum of American Art, New York. Gift of Ethel Redner Scull. 85.30A

quarters into the machine, setting off the photofloods. With and without her sunglasses, Ethel preened, mugged, bared her teeth, patted her chin, stroked her hair, and clutched her throat. She posed for more than one hundred shots, presenting herself in a wide gamut of moods—pensive, exuberant, seductive, cheerful, laughing.

Warhol selected the photographs he liked best and had them processed into twenty-by-sixteen-inch silkscreens. At first glance, the portrait appears to offer thirty-six different views. But there are only seventeen poses: many of the images are repeated—either reversed, deployed in a different registration, or printed on another color. In any case, the random sequencing suggests a cinematic succession of staccato single-frame images, a lively treatment that conveys the vivaciousness of the subject. Warhol seldom again

painted a portrait with so many contrasting poses on such an extensive variety of colored grounds.

Warhol's particular method of portraiture distanced him from his subjects to such a great extent that it did not really matter whether he used preexisting photographs, supplied by the sitter, or machine-made pictures that he supervised himself. As he worked from photographic sources rather than a live model, it did not even matter if his subjects were long dead. Andy's silkscreen technique enabled him to quote images from previous centuries and to make Pop re-creations of other artists' portraits, as he did with Leonardo da Vinci's *Mona Lisa.*

One of the most publicized art phenomena of the year was the month-long visit of *Mona Lisa* to The Metropolitan Museum of Art in February 1963. Spectators queued up for hours to wait their turn to

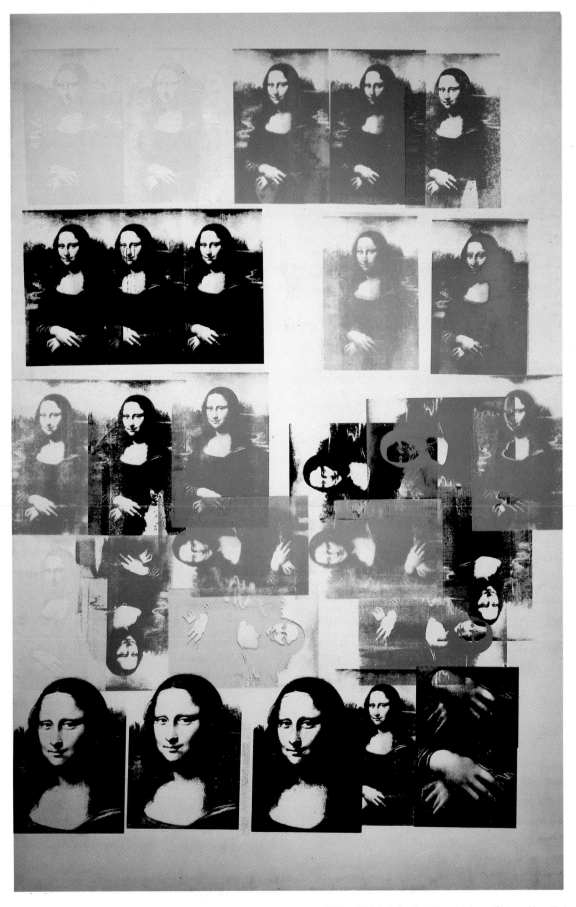

156. *Mona Lisa (Colored)*. 1963. Acrylic and silkscreen ink on canvas, 125¾ x 82⅛". Collection Blum-Helman Gallery, New York

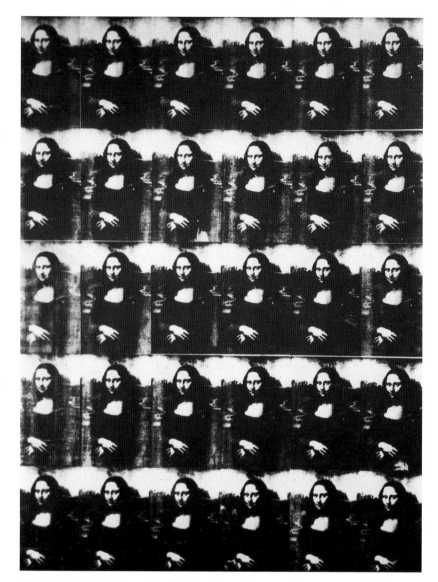

157. *Thirty Are Better Than One*. 1963. Acrylic and silkscreen ink on canvas, 110 x 82½".
Private Collection

file past the most famous portrait of all time. In anticipation of *Mona Lisa*'s arrival, many New York artists, including Warhol, created homages to the enigmatic Italian Renaissance lady. Warhol treated her with the same unreverential zeal that prompted novelty manufacturers to exploit her face on everything from ashtrays to T-shirts. He extolled her celebrity status by regimenting her black-and-white portrait like a sheet of postage stamps in *Thirty Are Better Than One* (plate 157). In *Mona Lisa (Colored)* (plate 156), he scattered two dozen replications of the half-length figure as

Leonardo presented it as well as one detail of the crossed hands and three details of the face, each repetition printed in a primary color or black. Although some of the images are printed sideways or upside down, all of the figures are positioned orthogonally, and efforts were obviously made so as not to overlap and thereby obscure Mona Lisa's face. The composition is not typical of Warhol's gridlike arrangements (Malanga claims credit for urging the artist to play around with the image), but the horizontal rows of repeated figures, randomly dispersed colors, and even application of the paint suggest that this was a deliberately constructed painting and not, as one writer has proposed, an "unadulterated accident."[13]

Warhol's prolific output of paintings was unquestionably augmented by Malanga, who approached his part-time work with tremendous energy and enthusiasm, behaving less like an hourly assistant than a full-time companion and helper. Though swarthy, outspoken, and girl-crazy, Gerard came to resemble Andy in that he was ambitious for fame, quick to intuit who could advance his career, and never hesitant about taking the initiative if it would help him get in with the right set of people and be welcomed as a peer by the New York poets he admired. Malanga was a romantic dreamer wearing a fixed expression of reverie; Andy sometimes wanted to snap his fingers in front of Gerard's face to get his attention. Malanga may not have been capable of writing great poetry at the time, but he at least aspired to it. Whenever a captive audience was on hand, he held impromptu poetry readings in Warhol's parlor while the artist looked on noncommittally.

In time, Malanga became a combination muse, factotum, and social connection between various "downtown" cultural groups. Warhol and Malanga constituted a dynamic pair whose combined and complementary energies enabled them to expand their impact upon various circles. Through Warhol, Malanga gained entrée to the worlds of fashion and art; in turn, Malanga, who kept up with just about every literary event in the city, introduced Andy to many poets, off-Broadway playwrights, and experimental filmmakers, and to several of the glamorous young women who would later star in Warhol's movies. Malanga was, in effect, the founding member of what would become Warhol's entourage of colleagues, friends, and hangers-on.

NOTES

1. Gerard Malanga, "A Conversation with Andy Warhol," *The Print Collector's Newsletter,* January–February 1971, p. 125.

2. Lawrence Alloway, brochure to the exhibition "Six Painters and the Object" (New York: The Solomon R. Guggenheim Museum, 1963), n.p.

3. "Pop Art—Cult of the Commonplace," *Time,* May 3, 1963, p. 69.

4. Barbara Rose, "Pop Art at the Guggenheim," *Art International,* vol. 7, no. 5, May 25, 1963, pp. 20–22.

5. "Pop Art—Cult of the Commonplace," p. 72.

6. G. R. Swenson, "Andy Warhol," *Art News,* November 1963, p. 26. This widely quoted interview is troublesome for art historians. Swenson and Warhol were good friends, but the artist was in one of his uncooperative moods, prompting the critic to conceal his tape recorder during the interview. Some of the more "intellectual" quotes attributed to Warhol sound as if they may have been doctored by Swenson, particularly the remarks concerning the *Hudson Review,* a literary quarterly that Warhol was not known to read.

 Swenson's discussion with Warhol was one of eight interviews with as many artists published under the title "What Is Pop Art?" in the November 1963 and February 1964 issues of *Art News.* Seven of Swenson's eight interviews were reprinted in *Pop Art Redefined* by John Russell and Suzi Gablik (London: Thames and Hudson, 1969). Through careless editing, the last eight paragraphs of Swenson's interview with Tom Wesselmann, starting on page 118 with the question "Is Pop Art a counter-revolution?," are appended to Swenson's interview with Warhol. As a result of this production goof, several of Wesselmann's remarks are erroneously attributed to Warhol; these bogus "Warhol" statements include his characterization of painting as "audacious"; his claim that he got his subject matter from the fifteenth-century Flemish painter Hans Memling and his content and motivation from Willem de Kooning; and his avowed love for the paintings of Mondrian, Matisse, and Pollock.

 Because of the *Pop Art Redefined* catalogue, the phony Warhol quotes are continually perpetuated. Richard Morphet, for instance, began his essay in the catalogue to the 1971 Warhol exhibition at the Tate Gallery in London with a long epigraph that ostensibly cites Warhol; the words are actually Wesselmann's. Art historian Thomas Crow also tripped up on the false Warhol quotes in an otherwise excellent article, "Saturday Disasters: Trace and Reference in Early Warhol, " *Art in America,* May 1987, pp. 128–36. Crow had the good sense to note parenthetically that Warhol was capable of "an inscrutable allusion to Memling as one of his sources." Warhol, indeed, would have been unable to distinguish a Memling from a lemming.

7. Swenson, "Warhol," p. 60. With tragic irony, Gene Swenson died at age thirty-five in a traffic collision in August 1969. He and his mother were driving along an interstate highway in western Kansas—they were second in a line of cars—when, ahead of them, a tractor-trailer suddenly jackknifed, killing everybody in the first three automobiles.

8. Gretchen Berg, "Nothing to Lose: Interview with Andy Warhol," *Cahiers du Cinema in English,* May 1967, p. 42.

9. Interview with Gerard Malanga, April 6, 1987.

10. Warhol was probably encouraged to use silver pigment by Frank Stella's first shaped canvases, striped in aluminum paint, which were exhibited at the Castelli gallery in September 1960.

11. "Oldenburg Lichtenstein Warhol: A Discussion" (transcript of a June 1964 radio broadcast, moderated by Bruce Glaser), *Artforum,* February 1966, p. 24.

12. *Atomic Bomb* is dated 1965 in many books and catalogues, but the five rows of repeated, slightly overlapping images on a single canvas suggest it was painted earlier, possibly in 1963 or 1964.

13. Patrick S. Smith, *Andy Warhol's Art and Films* (Ann Arbor, Mich.: UMI Research Press, 1986, 1981), p. 174. Smith theorized that *Mona Lisa (Colored)* was just "an extra sheet of canvas," used for cleaning the silkscreens, and that Warhol himself did not intend it as a work of art.

"I woke up and there was Andy, lying next to me on his side with his head propped up on his arm, looking at me. I asked, 'What are you doing?' He said, 'Watching you sleep.' He had watched me sleep for eight hours." —*John Giorno*[1]

158. The face of John Giorno reflects his state of repose in *Sleep,* filmed by Warhol in 1963.

Andy Warhol became a filmmaker during the summer of 1963, when he initiated a severely simple form of cataleptic cinema. He had been developing an interest in avant-garde films for about a year, frequently attending screenings at small, out-of-the-way, downtown movie houses. Independent filmmaking was then flourishing in New York, and just about everybody who could afford a 16mm movie camera seemed to be turning out low-budget, black-and-white, silent films that were determinedly artistic and uncommercial. (Many of the most prominent figures in the field, such as Kenneth Anger, Stan Brakhage, and Gregory Markopoulos, could afford sound and/or color.) Their films varied considerably in subject matter, technique, and style, but were collectively characterized as "avant-garde," "experimental," "independent," and most popularly "underground," a term rich with erotic and antiestablishment overtones. (Bared flesh and homoerotic themes, virtually nonexistent in Hollywood productions, certainly contributed to the popularity of these movies.) Many filmmakers repudiated the word "underground" because they disliked its implications of seediness and illegality. Warhol claimed that he never really understood the term at all: long after he became one of the most famous filmmakers of his generation, he said, "I can't see how I was ever 'underground,' since I've always wanted people to notice me."[2]

Warhol spent one or more weekends that summer in Old Lyme, Connecticut, where an artist-friend, Wynn Chamberlain, and Eleanor Ward had rented summer places. Chamberlain occupied a farmhouse, while Ward resided in a renovated icehouse on the same property. Chamberlain invited many of his friends for weekend visits, among them Warhol and Jack Smith, a filmmaker and actor. At the time, Smith's *Flaming Creatures* was the most notorious of all underground films; its campy cast, which included several vampish female impersonators, and its casual views of limp penises and bouncing breasts led to its confiscation by New York City police. It was a perverse fantasy-spoof on polymorphous sexuality, reaching a sort of climax with a combination orgy and earthquake. Much of the shock of the sixty-minute-long film was due to its amateurish technique: the hand-held camera quivered, shots were framed so that heads were cut off, and portions of the film were overexposed.

Warhol had seen *Flaming Creatures*, and now he had the opportunity to actually witness Smith shooting a new movie, *Normal Love*, in Old Lyme. Andy wanted desperately to make his own movies. As bedazzled as he was by the Hollywood school of glamour, he now realized that underground filmmakers such as Jack Smith were creating fresh and inventive works that redefined the nature of cinematic style. Warhol admired the way Smith casually accepted the contributions of whoever was around and whatever happened to occur. Smith's indifference to conventional film technique and his acceptance of chance were to be influential on Warhol's films. Andy couldn't tolerate being on the sidelines of this new and exciting world, so he bought himself a 16mm Bolex movie camera. One of the first things he filmed with his Bolex was a three-minute "newsreel" of Jack Smith shooting *Normal Love*.[3]

The Old Lyme farmstead was a hive of activity that weekend, with as many as forty people buzzing about. There were not enough beds to go around, even though several people camped out in Chamberlain's barn-studio. But that didn't matter, because almost everybody stayed up all night, revved up by amphetamines. (Warhol later speculated that he and his friends were more productive during the 1960s because the amphetamines provided them more "awake time.") Warhol claimed to need only two or three hours of sleep a night during the mid-1960s. He kept himself on the go by taking "speed" in the form of Obetrol diet pills, a combination of amphetamines intended as an appetite depressant; its side effects included nervousness, excitability, euphoria, and insomnia. Whatever the dosage (Andy claimed to take "only the small amount of Obetrol for weight loss that my doctor prescribed"), it was enough to give him what he called "that wired, happy go-go-go feeling in your stomach that made you want to work-work-work."[4]

Warhol liked to think that sleep was becoming obsolete, so he was more than a little fascinated with John Giorno, a friend of Wynn Chamberlain's who slept a lot. Giorno was a Wall Street stockbroker and self-styled poet, a well-built, muscular young man with dark hair, penetrating eyes, and an air of relaxed sensuality.[5] "I loved to sleep," Giorno said, "I slept all the time, twelve hours a day, everyday, and took a nap before Andy and I met and went out. Everytime Andy telephoned—morning, afternoon, or night—I would be asleep. He would say, 'What are you doing?' and I would say, 'Sleeping.' Or he would say, 'What are you doing? Don't tell me, I know.' "

Giorno was a frequent visitor to the Old Lyme farmstead, where, on occasion, he shared a room with Warhol. "It was one of those sweltering June nights," he said. "I got really drunk on Jamaican rum and passed out as soon as my head hit the pillow." When he woke up, he realized that Warhol had stayed awake all night, watching him. On the train back to New York, Warhol said to Giorno, "I want to make a movie. Do you want to be the star?" The poet, exhilarated, asked, "What do I have to do?" "I want to make a movie of you sleeping," Warhol said.[6]

During July and August, Warhol and Giorno, after going to movies and parties, would stop by the artist's house to pick up his movie equipment, then proceed to Giorno's apartment on East 74th Street between Second and Third avenues. Giorno usually had a vodka nightcap or two and took off his clothes while Warhol set up his tripod, camera, and clip-on photofloods. By the time Andy had his lens in focus, Giorno was fast asleep. Warhol shot one three-minute, black-and-white reel after another. When he was through, he left quietly. Giorno awoke in the morning to find the bedroom lights still on and dozens of empty film boxes and instruction sheets all over the floor.

Altogether, Warhol shot hundreds of reels, focusing on Giorno's head and various details of his nude torso (plates 158, 159), whose most private parts remained decorously covered by a sheet. Some close-ups portrayed Giorno's head in profile, while others concentrated on thigh and hip. From the foot of the bed, Warhol framed a foreshortened view of Giorno's chest, throat, and face.

Warhol's mode of operation was simply to mount his camera on a tripod, insert a reel of film, and turn on the motor drive, which enabled him to shoot an entire one-hundred-foot-long reel without interruption. He occasionally changed his vantage point between reels, but never moved the camera once the motor was turned on. He was attentive to composition and took pains to achieve crisp, contrasty lighting, but as soon as he had his setup, he put the camera on automatic.

Many of the body parts that Warhol recorded in close-up are not

immediately identifiable, evoking earlier abstractions of human anatomy by the sculptor Henry Moore and the photographer Bill Brandt. The opening scene is especially confounding—a detail of essentially quiescent but perceptibly animate flesh that finally resolves into an abdomen. In later shots, the camera stares fixedly at the sleeper's foreshortened chest and throat, his arm and hand, and his head in profile. The crumpled edge of a brightly illuminated white sheet often complicates the composition and obscures part of the body. The camera angles and close-ups are generally unexpected and sometimes quite striking, providing a forceful counterpoint to the somnolent subject. In editing his first major opus, Warhol simply deleted the blank strips at the ends of each one-hundred-foot reel and spliced the remaining film end-to-end into longer reels. He incorporated a great deal of duplicated footage in order to give the six-hour work a "better design."

The concept behind *Sleep* is, of course, the most startling aspect of the film. How many viewers will admit to a willingness to spend several hours watching a film of someone else in a barely animate state of unconscious torpor? The theme of the sleeping nude, however, has a long tradition in art, particularly in antiquity and again during the Renaissance. One of the most famous sculptures from the Greco-Roman world is the *Barberini Faun*, probably a Roman copy after a lost Greek original of the third century B.C. The marble figure represents an inebriated satyr, asleep on a rock, his sprawled limbs accentuating his unconsciously flaunted torso and genitals. Another of the ancient world's legendary sleepers is Endymion, often portrayed in art as a young shepherd of great beauty. Zeus granted the youth's wish for immortality by sending him into an eternal slumber. Like Selene, the moon goddess who fell in love with Endymion, passing by to kiss him whenever she liked, Warhol surely must have delighted in the leisurely pleasure of gazing unashamedly at his beautiful dreamer, so passive and vulnerable. While Selene supposedly had fifty daughters by Endymion, a no-less-determined Warhol managed to produce an extraordinary film as a result of his association with Giorno.

159. John Giorno's torso remains discreetly covered by the bedsheets in these scenes from *Sleep*.

160. Warhol peers through the lens of his Bolex 16mm camera to shoot a Taylor Mead film in the Factory, September 5, 1964. Photograph by Fred W. McDarrah

Warhol displayed fortuitous timing in making his debut as a filmmaker. Both the Pop art and underground film movements were peaking in creativity and public interest. He was the only major Pop artist making his own films and soon the most prominent of all the avant-garde moviemakers who also made paintings. His "motionless" movies were in sharp contrast to the then-prevailing conventions of experimental filmmaking in New York—the mobile, hand-held camera; the successions of discontinuous single-frame shots that resulted in a confusing blitz of images; and the choppy continuity resulting from frequent cutting. Warhol's concepts were also perversely antithetical to the work of many directors in the commercial film world, such as Richard Lester and Tony Richardson, who used rapid montage and jump cuts to abbreviate and accelerate action. (Richardson's widely admired *Tom Jones* won the 1963 Academy Awards for best picture and best director.) Andy was shrewd enough to realize that excessively long takes would be noticed.

With the technique represented by *Sleep*, Warhol brought

cinematic action to a virtual standstill, and his marathon films soon became notorious for their minimal content. His reductive inclinations (particularly those concerning lengthy durations and numerous repetitions) were reinforced by an awareness of several musical precedents: John Cage's notorious "silent" composition, *4'33"* (four minutes and thirty-three seconds of silence); La Monte Young's "eternal" drone music; and the marathon performance— more than eighteen hours long—of Erik Satie's *Vexations*, an eighty-second piano piece repeated 840 times; the work was performed in September 1963 in a Lower East Side hall by a rotating team of pianists, including John Cage, who played for an average of twenty minutes (or fifteen *Vexations*) at a time. Warhol, whether or not he attended the Satie concert, was certainly aware of it via Gerard Malanga, who sat through several hours of it.

Warhol deliberately set about making movies that involved elementary and/or inconsequential activities, all stretched out to exaggerated length. Although most films compress or telescope the passage of time, Warhol artificially slowed down the action in two

ways: first by instructing his performers to move as little and as slowly as possible, then by filming scenes at sound speed (twenty-four frames per second). When he later projected the films at silent speed (sixteen frames per second), he turned the initially sluggish movement into an even more trancelike slow motion. "I slowed down the movie to make up for all the three minutes I lost changing the film," he later rationalized, "and we ran it at a slower speed to make up for the film I didn't shoot."[7] (He could do this, of course, only so long as he made silent movies.)

During the last week of September, Warhol, accompanied by his movie camera and three chums, set out on a cross-country drive to Los Angeles, which he was visiting for the first time in connection with his show of Elvis Presley and Elizabeth Taylor portraits at the Ferus Gallery. He and Malanga, neither of whom knew how to drive, rode as passengers in Wynn Chamberlain's station wagon, which was driven alternately by Chamberlain and Taylor Mead, a poet and actor—and natural monologist. Born into a wealthy family in Grosse Pointe, Michigan, Mead liked to boast, "I've been a star since I was five years old. Every schoolteacher wrote plays for me." He had studied drama at the Pasadena Playhouse in Southern California, hitchhiked across the country five times, and been acclaimed for his starring role in Ron Rice's underground film *The Flower Thief* (1960). He was a scrawny man with a lackadaisical gait, a lopsided, elfin grin, and asymmetrical eyelids—the left one had an unnatural droop because of an injury sustained in what he called "the street wars."[8] His film work won him many adoring fans, who considered him an underground counterpart to Charles Chaplin and Stan Laurel.

Although Warhol had flown around the world in 1956, he had never seen any of the United States west of Pennsylvania, so he was fascinated by some of the open landscapes they passed through during the three-and-a-half-day trip. Andy noticed that the farther west they drove, the more Pop the highways looked. "Once you 'got' Pop," he said, "you could never see a sign the same way again. And once you thought Pop, you could never see America the same way again."[9]

Prior to his trip, Warhol had shipped his Elvis Presley paintings to the Ferus Gallery, thereby consternating Irving Blum. "Andy sent me the Elvises in one continuous roll," Blum said incredulously. "It was an enormous roll of canvas, roughly six and a half feet high and about 150 feet long. The printed images were in a single row. And he separately sent me a number of sets of knocked-down stretcher bars, all of the same height, but of varying widths. I called him up and asked, 'What on earth am I supposed to do with this, Andy?' and he said, 'Figure it out.'" Blum had no choice but to assemble the stretcher bars himself and try to match them as best he could with suitable images. Warhol had not given him any specific instructions about centering the figures, but Blum did so anyway, assuming that the Elvises, like the soup-can paintings, were intended to be symmetrical. The artist had further requested that the Elvis pictures be hung edge-to-edge along the gallery walls. In order to install the paintings in this manner, Blum had to alter the sequence of images from the way they originally appeared on the roll of canvas.[10]

The show also contained about a dozen forty-inch-square portraits of Elizabeth Taylor, which were hung in a horizontal row in the back room. Of the Liz pictures, Blum said, "There was one black-on-silver image, and all the rest were kind of skin-colored on a silver ground with painted-in faces." Both the Liz and the Elvis paintings were coolly received, and none sold, at least during the run of the show. "They didn't look enough like art," Blum said. "They looked machine-made."[11] In the view of one critic, the exhibition failed to generate shock or scandal: "The Presley subject is simply banal.... Warhol doesn't suggest in any of his works that he is an artist."[12]

One of the first things Andy did upon arrival in Los Angeles was to telephone Dennis Hopper, a young actor and photographer who a couple of months earlier had visited the artist in New York and bought one of his Mona Lisa paintings. Hopper, who had appeared in the films *Rebel Without a Cause* and *Giant*, and his actress-writer wife, Brooke Hayward, gave Andy a huge thrill by making him the centerpiece of a "movie star" party, enabling the dazzled artist to meet several Hollywood luminaries, including Troy Donahue, whose silkscreened portrait had been in Warhol's Stable show the preceding year, and Sal Mineo, the swarthy youth who had lovingly held James Dean's red jacket in *Rebel Without a Cause*, as well as Dean Stockwell, Suzanne Pleshette, and Russ Tamblyn.

While in Southern California, Warhol also attended the opening in early October of the Marcel Duchamp retrospective at the Pasadena Art Museum. Andy was photographed with Duchamp, talked with his wife, Teeny, and exchanged gossip with Pat and Claes Oldenburg, who was showing large-scale "soft" sculptures of food and clothing at the Dwan Gallery in Los Angeles that month.

During Warhol's two-week stay in Los Angeles, he filmed a silent black-and-white movie, *Tarzan and Jane Regained...Sort of.* It starred skinny Taylor Mead, strutting around in a bikini and striking "king of the jungle" poses. The part of Jane was played by Naomi Levine, a buxom, frizzy-haired New York filmmaker who had met Warhol a couple of months earlier, around the time that she was impersonating a monster character, The Spider, in *Normal Love.* Upon hearing that Warhol might make a film during his visit to Los Angeles, she had flown out to join him and succeeded in talking herself into the role of Jane. Levine, according to Malanga, was "crazy" about Andy, "as so many crazy girls are." The production itself was modest. Warhol shot some scenes around the bathtub in the Beverly Hills Hotel suite he was staying in. During the filming of a scene in the backyard of an acquaintance, Naomi startled Andy by jumping out of her clothes and plunging naked into a swimming pool. Dennis Hopper, Pat and Claes Oldenburg, and artist Wally Berman also appeared in smaller parts. Still, *Tarzan* never amounted to much more than an exuberant home movie.

After returning to New York, Warhol continued to attend underground films at the Film-Makers' Co-operative, run by Jonas Mekas, a Lithuanian-born filmmaker who wrote a weekly "Movie Journal" column for the *Village Voice* and called himself the "lonely historian of the new cinema."[13] The Film-Makers' Co-operative was a small, chaotic organization that moved from theater to theater, showing experimental, often controversial, and invariably uncommercial works by independent filmmakers. Among the Co-op's most regular patrons were plainclothesmen from the New York City police department's vice squad, who often confiscated the prints and arrested the projectionist.

Warhol resumed shooting a series of *Kiss* films that he had begun before the Los Angeles trip—three-minute, black-and-white close-ups of couples engaged in largely motionless kissing. Several episodes were filmed in Naomi Levine's apartment on Manhattan's Lower East Side and portrayed her touching lips with Malanga, poet Ed Sanders, and actor Rufus Collins. Levine offered to introduce Warhol to Mekas, who claimed never to have heard of the artist. When they finally met, Mekas recognized Andy's face and realized that he had been frequenting the Co-op for months. Warhol was sufficiently emboldened to bring his *Kiss* films to Mekas, who screened them one at a time like a serial before each program. Mekas eventually became one of Warhol's most persistent and influential boosters in the film world.

Warhol's circle expanded as he began to associate with many of the dancers, performers, and designers affiliated with Judson Memorial Church on Washington Square in Greenwich Village. He became especially friendly with an off-Broadway lighting designer, Billy Linich (later known as Billy Name), a tall young man with a very lean and flat body, rather like a broad-shouldered ironing board. While Linich's angular limbs suggested a wiry energy, he moved at a languid pace, almost as if in slow motion. Everybody liked Billy because of his sweet, good-natured, and calming disposition. (Linich had first met Warhol in the late 1950s, while waiting on tables at Serendipity. He later worked at a bookstore named Orientalia, where he became a devotee of esoteric religious literature.) Every once in a while Linich and his friends assembled in his East 7th Street apartment, the walls of which he had covered with aluminum foil. Warhol thought the place looked "terrific." The gatherings often turned into gleeful haircutting sessions, as Linich scissored the locks of any guest who wanted a free trim. (He had picked up his tonsorial expertise in Poughkeepsie, New York, by watching his grandfather, who worked as a barber.) Linich's haircutting prowess and decorating skill would assure him a major place in Andy's future.

Warhol had to vacate the firehouse by the end of 1963, so he looked around and found a large fourth-floor loft at 231 East 47th Street, between Second and Third avenues, a few blocks away from Grand Central Station. The space measured about fifty by one hundred feet and had windows all along the south side, facing the street and overlooking the Vanderbilt YMCA. Andy set up his painting area with a workbench near the windows. The building was serviced by a freight elevator, which was little more than a floor

and a grate, that opened directly into a front corner of the loft. On the north wall near the exit to the stairs, there was a pay telephone, a sensible choice for someone who had spent years eluding the telephone company because of his former roommates' long-distance charges. Andy's visitors dubbed the place the Factory because of the prodigious amount of painting and filmmaking that took place there. Within a short time of his move, which occurred in late November or early December, the Factory became the epicenter of New York pop culture.

Warhol invited Billy Linich to design his new studio; Linich eventually became the Factory's superintendent and concierge as well. He created the silver setting by covering the concrete walls and some of the three ceiling arches with aluminum foil. He sprayed a rough brick wall with silver paint, transforming it into a shimmering surface. He continued spraying until he had covered almost everything—desks, chairs, copying machine, toilet, dismembered mannequin, and pay phone—with a gleaming metallic silver. He even coated the floor with Du Pont aluminum paint—but the traffic was so heavy that he had to repaint it every two weeks to keep it shiny. Linich spent so much time revamping the Factory—his amphetamine-fueled imagination never ran out of self-imposed chores—that he began staying there. As the Factory had two bathrooms in the rear, he decided to convert one of them into his private quarters, where he slept on the floor. A year or two later, when he started to document the Factory and its denizens with a 35mm camera, he also used the space as a darkroom. He lived on next to nothing. "Every week or two, I asked Andy for twenty dollars for food," he said.[14]

Linich was a gifted scavenger. A few months after his move to Warhol's studio, he noticed during one of his midnight outings a bulky couch, discarded on the sidewalk of 47th Street near Third Avenue, and dragged it back to the Factory. The maroon sofa had a gray-striped back that curved forward at both ends. It became not only an important part of the decor but also the major prop in one of the following year's films, *Couch,* an episodic movie portraying a succession of visitors engaged in various types of social and sexual intercourse.

Linich's hands and scissors starred in one of the first movies made at the Factory, the thirty-three-minute-long *Haircut,* possibly filmed in December. Essentially a long, silent close-up of John P. Dodd, a fellow lighting designer, getting his hair trimmed, the film is badly underlighted and rather ineptly photographed, with much of the background lost in impenetrable murk. The opening reels present Dodd sitting in left profile with a cigarette, as Linich, wearing a dark T-shirt, scissors hair around the left ear. Linich's full face comes into view in the third reel as he moves to trim Dodd's right side. The action picks up a bit when Dodd begins to chew gum, but most of the film appears to be shot in slow motion. In the sixth reel, the camera lens suddenly pulls back, showing all of the chair. A cat passes by in the right foreground. The next reel presents another vantage point, a somewhat better composition, still showing all of the chair but with Dodd's head at the top of the frame. Linich continues to snip away, pausing long enough for Dodd to light another cigarette. The film seems a pointless exercise in tedium, lacking the conceptual flair of *Sleep* and the smoldering eroticism of some of the films that immediately followed.

Among the purest examples of Warhol's early films is *Eat* (plate 162), starring one of his few pals at the Stable Gallery, the artist Robert Indiana, whose "sign paintings" were then identified with the Pop movement. The film was shot in Indiana's studio on Coenties Slip in downtown Manhattan on a Sunday morning, February 2, 1964. Warhol's only direction, according to Indiana, was, "Eat this one mushroom"—a not-so-easy task considering that the action had to be prolonged through nine reels (nearly thirty minutes).[15] Indiana, wearing a hat and a cardigan, sat in a high-backed carved-oak chair, dramatically sidelighted by bright winter sun that poured in through an off-camera window. He proved to be an ideal sitter for Warhol's version of cinematic portraiture: the openness and impassiveness of his expression—as well as his large, smooth eyelids and level gaze—unintentionally evoke the placid male saints and patrons in fifteenth-century Netherlandish painting by artists such as Hans Memling and Petrus Christus. Indiana nibbled contentedly and unhurriedly at his mushroom, his meditative gaze shifting slowly between the mushroom and the window.

The first reel starts off with Indiana holding a whole mushroom. He takes about three nibbles, then looks away toward the light and

calmly masticates. He then takes a tiny fourth bite from the edge of the cap. In the second reel, he places the remainder of the mushroom in his mouth, looks off to one side, and swivels his chair. The following reel shows him holding the mushroom's stem in his left hand, its cap in his right hand; he pops the stem into his mouth and takes a bite out of the cap.

In the fourth reel, Indiana's cat jumps into the frame and with the artist's help parks on his left shoulder. The animal turns around, curiously sniffs the mushroom, which is mostly intact, then jumps out of the frame. In the next reel, Indiana is holding the cat up to look at the camera; the cat appears to be eyeing something behind the camera. Indiana smiles, shifts his pet to one side, swivels again, and nibbles on a small piece of mushroom. In the succeeding reel, Indiana starts out with a small piece of mushroom. He holds the cat again, offers it a nibble, lifts it in the air, and places it on his left shoulder. The cat jumps off. Indiana picks his teeth with his little finger.

As the seventh reel begins, Indiana is leaning forward, out of focus, masticating. No mushroom is in sight, but then he puts a very tiny piece in his mouth. In the eighth reel, surprisingly, he once again starts out with an almost whole mushroom. By the last reel, the mushroom has been consumed, and Indiana is shown in a state of after-repast satisfaction, rocking, slowly masticating, and gazing serenely and vacantly to one side.

Some viewers insisted they saw Indiana eat several mushrooms, while others wondered why the fungus, if there was only one, appeared miraculously to replenish itself. The reason was simple: in editing the movie, Warhol did not assemble the reels in accurate sequence.[16] He may have rearranged the series deliberately—or he may not have noticed, which is highly unlikely. Whatever the case, his nonlinear editing made the film both more artistic and poetic.

Warhol's editing continued to be minimal, as he refused to make any internal cuts within a spool of film. He simply spliced the entire reels together end-to-end, including the leader (the blank

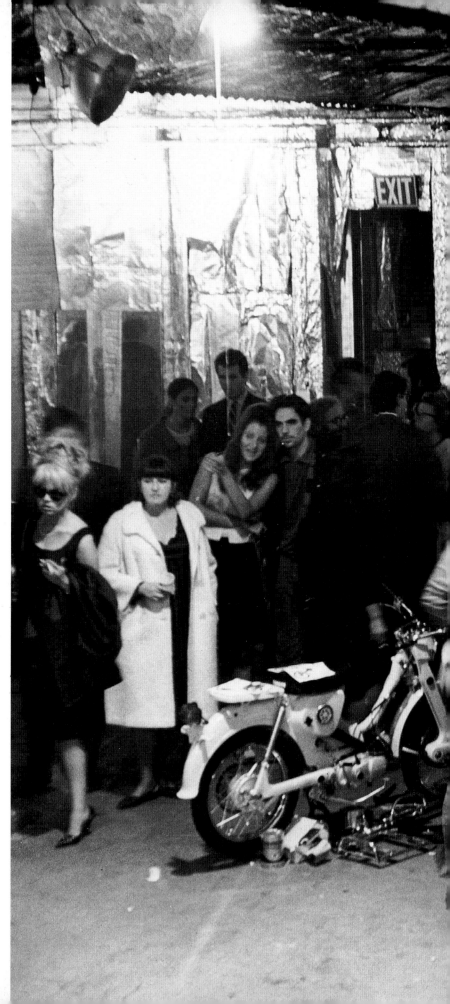

161. The silver Factory instantly became one of the trendiest gathering places for New York's "in" crowd, some of whom can be seen here enjoying Warhol's hospitality on September 1, 1965. Photograph by Fred W. McDarrah

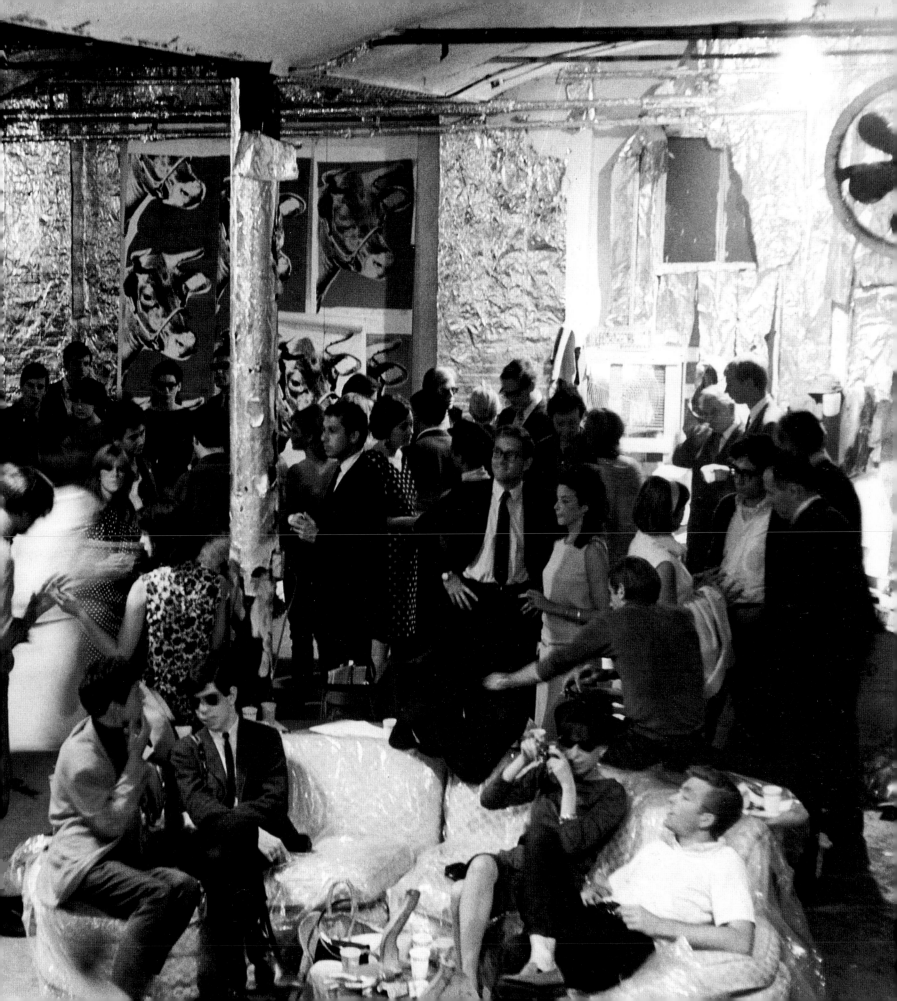

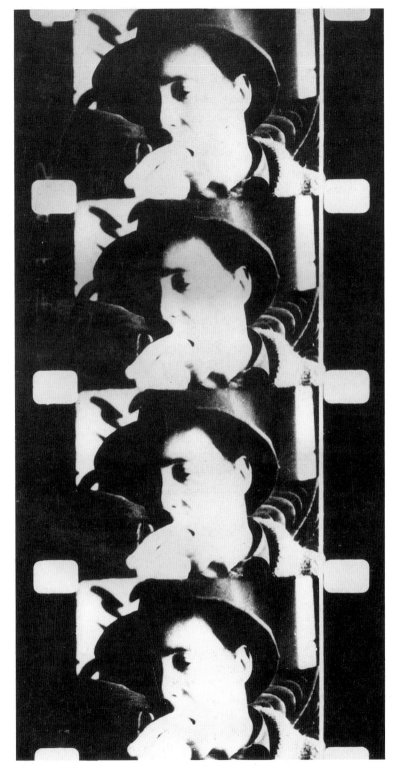

162. Robert Indiana examines one of the mushrooms he will consume in the 1963 film *Eat*.

sections at the beginning of each spool), so that the image is periodically interrupted every three minutes or so by a strip of clear, perforated film. These regular intervals of fading image followed by flashes of white light provide both structure and rhythm to the film.

To complement *Sleep* and *Eat,* which record basic physical functions, Warhol decided to document a sexual activity. The result was *Blow Job,* filmed in the Factory probably during the early weeks of 1964. Once again, he succeeded in blurring the distinction between his players' on-camera "acting" and their actual bodily experience, making it difficult for his audience to separate the actors' performances from the acts they were performing. While the film ostensibly records an oral sex act, all the spectator gets to see is a sustained close-up, approximately thirty minutes long, of a young man's impassive face and the collar of his leather jacket as he stands against a brick wall. Warhol initially invited an actor friend to star in the film, telling him that only his face would be filmed as several men took turns arousing him with their fellations until he reached orgasm. (This must have been one of the artist's more diabolical phone calls as he teasingly stimulated the actor's fantasies and vanity with promises not only of multiple sex partners but also a thirty-minute close-up!) The sought-after player failed to show up on the appointed day, however, so Andy and his cohorts recruited a good-looking youth who happened to be hanging around the Factory.

The film appears to chronicle the complete sex act from beginning to end, but at an exaggeratedly slow pace. It is in effect an unusually prolonged reaction shot, and viewers inevitably read into the performer's facial expressions a wide variety of feelings, ranging from boredom and arousal to concentrated pleasure and final ecstasy. The scene is illuminated by a bright overhead light that creates striking shadows on the actor's face as he moves his head. When the film opens, his eyes are lost in deep shadows, which lengthen as he lowers his face, perhaps the only time that he glances in the direction of his off-camera fellator. Suddenly, his head tilts back and his full face comes into view. His lips are parted and his clear-eyed gaze sweeps the ceiling. A strip of clear film with punch holes flashes by, followed by a view of the young man as his head tilts back. His lips are clenched and his half-open eyes are

unfocused. He swallows. After another flash of white light, his face tenses as he rolls his head and appears to sigh. Following more white leader, he lifts his hands to the wall, again tilting his head back and clenching his lips. In the next reel, he swallows hard and puts his hand to his mouth. By this time, the flickering bursts of light between reels have come to signify periodic paroxysms of rapture.

Two reels later, the young man is obviously in a state of concentrated ecstasy. His eyes assume a faraway, unfixed expression, his eyelids flutter, and his head involuntarily rolls to the left as he finally yields to his orgasmic climax. Afterward, he sweeps his brow and hair with his right hand and assumes a position of repose. He looks at the camera and wipes his mouth. In the eighth and final segment, he simply relaxes. He inserts a filter cigarette between his lips, lights up, and smokes for the duration of the reel. With his left hand, he massages his neck and face.

Nobody caught the name of the handsome young performer, and he apparently never returned to the Factory. But years later, Warhol would think he spotted the youth in a Clint Eastwood movie.

NOTES

1. Interview with John Giorno, March 16, 1988.
2. Andy Warhol and Pat Hackett, *POPism: The Warhol '60s* (New York: Harcourt Brace Jovanovich, 1980), p. 47.
3. In March 1964 Warhol's three-minute "newsreel" on the making of *Normal Love* was screened at a New York theater on the same bill as Jean Genet's homoerotic film *Un Chant d'Amour,* which became the object of a New York police raid. Both films were confiscated, and Warhol's apparently disappeared for good.
4. Warhol and Hackett, *POPism,* p. 33.
5. Giorno later developed into a Pop poet of "found" texts, and in the late 1960s founded Dial-A-Poem, the first time that telephone lines were used to offer access to recordings by American poets reading their own works.
6. Interview with John Giorno, March 16, 1988.
7. Andy Warhol, *The Philosophy of Andy Warhol: From A to B and Back Again* (New York: Harcourt Brace Jovanovich, 1975), p. 95.
8. Interviews, with Taylor Mead, January 1968 and November 23, 1988.
9. Warhol and Hackett, *POPism,* p. 39.
10. Interview with Irving Blum, October 2, 1987.
11. Interview with Irving Blum, October 2, 1987.
12. Gerald Nordland, "Marcel Duchamp and Common Object Art," *Art International,* vol. 8, no. 1, February 15, 1964, p. 31.
13. Jonas Mekas, *The Village Voice,* June 3, 1965, p. 14.
14. Interview with Billy Name, April 4, 1987.
15. Letter from Robert Indiana, dated February 1, 1988.
16. Letter from Robert Indiana, dated February 1, 1988.

"**What holds his work together in all media is the absolute control Andy Warhol has over his own sensibility—a sensibility as sweet and tough, as childish and commercial, as innocent and chic, as anything in our culture.**"*—Henry Geldzahler*[1]

163. *Flowers*. 1964. Acrylic and silkscreen ink on canvas, 24 x 24". Collection Roy and Dorothy Lichtenstein, New York

While Warhol continued his experiments with virtually motionless cinema, his first major epic, *Sleep,* was about to create waves of indignation throughout the film world and among the general public. *Sleep* was screened once nightly at the Gramercy Arts Theater from January 17 through January 20, 1964. As with the soup-can paintings, nobody actually had to see *Sleep* in order to be provoked by the very idea of such a movie. Its aesthetic merits could be debated without anybody having to view the actual thing.

"Andy Warhol's films conceal their art exactly as his paintings do," claimed Henry Geldzahler in a statement he wrote for the handbill. "[His] eight-hour *Sleep* movie must be infuriating to the impatient or the nervous or to those so busy they cannot allow the eye and the mind to adjust to a quieter, flowing sense of time. What appears boring is the elimination of incident, accident, story, sound, and the moving camera. As in Erik Satie's *Vexations* ...we find that the more that is eliminated the greater concentration is possible on the spare remaining essentials. The slightest variation becomes an event, something on which we can focus our attention."[2]

Archer Winsten, the *New York Post* movie critic, disputed the claim that *Sleep* was eight hours long, reporting that the screening lasted a mere five and a half hours. Moreover, he added, it was not the longest movie ever made, being considerably shorter than Erich von Stroheim's *Greed*, which ran eight and a half hours in its original, unshown version. Winsten, who attended the first hour or so of the Friday night screening, also noted that only six of the 120 seats in the theater were occupied. The movie was projected to the sound of two transistor radios on stage, each tuned to a different rock 'n' roll station. Returning on Sunday night, Winsten saw more people in the lobby, talking about the film, than in the theater, watching it. But Warhol, who was also in the lobby, appeared pleased, his face glowing and optimistic as he talked with Mekas. "Our hirsute hero," Winsten wrote, "slept in front of us, completely nude, undraped but not indecently revealed, and shadowed or magnified so that an element of mystery kept one's interest at a low, very low, boil...once or twice he breathed more rapidly and more deeply, giving rise to speculation on what he might be dreaming."[3]

When the much-publicized movie was screened in June at the Cinema Theatre in Los Angeles, it nearly incited a riot. The audience

176

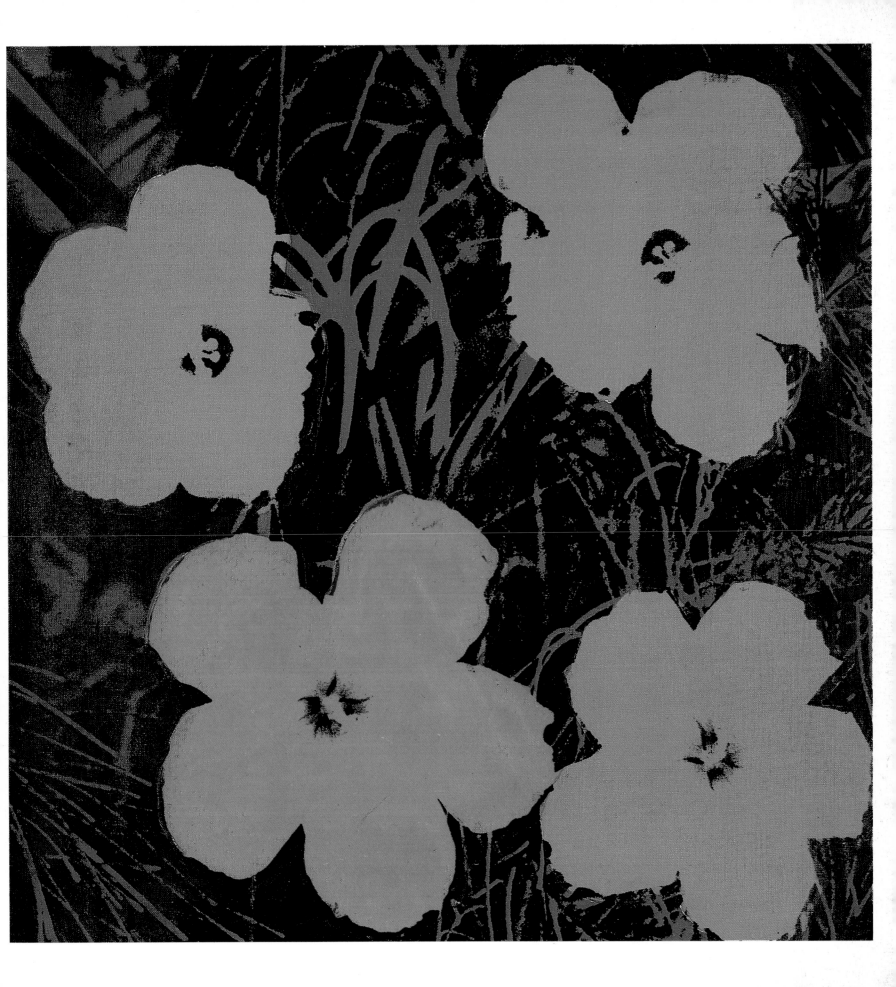

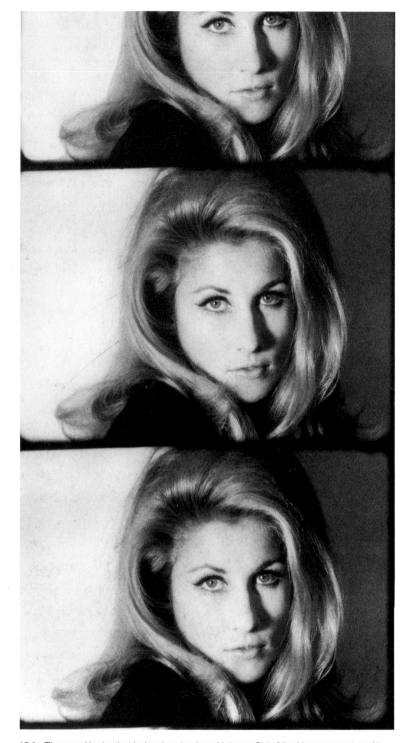

164. The good looks that helped make Jane Holzer a Girl of the Year are captured in one of Warhol's three-minute *Screen Tests*, 1965.

of about five hundred people became restless during the opening forty-five-minute scene of the sleeper's abdomen. When the shot finally changed to a close-up of the man's head, someone in the audience ran up to the screen and shouted into the sleeper's ear: "Wake up!" Before long, an unruly crowd of some two hundred patrons was angrily demanding their money back. But about fifty people stayed to the end.

Throughout 1964, Warhol shot so many movies that he didn't even bother to title a lot of them. The Factory began to attract drop-ins, people who wanted to be in the movies or to watch them being made. Almost anybody who visited the place was likely to wind up before the camera and become the subject of a stationary, three-minute-long filmed portrait.

Many of Warhol's "motionless" films of the early 1960s are essentially full-face close-ups (the most informative and iconic view), which he centered and tightly framed. As a photographer, he favored contrasty black-and-white tones and dense shadows, which he achieved with strong sidelighting. Once he had a satisfactory setup, he could turn on the motorized camera and walk away. The subjects of these filmed portraits, following instructions, remained as still as possible, their faces only sporadically animated by the flicker of an eyelid or the tremor of a lip.

As viewers stare at the immobile and inexpressive face on screen, they may think of all the worthwhile things they should be doing instead of sitting there, bored out of their minds. (Warhol once claimed that his "motionless" movies "help audiences get more acquainted with themselves. When nothing happens, you have a chance to think about everything.") But if moviegoers can survive the first minutes of seemingly unbearable tedium, they adapt to the trancelike pace of the film and begin to concentrate on the image, examining it in detail. For three minutes the screen might show a close-up of a man's face, so fixed that it could be a still photograph. Suddenly, the performer blinks or swallows, and the involuntary action becomes in this context a highly dramatic event, as climactic as the burning of Atlanta in *Gone with the Wind*. (Warhol once said that his best actor was someone who blinked only three times in ten minutes.)

While such films can be a trial to watch in a theater, they can be

peripherally entertaining when run off on the walls of a club or drawing room as cocktail party decor. Warhol himself often seemed to envision his films as a mildly animated form of wallpaper that did not demand concentrated attention.

Starting in 1964 and continuing for a year or more, Warhol made a series of three-minute film portraits of *Thirteen Most Beautiful Girls, Thirteen Most Beautiful Boys, Fifty Fantastics,* and *Fifty Personalities*—the subjects usually chosen by happenstance. The number of people photographed for these films usually exceeded the figure specified in the titles.[4] He also filmed additional episodes for the previous year's series of *Kiss* movies. One of Andy's star performers—she was one of the lovelies in *Thirteen Most Beautiful Girls* and she saluted Malanga with her lips in *Kiss*— was Jane Holzer, a young Park Avenue housewife (plate 164).

Jane Holzer exemplified a hip new type of socialite. Familiarly called "Baby Jane," she received extensive press for being a "way-out leader of New York's 'in' group," who often performed in Warhol's movies. She was a ubiquitous figure in the floating world of trendy events, a go-go Goldilocks trying out virtually every fashion collection and attending a multitude of gallery and theater openings and endless rounds of parties and discos. The press dutifully noted every detail of her fashion look—the leonine mane of blond hair, the casual combination of low-slung pants and poor-boy sweaters, and her partiality for Courrèges and offbeat English designers. In December 1964 she held a party at her apartment, letting her guests guzzle their drinks against a background of projected Warhol films that showed her in giant close-up chewing gum and brushing her teeth. It was exactly that kind of offbeat swagger that led to her being labeled as 1964's Girl of the Year. The title was largely a journalistic concoction, a term used to identify an attractive, chic, and highly visible socialite whose stylish presence helped to make any event fashionable.

The Factory functioned as a combination clubhouse, community center, lounge, cruising area, and stamping ground for some of New York's more outlandish types—preening fashion models, ranting amphetamine heads, sulky poets, underground moviemakers, and imperious magazine editors, as well as wide-eyed college students and occasional celebrities such as Tennessee

Williams and Bob Dylan. By now, professional photographers from all over the Western world were flocking to this East 47th Street location, the new frontier of artistic far-outness.

The Factory's gritty sparkle was almost entirely due to Linich, who was tireless in his efforts to silver the place. Being a great opera fan, he also provided much of the background music. Most of the opera records that he played at the Factory were his, but some came from Warhol's house and others from Henry Geldzahler's collection. Andy, according to Billy, especially liked the florid harmonics of Richard Strauss's *Elektra*; but if Ondine, one of the Factory's most talented actors (and an outrageous speed freak) was around, the air was usually filled with the emotionally intense arias of Maria Callas.[5]

Malanga, like Linich, contributed greatly to the special ambience of the Factory. While the latter was essentially in charge of the physical environment—the decor, lighting, and sound— Malanga functioned as host, social director, and sergeant at arms who managed the heterogeneous crowd of visitors. He was primarily responsible for bringing in many of the beautiful and photogenic young women. When an attractive female caught his eye at a party or in the slick pages of a fashion magazine, he made a point of finding out who she was and pursued her, writing poems about her and offering her a screen test at the Factory. He was an important catalyst insofar as he introduced Warhol to many people in other creative fields. During Malanga's cultural forays around the city, he "collected" creative people and pretty faces—fashion models, poets, and filmmakers—and brought them to the Factory. "It was a constant open house," Andy said, "like the format of a children's TV program—you just hung around and characters you knew dropped in."[6]

Warhol modestly claimed that his visitors were more interested in seeing each other than they were in seeing him. "I don't really feel all these people with me everyday at the Factory are just hanging around me," he said. "I'm more hanging around *them*."[7]

The size of the Factory and the variety of activities created a fractured setting with pockets of activity here and there, with idle spectators wedged in among clusters of people who were actually working on something. Most of the drop-ins just wandered around

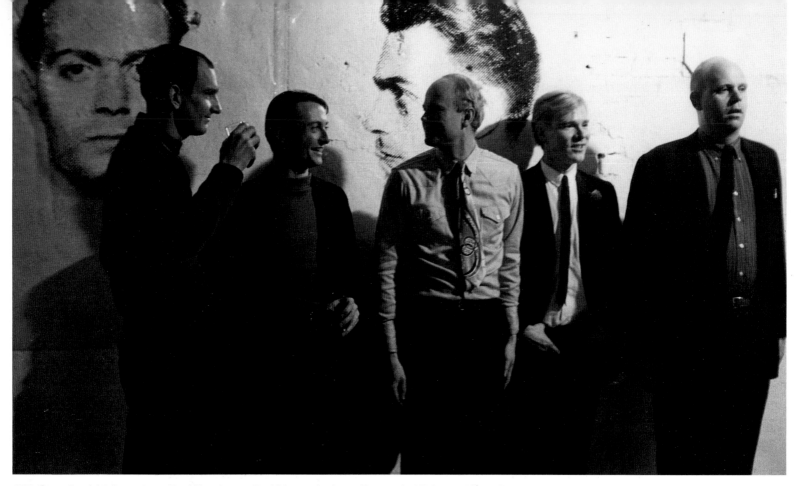

165. Pop art's mighty innovators—Tom Wesselmann, Roy Lichtenstein, James Rosenquist, Warhol, and Claes Oldenburg—join forces at a Factory party on April 21, 1964, following the opening of Andy's Brillo box show at the Stable Gallery. Photograph by Fred. W. McDarrah

and coolly sneaked sidelong stares at one another. No one ever seemed sure who the others were and what they were doing there. Everybody, of course, was trying to win Andy's attention. He galvanized people into action as he passed by, but his expression seldom revealed whether he was ignoring some of his visitors deliberately or unintentionally. Despite his pauperish appearance, Warhol's manner was casually regal, as if he were a Pop counterpart to Louis XIV, enjoying the courtly rituals of daily life.

Andy ceased to entertain in his town house, preferring that his friends visit him at the studio. Many pals and acquaintances turned up at the Factory and hung around for hours, waiting to see if they'd be invited along to that evening's parties. Warhol found himself surrounded by a growing entourage of cronies, many of whom had their own hangers-on. Always hesitant about specifying who could or could not tag along, Andy made oblique expressions and mumbles. Malanga and Linich knew instinctively which people Warhol wanted to take along and which he wanted to ditch, and they usually performed the task of separating the tagalongs from

the discards. Malanga noted how people got along easily with Andy when it was just the two of them, but how the artist manipulated his pals into vying with one another for his attention and companionship. "It was like a gladiatorial contest," said Danny Fields, a crony in the rock music world. "He'd just lick his chops and sit back and watch these people have at each other and pretend he didn't know anything about it. He would let them crawl all over each other's egos and bodies and reputations to get closer to him."[8]

During 1964, Warhol bought his first tape recorder. He carried it around with him constantly, at first thinking he might be able to transcribe his conversations into a play. Although Warhol sighed dramatically over pretty faces, he much preferred the company of talkers. "The acquisition of my tape recorder really finished whatever emotional life I might have had," he said, "but I was glad to see it go. Nothing was ever a problem again, because a problem just meant a good tape, and when a problem transforms itself into a good tape it's not a problem any more….Better yet, the people telling you the problems couldn't decide any more if they were really having the

problems or if they were just performing."[9] Warhol was a patient listener, recording his companions' chatter with such determined passivity that many of his friends transferred their emotional dependence to him, as they might otherwise do to a psychiatrist, which may account for the powerful hold he had over his friends and acquaintances.

Although Warhol was churning out thousands of feet of movie footage, he still found plenty of time for his paintings. Amid the fitful swirl of activity, he managed to work on his silkscreens at the front of the loft, seemingly oblivious to the many visitors. Some of the most visible pictures at the Factory were portraits, ranging in subject from the former First Lady to the nation's most-wanted fugitives. Warhol derived his powerful portraits of Jacqueline Kennedy from news photographs taken before and after President John F. Kennedy's assassination in Dallas in November 1963. The "before" photographs portray the smiling First Lady, wearing her famous pillbox hat, as she sits with her husband in the backseat of the car during the motorcade. The next photograph shows the stunned Mrs. Kennedy standing hatless beside Lady Bird and Lyndon Johnson, as he is being sworn in as president aboard *Air Force One* before flying back to Washington. The remaining "after" photographs in the series present the grieving widow in mourning attire during the funeral ceremonies in Washington.

By cropping in on Mrs. Kennedy's face, Warhol emphasized the heavy emotional toll upon her during those tragic closing days of November. The so-called Jackie portraits, far from displaying any indifference on Warhol's part to the assassination, clearly reveal how struck he was by her courage during the ordeal. Most of the Jackies were screened in black on off-white or blue grounds; the latter works were particularly elegiacal. Warhol marketed some of the panels individually, while others were grouped in multiples, often of sixteen. He regimented a single view in a grid, or repeated one image in each row, or scrambled all the versions (plates 166, 167, 168). The mixed multiple portraits often make viewers feel as if they were walking along a modern-day Via Dolorosa as they relive the First Lady's agony in a new, secular version of the Stations of the Cross.

Other Warhol portraits were very briefly on view at the 1964–65 New York World's Fair, which opened in Flushing Meadow that spring. Architect Philip Johnson, who designed the New York State Pavilion for the fair, had invited several artists, including Warhol, Rauschenberg, Lichtenstein, Indiana, and John Chamberlain, to create artworks for the exterior of his building. Warhol chose as his subject thirteen alleged criminals, inspired by the Federal Bureau of Investigation's Ten Most Wanted Fugitives list and based on F.B.I. mug shots. The state of being "wanted"—it didn't much matter *why* one was wanted—obviously had an appeal for Andy. His source photographs were unusually small, reportedly only one and one-half inches by one and one-fifth inches. They were converted to silkscreens measuring forty-eight by forty inches, which would account for the huge dots and overall graininess of the image. Because the screened images were narrower than the four-foot-square canvases, blank bars remained on the left or right side of the faces, giving a varied rhythm. The twenty-five-unit painting (plate 169), which hung in a five-by-five grid, showed the fugitives in full face and in profile, but inconsistently—the two views of an individual's face did not appear side by side but were scattered. The three blank panels at the lower right corner might have implied that some of the men had been captured or that there was room for more faces.

At the time, Warhol was amused by the prospect that his huge poster-like pictures might actually lead to the apprehension of any "most wanted men" who were foolhardy enough to visit the fair. But the artist's source photographs were in many cases several years old and some of the fugitives he pictured had already been captured. In any case, officials feared that labeling the faces as "most wanted men" would subject the state to lawsuits. The word came down—either from New York Governor Nelson A. Rockefeller or from Robert Moses, the powerful city planner and autocratic president of the 1964–65 World's Fair—to remove the offensive faces. Warhol evidently blamed the latter for the censorship, because he proceeded to silkscreen twenty-five identical portraits of a ferociously smiling Moses, which the artist wanted to substitute for the "most wanted men" panels. But Philip Johnson balked, thinking it would be in extremely bad taste to offend the head of the fair. Though Johnson was among Warhol's most loyal collectors, the architect and the artist had an unpleasant skirmish, which was

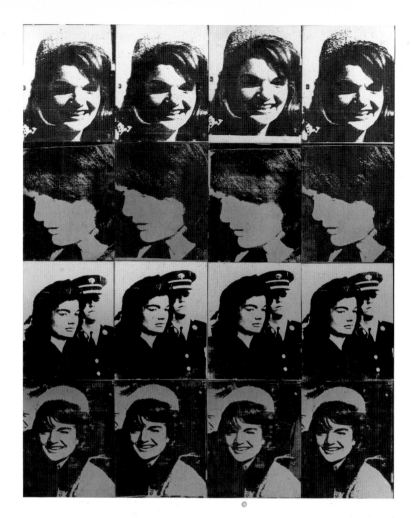

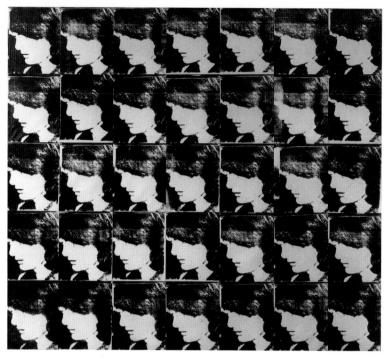

167. *Jackies.* 1964. Acrylic and silkscreen ink on canvas, thirty-five panels, each 20 x 16″. Museum of Modern Art, Frankfurt a/M

166. *Sixteen Jackies.* 1964. Acrylic and silkscreen ink on canvas, sixteen panels, each 20 x 16″. Walker Art Center, Minneapolis. Art Center Acquisition Fund, 1968

finally resolved when the *Most Wanted Men* panels were left in place, but obliterated with a coat of silver paint.

Warhol's ill-fated appearance at the World's Fair occurred about the same time as his second show at the Stable Gallery, which opened on April 21 and consisted entirely of trompe l'oeil grocery-carton "sculptures." Once again, he had appropriated preexisting imagery of commercial products and advertising design, but now he extended his principle of repetition into three dimensions. His trusty assistant, Nathan Gluck, was sent to the supermarket across the street from Warhol's house to collect empty cardboard cartons, but Gluck returned with arty boxes that had contained exotic fruits and other gourmet fare. "No, no, no," Warhol complained, "I wanted something more ordinary." Malanga was next delegated to go on a grocery-store expedition and specifically instructed to bring back something "common."

Warhol created his grocery-carton sculptures in several stages,

first by hiring carpenters to construct hundreds of wooden boxes, all built to the exact dimensions of their cardboard prototypes—Brillo soap pads (plate 173), Mott's apple juice, Kellogg's cornflakes, Del Monte peaches, Campbell's tomato juice, and Heinz ketchup. Linich then painted the boxes white or a light tan, depending on the actual color of the originals. Next, Warhol and Malanga silkscreened the boxes on all four sides as well as the top and sometimes the bottom, reproducing the original graphic designs. The finished sculptures were such accurate facsimiles that they appeared almost indistinguishable from their cardboard models.

The box show was a "concept" exhibition carried to an absurd conclusion. With astonishing boldness, Warhol crammed both front and back rooms of the gallery with hundreds of brand-name cartons, making the place resemble a grocery distributor's warehouse (plates 171, 172). About four hundred boxes were regimented in rows on the floor or casually stacked in tiers several

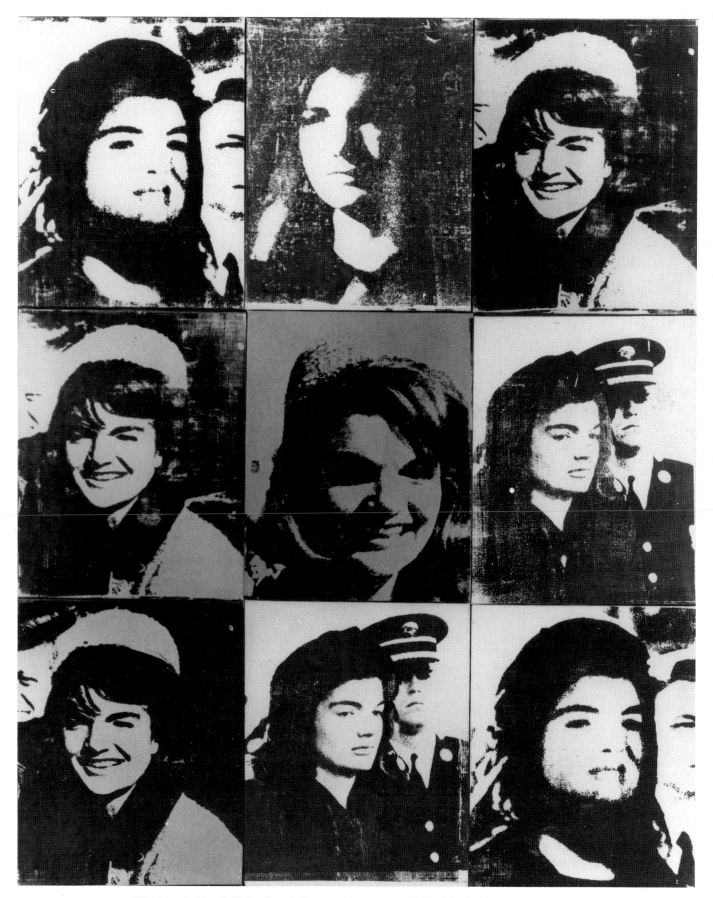

168. *Nine Jackies.* 1964. Acrylic and silkscreen ink on canvas, 60¾ x 48¼″. Collection Ileana and Michael Sonnabend, New York

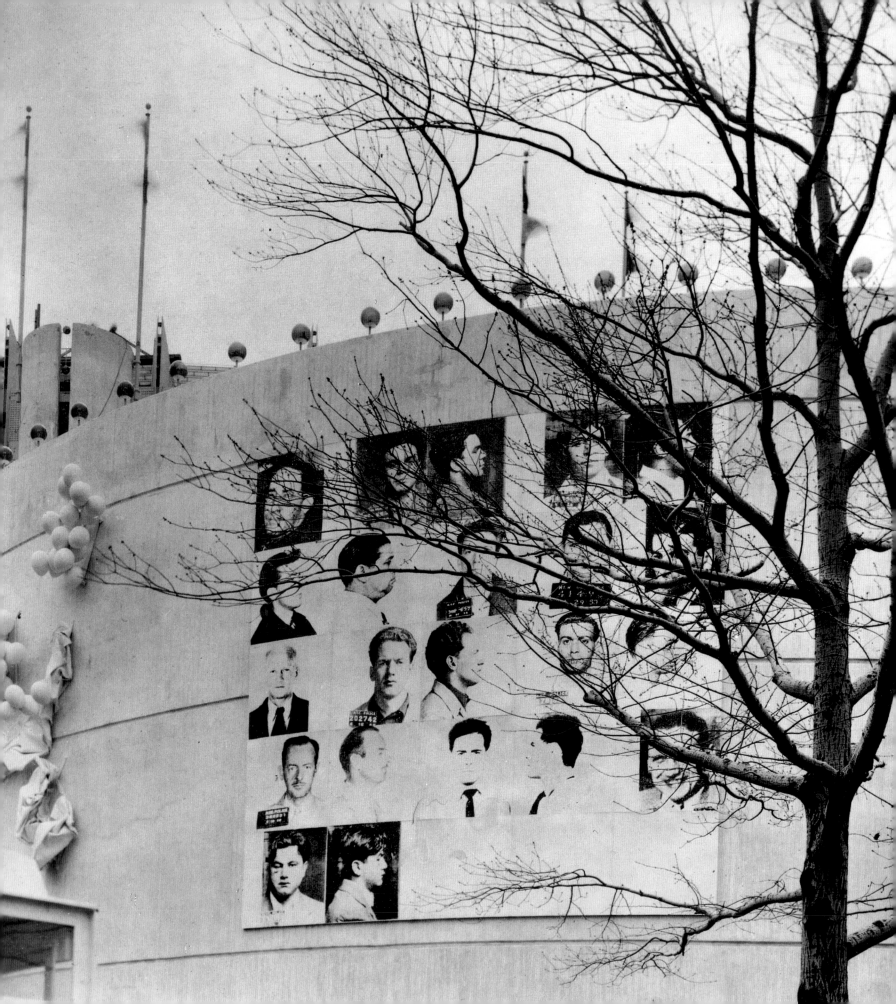

feet high, making it awkward for spectators to pass through the crowded exhibition. The installation implied that collectors could buy as many boxes, or units, as desired and stack them as randomly or as methodically as they wished. Opening-night spectators were clearly amused and baffled, tittering and giggling as they squeezed past each other in the aisles.

The show was an "ideological tour de force," in the words of critic/painter Sidney Tillim, who reviewed the show in *Arts Magazine,* "with the dry goods disguising its essential nihilism…. This preoccupation with quantity is a defense against space by refusing to decide that anything in it is important….The decision not to decide is a paradox that is equal to an idea which expresses nothing but then gives it dimension." Tillim interpreted the display "as a gesture of aggressive passivity….The visual emptiness of it all is the price he seems willing to pay for an instant of sublime but compulsive negation."[10]

At first glance, Warhol's box sculptures appeared to follow in the tradition of Duchamp's ready-mades. A half century earlier, the French artist had designated certain mass-produced objects as his own artistic "creations." Duchamp's ready-mades (the bicycle wheel, bottle rack, urinal, among others) exemplified his proposition that art need not be handmade or unique. He established the aesthetic concept by which anyone could take an ordinary "found object" and present it as a work of art merely by denying its intended function, and transforming its context rather than its form, thereby presenting it as a purely aesthetic item.

Like so much of Duchamp's work, Warhol's boxes were conceptually provocative. They raised several questions, not the least of which was what exactly made them art? Could it be that Warhol's grocery cartons, like Duchamp's found objects, became artworks simply because he displayed them in a gallery?

The essential difference, of course, is that Warhol's boxes, while deprived of their original function, are not found objects at all, but handmade counterparts to the mass-produced items that Duchamp designated as works of art. Warhol's boxes, in contrast to

169. *Thirteen Most Wanted Men* at the New York State Pavilion, 1964 World's Fair. Acrylic and silkscreen ink on masonite, twenty-five panels, each 48 x 48″. Not extant

170. *Self-Portrait.* 1964. Acrylic and silkscreen ink on canvas, four panels, each 20 x 16″. Collection Mr. and Mrs. Brooks Barron, Michigan

Duchamp's ready-mades, were re-created in another medium. In this respect, Warhol took his conceptual cue from Jasper Johns's *Painted Bronze* sculpture of 1960. Johns's trompe l'oeil work consists of a pair of cast-bronze cylinders, one empty and one solid, mounted on a low pedestal and scrupulously painted to replicate Ballantine ale cans. Thus, the artist's technical skill at replicating his subject retains its traditional importance. But the nagging questions remain: Can mere replication be art? Did handcraft assure the boxes' status as art?

The box show generated a new wave of controversy and added another layer of notoriety to Warhol's reputation. Even more sensationalism accrued to the show when a New York painter, James Harvey, surfaced to claim credit for having designed the

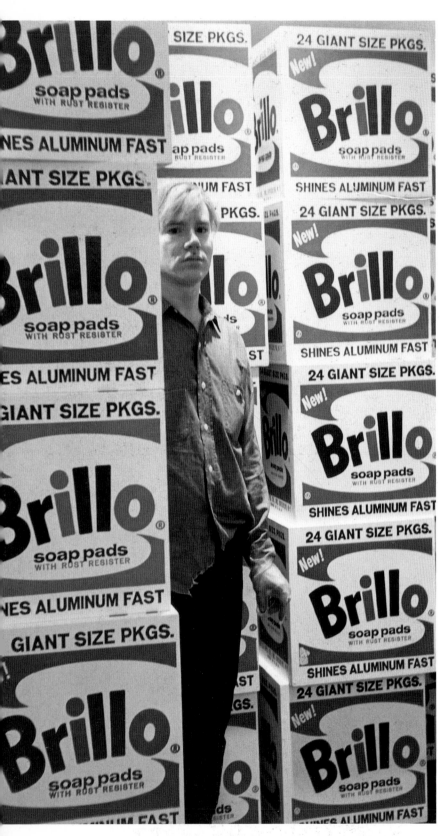

171. Warhol amid his Brillo box sculptures at the Stable Gallery, New York, opening day, April 21, 1964. Photograph by Fred W. McDarrah

prototype of the Brillo carton in 1961. Harvey was a second-generation Abstract Expressionist who supported his "serious" art by working for an industrial design firm. He was understandably chagrined to discover that one of his product designs, which he himself did not take seriously as art, had been turned into a Pop icon, bringing greater fame to Warhol.

While the exhibition attracted considerable attention, it was by no means a commercial success, even though the boxes were modestly priced between two hundred and four hundred dollars. Warhol was far more optimistic about sales than was Eleanor Ward, who found the boxes "very difficult" to sell. "He thought everyone was going to buy them on sight, he really and truly did," Ward said. "We all had visions of people walking down Madison Avenue with these Campbell's Soup boxes under their arms, but we never saw them."[11]

Eventually, the Brillo box furor reached Canada. Early in 1965, Toronto art dealer Jerrold Morris, who had scheduled a Warhol exhibition for March, ran into difficulty when he attempted to import eighty of the artist's painted-wood replications of grocery cartons, valued at $250 apiece. Canadian law permitted only "original sculpture" to be imported duty-free, and that nation's customs officials claimed the pieces were not art but merchandise and, therefore, subject to a 20 percent duty, or $4,000. The final arbiter in the matter was Dr. Charles Comfort, director of the National Gallery of Canada. His claims to fame included an embarrassing exhibition of paintings, containing several works of very questionable authenticity, from the Walter P. Chrysler, Jr., collection. Despite his clouded reputation as a connoisseur, Dr. Comfort looked at photographs of Warhol's painted-wood cartons and declared they were not fit to enter the country as duty-free works of art. "I could see they were not sculpture," he said. Morris, the irate dealer, charged the government with making Canada "the laughingstock of the art world."[12]

Warhol's boxes helped pave the way for Minimal sculpture. His ideas concerning irreducible three-dimensional forms, repetition, and semimechanical fabrication influenced the thinking of many sculptors who were designing simple polyhedrons with uninflected surfaces, often painted in flat colors. After Warhol's box show, it

became commonplace among artists to have their work industrially fabricated, to have it manufactured in multiples, and to withhold as much evidence of handcraft as possible.

Although Warhol's two exhibitions at the Stable Gallery had established him as a leader of the Pop movement, he was experiencing financial difficulties with Eleanor Ward that soon led to the end of their business relationship. As so often happens in galleries, artworks were being sold but the money was somehow failing to get transmitted to the artist. Warhol would eventually sue Ward for money that she allegedly owed him from the sale of his works. He was no longer her "Andy Candy."[13]

During the spring of 1964, around the time of the Brillo box show, Leo Castelli invited Warhol to join his gallery. Initially, the dealer had thought it best for the Pop artists to be spread around at different galleries to create the impression of a widespread movement. Now that Pop was an established style, he saw no reason why he should not represent the best of the bunch. He no longer anticipated any "collision" between Lichtenstein and Warhol, because of the latter's move into silkscreening, repetition, films, and, now, sculpture. So Andy was finally welcomed into the gallery that he had most wanted. (In 1965, following the demise of the Green Gallery, Castelli picked up James Rosenquist, consolidating his stable of the top three Pop painters.)

Warhol was too terrified of Ward to tell her he was leaving, so Linich ended up typing a curt letter, which he signed himself, saying, in effect, that as of such and such a date, "Andy will no longer be with the Stable Gallery. He will be with Castelli." Samuel Adams Green, a mutual friend of both the artist and the dealer, became an intermediary in their dispute. "It was a bitter split," Green said. "Eleanor considered Warhol an ingrate, believing that she had put herself and her gallery's reputation at risk by showing Andy's work, which had been turned down by every serious gallery in town. She was convinced that her prestige and collectors had 'made him.' From Andy's point of view, Ward had been holding out on monies she owed him. The conflict got nasty. Eleanor was pressuring me to convince Andy against the move. She believed that Castelli only wanted him to make Rauschenberg and Johns look more important by comparison—that he wouldn't promote

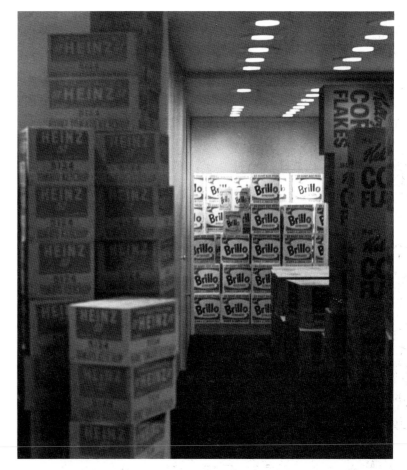

172. Warhol's facsimile sculptures of Heinz Ketchup and Brillo cartons made the Stable Gallery resemble a grocer's warehouse. Photograph by Billy Name/Factory Foto

173. *Brillo Box*. 1964. Acrylic and silkscreen ink on wood, 17 x 1 7 x 14″. Courtesy Leo Castelli Gallery, New York

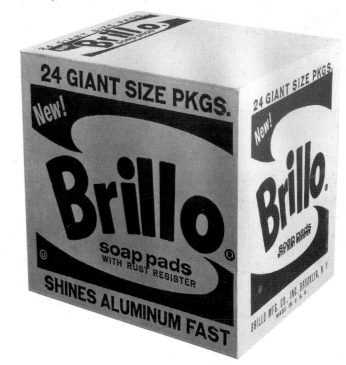

Andy with the same zeal as he did his 'old masters.' Andy wouldn't listen to any of this because he simply wanted to be one of the Big Guys."[14] (Green maintained that it was around this time that Warhol ceased to be extremely generous in giving his works away: "suddenly he became terribly parsimonious about it; he really thought of it as currency that he was giving away."[15])

From Castelli's vantage point, Warhol simply felt more at home in his gallery, "where the others were." The dealer's already prestigious reputation was greatly enhanced when one of the "others"—Rauschenberg—won the top prize at that year's Venice Biennale, confirming the importance of a new generation of American artists and signaling a shift in taste away from the painterly abstraction of the 1950s toward a new Pop-oriented figuration. Castelli's international connections were flourishing, while Ward had almost none. Ward was "rather angry for a little while," Castelli conceded, "but then really there's nothing she could have done to keep Andy. Andy just wanted to go away and wanted to come to my gallery."[16]

On a Saturday night in June, Warhol produced another marathon film that brought his motionless-movie period to a climax. The film was *Empire*, a seven-hour-long stationary shot of the top of the Empire State Building as viewed from a window some forty floors high in the Time-Life Building, sixteen blocks to the north.[17] He rented an Auricon camera for the occasion, not because he wanted to take advantage of the equipment's ability to record synchronized sound directly on the film (*Empire* is silent), but because the camera took 1,200-foot spools of raw stock, enabling the artist to shoot thirty-five-minute takes. Jonas Mekas, who had used an Auricon in his own filmmaking, assisted as cameraman, and Gerard Malanga lugged the fourteen reels of film, of which twelve were shot.

John Palmer, an aspiring young cinematographer, prepared for the nighttime shooting by setting the lens aperture at its lowest f-stop. (For this, he was credited with the film's codirection.) But as the filming began around 6:00 P.M. in full sunlight, the opening reels were totally overexposed. In fact, the Empire State Building didn't become legible until the second reel. As the light in the sky diminished, the building gradually loomed into view. During the third and fourth reels, office lights were switched on all over the midtown

area and—at "a very dramatic moment," Malanga noted—the Empire State Building's spire was illuminated by exterior floods. "The Empire State Building is a star!" Warhol exclaimed.[18] During the eleventh reel, about 1:00 A.M., the building's exterior lights were turned off; this sparked the audience's applause at the film's premiere at the City Hall Cinema in March 1965. The twelfth and final reel chronicled the city's decreasing lights, finally ending about 1:30 P.M.

Mekas hyped the film in his next *Village Voice* column: "Last Saturday I was present at an historical occasion: the shooting of Andy Warhol's epic *Empire*....The camera never moved once. My guess is that *Empire* will become *The Birth of a Nation* of the New Bag cinema."[19] Warhol's own assessment was more modest. The only point to the movie, he said, was "to see time go by. A couple of planes went by and a light went out and that's all that happened."[20]

Warhol had two 1,200-foot reels of film left over from the shooting of *Empire,* and, as he did not have to return the rented camera until Monday, he invited Henry Geldzahler to the Factory on Sunday afternoon to appear solo in a seventy-minute-long movie. This marathon portrait made the artist's earlier three-minute close-ups look like snapshots. Geldzahler asked Warhol what he should do and Andy said, "Don't do anything. Just sit on the couch and smoke your cigar."

"I was horrified," Geldzahler said, "because Andy didn't stand behind the camera." Warhol loaded the camera, started it, then walked away to make some phone calls. "He'd come back once in a while and wave at me, so that it was a fantastic experience for me. First of all because the hour and a half went by so quickly." Geldzahler happened to be "stoned" on "good pot," which no doubt helped make time fly.[21] The finished film, according to Geldzahler, had "a quality of portraiture that I really hadn't seen before, because within the hour and a half with nobody standing behind the camera, I'd gone through my entire gesture vocabulary, and everything about me that I knew was revealed in the film because there's no way of hiding."[22]

During the summer Warhol worked sporadically on *Batman Dracula* (starring Jack Smith, and never released). One scene, shot in a Gramercy Park apartment, featured a topless Naomi Levine,

voluptuously toying with a lot of fruit on a bed, its canopy upheld by human bedposts—four young men in black leather garb. Warhol repeatedly attempted to photograph a scene in which Jack Smith was to enter the room via the balcony and bite Naomi's neck, but the actor moved in such slow motion that he never reached the bed before the camera ran out of film. Warhol also filmed suggestive close-ups of various people eating bananas (plate 175), and *Couch* (plate 174), which was shot on the Factory's well-worn maroon sofa with a cast that included Gerard Malanga, Billy Linich, Naomi Levine, Ondine, Jane Holzer, Taylor Mead, the poets Gregory Corso and Allen Ginsberg, novelist Jack Kerouac, model Ivy Nicholson, actor Rufus Collins, artist Mark Lancaster, and many others.

Many "serious" filmmakers and movie buffs, not surprisingly, were fed up with Warhol's cinematic pranks, as well as with Mekas's puff pieces in the *Village Voice*. The August 27, 1964, issue of that paper carried a letter from independent filmmaker Peter Emanuel Goldman, who complained, "I have tolerated [Mekas's] praise of films shot without cameras, films shot without lenses, films shot without film, films shot out of focus, films focusing on Taylor Mead's ass for two hours, etc....But the August 13 column in praise of Andy Warhol was a bit too much....Calling Warhol the most revolutionary and purest of all film-makers, he sees the day when dozens of films will be made in this manner. I can just see the ads in the papers: 'Guaranteed to bore—fourteen hours of pure blank screen!' Or 'Sit and watch a thumbnail for twelve hours—no change of camera angle!' "

Mead composed a sassy reply that was published in the letters column of the September 3 issue of the *Village Voice*: "Andy Warhol and I have searched the archives of the Warhol colossus and find no 'two-hour film of Taylor Mead's ass.' We are rectifying this undersight with the unlimited resources at our command." Indeed, a seventy-minute-long, silent, black-and-white film, *Taylor Mead's Ass*, was put into production that very month. The movie was shot at the Factory

174. Gerard Malanga, Kate Heliczer, and Rufus Collins play a lovesome trio in *Couch*, filmed at the Factory in 1964.

175. David Bourdon uses his teeth to peel a banana in a never-released Warhol film of 1964.

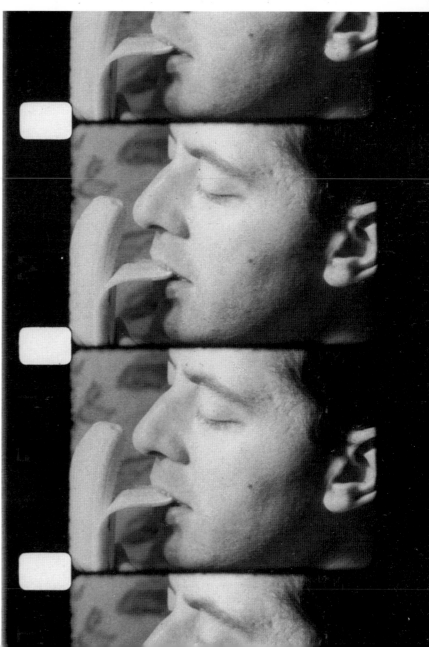

with the stationary camera focused on Mead's bare backside as he improvised various actions, such as kneading his buttocks with a rubber-gloved hand or menacing himself with the wand of a vacuum cleaner. Mekas's description of the film gives away the whole plot: "Close-ups of Taylor Mead's buttocks, very white, overexposed, rather abstract; later, more concrete."[23]

Toward the end of September, four of Warhol's films—*Sleep, Kiss, Haircut,* and *Eat*—were featured at the New York Film Festival at Lincoln Center. Each "motionless" movie was represented by a three-minute excerpt that looped continuously through one of four Fairchild 400 machines—small box-type projectors resembling television sets, designed to show 8mm movies in the home. The four films were projected from 5:30 P.M. until midnight each day during the festival, which ran through September 26, on the Grand Promenade at Philharmonic Hall. Consequently, almost everyone who entered and exited the theater had to walk by Warhol's films, a situation that brought him tremendous exposure. But Warhol, expressing typical dissatisfaction, was unhappy that his films were *at* the festival instead of *in* it.

Warhol commissioned La Monte Young to compose a taped soundtrack that could be used to accompany all four films at Lincoln Center. Young created a suitably soporific score that consisted of the droning sound of a violin bow played over a brass mortar. The single, continuous note was G.

The music was becoming ever more florid at the Factory, where Linich, abetted by Ondine, attracted a circle of attenuated, spaced-out, scruffy-looking young men who were frenetically involved in underground pharmaceutics. Seldom appearing before nightfall, frequently attired in black chinos and T-shirts, and wearing very dark sunglasses, they bought, sold, and otherwise exchanged a broad range of mood-altering drugs. The most prevalent commodity appeared to be methamphetamine, or speed, a drug that stimulated the nervous system and apparently kept the user wired up and determinedly thin. Linich's visitors referred to one another by nicknames such as Rotten Rita, Binghamton Birdie, Silver George, and Stanley the Turtle. Many of them were notorious for swiping each other's boyfriends and drugs.

The Factory's clouded reputation as a kind of amoral free zone where anything could happen attained a new peak one autumn day in 1964 when Dorothy Podber, a former neighbor of Linich's on the Lower East Side, visited the place. Petite, skinny, and mischievous, she was attired in a motorcycle jacket and accompanied by two friends, also dressed in black leather, and her Great Dane. Podber walked to the front of the Factory, where Warhol had leaned several forty-inch-square *Marilyn Monroe* portraits against the wall, slowly took off a pair of white gloves, reached into her purse, pulled out a pistol, and aimed at the movie star's forehead, shooting a hole right through the entire stack. Then she returned the gun to her purse, put on her gloves, and smiled triumphantly in Warhol's direction before departing on the elevator. It was the first time anyone had fired a gun in the Factory, and Andy was visibly upset. But he had the canvases repaired and they subsequently became known as the Shot Marilyns.

Another of Linich's crazy friends was Fred Herko, an intense, sinewy, dark-skinned dancer, choreographer, and celebrated Greenwich Village speed freak, who gave flamboyant performances in many avant-garde concerts, frequently at Judson Memorial Church on Washington Square. Freddy, as he was affectionately known to his many friends, was an energetic and dashing figure whose every gesture evoked theatrical grandeur, but also a tormented individual who was too often drugged and undisciplined. He found it bothersome to maintain his own living quarters, so he dispersed his possessions and camped out in other people's apartments until it was time to move on. He was seldom gainfully employed (though he did play piano part-time for dance classes) and relied increasingly on the largesse of others. Andy adored Freddy and starred him in a few of his earliest movies, including *Roller Skate,* filmed in September 1963, in which the dancer glides on a single skate through city streets, his arms outstretched, one leg extended backward, and his chin held high. Freddy also appeared in *Thirteen Most Beautiful Boys* and an episode of *Kiss,* in which he costarred opposite his good and close friend, Johnny Dodd.

Herko's life was spinning out of control by the autumn of 1964. On October 27, he was glimpsed by Johnny Dodd in Joe's Dinette on Jones Street in the Village. "Freddy was covered with filth, and he

was dancing on the counter," according to Dodd. "He said he hadn't had any drugs for three days, but he was whacked out and his body was quivering." Dodd invited Herko to his fifth-floor apartment on nearby Cornelia Street. There, Freddy poured a bottle of Dodd's perfume into a tub of steaming hot water and took a long bubble bath. He seemed to cheer up as Dodd, who knew that "Freddy was a Mozart freak," put a recording of the composer's *Coronation Mass* on the phonograph. Herko dried himself, then started dancing naked around the living room, whirling round and round, periodically making a long run toward the front windows. Dodd couldn't help but wonder if this was going to be the "suicide performance" that Freddy had been promising his friends for so many weeks. "It was obvious that Freddy had to do it now: the time and the place were right, the decor was right, the music was right." Herko made another long run and, like Nijinsky in *Le Spectre de la Rose,* leaped out an open window, his momentum carrying him almost to the opposite side of the street. He was twenty-nine years old.[24] Several of Andy's friends heard him lament on various occasions that he had not been there to film it.

Warhol dedicated a painting of white flowers to Herko in his first show at the Leo Castelli Gallery, which opened on November 21. The artist filled the main gallery with silkscreened paintings of flowers, their big, floppy blossoms virtually ablaze with highly saturated Day-Glo hues. All but one of the pictures were square and printed with the same image—a bee's-eye view of four blossoms against a grassy background (plates 163, 176). One whole wall was hung with rows of two-foot-square paintings, while another wall featured a few eighty-two-inch-square blowups of the same image. The biggest painting in the show, *Large Flowers*, measured more than thirteen feet wide and contained only half (or two flowers) of the same composition. The cheerful and refreshing Flowers series includes some of Warhol's most lushly colored, decorative, and ingratiating paintings.

Warhol derived his flowers from a color photograph of seven hibiscus blossoms (three of which bled off the left edge), printed as a two-page foldout in the June 1964 issue of *Modern Photography.*[25] (Many viewers misidentified the flowers, perhaps because the petals were drastically flattened as a result of the artist's silkscreen process; homophobic critics persisted in calling them pansies.) The photograph was shot by Patricia Caulfield, the magazine's executive editor, and it was used to illustrate an article on a Kodak color processor designed for amateurs. The flowers in Caulfield's picture are pink, red, and yellow, and shown against foliage that more nearly resembles a coniferous-type shrub than hibiscus leaves.

Warhol sent the color photograph out to be converted into black-and-white silkscreens of varied sizes—but not before he had made some crucial changes. First, he cropped the left edge of the picture, eliminating the three incomplete flowers. The remaining four blossoms almost, but not quite, fitted into a square format. "I like painting on a square," Warhol said, "because you don't have to decide whether it should be longer-longer or shorter-shorter or longer-shorter: it's just a square."[26] Warhol achieved his ideal square by cutting out the flower in the upper right corner of the photograph and rotating it 180 degrees, moving it closer to the other three blossoms. As a result, one petal of the shifted flower touched a petal of its neighboring blossom.[27]

The flowers appear to hover in an unspecific space, unattached to any stems or foliage. The background greenery shoots off in several directions and, with the absence of ground and horizon lines, it is not at all clear whether the viewer is presented with an aerial or an elevation view. Consequently, the square *Flowers* have no conventional top and bottom and their owners may hang them any side up. (When Warhol had a say in the installation of groups of Flowers paintings, he always displayed a preference for a random mix of "any side up.")

Warhol made no attempt to imitate any of the hues in the original photograph. His Day-Glo *Flowers* sometimes appear to float right off the canvas, as if disembodied from the background—"like cut-out gouaches by Matisse set adrift on Monet's lily pond," as this writer noted in a review of the show.[28] Some viewers perceived the blossoms as hovering in front of the canvas, while others saw them as occupying a vertical plane behind the canvas. In fact, the illusion that the floating blossoms do not occupy the same surface as the background (particularly effective in the larger paintings), was created by the intensity of the chroma contrast, a striking

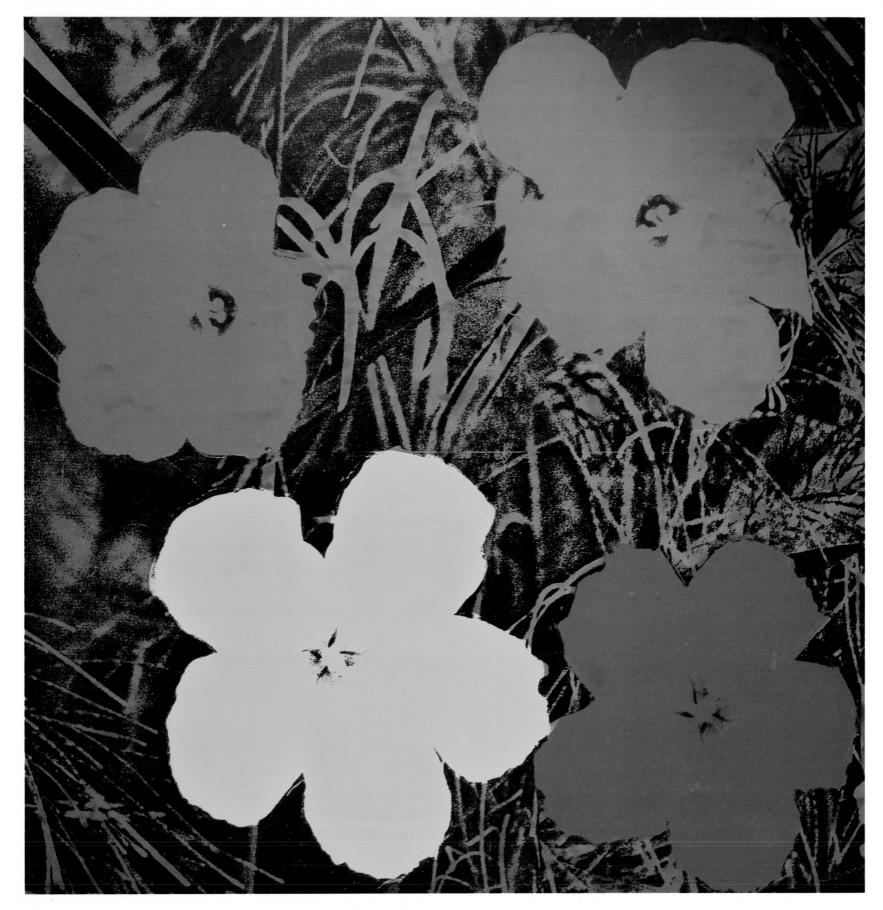

176. *Flowers.* 1964. Acrylic and silkscreen ink on canvas, 82 x 82″. Private Collection, New York

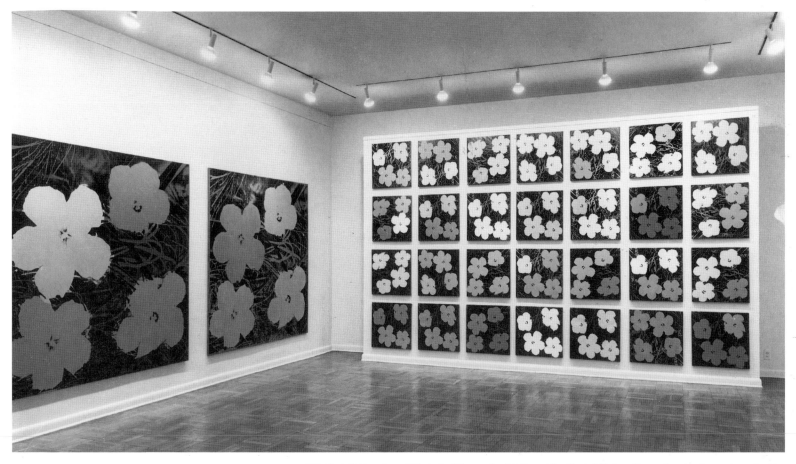

177. Installation view of Warhol's "Flowers" exhibition at the Castelli Gallery, November 21–December 17, 1964

demonstration of the ability of colors to suggest advancing or receding planes.[29]

Andy produced most of his Flowers paintings in June and July, turning out as many as eighty a day. "Friends come over to the Factory and do the work with me," Warhol said. "Sometimes there'll be as many as fifteen people in the afternoon, filling in the colors and stretching the canvases." They manufactured an estimated total of more than 900 Flowers in all sizes.[30] Collectors loved the cheery paintings and Castelli's show quickly sold out. (But Leo Castelli and Ivan Karp would soon learn how difficult it was to sell the artist's paintings of car crashes, electric chairs, and most wanted men, subjects that most collectors found disagreeable.)

Warhol's Flowers capped the end of an extraordinary year in which the artist had achieved notoriety with his Brillo boxes, his

Most Wanted Men at the New York World's Fair, and *Empire*, the lengthiest of his virtually motionless movies. Within eighteen months, he had gone from an aspiring filmmaker who didn't know how to operate a movie camera to a featured director at the New York Film Festival. He had made his way despite obstacles and delays into Leo Castelli's gallery, and his silvered Factory had become the focus of international attention. Almost everything he did seemed to generate news.

His accomplishments as a moviemaker were rewarded at a midnight ceremony at the New Yorker Theatre at 89th Street and Broadway on December 7, 1964, when *Film Culture,* a quarterly periodical—and the main forum for underground filmmakers— edited by Mekas, presented the artist with the magazine's sixth Independent Film Award, specifically for *Sleep, Haircut, Eat, Kiss,*

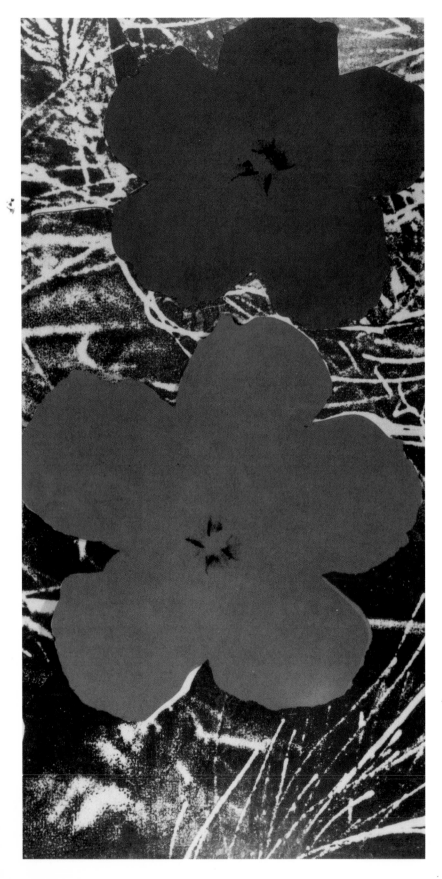

and *Empire*.[32] (Jack Smith's *Flaming Creatures* had received the award the previous year.) Warhol's striking ideas and prolific output certainly compelled attention, but the enormous publicity that he helped focus on underground movies no doubt also contributed to his winning the award, which was presented on film rather than on stage. In Mekas's *Award Presentation,* filmed in Warhol's simplistic style, the artist and his collaborators posed for a group portrait in a stationary shot as Mekas handed them a basket of fruits and vegetables that was passed around.

Warhol, according to the *Film Culture* citation, was taking cinema "back to its origins" for "a rejuvenation and a cleansing." His recordings of ordinary actions (or inactions) were compared favorably to the marvelous simplicity of the 1890s cinema of the French pioneers Louis and Auguste Lumière, who thrilled audiences with moving pictures of workmen demolishing a wall and a train entering a station. "In his work, [Warhol] has abandoned all the 'cinematic' form and subject adornments that cinema had gathered around itself until now. He has focused his lens on the plainest images possible in the plainest manner possible. With his artist's intuition as his only guide, he records, almost obsessively, man's daily activities, the things he sees around him…Andy Warhol's cinema is a meditation on the objective world; in a sense, it is a cinema of happiness."[33]

178. *Large Flowers*. 1964. Acrylic and silkscreen ink on canvas, 144 x 72″. Collection Isabelle Collin Dufresne (Ultra Violet), New York

NOTES

1. Henry Geldzahler, Film-Makers' Co-operative handbill, January 1964; reprinted in "Andy Warhol," *Art International,* VIII/3, April 25, 1964, p. 35.

2. Geldzahler, "Warhol," p. 35.

3. Archer Winsten, "Rages and Outrages," *New York Post,* January 20, 1964.

4. The "beautiful girls," for instance, numbered at least fourteen: actresses Sally Kirkland, Beverly Grant, and Nancy Fish; Ethel Scull; artists Jane Wilson, Marisol, Olga Klüver; writer Ann Buchanan; models Imu and Ivy Nicholson; art critic Barbara Rose; dancer Lucinda Childs; and socially prominent Jane Holzer and Isabel Eberstadt.

5. Ondine's legal name was Robert Olivo; his friends called him Ondine after the naiad heroine in the Jean Giraudoux play.

6. Andy Warhol and Pat Hackett, *POPism: The Warhol '60s* (New York: Harcourt Brace Jovanovich, 1980), p. 75.

7. Gretchen Berg, "Nothing to Lose/Interview with Andy Warhol," *Cahiers du Cinema in English,* May 1967, p. 40.

8. Jean Stein, *Edie, An American Biography,* edited with George Plimpton (New York: Alfred A. Knopf, 1982), p. 204.

9. Andy Warhol, *The Philosophy of Andy Warhol: From A to B and Back Again* (New York: Harcourt Brace Jovanovich, 1975), pp. 26-7.

10. Sidney Tillim, "Andy Warhol," *Arts Magazine,* September 1964, p. 62.

11. John Wilcock, *The Autobiography & Sex Life of Andy Warhol* (New York: Other Scenes, 1971), n.p.

12. Jay Walz, "Canada Rules Out Boxes as 'Art,'" *The New York Times,* March 9, 1965.

13. In January 1970, Warhol sued Ward for the return of two paintings *(Mona Lisa in Color* and a car crash), which he valued at $60,000, as well as for $60,000 cash, which he said she owed him for works sold at the gallery. ("Warhol Sues a Gallery for 60G, Paintings," *New York Post,* January 8, 1970.)

14. Interview with Samuel Adams Green, October 4, 1988.

15. Wilcock, *Autobiography,* n.p.

16. Wilcock, *Autobiography,* n.p.

17. Although some filmographies claim *Empire* is eight hours long, Gerard Malanga maintains that it consists of twelve reels of film, each thirty-five minutes in duration, which would make the entire work only seven hours long.

18. Jonas Mekas, "Movie Journal," *The Village Voice,* July 30, 1964, p. 13.

19. Mekas, "Movie Journal," p. 13.

20. Warhol, Minneapolis lecture, February 1968.

21. Wilcock, *Autobiography,* n.p.

22. Geldzahler, quoted in *Andy Warhol,* a film by Lana Jokel, 1972; produced and distributed by Blackwood Productions, New York.

23. Jonas Mekas, "The Filmography of Andy Warhol," in John Coplans, *Andy Warhol* (Greenwich, Conn.: New York Graphic Society, 1970), p. 149; the film was shown at the Cinémathèque on January 3, 1966.

24. Interview with John P. Dodd, January 17, 1988.

25. *Modern Photography,* Vol. 28, No. 6, June 1964, pp. 84-89, 102.

26. Warhol, *Philosophy,* pp. 148–49. The quote continues: "I think every painting should be the same size and the same color so they're all interchangeable and nobody thinks they have a better painting or a worse painting. And if the one 'master painting' is good, they're all good."

27. The peril of plumbing Warhol's art for deep significance was demonstrated by Peter Gidal in *Andy Warhol: Films and Paintings* (London: Studio Vista/Dutton, 1971), p. 40.: "If one looks closely [at the four flowers], one can see that two are male, two female, and it is the two female who are almost touching. The sense of nearness and separatedness, of tension before touch, is brought out even in as basic an image as the picture-postcard-like *Flowers....*And one questions again: why are two touching (just barely), the other two not?"

28. David Bourdon, "Andy Warhol," *The Village Voice,* December 3, 1964, p. 11.

29. The advancing colors and floating character of Warhol's Flowers paintings were discussed at length by Angela Little in her "Shades of Meaning" column in *Color Engineering;* November–December 1965, p. 4; January–February 1966, p. 8; and May–June 1966, p. 5.

30. Rainer Crone, *Andy Warhol* (New York: Praeger Publishers, 1970), p. 30.

31. The program included Mekas's filmed presentation of the award, as well as excerpts from Warhol's *The Shoulder* (Lucinda Childs), *Dracula, Thirteen Most Beautiful Boys* (Freddy Herko), *Thirteen Most Beautiful Girls,* and all of *Henry Geldzahler.*

32. "Sixth Independent Film Award," Film-Makers' Cinémathèque handbill, December 1964.

"Warhol's ideas on direction are simple to the point of idiocy—or genius. He puts the camera on a tripod, and it starts turning, sucking in reality like a vacuum cleaner."—*Andrew Sarris* [1]

Warhol's second-period films, all in sound, were vehicles that he specially tailored for a new phenomenon—the underground superstar. Sensing that avant-garde cinema needed its counterparts to Hollywood's legendary stars, Warhol began to establish a stable of performers comparable to that of the old studio system. Between the final weeks of 1964 and the early months of 1965, he ushered in a new era of cinematic glamour with films constructed around the personalities of two underground movie queens: Mario Montez, a female impersonator, and Edie Sedgwick, a scintillating young socialite. Montez, representing a perverse inversion of movie-star attractiveness, contributed a new element of absurdity to Warhol's already controversial reputation, while Sedgwick gave him chic respectability among the socially prominent. Together, Montez and Sedgwick comprised the alpha and omega of the Warhol school of performance art. Each offered a provocative combination of vulnerability and innocence as well as kinky far-outness.

Mario Montez, born in Puerto Rico and reared in New York's Spanish Harlem, was a slim, dark-skinned young man who sharpened his talent for female impersonation by watching old Hollywood movies on television. He had made his screen debut in 1963, playing a mysterious Spanish lady in Jack Smith's *Flaming Creatures*. The actor's professional name was an homage, of course, to Maria Montez, the exotic siren of Universal Studios' Arabian desert epics of the 1940s. (The Dominican Republic–born actress died in 1951.) Mario was one of the first underground superstars to assume a fictitious name; within a few years, Warhol's casts would include performers with outlandish names such as Ingrid Superstar, Ultra Violet, Candy Darling, and Holly Woodlawn. Mario worked as a postal or shipping clerk by day and became a luminary at night. The hardest part of his double life was preventing his relatives and coworkers from discovering that he was a resplendent queen of underground films.

Mario Montez only "went into costume" for theatrical roles and, being a pious Roman Catholic, worried that performing in drag was a sin. He also represented a new type of female impersonator: unlike the soignée 1950s variety, who created immaculate impressions of lacquered showgirls or campy send-ups of Bette

179. Andy Warhol in his glittery Factory, 1965. Photograph by Jon Naar

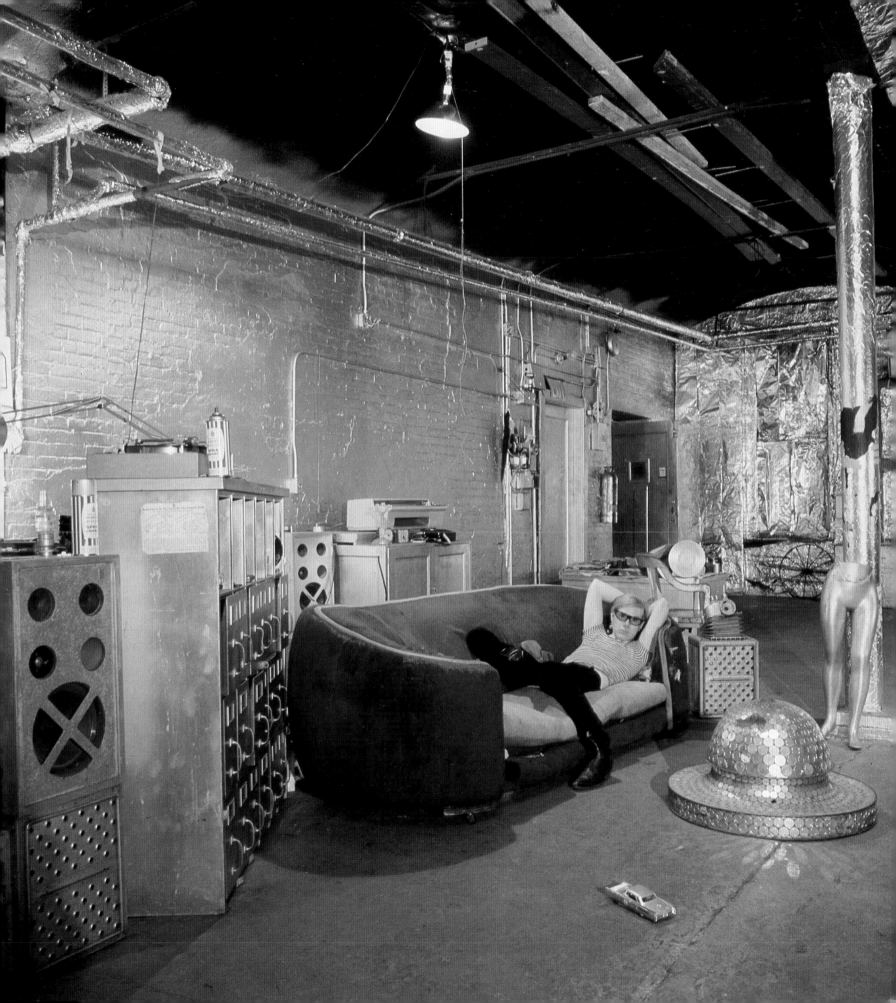

180. Edie Sedgwick shows her winsome side in one of Warhol's three-minute *Screen Tests,* 1965.

Davis, Montez exemplified a tacky discount version of the Hollywood dream. Although he designed and sewed some of his costumes, he bought most of his size-ten dresses in thrift shops, seldom paying more than four dollars. His illusion of femininity was as imperfect as his command of English, but he excelled at conveying the *aura* of movie-queen glamour. His flamboyant performances always elicited the audience's sympathy, and he soon acquired cult status as a classic of underground camp.

Edie Sedgwick, by contrast, was a poised and vivacious young beauty, sophisticated, clever, and witty. Her sparkling personality, husky voice, and jangly laugh (which reminded some listeners of clinking ice cubes in a cocktail) suggested tremendous potential as an actress. Edie was twenty-two years old in 1965, stood five-foot-five, and weighed slightly more than one hundred pounds. She had a pert, animated face with milky white skin, a bright smile, and large brown eyes that everyone agreed were the color of dark chocolates. She kept her brown hair fairly short and wore dangling earrings that nearly grazed her shoulders. Her typical attire exemplified the far-out fashion look of the mid-1960s: her trademark was the black dancer's tights she wore to show off her slender, shapely legs. On top, she might wear anything from a dime-store T-shirt to a short fur coat, providing the bottom edge hit no lower than the tops of her thighs. (Warhol later would claim that she inspired the miniskirt.) Andy escorted her to all the glittering parties, helped launch her reputation as the 1965 Girl of the Year, and promoted her as the leading superstar in his films.

By an odd coincidence, both Montez and Sedgwick made their debuts in Warhol sound films (*Harlot* and *Vinyl,* respectively) but had nonspeaking roles. *Harlot,* made at the Factory in December 1964, was the first feature that Warhol shot after buying a 16mm Auricon movie camera, which enabled him to record sound directly on the film as it ran through the camera. (Later on, he achieved better sound quality by recording on tape and paying a film laboratory to transfer the audio record to the sound track.) It was never quite clear what value Warhol placed on audible sound tracks. Sometimes he indicated that he considered good sound a desirable virtue; at other times, he observed that it was too costly. But all the evidence suggests that he actually preferred a sound track with a reality of its

own—as an asynchronous counterpoint to the onscreen image. Warhol had no interest in conventional narrative, so sound presented him with a challenge that he attempted to sidestep with various antinarrative devices.

With the addition of sound, Warhol's films began to require crews. Gone were the days when he could show up all by himself at somebody's apartment to shoot a few three-minute reels of film with his Bolex. He now needed several assistants to carry the heavier and bulkier Auricon and the larger thirty-five-minute reels of film, as well as people to look after the microphones and the lights. Scenarists and performers became important elements of the Warhol movie-making apparatus, which mirrored in minuscule fashion the workings of a Hollywood studio.

Harlot, one of his typically motionless *tableaux vivants*, is a seventy-minute-long, black-and-white film accompanied by off-screen dialogue that relates only tangentially to the on-screen "action."[2] The title is a play on the name of Jean Harlow, whose life story was then the subject of two Hollywood movies (one of which starred Carroll Baker). Montez, done up in all-white Jean Harlow drag with a platinum-blond wig, long gloves, and large glittery bracelets, is the center of attraction. He shares the sofa with Carol Koshinskie, a buxom young woman who stares coolly at the camera while determinedly holding a fluffy white cat throughout the proceedings. Gerard Malanga, wearing a suit and tie, and another of Warhol's assistants, Philip Fagan, are situated behind the couch. Malanga looks adoringly at Montez.

The "action" consists of Montez eating a series of bananas, which he periodically and tantalizingly extracts from various places, consuming them at a leisurely pace with lip-smacking voluptuousness. He peels a banana and expectantly opens his mouth as he mechanically flutters his false eyelashes. One can hear Warhol's voice in the background, sounding as if he is talking on the telephone. Having consumed the banana, Montez airily throws the peel onto the floor. He then extracts a second banana from his handbag. Its skin is also hurled off-screen with abandon. Warhol is still on the telephone. Koshinskie offers Montez a third banana. As it is lovingly peeled, the exposed fruit suddenly falls out of its casing, an accident that invariably draws a laugh from the audience.

In the second reel, Montez plucks a fourth banana from behind his back and raises his stockinged legs over one arm of the sofa, showing off a few inches of bare thigh and his large T-strap shoes with high heels. He engages in a prolonged kiss with Malanga. Montez reaches into his purse to remove a fifth and final banana, which he rubs sensually against his leg. Warhol is still on the phone.

Harlot's dialogue consists of a three-way conversation between Billy Linich and poets Harry Fainlight and Ronald Tavel. Warhol, who liked the idea of juxtaposing the image with disassociated voice-overs, had at first suggested that the trio talk from a position where they could not observe the on-camera action. The speakers compromised by sitting at the other end of the loft, where they could witness and either discuss or ignore the on-screen performance.

Warhol first met Tavel, a talented, Brooklyn-born writer, in November 1964, when he and Malanga attended the young man's poetry reading at Le Métro coffee house in the East Village. When the reading was over, Warhol sent Malanga to invite Tavel to their table. "I like the way you read," Warhol told the poet, inviting him to read something, anything at all, for his first sound film.

Warhol and Tavel worked together on some of the best and funniest films that emerged from the Factory during the following year, one of the few periods in which the artist produced scripted films. As a screenwriter, Tavel displayed an outrageous imagination, a sardonic sense of humor, and a flair for satire, not to mention a gift for language. They turned out about two seventy-minute-long films each month, usually shot on weekends, when most of the participants were available. But their collaboration was often bumpy. Tavel wished to get more complex, while Warhol always sought to simplify. The author wanted to rehearse his scripts, while the artist insisted on filming them immediately and without retakes. During every film, Tavel always threatened to leave in a huff. "I didn't take these movies seriously when I was doing them," Tavel said. "I considered myself a novelist." (He subsequently wrote a number of plays, including *Gorilla Queen* and *Indira Gandhi's Daring Device*, for off-Broadway production.) Tavel felt at the time that "Warhol's concept of each movie was so much more important than the product that reading a good analysis of the film would be more interesting than seeing it."[3]

Tavel often tailored his scenarios to the personalities of the Factory's star performers. One of the earliest and perhaps funniest of the Warhol-Tavel productions is *Screen Test #2*, a seventy-minute-long black-and-white work consisting of two reels, filmed in February 1965.[4] The format is a stationary close-up of Montez, wearing a black wig and impersonating an actress who is auditioning for the role of Esmeralda, the gypsy dancer in Victor Hugo's *Notre Dame de Paris*. He is subjected to many embarrassing questions that are posed off-camera by Tavel, who plays a rather demonic interrogator, intent upon humbling and humiliating the "actress." Tavel instructs Montez to lift his skirt and scrutinize his penis, saying, "Don't worry, the camera won't pick it up." Montez protests, "I know what it looks like," and disdainfully attempts to restore the illusion of female glamour. Tavel commands Montez to repeat various vulgar words and phrases, which the latter does with evident distaste. As Warhol noted, "Mario had that classic comedy combination of seeming dumb but being able to say the right things with perfect timing; just when you thought you were laughing at him, he'd turn it all around."[5]

Montez, following his triumph as Harlow, went on to impersonate other Hollywood movie stars for Warhol. He played Lana Turner, trying on dozens of sweaters and dealing with the murder of her gangster boyfriend, in *More Milk, Yvette*. He was especially hilarious as Hedy Lamarr, proclaiming "men are such playthings to me" and protesting his innocence after being arrested for shoplifting, in *Hedy*, also known as *The Fourteen Year Old Girl*. That film, scripted by Tavel, opens with Montez on an operating table, surrounded by surgeons who are performing a face-lift with crude instruments. Afterward, he alights from the table, examines himself in the mirror, and girlishly sings "I Feel Pretty."

Montez also played a Betty Grable–type song-and-dance girl in *Camp*, an all-star revue filmed toward the very end of 1965 with a cast of Factory regulars that included Baby Jane Holzer, Jack Smith, Tosh Carillo (one of the "pretties" from Warhol's pre-Pop days), and Gerard Malanga, who served as emcee and host. Montez, wearing a long, flowery dress, sang "If I Could Shimmy Like My Sister Kate." "As he dances," a reviewer noted, "the cameraman zooms in and out. Never has the zoom been so gratuitously abused. Another cameraman might use the same technique to suggest an earthquake or the shock of a rocket ship blasting off."[6]

Immediately after *Screen Test*, Warhol made one of his many never-released films—*Suicide*. Ever since Freddy Herko's demise, Warhol had been frustrated by his inability to find a volunteer for the title role. He talked constantly of how exciting it would be to make a movie of someone actually expiring on-screen. He told his suicidal friends—and there were many of them—to call him immediately if they ever got serious. Warhol was elated when he came across a young man who had slashed his wrists about two dozen times. Andy talked him into describing the various attempts on his life as the camera focused on his wrists and hands. But in reliving his past, the man became increasingly distraught and subsequently threatened to sue if the film was ever shown in a theater.[7]

In March 1965, the Warhol-Tavel team collaborated on *The Life of Juanita Castro*.[8] The film burlesqued Cuban Premier Fidel Castro and his communist regime, an "in" political topic at the time, with Castro's revolutionary colleague, Ernesto "Ché" Guevara, having spoken that past December at the United Nations. The concept for the film was sparked by an article written by Castro's sister Juanita, headlined "My Brother Is a Tyrant and He Must Go," published in the August 28, 1964, issue of *Life* magazine. Montez was offered the title role, but turned it down. Consequently, Juanita Castro was played by independent filmmaker Marie Menken, a tall, hulking woman whose appearance suggested she could bring any barroom brawl to an immediate and drastic conclusion. In what was considered to be an amusing sex-role reversal, Fidel Castro, his brother Raul, and Guevara were played by women.

Tavel, who appeared on-camera in the key role of stage manager, initially seated the cast in three rows so that they all faced the lens. Warhol peered through the viewfinder and decided to shoot the scene at an angle in order to get a better composition. The performers remained where they were, looking away from the actual camera toward an imaginary camera. Tavel provides the performers with their lines and directions. "Juanita," he tells Menken, "say to Fidel, 'you never really cared for the poor peasants,' " and Menken repeats after him, "You never really cared for the poor peasants."

Warhol's bizarre camerawork intrigued the witty film critic Andrew Sarris, who wrote in the *Village Voice*: "When Juanita is ordered to stand up to take her close-up (from the imaginary camera) she naturally steps out of the frame of the real camera. The whole thing is outrageous, but it [the film] never falters in its inept insistence on making a comment on a revolution that has long since been consigned to camp."[9]

Warhol and Tavel next decided to do a takeoff on a Western. Tavel conceived his scenario, not surprisingly, as a sex charade, with the cowboys getting turned on by each other and the horse. The production, titled *Horse*, was filmed at the Factory in April with a rented equine star, who arrived via the freight elevator, and an all-male cast consisting of art critic Gregory Battcock, Tosh Carillo, and regular visitors Daniel Cassidy and Larry Latreille. The performance took place in a front corner of the loft against a background of stair-exit and elevator doors. During the filming, the elevator door repeatedly opened, spilling arriving visitors onto the set, from which they awkwardly retreated. Nobody could figure out whether Warhol anticipated these interruptions or merely accepted them.

The human performers had to peer past the floodlights to read their lines, which were scrawled on shirt cardboards. Malanga held up the cards with the characters' names and Tavel carried those with the dialogue and stage directions. The actors were under enormous stress, according to Tavel, because one of his signs ordered them to "approach the horse sexually." The performers sprawled themselves all over the horse, molesting it to the point where the fearful animal struck out and kicked Carillo in the head. "But he didn't know it," Tavel said. "Like somebody who's been stabbed, he kept right on going."[10]

Another of Tavel's cue cards said, "YOU NOW ATTACK TOSH," who played an outlaw whose cheating in a game of strip poker incites the others to beat him up. As soon as the actors saw that sign, they attacked Carillo with such ferocious zest that they seemed about to reduce him to pulp on the concrete floor. Tavel and Malanga hastily put up a sign reading, "STOP/ENOUGH," which went ignored; the two had to run onto the set to break up the fray.[11]

Horse was followed immediately by another movie with a scenario by Tavel, titled *Vinyl*, also filmed in April or early May. *Vinyl* too was intended to feature an all-male cast, but just before the Auricon's motor was turned on, Edie Sedgwick showed up at the Factory and Warhol made her a last-minute addition to the cast, telling the others, "It's okay, she looks like a boy." He positioned her atop a large trunk, and she remained there throughout most of the film without speaking a single line.

Warhol had met Edie Sedgwick at a party a few weeks earlier and, like so many others, had been instantly captivated by her. He thought she had "magic," an indisputable star quality. The bridge of her nose bore a narrow scar she had acquired (along with a broken knee) in a recent automobile accident. She was at the party with a friend, Chuck Wein, who acted as her escort, confidant, mentor, and agent, and they both wanted to get involved in film and theater. Andy sensed that she would be an asset to his movies, so he invited them to the Factory, suggesting that maybe they could "do some things together."

Edie was the seventh of eight children born into a wealthy family that lived on a three thousand acre cattle ranch in the Santa Ynez Valley, about fifty miles inland from Santa Barbara, California. She possessed an impressive genealogy, being related to many eminent Massachusetts educators and literary figures, including Catharine Maria Sedgwick, a nineteenth-century novelist; Endicott Peabody, the founder of the Groton School; and Ellery Sedgwick, editor of the *Atlantic Monthly* from 1908 to 1938. In the fall of 1963, Edie went to Cambridge, Massachusetts, where two of her brothers had attended Harvard, to study art privately with the sculptor Lilian Saarinen. But Cambridge was too suffocating for such an ebullient young woman, so the following year she moved to Manhattan, where she first settled into her maternal grandmother's apartment on Park Avenue and then found a place of her own on East 63rd Street near Madison Avenue.

Despite her scarcely healed knee, Sedgwick was dancing regularly at Manhattan's liveliest discothèques. She enjoyed being extravagant and usually picked up the check, always signing for things because she never carried cash. Warhol was attracted to Edie because she was not ashamed of her wealth and never gave the impression that she thought other people were only after her money.

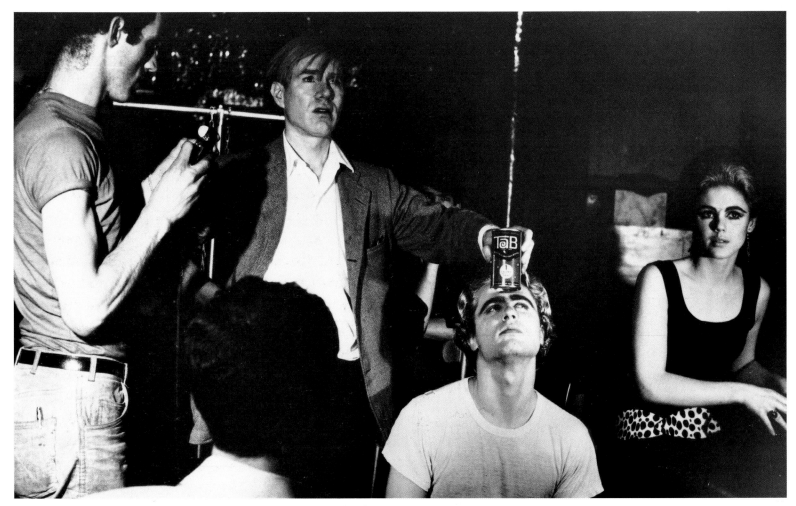

181. Billy Name and Andy Warhol (both standing) test lighting and focus in preparation to shoot *Vinyl* at the Factory, 1965, while Edie Sedgwick and Gerard Malanga await their turn to perform.

Though she struck most acquaintances as an innocent and winsome young woman, Edie Sedgwick had a darker side that would not become generally known until years later, when many of her problems were blamed on Warhol. As a teenager, she had been anorectic, threatened by the incestuous impulses of her father, and incarcerated in psychiatric institutions. At age twenty, while briefly out of the Westchester Division of New York Hospital, she met a Harvard man and surrendered her virginity to him in her grandmother's apartment. When she realized she was pregnant, she was able to use her psychiatric history to get a legal abortion. In Cambridge, she had been introduced to LSD (lysergic acid diethylamide), and discovered that she liked to date homosexual men because they didn't paw her, though some used her as bait to

lure straight youths for themselves. Moreover, she had been emotionally crushed by a pair of recent family tragedies. Her brother Francis Minturn (Minty), whose alcoholism and homosexual orientation led to his confinement in one of the same mental institutions that had earlier housed his sister, hanged himself against a bathroom door in March 1964, the day before his twenty-sixth birthday. The following New Year's Eve, Edie's oldest brother, Robert Minturn (Bobby), was riding a motorcycle without his helmet on New York's Fifth Avenue when he crashed into the side of a bus; he never regained consciousness and died twelve days later at age thirty-one. After so dire a youth, Edie's bit part in a Warhol movie must have seemed like a lark.

Vinyl, a demented, black-humored takeoff on Anthony

"Okay, okay, I am a J.D. [juvenile delinquent]," Malanga continues. "So what? I like to bust things up and carve people up and I dig the old 'up yours'…and then if I get busted by the cops, so what?…While I'm still free, it's me that's having the fun, you dig?" With the pop song "Nowhere to Run," recorded by Martha & the Vandellas, blaring in the background, Malanga, having doffed his jacket, begins an energetic, gyrating, rock 'n' roll dance solo. Sedgwick, who up to this point has been smoking one cigarette after another, occasionally flicking her ash on the floor, starts waving her arms around in sympathetic response.

While Malanga dances in the foreground, another type of action is occurring in the darkly vague background. The newsboy has been stripped of his shirt and tied to a chair, where he is being tormented by two men, a sadistic doctor, played by Tosh Carillo, and his leather-clad assistant, Jacques Potin. (Carillo was rumored to be a real-life sadist. According to Tavel, he worked in a florist's shop that "specialized in funeral wreaths."[12]) Carillo puts a plastic bag over the boy's head and forces him to inhale "poppers" (amyl nitrate). The doctor lights a candle, holds it just above the boy's chest, and carefully drips a meandering line of hot wax on the naked flesh, periodically interrupting his labors to take a swig of Tab. His assistant, who is now shirtless, caresses the newsboy's torso, then suddenly slaps his face. More matches and candles come into play. Before long, the newsboy's torso is crisscrossed with dark, glistening lines.

After the music ends, Victor gets into an altercation with a police officer. "Go to hell, cop," he says, spitting. But the officer subdues Victor, who whimpers, "I'll be a good boy, sir." "You can't be," the law enforcer snarls. "You're bad. But we can make you good."

The cop summons the doctor, who ties Malanga to a chair, covers his entire head with a zippered-leather mask, stamps a foot on his crotch, and asks, "Do you feel pain?" During a lull in the "treatment," Tavel, off-screen, announces the credits: "Victor is played by Gerard Malanga. Cop is played by J. D. McDermott. The doctor is played by Tosh Carillo," and so on. Edie Sedgwick is billed as an "extra." Earlier, Warhol had suggested to Tavel that he recite the credits, a few at a time, whenever the action seemed to get slow. This process of interspersing the performance with voice-over

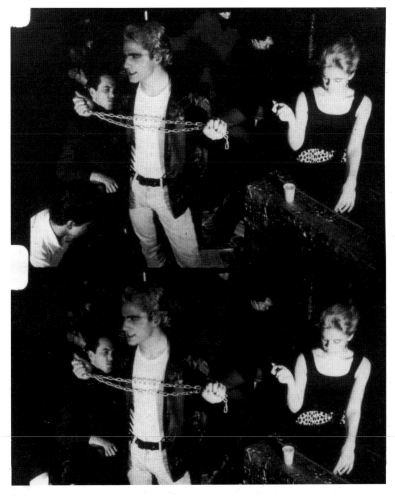

182. Gerard Malanga stars as a young tough in *Vinyl*, but Edie Sedgwick, in a nonspeaking role, nearly stole the scene.

Burgess's novel *A Clockwork Orange*, was intended as a star vehicle for Gerard Malanga. The seventy-minute, black-and-white film is highly stylized and consists essentially of two long, stationary takes with an occasional zoom. Malanga played an antisocial leather-jacketed thug named Victor who gets his kicks out of beating up innocent newsboys, like the one played by an adolescent-looking Larry Latreille. "Excuse me, sir," Victor says derisively. "Pardon me, sir. I see you have some books in your hand, sir. It is uncommon to see someone who still knows how to read, sir." Malanga convincingly belts out his lines, but his delivery is halting because he had difficulty reading Tavel's off-stage cue cards.

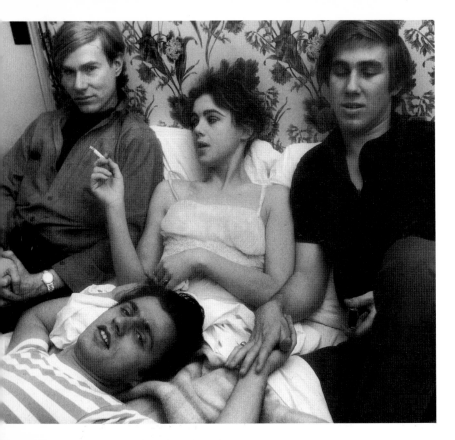

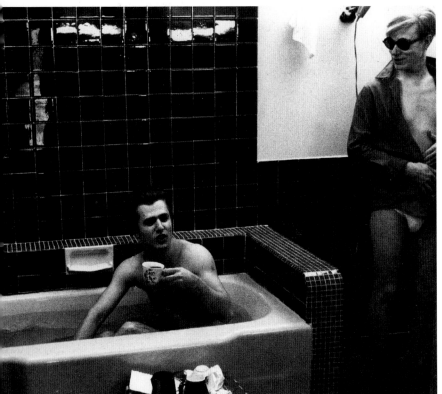

183. Andy, Edie Sedgwick, Chuck Wein, and Gerard Malanga relax in a Paris hotel room while awaiting the opening of his "Flowers" exhibition on May 1, 1965. Photograph by Harry Shunk

184. In their Paris hotel bathroom, Gerard Malanga and Andy Warhol prepare to face the day. May 8, 1965. Photograph by Harry Shunk

credits was pursued in many of the films that followed *Vinyl*, contributing another dimension of artifice to the already unbelievable action. "All my films are artificial," Warhol remarked about this time, admitting that he didn't know "where the artificial stops and the real starts."[13]

The film concludes with an impromptu dance sequence as the lens zooms back and another song, "Tired of Waiting for You," recorded by the Kinks, is heard. Carillo and Malanga embrace and dance. Sedgwick stands up and joins Potin and Latreille in their jubilant variations on the twist. Then Carillo starts to cut Malanga's hair as the film whitens at the end of the reel.

Although her part was small, Edie Sedgwick very nearly stole the picture. As Tavel noted, *Vinyl* corresponded to one of those Hollywood vehicles for a famous star in which a newcomer in a bit part looms into prominence, as Marilyn Monroe did in *The Asphalt Jungle*. Sedgwick, after her success in *Vinyl*, was elevated to leading roles in several other Warhol movies, essentially playing herself and often improvising her own lines. She differed from most of the other performers in Warhol's stable in that she was never campy or satiric.

Sedgwick's first starring role was in *Poor Little Rich Girl*, a seventy-minute-long, black-and-white movie, in which she talks about her privileged but unhappy past, family wealth, governesses, boarding schools, disinheritance, and the pitfalls of life as a young American aristocrat. Except for a few seconds, the first thirty-five-minute reel is out of focus.[14] As Warhol soon discovered, it was virtually impossible to work with Sedgwick without also collaborating with her Svengali, Chuck Wein, who insinuated himself into the artist's films and took credit as scenarist and codirector.

Warhol and Sedgwick immediately became fast and inseparable friends. They were perfectly mated for attracting attention at social outings and rapidly turned into one of New York's most photographed couples at hundreds of parties. She brought beauty, glamour, and sex appeal into his life, made his odd, pasty presence acceptable to Park Avenue hostesses, and helped legitimize him in high society. He in turn broadened her horizons by introducing her to the exciting worlds of avant-garde art and

underground movies. Like binary stars, they revolved around each other to create ever-changing shifts in luminosity and sparkle.

In April, Andy and Edie attended the opening of "Three Centuries of American Painting" at The Metropolitan Museum of Art. He wore yellow sunglasses and a tuxedo jacket over paint-splattered black work pants; she wore lilac pajamas over a body stocking and had bobbed her hair and stripped it silver to match his. Although many celebrities were on hand, the photographers seemed primarily interested in the Pop artist and his date. They even posed for pictures with Lady Bird Johnson—the first of the First Ladies with whom Warhol would be photographed over the years.

That May, Warhol and Sedgwick—and their respective adjutants, Malanga and Wein—went to Paris to attend an exhibition of the artist's smaller Flowers paintings at Ileana Sonnabend's gallery (plate 186). (Sonnabend paid for all four airplane tickets.) The quartet stayed at a Left Bank hotel near the gallery and went to all the "in" clubs, such as New Jimmy's. Warhol's exhibition—the walls were densely covered with hundreds of his bright-colored blossoms—and his outings with Edie received a good deal of attention in the French press. The flamboyant appearance and life-style of "Edith Sedgwick, twenty-two, white-haired with anthracite-black eyes and legs to swoon over, who stars in Andy Warhol's underground movies" were zestfully noted in American *Vogue*. "In Paris Warhol's gang startled the dancers at Chez Castel by appearing with fifteen rabbits and Edie Sedgwick in a black leotard and a white mink coat. In her deep, campy voice, strained through smoke and Boston, she said: 'It's all I have to wear.' "[15]

Sonnabend's gallery, located at 37, Quai des Grands-Augustins, was only a short distance from the studio in which Picasso had lived during World War II, making Andy wonder if the great Spanish artist had finally heard of *him*. Warhol admired Picasso more than any other artist, "because he was so prolific."[16] It was typical of Warhol that he esteemed Picasso not so much for his aesthetic significance as for his productivity, not to mention his ability to scribble his name on virtually anything and thereby increase its value.

Warhol had no intention of letting up on his own productivity, but he decided it was time to concentrate on movies. At his vernissage,

he made an announcement that he'd been thinking about for months: he was going to retire from painting. "I've had an offer from Hollywood," he told a reporter, "and I'm seriously thinking of accepting it."[17]

Warhol was a lifelong, star-struck fan of Hollywood movies, and their influence upon him and his art was self-evident. "I like American films best," he said. "I think they're so great, they're so clear, they're so true, their surfaces are great. I like what they have to say: they really don't have much to say, so that's why they're so good. I feel the less something has to say the more perfect it is."[18] He displayed remarkable naiveté, however, in suggesting that he had a future in Hollywood. While his films generated plenty of notoriety, there was virtually no audience or market for such work. Given Warhol's very limited filmmaking experience, not to mention his almost nonexistent craftsmanship, it was presumptuous of him to believe that a major studio would bankroll his endeavors. But he would make many trips to Hollywood over the next decade, courting various producers and studio executives without success.

Warhol sensed that it was his moment to step into the spotlight because he epitomized the with-it attitudes of the cultural avant-garde. During the spring of 1965, following the artist's return from Paris, one of his friends hosted a "Fifty Most Beautiful People" party at the Factory. The place was by now a Pop temple, a silvery pantheon that attracted the curiosity of pilgrims from all levels of society and from all over the world. Almost everyone who set foot in the Factory became extremely self-aware—perhaps it was the mirror-like decor and popping flashbulbs that made them feel that their every move was being scrutinized for potential significance. In Andy's domain, even outcasts could imagine themselves stars. The slumming celebrities who came to see what all the fuss was about wound up a part of the kaleidoscopic scene. At the "Beautiful People" party, Andy's eyes widened every time the elevator door opened to reveal one famous face after another, including those of Judy Garland, Rudolph Nureyev, Tennessee Williams, and Montgomery Clift. These were people Warhol had idolized, but he recognized that their era was fading while he and Edie and his galaxy of underground superstars were on the rise.

Seeking to burnish and exploit Sedgwick's ascending

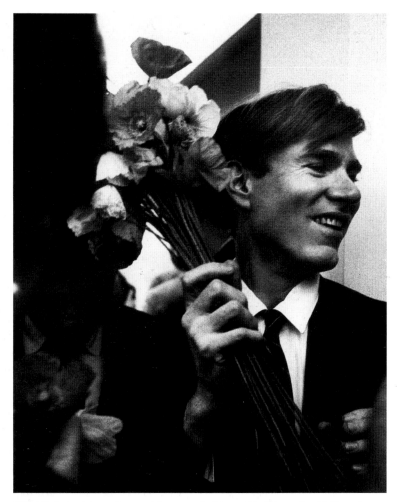

185. Warhol receives a bouquet from a well-wisher at his "Flowers" exhibition at Galerie Sonnabend in Paris, May 12, 1965. Photograph by Harry Shunk

Edie out late every night and got her stoned on booze and pills, thereby assuring her inability to perform Tavel's script the next day. Instead of helping her to prepare for her parts as written, Wein was advising her that memorizing lines was "old-fashioned" and that she needed only to walk in front of the camera and improvise. On the day of the shooting, Sedgwick, not surprisingly, blithely admitted that she didn't know any of the dialogue. She further annoyed Tavel by asking what his script was about. He told her that he hoped it meant "nothing." "I don't know what that means," she complained, to "say it doesn't mean anything."[19] When she needed coaching, it was decided, she should simply sneeze, and someone behind the refrigerator would whisper her lines to her.

None of the actors was adequately prepared, as it turned out, so Tavel hid pages of his script all over the set—on the table and inside the cabinets and the refrigerator. The performers were periodically distracted by a professional photographer, who entered the set from the foreground to take pictures. Occasionally he walked directly in front of the movie camera, briefly obscuring the action. During screenings of the film, people in the audience often turned around to see who was walking in front of the projector.[20]

Warhol's anything-goes cinematic aesthetic was as opaque to some of his colleagues as it was to his public. Wirtschafter, for instance, observed that the artist's "passivity," his cool acceptance of chance and indifference to professional technique, never let anyone in on his learning process. "He would accomplish just a horrible piece of footage," Wirtschafter said, "and he would turn around and say, 'Oh, that's just so beautiful.' " A remark such as that would leave Wirtschafter wondering whether Warhol had really learned to see "the beauty of the footage" or whether he was, in fact, covering up his realization that the filming was a disaster.[21]

As with his Pop paintings, Warhol's films were not intended to carry weighty loads of profound meaning. Nevertheless, the films were subjected to deep readings and intricately contrived theories. Their very blankness and emptiness left them open to all kinds of incredibly convoluted interpretations as critics attempted to

reputation, Warhol asked Tavel to devise a special cinematic vehicle for her—something simple and preferably plotless. Tavel took the artist's perversity a step further and, striving to write scripts with "no meaning," did away not only with plot, but also with characters. He gave all the performers in his scenario the same name, making it difficult for anybody to figure out who was who. The result was *Kitchen*, a seventy-minute-long, black-and-white work filmed that June. The movie took place in the spacious white kitchen of a downtown loft belonging to Bud Wirtschafter, a cinematographer who provided technical assistance on several Warhol films.

According to Tavel, the production was sabotaged by Chuck Wein, who wanted to take over as scenarist and director. Wein kept

186. Warhol surveys his "Flowers" show at Galerie Sonnabend, May 1965. Photograph by Harry Shunk

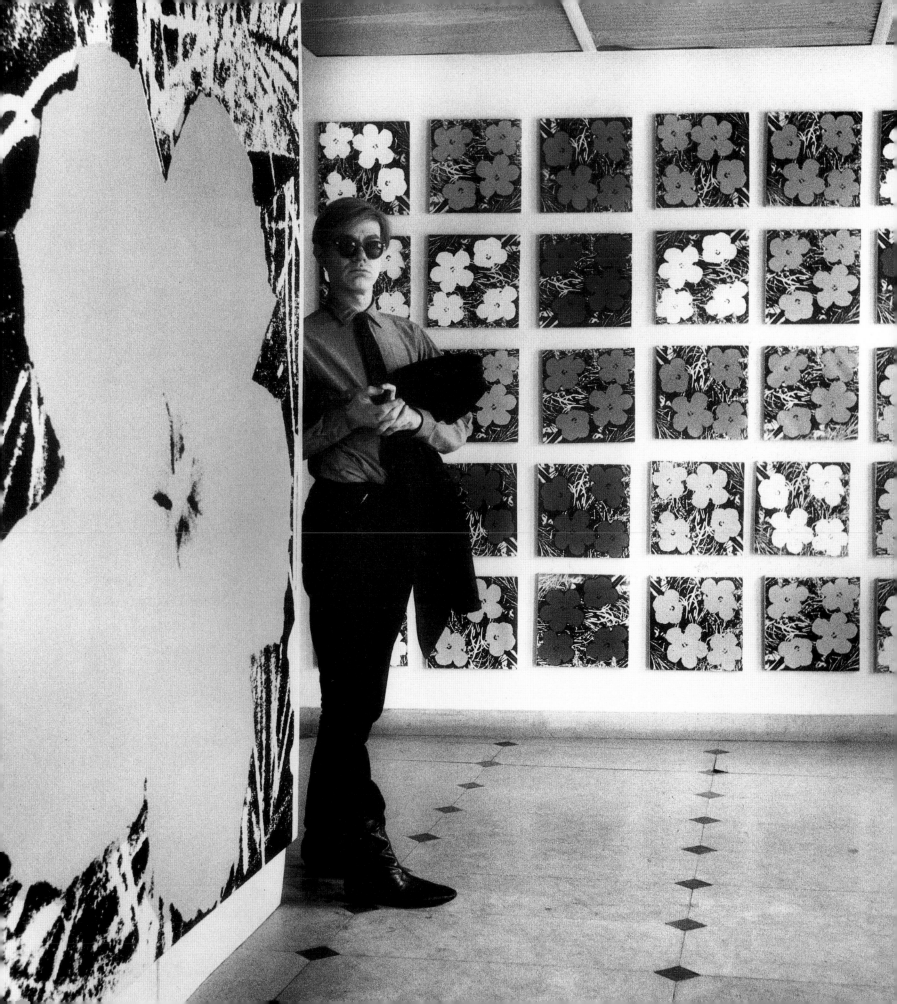

explicate their significance. Even writer-filmmaker Norman Mailer couldn't resist claiming some intellectual depth for *Kitchen*, declaring that it "may really be the best film made about the twentieth century." Although Mailer admitted that it was "almost unendurable to watch" and that "you can't understand a word," he concluded, "when in the future they want to know about the riots in our cities, this may be the movie that tells them."[23]

Warhol was hardly an ideal director from the viewpoints of his scenarists, actors, and other collaborators, because his lack of interest in conventional cinematic technique inevitably undercut their artistic contributions. His quixotic camerawork, with its wandering, pointless zooms and pans, had no visual or narrative necessity. Warhol's inattentiveness to the drama being played out before his lens, combined with his maddening tendency to walk away from the camera, makes the often-repeated assertion that he was a voyeur rather questionable. If that was true, the movie camera served as his voyeuristic stand-in.

Many of Warhol's films were publicly screened during the summer months at the Astor Place Playhouse. When *Vinyl* and *Poor Little Rich Girl* appeared there on a double bill in June, Malanga invited a few people to the screening, among them a young independent filmmaker, Paul Morrissey. Tall and long-legged, with an aquiline nose and flyaway hair, Morrissey reminded some people of a comical sort of running bird, perhaps a member of the ostrich family. He had a cackling laugh, a sardonic sense of humor, and the ability to be perceptive, opinionated, and funny all at once. Malanga introduced him to Warhol, who in turn invited Morrissey to the Factory the next day to watch them make a new movie.

Born in Yonkers, New York, Morrissey had a jesuitical view of life, shaped by sixteen years of Catholic education, including four years at Fordham University in the Bronx. After graduating, he worked briefly for an insurance company and then for New York City's Department of Social Services, where he became a caseworker in Spanish Harlem—an experience that did not make him more tolerant of the underprivileged. His satirical sense of humor was visible in his films, which were closer to conventional narrative movies than to the avant-garde works promoted by Jonas Mekas. Morrissey could infiltrate the experimental frontiers of cinema and

even cast Taylor Mead—as he once did—in one of his films, but the young moviemaker eventually would be perceived as an aesthetic reactionary.

In any case, Morrissey started hanging around the Factory, making himself useful with technical know-how and business acumen. He proved helpful in many ways—from actual production to marketing and distribution—and soon became Warhol's right-hand man in all movie matters. No matter how many tasks he assumed, Morrissey never stopped talking. He was forever ridiculing contemporary art, particularly abstraction, which he loathed, his favorite artworks being nineteenth-century academic landscape and genre painting. He was also outspoken in his loathing of rock music and contemporary poetry, and he frequently engaged in lengthy debates about the Catholic Church with Ondine.

Morrissey reserved his greatest contempt, however, for drugs and those who used them. He believed that the Factory should be more business-like, and he resented the large number of drop-ins, particularly those who came supplied with drugs and their related paraphernalia. While amphetamines and marijuana were by far the most commonplace commodities at the Factory, all kinds of addictive substances were beginning to surface there as well. Billy Linich, whose closest friends were part of the problem, periodically put up signs that said "NO HANGING OUT" and "NO DRUGS ALLOWED," but that did not discourage anyone so inclined from shooting up in the middle of the Factory. Andy was discomforted by the sight of visitors plunging hypodermic needles into their flesh, but he never lost his cool.

Warhol's movies became increasingly improvised; the actors were merely provided with a "situation" and expected to make up their own lines. Tavel's scripts grew progressively sparser, mainly because nobody was taking them seriously. Instead, he wrote an outline, then met with the actors to tell them what the story was about. He gave them some cues and they took it from there. The Sedgwick-Tavel working relationship, which was never overly cordial, came to an end in July as they were about to shoot a movie called *Space*. She read only a few of her lines before fuming: "What is all this about? How stupid!" She announced she wasn't going to

memorize anything and tore the script up in front of everybody. Sedgwick and Wein, according to Morrissey, "purposely made sure" that, when the camera was started, nobody paid "any attention to the dialogue that was planned and they just fooled around."[24] Tavel, humiliated and angry, stormed out, and that was probably the last time he ever saw Sedgwick.

Sedgwick turned in one of her most engaging performances in *Beauty #2*, a seventy-minute, black-and-white movie, filmed in an East Side apartment in July.[25] The "scenario" was by Chuck Wein, who, according to Morrissey, "thought he was writing the movies that Edie was in by talking to her off-camera" and "called himself the author" because "he took her to the shooting."[26] The tableau presents Edie, wearing a lacy bra and skimpy panties, sitting on a bed, engaged in a three-way conversation with a gentleman caller, played by Gino Piserchio, who is shirtless on the other end of the bed, and Wein, who remains off-screen. They are the ostensible angles of a romantic triangle. Between Sedgwick and Piserchio is a Doberman pinscher, named Horse, who can scarcely wait to jump onto the floor and get off-screen. His is the most sensible performance in the film, a sophomoric and self-indulgent production.

Wein, following Tavel's example as an off-screen interrogator, leads the other two players in conversation. Sedgwick sounds whimsically confused or tipsy as she tries to sort out her costars: "I wish, I can't figure out—that's Horse and that's Gino." Piserchio strips down to his briefs, perhaps to help distinguish himself from the dog, and they continue their prattle while chain smoking and drinking vodka martinis on the rocks.

The talk turns to the scar across the bridge of Edie's nose. "When I had the accident," she says, "I didn't think about whether it hurt my face or changed the way I looked at all until twenty-four hours later. You could say I was in a state of shock."

"You're not vain and narcissistic," Wein assures her. "No," she responds, "I'm just self-involved."

There is no discernible sexual magnetism between Sedgwick

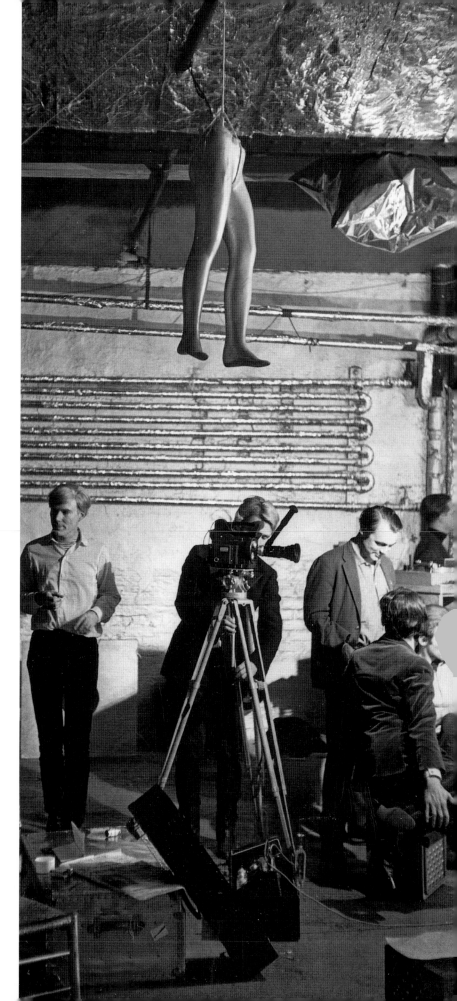

187. Warhol prepares to shoot a film at the Factory as Gerard Malanga, obscured by camera, and John Wilcock look on, October 30, 1965. Photograph by Fred W. McDarrah

and Piserchio, and they both look rather hopefully to Wein, who says, "Let me read. Get to know each other, there isn't that much time." Finally, Piserchio runs his hand across Sedgwick's stomach and tentatively kisses her as his hand proceeds to her leg and buttock. She looks as if she does not want to muss her makeup or hair. He reaches for his half-smoked cigarette, and they both listen to Wein read aloud.

Edie adjusts her makeup and expresses concern that Wein is making a practice of watching her. She brushes her hair. Then she starts kissing Gino—to please Wein or to make him jealous? "If you're not enjoying it," Wein says, "why don't you just stop?" "Shut up!" Edie says, "and what are you doing here anyway?" She picks up the butt-glutted ashtray and hurls it off-camera at Wein. The sound of broken glass suggests she has demolished his vodka martini. For a few seconds, the moviegoer anticipates that "something real" is finally happening, but, instead, the film comes to an end.

Andy and Edie continued to be one of New York's most wanted couples, invited to several parties every night. *Time* claimed these "magic names" of the moment went to "more parties than a caterer" and described Edie as "an electric elf whose flashing chocolate-colored eyes and skittish psyche make her a perfect star for [Warhol's] slow-moving movies."[27] Eager hosts sent limousines for them. But even if a party was good, Edie could scarcely wait to move on to the next place. "People were glad to have us at their parties," Warhol said, "but they weren't exactly sure why they should be glad."[28]

The twosome often wore similar outfits, with both in boat-neck striped T-shirts, he in dark pants, she in black tights. Some reporters claimed, incredibly, they could not tell Andy and Edie apart. "People say Edie looks like me," Warhol said, "but that wasn't my idea at all: it was her own idea and I was so surprised."[29] When *Esquire* sent Warhol a questionnaire asking who he would like to play himself in a dramatic treatment of his life, he chose Edie Sedgwick, "because she does everything better than I do."[30]

In August, the Warhol entourage turned up at a socialite-packed party at a Manhattan club called The Scene. Edie, wearing a blue surfer's shirt over black panties and mesh tights, frugged, jerked, and twisted, swishing her long earrings this way and that as, in the background and larger than life, *Beauty #2*, showing her lounging on a bed in the briefest of undies, was projected against a wall. At this moment Edie had no real contenders for the title of Girl of the Year. ("I didn't know I was replacing Jane," she said innocently. "In fact—I'd never even heard of her. I hardly ever read the papers."[31])

When Andy and Edie attended a screening of *The Vampires* at the Lincoln Center film festival in September, her outfit created a commotion because, in addition to her customary black leotard and false eyelashes as large as baby bat wings, she wore a dramatic black ostrich-plumed cape that seemed ideal for a high-fashion sendup of Mme Dracula. Another glamorous highlight of New York's nightlife that season was the moment when the Girl of the Year met one of the world's sexiest rock-'n'-rollers at The Scene. Amid blinding flashbulbs, breathless patrons pushed and shoved to get within earshot of the historic conversation. Edie Sedgwick: "How do you do? I just love your records." Mick Jagger: "Oh, thank you."

Sedgwick spent most of her days at home, talking on the telephone. Editors, reporters, and photographers called to set up appointments for interviews, portraits, and fashion pictures. Young men she had met the night before telephoned to ask for dates: she fended off these would-be suitors by saying she was too busy shooting a movie at the Factory. Warhol was constantly on the phone, wanting to hear every detail about her press contacts and her romantic life. Through Edie, he was able to flesh out his fantasies of being pursued by a stream of young men who were not only handsome and socially well-connected but also incredibly rich.

Sedgwick was sometimes incapacitated by the challenge of dressing for her public outings, as if overwhelmed by the knowledge that she would be a primary object of inquiring stares and intrusive photographers. She could go through an entire pack of cigarettes as she agonized about what to wear, seldom reaching a decision until every piece of furniture was piled high with layers of rejected clothes. She devoted a couple of hours each day to her makeup, which she worked on until it was flawless, often finishing with gold glitter on her cheeks. (Her cosmetics bills were extraordinarily high, partly because she usually bought all the new colors in a manufacturer's line.) Then in the late afternoon she left for

the Factory, and, from there, to a dozen or so parties, returning home the following dawn.

Between the clothes and the cosmetics, the limos and the restaurants, Edie reportedly went through about eighty thousand dollars in six months. Rumor had it that she used up her entire trust fund and now had to make do on a five-hundred-dollar-a-month allowance from her parents. On occasion she would take a dozen friends to a restaurant for dinner and spread all her outstanding bills on the table, enlisting their aid in sorting them out.

By September, Edie was displaying ambivalence about her reputation as a Warhol superstar, claiming she wasn't being taken seriously and wondering whether she should break away from him and embark on a career as an aboveground actress. Some of her friends were advising her that her relationship with Andy might harm her chances for a career. Although she wanted to be perceived as a serious actress, she quickly lost her patience with anyone who suggested that she might study acting; drama lessons were for amateurs, not for someone who had starred in as many movies as she had. One night over dinner at the Russian Tea Room, Warhol told her that he had been offered a few nights of screenings at the Film-Makers' Cinémathèque and thought it would be a great idea to mount an Edie Sedgwick retrospective. "Everybody in New York is laughing at me," she said. "I'm too embarrassed to even leave my apartment. These movies are making a complete fool out of me! Everybody knows I just stand around in them doing nothing and you film it and what kind of talent is that? Try to imagine how I feel!"[32] The proposed Edie Sedgwick Retrospective was scaled down, possibly for purely practical reasons, to an "Edie Sedgwick Double Bill," consisting of *Beauty #2* and *Vinyl*, that played the Astor Place Playhouse during the first three days of October.

Not surprisingly, there was no part for Edie in Andy's next movie. This was his way of demonstrating how expendable she was, and his ploy succeeded in making her temporarily more tractable. He was spending several hundred dollars a week on his films and not getting any significant return on his money. Wein, and possibly Morrissey as well, sympathized with his desire to make a profitable feature and persuaded him that a film about a male hustler might, so to speak, do the trick. And who was better suited to play the leading role than Wein's new protégé—the beefy, somewhat slow-witted Paul Johnson?

A six-foot-tall New Jersey youth, Johnson had been discovered by the Warhol entourage at a discotheque. His sex appeal and air of general availability made a favorable impression upon several members of the party, so he was invited to the Factory for a screen test. (Johnson later claimed to have stayed there three years. "Most people didn't know I lived there, because I was taking speed.") Johnson tried to ingratiate himself with Warhol, and sometimes approached the aloof artist to suggest something they could do together. But Warhol never conversed with him directly. "He would listen very nicely," Johnson said, "and ask Gerard to give me his reply.... He looked down on me, I guess. Took me for a fool, which I guess is what a lot of people do." In fact, Johnson was widely esteemed as "everybody's lover." He was "the personification of total sexual satisfaction," according to Ondine, "beautifully vapid" and "without a brain in his head."[33]

On Labor Day weekend, Warhol, Johnson (renamed Paul America), and a cast and crew that included Malanga, Wein, and Morrissey set out for Cherry Grove, the Eden-cum-Sodom of Fire Island, off Long Island's southern shore, to shoot *My Hustler,* a seventy-minute-long, black-and-white film. It turned out to be one of Warhol's most humorous and entertaining films, as well as a commercial success.

The story line concerns the battle for possession of a young blond stud (Paul America), whom an older john has hired for the weekend through a call-boy operation called Dial-A-Hustler. The client, played with dry bitchiness by Boston literary scholar Edward Hood, soon has his hands full, trying to prevent his "property" from being poached by treacherous Fire Islanders, who include a lithe, meddlesome young woman neighbor (Genevieve Charbin) and an experienced older hustler (Joe Campbell).

The first reel opens on Hood, sitting on the veranda of his beach house, berating a servant. The camera pans erratically to Paul America, in striped trunks, as he walks to the beach and finds a place to loll on the sand. "All they do is sun and preen," marvels Hood, who wears dark glasses and files his nails. Charbin, wearing a skimpy, two-piece bathing suit, joins Hood on the porch, saying

188. Paul America plays the hotly contested property in *My Hustler*, 1965.

189. The bleached-blond callboy is about to hear the tricks of the trade from darker Joe Campbell in *My Hustler*.

she couldn't wait to get over after glimpsing the new boy from her house. "Darling, the entertainment is not for you," Hood tells her. "Get your lascivious eyes off that beautiful body."

Another menace appears in the form of a trim-figured man (Campbell), who approaches the peroxided call boy on the beach and strikes up a conversation with him. Hood, furious, summons the interloper to the house. As the man approaches, Hood says, "Oh my god, I know him, it's the Suger Plum Fairy," a "tired, aging, old hustler." Hood makes a bet with his unwelcome visitors: "that neither one of you can get this fellow at all, try it any way you can."

The premise is obvious and the characters are stereotypical, but the performances are lively and credible. Charbin takes her turn first, joining the boy on the beach. Before long, she is applying lotion to his back and frolicking in the surf with him. "All she's concerned to do is turn him off me," Hood complains, "and then she does nothing with them. She drops them, in fact. I say they get a much fairer and squarer deal from me, from any john."

The older hustler, who claims to have flourished in his line of work for eighteen years, and the young call boy dominate the second reel of the movie, which takes place in a bathroom of the john's house. As they bathe, shave, deodorize, and groom themselves before a large mirror, they discuss how best to succeed in their chosen trade. The entire scene was filmed in a single, unrehearsed thirty-five-minute-long take and the improvisation is surprisingly engaging. The older hustler offers to put the youth in touch with an easy score—"But why should I do it for nothing?" "You mean you want ten bucks or something?" Paul America asks.

The older hustler makes it clear that his own friendship does not come cheaply. "Why should I introduce you to all my johns?... Just because you meet somebody and you have sex with somebody doesn't mean you're friendly." In a show of attentive concern, he applies Noxema to America's back. Minutes before the reel ends inconclusively, Hood sidles into the frame, leaning against the wall alongside the bathroom door; he faces the camera while attempting to recapture America's attention with a surefire lure. "Have you ever seen so much cash in one wallet?" Hood asks. "Do you know how much more there is where that comes from? Do you know the places I could take you? I can get you girls, beautiful rich

girls, only you'd be with *me* most of the time. I can teach you things, Paul. I'm very well educated. I have a large library."

"I was completely unaware of what *My Hustler* was all about," Paul America maintained at a later date. "They didn't *tell* me. I was on LSD the whole time, and I thought I was just going through some practice motions." He was under the impression that the company was going to return to Fire Island to "finish" the film, but couldn't because of "trouble" with the man who put up the money. "We used his house for the movie, and it was destroyed—the furniture all torn up and burned in the fireplace. We were like little children in a playpen, or in a sandpit."[34]

Some participants in the production maintained that Chuck Wein doctored the scrambled eggs with LSD one morning, leading to conflicting reports about who ate the mind-expanding breakfast and who didn't. Warhol claimed he did not touch the eggs and sustained himself over the weekend on tap water and candy bars that came in sealed wrappers. Morrissey, always an impassioned spokesman against all drugs, was reportedly found under the boardwalk, curled up in a fetal position. From that day on, one of his top priorities was to maneuver Wein out of the Factory.

Although Warhol was primarily occupied with his movies, he was still turning out many paintings, for which he revamped old images. He painted a couple of dozen new paintings of Campbell's Soup cans, this time silkscreened on three-foot-high canvases. Some, including one commissioned by the Campbell Soup Company, were in the familiar red-and-white scheme, but most were in arbitrary or "fauve" colors, such as purple, green, or pink, that contrasted dramatically with the original label (see plate 190). He also made more than a dozen single portraits of Elizabeth Taylor, usually on brilliant monochromatic grounds in forty-inch-square formats. And he produced a great many *Little Electric Chairs*, silkscreened in black on bright, flat-colored grounds. None of these paintings offered anything significantly new—except for the arbitrary hues of the "fauve" soup cans—but they were "trademark" Warhol images and therefore appealing to collectors.

In October, Warhol and Sedgwick, accompanied by an entourage that included Malanga and Wein, went to Philadelphia to attend the opening of the artist's first one-man museum show,

organized by Samuel Adams Green, the director of the Institute of Contemporary Art at the University of Pennsylvania. Green had commissioned exhibition posters that reproduced one of Warhol's S & H Green Stamps paintings and he had persuaded the Campbell Soup Company (headquartered in nearby Camden, New Jersey) into donating actual soup-can labels, the backs of which were printed with invitations to the members' preview.

Although Andy and Edie were electrifying New York nightlife, nobody had much reason to suspect that their appearance in Philadelphia during the first week of October would cause chaos. But so many people turned up at the ICA preview to gawk at the celebrated team that things got out of hand. In the crush, television lights fell against the paintings, while some spectators were pushed against the canvases. Green, realizing that the public opening the following night was going to be even more frantic, decided to remove virtually all of the paintings to prevent them from being ruined. When some two thousand people tried to cram themselves into the building the next evening, they completely misunderstood the absence of art, of course, and thought that the mostly bare walls were proof that Warhol's art was a sham and a put-on.

As the Warhol retinue tardily approached the gallery around 9:40 P.M. amid popping flashbulbs, floodlights, and television cameras, pandemonium swept the crowd. Warhol, sporting a black turtleneck and yellow sunglasses, and Edie, wearing a pink Rudi Gernreich floor-length T-shirt dress made out of elasticized material, managed to enter the building without duress. Inside, however, they were immediately overwhelmed by the crush. Linking hands with each other, the Warhol entourage made a run for the rear gallery. Almost everyone tried to follow them, and several people were nearly knocked to the floor in the stampede. The gleeful cries at Andy's and Edie's arrival turned to angry shouts and screams of terror as people were dragged along in the tide. Henry Geldzahler, Ivan Karp, and Gene Swenson were among Warhol's many friends who were nearly trampled in the melee. Andy and Edie, led by Green, took refuge on an iron staircase as campus policemen, posted at the foot of the stairs, held back the crowd with their sticks.

The staircase, unfortunately, no longer led anywhere, its upper landing having been sealed off many years before. So Warhol and

his party were stranded above the heads of the unruly throng. Nobody wanted to budge. The Warhol entourage remained on the staircase above a barrier of security men, and the shoulder-to-shoulder crowd below continued to gaze in wonder. A rapturous smile settled on Andy's face. He had attended enough rock 'n' roll shows to know that young fans liked to scream and carry on over their favorite stars, yet it was "incredible," he said later, "to think of it happening at an *art* opening. Even a Pop Art opening. But then, we weren't just *at* the art exhibit—we *were* the exhibit."[35]

Edie captivated the audience by unloosing the extremely long sleeves that were bunched up along her wrists and dangling them tantalizingly over the heads below, instantly drawing them up again if anybody tried to grab them. A microphone was passed up to her and she proceeded to demonstrate why she had been granted superstar status. She flashed her radiant smile, chatted up the crowd, fielded questions, danced a little, and finally charmed onlookers into behaving as if they were attending a love-in. "Oh, I'm so glad you all came tonight," she said. "Aren't we all having a wonderful time?"

Many people had brought books of S & H Green Stamps or cans of Campbell's Soup for the artist to autograph, and these were respectfully passed from hand to hand over the sea of heads to the staircase, where Warhol and Sedgwick busily scribbled their names on whatever souvenirs or scraps of paper came their way. Finally, Green persuaded students to gain access to the floor above and chop through the ceiling with an ax, enabling Warhol and his entourage to make their antic escape. "It was the only way out," Green explained.[36]

Andy and Edie had become such prominent cult figures that, a few weeks later, Roy Lichtenstein and his wife, Dorothy, went to a Halloween party dressed as the silvery duo. Lichtenstein's costume consisted of a leather jacket, blue jeans, paint-spattered shoes, and "funny" sunglasses. He powdered his face, sprayed his hair with silver paint, and sharpened the impersonation by restricting his remarks all evening to "Oh, wow!" and "How glamorous!"

Sedgwick's eccentric fashion look was penetrating mainstream America as fashion editors continued to rave over her striking looks and style. Edie was "The Girl with the Black Tights," as *Life* headlined the superstar in its November 26, 1965, fashion story, which showed her modeling several items, including the Gernreich dress she had worn in Philadelphia. "This cropped-mop girl with the eloquent legs is doing more for black tights than anybody since Hamlet."

"To be, or not to be"—with Andy: that was question confronting Edie. While the image of Warhol and Sedgwick as a chic, partying couple was fast becoming a cliché in the mass media, their relationship was, in fact, coming apart. Although she found it difficult to sever herself from the Factory, she managed to become more demanding, staging an occasional tantrum. She also initiated talks with many people in the talent-processing industry, but seemed unable to connect with the right agents. Her judgment may have been clouded by the increasing quantities of amphetamines and other drugs that she was taking in order to deal with the pressures of being Girl of the Year.

Sedgwick's career as a Warhol superstar moved toward a nebulous conclusion in December, when she played the title role in *Lupe*, based on the life and suicide of the Mexican-born movie star Lupe Velez, who overdosed on Seconal in 1944. The film, which was shot in a West Side apartment, had a scenario by Robert Heide, a playwright whose one-act, two-character drama, *The Bed,* had been one of the year's biggest off-Broadway successes. (Warhol had filmed *The Bed* a couple of months earlier in two successive black-and-white reels that he chose to project simultaneously, side by side, on a split screen in one of his earliest experiments in "expanded cinema.") Heide's relatively placid drama was inspired by Kenneth Anger's lurid account of Velez's death in *Hollywood Babylon:* "Lupe obeyed an instinct even stronger than death and ran, teetering on her high heels, toward the bathroom. But she slipped on the marble tiles as she ran up to the toilet bowl—which turned out to be her last mirror!—and head first, she fell in and broke her neck."[37] Though Heide's scenario was only four pages long, Sedgwick could not—or would not—memorize her lines.

Lupe's two thirty-five-minute color reels were projected side by side at the Film-Makers' Cinémathèque on West 41st Street the following May. In the film, Sedgwick acts out the part of someone whose life is depressingly empty. One reel starts out with a close-up of her asleep in bed. After several minutes, she awakes, lights a

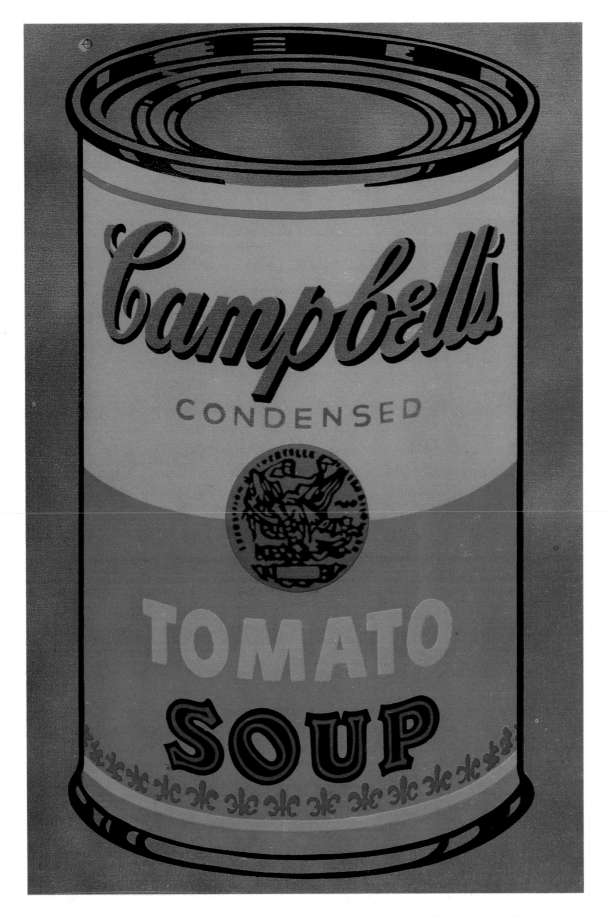

190. *Colored Campbell's Soup Can.* 1965. Acrylic and silkscreen ink on canvas, 36 x 24″. Collection John and Kimiko Powers

cigarette, and makes a telephone call. Linich eventually enters the scene and trims her hair, preparing the Lupe-figure for her final fade-out. In the other reel, she paces about a luxurious apartment, plays with a cat, smokes, drinks, dances a little, and picks at some food. The last five minutes show her slumped on the bathroom floor, her head lying on the toilet seat—a decidedly unglamorous image for the Girl of the Year.

The day after the shooting, Andy, Edie, and Heide met at the Kettle of Fish, a hip hangout on Greenwich Village's MacDougal Street. The group was later joined by folk-rock singer-composer Bob Dylan, who was chauffeured there in a limousine. Edie had been seeing a lot of Dylan, supposedly inspiring his hit song "Just Like a Woman." Warhol, experiencing a combination of envy and rancor, disapproved of their relationship. He believed that Edie owed her instant fame to him and that Dylan, who had contributed nothing to her reputation, was filling her head with romantic fantasies about becoming his costar in a major theatrical film. (Dylan, as it turned out, had nearly as little future in commercial cinema as Sedgwick.) Warhol's durable dislike for Dylan was also based on one of the singer's earlier visits to the Factory, when he had posed for a film portrait; afterward, Dylan picked up a painting of Elvis Presley and walked out with it, saying, "I'll take one of these as payment." Andy, though shocked, retained his cool, saying nothing at the time but never forgiving Dylan.

After Sedgwick and Dylan departed in his limo, Warhol and Heide walked over to Cornelia Street and looked at the site where Freddy Herko had jumped to his death the previous year. "When do you think Edie will commit suicide?" Warhol asked with a sardonic half-smile. "I hope she lets us know so we can film it."[38]

Despite the numerous Warhol vehicles in which she had starred, Sedgwick never had a challenging role. While she displayed a commanding screen presence, she possessed neither the ambition nor the discipline to become a serious actress. She was victimized in part by her collaborators: the out-of-focus photography, bad sound, and sketchy scenarios would have derailed a far more serious actress. Consequently, she was unable to make the transition to commercial entertainment cinema. Sedgwick ultimately failed to parlay her celebrity into anything worthwhile, allowing her opportunities for a career to dissipate. As her relationship with Warhol waned, Sedgwick fell into a netherworld of drugs and mental illness. Many people held Warhol responsible for her spectacular tailspin and Edie herself eventually came to think of him as diabolical.

"Now and then," Warhol acknowledged, "someone would accuse me of being evil—of letting people destroy themselves while I watched, just so I could film them and tape record them. But I don't think of myself as evil—just realistic. I learned when I was little that whenever I got aggressive and tried to tell someone what to do, nothing happened—I just couldn't carry it off." He believed that by keeping his mouth shut, his silence might cause people to reconsider their ways. "When people are ready to, they change. They never do it before then, and sometimes they die before they get around to it. You can't make them change if they don't want to, just like when they do want to, you can't stop them."[39]

NOTES

1. Andrew Sarris, "Films," *The Village Voice,* December 9, 1965, p. 21.
2. *Harlot* had its premiere at the Café Au Go Go on Bleecker Street in Greenwich Village on January 10, 1965.
3. Interview with Ronald Tavel, May 28, 1988.
4. The premiere of *Screen Test #2* took place at the Film-Makers' Cinémathèque at the Astor Place Playhouse on June 12, 1965.
5. Andy Warhol and Pat Hackett, *POPism: The Warhol '60s* (New York: Harcourt Brace Jovanovich, 1980), p. 181.
6. Thom Andersen, "Film," *Artforum,* June 1966, p. 58.
7. Interview with Ronald Tavel, June 10, 1988.
8. *The Life of Juanita Castro* had its premiere at the Film-Makers' Cinémathèque on March 22, 1965.
9. Andrew Sarris, "Films," *The Village Voice,* December 9, 1965, p. 21.
10. Interview with Ronald Tavel, June 13, 1988.
11. The premiere of *Horse* was at the Film-Makers' Cinémathèque on November 22, 1965.
12. Patrick S. Smith, *Andy Warhol's Art and Films* (Ann Arbor, Mich: UMI Research Press, 1986, 1981), p. 497.
13. Gretchen Berg, "Nothing to Lose/Interview with Andy Warhol," *Cahiers du Cinema in English,* May 1967, p. 42.
14. *Poor Little Rich Girl* had its premiere at the Film-Makers' Cinémathèque on June 4, 1965, where it played on a double bill with *Vinyl.*
15. "People Are Talking About...Youthquakers," *Vogue,* August 1965, pp. 90–96.
16. Warhol and Hackett, *POPism,* p. 114.
17. Jean-Pierre Lenoir, "Paris Impressed by Warhol Show," *The New York Times,* May 13, 1965.
18. Berg, "Nothing to Lose," p. 40.
19. Jean Stein, *Edie, An American Biography,* edited with George Plimpton (New York: Alfred A. Knopf, 1982), p. 280.
20. *Kitchen* had its premiere at the Film-Makers' Cinémathèque on March 3, 1966.
21. John Wilcock, *The Autobiography & Sex Life of Andy Warhol* (New York: Other Scenes, 1971), n.p.
23. Vincent Canby, "When Irish Eyes are Smiling, It's Norman Mailer," *The New York Times,* October 27, 1966.
24. Wilcock, *Autobiography,* n. p.
25. *Beauty #2* had its premiere at the Film-Makers' Cinémathèque at the Astor Place Playhouse on July 17, 1965.
26. Wilcock, *Autobiography,* n.p.
27. "Society/Edie & Andy," *Time,* August 27, 1965, p. 65.
28. Warhol and Hackett, *POPism,* p. 122.
29. Berg, "Nothing to Lose," p. 40.
30. Berg, "Nothing to Lose," p. 40.
31. "Society/Edie & Andy," *Time,* pp. 65, 67.
32. Warhol and Hackett, *POPism,* p. 123.
33. Stein, *Edie,* pp. 212–13.
34. Guy Flatley, "How to Become a Superstar—and Get Paid, Too," *The New York Times,* December 31, 1967.
35. Warhol and Hackett, *POPism,* p. 133.
36. Interview with Samuel Adams Green, October 4, 1988.
37. Kenneth Anger, *Hollywood Babylon* (Phoenix, Ariz.: Associated Professional Services, 1965), p. 235.
38. Interview with Robert Heide, April 15, 1988.
39. Warhol and Hackett, *POPism,* p. 108.

In 1966, American youth literally faced an acid test as many of their counterculture heroes advised them to "turn on, tune in, drop out." Swallowing a dose of LSD—or "dropping acid," as they used to say —opened the doors to a mind-blowing world of intense sensations. Ironically, Warhol, who never advocated the use of mind-expanding drugs, became a pioneer in a new entertainment phenomenon— the psychedelic club that simulated the sights and sounds experienced under the influence of LSD with pulsating and polarized light projections and electronic sound distortions.

While he himself did not perform on stage, Warhol directed a troupe of performers that included rock musicians, dancers, and various lighting assistants who handled the multiple movie and slide presentations. By simultaneously projecting three or so films, frequently altered with theatrical gelatins, onto the walls as well as over the live performers and the audience, Warhol and his cohorts barraged spectators with cinematic images and colored lights amid a not-so-musical setting of amplified screeches and drones. All was intended to evoke the wild throbbing patterns and the intense, distorted hues and sounds familiar to users of hallucinogenic drugs.

Warhol's involvement with psychedelic light shows stemmed from his participation in an Expanded Cinema festival at the Film-Makers' Cinémathèque in November 1965. Jonas Mekas and his colleagues at the Cinémathèque had organized an ambitious series of programs that surveyed a broad spectrum of formal innovations involving projected images. The various presentations explored the uses of multiple screens, multiple projectors, hand-held projectors, interrelated screen and live images, moving slide projections, kinetic sculpture, balloon screens, video projections, and many light and sound improvisations. The participants included several widely known figures, such as Claes Oldenburg, Nam June Paik, Robert Rauschenberg, and Robert Whitman, as well as a number of emerging psychedelic "light" artists, such as Jackie Cassen, Don Snyder, and Gerd Stern and the USCO group. Warhol's two evenings, November 22 and 23, featured split-screen movie projections accompanied by a rock group and the early glimmers of a light show.

Warhol was eager to annex himself to the pop music scene. Ever since his infatuation with live rock 'n' roll shows in the early

"After the briefest of pauses, onstage came The Velvet Underground, a four-member musical group whose most notable attribute is a repetitive howling lamentation which conjures up images of a schooner breaking up on the rocks. Their sound, punctuated with whatever screeches, whines, whistles, and wails can be coaxed out of the amplifier, envelops the audience with disploding decibels, a sound two-and-a-half times as loud as anybody thought they could stand."—John Wilcock [1]

191. *Cow Wallpaper.* 1966. Silkscreen ink on paper, image 44 x 30". Courtesy Leo Castelli Gallery, New York

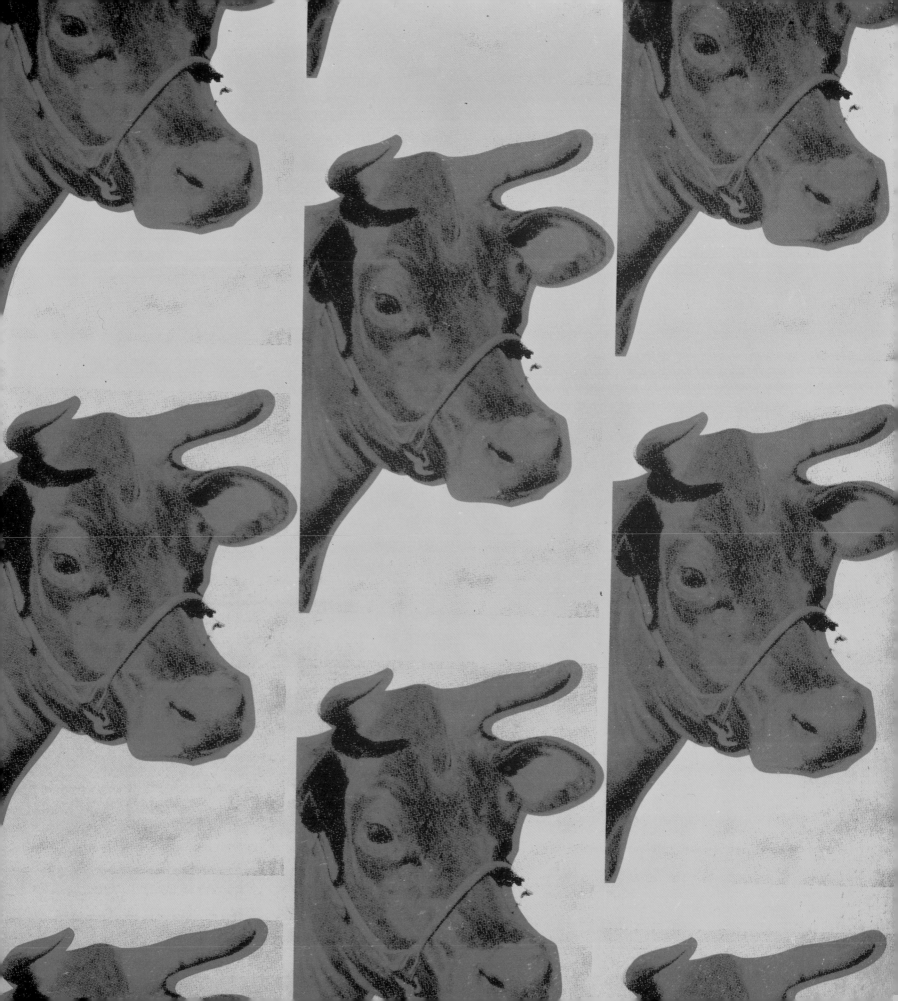

192. Nico, the glamorous German model, possessed a singing style that left some listeners speechless.

1960s, Andy had believed that the world of pop music offered promises of glamour and pots of gold. Soloists, he noted, had been largely supplanted in the Top-40 charts by bands such as the Beatles, the Supremes, the Rolling Stones, and the Beach Boys. To Andy, who frequently flattered his friends one at a time into artistic collaborations, the thought of combining forces with an entire group of musicians was immensely appealing. Just as discotheques and light shows were coming into their own, he demonstrated his shrewd sense of timing once again by linking up with a rock group.

Toward the end of 1965, Gerard Malanga, still the Factory's primary talent scout, brought Warhol and Paul Morrissey to Café Bizarre, a Greenwich Village cabaret, to hear a group of rock musicians who called themselves The Velvet Underground. Although the band had no official leader, its mentors and chief composers were snub-nosed Lou Reed, who sang in a listless and nasal monotone and played guitar, and John Cale, whose instruments included the electric viola. Reed and Cale had been knocking around the Village for quite a while, meeting so little success that they sometimes resorted to selling their blood to make ends meet. Eventually, they joined up with two other musicians, Sterling Morrison, who played bass guitar, and Maureen Tucker, a sweet-faced young drummer.

The Velvet Underground radiated an air of hostility and malevolence. Their unmelodic whines and drones were painful to the ear, and their lyrics were determinedly decadent, dwelling on subjects that ranged narrowly from illicit drugs to perverse sexuality. But something about their mediocre material and nutty amateurism must have appealed to Andy. He invited them to drop by the Factory, and before long, The Velvet Underground was rehearsing there, surpassing in decibels the opera records that still blared at any hour.

Warhol and the Velvets established their alliance without any preconceived plans. It just seemed obvious that they should link their music with his movies. The idea of combining movies and live music was not unique, nor was the concept of superimposing a light show on a rock performance. But there was still plenty of room for experimentation, so both Warhol and the Velvets were optimistic that their collaboration would be worthwhile.

According to Malanga, Warhol realized from the start that the Velvets by themselves were not very charismatic on stage, prompting him to search for someone more attractive to put in the spotlight. This featured role seemed ideally suited to Nico, a sleek blond fashion model who wanted to make a name for herself as a singer. Born in Cologne, Germany, and originally named Christa Paffgen, Nico grew up in Berlin and later worked as a model in Paris and Rome, where at age seventeen she played a minor role in Federico Fellini's 1960 film classic, *La Dolce Vita*. She was about twenty-three years old when she arrived in New York in January 1966. With her statuesque figure (she was five feet, nine inches tall), clean-cut features, and straight shoulder-length hair, with bangs that framed her large ice-blue eyes and heavily mascaraed lashes, she was quickly registered with the prestigious Ford Model Agency and groomed for stardom in Warhol's films.

To Warhol, Malanga, and Morrissey, Nico represented a new type of female superstar, a mysterious and somewhat gloomy "moon goddess." They began promoting her as the 1966 Girl of the Year, thinking that, because she was so introverted and European, she might provide a welcome contrast to the vivacious, extroverted, all-American personalities of Baby Jane Holzer and Edie Sedgwick, both of whom had played this social role to the hilt. Nico, meanwhile, enjoyed the prospect of becoming an underground film star, claiming to have turned down several offers to appear in commercial movies in order to work with Warhol.

Although she looked wonderful on film, Nico was not especially animated, and she spoke haltingly and reluctantly, often appearing deliberately uncommunicative. Her singing voice was unmelodious and so adrift that listeners had to wonder if she was deliberately off-pitch. Still, Warhol thought she would be an attractive vocalist for The Velvet Underground, and he threw her into the act. The Velvets resented being treated as a backup band for Nico, so the teaming of the German chanteuse with the New York rock group was destined to be a dissonant match.

Warhol and The Velvet Underground made a sensational joint appearance at an annual black-tie banquet of the New York Society for Clinical Psychiatry at Delmonico's Hotel on Park Avenue in mid-January. Andy had been invited to speak to the group, but as he always refused to lecture, he decided to entertain the group with two of his movies, *Harlot* and *Henry Geldzahler*, and the Velvets' music. The several hundred psychiatrists and their spouses evidently were unprepared for the audiovisual assault. Soon after the main course was served, they were startled almost out of their chairs by fiercely amplified rock music, which drowned out conversations. Nico, making what may have been her New York singing debut, groaned incoherently into the microphone. On stage, Malanga threw himself into his strenuous whip dance, while Edie Sedgwick launched into leggy gyrations. Filmmaker Barbara Rubin, accompanied by Jonas Mekas and a crew carrying portable photofloods, roamed among the tables, aggressively closing in on certain headshrinkers and asking them embarrassing questions about their sexual practices. The interviewees were intimidated by her *cinéma-vérité* style, and many abandoned their roast beef and red wine to leave in a huff. The next day's *Herald Tribune* ran a story headlined "Psychiatrists Flee Warhol," spreading the notion that the artist's perversity was uncontainable, terrifying even professionals in the field.

Mekas continued to endorse Warhol's cinematic experiments, advising his readers in the *Village Voice* to see more of the artist's current productions. He particularly praised *Edith Sedgwick*, a double-screen projection, calling it "among the most important new works I have seen anywhere." Warhol, Mekas wrote, "may be the greatest portraitist living." His portrait of Sedgwick, "with four faces (and four soundtracks) projected at the same time (combination of rear-screen projection, videotape, and actual filming) belongs to the best cinema made today, and, it is also possible, marks one of the climaxes in Andy Warhol's creative work."[2]

During the second week of February, Warhol and his colleagues presented a week of mixed-media performances at the Cinémathèque, then located in the basement of the Wurlitzer Building on West 41st Street. (The ad read: "ANDY WARHOL, UP-TIGHT/presents live/The Velvet Underground, Edie Sedgwick, Gerard Malanga/Donald Lyons/Barbara Rubin/Bob Neuwirth/Paul Morrissey/Nico/Daniel Williams/Billy Linich" and promised "Up-tight Rock 'n Roll, Whip Dancers, Film-maker Freaks."[3] The films included *Vinyl, Empire, Eat,* and the premiere of *More Milk, Yvette,* starring Mario Montez in a takeoff on Lana Turner.

One of the undisputed stars of these presentations was Malanga, dressed in black leather and cracking a long whip, demonstrating his considerable talents as a go-go dancer. (As a teenager, he had danced regularly to Top-40 songs on disc jockey Alan Fried's "Big Beat" television show.) He easily upstaged the band by going through a series of jerky, primitive moves and energetically gyrating himself into convoluted skeins of an electrified plastic tape that glowed with a phosphorescent green hue.

The Velvet Underground's musical style was deliberately offensive—abrasive and discordant, full of unpleasant feedback and electronic distortion. They seemed intent upon alienating their listeners, singing their angry, scornful lyrics so that the words were unintelligible, repeating certain phrases with relentless monotony, playing with their backs to the audience if they felt like it, and changing tempos if they suspected anybody thought the music was meant to be danceable. Audiences walked out in a daze, and it took about fifteen minutes for all the vibrations to clear out of their ears.

Nico's musical style also left much to be desired, although she was certainly a striking image onstage. Writers delighted in finding analogies for her unmelodious voice, which sounded like "an amplified moose"[4] or "like wind in a drainpipe."[5] Perhaps the most amusing critique was: "She sounded like a Bedouin woman singing a funeral dirge in Arabic while accompanied by an off-key air raid siren."[6]

Nico's ascendancy in the galaxy of Warhol superstars coincided with Edie Sedgwick's eclipse. After February, Edie seldom appeared in public with Warhol. Bob Dylan was still hinting that she might be his leading lady in a film, and at his urging, she signed a contract with his manager, Albert Grossman, who reportedly advised her to avoid Warhol and the questionable publicity that emanated from the Factory. Andy was annoyed when he found out about it. "We were going to get an agent together," he said, "and then she was trying to get an agent without me. That's what was so funny. I thought she was doing it with me, but she was trying to push me out of the picture. She had Dylan's agent. He was paying her bills. She just wanted somebody to pay her bills."[7]

Sedgwick told Warhol that she did not want him to show any of her films anymore and that she was going to costar in a film with Dylan. Warhol and Morrissey realized she had a crush on the singer and suspected she had deluded herself into thinking she could have a serious and lasting relationship with him. Andy could not resist puncturing her fantasy by asking, "Did you know, Edie, that Bob Dylan has gotten married?" She went white with shock, refusing to believe that Dylan had secretly married someone else without telling her. That ended her relationship with Andy. "She just couldn't get it together," Warhol concluded.[8]

By March, Warhol's multimedia show was ready to hit the road, playing out-of-town dates. That month, the Rutgers College Film Society invited Warhol to New Brunswick, New Jersey, to show some of his work. On the day of the big event, according to journalist John Wilcock, a longtime Warhol friend, the campus was "a hive of apathy." By the time the first of the three-car contingent arrived, fewer than two hundred of the one thousand available tickets had been sold and most of the posters that announced the event had been "torn down by anonymous ill-wishers." The program began with screenings of *Vinyl* and *Lupe*. Soon after, The Velvet Underground came onstage and filled the auditorium with the loud, piercing sounds that made Wilcock think of "a schooner breaking up on the rocks." Three movie projectors operated simultaneously from different areas of the hall, superimposing movies upon movies and images upon people who were appearing in the movies. Spectators, Wilcock noted, were subjected to multiple projected images of the blond vocalist: "Nico's face, Nico's mouth, Nico sideways, backwards, superimposed, on the walls, the ceiling, on Nico herself as she stands onstage impassively singing."[9]

By the second show, it was discovered that the screen was retractable, so the movies were shown on its constantly shifting surface, which must have had an effect on the focus. "Fantastic," Andy said, as he flickered colored gelatins in front of his projector lens. Malanga, his peroxided blond locks falling across his face as he bobbed his head and wagged a pair of long flashlights that beamed randomly into the audience, danced onstage with Ingrid Superstar, a sprightly new member of the entourage. (Ingrid, whose actual surname was von Scheven, was a Manhattan office temp from New Jersey. Naive, good-natured, and able to withstand more

than her share of ridicule, she apparently fell for Warhol's tantalizing line that she and Nico were the leading contenders for the 1966 Girl of the Year.) Then, disaffected students set off the fire alarm, but its series of stabbing rings and blinking red light only added to the excitement and urgency of the light-and-sound spectacle. At the end of the evening, the Film Society received one-third of the $1,300 take, and Warhol got the rest.[10]

Three days later, the eleven-member Warhol troupe was at the University of Michigan in Ann Arbor. They made the fifteen-hundred-mile round trip in a rented minibus, which, according to Wilcock, "offered some of the comforts of home—including a toilet that, like the one in the 47th Street Factory, didn't work."[11] Nico did the driving while the Velvets rehearsed on a mattress in the rear of the bus. In Ann Arbor, Malanga and Ingrid Superstar once again danced amid a tangle of luminous plastic tape, as Warhol inserted a colored gelatin filter into the film projector to turn *Vinyl* into a deep dark red and one of the slide machines swept the walls and ceiling with an image of a gigantic, unblinking eye. In contrast to Warhol's reputation for promoting boredom and repetition, his traveling rock and light show was never the same from one performance to the next.

Back in New York, Andy and Paul heard about a big dance hall available for hire in the Polski Dom Narodowy (National Polish Home) at 23 St. Mark's Place between Second and Third avenues, the main drag of the East Village. After checking out the place, an enormous second-floor room with a stage at one end and a balcony opposite, they instantly decided to sublet it for the month of April. The space was leased to Jackie Cassen, a psychedelic artist who worked with colored light projections. Cassen had collaborated on occasion with LSD guru Timothy Leary on theatrical "Psychedelic Celebrations," for which she crafted abstract slides with gels and dyes to evoke the retinal images and hallucinations experienced under that drug. Warhol didn't think very highly of her art, but he nonetheless invited her to work with him.

The next day Warhol's crew painted the place white so they could project films onto the walls. They brought in several movie and carousel slide projectors as well as spotlights and filters. The Dom had a revolving mirrored ceiling fixture, and Warhol brought down

193. Ingrid Superstar, an earthy New Jerseyite, harbored dreams of becoming the 1966 Girl of the Year. Photograph by Paul Morrissey

the large mirrored fixture that normally sat on the Factory floor; when both rotated, with spotlights aimed at them in the dark, they reflected swirling pinpoints of light all over the room.

In addition to the multitude of projectors and spotlights and the revolving mosaic of mirrors, the lighting apparatus included that hypnotic device so indispensable to any 1960s light show: strobe lights. Programmed to flash on and off several times per second, the strobes emitted a cold, harsh light that illuminated the surroundings with a rapid, pulsating rhythm. Their flicker created the illusion of arresting the continuous action around them and breaking it into a series of fleeting "still" images. No one needed to drop acid to get

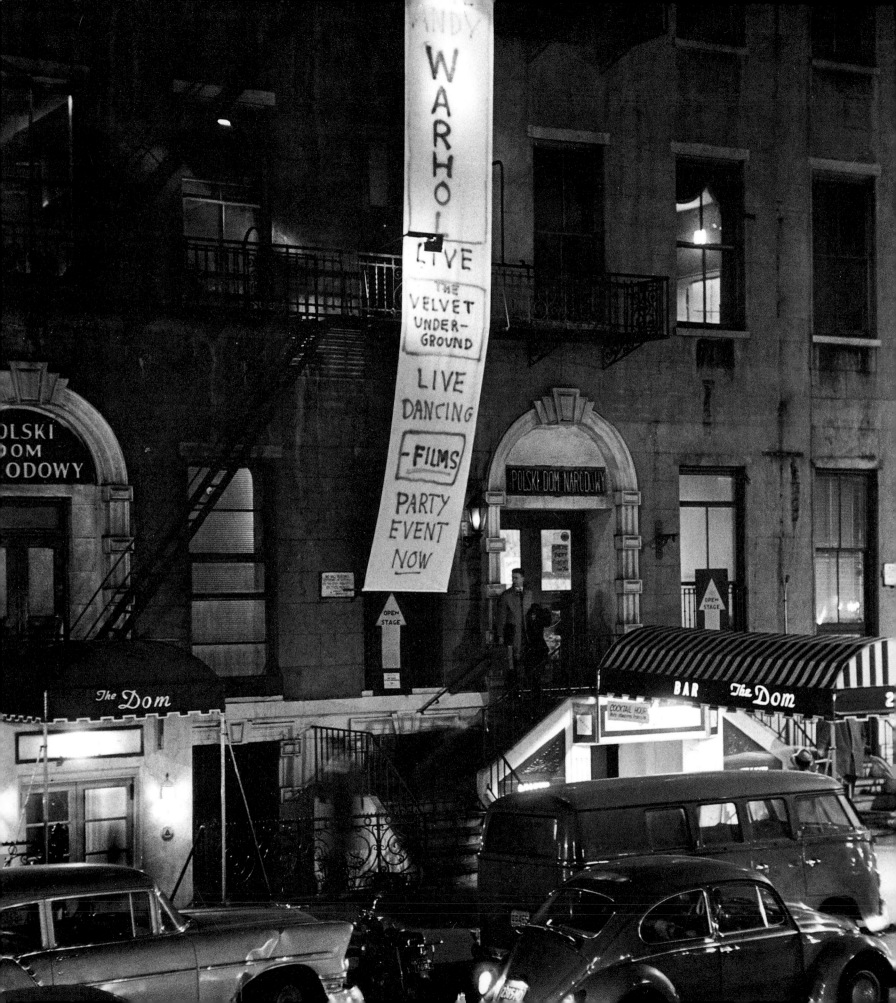

high on strobe lights; just placing one's closed eyes near a flashing strobe could produce an exhilarating sensation of animated colored patterns.

Warhol took out a half-page ad in the April 7, 1966, *Village Voice*: "Do you want to dance and blow your mind with/THE EXPLODING PLASTIC INEVITABLE/live/Andy Warhol/The Velvet Underground/ and/Nico." The ad also listed Malanga, Ingrid Superstar, Mary Woronov (a dark-haired actress who performed stylized S & M–type dances on stage), light works by Daniel Williams, color slides by Jackie Cassen, and movies (*Vinyl, Sleep, Eat, Kiss, Empire, Whips, Faces, Harlot, Hedy, Couch,* and *Banana*). For two dollars on weeknights (fifty cents more on Fridays and Saturdays), anyone could gain access to Warhol and his company of underground zanies.

For the entire month, the Dom was the hip home for Warhol's psychedelic extravaganza. Andy himself, attired in a black leather jacket, polo shirt, and black chinos, seldom ventured from his station on the balcony. (Robert Heide noticed that he wore a glow-in-the-dark crucifix around his neck.) He hovered near the movie projectors, occasionally slipping colored gelatin slides over the lenses, and supervised his lighting assistants as he kept an eye on the flow and mood of people on the dance floor. Andy was always glad to see the friends and admirers who sought him out on the balcony, and he put some of them to work, manning the equipment, while he took a break. The movies were usually projected three at a time onto the rear of the stage and the flanking walls, beaming huge close-ups of Mario Montez licking a banana, Robert Indiana nibbling a mushroom, and Malanga (in *Vinyl*) getting his T-shirt ripped off his torso. Meanwhile, the spotlights aimed at the revolving mirrored balls transformed the ceiling and upper walls of the dark cavernous hall into a crazy night sky with thousands of flurrying stars.

The Plastic Inevitable demonstrated Warhol's facility in conjuring a make-believe realm that encouraged people to see themselves as they wanted to be. Like the title character in the 1939 movie *The Wizard of Oz*, Andy may have been something of a fraud whose visual effects were based on a few projectors and some pretty elementary trickery, but he nonetheless liberated fantasies and instilled self-confidence in others. His message was essentially the same as the Wizard's: believe in yourself and you will become who you want to be. Andy certainly had what he wanted; though physically aloof and literally above it all on the balcony, he was the happy voyeur, surveying a galaxy of exhibitionists.

Like the Factory, the Dom attracted a lively cross section of people from all of the arts and the fashion world as well as thrill-seeking squares from the straight world and shady representatives from the downtown drug culture. On the dance floor, artists, models, computer salesmen, and speed freaks all danced to the same din.

An evening at the Dom gave patrons a pretext for dressing either up or down. Women's attire included miniskirts, body-hugging shifts, patterned stockings, and white boots, as well as more traditional high heels and long chiffon dresses. Men's clothing ranged from tie-dyed T-shirts and blue jeans or mod-style bell-bottomed trousers to an occasional tuxedo. Despite the prevailing darkness, many people wore dark or mirrored glasses as they danced, fiendishly grinding their hips while flourishing spastic-looking limbs.

The setting also provided ample opportunities to cruise for sex and drugs. The Factory's free-ranging colony of speed freaks, in particular, treated the Dom as one of their downtown community centers, a place to barter their stocks of methedrine and amphetamine. Two of the most prominent were Ondine and the Duchess, who, Warhol claimed, "would shoot people up in the crowd if they halfway knew them." "Once, from the balcony," Andy recalled, "I saw blood spurt in a strobe flash across Pauline de Rothschild and Cecil Beaton. Later Ondine came running out of the bathroom screaming that he'd dropped his 'spike' down the toilet by mistake."[12]

Ondine, the most flamboyant and mercurial of the Factory's speed freaks, was a brilliant, if demented, actor with a commanding stage presence. He had dark, Italianate features and an archaic smile that passed for attractive from some angles and looked caricaturish from others. Warhol and Ondine first encountered each

194. In April 1966, Warhol and his colleagues transformed the "Dom," on St. Mark's Place, into one of New York's most "in" clubs. Photograph by Fred W. McDarrah

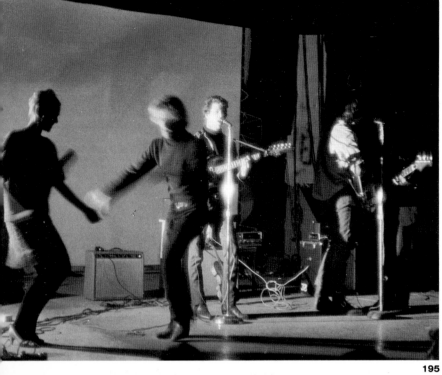

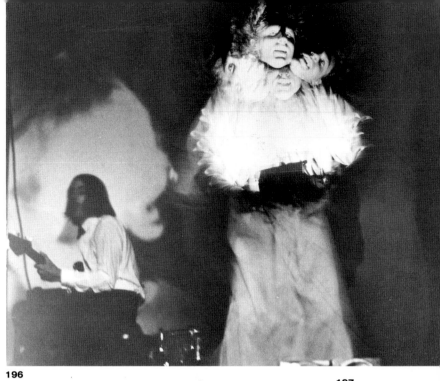

195 196

197

195. Edie Sedgwick and Gerard Malanga dance to the music of The Velvet Underground at the Filmmakers' Cinémathèque, February 8, 1966. Photograph by Fred W. McDarrah

196. Gerard Malanga performs his solo strobelight dance to the sounds of The Velvet Underground at the Dom, 1966.

197. Slide and movie projections create surrealistic effects as The Velvet Underground play at the Dom on April 1, 1966. Photograph by Fred W. McDarrah

198. Warhol operates the projectors from the balcony of the Dom. Photograph by Fred W. McDarrah

other in the early 1960s, though their "meeting" was hardly cordial. "I was at an orgy," Ondine explained, "and he was, ah, this great presence in the back of the room." Ondine, annoyed because Warhol was an uninvolved onlooker, impetuously searched out their host amid the tangle of bodies and demanded: "Would you please mind throwing that thing out of here?"

Rejection was a sure way to catch Warhol's attention. The next time they met, Warhol, still incredulous, said, "Nobody has ever thrown me out of a party."[13] Eventually, the two became good friends.

Andy was so intrigued by Ondine's wayward life and his fast, vivid, amphetamine-fueled speech that he decided to follow him around with a tape recorder for a twenty-four-hour period and turn the resulting marathon dialogue into a novel. Warhol had been tape-recording various conversations since 1964, hoping to convert some of them into slice-of-life plays. But none had ever worked out. Although he was determined to stay up all day and all night in order to tape Ondine (who could stay awake for days at a time), Andy ran out of energy and had to tape the balance on another day. It would take another year and a half to transcribe the tapes. The result was *a*, a "tape novel" published by Grove Press in 1968.

Unlike Ondine, the Duchess, whose real name was Brigid Berlin, had enjoyed a privileged upbringing. Andy liked to think of her as an "heiress," because her father, Richard E. Berlin, was president of the Hearst Corporation. Warhol romanticized her extravagance, telling others how she had squandered a trust fund by throwing parties on Fire Island and renting helicopters to fly into the city to pick up her mail. Brigid reportedly had been left one hundred thousand dollars by one of her father's friends, and had run through it in only seven months, spending it on trips, furniture, and a four-month marriage. At the end of her windfall, she was reduced to visiting her parents once a week to pick up rent money and a twenty-five-dollar allowance. She was basically on the outs with her parents and had been living at the Chelsea Hotel on West 23rd Street for about a year.

Andy's favorite "heiress" was better known by one of her aliases, Brigid Polk—because she sometimes boasted that she injected herself with fifty "pokes" of amphetamine a day. She had

been hooked on amphetamine since the age of fourteen, when a family doctor began treating her for a weight problem. Having lost a grand total of eight hundred pounds since she was a teenager, she never felt compelled to turn down an irresistibly rich dessert. Despite her chronic use of speed, she still presented a hefty, if graceful, figure as she careened around town on her bicycle, often stoned out of her mind. Brigid frequently zipped into the Dom, but in later years she would barely remember the place, recalling only that she had once sidled up to the bar next to Jane Fonda and engaged her in a conversation.

Andy doted on Brigid because she was a "rapper," and he never tired of listening to her intricately detailed stories. When she was at the Factory, Brigid "dished" with Rotten Rita, listened to opera records with Linich, and remained serenely unaware that Warhol was considered by some to be an important artist. Her unbridled outrageousness, however, endeared her to Andy, who marveled, "She'd shoot up anywhere—waiting in a movie line, if she felt like it."[14]

The Exploding Plastic Inevitable also attracted some memorable new faces, notably that of Eric Emerson, a twenty-two-year-old hairdresser and go-go dancer from New Jersey, who liked to show off his robust body in a black T-shirt and Levi's. Emerson was one of the Dom's most spectacular dancers, leaping into the air like a young springbok and doing splits as he landed on the dance floor. Unlike Malanga, who danced onstage with primal, earthbound energy, shaking himself like a wet dog, Emerson commanded attention for the elevation of his vertical takeoffs. Once in a while, he got his hands on a strobe light and danced with it as the pulsating flashes lit up his blue eyes and the ecstatic smile on his little-boy face, framed by dark-blond, shoulder-length hair. Warhol and Morrissey could not help but notice him from the Dom's balcony, and they were impressed by what they saw. They introduced themselves to Emerson and encouraged him to hang around.

Emerson was in many ways an exemplary child of the flower generation with liberated ideas about sex and drugs and ambitions to be a rock singer. He had sprung out of a working-class background to study dance and to perform professionally with the New Jersey Ballet Company. Then he gave that up to put himself through hairdressing school. Although he had an eighteen-year-old wife, his construction-worker father and his brothers considered him a "blossom." "My father thinks I'm a little sweet," Emerson said, "because I let my hair grow long. What he don't understand is that my generation can swing both ways. The last time I saw my father, I walked up to him and said, 'Hi, Pop,' and he hit me in the mouth with a closed fist. I know I could knock my father on his ass, but I respect him. I just let him hit me to get his rocks off."[15]

The bizarre mix of people who were attracted to the Exploding Plastic Inevitable tended to obscure the fact that its multimedia presentation was technologically primitive compared to many of the far more sophisticated psychedelic light shows that soon began turning up in flashy discos all over town. Although Warhol did not originate the rock music/light show/dance hall form of entertainment, he certainly contributed to its popularity.

Warhol's April stint at the Dom coincided with his second show at the Castelli Gallery, making it appear that he was uncommonly prolific. While he and his colleagues lured with-it New Yorkers to his psychedelic extravaganza downtown, he diverted his uptown public with two contrasting types of artworks—silver clouds and wallpaper patterned with pink cow heads. The front room of the gallery was bare except for several dozen helium-filled silver balloons, shaped like large bed pillows, approximately three by four feet, and made of aluminized plastic film, a shiny material that mirrored (and distorted) the scene around them.

The buoyant clouds were a striking sight as they grazed aimlessly about the room, clustering in midair just below the ceiling. Susceptible to air currents, changes in temperature, and static electricity, they endlessly rearranged themselves. Although their movements were mainly dictated by air currents or passersby, they often appeared to express behavioral traits of their own. As soon as one or two started to drift, they created a chain reaction, and, once all the clouds got moving, it took a long time for them to settle down. It was a novel experience to be confronted by floating forms that were soft and resilient and seemed to be both utterly passive and totally free.

The silver clouds demonstrated Warhol's uncanny ability to summarize and comment upon several sculptural ideas that were then in the air. In form, they possessed the simple and irreducible

volumes that characterized so much contemporary Minimal sculpture. Although they had no movable parts, their unrestricted motion and resistance to gravity clearly related them to the 1960s boom in kinetic works and the earlier air-driven mobiles of Alexander Calder. The plumpness and malleability of Warhol's objects corresponded to Claes Oldenburg's innovative "soft" sculptures. The clouds implicitly encouraged spectators to nudge them gently in order to see them float away; this qualified them as "participatory" artworks, still another trendy concept in an antielitist era that advocated greater "spectator participation" for a work's fullest realization. It is unlikely that Warhol intended to load the clouds with such a heavy freight of cross-references, but it is nonetheless remarkable that he managed to take such a "dumb" shape and make it intersect with Minimal, kinetic, "soft," and participatory sculpture.

Warhol devised the clouds in collaboration with Billy Klüver, a thirty-eight-year-old Swedish electronics engineer who worked at Bell Laboratories in Murray Hill, New Jersey. Klüver became widely known in the 1960s as "the artist's scientist" because he provided technical assistance to Swiss-born kinetic sculptor Jean Tinguely, Jasper Johns, and Robert Rauschenberg, among many others. In 1964, Warhol had asked Klüver if it was possible to construct a helium-filled floating light bulb. (Andy's chosen subject might have been prompted by his ownership of Jasper Johns's drawing of a reclining light bulb.) Klüver made some calculations and concluded that a free-floating, self-powered light bulb was not technologically feasible, as the batteries would have been too heavy to float and the lamp would have been too small to give off much light.

Meanwhile, one of Klüver's colleagues, Harold Hodges, came across a metalized plastic film called Scotchpak, produced as a wrapping material by the Minnesota Mining & Manufacturing Company. Scotchpak consisted of one sheet each of polyester film and polyethylene film laminated together with a thin layer of vaporized aluminum in between. It was heat-sealable and highly impermeable. When Klüver brought a sample to Warhol's foil-lined Factory, Andy took one look at it and said: "Let's make clouds."[16]

At first, they discussed simulating the scalloped shapes of cumulus clouds, but that would have necessitated complex curved

199. Warhol and pals prepare to release a test cloud from the roof of the Factory, 1965. From left: Waldo Diaz-Balart, Danny Williams, Paul America, Gerard Malanga, Warhol, Pontus Hultén, Harold Stevenson, Billy Klüver. Photograph by Billy Name/Factory Foto

edges. Andy finally settled on a rectangle, which meant that the plastic film could simply be folded in two and heat-sealed on three sides. Even with perfect heat-sealing, the clouds would have had to be reinflated periodically because no plastic is permanently impermeable to gases.

Warhol preferred the clouds to float in a scattered arrangement, halfway between the floor and the ceiling. If they were fully inflated, they tended to bunch up along the ceiling; if underinflated, they hovered too close to the floor. The solution was fairly primitive: lead fishing weights were tied to the pillow forms to moor them in midair.

The clouds were cheap—fifty dollars each—but collectors balked at buying them for one of the airiest of reasons: in order to keep the clouds afloat, their owners periodically had to reinflate them with more helium. Klüver believed that the works ought to have been sold with a ten-year service contract, which would have been many times more expensive than the clouds themselves. Leo Castelli knew such a servicing arrangement was unworkable—he could not picture himself dashing around the country to supply collectors with buoyant gas—so he planned to sell the silver balloons with small cylinders of helium for do-it-yourself refills.

Warhol's claim that the clouds were disposable art for people who felt burdened by too many possessions certainly didn't help lift sales. As he remarked in a television interview at the time: "You open a window and let them float away and that's one less object."

Warhol's silver clouds reminded some spectators of a legendary Marcel Duchamp installation, created for the Exposition Internationale du Surréalisme at the Galerie Beaux-Arts in Paris in January 1938. Duchamp suspended 1,200 secondhand coal bags from the ceiling of a darkened gallery whose walls were covered with paintings by various artists. Although the coal bags were empty, they retained their plump, filled-out shape and looked very heavy. Warhol, like Duchamp, was an idea man, but his intentions in making the floating pillows were very different. Duchamp was recycling "ready-made" objects into an art-gallery context and, in a typical ploy, switching the orientation of the coal bags from the floor

200. Warhol surveys his silver clouds at the Leo Castelli Gallery, New York, on April 1, 1966. Photograph by Fred W. McDarrah

to the ceiling; Warhol, by contrast, was fabricating new objects that had no previous context. The visual differences were even greater. Duchamp's coal bags were massed as a static relief sculpture on the ceiling, while Warhol's clouds were free agents with their own kinetic life.

It is highly unlikely that Warhol would have perceived, much less acknowledged, any specific connection between his clouds and Duchamp's coal-bag installation. But he was certainly familiar in a general way with the older man's work and, like many younger artists of the 1960s, idolized Duchamp, whose provocative work was rich in conceptual wit and irony. Warhol, on at least one occasion, expressed his desire to make a twenty-four-hour movie of a day in the life of the revered Dadaist. In February 1966, Andy brought his Bolex movie camera to the Cordier & Ekstrom gallery on Madison Avenue, where Duchamp was the guest of honor at a reception for a group exhibition organized to benefit the American Chess Foundation. Duchamp, then seventy-eight years old, was amused by Andy's idea and cheerfully posed for several three-minute reels (plate 204), but the lengthier film project was never realized.[17]

The buoyancy and random movements of Warhol's clouds appealed enormously to choreographer Merce Cunningham, long noted for his unconventional stage settings. Cunningham employed several of the gleaming forms as the floating decor for his plotless dance, *RainForest* (plate 203), created in 1968. The anarchic clouds perfectly complemented Cunningham's free-wheeling choreography for six dancers whose movements evoked forest creatures in a darkened setting. As the Cunningham company soon discovered, however, the clouds were temperamental performers with quirks of their own, not wanting to stir if the theater was too cold and becoming animated as soon as they felt the warmth of the stage lights. To prevent the decor from becoming too rambunctious, Cunningham ended up tethering the clouds so they wouldn't float right off the stage.

The second part of Warhol's exhibition at Castelli's consisted of

201. The artist inflates his gleaming clouds. Photograph by Fred W. McDarrah

202. Warhol, in dark glasses, greets spectators at the opening of his clouds and wallpaper exhibition, which continued at the Castelli Gallery through April 27. Photograph by Stephen Shore

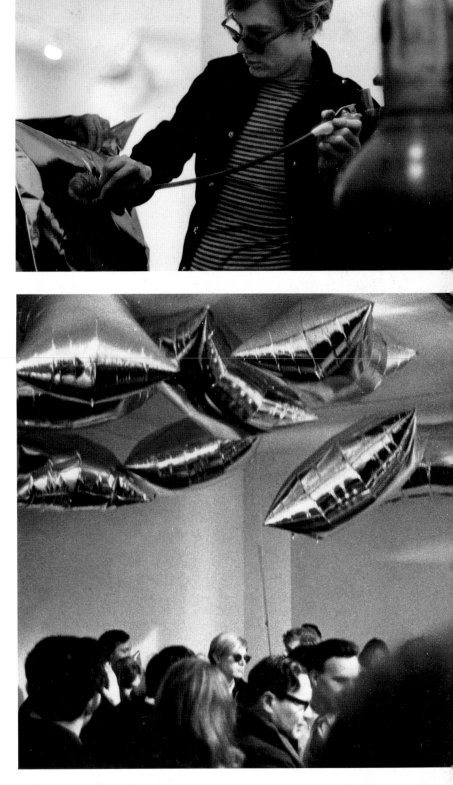

cow wallpaper (plate 205), the only artwork that greeted spectators in a rear room of the gallery. The boldly patterned walls presented the repeated image of a fluorescent pink cow's head, larger than life and staggered in rows against a sulfur-yellow background. The bovine subject had been recommended by Ivan Karp, who collected paintings of cows—a "wonderfully pastoral" and "durable" image in the history of art. After examining hundreds of photographs, Malanga found what seemed to him the ideal one in an agricultural journal that he unearthed in a secondhand bookstore. Warhol was not crazy about the photograph of a jersey cow, but he went ahead and had it converted into a silkscreen, choosing a vivid but abrasive color scheme, as if to suggest that the creature was on some kind of acid trip. The paper was printed and installed by professionals.

With his wallpaper, Warhol appeared to bring his idea of repeating unitary motifs to a logical, if absurdist, conclusion, covering every square inch of wall surface with a banal and uningratiating image. Warhol's purpose in creating wallpaper was interpreted as a didactic act, supposedly expressing the artist's dissatisfaction with painting, a medium that was widely perceived at the time to be an outmoded and—once again—"dead" form that was then being supplanted by minimalist and conceptual art. Warhol's show of wallpaper and clouds was obviously an attempt to do away with painting and sculpture in conventional formats.

Because his silver clouds, cow wallpaper, and multimedia light-and-sound show were all on view simultaneously, generating a cross fire of publicity, Warhol's cornucopia of surprises seemed endless. While still publicly proclaiming his "retirement" from painting, Andy in actuality continued to silkscreen many canvases, producing more electric chairs, some commissioned portraits, and a new batch of vividly colored self-portraits that would surface at a later date. When his month at the Dom was over, he and his troupe headed to Los Angeles, where they had a date to play three weeks in May at The Trip, a club on the Sunset Strip. (The booking coincided with Warhol's exhibition of silver clouds at the Ferus

203. Choreographer Merce Cunningham incorporated Warhol's silver clouds as mobile set decoration for his 1968 dance *RainForest,* performed here by Barbara Dilley and Cunningham. Photograph by Oscar Bailey

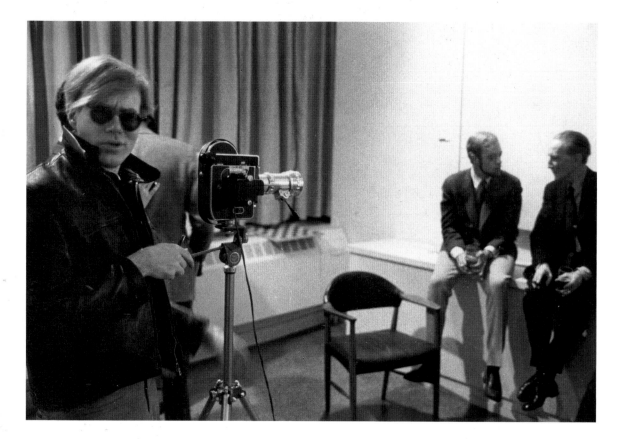

204. Andy aims his movie camera at one of his heroes, Marcel Duchamp, shown here with Sam Green at the Cordier & Ekstrom Gallery in February 1966. Photograph by Stephen Shore

205. For his second show with Castelli, Warhol decorated the rear gallery with his *Cow Wallpaper.* April 2–27, 1966

Gallery, where his soup-can paintings had made their debut four years earlier.) The opening night drew a lively mix of Hollywood celebrities, including Dennis Hopper, and a large number of pop musicians, such as Jim Morrison (the sultry lead singer of The Doors), Cass Elliot of the Mamas and the Papas, and Cher and Sonny Bono. The music aroused complaints that it was altogether too discordant, demented, and destructive. Cher's verdict was quoted in the next day's newspapers: "It will replace nothing except maybe suicide."

The Velvets played The Trip less than a week before the place was shut down because of a legal dispute, but they stayed in Los Angeles for the full three weeks in order to collect the money to which they were entitled under union rules. Warhol and Malanga went on ahead to San Francisco in mid-May, where the artist showed up as a guest on Gypsy Rose Lee's television talk show. He also appeared on a phone-in radio show where "everybody told us how awful we were."

Bill Graham, the impresario who masterminded the famous rock shows at San Francisco's Fillmore Auditorium, invited the Velvets to play there during the final weekend of May. The acidheads, bikers, and flower children of the Haight-Ashbury district, though long accustomed to groups such as The Grateful Dead, were allegedly "bewildered by the absolute malevolence of the Warhol entourage."[18] On their way back to New York, the Warhol troupe played Chicago, where the *Daily News* declared that "the flowers of evil are in full bloom."

That summer, Andy designed an album cover for *The Velvet Underground & Nico* (plate 207), the group's first recording under a major label. He devised a silkscreened image of a single banana with a stick-on peel that could be removed to show the flesh-colored fruit below. (The jacket led to the 1966 *Banana* screenprint of a single fruit in its yellow skin, imprinted on a piece of plastic that can be peeled off to reveal a reddish fruit.)

While Warhol was running around the country with the Exploding Plastic Inevitable, his good friend Henry Geldzahler had been appointed as the United States commissioner of that

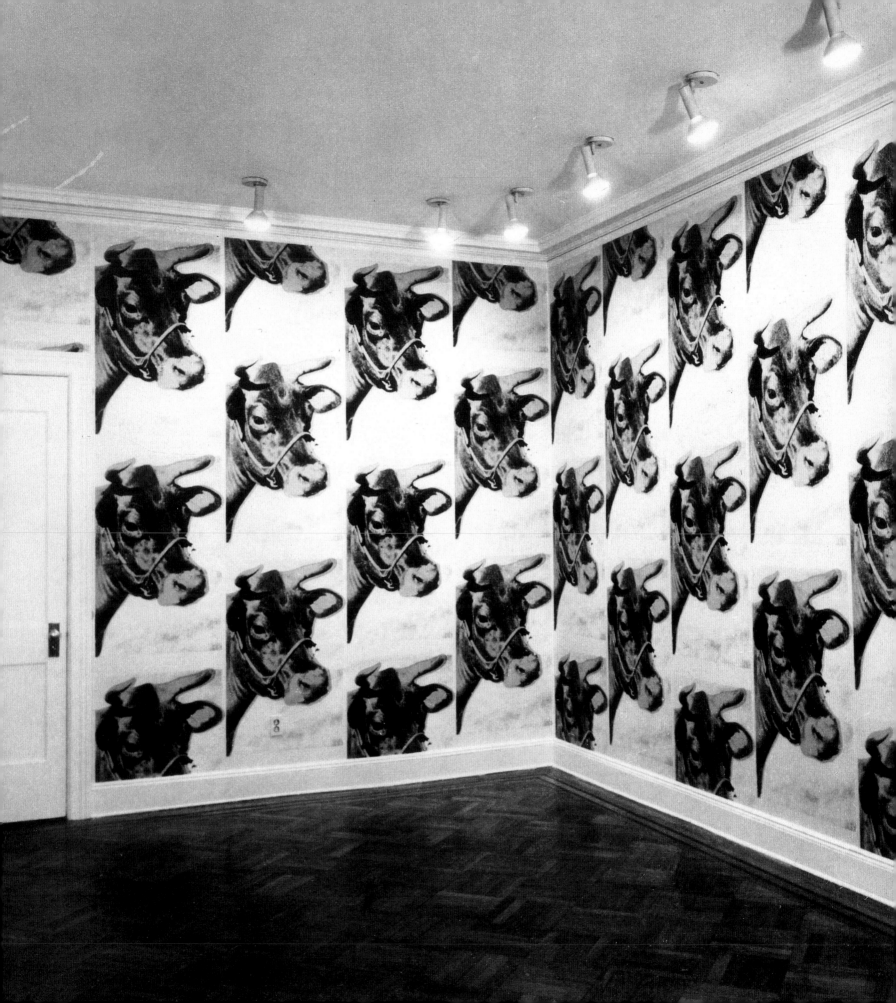

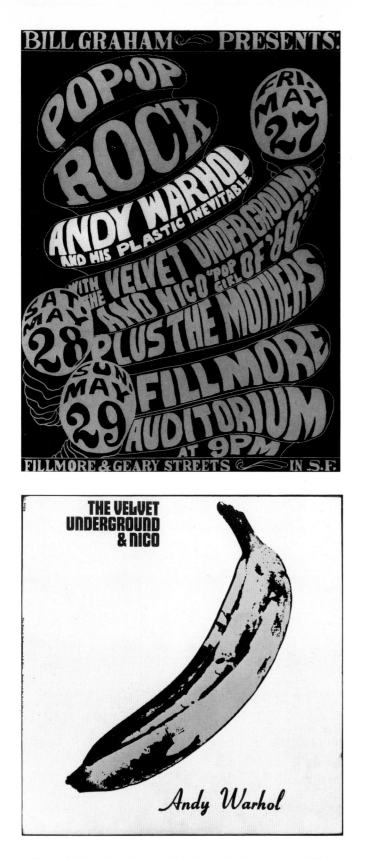

206. Warhol's rock music group played San Francisco's famous Fillmore Auditorium in May 1966, as announced in this Wes Wilson–designed flier.

207. Warhol designed a special album cover for The Velvet Underground in 1966; the silkscreened skin could be peeled away to expose the bare fruit. Distributed by MGM

summer's Venice Biennale. Andy, who first learned of this by reading the *New York Times*, thought it was odd that Henry had not divulged the news to him in person. He naturally had every expectation that Geldzahler would select him to represent the nation in the international exhibition. Warhol also nurtured hopes of winning the top prize, equaling Rauschenberg's triumph two years earlier—a success, he could not forget, that was partly achieved through an adaptation of his own silkscreen technique.

To Andy's dismay, Henry decided to show the paintings of three abstractionists (Helen Frankenthaler, Ellsworth Kelly, and Jules Olitski) and Warhol's old "competitor," Roy Lichtenstein. Geldzahler's choices were motivated in part by a driving need for self-preservation. He didn't want his already controversial reputation as a Pop personage to compromise his chances of being appointed The Metropolitan Museum of Art's curator of twentieth-century art. Henry justifiably feared that if he invited Andy to Venice, the artist would create pandemonium by bringing along his unruly entourage and their movies, amplifiers, and strobe lights. "I wasn't going to screw up my career," Geldzahler said.[19] Moreover, Warhol had been boasting for more than a year that he had "stopped painting." But Andy would not buy Henry's rationale. He was bitterly disappointed and felt betrayed by a friend whose loyalty he had taken for granted. As both were careerists, their friendship necessarily suffered when it conflicted with their ambitions.

Despite his lost opportunity to be lionized as a painter in Venice, Warhol was about to receive a new round of accolades for his achievement as a filmmaker. Over the course of the summer, he spent a great many hours, both inside and outside the Factory, devoting whole reels of film to some of his favorite people, including Nico, Ingrid Superstar, Ondine, Brigid Polk, and Eric Emerson. Sometimes he photographed them in thirty-five-minute-long close-ups, and at other times he filmed their often dissolute interactions with each other in improvised scenes. Few of the reels added up to much on their own, but when he compiled several of them into a single film, he created a shocking and disturbing record of a new "lost generation." By the end of the year, *Chelsea Girls* would be recognized as his cinematic masterpiece and hailed as "the Iliad of the underground."[20]

NOTES

1. John Wilcock, *The Autobiography & Sex Life of Andy Warhol* (New York: Other Scenes, 1971), n.p.
2. Jonas Mekas, "Movie Journal," *The Village Voice*, February 3, 1966, p. 21.
3. *The Village Voice*, February 3, 1966, p. 22.
4. Howard Smith, "Scenes," *The Village Voice*, September 29, 1966, p. 28.
5. Howard Thompson, "Film: For Andy's Hardiest," *The New York Times*, December 17, 1967.
6. "Mod Marriage in Minigown," *World Journal Tribune*, November 21, 1966.
7. Telephone conversation with Andy Warhol, November 23, 1971.
8. Telephone conversation with Andy Warhol, November 23, 1971.
9. Wilcock, "On the Road," *Autobiography*, n.p.
10. Wilcock, "On the Road," *Autobiography*, n.p.
11. Wilcock, "On the Road," *Autobiography*, n.p.
12. Andy Warhol and Pat Hackett, *POPism: The Warhol '60s* (New York: Harcourt Brace Jovanovich, 1980), p. 163.
13. Patrick S. Smith, *Andy Warhol's Art and Films* (Ann Arbor, Mich.: UMI Research Press, 1986, 1981), p. 423.
14. Warhol and Hackett, *POPism*, p. 159.
15. Interview with Eric Emerson, January 1968.
16. Interview with Billy Klüver, September 2, 1987. Klüver became founding president of Experiments in Art and Technology, Inc. (E.A.T.) in 1966.
17. Warhol's art collection contained many examples of Duchamp's work, including five Rotoreliefs, two copies of *La Boîte en Valise* (the "portable museum"), two of the ready-mades (the porcelain urinal titled *Fountain* and the snow shovel titled *In Advance of the Broken Arm*), and several etchings.
18. A. D. Coleman, "Theatre: Bridget Polk Strikes!," *The Village Voice*, January 11, 1968, p. 36.
19. Wilcock, *Autobiography*, n.p.
20. Jack Kroll, "Underground in Hell," *Newsweek*, November 14, 1966, pp. 109ff.

"Many strange lives open before our eyes, some of them enacted, some real—but always very real, even when they are fake—since this is the Chelsea Hotel of our fantasy, of our mind."—*Jonas Mekas* [1]

208. *Self-Portrait*. 1967. Acrylic and silkscreen ink on canvas, 22 x 22". Private Collection

The Factory's ever-increasing chaos made it difficult for Warhol and his assistants to accomplish routine chores. Over the years the various clusters of people attached to Warhol, Gerard Malanga, and Billy Linich had become unmanageable, and it was virtually impossible to get anything done in the anarchic atmosphere of a twenty-four-hour "open house." Linich's friends were constantly disappearing into his darkroom, often on furtive missions involving drugs and tricks to which they weren't entitled. Periodically, Linich, Malanga, or Paul Morrissey would have to make the rounds of the Factory and eject all the people who had no business there. A sign was finally put up: "Please telephone or make or confirm visits, appointments, etc. No drop-ins. The Factory. ALL JUNK OUT."

No one paid any attention to the sign, of course, but Warhol usually managed to concentrate on his projects despite the interruptions. One August night, he was working late, painting some commissioned portraits and taking fashion photographs for a publication named *Intransit*, when Malanga made an unwelcome appearance. The young man was having a bumpy time as he came down from an LSD trip, and he was being assisted in his recovery by two of his smart friends—Susan Bottomly, an attractive young brunette model from Boston, and poet-critic René Ricard. Warhol was dismayed to see them, especially as he planned to make a movie later that night. As Malanga recorded in his diary, "Andy wants me to clear out of the Factory because he wants to shoot the sound remake of *Blow Job*—but René beats Andy to the punch and gives the potential star of the film a 'job' on the staircase landing before Andy is ready to shoot and the star no longer wants to do the film and Andy is uptight because René has ruined the film project for Andy." The angry artist told Gerard that "René won't be allowed in the Factory because of his misbehavior." [2]

Several of Andy's friends from earlier days began to drop out of his life around this time because they didn't approve of some of the weird people who now surrounded him. Jane Holzer, for instance, thought the Factory had become a "very scary" place with "too many crazy people around who were stoned and using too many drugs.... The whole thing freaked me out, and I figured it was becoming too faggy and sick and druggy." [3]

Andy was filming like crazy all year, making as many as three

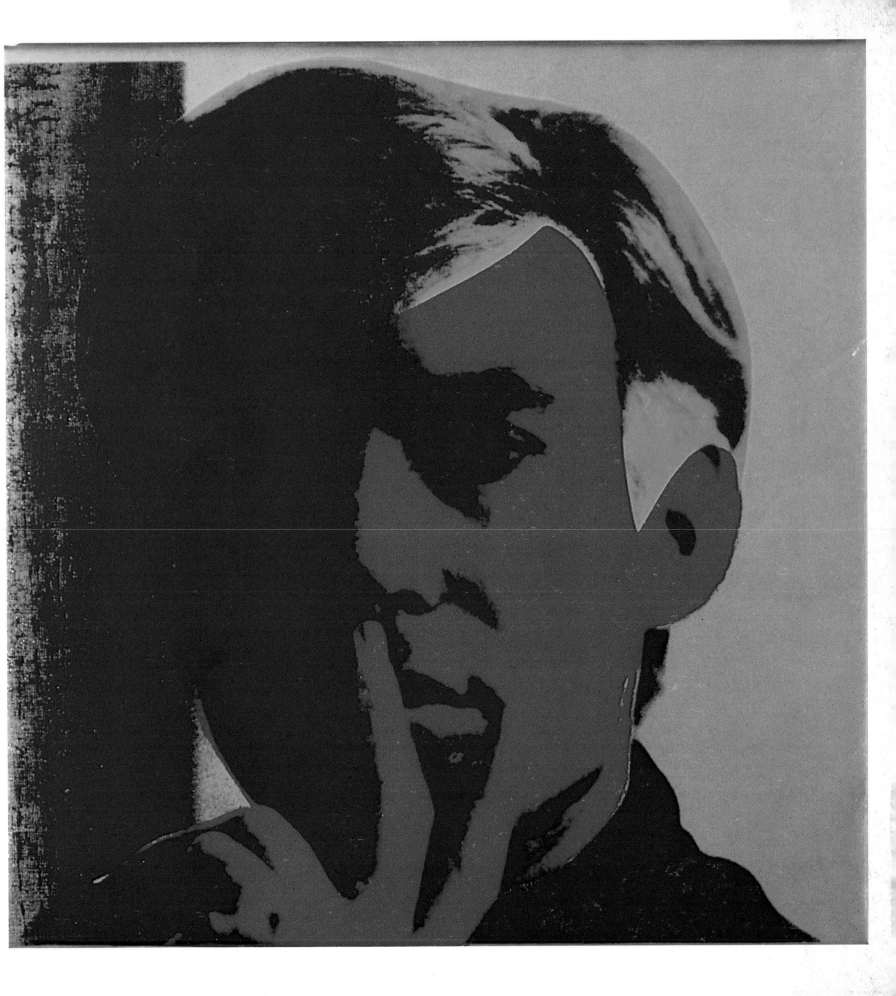

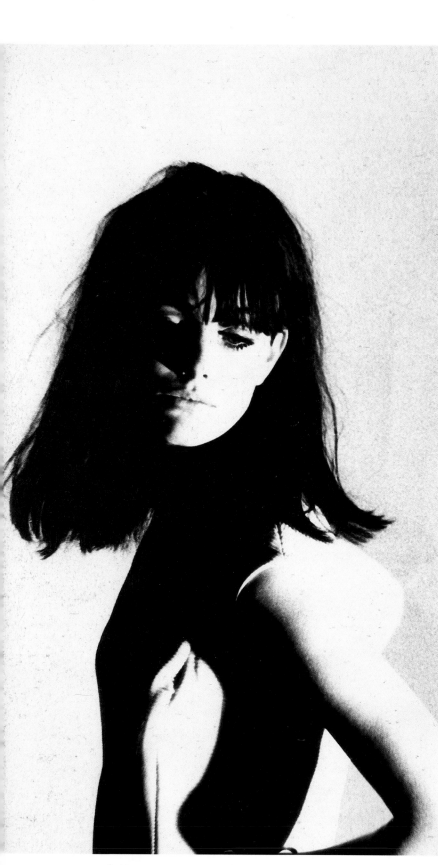

209. International Velvet (Susan Bottomly) sashays her way through a scene in *Chelsea Girls,* 1966. Photograph by Billy Name/Factory Foto

movies a week. He shot dozens of thirty-five-minute-long reels in the Factory and all over town. A few of the reels were scripted, but most were improvised. He filmed Eric Emerson and Ondine separately at the Factory. He filmed Marie Menken and Gerard Malanga, playing mother and son, in a Greenwich Village apartment, and he shot several sequences at the Chelsea Hotel, a famous establishment that catered to an international gathering of bohemian artists and writers, on West 23rd Street.

Many of Andy's female friends, including Nico, Brigid Polk and Susan Bottomly, were living at the Chelsea Hotel. Bottomly, easily recognized by her windshield-wiper lashes and thick eyeliner, performed in Warhol's movies under the name International Velvet, a takeoff on the 1940s film *National Velvet*, which starred Elizabeth Taylor. Bottomly's modeling career was a bit unorthodox, attaining one of its curious peaks when she was photographed sitting doubled up inside a garbage can for the February 1967 cover of *Esquire*, headlined "The New American Woman: through at 21." She and Brigid were among the most social of the Chelsea's residents, constantly visiting one another as if they all shared rooms in the same house. Brigid claimed that she spent most of her time in "in-house visiting," seldom returning to her own room more than once a week.

Oddly, while Warhol's creative process enabled him to base his paintings and drawings on preexisting picture sources, he preferred to improvise his movies without a script. Professional actors, he maintained, expected to be told what to say and to do and were often unable to improvise. So he turned to some of the exaggerated types lurking about the Factory and "cast" them, more or less, as themselves. Although plot outlines were sometimes decided upon in advance, the performers made up their own lines and devised their own actions as they went along. "I leave the camera running until it runs out of film," Warhol said, "because that way I can catch people being themselves instead of setting up a scene and shooting it and letting people act out parts that were written because it's better to act naturally than act like someone else because you really get a better picture of people being themselves instead of trying to act like they're themselves."[4] The result was often an engaging blend of real life and acted-out fantasies.

By now Warhol had a stable of superstars—people in whom he discerned a touch of star quality or "magic." Several of these performers possessed a natural flair for outrageous behavior. Without too much prompting, they launched into long and detailed monologues and stayed in character no matter what happened. Sometimes they immersed themselves so deeply into their self-impersonations that it was almost as difficult for them to separate actual feelings from fabricated emotions as it was for the audience.

Often, the reel came to an end just as the dialogue or situation was becoming really interesting, but Warhol seldom attempted to continue or develop the action in a subsequent reel. Each reel documented its corresponding chunk of time, arbitrarily recording whatever events took place within the thirty-five-minute-long time span.

At some point, the idea crystallized to take several of the reels that Warhol had been shooting during the summer and compile them into one long film, simultaneously projecting two scenes side by side. Warhol came up with a way to unify the episodic reels by treating each as a voyeuristic gaze into the private lives of various characters who might be staying, at least theoretically, in eight different rooms at the Chelsea Hotel. His format thus mirrored a popular type of fiction in which a hotel or boat represents a microcosm of the world. (Some outstanding examples of this type of narrative with multiple story lines are popular novels such as Vicki Baum's *Grand Hotel* or Katherine Anne Porter's *Ship of Fools*, and later television series such as *Hotel* and *The Love Boat*.)

Warhol's main motive in juxtaposing two scenes was not, as some critics maintained, to reduce the showing time. (Anyone who would make a six-hour movie of a sleeping man or an eight-hour movie of the Empire State Building is not concerned about being succinct.) Instead, his aim was to continue with the split-screen projections with which he had been experimenting since the previous year. The double screen seemed an apt format inasmuch as the film supposedly brings us inside various rooms of the hotel. It implies that each of the viewer's eyes is peering through a keyhole in adjoining rooms at actions that are occurring simultaneously.

Chelsea Girls is nearly three-and-a-half hours in length, but actually contains about seven hours of film. The work consists of

210. Eric Emerson delivers an intimate monologue against a dramatically illuminated background in *Chelsea Girls*. Photograph by Billy Name/Factory Foto

twelve different reels, eight in black-and-white and four in color. The simple device of juxtaposing two contrasting images side by side contributes to the spectators' mental stimulation, enhancing whatever tension they may feel in trying to follow two scenes at once. Viewers are free to concentrate on one of the adjoining rooms or to take in the overall pattern provided by the two shifting images.

Asynchronous and disruptive actions are running themes throughout the film, embodied both in the out-of-synch presentation of the side-by-side images and by the performers who sometimes appear on both sides of the screen at once. Occasionally, adjoining scenes, instead of competing with one another, display mysterious and tantalizing correspondences, as when Mary Woronov, for instance, enacts a sadistic, tough-talking bully assaulting Susan Bottomly on one side of the screen, while impersonating Malanga's mute, introverted fiancée on the opposite side of the screen. The contrasting performances imply a psychological dualism.

The presentation of the film was as casual as its making. It almost appeared as if the projectionist at the Cinémathèque had a stockpile of reels, but not the faintest idea in which order to show them. All he had to do apparently was to keep both projectors going. The reels were staggered by a few minutes so that none of the paired scenes began or ended simultaneously. When one ended, that half of the screen simply went blank while the projectionist changed reels. The reels could be screened in any sequence, at least theoretically, but tradition established that certain scenes follow or play opposite one another. Although each reel was shot with a synchronous sound track, the volume of one track was always made more audible than the other. As usual, there were no opening or closing credits. In the early screenings, the film was frequently shown with different sequences. Spectators who returned to see the film a second time often saw a significantly changed version. Several screenings perhaps qualified as unique presentations, prompting some reviewers to cite the date and hour of the performance they were writing about.

Chelsea Girls reflected a somber side of mid-1960s America, an era of disaffected youth who rebelled against the social values of their parents, protested the government's military presence in Vietnam, marched for a variety of causes ranging from civil rights to legalized marijuana, and struggled against sexual stereotypes. Warhol's movie seemed shocking at the time for its frankness in dealing with drugs, homosexuality, and the so-called counterculture. Although *Chelsea Girls* only indirectly addresses some of these issues, but it was viewed nonetheless as a disturbing manifestation of a generation of dropouts that was totally out of touch with the social and political realities of the prevailing culture. While American technology was sending a spacecraft, *Surveyor I*, to the moon in order to transmit pictures back to Earth, Warhol was filming drugged, self-absorbed New Yorkers who were tripping into a spaced-out world of their own. While the United States escalated its air war in Vietnam, Andy's people remained oblivious to the world at large.

The characters in *Chelsea Girls* are an uncommonly passive and self-absorbed lot. They spend all their time in small, claustrophobic rooms, where an unkempt bed is usually the main piece of furniture. Many of the individuals are absorbed in repetitive and tiresome role-playing, locked in little power games with their neighbors. Drugs, sex, and paranoia fuel their sordid lives and low-down fantasies. The world they have created for themselves embraces their deviousness. The women in the film are mainly cold-blooded and predatory creatures, and there is not one man in the entire cast who is indisputably heterosexual. A wearying sense of lethargy pervades the film. Perhaps it's all those beds.

In the first reel, Nico is seen trimming her bangs. The mood is placid and contemplative. A male voice is heard offscreen, followed by a harsh sound that suggests the microphone has been placed under a waterfall. The torrential noise turns out to be running water in the kitchen sink as Eric Emerson rinses a coffeepot. A child cries, "Mama," and Nico's son, Ari, enters. Nico speaks to her son in French. The camera zooms in on a kitchen cabinet. Nico brushes her hair. The camera pans up and down. Nico continues to cut and brush her hair, looking in a round hand mirror. While the three performers could represent a family, the silence and emotional distance between Nico and Eric suggest a less intimate relationship. The segment is essentially a very long close-up of Nico, and the volume of its unremarkable sound track is lowered as soon as its neighboring reel comes into view.

243

After a few minutes, the second reel, filmed in contrasty black-and-white at the Factory in late summer, featuring Ondine in his self-styled role as underground antipope, comes into view alongside Nico's close-up. Ondine is ensconced on a sofa, where he hears confession from a young woman. He presses her to admit all her wrongdoing, claiming he has seen her in a "few dyke joints," but she protests she is not a lesbian. Next, Ingrid Superstar appears in dark glasses, long earrings, and short hair, looking as if she had modeled herself upon Edie Sedgwick. (Ingrid played strong supporting roles in several reels, often as the object of various forms of abuse.) She talks about her sexual experiences. The camera bobs up and down. "I'm not a real priest," Ondine admits; "this is not a church." Ingrid and Ondine argue. "I can tell you exactly what's wrong with your mother," he says, advising Ingrid to give her mother some LSD.

After Nico disappears from her half of the screen, Brigid Polk appears, sitting on the edge of her bed and clutching a hypodermic needle in her mouth. Playing a gleefully malevolent, pill-pushing, syringe-jabbing speed freak, she delivers one of the most demonic performances in the film. The segment begins with Brigid giving Ingrid a shot of amphetamine. They disagree where the shot should be delivered. "I give pokes where I give them, Mary," Brigid says, pulling Ingrid's pants down a few inches and stabbing the needle into her backside. But something has gone wrong. Perhaps Brigid's sense of aesthetics has been offended. She removes the syringe and jabs it into Ingrid's fanny a second time. Ingrid sits on the floor, saying, "I feel fine," but she certainly doesn't look it. "She's going to be up for weeks," Brigid crows.

Brigid remarks in passing that she never goes to the Factory anymore because of Andy's "paranoia" about her drugs. "Aren't you in love with Andy?" Ingrid asks. (This is one of the few instances in the film of the so-called alienation effect, in which performers temporarily step outside their roles to comment on the proceedings.) "I better take a poke," Brigid says, plunging the hypodermic needle right through her tight jeans into her buttock. "It's easier that way."

During the scene, Brigid, lolling on her bed, engages in a series of incoming and outgoing telephone calls, speaking to people who do not realize they are participating in a filmed event. She tells some of them that she has drugs for sale, as the filthy soles of her bare feet come into view.

To someone off-camera, Brigid snaps, "You can't tell me what I'm supposed to do, what I'm not supposed to say. If you'd told me, I would never have done it." A man in a black shirt enters the frame and begins styling her hair. Looking in a mirror, she asks, "Are my eyes yellow?" Ingrid rouses herself long enough to invoke Brigid's fury: "I can't turn my back and she's into my drug basket!"[5]

The fourth reel is the first to offer a bit of sex play. It features Ed Hood in a reprise of his role as the elegant, put-upon john in *My Hustler*. This time, Hood, wearing a bathrobe, reclines on a bed alongside a younger man, clad only in briefs. Susan Bottomly enters the room with Mary Woronov, who rolls the young man onto his stomach and ties his wrists behind his back with a belt. She pulls down his underwear to expose his buttocks, and as he rolls over again, he inadvertently flashes his genitals. This fleeting view of a limp penis is the only graphic display of nudity in the entire film, and it was obviously an accident, which contributes to its shock value. The two women disappear, and Malanga and René Ricard enter the picture. Malanga sits on the bed and eats an apple. The entire segment seems as juvenile as a pajama party.

An inane all-girl party takes place in the next reel, which presents Susan Bottomly, Mary Woronov, Ingrid Superstar, and a new character, Angelina "Pepper" Davis, all vying to find enough space for their egos in the same small room. Bottomly preens around in a trendy leather miniskirt and a mesh blouse that reveals her bra. Ingrid, in an uncharacteristic act of aggression, attempts to push Bottomly out the window and succeeds, instead, in ripping her blouse. Bottomly closes the window and sits on the sill, crossing her arms in front of her chest.

A sixth reel, featuring the same all-female cast of characters, is loosely based on a Tavel scenario, *Hanoi Hannah, Radio Star*, which gives the segment an added dimension of outrageous wit. Like the author's *Life of Juanita Castro*, the sketch is a political satire with a female lead; in this case, the heroine is a North Vietnamese agent who broadcasts propaganda, similar to World War II's Tokyo Rose. Tavel distanced himself from the actual filming of the scene, preferring to mail his script to Warhol. ("I felt that we had outgrown

211, 212. Brigid Polk bad-mouths her fellow players in a scene from *Chelsea Girls*.
Photograph by Billy Name/Factory Foto

our use for each other," Tavel said. "I thought that he didn't need scripts anymore and he could do his best work without them, that they were holding him back."[6])

Woronov, who portrays Hanoi Hannah as a caustic bully, squabbles with Bottomly and abuses Ingrid, who cringes under a piece of furniture, shrilly tripping out. "We're the ones who are sadistic," Woronov shouts at Ingrid, "you're not supposed to love it." Bottomly shows her agreement by hurling assorted makeup at Ingrid. Woronov then beats up on Bottomly. When the telephone rings, Woronov asserts her dominance by refusing to let Bottomly answer. Next, Woronov phones in her news stories, including a report on produce, then switches to a live report from *Satellite Seven*. "Hello down there, this is your friendly *Satellite Seven*. I feel like an eagle today.... The Panama Canal is blocked. We suggest alternate routes around the Strait of Magellan."

In a return visit to Ed Hood's room, the young man in his underwear is apparently tipsy on beer. Hood accuses him of having seduced a member of President Lyndon Johnson's administration. Mario Montez, in fancy drag, wearing a black wig, glitter eye shadow, long gloves, and an organdy cape, makes a showy entrance and sings a few bars of a couple of Irving Berlin songs from *Annie Get Your Gun*. The men on the bed display their boorishness by talking through Montez's singing. "What do you like to do?" the young man asks the singer patronizingly. "I'm just a housewife," Montez replies icily. "I'm simply a property owner," Hood says; "I own *that*," he adds, pointing to his companion. "Would you like me to sing another song before I go?" Montez asks. When Hood airily asks for an aria, Montez huffs, "I know when I'm not wanted," and flounces out. Angelina Davis drops in and sensuously whips her long blond tresses on the young man's bare flesh. Ingrid Superstar comes in and, with Hood's assistance, tickles the youth.

Marie Menken, who had previously blustered her way through the title role of *The Life of Juanita Castro*, commandeers a reel in which she plays a harridan of a mother. Wearing a broad-brimmed black hat, she sits on a bed alongside Malanga, who plays her son. Woronov, in mannish attire with a white shirt, black pants, and polka dot tie, sits on another bed to the right. Menken drinks and argues with her uncommunicative son, and demands to know the name of

his mute "fiancée." "I don't know why I have a son like you," Menken complains. "This boy is selfish, wrapped up in himself, loathes his mother…I wish I'd had a daughter. She would have turned out much better." The camera pans wildly, like an oscillating fan on high speed, from Menken to Woronov, who were filmed in color against a grafitti-scrawled wall in a West 3rd Street apartment.

Visually, the most opulent episode of *Chelsea Girls* is the color sequence starring Eric Emerson, who improvises an extraordinary monologue while performing a narcissistic striptease amid a setting of vivid light projections. It is, in fact, the best performance of Emerson's brief career and one of the most impressive reels of film that Warhol ever shot. Andy's only direction to Eric was to keep talking and after a while to take off his clothes. The scene was filmed at the Factory and a good deal of its success is due to Linich's wizardly use of colored spotlights to evoke ever-changing psychedelic fantasies.

Emerson is alone in the dark as colored lights play over his head and upper body. Half his face is an intense blue, the other half a vivid red. He holds up a sheet of silver foil to examine his reflection. He speaks slowly, as if stoned, in a little-boy voice with a bit of a lisp that may be nothing more than a drugged slur combined with a New Jersey accent. Nobody dreamed that Eric, who could barely read or write, would turn out to be such an eloquent poet of sensual pleasures.

"My sweat tastes nice," Emerson says. "I like the taste of my sweat….Sweat is exciting….Some people use baby oil to lubricate their bodies…yet the body gives off the best lubricant in the world…. Sometimes, the sweat just comes by looking….Sweat tastes different on all different people…but they all taste pretty good…I wish I were a piece of sweat or a drop of sweat being licked by someone. Dripping down their neck, and having a tongue sweep along and pick me up…and then take me into their body—completely in. To go that far into someone's body."

He is intermittently illuminated by blinding flashes of red and white stroboscopic light. "I like taking off my clothes," he says, removing his shirt. His face and chest become a brilliant cerise silhouette against a deep blue background. As he sheds his jeans and discreetly fashions his shirt into a loincloth, his torso periodically

213. Angelina "Pepper" Davis and Ondine enjoy a rare respite from temperament off the set of *Chelsea Girls*. Photograph by Billy Name/Factory Foto

214. Mario Montez is dismayed by Patrick Fleming's boorish behavior in *Chelsea Girls*. Photograph by Billy Name/Factory Foto

turns red and blue. "I like the feeling of having nothing on…'cause I have something that no one can see. Even though they see all of me, they don't see any of me. They only see that what's shown. They don't see what's inside….So even though they see your body, they don't see anything, because what you have that's inside—that's the most important part."

Emerson's body temporarily becomes a black silhouette against a pulsating colored background. "I like when people think I'm a little funny….They call me gay, queer. I used to get upset, but I don't anymore 'cause I know I'm not funny in that way. Even though I may groove on having sex with a gentleman, that's not to me being gay. I just think it's having a good time with someone. Not only a good time, but a beautiful time….You enjoy me, and I'll enjoy you…. We'll laugh, we'll sing, we'll play, we'll sing songs together, we'll dance….I know how to make people enjoy me. I know how to make people happy….I'm the kind of person that lingers in someone's mind."

Emerson also appears on the opposite side of the screen, along with several other people, in another color reel with opulent colored lighting. The episode is known as *Their Town*, because Tavel's scenario is a takeoff on Thornton Wilder's play, *Our Town*. In contrast to the lurid psychedelic lighting, the situation is static and the performers remain essentially motionless amid a boxy, artificial setting. The dialogue is seldom audible because the sound track is virtually eliminated in order to emphasize Emerson's solo performance in the abutting frame.

Ondine returns in one of the two concluding reels, providing the film with its most histrionic episode. For many spectators, his spontaneous tantrum is the high point of the film—and certainly his greatest "performance." The Factory setting is the same as in Ondine's earlier scene, but this time the atmosphere crackles with emotional electricity. With half of his face in shadow, Ondine tightens a leather thong around his left forearm, then pokes a hypodermic needle into a vein in the back of his wrist.

The opening minutes are a warm-up as he addresses Morrissey and Malanga off-camera. "It's hard to talk, I tell you," Ondine says. "I don't think I'm going to say a word. I don't think I can." He goes on to say, "I don't want to be pope, I wasn't elected pope," but he offers to provide an inside view of the pope as a man. "We'll talk about what I'm like as a person….I just want to be true to my flock, whoever they may be. My flock consists of homosexuals, perverts of any kind, queens, thieves, criminals of any sort, the rejected by society…."

A few moments after shooting up, Ondine says, "I'm ready to get any kind of confession, Paul. Anyone who wants to confess may confess. I'm just a priest after all, besides being pope." A young woman named Rona enters from the left and perches on the sofa that is back to back with Ondine's. "Tell me what's troubling you," he says. "I want to put you in heaven, to lead my flock to eternal bliss." "Eternal bliss?" she asks. "Well," he says, displaying a bit of impatience, "that's what I'm here for, to bring my flock to heaven." "Heaven? Where's that?" she asks. "You figure it out, Mary," he tells her. "I'll give you a road map." She then antagonizes him by saying that she can't confess to him because he is a phony.

"I'm a phony, am I?" His wrath explodes and he slaps her vigorously across the face. "Get out," he commands, slapping her again and again. "Stop it," she says coldly, as she tries to defend herself from his assault; "get your hands off me." His amphetamine-fueled performance has shifted gears from playacting into a genuine display of emotional fireworks, a rage that obliterates for him the make-believe situation. He is no longer acting a part, but venting genuine anger. She flees the area, and Ondine rushes out of frame to pursue her. The camera stares fixedly at the empty sofa while he fulminates—a rather terrifying piece of fortuitous drama.

"You dumb bitch, how dare you come onto the set and tell me I'm a phony?" he bellows. "You miserable phony, you miserable whore, little Miss Phony, I'll hit you with my hand, you dumb bitch…. I want to smash your face." She is heard crying.

After ranting off-screen, he returns to his sofa and addresses the people behind the camera. He is still beside himself with rage. "Get out of here before I tarnish the rest of your filthy image. A whore, a whore, you filthy whore! How dare you! How dare you!" Looking toward the people behind the camera, he says, "Do you know what she had the nerve to do, audience of mine? She came onto my set as a friend who"—he lapses into a mincing falsetto to mimic her speech—" 'didn't know what to do' and said *I* was a phony….I'll beat

her up again, *and* her filthy husband and anyone *else*....God forbid her and all like her who pretend to do good in the name of good but they are not good....I really don't want to go on," he says, walking away.

The screen momentarily goes black, possibly because someone has passed in front of the camera. Then the lens zooms back to show a broader view and erratically pans to the left as Ondine flies around the Factory, wringing his injured hand. Technical director Paul Morrissey ruefully shakes his head. Gerard Malanga rushes up, looking concerned, realizes he is on camera, and disappears. Billy Linich walks by the edge of the action, urging everyone to calm down and continue the scene. Off-camera, the young woman sobs, "You had no right to do that." Ondine screams back, "What you're trying to undermine here is your very existence!"

Ondine returns again to his sofa and finally begins to calm down. "Anybody who doesn't punish wrong condones it," he says. "The only other thing I can say is that this may he a historic document." He makes a mock collapse on the sofa, while the woman is still heard crying off-camera. "I hope it's over, darlings," he says, "because I've had it." Made aware that the reel still has several minutes to go, Ondine, exhausted and having run out of things to say, asks those behind the camera for suggestions. But his stunned colleagues provide little help, so he improvises the final minutes quietly and without remorse.

Chelsea Girls concludes with a color reel of Nico, posing in medium close-up against an impenetrably dark background while a succession of psychedelic colored lights and patterns play across her face. Together with the opening reel, it constitutes the most tedious hour of the film, made bearable only by the fact that both reels are played off against Ondine's melodramatic episodes. Geometric Op patterns dapple her face and the camera zooms in and out wildly. Under Warhol's nondirection, Nico never managed to fulfill whatever cinematic promise she had offered in *La Dolce Vita*. She never quite succeeded, in fact, in any of her theatrical ventures —or, for that matter, as Girl of the Year. She had a beautiful face and looked great in still photographs, but her expression was too frozen, vacant, and monotonous for the motion-picture camera.

Chelsea Girls opened at the two-hundred-seat Film-Makers' Cinémathèque early in September and instantly attracted a following. The film returned for a second week's engagement from October 19 through 25. Press coverage and word of mouth prompted a third, relatively extended run, and the film reappeared at the Cinémathèque from November 6 through 9, and from November 19 through 30, with many screenings being completely sold out.

Jonas Mekas, not surprisingly, turned out to be one of the first and most eloquent champions of the film, calling it Warhol's "most ambitious" and "probably his most important work to date." With typical hyperbole, he said, "I know no other film, with the exception of *The Birth of a Nation*, in which such a wide gallery of people has been presented as in this film," referring to the cast of "lovers, dope addicts, pretenders, homosexuals, lesbians, and heterosexuals, sad fragile girls, and hard tough girls." *Chelsea Girls,* he added, "has a classical grandeur about it, something from Victor Hugo....It is a tragic film. The lives that we see in this film are full of desperation, hardness, and terror....The terror and desperation of *Chelsea Girls* is a holy terror:...it's our godless civilization approaching the zero point. It's not homosexuality, it's not lesbianism, it's not heterosexuality: the terror and hardness that we see in *Chelsea Girls* is the same terror and hardness that is burning Vietnam and it's the essence and blood of our culture, of our ways of living: this is the Great Society."[7]

On the basis of receipts at the Cinémathèque in November, the Film-Makers' Distribution Center (FDC), an organization founded by Mekas and several of his filmmaking colleagues to release underground films to commercial theaters, decided to gamble on a midtown booking at the six-hundred-seat Cinema Rendezvous at 110 West 57th Street, making it the first underground movie to get a two-week run in a midtown Manhattan art theater. The estimated investment was about $15,000, which included rental of the theater, advertising, and publicity expenses. The film opened on December 1.

During its engagement at the Cinema Rendezvous, *Chelsea Girls*, after deducting theater rental and advertising costs, netted $5,000, which was split equally between Warhol and the FDC. Then

the film moved to the Regency Theater on Broadway at 67th Street, where it played three daily performances for more than a month. From there it went to the York Cinema on the East Side. The FDC made arrangements with the Art Theater Guild, which had art houses all across the country.

The word around town was that underground cinema had finally found its *Sound of Music* in *Chelsea Girls*. In its first nineteen weeks of release in New York, the picture, which cost between $1,500 and $3,000 to make, grossed approximately $130,000 at the box-office, with about $45,000 as the distributor's share. This sum was divided equally between the distributor and Warhol. Following its reviews in the national press, the film was booked for theaters in Los Angeles, Dallas, Washington, San Diego, and Kansas City.

Newsweek's film critic, Jack Kroll, called the film a "fascinating and significant movie event."[9] His anonymous counterpart on *Time* called Warhol the "Cecil B. DeSade of underground cinema," whose film was "a very dirty and a very dull peep show." The review concluded: "There is a place for this sort of thing, and it is definitely underground. Like in a sewer."[10] The *New York Times* declared the movie "half Bosch and half bosh." "At its best," the reviewer wrote, " 'The Chelsea Girls' is a travelogue of hell—a grotesque menagerie of lost souls whimpering in a psychedelic moonscape of neon red and fluorescent blue. At its worst it is a bunch of home movies in which Mr. Warhol's friends, asked to do something for the camera, can think of nothing much to do."[11]

"Warhol doesn't exploit depravity as much as he certifies it," Andrew Sarris wrote in the *Village Voice*. He "displays some disturbing flourishes of technique. His zooms are perhaps the first anti-zooms in film history....[They] swoop on inessential details with unerring inaccuracy....A less conspicuous addition to Warhol's abracadabra arsenal is the traveling typewriter shot, which consists of a slow horizontal camera movement from left to right, culminating in a rapid return shot from right to left. What does it mean? Nothing that I can figure out....Nonetheless a meaningful form and sensibility emerge through all the apparent arrogance and obfuscation."[12]

Art writer Brian O'Doherty referred to the film's running Brechtian motif of personalities simultaneously inhabiting a character while stepping outside the role to comment on it:

"Surprisingly, nearly every character has density and presence, in itself a tribute to the way in which Warhol has developed not actors, but people who are able to slide in and out of a way of forgetting about the camera and returning to a more or less oblique awareness of it, at the same time processing their own lives, that is, to put it crudely, being themselves—even when they improvise another role."[13]

With the success of *Chelsea Girls*, Warhol became one of the most sought-after guests on the social circuit. The problem was that he always appeared with more than his share of escorts. He became notorious for taking his entourage everywhere, most annoyingly to private gatherings. If a hostess thought she had invited Andy by himself, she was likely to be aghast when he walked in followed by several companions. "It was like one whole party walking into another one whenever we arrived," he admitted.[14] Many hosts balked, trying to entice Andy inside while attempting to bar his hangers-on at the door. But Andy was reluctant to leave anyone behind, so he, too, usually retreated. Ethel and Robert C. Scull were among the party-givers who reluctantly deleted Warhol from their entertainments. "Lovey," Ethel cooed to Bob as they drew up a list of invitees, "you know that Andy won't go anywhere without his entourage, and that would make an extra ten or twelve people, at *least*."[15]

Warhol sometimes felt like a parent bird with an enormous brood of hungry chicks in his nest; as he frequently remarked, "I have so many mouths to feed." He was always looking for ways to get others to subsidize his entourage. Earlier in the year he had placed a small ad in the *Village Voice*: "I'll endorse with my name any of the following: clothing, AC-DC, cigarettes, small tapes, sound equipment, ROCK 'N' ROLL RECORDS, anything, film, and film equipment, Food, Helium, Whips, MONEY; love and kisses Andy Warhol EL 5-9941." Although extremely reluctant to pay any of the people who performed in his movies, he was consistently generous in taking his group to restaurants and picking up the tab. But his predicament became acute in September, when his troupe returned on Friday and Saturday nights to the Dom ballroom, now operating under the name of The Balloon Farm. (The visual components and lighting apparatus were slicker than before, but

already superseded by some of the city's swankier discos.) On a few evenings, the members of his entourage threatened to outnumber the paying customers. If Andy was to continue feeding his group, he would almost need a mess hall.

By that fall, many members of the Warhol entourage were hanging out at a restaurant called Max's Kansas City on Park Avenue South just north of Union Square; it had opened in late 1965, and was owned by Mickey Ruskin (no relation to English critic John Ruskin), who catered to the art crowd. Max's became the city's preeminent artists' hangout, as clubby as the Cedar Tavern had been for the Abstract Expressionist generation, and as vital as Le Boeuf sur le Toit had been for the Surrealists in Paris. Ruskin sometimes bartered food and spirits for art, so the front room featured imposing sculptures by Donald Judd, John Chamberlain, and Forrest Myers, while one corner of the back room was eerily illuminated by a Dan Flavin wallpiece consisting of red fluorescent tubes. Ruskin was an affable and tolerant restaurateur, who made a point of really knowing and caring about his clientele. He rejoiced in having the Warhol entourage in his establishment and worked out a deal: Andy would give Mickey a painting now and then, and, in return, those in the artist's group could sign for their dinners. None of the waiters and waitresses had any difficulty identifying those who were permitted to sign for their dinners—"we were all pretty visible," Ondine said. According to the demanding actor, "Mickey made it fabulous: he showed concern; he laughed and joked with us; he made us feel at ease; he reprimanded us when we were bad; he was like a gentle, loving father."[16]

Max's was a pretty exclusive watering hole to begin with, but the Warhol gang established their own enclave in the back room, where they cavorted noisily and vied with one another in outrageous antics calculated to capture Andy's attention. Brigid, who claimed to have gone to Max's the day it opened, thought it was "divine" to sit in the back room, having "a ball," not realizing that dozens of famous artists were on the premises. When she did finally figure out that she was among important painters and sculptors, she started badgering them to do "cock drawings" in her sketchbooks, then later equipped herself with a stamp pad so that she could collect inked impressions of actual penises, a project to which many of her subjects contributed without rising from their tables. Watching Brigid in action or Eric Emerson yodeling on a tabletop and baring his backside convinced most patrons that the atmosphere at Max's was something special.

In October, Warhol went to Boston for the opening of a comprehensive show of his paintings at the Institute of Contemporary Art. (Several of the early films were also shown, and on October 29, there was a mixed-media evening with The Velvet Underground and Nico.) The exhibition included paintings of flowers and disasters, silver clouds, several rolls of cow wallpaper, and two dozen wildly colored self-portraits, the latter being publicly shown for the first time.

The new series of self-portraits was based on a photograph of himself in which he gazes pensively at the camera, holding a couple of fingers over his lips (plate 208). They marked a new development in his portraiture with increased emphasis on garish, nonnatural color and avoidance of flesh tones. Some were printed in black on a silver ground, but most were painted in brilliant hues that correspond to his earlier "fauve" soup-can paintings. The bold, jarring colors called attention to his face while simultaneously canceling out most of his recognizable features. The self-portraits offer no detailed information about either his physiognomy or his psychological state; instead, they present him as a detached, shadowy, and elusive voyeur. They exemplified his ability to manipulate his public image, one of the recurring themes of his art. There he was in a variety of psychedelic color combinations, none of them naturalistic, and larger than life, yet often so abstract as to be difficult to recognize. The lurid, arbitrary hues suggest a chameleon personality—or a mutating persona—that assumes the coloration of its background. Andy appeared, in fact, to be hiding behind a camouflage of brilliant color.

Despite Warhol's increasing reputation as a "serious" filmmaker, he continued to engage in lunatic publicity stunts. During the first half of November, Andy, accompanied by Nico, her son Ari, Malanga, and Morrissey, journeyed by limo to the Abraham & Straus department store in Brooklyn, where the artist had been hired to promote a two-dollar do-it-yourself kit containing a paper dress and a paint box. Nico, wearing a paper dress, lay on a table

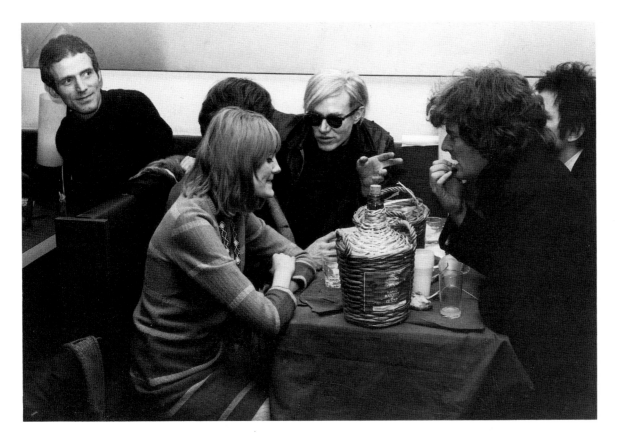

215. Billy Name, Ingrid Superstar, Warhol, and Paul Morrissey unwind during another hard day's night at Max's Kansas City, New York, November 21, 1967. Photograph by Fred W. McDarrah

while Warhol and Malanga repeatedly silkscreened the word "FRAGILE" in red paint all over her garment (plate 216). Warhol glued paper bananas to another dress as Nico's recording of "All Tomorrow's Parties" blared from a loudspeaker. Commercial ventures such as this prompted guardians of traditional artistic integrity to wring their hands and ask rhetorically if Andy Warhol would do anything at all, no matter how vulgar, for publicity.

On November 20, Warhol and his troupe were in Detroit to play at an English-style "mod wedding" during a "Carnaby Street Fun Festival" at the Michigan State Fairgrounds. The bride and groom had volunteered to be married publicly in exchange for a free honeymoon trip to New York City and a screen test at the Factory. The bride, a go-go dancer, wore a white satin minigown and matching boots that covered the knees, leaving only an inch or two of bare thighs. During the festivities, which attracted a crowd of about 4,500 spectators, The Velvet Underground played their screeching music, Nico wailed her mournful songs, Malanga slithered about on stage with his bullwhips, and Andy painted a

paper dress on a model—with ketchup and mustard squeezed from plastic dispensers.

Shortly afterward, Warhol had to concede that his career as a rock show entrepreneur was fizzling out. Among the managerial skills that he lacked was the ability to maintain even an illusion of harmony between the Velvets and Nico. Lou Reed was fed up with the statuesque chanteuse and refused to let her perform with the band anymore. Although her first solo album, *Chelsea Girl*, would be released in July 1967, she did not seem destined to win any gold records. The Velvet Underground recorded three albums for MGM/Verve, but their music was rarely heard on radio and they were seldom booked into leading clubs. Despite considerable publicity, they never attracted a sizable following. Between April 1967, when they appeared at a club called the Gymnasium, and June 1970, when they played at Max's Kansas City, they virtually vanished from the New York scene. Warhol's dreams of becoming a rock 'n' roll tycoon never came true, and his relationship with the Velvets was left to dissolve.

216. Gerard Malanga and Warhol stencil a paper dress worn by Nico in a department-store demonstration in Brooklyn, November 9, 1966. Photograph by Fred W. McDarrah

On November 28, Warhol was among the five hundred or so guests that Truman Capote invited to his instantly famous black-and-white masked ball. Even before the event took place in the grand ballroom at the Plaza Hotel, it was called "the party of the decade." Capote was at the pinnacle of his social career, and his ruthless snobbism created waves of gossip about who had been invited and who had been consigned to oblivion. His guest list included his favorite socialite "swans," such as Gloria Vanderbilt, Babe Paley, and Marella Agnelli, as well as New York Senator Robert F. Kennedy and a multitude of literary and theatrical celebrities, such as Frank Sinatra, Lauren Bacall, David O. Selznick, and Norman Mailer. Capote's old friend Cecil Beaton had flown over from England, but was in a critical mood, complaining of the "dreary

people" while admitting it was a "very good" party, "particularly by NY standards."[17] Andy was by now nearly as famous as Truman and Cecil, but he still felt like an outsider as he surveyed the crowd. He turned to his escort, Henry Geldzahler, and said: "We're the only nobodies here."[18]

Warhol's celebrity would enable him to go to the best parties and to hear the choicest gossip, but it would never lead him to think he was the social equal of the upper crust. Unlike Capote and Beaton, he never fancied himself as anything more than a toy of the rich, and he pursued wealthy people primarily because he viewed them as potential clients. Andy would never make Capote's mistake, in writing *Answered Prayers*, of creating unflattering portraits of his patrons.

NOTES

1. Jonas Mekas, "Movie Journal," *The Village Voice*, September 29, 1966, p. 27.

2. Gerard Malanga, "The Secret Diaries," *Mother*, May Days 1967, Number 8, p. 66.

3. Jean Stein, *Edie, an American Biography*, edited with George Plimpton (New York: Alfred A. Knopf, 1982), p. 228.

4. Gerard Malanga (interview with Andy Warhol), "My Favorite Superstar," *Arts Magazine*, February 1967, p. 26.

5. It took Brigid Berlin several years to overcome the terrifying image she created in *Chelsea Girls*. In those days, as she admitted, she had "a bottle of every different kind of pill there was." "I'm not proud to say I take fifty shots of amphetamine a day, I mean I don't now, but I used to make it all up and say it, because I was proud of it. I used to love to give it to other people, now, I would never give another person amphetamine because I think that is complete self-destruction and the cruelest and the meanest thing that a human being can do, because I could kill the doctor that did it to me." John Wilcock, *The Autobiography & Sex Life of Andy Warhol* (New York: Other Scenes, 1971), n.p.

6. Wilcock, *Autobiography*, n.p.

7. Mekas, "Movie Journal," p. 27.

8. Vincent Canby, "Cannes Will See Warhol Picture," *The New York Times*, April 25, 1967.

9. Jack Kroll, "Underground in Hell," *Newsweek*, November 14, 1966, pp. 109ff.

10. "Nuts from Underground," *Time*, December 30, 1966, p. 37.

11. Dan Sullivan, "Andy Warhol's 'Chelsea Girls' at the Cinema Rendezvous," *The New York Times*, December 2, 1966.

12. Andrew Sarris, "Films," *The Village Voice*, December 15, 1966, p. 33.

13. Brian O'Doherty, "Narcissus in Hades," *Art & Artists*, February 1967, p. 15.

14. Andy Warhol and Pat Hackett, *POPism: The Warhol '60s* (New York: Harcourt Brace Jovanovich, 1980), p. 149.

15. Jane Kramer, "Profiles/Man Who Is Happening Now," *The New Yorker*, November 26, 1966, p. 81.

16. Interview with Ondine, January 14, 1989.

17. Hugo Vickers, *Cecil Beaton: A Biography* (Boston/Toronto: Little, Brown, 1985), p. 508.

18. Warhol and Hackett, *POPism*, p. 196.

OUR LIVES, FLASHING IN FRONT OF US

"Once *My Hustler* made its debut—and took in $23,400 during its first week of showings at an old legitimate stage theater in midtown Manhattan—the way was clear for others to print their negatives of twilight zone sex capers."—*Confidential*[1]

217. *Big Electric Chair.* 1967. Acrylic and silkscreen ink on canvas, 54 x 74″. Courtesy Thomas Ammann Fine Arts, Zurich

After *Chelsea Girls*, Warhol concentrated almost entirely on movies that he produced and distributed under a corporate entity called Andy Warhol Films, Inc. He no longer had to sell his paintings in order to subsidize his movies, because *Chelsea Girls* earned enough money to produce the next two features, and every movie afterward made a profit. Andy and Paul Morrissey (who became a studious reader of *Variety*) now felt themselves to be part of the commercial movie establishment. But at the same time, they still hoped that a studio would put them in charge of a big-budget film. They frequently discussed projects with various movie moguls, but none was willing to put up a dime without seeing a script.

In April 1967, Warhol flew to Los Angeles, his "dream city," to attend the opening of *Chelsea Girls* at the Cinema Theatre. He was accompanied by an entourage that included Morrissey, Susan Bottomly (alias International Velvet), producer Lester Persky, John Wilcock, a French beauty—née Isabelle Collin Dufresne—who assumed the vivid name Ultra Violet, and one of the artist's current infatuations, a strapping, square-jawed young man who answered to the name Rodney La Rod. One night the whole entourage descended on station KPFK to do the Radio Oz show, on which International Velvet pretended to be Andy.

Chelsea Girls continued to do well wherever it played. "Despite its extraordinarily frank language and one scene of complete male nudity, it has not yet run into any police censorship," the *New York Times* reported toward the end of April.[2] That situation was remedied on May 30, when Boston vice squad detectives seized the film following an afternoon screening at the Symphony Cinema II Theater, where the movie had been playing for two and a half weeks. The manager of the theater was found guilty of four charges under the state's obscenity laws and fined five hundred dollars on each count.[3] Warhol was delighted to be able to say that his film had been "banned in Boston," traditionally a publicist's dream.

Chelsea Girls was invited to be shown during the Cannes Film Festival's Critic's Week that spring. Andy departed for France, feeling confident that *Chelsea Girls* would be a hit at the festival and attract distributors in foreign countries. He brought along an entourage that included Nico, Gerard Malanga, Bottomly, Eric Emerson, Morrissey, and La Rod. When Warhol arrived in Cannes,

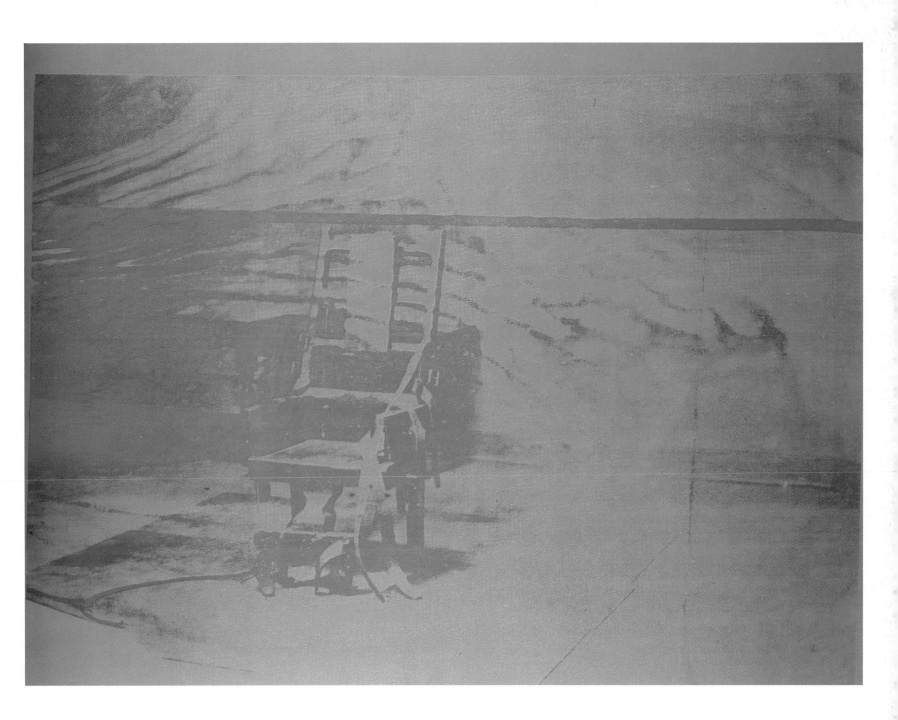

however, he learned that festival officials pretended to know nothing about the telegram inviting *Chelsea Girls* to be screened. Rumor had it that the work had been censored by a festival director, who feared a scandal. Despite pleas and a petition with hundreds of names, the film was not permitted to be shown. Though bitterly disappointed, Andy hung around Cannes anyway and managed to meet and elicit sympathy from such cinematic celebrities as Brigitte Bardot, whose portrait he would later paint.

Because *Chelsea Girls* was such a box-office success in New York, Warhol and Morrissey decided to revive *My Hustler* and booked it into the Hudson Theater on West 44th Street. The *New York Times*'s chief movie critic, Bosley Crowther, took a look at *My Hustler* and reported that it had "the literal, crude appearance of a home movie shot at the beach," noting that it was "filmed and put together in a careless and amateurish way—there's a lot of wild panning, lens zooming and montaging of bad exposures and reel-end cuts." The improvised dialogue was "sordid, vicious, and contemptuous. The only thing engaging about it is a certain quality and tone of degradation that is almost too candid and ruthless to be believed."[4]

Crowther's pan may have contributed to *My Hustler*'s success. According to *Confidential*, it took in $23,400 during its first week of showings, although Morrissey later told John Wilcock that it grossed only $18,000 during that period (of which Warhol netted $4,000.)[5] After a successful seven-week run of *My Hustler* during July and August, the Hudson Theater became a virtual showcase for Warhol's new productions—*I, a Man* (which opened in late August), *Bike Boy* (which opened in October), and *Nude Restaurant* (which opened in November). When *I, a Man* moved into the Hudson, *My Hustler* went to the 42nd Street Cinema.

Many of the racy sex farces—*I, a Man, Bike Boy,* and *Lonesome Cowboys,* among others—that were produced by the Factory throughout the late 1960s reflected the increasing influence of Morrissey, a relatively conventional filmmaker who sought to make feature-length movies that would be commercially feasible in regular theaters, but not so sexually explicit as to alarm the censors. He couldn't have agreed more heartily with the theater-owners and theater chains who believed that the only valid reason to put a film into a theater was to earn money. "They're not that crazy about films that are artistic," he noted. "And so they've helped me appreciate the sense that films are business to make money first and foremost."[6]

Morrissey liked stories and characters, so there was a greater emphasis upon narrative, often with a series of episodic sequences. The Morrissey-influenced films were centered around a good-looking male lead, usually a "stud" or hustler, placed in situations that required a fair amount of casual nudity, lots of salacious small talk, and surprisingly little in the way of explicit sex. The films tended to be "dirty"—one of Morrissey's favorite words—but not erotic. Some of these movies were shown not only in "art" theaters but also in "sexploitation" houses, where they attracted uncharacteristically "intellectual" audiences—the kind that call the theater to find out the starting time.

Morrissey served as Warhol's executive producer, "scriptwriter," editor, crew, and business manager. His contributions to the films were beneficial insofar as he made them more commercial, but also detrimental because he made them more conventional. Morrissey's cinematic ambitions were rather routine; he displayed little curiosity about either the formal or expressive possibilities of the medium.

"My influence was that I was a movie person, not an art person," Morrissey said. "An art person would have encouraged Andy to stay with the fixed camera and the rigid structure. Andy has always had two things: form and content. The form was extremely stylized and people thought the content was very frivolous. My notion was that the content is what is said by the people and how they look. The emphasis now is less or very minimally on the form and all on the content. And of course modern art is completely concerned with form and the elimination of content. Andy served his apprenticeship as a revolutionary in the movie world. But it's pathetic to see a person not develop and not grow."[7]

Warhol seldom displayed the slightest interest in outgrowing his preference for visually erotic content. He had already recorded various sexual couplings in *Couch* and had discreetly filmed an oral sex act in *Blow Job*. But he still longed to make a movie of explicit sexual intercourse. Claiming that he "loved porno," he admitted to wanting to make a movie that was "pure fucking, nothing else, the

way *Eat* had been just eating and *Sleep* had been just sleeping."[8] He intended to call it *Fuck*, of course, and he was so thrilled by the potential shock value of that name that he was always looking to film a situation that would justify the title.

Warhol initially had hoped to cast Jim Morrison, the torrid "light-my-fire" vocalist of The Doors and one of the leading male sex symbols of the era, in the title role. According to the artist, Morrison had actually agreed to bring a young woman to the Factory and to have sex with her in front of the camera. Andy could hardly wait to go into production and he anticipated no setbacks; after all, he had heard all those sensational stories about Morrison masturbating during stage performances. Moreover, Andy claimed he had seen Morrison in a popular Manhattan disco "drinking screwdrivers all night long, taking downs with them, and he'd get really far gone— he'd be totally oblivious—and the girls would go over and jerk him off while he was standing there."[9] Andy was profoundly disappointed when the scheduled shooting day arrived and Morrison failed to show up. Andy could only conclude that the singer's manager would not let him make the movie.

A friend of Morrison's, Tom Baker, who actually was a professional actor, volunteered to play the role. He certainly looked right for the part—lean, blue-eyed, clean-featured, and not at all self-conscious about doffing his clothes. Warhol gladly gave him the part and matched him up with some of the Factory's leading female players, including Nico, Ingrid Superstar, Ultra Violet, and Ivy Nicholson—the beautiful brunette fashion model who was telling everyone of her plans to marry Andy. (A couple of months earlier, *Women's Wear Daily* reported that Nicholson had dropped into the publication's New York office "to announce her engagement to pop artist Andy Warhol. She said they'll be married during the filming of his new movie. No word yet from the groom."[10]) With the exception of Ivy, who was saving herself for Andy, most of the Factory's leading ladies were eager to play the love interests who pass through Baker's life in various states of dress and duress. But just as the film was about to turn, all the performers shied away from actual lovemaking on camera. Baker, in particular, did not want to jeopardize a possible career in Hollywood movies.

As a result, Warhol's anticipated cinematic paean to explicit sex

218. Warhol and Paul Morrissey film a scene that may have been included in the twenty-four-hour-long version of "★ ★ ★ ★," 1967. Photograph by Billy Name/Factory Foto

became *I, a Man*, a 100-minute-long color film—and one of the artist's most mediocre productions, made in July 1967. The title was a takeoff on *I, a Woman*, a Swedish erotic film that had been a big commercial success in the United States. Warhol's version chronicles the amorous pursuits of a young man in a series of seduction scenes, scoring with some women and squabbling with others. The film offers only fleeting views of casual nudity and a few incidents of simulated-looking lovemaking.

The opening scene shows Baker and a young woman in a brass bed. "Have you ever made it underneath the bed?" he asks. She hasn't but is game to try, so they roll out from under the covers in opposite directions—he is totally nude—and collide obscurely on the plush blue carpet below, while the camera focuses on their bobbing feet. Later, he grooms himself in the bathroom, twice finding a pretext to lower his pants, showing off his trim buns.

219. Tom Baker, hip lothario, closes in on a "chick" in the 1967 film *I, a Man*. Photograph by Billy Name/Factory Foto

In another scene, Baker engages in a bland flirtation with Ultra Violet. This was one of her few performances in a "major" Warhol film (she had been a seated extra in *The Life of Juanita Castro*), and it went a very short distance in advancing her career as an actress, but she parlayed it into a tremendous amount of media exposure, becoming widely perceived as one of the Factory's leading superstars. The daughter of a conservative glove manufacturer, she had been reared in Grenoble. But she was too eccentric for that staid city, where she smoked cigars in the cafés and lit them with *cent-franc* bills, so in 1953, at age eighteen, she moved to New York. There, she became the last mistress of the eccentric Russian-born painter John Graham and then the good and close friend of

Salvador Dalí who introduced her to Warhol, who in turn ushered her into the spotlighted world of underground movies and gossip columns, fueling her raging passion for fame. Revamping her fashion look to complement her adopted name, she garbed herself in extravagant violet silk and brocade costumes. She rubbed cranberry juice or jelly into her curly brunette hair to tint it purple and used a sliver of fresh beet to renew the vibrant color of her lips and cheeks during the course of an evening. Ultra made herself chronically available to appear on television talk shows, where she displayed her vivacious smile, effervescent laugh, and her ability to find humor in almost any situation. Most amazingly, she possessed a sixth sense for discovering photo-opportunities, always turning up at events at the precise moment when news photographers' flashbulbs were about to pop. If another female superstar happened to be posing with Warhol, Ultra maneuvered herself to their right so that her name would appear first in the caption.

In retrospect, the most interesting casting in *I, a Man* was that of Valerie Solanas, a feminist tract writer with a belligerent style. Solanas made her living by panhandling on the streets, selling her tracts, and reportedly hiring herself out to men who paid to watch her engage in sexual acts with her girlfriends. She was never a member of Warhol's entourage, but she exemplified the psychopathic hangers-on who were attracted to him. On an earlier occasion, she had telephoned him at the Factory and offered him a film script, called *Up Your Ass*. Warhol thought the title was "so wonderful" that he invited her to bring it right over. But when she came in with the script, he found it "so dirty" that it occurred to him that she might be a "lady cop" trying to entrap him. It was indicative of both his paranoia and his sense of self-importance that he assumed the New York City police department would write an entire play in order to nab him on a morals charge.

Later, Solanas repeatedly called the Factory, demanding the return of her script. Nobody could find it. Feeling that she had been ripped off, Solanas started badgering Warhol for money. When she telephoned one afternoon, Warhol offered her twenty-five dollars if she would play a part in his movie. She promptly appeared, wearing her customary black cap, and improvised a short, amusing encounter with Baker on a staircase.

The scene between Baker and Solanas was shot in impenetrable darkness with only their faces emerging in bright light. Solanas had apparently pinched Baker's fanny in an elevator, and now he can't understand why she won't take him to her room. She says: "Just because you have a squishy ass doesn't mean I love you....Give me one good reason why I should take you into my pad. You go along with every chick who squishes your ass." He tries to entice her by taking off his shirt, asking, "You dig men's tits? You're missing out on a nice thing." She turns him down, saying "I wanna go home and beat my meat."

By now, Warhol had come to the realization that Solanas was not a cop. What he did not know, however, was that she was the founding—and perhaps the only—member of the radical Society for Cutting Up Men (S.C.U.M.), which advocated the total elimination of the male sex. She continued to harass Warhol with hostile telephone calls, still imagining that he had some legal claim on her writings and now accusing him of dubbing over her lines in the movie.

I, a Man displayed Warhol's new cinematic flourish—the so-called strobecut, which he created by turning the camera on and off during the course of a scene without regard for what the performers were saying or doing. One of his reasons for doing this, he said, was to give the film "texture." Because everyone asserted that he never stopped the camera, he decided to flick it off and on periodically to create the impression that the film was edited. Consequently, when the movie was shown, there were intermittent white flashes, a kind of staccato strobe effect, accompanied by a shrill, stuttering screech on the sound track. "With the strobecut," claimed film critic Gene Youngblood, "I believe Warhol has invented a technique of major importance in film form. It's sort of a Brechtian-Godardian ploy which distances the viewer by interrupting a scene to remind him that it is, after all, only a movie shot with a camera that can be turned on and off, giving birth to, or killing, cinematic life with the flick of a switch."[11]

The abrasive strobecuts and lusty cast of *I, a Man* did not succeed in wooing all the critics. "The nudity," the *New York Times* reviewer noted, "is no match for the bareness of the dialogue's drivel and the dogged tone of waste and ennui that pervade the entire film."[12]

220. Andy and Ultra Violet brighten a *Life* magazine party for newsmakers of 1968 held on January 6, 1969. Photograph by Walter Daran

While Warhol worked on *I, a Man*, a rival group of filmmakers was shooting an "aboveground underground" movie called *Ciao! Manhattan*. This unfortunate venture was being put together by various graduates of the Warhol school of cinema, including cameraman John Palmer (the phantom codirector of *Empire*), writer-director Chuck Wein, and coscenarist Genevieve Charbin, among others. The film featured Baby Jane Holzer in a supporting role and Edie Sedgwick as the leading lady. The production got off to a bumpy start because of Sedgwick's increasing dependency upon drugs.

Edie was mainlining speed to stay awake, then taking massive doses of barbiturates to fall asleep, often nodding off with a lit

cigarette in her hand and burning holes in the mattress. In October 1966, her East Side apartment caught fire in the middle of the night —she claimed she was lighting candles when the draperies suddenly went up in flames. She was treated for burns on her arms, legs, and back at Lenox Hill Hospital. Never returning to that charred apartment, she moved to the Chelsea Hotel, where she was given star treatment as a real-life "Chelsea girl" by many of her fellow tenants. When she visited the family ranch in California that Christmas, her distraught parents, upset by her self-destructive behavior, called the police and had her sent to the county hospital's psychiatric ward. After a brief incarceration, Edie returned to New York and the Chelsea Hotel, where she somehow sparked another fire, which devoured her room and claimed the life of her cat, whom she had prophetically named Smoke. Fearing that no other hotel would take her in, she settled into a friend's apartment in the East Village, where she incinerated one mattress after another. In May, she showed up for a newspaper interview with both hands so heavily bandaged as to resemble baseball mitts. Her interviewer reported that she looked "like a sweet, fragile doll who has been pulled out of the furnace. There are scabs on the tip of her nose and the edges of her ears."[13]

One of *Ciao! Manhattan*'s supporting players was Susan Hoffmann, a lanky, frizzy-haired blonde whose austere, classical features reminded some people of a combination of Marlene Dietrich and Greta Garbo. She had alabaster skin, a modest bosom, thin lips, and a sharp, querulous voice. She thought of herself as an aspiring painter, hanging out with the art-world heavies in the front room at Max's Kansas City, where she often stared disapprovingly at Warhol and his weird-looking entourage as they rushed to the back room. But after she saw *I, a Man*, she was impressed by his liberal treatment of heterosexual themes. One night when Hoffmann and Warhol were both at the same party, she cornered him and asked to be in his next film. "O.K.," he said, "you can be in the one we're shooting tomorrow, if you take off your blouse. If you won't, you can be in the one we're shooting the next day." She decided she had better show up for the "blouse-off movie," or he might change his mind.[14]

The next day, Hoffmann appeared at the apartment where

Warhol and Morrissey were filming a scene that ultimately became part of *Loves of Ondine*. When the moment came for her to remove her blouse, she surprised everyone because she had covered each of her nipples with a Band-Aid; if Ondine wanted to see her naked, she said on-camera, he would have to pay for every item of apparel she removed, including the two adhesives. Andy and Paul were both impressed by her sophisticated, screwball humor, her ability to keep talking in any situation, and her commanding presence on screen. They gave her the name Viva! and from then on cast her in nearly all their movies. (The exclamation point, though a witty touch, was soon dropped.) She became the brightest superstar of the next several films, including *Nude Restaurant, Lonesome Cowboys,* and *Blue Movie.*

Viva was intelligent, politically savvy, and the best educated of any of Andy's Girls of the Year. The eldest of nine children born to conservative parents in Thousand Islands, New York, she had been reared in nearby Syracuse, where her father was a prominent criminal lawyer. ("I got my acting lessons in the courtroom," Viva always claimed.) She had gone to parochial grade schools, then attended Marymount, a Catholic college in Tarrytown, New York. In her junior year, she went to Paris to study at the Sorbonne and lived in a convent on the Right Bank while she studied art. Back in New York, she painted and sometimes modeled in the nude for other artists. With Warhol's encouragement, Viva also became a stylish writer, often reviewing her own films for a local tabloid, *Downtown,* using the by-line of Susan Hoffmann to give herself raves, blithely comparing herself to a "hilarious" combination of Greta Garbo, Myrna Loy, and Carole Lombard. Viva was a great asset to Warhol's films and she became his main consort at social affairs. Andy was soon feeding her more advice than she could handle, goading her to go after the lovers, husbands, and money for which she yearned, and telling her whom to date with promises of "Go with him: big prick, big dick."[15]

Warhol propelled Viva toward stardom when he featured her in *Bike Boy,* a color film that, like *I, a Man,* chronicled a series of often comic sexual encounters between a well-constructed stud and various women, who in this case are much more lecherous than he is. The title role was played by Joe Spencer, a doltish young man

who swaggered around in blue jeans and a black leather jacket. The film's opening scene takes place in a stylish menswear shop. Customers dart in and out of the dressing rooms as two purring, homosexual salesmen flutter around Spencer, cajoling him into trying on various types of revealing clothing. But he doesn't like their wares and decides to stick with his motorcyclist's outfit. In a later scene, set in a kitchen, Ingrid Superstar engages in one of her funniest monologues, relentlessly enumerating the hundreds of ways in which eggs can be cooked and served, while the obviously bored leather boy stands in the foreground, facing the camera and coolly ignoring her. She bares her breasts in a desperate effort to gain his attention. Toward the end of the film, Viva and Spencer are both nude, sitting on a couch, as she mercilessly teases him about his sexual abilities. She finally forces him to admit that he cannot make love to her while riding on his motorcycle at sixty miles per hour. This confession appears to leave him in a state of impotence.

"Andy Warhol is back with another of those super-bores, this one called *Bike Boy*," the *New York Times* reported after the premiere of the film on October 6, 1967. "It opened yesterday at the Hudson Theater. It belongs in the Hudson River." The review noted that the film was "carefully punctuated with nudity, primarily male, and some of it complete." The hero "babbles incessantly and obscenely about his sexual prowess, capacity and versatility....The fade-out shows the hero languidly and lovingly soaping himself under a shower. *Bike Boy* needs a lot of soap."[16]

The February 1968 issue of *Confidential*, the scandal-mongering monthly magazine that claimed it "tells the facts and names the names," ran a photograph of Warhol and a *Bike Boy* ad on its cover in connection with an article headlined, "Coming: Homosexual Action Movies." Reproducing ads for *Bike Boy* and *My Hustler*, the article claimed that the latter film signaled "the advent of a swarm of raw homosexual movies—aimed at both men and women sex deviates." *My Hustler* was "the first full-length film to take a look at the lavender side of life without pointing a finger in disgust or disdain, but concentrating, instead, on the way life really is in the limp-wrist world."[17] Andy, far from being embarrassed about appearing on the cover of *Confidential* (his relatives in Pittsburgh were mortified), thought it was "just great."

221. Warhol was delighted to make the February 1968 cover of *Confidential* magazine.

On November 13, five weeks after the premiere of *Bike Boy*, another Warhol film, *Nude Restaurant*, filmed in color in New York's Mad Hatter restaurant, began a run at the Hudson Theater. Everyone in the cast, which in addition to Viva includes Taylor Mead, Louis Waldon, Allen Midgette, and Ingrid Superstar, is nude except for G-strings. Viva recounts her school days. "Since I left the convent," she complains, "all I've met are a bunch of faggots. At least in the church you were sure of a good lay." Warhol, never at a loss for outrageous assertions, liked to maintain that *Nude Restaurant* was actually an antiwar movie made in the form of "a nudie" so that more people would be inclined to see it.

222. Viva and Abigail Rosen share small talk and bath water in *Tub Girls,* 1968. Photograph by Billy Name/Factory Foto

223. Viva also bathes with Jim Davis in *Tub Girls.* Photograph by Billy Name/Factory Foto

When *Nude Restaurant* opened at Cinémathèque 16 in Los Angeles almost a year later, critic Gene Youngblood pronounced it "a fantastic film, a great and profoundly moving film, a distillation of everything that was ever valid and revolutionary and magical in Warhol's non-art." Finding it even more "rewarding" than *Chelsea Girls*, he went on to say: "Taylor Mead and Viva may well be the greatest living non-actors, the greatest contemporary 'stars' by any traditional definition of the term....To watch him [Mead] blinking, flitting, twitching, quipping through *Nude Restaurant* in a black net jock strap is living theater of the absurd. I'd gladly trade every mumbling Marlon Brando movie for just one shot of Taylor Mead tweaking Ingrid Superstar's nipples with a gleeful grin."[18]

Despite Warhol's public claims to have given up painting in order to pursue a career in commercial films, he never really stopped making art. In 1967, he surprised the art world with an astonishing set of ten silkscreen prints based on his famous portraits of Marilyn Monroe. Almost immediately, these thirty-six-inch-square portraits of the movie queen became classic icons of the 1960s. Their success launched him on a new career as printmaker.

Warhol's *Marilyn* silkscreens are even more vivid and lurid than his earlier portraits of her on canvas. He chose lush, nonnaturalistic colors, with the blazing hues juxtaposed in startling combinations, a more florid extension of his "fauve" Campbell's Soup cans and self-portraits. He printed, for instance, metallic silver "shadows" over a pink face, blue mouth, and orange hair, while, in another version, he superimposed dark green shadows over a magenta face and light green hair. The most somber, indeed morbid, of the portraits is in shades of black and gray, and it is certainly among the most powerful prints he ever made. An austere and funereal image, it almost ghoulishly evokes the extravagant glamour and tragedy of Monroe's life. From the beginning, Warhol's Marilyns were considered the most desirable of all his prints. For a few years, it was virtually impossible to make the rounds of savvy art collectors' homes without encountering the Marilyns at every turn. Their initial popularity was due in large part, of course, to Monroe's enduring appeal. But the prints' artistic staying power is due to Warhol's audacious originality as a colorist.

Marketed in an edition of 250 portfolios, the entire set of ten prints was initially priced at $500. Their commercial value steadily soared. In November 1987, a set of nine of the screenprints (lacking the black *Marilyn*) was auctioned at Sotheby's in New York for $125,000. An individual black *Marilyn* had sold at auction six months before for $25,000.

Warhol was delighted when they sold out quickly. The success of the Marilyns prompted him to look into the production and marketing of fine-art prints, which became a major art industry in the 1960s. The Marilyns, like all of his later silkscreen prints, were commercially processed print jobs based on original Warhol artworks. The popularity of contemporary prints boomed throughout the decade, thanks in large measure to the technical innovations and high-quality production of workshops such as Tamarind and Gemini in Los Angeles and Universal Limited Art Editions on Long Island. (Rauschenberg and Johns were among the many artists who had been creating prints at Universal Limited Art Editions since the early 1960s, helping to refocus the art world's attention on graphics.) When Warhol ventured into this field, he did so not through the established graphics workshops, but instead produced and often distributed the prints himself.

Many of Warhol's prints are as large as posters, feature bold but decorative colors, and usually reiterate the same subjects and images as his paintings. His earliest Pop print appears to be *Cooking Pot* (1962), with a black-and-white image derived from a newspaper advertisement. Some of his other early prints were *Birmingham Race Riot* and various Jackies, all simulating the grainy look and style of his paintings. The craft and collaborative aspects of printmaking held no appeal for Warhol. He never made an etching, lithograph, or any other type of print that would require him to work directly on a stone or metal plate. His evident lack of interest in lithography or etching might appear odd and inconsistent; after all, his blotted-line drawing technique of the 1950s was essentially a graphic process that he might easily have adapted to stone or metal. But traditional printmaking was probably too tedious a process for Andy, who always favored the easy way.

During the summer, Warhol met Frederick W. Hughes, a young Texas dandy who was destined to become one of his closest friends

224. International Velvet and Allen Midgette look deeply into each other's mascara in "★ ★ ★ ★," 1967.

and advisors. Slim and dark-haired with bemused brown eyes and an aristocratic nose, Hughes was a bit of a snob who let people believe he was related to reclusive millionaire Howard Hughes, the famous airplane and movie mogul. As a fifteen-year-old high-school student in Houston, Fred had worked afternoons as a "roustabout" at Houston's Museum of Fine Arts for director James Johnson Sweeney, helping to install shows, going for coffee, and so on. Through Sweeney, Hughes met Dominique and John de Menil, prominent French-born Houstonians with homes in Paris and New York and collectors of art on an international and epic scale. (Dominique was an heiress to the Schlumberger fortune; John was chairman of the board of Schlumberger, Ltd., a multinational oil-field services company, and a trustee of The Museum of Modern Art in New York.) The de Menils took a liking to Hughes—he was tactful and diplomatic—and he made himself useful to them, becoming their salaried employee and all-around "courtier." "I was always

considered a social asset," Hughes says, referring to his ability to mediate between various factions.

In the fall of 1966, he helped organize a Merce Cunningham Dance Company benefit sponsored by the de Menil Foundation at Philip Johnson's famous Glass House in New Canaan, Connecticut. (Johnson had designed the de Menils' house in Houston.) At the benefit, Hughes approached Henry Geldzahler and asked to be introduced to Andy Warhol.

Andy was enchanted by Fred from the moment that the elegantly dressed youth, escorted by Geldzahler, made his entrance into the Factory. Unlike so many of the shiftless druggies who then surrounded Warhol, Hughes reminded Warhol of the foppish "pretties" from his past. Fred was a perfectionist about his attire, wearing splendidly tailored suits, sport jackets with braided trim, and patterned shirts with matching bow ties. The chief eccentricity in his apparel was a black ten-gallon hat. In Andy's eyes, Fred was as lively and graceful as a colt. Warhol was also flattered when Hughes told him that he owned one of Andy's paintings and, furthermore, had arranged for some of Andy's films to be screened in Houston.

But good looks and loyalty were not everything. Warhol recognized that Hughes possessed something even more valuable —access to the de Menil millions. Fred's connection with the de Menils became, in effect, his dowry when he allied himself with Warhol. Hughes rose very quickly in the Factory hierarchy, starting out as a factotum and almost immediately rising to the position of vice-president of Andy Warhol Films, Inc. Still, there was little hint at the beginning that he would eventually become second in command of the Warhol empire, outlasting and superseding Malanga, Linich, and Morrissey.

One of Hughes's first tasks was to organize an excursion for Warhol, John de Menil, and himself to Expo '67 in Montreal, where the artist had six of his *Self-Portraits* in six-foot-square formats hanging in the United States Pavilion, a marvelous geodesic glass dome designed by Buckminster Fuller. The pavilion contained an impressive array of large-scale contemporary paintings, several of them created expressly for the world's fair, by many of the nation's leading painters, including Barnett Newman, Robert Motherwell,

Kenneth Noland, Frank Stella, Robert Rauschenberg, and Roy Lichtenstein. The paintings were hung on long white banners, as high as ninety feet and as wide as twenty feet, suspended by cables from the top of the dome. Many of the works were monumental in size: Helen Frankenthaler's painting was thirty feet high, Jim Dine's pair of monochrome panels was thirty-five feet high, and James Rosenquist's *Firepole* (a colossal close-up of a fireman's legs) was thirty-three feet high. Jasper Johns was represented by *Map, Based on Buckminster Fuller's Dymaxion Projection of the World*, a shaped canvas composed of rhomboidal and triangular planes that measured more than fifteen by thirty feet. Warhol's inclusion in the exhibition furthered his reputation on two fronts. First, it prominently proclaimed him as an artist who could hold his own with some of the most eminent names in American art. Second, it disseminated the notion that he was an enigmatic persona, whose facade, in acid colors, masked his true identity. In contrast to the other artists, who were for the most part abstractionists, Warhol offered 216 square feet of flagrant self-aggrandizement. His multiple giant images of himself appeared charged with iconic overtones and helped to establish his international personality cult. He could not have made a more calculated appeal to the curiosity of Expo visitors, who were made to realize that his was a celebrity face.

Shortly afterward, the de Menils commissioned Warhol to film a sunset. The subject sounded ideally Warholian, and Andy actually shot several thirty-five-minute color reels of sunsets in East Hampton, San Francisco, and New York City, but none of them resulted in what he considered to be a satisfactory, self-contained film. Some, however, ended up in the longest and most episodic of all his films—the twenty-five-hour-long "★★★★" (or *Four Stars*); the title refers to movie ratings in newspapers. Like *Chelsea Girls*, it was a compilation of miscellaneous reels that he had not set out to link together. All the reels were in color and many were shot in scenic locations; Warhol filmed all over New York and during the course of the previous year's trips to San Francisco, Sausalito, Los Angeles, Philadelphia, Boston, and East Hampton. (Some of the outdoor footage is overly pretty and self-indulgent.) The large cast includes many familiar faces from the Warhol stock company: Nico, International Velvet, Ondine, Ingrid Superstar, Ivy Nicholson, Ultra

Violet, Brigid Polk, Taylor Mead, Gerard Malanga, Eric Emerson, René Ricard, and Allen Midgette. Andy also cast his mother in a couple of reels that were filmed in her basement kitchen; in one, she played a woman who hires Mario Montez, done up in drag, as a babysitter for Ari (Nico's son). To make the film more complex visually, Warhol simultaneously projected different reels of film on the same screen, each accompanied by its own sound track.

"★★★★" was shown in its twenty-five-hour-long version only once, at the New Cinema Playhouse on West 41st Street on December 15, 1967. The screening started at 8:30 P.M. and ended at 9:30 P.M. the following evening. Some spectators drifted in and out, took naps in the lobby, or fell asleep in their seats. The theater's manager claimed that about one-third of the patrons who had shown up for the start of the film were still present by midafternoon on the second day. About twenty people stuck it out to the very end. Warhol himself saw the "complete" version. "I knew we'd never screen it in this long way again," he said, "so it was like life, our lives,

flashing in front of us—it would just go by once and we'd never see it again."[19]

Soon after the marathon premiere, a two-hour version of "★★★★" began a regular daily run at the same theater, eliciting a relatively mild response. One of the most favorable reviews appeared in the *New York Post*, which observed that the superimposed images on one screen were not "as messy or trying as one might expect—less distracting actually than the double screen techniques....Warhol makes his film like wall-to-wall carpeting. You can cut any size piece to fit the occasion."[20] The movie had very little commercial viability, and most of its reels quickly disappeared into storage. A reconstruction of the twenty-five-hour version, as originally shown, would be virtually impossible, because no one bothered to keep a record of which reels were included or in what sequence they were projected. When Warhol reflected on that screening, he called it a "milestone" that "marked the end of the period when we made movies just to make them."[21]

NOTES

1. Bruce Normale, "Coming: Homosexual Action Movies," *Confidential*, February 1968, pp. 14–15.

2. Vincent Canby, "Cannes Will See Warhol Picture," *The New York Times*, April 25, 1967.

3. "Exhibitor of 'Chelsea Girls' In Boston Is Fined $2,000," *The New York Times*, June 9, 1967.

4. Bosley Crowther, "Screen: 'My Hustler' Opens at Hudson," *The New York Times*, July 11, 1967.

5. Normale, "Homosexual Action Movies," pp. 14–15.

6. John Wilcock, *The Autobiography & Sex Life of Andy Warhol* (New York: Other Scenes, 1971), n.p. In this same interview, Morrissey indicates that Warhol evidently received substantial income from film rentals over the years. Five years after *My Hustler* was made, it was rented for one day to the University of California and brought in $922, of which the Factory received half. The film cost only $500 to make.

7. Interview with Paul Morrissey, December 1, 1970.

8. Andy Warhol and Pat Hackett, *POPism: The Warhol '60s* (New York: Harcourt Brace Jovanovich, 1980), p. 294.

9. Warhol and Hackett, *POPism*, p. 190.

10. "Eye," *Women's Wear Daily*, May 24, 1967, p. 92.

11. Gene Youngblood, "New Warhol at Cinémathèque," *Los Angeles Free Press*, February 16, 1968, p. 12.

12. Howard Thompson, "The Screen: Andy Warhol's 'I, a Man' at the Hudson," *The New York Times*, August 25, 1967.

13. Elenore Lester, "What Would Antonioni Say?" *The New York Times*, May 28, 1967.

14. Viva, "The Superstar and the Heady Years," *New York Woman*, May/June 1987, p. 29.

15. Viva, "The Superstar," p. 29.

16. Howard Thompson, "Screen: More Warhol," *The New York Times*, October 6, 1967.

17. Normale, "Homosexual Action Movies," pp. 13–14.

18. Gene Youngblood, "Expanded Cinema," *Los Angeles Free Press*, October 25, 1968, pp. 40–42.

19. Warhol and Hackett, *POPism*, p. 252.

20. Frances Herridge, "Movie Scene: More Warhol at the New Cinema," *New York Post*, December 18, 1967, p. 23.

21. Warhol and Hackett, *POPism*, p. 251.

"**You want to know the truth about Andy? He really digs women. He digs being around them more than men. But he can't associate sex with his emotional life like the rest of us, so he puts women on a pedestal. Now to compensate for this, to justify himself, he likes to show them as vulgar, coarse, crude, and unromantic.**"— *Viva*[1]

225. Taylor Mead (right) offers his companionship to Tom Hompertz in a scene from *Lonesome Cowboys*, 1967.

Warhol talks! Who would have guessed that the normally reticent artist, so widely noted for his noncommittal "uhs," "wows," and "greats," might embark during the autumn of 1967 on a career as college lecturer? He was lured into this improbable line of work by a Boston lecture-booking company, the American Program Bureau, which shrewdly reasoned that student organizations would consider the controversial artist-filmmaker a big attraction. In fact, Robert Walker, the president of the bureau, had scheduled fifty college lectures for Warhol even before contacting the artist. Warhol initially shied away from the venture, claiming he had nothing to say, but Walker talked him into it by suggesting that the artist screen about forty minutes' worth of his underground movies and follow that with a ten-minute question-and-answer period.

Andy rationalized that the lecture business could generate some easy income and perhaps also increase the potential audience for his films. For the next several months, he was flying into large and small airports all over the country, sometimes staying away from home for a week at a time. Before long, a spokesman for a rival lecture bureau was grumbling, "The Timothy Leary-Andy Warhol kind of nut has taken over the college platform."[2]

Warhol's usual fee was $1,000 per lecture; sometimes he got as much as $1,250, but he often settled for $750. He had to pay all his own expenses, however, and, as he usually took Paul Morrissey and Viva along with him to do most of the talking, he seldom cleared very much. Although Andy enjoyed his celebrity status among young people, he considered his college tours a rather tedious and boring way to earn money. He fretted about spending so much time away from the Factory, missing opportunities to shoot movies, negotiate business deals, and make appearances at all the right parties. He also worried about leaving his increasingly frail and forgetful mother alone for days at a time. Moreover, he felt, not inaccurately, that his person—as opposed to his persona—was a bit of a letdown for many students, who expected somebody a little less bland and a lot more glamorous. Andy thought it would be "great" if he could send out another party in place of himself— somebody, according to Morrissey, "who was a little more talkative and looked a little more dashing."[3]

Warhol and Morrissey contemplated whom to cast in this

268

demanding role and chose Allen Midgette, a tanned, dark-haired, brown-eyed young actor who had appeared in several Factory films. (For a couple of years in the early 1960s, Midgette lived in Italy, where he acted in two films directed by Bernardo Bertolucci and one by Pier Paolo Pasolini. After returning to New York, he met Susan Bottomly at a discotheque and, through her, became involved in Warhol's movies, which he never took very seriously.) Midgette did not look anything at all like Warhol—he was part Cherokee Indian—but he was a polished and attractive performer, and seemed a sure bet to make a favorable impression upon students.

One night, when Midgette innocently sauntered into Max's Kansas City, he was ambushed by Morrissey, who was waiting for him in a booth, holding Warhol's sunglasses and leather jacket. "Do you want to go to Rochester tomorrow and impersonate Andy at a lecture he's supposed to give there?" Morrissey asked. "Why would I want to do that?" replied Midgette, who was accustomed to receiving nothing at all for whatever he did in connection with the Factory. "Well, you'd get six hundred dollars," Morrissey said. Midgette, suddenly available, did not stop to ponder the legal consequences of an impersonation for hire.

Midgette went a little overboard in devising his makeup. He plastered his tanned face with Erase, the lightest shade in the Max Factor cosmetics line, and slathered the stuff all over his eyebrows and lips, inside his ears, up his nostrils, and over the backs of his hands. "I added a little powder to my face and put a touch of lipstick to the nose." He sprayed his brown hair silver and sprinkled a layer of talcum powder on top. By the time he concealed his brown eyes behind dark glasses and turned up the collar of Warhol's black leather jacket, the actor with the clown-white face might have found gainful employment at any circus. But Morrissey claimed he looked like "the genuine article"—from ten feet away.

Midgette thought it would be easy to imitate Andy because he could answer almost any question with a typically Warholian "yes," "no," "maybe," "I don't know," "okay," or "you know, I really don't think about it." Like Warhol, Midgette chewed gum strenuously, but for the reason that it caused him to keep his facial muscles moving, and therefore, he hoped, made his visage a little less memorable. He made his debut as Warhol in Rochester, New York—a day trip

with two film showings in a gymnasium and a party in between. After the film was over, he was a bit taken aback when the very first question put to him was: "Why do you wear so much makeup?" Without losing a beat, he replied, "You know, I really don't think about it."[4]

Midgette's impersonation was so expert that Morrissey soon telephoned him to say, "We've got a lecture tour lined up for you." For a week in early October, Midgette and Morrissey visited the University of Utah in Salt Lake City, the University of Montana in Missoula, the University of Oregon in Eugene, and Linfield College in McMinnville, Oregon. Morrissey handled all the arrangements, receiving the lecture fees and giving Midgette his cut, which had dropped to four hundred dollars. "I had to have lunches with students and dinners with faculty," Midgette said. He feared constantly that he would be booby-trapped by a seemingly innocent question. One instructor, for instance, asked, "Mr. Warhol, when did you win the Coty award?" "It was the most difficult acting job I've ever done," Midgette said.[5]

When Midgette and Morrissey flew into Salt Lake City, a flight attendant advised passengers to "hold onto your hats" because they would be disembarking in a high wind. As Midgette descended the portable metal stairway, a gust blew a cloud of talcum powder off his hair, in full view of a group of waiting students. While in Salt Lake City, Midgette ran out of silver hairspray and Morrissey couldn't find any "in the whole state of Utah."

Midgette's question-and-answer sessions were generally unilluminating about Warhol's art and films, and many students and faculty members were disappointed by the brevity and inadequacy of his responses. There were even a few complaints. One student posed a question, adding, "Would you answer in twenty-five words or more?" Midgette knew very little about Warhol's paintings, so he found it tricky to respond to questions about specific subjects and techniques. He received no help at all from Morrissey, who remained blind as ever to Warhol's accomplishments as an artist, preferring to ridicule all modern paintings, including Andy's.

Television reporters occasionally tried to interview Midgette, but, like the real Warhol, he managed to avoid them. After a series of successful impersonations on university campuses, Midgette,

having collected about $2,600 in appearance fees, took off for an extended stay in Mexico.

Warhol maintained his part of the deception through the end of the year, when Random House published his novelty book, *Andy Warhol's Index (Book)*. Instead of featuring a portrait of himself on the back cover, Andy used a photograph of Midgette's face—but with printed letters that spelled out "Andy Warhol" superimposed on the actor's upper lip. Andy seemed determined to clone himself, but with a more attractive face.

The *Index (Book)* is a Pop-style pop-up volume, a souvenir picture album of the Factory. Warhol conceived and designed it in collaboration with several people, among them Billy Linich, who during the mid-1960s started calling himself Billy Name (his inspiration being all the application and registration forms that routinely ask for "Name"). Billy took many of the contrasty black-and-white photographs, including the one of Midgette on the back cover. The book also features full-page photographs of Nico, Malanga, Morrissey, Ivy Nicholson, Henry Geldzahler, Mario Montez, and others. The various spreads contain pop-up paper constructions of a biplane, a castle (with photographs of Warhol, members of his entourage, and cow wallpaper appearing in some of the windows), and a tin-can label for Hunt's tomato paste, as well as a three-layer foldout of a nose that changes color and size as each sheet is lifted. In addition, the book contains a white balloon, a 45 rpm plasticized-paper record superimposed on a photograph of Lou Reed's face, and a red paper accordion that squeaks when the page is opened. Displaying much of the same sort of whimsy that figured in Warhol's picture portfolios of the 1950s, the *Index (Book)* is a particularly sophisticated and clever work.

Warhol and Morrissey, sharing the desire to make a hit movie that would turn into a box-office bonanza, decided to film a Western and to shoot it entirely outdoors, on location in Arizona. It would star Viva, playing a frontier tart in the tradition of Marlene Dietrich in *Destry Rides Again*, and the action would involve a gang of good-looking cowboys who, unlike their counterparts in classics of the genre, such as *Stagecoach, Shane,* and *High Noon*, would drop their chaps at the sight of a bronco, shun gunfights, and openly lust for one another.

During the last week of January 1968, Warhol and more than a dozen of his colleagues gathered in Oracle, Arizona, to make his most ambitious production so far, with a longish schedule (five days) and an unusually ample amount of stock (ten thirty-five-minute-long reels of 16mm color film). The plan was to shoot two reels a day and to edit the result into a two-hour film that would be translated into a 35mm print for commercial distribution. (While there, Warhol also intended to shoot another sunset reel for the de Menil project, but never got around to it.) The movie started out as a horse-opera version of *Romeo and Juliet* with a working title of *Ramona and Julian* and ultimately turned into *Lonesome Cowboys*, a 110-minute-long work that would become one of Warhol's most widely exhibited and famous films.

Lonesome Cowboys failed, however, to live up to anyone's expectations, indicating some of the weaknesses of Warhol's cinematic technique. Although most of the cast was brilliant at improvisation, they often departed so far from the scenario that it was all but impossible to detect a coherent story line. The plot initially involved a group of "brothers," but, as Morrissey explained, "They aren't really brothers, they're, well, sleeping together, or whatever, but they say they're brothers so people won't talk. There were supposed to be some lines about that—but the way we work—well, they forgot to say it, so you sort of don't know whether they're brothers or not."[6] Certain key scenes were never shot at all, making it extremely difficult to edit the film. Despite its many moments of visual beauty, the movie, as Warhol himself realized halfway through the project, was simply not working out. His films were arresting and provocative only so long as they were based on a clear, simple concept and photographed in a rigid structural format. He possessed no sense of narrative development and was virtually incapable of telling a story cinematically.

Warhol had given little thought to the plot or characters of his film and was trusting, as usual, to chance. ("Andy never really thinks of stories," Morrissey said. "As soon as you take a story line, you take on a moral position."[7]) Someone, however, had prepared a two-page typed outline, but it was largely ignored from the start. Viva played the major female role, that of Ramona, a vivacious blonde who operates a Tucson dance hall/bordello. Her costar was described as

226. Taylor Mead plays the heroine's philosophizing nurse in *Lonesome Cowboys*.

a "sixteen-year-old wanderer" named Julian. This role was given to Tom Hompertz, a strikingly handsome California surfer with curly blond hair, green eyes, and a neoclassical profile that evoked memories of the pretty youths depicted by nineteenth-century English painter Edward Burne-Jones. Andy and Viva had discovered Hompertz a month or two earlier when they made a lecture appearance at San Diego State College, where he was an art major in his junior year. The other major figure in the film was Mickey, the eldest and most macho of the cowboy "brothers." This part was given to Louis Waldon, a robust and virile performer with a gravelly voice who previously had appeared in *Couch* and *Nude Restaurant*. Taylor Mead was cast as Ramona's nurse; he described his part as "one of the least demanding roles I've ever had."

Waldon's fellow cowboys were played by Eric Emerson, Allen Midgette, Julian Burroughs, and Joe Dallesandro, who eventually would become the Factory's biggest male star. Dallesandro, a taciturn nineteen-year-old youth with clean-cut features and a muscular torso, ordinarily worked as a cutting-machine operator at a Manhattan bookbinding company. He turned out to be so photogenic and possessed such a magnetic screen presence that Morrissey would zealously promote him on an international scale.

The part of the sheriff (who moonlights as a bordello tart) was taken by Francis Francine, the professional name of a portly middle-aged actor who specialized in *femmes fatales*, having played one of the title roles in Jack Smith's *Flaming Creatures*. His mother had been a member of a six-sister vaudeville act, but the closest he got to a Broadway stage was his job as doorman at a Times Square movie theater. In his youth, he had played the "alligator-skin boy" in a carnival, applying to his body a chemical solution that dried in cold scales. (Women screamed when they touched his skin.) In *Lonesome Cowboys*, he would succeed in projecting a sensual female image, for which he painstakingly combed out his ratty wig and lacquered his fingernails a seductress red.

The company converged on Oracle from various directions. Vera Cruise, a young woman who had been offered a part in the movie, drove west from New York, accompanied by Emerson. Cruise had a reputation for driving vehicles that didn't belong to her and she generally traveled at excessive speed, as if she thought she

were being pursued by patrol cars. In New Mexico, she braked long enough to pick up John Chamberlain, the sculptor of crumpled auto-body parts, and Midgette, and all four proceeded to Arizona. Hompertz drove east from San Diego. Viva, Mead, Dallesandro, Francine, and Fred Hughes, the sound technician on the film, were among those who flew from New York to Tucson.

"Now that everyone's here," Morrissey announced, "we've got to think of a script." Warhol's performers were expected, as usual, to improvise their own dialogue. Morrissey directed much of the action, suggesting ways in which the performers could interact with one another for the duration of a reel. On camera, the performers reenacted existing relationships or played out their fantasies, which they adapted to a Western context. The unanimous opinion among Warhol's company was that actors should be capable of making up their own lines. "If an actor can't make up his own lines," Morrissey declared, "he's no good." Warhol concurred, asking, "How can people read other people's words? It sounds so phony." "Everyone always thinks that the people we use in our films are *less* than something," Morrissey said. "Our people are *more* than actors. Actually, everybody we use has to be thousand times extra to stand up to our kind of filmmaking."

One reason for the last-minute plot revisions was that two of the principals, Brigid Polk and Ondine, failed to show up, presumably because of their skepticism about Arizona's amphetamine supply. Brigid was to have played the leader of a rival gang of cowboys, and Ondine had been slated for the role of Padre Lawrence, described in the scenario as a "degenerate and unfrocked priest who tries to hide his addiction to opium-laced cough syrups." (John Chamberlain was offered Ondine's role, but turned it down. He was also invited to play the father of the cowboy brothers, but declined that part, too, on the grounds that he wasn't old enough.)

By the time Warhol started production on *Lonesome Cowboys*, his earlier films had earned about a quarter of a million dollars in rentals. The movies that played at the Hudson Theater brought in between $10,000 and $15,000 a month, although the combined cost of theater rental and advertising ate up about two-thirds of that sum. Viva claimed to have raised the money for *Lonesome Cowboys*, getting one of her father's friends to put up $3,000,

227. Almost everyone in the wacky western lusts after Tom Hompertz.

228. Taylor Mead ministers last rites to *Lonesome Cowboys*'s star-crossed lovers, played by Viva and Tom Hompertz.

enough to buy ten reels of color film and ten round-trip airplane tickets. While in Arizona, the performers worked for a flat fee (and were asked to sign releases); the minimum fee was ten dollars a day with room and board.

On Friday, his first day of shooting, Warhol spent several hundred dollars to rent space, costumes, props, and horses at Old Tucson, an outdoor Western movie lot that reproduced the main street of that town as it looked in the third quarter of the nineteenth century. Old Tucson was originally built for the 1939 movie *Arizona*, starring Jean Arthur and William Holden and directed by Wesley Ruggles, and was still in use, mainly for television shows such as *Death Valley Days* and *High Chaparral*. (On the day of the Warhol shoot, actor Robert Taylor was also working on an episode of *Death Valley Days*.) It also operated as a tourist attraction, charging admission and mounting an occasional gunfight and cowboy action stunts to amuse visitors.

The company arrived at Old Tucson during a light drizzle, causing Warhol to remark, "It's been beautiful until today. I hope it

rains during the whole time we're here." (Perhaps he envisioned making the first rainy Western. He succeeded in making the first Western without a saloon brawl or a gun duel.) An Old Tucson set director took charge of assembling props and costumes, and roping off the street to keep spectators on the sidelines. About seventy tourists gathered to watch the shooting. Warhol smiled as he surveyed the crowd, saying, "We've got more people here than Robert Taylor had yesterday in the sunlight." Six horses were brought out for Waldon, Midgette, Dallesandro, Hompertz, Emerson, and Burroughs, and the actors rode to the far end of the street out of camera range to make ready for their first appearance. Viva and Mead took their positions on the porch of a storefront with a sign that announced "Cactus Creations." A reporter from a Tucson newspaper interviewed Viva and asked why she was wearing a black riding habit instead of western garb. She replied, "I think I'm out riding on a fox hunt in Maryland with Jackie Kennedy, but I had a bad trip."

The first scene to be shot was a confrontation between the cowboy brothers and Viva. One of the horses, perhaps alarmed by her shrill screaming, relieved itself in a great cataract. "This is a clean town," she protested, "and I don't want horse piss in the middle of the street." Her improvisation was clever, but Warhol missed the action because he was zooming in on a storefront sign across the street. Later, Waldon and Viva got into a shoving match and she fell against the rear legs of her horse. The animal reared and for a moment looked as if it were going to trample the superstar. Viva got up, her back covered with mud, and resumed the scene. Again, Warhol missed the action. She tried once more to attack Waldon, who forced a kiss upon her, causing her to fall against her horse once more, this time losing the heel of one of her boots. "How can I go to the press club with no boots?" she wailed.

One of Old Tucson's leathery employees marveled to a colleague, "Every time they rehearse, it's a different scene." The local cowboys also noticed that Warhol's performers were seldom told whether the camera was on or off. "They're still acting," one of them said. "Doesn't anyone call cut around here?" By 3:30 P.M., only one reel had been shot.

At first, Old Tucson's employees had looked tolerantly upon the

229. Eric Emerson (right) teaches Taylor Mead and Joe Dallesandro some new dance steps in a scene from *Lonesome Cowboys*.

unconventional Easterners, but their attitude soon shifted to downright hostility. They were offended by the effeminacy, foul language, and outrageous behavior of some of the members of Warhol's troupe. They were particularly scandalized by Emerson, who used a hitching rail as a dancer's *barre*, doing leg exercises while explaining that this was a great way to firm up one's buttocks. Because Viva was the leading lady, her screamed obscenities were particularly objectionable, causing distressed tourists to lead their children away from the set. One of the construction workers displayed his contempt for the New York weirdos by hammering and sawing throughout the filming. The objections mounted and at one point even Robert Taylor came over to glare at the scene. Old Tucson's staff became increasingly outspoken about the "perverts," and for a while it looked as if they might organize a posse to drive the troupe off the lot.

The actors' shenanigans generated complaints and flushed out a deputy sheriff who soberly watched the proceedings. Warhol's entourage evidently looked so disreputable that Old Tucson officials did not expect to get back all their rented horses, hats, and assorted paraphernalia. The sheriff radioed a message to the men at the main entrance, ordering them to close the gate until a check confirmed that all props had been returned. When the Warhol troupe finally exited the front gate, the construction worker who had hammered throughout the filming, yelled to Viva: "Go back to your own state, pig!" She screamed some choice obscenities back at him while her fellow actors forcefully prodded her through the parking lot and into a car.

Warhol's group drove directly from Old Tucson to the Tucson Press Club, where Morrissey and Viva fielded most of the questions at a cocktail conference. "This is our two-hundredth film without a script," Morrissey said. "Oh, there's never a script," Viva added. "We write it afterward from the sound track. How do we act without a script? Everyone pushes me in the mud." Describing herself as "the last dying gasp of verbosity," she reminded listeners that "Mae West also wrote her own lines. She was really quite a woman. She had a Rabelaisian sense of humor. Men seem to have trouble doing these nonscript things. It's a natural for women and fags—they ramble on. But straight men can't."

"Our movies are not experimental as films," Morrissey said, "but experimental as drama. There's a minimum of dramatic interest, but they are still interesting because of the content of the dialogue. They are very primitive as films but revolutionary as drama." A journalist asked when the film would be released. Morrissey answered, "As soon as it comes back from the drugstore."

"Mr. Warhol," someone asked, "are you trying to prove something?" "Well, we work very hard," the artist said. After a long pause, he added, "I believe in entertainment." To a question about his background, Warhol replied with a straight face that he was Cherokee (perhaps a cryptic reference to his impersonator Midgette).

The remainder of the shooting was done at Rancho Linda Vista, an eighty-acre guest ranch outside the town of Oracle, about forty miles northeast of Tucson. The cast and crew stayed in various cottages on the property. On Saturday morning, Warhol, always the last to rise, walked over to Viva's bungalow and found her without makeup. "Viva," he told her, "that's the way you should have looked yesterday." She gave him a startled, uncomprehending look. "Why do you want me to look ugly? You know I look ugly without my makeup. Everyone's going to say you're putting down women and that it's another homosexual exploitation film. Besides, the men *all* wear makeup." "*I* didn't want them to wear makeup," Andy protested; "*you* put it on." "Well, they *asked* me to," she said.

Within a day of their arrival at the ranch, most of the cast had warmed up to their roles and were playing them both on and off camera. "Half the time," Mead noted, "you don't know whether the emotions are really real." Viva and her movie antagonist, Waldon, both suitors of the Hompertz character, battled and cursed each other around the clock. She impugned Waldon's manhood once too often, provoking him to instigate a mock gang rape. One day, Viva rode into the corral, expecting to play a scheduled scene, when she was assaulted and stripped to her socks but technically unviolated. "Disgusting pigs!" she screamed. "Look at all those children shocked out of their minds!" (Children were indeed in the vicinity, but it was their parents who were jolted enough to call the sheriff.) On camera, Viva made a rape complaint to sheriff Francine:

"For God's sake, find me a doctor. After all, I can't go to Japan and have my hymen resewn in."

By now, the Warhol troupe was notorious. Their unconventional sexuality, foul language, marijuana use, and far-out costumes were simply too much for Oracle's community standards. The sheriff made daily appearances at the ranch to investigate complaints of nudity, obscenity, and unnatural sex acts. One morning he was pacified by a sympathetic man-to-man talk with Frankie Francine, dressed for his role as a badge-wearing lawman; when the sheriff returned a little later, he was startled to find his movie counterpart in lurid makeup and drag. Through the remainder of the afternoon, men with binoculars lurked behind distant rocks or cacti as they monitored every move on the set. On another day, a helicopter hovered overhead, and a man with binoculars leaned out of the vehicle. Everyone assumed that this was the sheriff, but he later was seen peering at the actors from behind a water tank. The nocturnal intruders were even creepier. Lecherous ranchhands came snooping around after dark to see if there was any sexual action. Once a pair of cowboy Peeping Toms were invited inside a bungalow for a beer, they were visibly surprised to find the entire company sedately watching the Ed Sullivan variety show on television.

No one knew how the film was going to end, because the performers were still improvising their characters. Waldon was determined to take Hompertz away from Viva, but Emerson now asserted himself. "Tom and I are going to ride off into the sunset," he said. "We're going to California to play around, but I'm going to shoot him halfway there and come back and get Viva for myself." Consequently, they shot a scene in which Waldon tries to dissuade Emerson from going off with Hompertz. "You'll be running away all your life," Waldon said. "You've given up your ballet, and now you're giving up your chance to be a cowboy."

Monday morning found Warhol fretting about what to film with the last four reels. The movie did not seem to be jelling in any way, and he felt they were just shooting a lot of random scenes. "Maybe I should just shoot a cactus for thirty-five minutes," he said. "If we have to think about art, cactus is the most beautfiul piece of sculpture around." He then remarked, "If only we could do

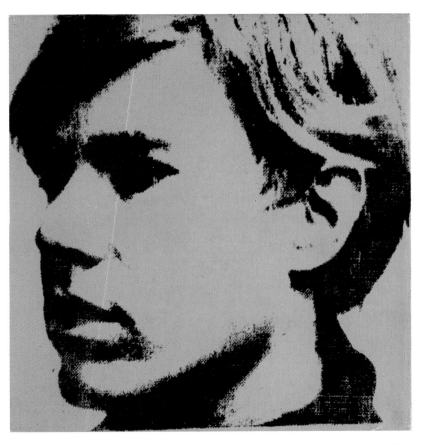

230. *Self-Portrait, Three-Quarter Profile.* 1967. Acrylic and silkscreen ink on canvas, 8 x 8″. Collection James Warhola, Rhinebeck, New York.

something to make it [*Lonesome Cowboys*] seem more profound." When the time came to edit *Lonesome Cowboys*, he would concede, "You can't make a movie out of it, so we're just going to cut out the best parts and paste them together. I don't really believe in montage, but I guess we've used it."

Warhol wasted part of a reel on what was to be Hompertz's monologue, filmed outside one of the bungalows. "I don't have anything to talk about," Hompertz said. "Talk about your rash," Morrissey told him, "how you get a chemical reaction from horses. Just talk about your skin condition, and if you've had your appendix out, things like that, but don't talk about modern things." Hompertz fluffed take after take. From the sidelines, Dallesandro dryly observed, "He's just a beauty, a pretty boy."

During a scene with Waldon, Hompertz, and Emerson, Viva poked her head out of a window and screamed, "I raised all the

money for this movie and I'm not even in it." "They're talking about you, dear," Mead assured her in a cooing tone. "They're building up to your entrance."

On the fifth and last day of shooting, the crew went out in a rented station wagon and parked near a corral with three horses. Viva, wearing a white riding costume, and Hompertz took their positions by the fence.

The scene went poorly. In take after take, Hompertz just smiled blandly, leaving Viva to do all the talking. She was in an irritable mood and soon ran out of funny or clever things to say. She finally lost her temper, snapping, "Viva shuts up!" One of the Peeping Tom cowboys drove his Jeep into the corral and parked right behind her. In a testy voice, Viva said, "Can you move your car? I haven't finished my line."

"Your line was no good anyway," Warhol told her.

Then a carful of students and instructors from the University of Arizona pulled up and parked. Like the sheriff, they were chronic visitors, primarily because they were filming a documentary of the Warhol production.

"Please don't follow us anymore," Morrissey told them. "We're going to be shooting out the back of the car and we're going to be doing dirty things."

The crew piled back into the station wagon and moved on to find a secluded spot where Viva and Hompertz could perform a nude love scene. They finally settled on a dry ravine, screened from nearby dirt roads and neighboring ranches by big boulders, scrubby trees, and brush. Warhol decided to finish off the remaining three minutes on the reel by letting Mead do a monologue. Mead, delighted, brandished a stalk of yucca like a staff and improvised a whimsical soliloquy on the "confusion of life." He was just reaching the high point of his speech when the reel came to an end and Warhol began moving the camera and tripod to another location. "But I only have three more words," Mead protested. "You want to save all of the last reel for their love scene?"

"We wasted too much time on those cowboy fag scenes," Viva said scornfully, complaining that she should have had no fewer than three reels of love scenes.

"Take your pants down to your knees," Warhol told her.

"Oh, Andy, that's so awkward!" she said, accusing him of portraying women as vulgar and coarse.

"Oh, Viva," Warhol groaned, "that's not true."

"Andy knows more about women than anyone else," Viva continued, "because women confide in him. He loves to gossip. I used to call him every night between 4:00 and 5:00 A.M. and we'd gossip until 6:00 or 7:00, and that's why I don't get any sleep. He knows what women like."

Hompertz took his shirt off and got into position beside Viva. "Oh, Paul, there's a shadow on him," Warhol said, casting a distressed look all around. No one reacted. "If you don't care, I don't care, but I thought we weren't interested in shadow. There's shadow on his hands. And look at the shadow on his body. Well, I don't care. Let's do it."

On camera, Viva began to sing liturgical music. Morrissey interrupted to tell them to disrobe completely. "Tell Tom to take his pants off and then you take your pants off. And don't talk too dirty— or else we can't show it."

From the sidelines, Mead muttered that Morrissey spoiled the actors' moods by giving too many directions. "He's worrying too much about 'the public.' Andy should fire him."

Viva asked Hompertz if he'd like to hear another Gregorian chant. "If you take off your pants, I'll sing it for you. Then I'll take off mine." She gave him a sweet, expectant smile. When the actor did not budge, her smile faded and she angrily faced the camera and announced, "He won't take his pants off." Then, glaring furiously at Hompertz, she snapped, "Now let's get down to it." He obeyed, but her command evidently had a chilling effect.

The performers went through some desultory embraces. Viva, as it turned out, was in quest of greater realism than Hompertz could muster. "Why can't you *do* it?" she asked. "I want him to *really* do it."

"Now here's where you take the pill and Taylor comes in," Morrissey said. Six minutes of film remained. Mead, stripped down to a makeshift bikini, emerged from behind the bushes and went through the histrionic motions of discovering the star-crossed lovers, to whom he offered a "poisoned" leaf. "Yes, let them die," he declaimed, "and I'll lick them because I have no water to wash the

bodies." Slurping Viva, he said, "It's me that's always loved you most, Ramona. These cowboys are too rough for you."

At the end of the reel, Viva sat up and complained, "All I can say is I feel like a failure as a sex symbol." But that was not the public image she projected following her return to New York. There, while being profiled for an article in *New York*, she revealed herself to be an uncommonly liberated woman who boasted about her sexual conquests. "The first two nights," she told the writer, "I slept with John Chamberlain, who is an old lover of mine. I slept with him for security reasons. Well, then, it was a different one every night. One night Allen Midgette and what's his name, Tom Hompertz, both made it with me. Andy looked in the window and said 'What are you doing in there? I told you not to. You're supposed to save it for the camera.' Then there was Little Joe [Dallesandro] who was sweet, and Eric [Emerson] who was just so rough….Paul Morrissey thinks I'm a nymphomaniac, but I don't. I just like to sleep with people, because I hate to sleep alone."[8]

Lonesome Cowboys brought Warhol and Viva to the attention of the Federal Bureau of Investigation, and for several years that government agency would keep an expanding dossier on the artist. Only three days after Warhol's arrival at the Rancho Linda Vista on January 24, the F.B.I. had been notified that he was making an obscene film.[9] Because Warhol was presumably returning with the film to New York, the F.B.I. could categorize his case as "Interstate Transportation of Obscene Matter." During February and March, the F.B.I.'s Phoenix office tried to establish the identities of the actors, director, and other personnel and to determine how the film had been transported to New York and by whom. Agents reviewed the guest registration forms at Rancho Linda Vista and rummaged through local newspaper morgues, unearthing a clipping with a large photograph of Warhol and "the white female known only as VIVA."[10] The Phoenix office also checked airline passenger lists to learn whether Warhol was on board American Airlines Flight #90 on or about January 30. But the investigation progressed slowly, and not until September did the F.B.I. realize that the sought-after list was in the airline's New York accounting office.

In addition to the sleuthing in Phoenix, F.B.I. offices in New York, San Francisco, and Atlanta would also join the investigation, doubtlessly expending an enormous amount of time and money in the attempt to have *Lonesome Cowboys* prosecuted for obscenity. While some of the F.B.I.'s tactics were as laughable as the pratfalls in a Keystone Cops comedy, they also displayed a chilling disregard for the right of free speech by presuming that *Lonesome Cowboys* was obscene before the film had been publicly exhibited—or even edited.

As the F.B.I. harassed Warhol, his film distributors, and the theater owners who showed his movies, a much greater disaster awaited him in his own Factory.

NOTES

1. Interview with Viva, January 1968.
2. Natalie Gittelson, "No Business Like Lecture Business," *The New York Times Magazine*, June 9, 1968, pp. 32–33, 132–36.
3. Don Bishoff, "Andy Warhol or Someone Gives a Non-Lecture Tour," *New York Post*, February 8, 1968.
4. Interview with Allen Midgette, March 28, 1988.
5. Interview with Allen Midgette, March 28, 1988.
6. Neal Weaver, "The Warhol Phenomenon: Trying to Understand It," *After Dark*, January 1969, p. 30.
7. Interview with Paul Morrissey, January 1968. Most of the quoted statements made during the production of *Lonesome Cowboys* were addressed to or overheard by the author, who was present throughout the five days of filming.
8. Barbara L. Goldsmith, "La Dolce Viva," *New York*, April 29, 1968, p. 38.
9. Margia Kramer, *Andy Warhol et al., The F.B.I. File On Andy Warhol* (New York: UnSub Press, 1988), p. 9. Kramer is an artist with a special interest in feminist, civil rights, and civil liberties issues, who, under the Freedom of Information Act, requested copies of documents in the F.B.I.'s file on Warhol; thirty-eight of the seventy-one pages in the dossier were released to her.
10. Kramer, *F.B.I. File On Warhol*, p. 17.

"I am so scarred I look like a Dior dress....The scars are really very beautiful; they look pretty in a funny way."—*Andy Warhol*[1]

The silver Factory was fated for the wrecker's ball. Toward the end of 1967, Warhol was notified that the East 47th Street building that housed his studio would be razed to make room for a new apartment building. The huge aluminum-foiled loft that had served as the setting for his "mass-produced" art, his countless movies, the cacophonous din of Velvet Underground rehearsals, not to mention a cornucopia of boisterous parties, wayward sex, and illicit drugs, would soon recede into the shadows of New York legend. When the Warhol troupe returned from filming *Lonesome Cowboys* in Arizona, they relocated in new, relatively office-like quarters.

Billy Name, Paul Morrissey, and Fred Hughes had all deliberated about what kind of space and which neighborhood would be most desirable for the new Factory. (Gerard Malanga was on an extended visit to Rome and played no role in the Factory's move.[2]) Name located a three-story building next to the Academy of Music on East 14th Street that he thought suitable, believing they could plug their movie operations right into the theater. Hughes argued in favor of another loft space because he thought it entirely possible that Andy might want to resume painting one day. Morrissey wanted a more conventional office in which to conduct business related to film production and distribution. After much scouting around, he located the "perfect" place—the entire sixth floor of the eleven-story Union Building at 33 Union Square West between East 16th and 17th streets. The space was long and narrow, and had hardwood floors, a pair of self-service elevators, and large windows in the front that overlooked Union Square Park. The location was ideal for transportation—and Max's Kansas City was only a couple of blocks away.

Andy, Paul, and Billy were all in agreement that silver decor had had its day and that the new look should be black and white. They constructed a wall that divided the space into two areas, a white front room that functioned as a business office and a black back room where the films would be screened. Morrisey oversaw the decoration of the front room, outfitting it with two large desks (for himself and Hughes), each consisting of a large sheet of plate glass resting on mirrored storage cabinets. The desks were intended to impress upon visitors that the Factory was now a business office and no longer a lounge for hangers-on. White telephones on each

231. Front page of the *New York Post*, June 4, 1968

WEATHER

Mostly Sunny.
80.

Tomorrow:
Sunny, 80-85.

SUNSET: 8:22 PM
SUNRISE
TOMORROW: 5:26 AM

New York Post

© 1968 New York Post Corporation

Vol. 167
No. 169

NEW YORK, TUESDAY, JUNE 4, 1968

10 Cents
15c Beyond 50-mile Zone

LATE CITY

Over the
Counter Stocks

ANDY WARHOL FIGHTS FOR LIFE

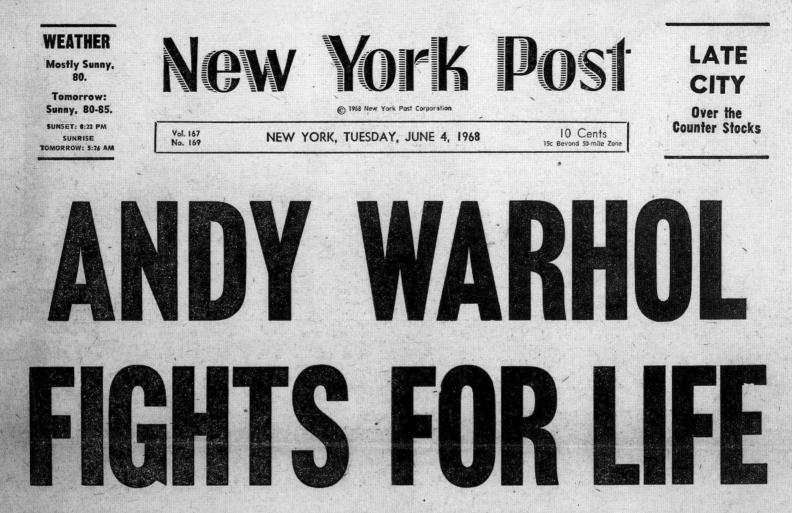

Marcus Taking Stand

**By MARVIN SMILON
and BARRY CUNNINGHAM**

Ex-Water Commissioner James Marcus was expected to be the government's first witness today in the bribery conspiracy trial that has wrecked his career and saddled the Lindsay Administration with its only major scandal.

His opening testimony follows a dramatic scene in U. S. District Court yesterday when Marcus, 37, changed his plea to guilty in a surprise switch which visibly jolted four of the five other defendants in the alleged $40,000 kickback plot.

The dapper former aide and confidante of the Mayor said he was in no way coerced or promised anything to change his original plea of Continued on Page 2

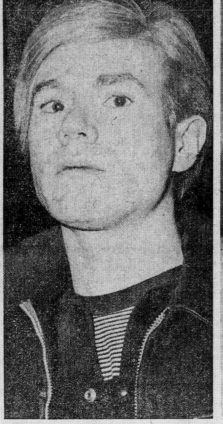

Post Photos by Boxer and Engel

Pop artist-film maker Andy Warhol makes the scene at a recent Long Island discotheque party. Valeria Solanis, who surrendered to police after he was shot and critically wounded, is shown as she was booked last night.

By JOSEPH MANCINI
*With JOSEPH FEUREY
and JAY LEVIN*

Pop artist Andy Warhol fought for his life today after being gunned down in his own studio by a woman who had acted in one of his underground films.

The artist - sculptor - film-maker underwent 5½ hours of surgery performed by a four-man team of doctors at Columbus Hospital late last

*Andy Warhol: Life and Times.
By Jerry Tallmer. Page 3.*

night and was given a "50-50 chance to live."

He remained in critical condition today and his chances for life had not improved.

At 7:30 last night, just three hours and 10 minutes after the shooting, Valeria Solanis, 28, a would-be writer-actress, walked up to a rookie policeman directing traffic in Times Sq. and surrendered.

She reached into her trench coat and handed Patrolman William Schmalix, 22, a .32 automatic and a .22 revolver. The .32 had been fired recently, police Continued on Page 3

desk added a Hollywood touch. The whitewashed walls were decorated with vintage color photographs of 1930s movie stars such as Claudette Colbert, Kay Francis, Katharine Hepburn, and Shirley Temple, as well as large photographic portraits of Factory superstars. The names of recent Warhol films were displayed on small electrically illuminated signs with snap-on letters.

Andy closeted himself in a small office on the north side of the front room, treating it as an inner sanctum that he could clutter up without getting in anyone's way. Most of the old Factory regulars seldom visited the new place, saying they didn't feel comfortable with its antiseptic look and Warhol's newfound inaccessibility.

Billy Name, who more than anyone had created the silvery spectacle of the old Factory, played a modest role in decorating the new quarters. He oversaw the decor of the screening room in the rear, which also served as an editing room and storage space. Billy chose the larger of the new Factory's two bathrooms as his darkroom, which again doubled as his living quarters. He painted it black, too, and secluded himself in his dark cell, straining his eyes as he studied various Buddhist and occult texts. In time, he became virtually invisible, the Factory's resident phantom who rarely appeared when anyone else was around.

One morning Morrissey was stripping layers of paint off the wood trim in the new Factory when a shy young man came in to deliver a Western Union telegram. Something about the quiet, clean-featured youth with a barely audible voice and hesitant smile made a favorable impression upon Morrissey, who engaged him in conversation. The "messenger" turned out to be Jed Johnson, a nineteen-year-old California college student who had very recently arrived in New York with his twin brother, Jay. (After their first semester at Sacramento's California State University, they had decided to take a semester off and see the country.) The brothers had been mugged on their first day in New York. They went to a Western Union office and wired home for money; while the penniless youths awaited a response, a kindly employee suggested they deliver telegrams in order to get some tips with which to buy food. Morrissey was moved by the young man's plight and offered him a part-time job helping to renovate and organize the Factory. Johnson started out doing various odd jobs and eventually

graduated to the sound-recording and editing of the films.[3]

In early February, Warhol was exposed as a "put-on specialist" when the news got out that he had sent an imposter to four western colleges the previous October. His ruse was discovered by a sharp-eyed student who noticed that a photograph of the artist in the *Village Voice* contrasted dramatically with his own snapshot of the "Warhol" who had visited his campus. The student's detective work inspired university officials in Oregon and Utah to investigate the identity of the man who had visited their schools. Don Bishoff, a newspaper reporter in Eugene, Oregon, brought everything into the open simply by placing a telephone call to the Factory. Morrissey told him that Andy simply "thought it would be nice if he could invent another person in place of himself." Warhol himself admitted all: "Oh, well, we just did it, well, I, uh, because, uh, I don't really have that much to say. The person who went had so much more to say. He was better than I am. He has what the people expected. They liked him better than they would have me—because I've been going on tours since then and they'd rather have somebody like that than me." The reporter asked how he could be sure "it was the real Andy Warhol" he was talking to on the phone. "Well," Warhol replied faintly, "I don't know."[4]

As a consequence of his prank, Warhol had to either redo the phony lectures or refund the schools' money. The notoriety of his non-lecture assured greater attendance at his next college appearances, as students came out to see if he was the genuine article.

Also in early February, Warhol, accompanied by Viva and Morrissey, flew to Stockholm for three days to attend the opening of a comprehensive show of his work at the contemporary arts museum, the Moderna Museet. The facade of the building was covered with the artist's intensely bright cow wallpaper, providing a blazing contrast with the surrounding snow. Andy, who dressed warmly for the occasion (wearing *two* pairs of shocking pink tights under his pants), exhibited twelve large flower paintings and ten big electric chair pictures that he had made the previous year in anticipation of the show. Unlike the earlier Electric Chairs, which had been silkscreened in black on monochrome grounds, the Big Electric Chairs (see plate 217) were printed—sometimes doubly and off-register—in colored pigments. Warhol cropped the photograph,

eliminating the "silence" sign and bringing the chair to the foreground. The exhibition also contained about five hundred *actual* Brillo boxes—not Andy's facsimile sculptures, but real cardboard containers. In addition, there were eight inflated-plastic clouds (five by three and a half feet), which sank to the floor through lack of helium; ten Marilyns; and ten film loops shown on three projectors. *Chelsea Girls* and *Bike Boy* were among the movies shown. The accompanying catalogue relentlessly promoted the Warholian concept of repetition, offering two reproductions of each painting on facing pages and repeating some of the pictures, such as *210 Coca-Cola Bottles*, for sixteen consecutive pages. The catalogue also offered an exhaustive look at life in the old Factory by including more than 270 full-page photographs by Billy Name and 180 full-page photographs by Stephen Shore. Unlike most museum publications, the catalogue contained not a single work of critical commentary on the art but did offer fourteen pages of Andy's often-quoted aphorisms, including "I like boring things" and "In the future everybody will be world famous for fifteen minutes."

Following his return from Stockholm, Warhol, accompanied by Viva and Morrissey, set out on a four-day journey to the Platteville and River Falls campuses of Wisconsin State University, and the Minneapolis and Duluth branches of the University of Minnesota. After the movies were shown (usually reels from "★ ★ ★ ★"), Morrissey answered most of the questions and Viva bantered with the students. The most frequently asked question, of course, was "How do we know he's the *real* Andy Warhol?" When asked if he wasn't really Allen Midgette, Warhol invariably said "yes."

After seeing "★ ★ ★ ★" in Platteville, Warhol remarked to one of his traveling companions, "My movies are empty, empty, empty. They're too beautiful, too planned. Even [Jean-Luc] Godard is more real." But then he looked on the bright side and declared that his own film was "so modern—it has no feeling."[5] School administrators, however, found "★ ★ ★ ★" objectionable and complained to the lecture bureau in Boston, while also phoning ahead to warn the River Falls campus. In River Falls, a faculty member told Andy to go ahead and show the uncensored film because the university would stand behind him as long as he explained the work afterward.

The Warhol trio might have passed for members of the local Parent-Teacher Association, so eager were they to dissociate themselves from unconventional sex and drugs. A student asked if Eric Emerson had been on drugs during the filming of *Chelsea Girls*. "Uh, I don't know," Warhol said. "He sued for $250,000 after the movie was made. Then we took him to Europe and introduced him to the Beatles and left him there. We thought he would make it as a rock 'n' roll star. Eric is marvelous. He can do anything." And what about Ondine? "He used drugs to slim himself," Morrissey said. "No one uses drugs anymore," Andy added. Asked about the prevalent homosexual themes in the movies, Viva said, "Well, those are the old ones. They're all straight now. I've converted them."

Who was Andy's favorite director? "Hitchcock." How did Warhol achieve certain technical effects? "We used the wrong kind of film." Did Warhol ever disagree with the things Morrissey said on his behalf or was the latter his spokesman? "Yes, to both questions." Would Warhol take up other art forms? "A small circus."[6]

Viva was an ideal consort for Warhol's public appearances, providing a witty, sexy, and outrageous dimension to their joint performances. Journalists were immediately attracted to her because she was so photogenic and quotable. Andy primed her fantasies of stardom, alternately pumping up and then deflating her ego. Like so many others, she submitted totally to his psychological manipulations, believing that he had the power to transform her into a great star. "Andy has a certain mystique that makes you want to do things for him," she confided to an interviewer. "Sometimes though when I think about Andy, I think he is just like Satan. He just gets you and you can't get away. I used to go everywhere by myself. Now I can't seem to go anywhere or make the simplest decision without Andy. He has such a hold on all of us. But I love it when they talk about Andy and Viva."[7]

The constant linking of Andy's name with Viva's reminded some people of a time when one of the most fashionable twosomes in town had been "Andy and Edie." Unlike Viva, who was currently basking in public attention, Sedgwick was shuttling from private to state hospitals. She spent three months being treated for malnutrition at Gracie Square Hospital, put in time at the New York Psychiatric Institute, and was committed for three months to

232. *Daily News.* 1968. Silkscreen ink on paper, 50 x 30″. Collection Nelson Lyon, Los Angeles

Manhattan State Hospital on Ward's Island in the East River. When she was not institutionalized, she was chronically overdosing on barbiturates and speed, at one point going into a coma that proved nearly fatal. A newspaper reporter sought to track her down through Warhol, who said, "I don't really know where she is. We really were never that close. She left us a long time ago…she went on her own and we never saw her anymore….I never really knew her very well."[8] When Andy's friends crossed him, he typically pushed his memory's "erase" button.

In May, Warhol and Morrissey went to La Jolla, California, to make a surfing movie starring Viva, Eric Emerson, Tom Hompertz, and Ingrid Superstar, among others. Around the time he was filming waves in Southern California, he was being verbally attacked in New York by playwright Imamu Amiri Baraka, then known as LeRoi Jones, who appeared onstage at a Black Panthers benefit at the Fillmore East theater. Baraka harangued the audience on black-white relations, saying, "We do not want [our children] to grow up to be Marlon Brando. We do not want them to grow up to paint Campbell's Soup cans. We do not want them to grow up to think that somehow the celebration of homosexuality is aesthetic and profound."[9] From a militant black viewpoint, evidently, Warhol symbolized condensed swish. But there was probably not a parent anywhere in the nation who considered Andy Warhol a suitable role model for children.

During the spring, several members of Andy's gang were engaged to play cameo roles in the movie *Midnight Cowboy,* to be shot during the summer in New York. The film, based on a novel by James Leo Herlihy and directed by John Schlesinger, concerned the misadventures of a Texas "cowboy" named Joe Buck, played by Jon Voight, who arrives in New York expecting to make his fortune by sexually servicing rich, lonely women. Tom Baker was reportedly considered for the role but dropped after the director saw *I, a Man.* The Buck character falls in with a sleazy assortment of Times Square characters, including Ratso Rizzo (played by Dustin Hoffman), a scrounger and con man who turns out to be the naive hustler's only friend in the city. Schlesinger sought to recreate New York's underground movie scene by hiring Viva, Ultra Violet, Taylor Mead, and several other people associated with Warhol to appear in a big downtown party scene. Viva was cast as the party's hostess, a filmmaker modeled upon Warhol himself. Shown at the party was a black-and-white "underground" movie of Ultra Violet (actually filmed by Paul Morrissey). *Midnight Cowboy*—perhaps because it contained so little creative input from the Warhol contingent—would win Academy Awards for Best Picture, Best Director, and Best Screenplay.

Although the Factory was a less casual place than before, anyone could still wander in. On a typical spring day in 1968, there was besides a half-dozen or so of the regular faces, an intermittent succession of old and new and mostly uninvited visitors. One of the reasons there was so much camaraderie among Warhol and many of his closest friends and colleagues was that they were all Catholics, though usually of the "lapsed" or renegade variety. Morrissey, Ondine, Malanga, Name, Hughes, Brigid Polk, and Joe Dallesandro were all Catholics, as were Ultra Violet and Viva, both of whom were convent-educated. Andy surrounded himself with people who knew how to strike a choirboy's innocent look while being caught in a "naughty" act. They were like parochial schoolchildren who do silly and infantile things in order to shock and torment the teaching nuns. At heart, they remained aware that they might someday be penalized for their breaches of conduct.

The telephones rang constantly. One caller wanted Viva to do voice-overs for *Ciao! Manhattan* to "unify" it. A television casting director tried to invite several "Warhol people" to provide "background color" in a television special on discotheques, but Warhol turned down the invitation because the caller "didn't say he would pay for drinks." Warhol's Minneapolis dealer, Gordon Locksley, was on a telephone line, but the artist didn't feel like talking to him. Nico was on another line, upset because the president of M-G-M Records wouldn't listen to her tapes in the middle of the night. An underground film distributor called, wanting to talk to Morrissey about bookings. When Warhol himself picked up a ringing phone, it turned out to be somebody wanting to buy a painting. "Oh, we're out of art," he said, hanging up.

On Monday, June 3, Warhol did not get to the Factory until late afternoon, arriving by taxi about 4:15 P.M. As he paid the driver, he saw Jed Johnson coming down the street, returning from the

hardware store with a bag of purchases. Andy lingered on the sidewalk, awaiting Jed, when Valerie Solanas, the rancorous bit player from *I, a Man*, suddenly materialized on the curb. She had been waiting for Warhol outside the building for a couple of hours, having shown up at the Factory earlier and been given the brushoff by Morrissey, whose barbed remarks were calculated to keep her at a distance. When Hughes had gone out to lunch, he had noticed Valerie standing outside near the door.

Warhol was not thrilled to see Solanas, who had resumed pestering him by telephone lately. Nevertheless, he, Jed, and Valerie entered the building together and took the elevator to the sixth floor. Andy noticed that Valerie wore lipstick and eye makeup, which he had never seen on her before. Otherwise, she was dressed in her usual mannish attire—khaki pants, a pullover sweater, and despite the warmth of the day, a long, fleece-lined coat. What he could not see was that she carried two handguns, one in each pocket.

As they stepped off the elevator, they saw Morrissey and Hughes, both at their desks taking telephone calls. Mario Amaya, the urbane, thirty-four-year-old founding editor of the London magazine *Art and Artists*, was impatiently awaiting Warhol to discuss a projected exhibition in England. As Jed Johnson disappeared into Warhol's small office to put his purchases away, Amaya sized up Solanas and concluded she was "creepy and crying and moody and peculiar."[10]

"It's Viva," Morrissey said to Warhol, waving his phone to indicate that she wanted to talk to him. Andy took the receiver as Paul walked off toward the bathroom in the rear. Viva was calling from Kenneth's fashionable beauty salon. Amaya turned away to reach for a cigarette. As Andy listened to Viva gab, he suddenly heard an explosive noise. He turned around and saw Solanas pointing a gun at him. He realized she had just fired at him and missed.

"No!" Andy screamed, "No, Valerie! Don't do it!" She pulled the trigger again. He fell to the floor, not really knowing whether he had actually been hit or not. He tried to crawl under the desk, but she pursued him, moving in closer to shoot again. He felt "horrible, horrible pain, like a cherry bomb exploding inside me."[11] As Andy lay bleeding, unable to move, he heard screams and more gunfire.

Viva, still on the line, thought the noise sounded like a cracking whip and wondered what kind of horseplay the Factory boys were engaged in now.

Amaya, hearing gunfire, assumed a sniper was shooting through a window and immediately dropped to the floor. When he looked up, he saw Solanas standing about three or four feet away, taking a couple of potshots at him. One bullet entered his left side above the hip and emerged from his back, missing his spine by only a quarter of an inch. Though wounded, Amaya made a flying leap into the screening room and slammed the big double doors behind him. Morrissey, oblivious to the gunfire, emerged from the bathroom at the rear of the Factory and was surprised to see that Amaya was bleeding and desperately holding the doors to the screening room shut.

Solanas then tried to open the door to Warhol's office, but apparently thought it was locked; Jed was on the other side, pressing against the door as he watched the knob turn back and forth. She next focused her attention upon Hughes, the only other potential target remaining in the front room. He was half hidden under his desk. He rose to his knees, pleading, "Valerie, *please* don't shoot me. I'm innocent." She seemed ambivalent about whether or not to pull the trigger. She went to the elevator, pushed the call button, then walked back to Hughes and pointed the gun directly between his eyes. "I have to shoot you," she told him. As her finger tightened on the trigger, the elevator door opened and Hughes shouted, "You'd better get out of here right away! There's the elevator! Just *leave*!" She fled.[12]

Hughes rushed over to Warhol, who was still conscious but in great pain and barely able to breathe, and attempted to give him artificial respiration. The place was in total chaos as Morrissey and the others frantically tried to summon the police and an ambulance. Billy Name, having mistaken the gunfire for ordinary "working sounds," finished up whatever he was doing in his darkroom and ventured out of his cloister to see what was going on. He was confronted by the sight of Amaya, excitedly lifting his bloodied shirt and asking everybody to count how many holes were in his back. When Billy saw Andy lying on the floor in the front room, he rushed over and threw himself down by the bleeding body. Andy mistook

233. Following his near-fatal shooting on June 3, 1968, Warhol is carried to the ambulance that would transport him to Columbus Hospital. Photograph by Jack Smith, New York *Daily News*

Billy's sobs for laughter, saying, "Don't laugh, oh, please don't make me laugh."[13]

The elevator door suddenly opened, causing everyone in the front office to scream and run for cover. Malanga and four other people stepped out of the elevator to face a scene of such pandemonium that a few of them stepped right back in to get out of the place as hurriedly as they could. Malanga stayed, of course, surveyed the damage, and told Morrissey that he was going uptown to break the news to Mrs. Warhola and to bring her to the hospital.

The police showed up about half an hour later, not an uncommonly slow response in Manhattan, and Warhol was carried out to an ambulance and taken, along with Amaya, to Columbus Hospital on East 19th Street between Second and Third avenues. Hospital staffers insinuated that Warhol's state was "hopeless," but

Amaya prodded them to make every effort to save him, assuring them that the patient was a famous artist with lots of money. Amaya himself was miraculously almost unharmed. An examination established that a single bullet had whizzed in and out of him without causing significant damage; he got bandaged up, went home, changed into a clean shirt, and set off for his previously scheduled dinner party that evening.

Within the hour, news of the shooting was broadcast on radio stations and disseminated by wire services. Soon, the narrow lobby at 33 Union Square West was crammed with police, reporters, news photographers, and alarmed tenants who wondered if it was safe to remain in the building. Outside, the police set up barricades to clear the sidewalk and hold back the gathering crowd of onlookers. Upstairs, several detectives took measurements, extracted slugs from the wall, poked through drawers, and scrutinized publicity

photographs of the Factory's superstars. The police eventually took Hughes and Johnson, whom they suspected of being implicated in the shooting, to the 13th Precinct Station on East 21st Street and grilled them until about 9:00 P.M.

At Columbus Hospital, dozens of Warhol's friends and colleagues—including Viva, Leo Castelli, Ivan Karp, Ultra Violet, Brigid Polk, Taylor Mead, Nico, and Louis Waldon—gathered in a lounge, where they waited tensely for news. Warhol was in an operating room, being attended by several surgeons, but the lack of information seemed ominous. The telephones rang constantly as reporters sought background information on the artist and his assailant. During their interviews, some of the superstars spoke of Warhol in the past tense.

Subsidiary dramas were being played out in other parts of town. Malanga had taken the subway—the fastest route—to Warhol's town house. Mrs. Warhola let him in, and, as she closed the door behind him, the telephone began to ring. Malanga rushed to answer it; as he suspected, the caller was a friend of Mrs. Warhola's who had just heard the news of Andy's shooting on the radio. Malanga thanked the caller, hung up, and said, "Julia, Andy got hurt. He injured his stomach. I'm going to take you to the hospital." There, after learning of her son's condition, the frail old woman in the babushka was heard to weep, "My little Andy, they hurt my little Andy." She appeared briefly at the edge of the lounge area, propped up between Malanga and Viva, crying and talking to herself as a flock of photographers elbowed each other to get pictures. Viva held onto Mrs. Warhola and calmly insisted, "He isn't going to die." Because of Mrs. Warhola's heart ailment, hospital attendants put her in a wheelchair and took her to a private room.

About 7:00 that evening, Solanas turned herself over to a policeman directing traffic at Seventh Avenue and 47th Street, handing him a .32 automatic—it had been recently fired—and a .22 revolver that she had in another pocket. She was arrested and taken to the 13th Precinct Station, where Hughes and Johnson were still being quizzed. At the news of Solanas's arrest, many of the journalists fled the hospital for the precinct station, only a few blocks away. Village Voice columnist Howard Smith reported that an array of photographers waited an hour for her to appear after being

questioned upstairs. "When she finally came through the door," he wrote, "her hands cuffed behind her back, it was bedlam. Photographers climbed behind the booking desk, elbowing cops out of the way. While police tried to book her, she posed and smiled for photographers. It was impossible to book her; the clicking and whirring of the cameras drowned out the sound of her voice. The police gave in, and let the press interview her."[14] Why had she shot Warhol? "He had too much control over my life."[15]

At 9:35 P.M., Dr. Massimo Bazzini, the medical director of Columbus Hospital, came into the lounge to report on Warhol's condition. At that time, the artist had been on the operating table for more than four hours. (A team of doctors would continue the surgery for another couple of hours.) Dr. Bazzini announced that a single .32 bullet had apparently entered the left side of the artist's torso and ricocheted through his liver, spleen, pancreas, esophagus, one pulmonary artery, and both lungs. (Later reports indicated that two bullets entered his body.) Warhol's condition was "critical," but he had a "fifty-fifty chance of survival." It seemed somehow natural that Andy, given his taste for tabloid melodrama and clichés, would elicit a phrase such as "fifty-fifty chance."

The shooting inspired front-page headlines in the following day's newspapers. The New York Daily News proclaimed "ACTRESS SHOOTS ANDY WARHOL," while the New York Post's banner was "ANDY WARHOL FIGHTS FOR LIFE." Through an odd coincidence, the date, June 4, was exactly six years from the day of the New York Mirror's front page that Warhol depicted in 129 Die.

That same day, June 4, Solanas made a contentious appearance in Criminal Court, where she was charged with two counts of felonious assault and possession of a deadly weapon. She angrily asserted that she had shot Warhol because "he had a legal claim" on her work. "I was right in what I did!" she shouted. "I have nothing to regret." She was brought back to court the next day, but rejected legal help, defiantly yelling, "Warhol deserved what he got! He is a goddamned liar and a cheat. All that comes out of his mouth is lies."[16] The judge sent her to Bellevue Hospital for psychiatric examination.

In the flurry of news stories that followed, Solanas was portrayed as a "crusader for a one-sex world" who had shown signs of a

disturbed psyche since childhood. Born in Atlantic City, New Jersey, in May 1936, she had majored in psychology at the University of Maryland at College Park, where she worked in an experimental animal laboratory; her experiences in tormenting caged creatures possibly helped prepare her for her later verbal and physical assaults on Warhol.

Her hate-filled S.C.U.M. manifesto, which she had sold in Greenwich Village coffee houses and on the streets and sometimes through ads in the underground press, called for the complete elimination of the male sex. The male of the species, she argued, was "a biological accident," "an incomplete set of chromosomes," and "a walking abortion." Women, she claimed, could reproduce without the assistance of males and bring forth only females. Therefore, she called on "civic-minded, responsible, thrill-seeking females" to "overthrow the government, eliminate the money system, institute complete automation, and destroy the male sex."[17] She imagined a utopian future when the "few remaining men" would voluntarily visit "the nearest friendly neighborhood suicide center where they will be quietly, quickly, and painlessly gassed to death."[18] She was obviously no Daddy's Girl.

Only a day after Warhol had been headlined in New York's newspapers, he was swept off the front pages by the assassination of Robert F. Kennedy in Los Angeles. The forty-two-year-old New York senator and former U.S. Attorney General had just won California's June 4 Democratic presidential primary when he was gunned down by a Jordanian assassin in the Ambassador Hotel. He would die twenty-six hours later. In the wee hours of that night, Brigid Polk, who had spent the evening with Viva at Andy's house, trying to comfort Mrs. Warhola, stopped at Max's Kansas City on her way home. As Brigid walked in, some of her pals yelled out to her, "Bobby Kennedy's been shot." She said, "Oh, will you stop joking!" while she thought to herself, "After Andy and everything, to pull something like that!" Then she heard a news broadcast and realized the story was true. She headed for the back room and encountered Robert Rauschenberg, who was coming down the stairs—he had been dancing on the upper floor. "I said, 'Hi, Bob,' and he smiled at me. I said, 'Bobby Kennedy was just shot.' And he fell down to the floor and he was crying and then he got up and he

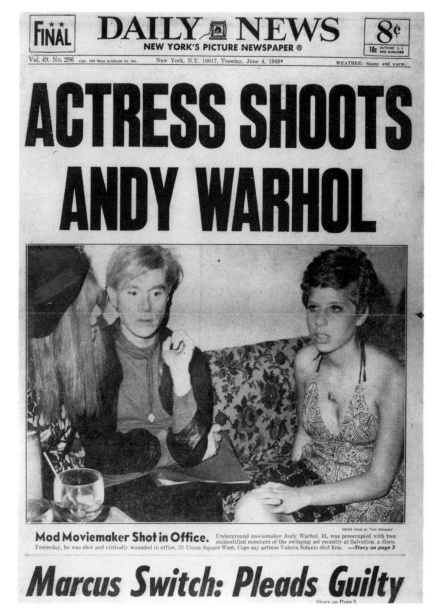

234. Front page of the New York *Daily News*, June 4, 1968

was sitting at a table—this was after Max's closed—and he said, 'Is this the medium?'"[19]

The combined shock of the Kennedy/Warhol shootings created confusion and disillusionment throughout the New York art world. When the painter Frank Stella came home from his studio, his wife, the art critic Barbara Rose, was distressed that both Kennedy and Warhol were in grave danger. Stella told her, "Bobby's going to die and Andy's going to live. That's the way the world is." "Oh, Frank," she said, "how can you say that?" "You'll see," he said. Rose interpreted Stella's remark as "an American parable—a kind of real American story."[20]

Late at night, there was consternation in the editorial offices of Life as the editors scrapped a lead story on Warhol for one on Kennedy. The managing editor cursed Warhol, accusing him of having injected so much craziness into American society that it was leading to the killing of the country's political heroes.

Andy, for several days after his shooting, was kept alive on a respirator. A week later, he remained in critical condition in the intensive care unit, but was breathing on his own, functioning without the aid of any machine. His rib cage was penetrated by plastic tubes, draining pus. The man who had once professed his desire to be like a machine would eventually describe his dependency upon medical apparatus by saying, "It was not at all like being a machine. It was real feeling, so painful."[21]

Many of Warhol's friends maintained private vigils in their efforts to will him back to life. Nico secluded herself in her apartment and lit hundreds of candles. Billy Name spent several hours every night standing outside the hospital and keeping watch on the windows nearest to Andy, praying for him. Meanwhile, Ivy Nicholson, who had been prepared to hurl herself from a high-rise window the moment her "fiancé" expired, assured everyone that, after they were married, nothing like this would ever happen to Andy again. As for the patient, he was permitted few visitors other than his mother and brothers.

One instrument that greatly accelerated Warhol's recovery was the telephone. Though he was still on the critical list, he was able to make outgoing calls. "When I called people up and they heard my voice for the first time since the shooting, sometimes they'd start to cry," he would later write. "I was very moved to see that people cared about me so much, but I just tried to get everything back to a light gossipy level as quick as possible."[22]

Warhol's optimism was tempered by the knowledge that he had received a lot of negative press coverage as a result of the shooting, and he expressed concern that this might affect his treatment. "Everyone at the hospital expected me to be horrible and they're so surprised I'm not," he reported in one of the calls from his bed. "They keep saying, 'You're not at all like we expected.' They probably think it's a put-on."[23]

While Warhol slowly recovered at Columbus Hospital, Solanas remained in the psychiatric ward of Elmhurst General Hospital in Queens, undergoing tests. On June 13, two representatives of the New York chapter of the National Organization of Women (NOW) appeared in court to charge that Solanas was being improperly detained and that she was being treated prejudicially because she was a woman. One of them, the activist lawyer Florynce R. Kennedy, characterized Solanas as "one of the most important spokeswomen of the feminist movement."[24] The other NOW representative, Ti-Grace Atkinson, then president of the New York chapter (and, ironically, a former director of Philadelphia's Institute of Contemporary Art), had not yet read the S.C.U.M. manifesto; but she would soon maintain, according to Solanas's publisher Maurice Girodias, that Valerie "would surely go down in history as the first outstanding champion of women's rights."[25] On June 28, Solanas was indicted on charges of attempted murder, assault, and illegal possession of a gun, and sent back to Elmhurst Hospital for more psychiatric tests. In mid-August, she would be declared incompetent to stand trial and committed to a mental institution.

Solanas's shooting of Warhol added another dimension of sensation and notoriety to the artist's reputation, securing his celebrity stature and authenticating him as an almost mythic martyr of an uncommonly politicized and violent era. Although his attempted murder did not generate the national havoc and disillusionment that followed the Martin Luther King, Jr., and Robert F. Kennedy assassinations that same year, it still functioned as a historical marker; from then on, people would discuss Warhol's art and life in reference to "before" and "after" the shooting. Life, in

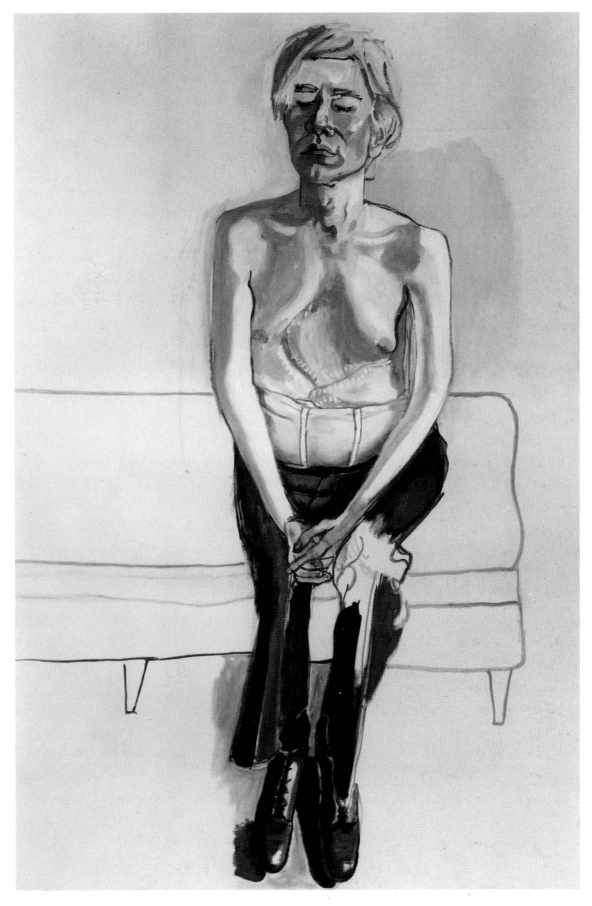

235. Alice Neel. *Andy Warhol.* 1970. Oil on canvas, 60 x 40″. Whitney Museum of American Art, New York. Gift of Timothy Collins

Andy's case, did appear to imitate his art. Few of his followers failed to notice how Valerie's actual gunfire echoed the violent images in his paintings—the portraits of Elvis Presley aiming his gun at the viewer, the pictures of James Cagney holding a gun in each hand, and the series of close-ups of Jacqueline Kennedy in the moments before and after the President had been shot in the head by a sniper. Solanas's attack upon Warhol was so extremist and absurd that it inevitably impressed some of the artist's detractors as another form of Warholian put-on, as if he had deliberately invited her murderous attention in his unwholesome bid to gain publicity.

On July 15, the 299-seat Garrick Theatre, a former showcase for off-Broadway plays at 152 Bleecker Street in Greenwich Village, was renamed The New Andy Warhol Garrick Theatre and opened with double-billed revivals of *Bike Boy* and *Nude Restaurant*. The company that leased the theater maintained that Warhol had earned the honor because he was primarily responsible for the acceptance of underground movies by art houses and moviegoers.

Warhol remained in the hospital for nearly two months, finally checking out on July 28. He was escorted home by his nephew, Paul C. Warhola, a seminary student at Catholic University of America in Washington, D.C., who had spent much of his summer vacation in daily visits to the hospital. Even with Paul helping him up the stairs to his bedroom, Andy had to stop every so often to catch his breath. "He still had drainage from at least one, maybe two, open wounds and a visiting nurse had to change the bandages regularly at home," said Paul, who stayed on for a week or so after the artist was back in his house. "He was ambulatory, but very weak and frail-looking." Paul sensed that his uncle had "an underlying fear of not fully regaining his physical health again."[26]

Warhol seemed to view his surgical scars as the stigmata of his celebrity. In the years to come, recognizing the public's morbid fascination with his shooting, he would agree to bare his scarred torso for other painters and photographers who sought to portray his maimed body in passive poses like a modern-day Christian martyr. In 1969, fashion photographer Richard Avedon produced a macabre close-up of the artist's torso, framed by the black leather jacket he is wearing; with his shirt pulled up and with one hand pulling down the elastic band of his underpants, Warhol appears to be pointing out the tracery of crisscrossed surgical slices and suture marks left behind in his flesh. In 1970, the New York portrait painter Alice Neel depicted Warhol with a meditative look on his face (his eyes are closed) as he sat shirtless on the edge of a couch, clasping his hands between his knees, his surgical corset in plain view (plate 235). She pitilessly portrayed him as a half-dressed carcass with the droopy breasts of an old woman. Years later, after seeing her portrait of him at the Whitney Museum of American Art, he remarked, "Wasn't the picture of me gruesome? It is grue*some*."[27]

Andy learned to overcome the horror of his scar tissue and to see it as an ornamentation unique to him. Nevertheless, he would be psychologically damaged for the rest of his life.

NOTES

1. Leticia Kent, "Andy Warhol: 'I Thought Everyone Was Kidding,'" *The Village Voice*, September 12, 1968, pp. 37–38.

2. While in Rome, Malanga, running short on money, forged a series of "Warhols" —silkscreened images based on a news photograph of the dead Cuban leader Ché Guevara. He made two phony paintings, gave one to a girlfriend and offered the other for sale—priced at $3,000—through a Rome gallery; in a February 1968 exhibition at that gallery, he also showed signed and numbered silkscreen prints from an edition of fifty, priced at fifty dollars each. When the dealer sought to verify the provenance of the "Warhol" Guevaras, Malanga wrote to Warhol, explaining that if the works were not authenticated, the poet would be "denounced—Italian style" and thrown into jail. Malanga enclosed a newspaper review of the show, commenting, "Andy, this is the *first* time that your art work has been praised by the Communist press." "What nerve!" Warhol remarked. Not one to be outwitted, he wired back, authenticating the paintings but stipulating that all monies were to be sent directly to him as "Mr. Malanga was not authorized to sell the artwork."

3. Interview with Jed Johnson, November 30, 1988.

4. Don Bishoff, "Andy Warhol or Someone Gives a Non-Lecture Tour," *New York Post*, February 8, 1968.

5. The companion was the author, February 12, 1968.

6. All remarks by Warhol, Morrissey, and Viva were made during the course of appearances before student audiences at Wisconsin State University at Platteville (February 12) and River Falls (February 13) and at the University of Minnesota in Minneapolis (February 14).

7. Barbara L. Goldsmith, "La Dolce Viva," *New York*, April 29, 1968, p. 40.

8. Helen Dudar, "Edie Sedgwick: Where the Road Led," *New York Post*, May 2, 1968.

9. Don McNeill, "Run, Do Not Walk, To the Nearest Exit," *The Village Voice*, May 23, 1968, p. 3.

10. John Wilcock, *The Autobiography & Sex Life of Andy Warhol* (New York: Other Scenes, 1971), n.p.

11. Andy Warhol and Pat Hackett, *POPism: The Warhol '60s* (New York: Harcourt Brace Jovanovich, 1980), p. 273.

12. The sequence of events was reconstructed from various published sources, mainly news clippings, Warhol's *POPism* (pp. 270–74), and interviews in Wilcock's *Autobiography*, as well as the author's interviews with Billy Name, Gerard Malanga, and Jed Johnson.

13. Warhol and Hackett, *POPism*, p. 273.

14. Howard Smith, "The Shot that Shattered the Velvet Underground," *The Village Voice*, June 6, 1968, p. 54.

15. Joseph Mancini, "Andy Warhol Fighting for Life," *New York Post*, June 4, 1968.

16. Frank Faso, "Court Orders Bellevue Test for Actress," *Daily News*, June 6, 1968.

17. Valerie Solanas, *S.C.U.M., Society for Cutting Up Men Manifesto*, with a commentary by Paul Krassner (New York: The Olympia Press, 1968), p. 31.

18. Solanas, *S.C.U.M.*, pp. 82–83.

19. David Bourdon, "Brigid" (interview with Brigid Polk), *Other Scenes*, June 1–14, 1969, n.p.

20. Jean Stein, *Edie, An American Biography*, edited with George Plimpton (New York: Alfred A. Knopf, 1982), p. 292.

21. Telephone conversation with Andy Warhol, June 1968.

22. Warhol and Hackett, *POPism*, p. 282.

23. Telephone conversation with Andy Warhol, July 24, 1968.

24. Marilyn Bender, "Valeria Solanis a Heroine to Feminists," *The New York Times*, June 14, 1968.

25. Solanas, *S.C.U.M.* (publisher's preface), p. 25.

26. Letter from Paul C. Warhola, February 16, 1989.

27. Telephone conversation with Andy Warhol, February 9, 1974.

FLESH PLUS TRASH EQUALS CASH

"It is possible future ages will see Andy in the image of Mary Magdalene; the holy whore of art history who sold himself, passively accepting the attention of an exploitative public which buys the artist rather than his art, which it is perfectly willing to admit is trash."—*Barbara Rose*[1]

Warhol spent his fortieth birthday at home, recovering in bed from his physical injuries. Relatives who had come in to take care of him and his mother departed as things got back to normal. At the end of each day, Jed Johnson usually dropped by to deliver Andy's mail and telephone messages. About two weeks after his return from the hospital, Warhol asked Johnson to bring him reels of *Lonesome Cowboys* so that he could begin editing the film down to a two-hour length. Because Andy could get up only a few hours each day, Jed began assisting him in the editing, which was accomplished in the front room on the parlor floor. The paneled room in the rear was almost impassable because of the clutter. As Johnson increasingly spent more time with Andy, he began straightening up the house, rearranging the furniture, and eventually painting every room. Soon he was doing the grocery shopping and helping to fix dinner.

Realizing how difficult it was for both Andy and his mother to get anything done, Johnson moved into the household a few weeks later. Some outsiders perceived Johnson's arrival as a live-in companion as evidence of an amorous relationship, which Johnson neither denied nor admitted. "I guess you could just call me the housekeeper," he dryly described himself years later. Mrs. Warhola was disgruntled by what she perceived as Johnson's intrusion in her home, but she was in poor physical condition (heart problems, arthritis, and weak legs) and headed toward senility. Johnson accompanied her on weekly visits to her physician and looked after her last two Sams, both cats also experiencing the afflictions of old age.[2]

At the Factory, Paul Morrissey took charge and, in "the-show-must-go-on" spirit, decided to capitalize on Warhol's headlines by releasing *The Loves of Ondine*, which opened at The New Andy Warhol Garrick Theatre on August 1. The movie, which starred "Pope" Ondine and featured Brigid Polk and Viva in supporting roles, had been filmed during the previous summer and fall. Its year in storage had not improved it. Viva, despite her witty debut, could not save the film, which had extremely poor sound, from being a dud.

The Loves of Ondine is historically noteworthy because it introduced not only Viva, the most scintillating of Andy's leading ladies, but also Joe Dallesandro, who soon became the Factory's most likely candidate for matinée idol. Dallesandro, by his own

236. Joe Dallesandro plays a junkie burglar who is outsmarted by Jane Forth in a scene from *Trash*, 1970.

294

account, met Warhol and Morrissey accidentally, outside John Wilcock's Greenwich Village apartment, while trying to buy drugs elsewhere in the building. "I was going to score dope," Dallesandro said, "and they were there, making a film in this building." He was talked into playing a scene in his jockey shorts, wrestling Ondine and Brigid Polk.[3]

Dallesandro normally dressed in a butch style and assumed the sullen, self-assured air of a macho hustler. He had no formal dramatic training, but was tremendously photogenic and naturally poised on camera. When Morrissey first viewed the reel in which Dallesandro appeared, he was instantly impressed by the youth's commanding screen presence. The clean-cut profile and square jaw were traditionally movie-star handsome. Later, in taking out a full-page ad for *The Loves of Ondine* in *the Village Voice*, Morrissey put the emphasis on Dallesandro. While photographs of Ondine and Viva were also included, the centerpiece of the ad—and the only reason that many people would bother to see the film—was a sexy photograph of Dallesandro in his white jockey shorts, looking as if he were about to swoon as his own fingertips grazed his neck. He possessed a physically robust and voluptuous beauty and was comfortable with the knowledge that his physique aroused sensual appetites in both women and men. He would be virtually unique among the Factory's stable of superstars because he lacked even the slightest trace of self-mockery or campiness.

Dallesandro had no problem improvising his lines, especially as literacy was not his forte. He had read just one book in his entire life—a biography of industrialist Andrew Carnegie—and only to pass an English class in his New Jersey high school. Expelled for beating up several of his teachers, he and his pals stole automobiles for the thrill of speeding around; he claimed to have swiped forty-seven cars before the police caught up with him and made it possible for him to serve time in a prison camp. He married his first wife after she became pregnant by another man; she also happened to be the daughter of his father's new wife. "The big problem in our marriage," as he put it, "was that her mother was my stepmother as well as my mother-in-law." At the time of his casting in *The Loves of Ondine*, Dallesandro was employed in a Queens pizza parlor, his loftiest ambition being to own his own pizzeria and to toss dough in the air.[4]

It is unlikely that Dallesandro would have been promoted as quickly if Warhol had been in command, because Andy always preferred talkers to lookers. (No one, in fact, ever witnessed a conversation between Warhol and Dallesandro.) "Andy is better at finding great female stars," explained Morrissey, who could scarcely contain his enthusiasm for the taciturn Dallesandro.[5]

As Morrissey's first film with Warhol had been *My Hustler*, he naturally saw parallels between that work and the current, more elaborate production of *Midnight Cowboy.* He was convinced that he and Andy could have dealt with the subject of a 42nd Street male prostitute more realistically, and wondered if they had made *My Hustler* "too early." Maybe the time was ripe to do another film on the subject—in color? With the approval of Andy, who was still recuperating, Morrissey sped into action and developed a scenario constructed around Dallesandro in the lead role.

The theme of the hustler appealed less to Warhol than to Morrissey, who relished the satirical possibilities of a male sex object that drives other characters wild. In Morrissey's view, hustlers were less dangerous hoods with larceny on their minds, than sweet, innocent, and malleable young men, forced by circumstances to offer their bodies for hire, thereby submitting their flesh, if not their hearts and souls, to the guileful wills of others.

Morrissey titled his film *Flesh* and improvised a plot that was basically a chronicle of meetings between the hustler and his partners. The film opens with Dallesandro sprawled naked on a bed, sleeping in an artfully discreet position. Joe's wife, played with shrill nastiness by Geraldine Smith, rouses him from his slumber and orders him into the streets to hustle enough money so that her girlfriend can get an abortion.

Having introduced Dallesandro as a good-natured and even responsible husband, coerced into hustling by his harridan of a wife, the film proceeds to establish him as a gentle and loving father. One of the film's few charming scenes shows Dallesandro and his infant daughter, both nude, enjoying a few moments of peace and solitude as they play quietly on a living-room rug.

Dallesandro displays no moral qualms about peddling his flesh; he is apparently experienced in this line of work. His pursuit of tricks leads him from one compromising situation to another. In an

amusing encounter, an older john, who is also an aesthete and sketch artist, pays Dallesanro to model in the nude; coached by his client, the young man obligingly strikes a succession of classical—though unfamiliar to him—poses. Later, he has a talky transaction with Louis Waldon, playing a war veteran who hopes to get the hustler for free.[6]

One of the most memorable scenes in the film has Dallesandro standing with his back to the camera as he supposedly receives oral stimulation from Geri Miller, a topless go-go dancer. While this act is being performed, two nonchalant female impersonators (Jackie Curtis and Candy Darling) sit on a nearby sofa, reading out loud some gossipy tidbits from movie magazines. It was their only scene in the film, but they easily stole it—especially the platinum-blond and very ladylike Candy Darling.

After his labors, Dallesandro returns home with the money to find his wife in bed, enjoying a sapphic relationship with her girlfriend, played by Patti D'Arbanville. None of his male tricks has humiliated him nearly as much as his callous wife. But he doesn't seem to care. Nude again, he collapses exhaustedly onto the bed, the final scene mirroring the first one.

Flesh made its debut at the Andy Warhol Garrick Theatre in September and became an instant hit, running for several months. Though it was entirely a Morrissey concoction, the film was billed as "Andy Warhol presents Joe Dallesandro in *Flesh*." Warhol was credited as the producer, Morrissey as the director. The film launched Dallesandro as a big underground star. Even the *New York Times* reviewer conceded that the young actor was "reminiscent of the early Brando in laconic speech and manner."[7] (Morrissey would be so convinced that his protégé was a young Brando that he later would wage a campaign to get him the role of Brando's youngest son—the part played by Al Pacino—in Francis Ford Coppola's film version of *The Godfather*.)

Naked, Dallesandro was a star of the first magnitude. His height was perhaps less than ideal and he was a bit short in the leg, but when his marmoreal torso appeared on screen, audiences hushed. Making only minimal movements and speaking as rarely as possible, he maintained an enigmatic aura that enabled audiences to project their fantasies upon him. "If you watch carefully,"

237. Time doesn't fly, but the food does, in the 1967 film *The Loves of Ondine*.

238. Jackie Curtis and Candy Darling read movie magazines while Joe Dallesandro is otherwise engaged in *Flesh*, 1968.

Dallesandro told an interviewer a couple of years later, "you'll see that my best performing comes when I have my clothes off....Next time you see a film where I'm naked, watch my face and you'll see what I mean."[8]

Careful watchers also detected striking dissimilarities in the work of Warhol and Morrissey. Where Warhol's *Blow Job* had been stylized, allusive, and conceptually erotic, *Flesh* treated the same subject (in the scene with Dallesandro and Geri Miller) in a more naturalistic, explicit, and physical manner, playing it for raunchy laughs. In contrast to the abstracted details of male anatomy in Warhol's *Sleep, Flesh* presents Dallesandro's nude body in its entirety, leaving little to the imagination.

Flesh prompted some critics to choose sides between Morrissey and Warhol. Jonas Mekas, for example, whose admiration for Warhol's films did not extend to Morrissey's, wrote, "I am a little bit amazed how anyone could mistake it for an Andy Warhol film. *Flesh* is an equivalent of an average Olympia sex novel. Nothing very much stands out, it has no special aesthetic or stylistic values, but it keeps going without boring you....*Flesh* is constructed, plotted, and executed with a definite calculation to keep one interested in it....A Warhol film never gives you an impression that it wants to make itself interesting...*Flesh* remains on the level of a caricature. In a Warhol film, even when an 'actor' acts, it looks like he's living it; in a Morrissey film, even when an actor lives it, it looks like he's acting."[9]

Critic Rex Reed disagreed, declaring in the *New York Times* that *Flesh* was "a wildly funny and highly innovational movie." He called it "the first Andy Warhol movie of any importance I've ever seen (probably because he had nothing to do with it except lend his name to its release), featuring the first naked Warhol superstar who can act (Joe Dallesandro) and dialogue so sharp even Joe Mankiewicz would be proud to have written it."[10]

In addition to Dallesandro, *Flesh* also helped to make stars out of Jackie Curtis and Candy Darling. Candy, who had been christened James Slattery, was from Massapequa, Long Island. Even as a child, he had been dazzled by the artificiality of women with platinum blond or white hair. When he was about nine years old, he began to play out fantasies of being Lana Turner in the 1950s film spectacle *The Prodigal*, filling the bathtub and pouring food color into the water to tint it a rich "Technicolor blue." He moved the houseplants from the living room into the bathroom to create a setting of tropical splendor, reddened his lips with his mother's lipstick, wrapped a yellow towel around his head (it made him feel more like Lana), and finally slipped his gangling white body into the cerulean water to continue his vivid daydreams. After Lana, it was Kim Novak. She took over his whole make-believe life, controlling his mind to such an extent that he bought movie magazines only if she was in them. After he grew up and plucked his eyebrows and bleached his hair platinum blond, however, Candy looked as though Jean Harlow had battled Lana and Kim for custody of his persona.

Jackie Curtis was the most literary of the Warhol transvestites. He had grown up as John Holder, Jr., in the East Village, where his grandmother owned a neighborhood saloon named Slugger Ann's. Jackie was easily recognized even from a distance by his frizzy dyed-red hair, the "Blood Alley" red on his nails and lips, the glitter on his eyelids, his tinsel boas, and the runs in his stockings. He aspired to a fashion look that he described as "slatternly," appearing both "trampy and classy" in vintage clothing that he searched out in thrift shops. He also wore a tattoo—"ANDY," with a big "A" enclosing the other three letters—on his left shoulder. A playwright, he wrote and directed several campy, off-Broadway plays, including *Heaven Grand in Amber Orbit, Glamour, Glory, and Gold,* and *Vain Victory,* all parodies of old Hollywood movies.

All of Andy's friends and fans were elated when, on September 5, he made his first public appearance since his shooting, attending a party with Viva and Ultra Violet to celebrate the completion of *Midnight Cowboy.* The following day's *New York Post* announced his return with a front-page photograph of him and Ultra Violet. When a reporter quizzed him about Valerie Solanas, Andy blandly said, "I don't think she was responsible for what she did. It was just one of those things." He admitted to being more fearful than before, and newly afraid of God, especially when he was alone. "Having been dead once," he said, apparently in reference to a near-death experience on the operating table, "I shouldn't feel fear. But I am afraid. I don't understand why...I am afraid to go to the Factory."[11]

Still Warhol forced himself to show up at the Factory almost every day. (His movements were somewhat restricted by having to wear surgical corsets to support his weakened abdomen, but he compensated for this inconvenience by dyeing them in bright colors to make them more decorative.) On Thursday, September 19, he hosted a Factory reception for about two hundred people in honor of Nico's latest album of original songs, *The Marble Index*.

No matter how many people were around, Warhol felt apprehensive whenever he heard the elevator approach the Factory's floor. He tended to hold his breath while he waited to see who would step out of the cabin. At the end of one workday, he telephoned a friend from the Factory to report that he found himself alone and was too afraid to take the elevator to the lobby. Every time the indicator light on the elevator panel lit up, signaling that the car was in use, he became filled with dread, and watched in horror to see if the doors would open on his floor; he could not breathe easily until the indicator light went off. Although the friend offered to go to the Factory and escort him to a taxi, he finally summoned the nerve to exit the building on his own.[12]

Toward the end of 1968, Warhol's book *a*—the transcribed tapes of his outings with Ondine—was published by Grove Press. The 451-page "tape novel," according to the dust jacket, related "one day in Ondine's life—a day that begins with Ondine popping several amphetamine pills and ends, twenty-four hours later, in an orgy of exhausted confusion."[13] Much of that confusion spilled over, alas, into the design of the book, the format of which went back and forth between single and double columns of dialogue, printed intact with every misspelling provided by the typists who transcribed the tapes. The book was unreadable and, not surprisingly, received resoundingly negative reviews. *Time*, which headlined its review "Zzzzzzzz," called it "an unedited transcript of twenty-four hours' worth of drug-induced schizophrenic chatter."[14]

Despite the devastating book reviews, Warhol was not discouraged from continuing to use his tape recorder to preserve many of his conversations. Though a tape recorder and a Polaroid camera had long been part of his artistic arsenal, he now appeared to want to document virtually every encounter with the people who entered his life. He rarely made his daily rounds without a plastic

239. Ingrid Superstar and French actress Martine Barat greet Warhol at a reception for Nico's latest record—the first Factory party since his shooting—in September 1968. Associated Press/Wide World Photo

shopping bag, in which he carried his photographic equipment, tape recorder, medicine, and cosmetics. At home in the mornings and evenings, he taped his marathon telephone conversations with his pals, squandering his time exchanging gossip, soliciting ideas, and "making trouble." "I'd provoke any kind of hysteria I could think of on the phone just to get myself a good tape," he admitted.[15]

Warhol's interests seemed a bit more prurient after his shooting. His earlier "cock" drawings, Polaroids of buttocks, and films such as *Couch* and *Blow Job* had suggested a consistent pattern of lascivious thought, but his conversations now displayed a more open and persistent lewdness. Perhaps the injuries to his body, which restricted his own movements and caused him constant worry, also ignited his imagination about the pleasures that other people were finding through intimate bodily contact. The very first movie he made after returning to work was a candid view of

heterosexual lovemaking, starring Viva and Louis Waldon. Andy had initially wanted to call the film *Fuck*, but he later settled on the less inflammatory title *Blue Movie*.

The film was shot on a Saturday afternoon in October, in a high-rise Greenwich Village apartment overlooking the Hudson River, the same apartment where Morrissey had filmed Waldon's scene for *Flesh* one week earlier. Warhol and Viva had paid a surprise visit during the shooting of *Flesh*, and Andy remarked that the apartment was exactly the type of "tacky modern" setting he wanted for Viva's fornication spectacle. As Viva's first choice for the male lead turned down the role, Waldon was then offered the part, which he gladly accepted, and a date was set for the filming—despite the repeated objections of the apartment's tenant.[16]

On the following Saturday morning, Waldon, Warhol, Morrissey, Viva, Fred Hughes, and Gerard Malanga converged on the apartment. The bed was moved into the living room, and Andy determined its positioning and the location of the camera. He did all the photography and contributed what little there was in the way of directing. Hughes operated the sound equipment and Morrissey and Malanga mostly looked on. No one was aware at the time that this would be the last Warhol movie in which Viva would appear. Although she later claimed it was his "best movie," she also complained that he had ruthlessly exploited her and damaged her public reputation.

For a sex film, *Blue Movie* is uncommonly talky with a great deal of languorous teasing and very little in the way of actual physical penetration. The film begins with Viva, in a diaphanous blouse and pants, and Waldon, in a flowered sport shirt and pants, sprawled on a bed. They converse naturally, relating anecdotes from their own experiences. Viva tells how Brigid poured a jar of baby food all over her: "She was so up there that she said, 'Give me that.' And I gave it to her and she lifted her hand like when she shot the water pistol out the taxi window at the woman and they put her in jail because Khrushchev was in town and they thought she was going to assassinate him because she had a *water* pistol, and her lawyer told her to say that her arms were causing her hands to swerve causing the gun to go off...well, her arms were causing her hands to cause pear baby food to go all over me. And she immediately said, 'I

DIDN'T DO IT. I DIDN'T DO IT.' And then I didn't get mad. I just quietly wiped it off and then she got all upset because I didn't get mad."[17] Following that less-than-erotic dialogue, they disrobe, and Waldon observes that Viva's nipple reminds him of "a dried apricot."[18]

In the second reel, they get around to some affectionate intercourse. The sex in *Blue Movie* is unusually casual, unhurried, and naturalistic, with the couple displaying a tenderness that is ordinarily lacking in hard-core movies. In the third reel, as they bask in the afternoon sun that pours in through the windows, Viva talks about socially redeeming subjects such as President Lyndon Johnson and the United States involvement in Vietnam. In the fourth and final reel, they get dressed, Viva cooks dinner in the kitchen, and they end up in the bathroom, where they disrobe and take a shower together. Viva soaps Waldon's penis, then kneels down and blows on it as if she were inflating a balloon. Shortly before the film ends, Viva looks toward the camera and asks, "WHAT, IS IT ON? IS IT STILL ON?"[19]

"What I'd had in mind," Viva later explained, "was a leisurely, sensual pas de deux. What transpired were some forced and strenuous exercises at the *barre*."[20]

A few weeks after *Blue Movie* was shot, *Lonesome Cowboys* became the most controversial film at the San Francisco Film Festival (which also included Jean-Luc Godard's *Weekend*). On November 1, its midnight screening at the Masonic Auditorium was a sellout. Warhol remained in New York, but Morrissey and Taylor Mead attended the festival and introduced the film. Morrissey archly informed the audience that the Warhol company was "broadening" its horizons "to incorporate degenerates from all parts of the country." The *New York Times* film critic Vincent Canby reported that the movie was "a low-camp satire" and "a sort of zany gray Western."[21]

Canby was not the only critic in the house. The Federal Bureau of Investigation had sent two eagle-eyed special agents to review the film. In a memo dated November 6, they supplied a keen appraisal of the film's lustiest moments. "All of the males in the cast displayed homosexual tendencies and conducted themselves toward one another in an effeminate manner," the F.B.I. men reported. "Many of the cast portrayed their parts as if in a stupor from marijuana, drugs

or alcohol....The movie opened with the woman and her male nurse on a street in the town. Five or six cowboys then entered the town and there was evidence of hostility between the two groups. One of the cowboys practiced his ballet and a conversation ensued regarding the misuse of mascara by one of the other cowboys.... Later in the movie the cowboys went out to the ranch owned by the woman. On their arrival, they took her from her horse, removed her clothes and sexually assaulted her. During this time her private parts were exposed to the audience....The position of the male and female suggested an act of cunnilingus; however, the act was not portrayed in full view of the camera."[22]

"There are other parts in the film," the F.B.I. memo continued, "in which the private parts of the woman were visible on the screen and there were also scenes in which men were revealed in total nudity. The sheriff in one scene was shown dressing in woman's clothing and later being held on the lap of another cowboy....Another scene depicted a cowboy fondling the nipples of another cowboy. There were suggestive dances done by the male actors with each other. These dances were conducted while they were clothed and suggested love-making between two males. There was no plot to the film and no development of characters....Obscene words, phrases and gestures were used throughout the film."[23]

Lonesome Cowboys contributed in a minor way to a widespread "erotic renaissance" in the arts. In a climate of freedom and permissiveness, nudity and sex were flourishing in both the theater and films. The Broadway musical *Hair*, which opened in April 1968, featured a nude "be-in" that was many theatergoers' first encounter with full-frontal nudity. In Los Angeles, the play *Fortune and Men's Eyes* was staged with a realistic scene of homosexual rape performed by unclad actors. *Oh, Calcutta!*, which would open on Broadway in June 1969, offered viewers a cast of nude men and women and a cornucopia of erotic sketches. On the silver screen, many of Hollywood's major stars were shedding their clothes. To keep up with the sex revolution, publishers launched a plethora of explicit tabloids with raunchy titles, the most successful and durable being *Screw*. Given the moral confusion of the times, it was to be expected that guardians of decency would go after highly visible figures such as Warhol.

It sometimes seemed to Andy that almost everybody was out to get him. One of his recurrent nightmares came true at the Factory on Christmas Eve, when he answered the telephone and "almost fainted" when he heard Valerie Solanas's voice on the line, demanding that he drop all criminal charges against her. She was at liberty, having been adjudged competent to stand trial and released from Mattewan State Hospital on December 16 because a man, whose name Warhol did not recognize, put up ten thousand dollars' bail. In a series of threatening calls, according to Warhol and Morrissey, she insisted that they buy all her manuscripts for twenty thousand dollars and arrange for her to appear as a guest on television talk shows. If she didn't get her way, she allegedly said, "I can always do what I did before."[24]

The district attorney's office, informed of the call, went to court and got a warrant for Solanas's rearrest for aggravated harassment. But the police could not find her. Oblivious of the warrant, Solanas showed up in court on January 10, 1969, learned that her bail had been revoked, and was sent to the Women's House of Detention. On February 25, pled guilty to first-degree assault. On June 9, she was sentenced to an up-to-three-year prison term. "I didn't intend to kill him," she told the judge. "I just wanted him to pay attention to me. Talking to him was like talking to a chair." Other people, she added, had received lighter sentences for more serious crimes. She was sent to the Bedford Hills Correctional Facility, a state prison for women, in Westchester County.[25]

Solanas's irrational assassination attempt and her renewed threats of mayhem made Warhol realize he had to dissociate himself from some of the unstable and unpredictable people who surrounded him. His close encounter with death gave him a scarier perspective on the nutty people who formerly amused and fascinated him—and frequently provided him with ideas. Now, how could he ever know which of the crazy "kids" were potentially lethal and which weren't? "The fear of getting shot again," he said, "made me think that I'd never again enjoy talking to somebody whose eyes looked weird. But when I thought about that, I got confused, because it included almost everybody I really enjoyed!"[26]

As everyone at the Factory was newly security conscious, the decision was made to construct a small foyer by the elevators; a

Dutch door—with its lower half always kept locked—permitted a receptionist to screen visitors before admitting them. The days when just anyone could saunter into the Factory were over. Some of the new employees were neatly dressed, businesslike, and so devoid of any type of personal flamboyance that they might have passed for rising executives in an insurance company. Many of Andy's old pals, including some of his favorite superstars such as Viva, Ondine, and Taylor Mead, felt unwelcome or rejected, as if they were being phased out. While many of Andy's brood continued to perceive him as an all-providing mother hen, they came increasingly to view Morrissey as the wicked stepmother. Sooner or later, nearly all of the old Factory crowd turned on him; Brigid feuded with Morrissey for years, Malanga regretted that he had invited him into their circle, and Viva complained that Paul wanted only to make money and disposed of anyone "unfashionable or uncommercial." In Morrissey's defense, however, it must be said that he carried out many of his boss's unpopular decisions, playing the villain's role— hatchet man, bad cop, or artist's wife—so that Warhol could maintain his benign image.

Noticing that artists such as Michael Heizer and Robert Smithson were becoming famous for large-scale environmental projects and earthworks, Andy set his mind to creating something elemental with rain, wind, or snow. By April 1969, he had constructed three mechanical mock-ups at the Factory. One was a large glass-faced construction containing white polyethylene particles; air blowers sent the particles flurrying to simulate whirling snowflakes. A second construction was a wind machine, consisting mainly of a wooden box encasing an air blower. The third project was a rain machine with a simple pump system that circulated water through a length of pipe on top, the water falling through a series of holes in the pipe into a trough concealed beneath an artificial grass bed. These new works did not amount to much artistically, but they demonstrated his continuing desire to be far-out.

Maurice Tuchman and Jane Livingston, curators at the Los Angeles County Museum of Art, had solicited Warhol's participation in an art-and-technology program that was intended to place artists in residence for up to twelve weeks in various California industrial corporations to see what kind of collaborations might result. During

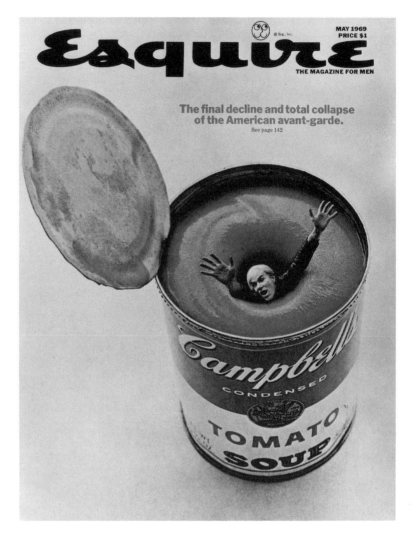

240. Warhol was down and out with the avant-garde, according to the May 1969 issue of *Esquire* magazine.

Warhol's visit to Los Angeles in February 1969, Tuchman and Livingston had discussed with him the notion of working with lasers to make three-dimensional holographic images.

But this was to be an artistic collaboration that fizzled. Warhol did not get his holograms but had to settle instead for a process of three-dimensional printing conventionally used on greeting cards, with a layer of lenticular plastic. Warhol was well aware, as he dryly observed to one of the curators, that the process was not "all that glamorous or new or exciting." The image he chose was a photograph of four plastic daisies spread out against artificial foliage, reproduced in a square format that was repeated serially on five

separate panels, each four by eight feet. This mural of plastic daisies ultimately functioned as a backdrop for an inelegant metal construction that permitted water to drizzle from overhead pipes into a trough on the floor. The *Rain Machine* was contracted to Today's Displays, a New York firm, and the finished construction was shipped to Osaka for inclusion in the United States Pavilion at Expo '70; there had been no time to build a mock-up for Warhol's approval and still meet the Expo deadline. Not until Tuchman and a design team installed the piece in Osaka did anyone notice that the three-dimensional illusion of depth was barely perceptible from a spectator's vantage point because the scale of the flowers was too small.[27]

Six months after its San Francisco premiere, *Lonesome Cowboys* opened in New York at the Andy Warhol Garrick Theatre and the 55th Street Playhouse. (According to Morrissey, the Garrick was the only theater in town interested in showing the film; the 55th Street could be hired by anyone for $2,700 a week.)[28] Critics pounced on it. Andrew Sarris, writing in the *Village Voice*, opined that "The tediously and fatalistically passive homosexuality of Warhol's world has degenerated through mindless obsessiveness into nastily contrived anti-heterosexuality. Viva! allows herself to be used as a scrawny fag hag for the dubious purpose of desecrating not merely the ideal but even the idea of authentic womanhood." With Warhol "forced to play genre games, the undisciplined narcissism of his menage clutters the screen with giggly egos out of synch with each other and with any coherent conception imaginable in the inscrutable incoherence that seems to sum up Warhol's wonders."[29]

Time magazine noted: "Now that Boris Karloff and Bela Lugosi have passed on, Viva! stands unrivaled as the screen's foremost purveyor of horror. By the simple expedient of removing her clothing, she can produce a sense of primordial terror several nightmares removed from any mad doctor's laboratory."[30]

Despite its critical drubbing, *Lonesome Cowboys* received national distribution, often attracting more attention from district attorneys than from the paying public. When the movie was shown in Atlanta, county police confiscated the film and photographed the audience for inclusion in their "undesirables" files. Later, the county solicitor stated on television that members of the audience were likely to be "sex criminals," and lawmen publicly announced they would compare the photographs with pictures of "known homosexuals." The American Civil Liberties Union sued to have the photographs destroyed, charging that the raid was illegal and unconstitutional.[31]

After *Lonesome Cowboys* languished at the box office, Warhol, perceiving that "all sorts of dirty movies" were playing around town, decided to follow up with *Blue Movie*, which opened at the Garrick Theatre in July. It, too, received lukewarm notices. "*Blue Movie* is a cheerful stag film," Canby told his *Times* readers, "rather prettily photographed in a greenish-blue color, in which the performers actually do what has only been simulated in more conventional films." He estimated that approximately one-third of its footage— "thirty-five minutes, according to the man from *Variety*, who apparently clocked it"—was "pornographic, showing superstar Viva and her co-star, Louis Waldon, wrestling atop a bed and finally carrying out the sex act with a lot of conversation." He reported that a program note described the film as "about Vietnam and what we can do about it." "In this," he added, "Warhol is just being whimsical."[32]

On July 31, scarcely more than a week after *Blue Movie* opened, New York City police raided the Garrick Theatre, seized the print, and arrested the theater manager, the projectionist, and the ticket seller for possession of obscene materials. The district attorney's office initiated the seizure after a criminal court judge viewed the film at the theater. On September 17, a three-judge panel in Criminal Court, after deliberating less than thirty minutes, ruled unanimously that *Blue Movie* successfully met all the criteria for obscenity: taken as a whole, it aroused prurient interest in sex, offended contemporary community standards, and was totally without redeeming social value, making it "hard-core pornography" and therefore in violation of the penal code. In contrast to this verdict, Al Goldstein, the publisher of *Screw*, found the film "so amateurish and boring that it shocks me that three New York City judges even bothered to label it obscene."[33]

During the fall of 1969, Warhol began to publish *Interview,* a new monthly tabloid that he originated with John Wilcock, who was then

publishing his own newspaper, titled *Other Scenes.* "I was at the Factory one afternoon," Wilcock recalled, "and Andy was complaining as usual about not having his million dollars to do a movie. I said offhand, 'Why don't you do a newspaper, Andy?'" The suggestion set Warhol to pondering the possibilities of starting a magazine that consisted of taped interviews with film celebrities.[34]

Wilcock, who was running a typesetting business out of his Greenwich Village apartment, proposed that he and Warhol share the expenses of the publication; he would provide the typesetting and Andy could pick up the bill for the printing, which would run between five and six hundred dollars an issue. Wilcock also recommended that Warhol put his name on the cover—"Otherwise, why would people buy another crappy newspaper?" But the artist didn't like that idea at all; he wanted the title to be *inter/VIEW* (later it was changed to simply *Interview*). Wilcock then asked what kind of format Warhol wanted, expecting the artist to come up with something "real revolutionary." Instead, Warhol said, "I want it to look like *Rolling Stone.*"[35]

When the first issue of *Interview* appeared, it called itself "A Monthly Film Journal" and was priced at thirty-five cents. The black-and-white cover photograph was a movie still of Viva, James Rado, and Jerome Ragni, all posed discreetly in the nude for French director Agnes Varda's made-in-Hollywood film *Lion's Love.* All the photographs in *Interview* were publicity stills or stock photos.

Malanga was named co-editor and put in charge of running the editorial side of the operation. One of Warhol's main reasons for starting the magazine, according to Malanga, was to get press passes to film showings and festivals. In the beginning, no one paid much attention to the refinements of editorial style. Many of the tape-recorded conversations preserved every "uh" and "uh...uh" for posterity. Wilcock took no part in the editorial development, but was listed on the masthead as copublisher. He considered himself a fifty-percent owner of *Interview* at this time.

After about a year, Wilcock planned to move to England. As he had nothing on paper to assure him even a small percentage of the magazine, he had no choice but to sell out to Warhol. "*Interview* still wasn't making any money, of course," Wilcock reported, "so Andy said he'd buy me out for the cost of a year's typesetting. I presented

him with a bill for $6,000 and he paid me $5,000 altogether in bits and pieces. I began to think I'm never going to see the rest of this money, so I said to him one day, 'You know, Andy, you still owe me a thousand dollars on that typesetting bill. Why don't you give me some of your work?' Andy settled the debt by giving Wilcock two of his 1970 silkscreen prints of flowers, which then had a commercial value of about five hundred dollars each. "Almost immediately," Wilcock observed, "Andy, being sole owner, put his name on the cover."[36] Subscriptions picked up, not entirely welcome news to Andy. "I hate subscribers," he said. "If we fold, I don't want to have to send back the money."[37]

Over the years *Interview* evolved from an amateurish movie-fan magazine with tedious dialogues and fussy-looking graphics into a sleek journal that chronicled the careers and life-styles of a wide range of celebrities, mainly in the entertainment, art, and fashion worlds. It would become national and then international in its coverage of veteran actresses, rock stars, starlets, and pretty cosmopolites. It also would change from using free pick-up photographs to commissioning its own group of contributing photographers to shoot glamorous portraits. The magazine's readership, according to surveys, was young, rich, and fashion-conscious. Still, *Interview* would not become profitable, according to Warhol, for another ten years.

During this period, Warhol seldom left home without his Polaroid camera. He became in effect an ambulatory light show, setting off a series of blinding flashbulbs as he punctuated virtually every social encounter with prodigal picture-taking. His zeal was infectious and promoted a great deal of exhibitionism on the part of his subjects. He took "thousands" of Polaroids of genitals. "Whenever somebody came up to the Factory," he said, "no matter how straight-looking he was, I'd ask him to take his pants off so I could photograph his cock and balls. It was surprising who'd let me and who wouldn't."[38]

One of Warhol's closest and most conspiratorial pals at this time was Brigid Polk. A diabolical duo, they brought out the naughtiness in each other. "She's nutty," he exclaimed. "She's like a dropout. She's like my daughter! Brigid has got a lot of ideas. She's the windup toy."[39] She was still darting about town with her ink pad

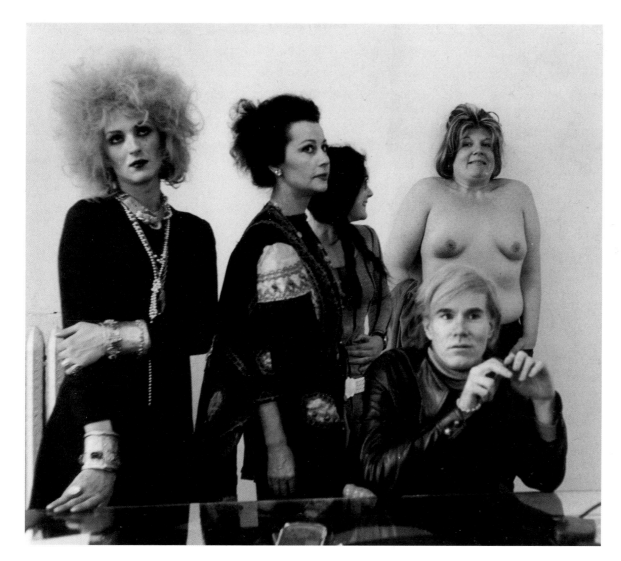

and sketchbooks, collecting impressions of cocks, and Andy was forever goading her to strip from the waist up so he could take impromptu Polaroid photographs of her in various art galleries and other public settings. She was epically overweight with folds of flesh cascading down her torso; when she went topless, she resembled a vat of melting vanilla ice cream.

In the fall of 1969, rumors began to circulate throughout the art world that Brigid Polk was making Warhol's paintings for him. This false information apparently originated in an item that appeared in a Los Angeles magazine called *Coast FM and Fine Arts*. *Time* pursued the story, quoting Brigid: "'Andy?' she hooted. 'I've been doing it all for the last year and a half, two years. Andy doesn't do art any more. He's bored with it. I did all his new soup cans.'" Brigid

added that she also forged his name. Was it true? *Time* asked Warhol. Yes, he replied, Brigid did all his work.[40] Andy then claimed to be surprised when the German press started to call him for more clarification; it seemed that German collectors were panicking because they might own overpriced Polks instead of valuable Warhols. "So I had to make a public retraction," Andy said. "Fred screamed at me for days because he was so tired of taking transatlantic calls and telling people who'd invested hundreds of thousands of dollars in my work that ha-ha, I'd only been kidding."[41]

In January 1970, Morrissey directed Dallesandro in *Trash*, the second film in their hustler trilogy. The actor played a passive, down-and-out, lower East Side junkie—a piece of "drug trash"—whose frequent need for a fix leads to a series of comic misadventures. The

film opens with a close-up of Dallesandro's pimpled buttocks as someone in flouncy white sleeves kneels before him in an apparent act of oral stimulation. The lens eventually retracts, and reveals the kneeling figure to be Geri Miller, the go-go girl who performed the same act in *Flesh*. This time around, however, Dallesandro is chronically impotent, driving his would-be sex partners to heights of hysteria.

One of Dallesandro's costars was Jane Forth, a petite brunette teenager with plucked, comma-shaped eyebrows and porcelaneous features from Grosse Pointe, Michigan. Warhol, thinking she had the makings of a superstar, cast her as a spoiled, disdainful housewife whose modern apartment Dallesandro attempts to burglarize. Jane, spotting the intruder shortly after he surreptitiously enters her apartment through a window, asks incredulously, "Are you saying you're trying to rob me?" She tells him, "I'm a rich newlywed with no furniture, and no jewels—I wear only plastic. The only valuable thing we have is this plant—it cost three hundred dollars." When her husband comes home, she introduces Joe as a high-school friend from Grosse Pointe High with no place to stay. She draws a cold bath for Joe and stays to watch as he bathes. Shortly afterward, the nude junkie gives himself an injection—the camera lingers in a tight close-up of his arm—then keels over on the living room floor. Jane and her husband try to revive him by walking him around the room. The husband, annoyed at having an overdosed junkie on the premises, commands Jane to open the front door. "Is this the way you treat guests in my house?" she asks, as her husband dumps Dallesandro in the hallway and tosses his clothes after him.

Jane Forth was delightful in the part and might have made a memorable impression playing high comedy, but despite Warhol's backing, she ended up as a supporting player while Holly Woodlawn emerged as the female star of the picture. Woodlawn, a snaggle-toothed female impersonator, stole every scene he was in. Born in Puerto Rico the offspring of a German father and Spanish mother, he was brought up as Harold Danhakl in Florida. At age fifteen he ran away from home and went to New York, where he camped out in abandoned buildings, slept in all-night movie houses, and panhandled for wine money. Eventually, Harold

metamorphosed into Holly Woodlawn. He made his acting debut in 1969, playing a chorus girl in Jackie Curtis's *Heaven Grand in Amber Orbit,* where he was discovered by Warhol and Morrissey and cast in *Trash*. Holly's performance in *Trash* was so good that his role was expanded to six days' work, for which he received a daily fee of twenty-five dollars.

In the film, Holly's character plays Dallesandro's lover-protector, a resilient scavenger who will rob even a poor box in order to make a better life for herself and her man in their grim, Lower East Side basement. Though she adores Joe, his inability to satisfy her sexually encourages her to ravish other men. One day, Holly brings home a a high-school senior whom she has picked up outside the Fillmore, an East Village theater noted for its rock concerts. The boy wants to buy something mildly narcotic. Holly quizzes him about his sexual experience with girls, then runs out to pick up some drugs for him. Dallesandro, who stays in the apartment, cautions the youth, "She just wants to suck your dick and take your money." Holly returns with drugs and a hypodermic needle. The boy protests. "It's not a needle," Holly tells him; "it's like a penicillin shot." She pulls down his pants and pokes the needle into his bare buttock. "I gotta go to the Fillmore," the boy says before he passes out. "Don't worry about the Fillmore," Holly says; "it'll be there tomorrow." She maneuvers his body onto a mattress, opens his shirt, and starts pressing her lips to his flesh.

In a later scene, Holly tries unsuccessfully to arouse Joe. "Why don't you use the beer bottle?" he asks. "All right," she says, "but tomorrow I want to use you." With an empty bottle of Miller High Life in hand, Holly frenetically masturbates, thrashing all over her bed while Dallesandro lies passively on his mattress on the floor and looks away blankly.

Holly, despite the shabbiness of her daily life, is goal-oriented: she wants to have a baby, to go on welfare, and to free Joe of his drug addiction. "I have a right to be on welfare," she proclaims; "I was born on welfare and I'll die on welfare." She stuffs a pillow under her clothing to deceive a social worker into thinking she is pregnant. In one of the film's funniest episodes, Holly tries to outwit a caseworker (Michael Sklar), who interviews her and her live-in boyfriend at home. Sklar tells Joe that he will have to register in a

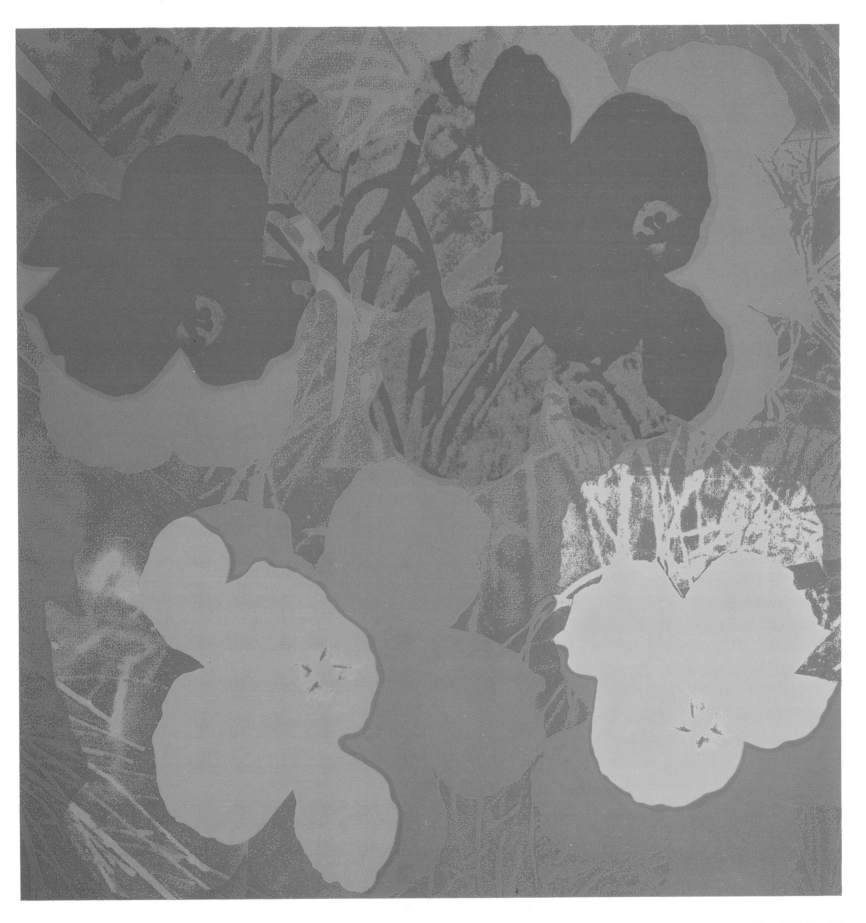

242. *Flowers*. 1970. Silkscreen ink on paper, edition of 250, 36 x 36″.

methadone program if he continues to live there, because, while Holly, living by herself, qualifies for welfare, she does not meet the requirements so long as she lives with a heroin addict. But Sklar is willing to bend the rules if Holly will give him her "really great shoes" —campy 1940s footgear that the social worker thinks would make a marvelous lamp base. An argument ensues. "Give him the goddam shoes," Joe yells, but Holly refuses to yield the treasures she has foraged for herself. She stands up and the pillow falls out of her clothing, ending her scheme to defraud the welfare department. The caseworker leaves, and Holly ends by asking Joe if she can give him a blow job, thus ending the film on the familiar note with which it began.

With Morrissey in charge of Warhol's film productions, Andy could concentrate once again on his art. In 1970, well aware of the booming market in graphics, he recycled the earlier image of *Flowers,* designing and publishing a portfolio of ten screenprints (see plate 242) based on the same photograph as his earlier paintings.[42] The portfolios were published in an edition of 250 and priced at three thousand dollars—six times the original retail price of the *Marilyns.* Once more, he took extravagant liberties with color, choosing rich reds, oranges, and yellows for many of the big, scalloped blossoms and situating them against grassy fields of nonnaturalistic hues such as red-and-yellow or pink-and-white. Two of the prints are exceptional because the set of flowers is printed in contrasting and overlapping color schemes.

Amid the bustle of the Factory—all the simultaneous efforts to produce new art projects and movies and to regularly publish *Interview*—Warhol noticed an area of conspicuous inactivity. Billy Name had become a virtual recluse, and Andy worried about him. Billy rarely ventured out of his black room when anyone else was in the Factory, and those who glimpsed him reported that he appeared wraithlike and in deteriorated health. The only evidence that he was eating were the scraps of cellophane from packages of crackers and wafers that turned up in the trash. When people knocked on his door to ask if he was all right, or needed anything, he seldom acknowledged them. Many of his old friends were unwelcome in the "secure" Factory with its locked-door policy, but the few who managed to gain admittance both to the Factory and to

Billy's chamber reported that he had shaved his head and was reading occult books by Alice Bailey, a disciple of Mme Helena Petrovna Blavatsky, the nineteenth-century spiritualist and theosophist. Billy's interest in mysticism and reincarnation, initially sparked during his employment at the Orientalia bookshop, was inspiring him to live like a crazed Buddhist hermit. When people went to the adjoining bathroom, they sometimes heard two voices on the other side of the wall. Had someone moved in with Billy? After much comparative listening, the Factory crew finally decided that both voices belonged to Billy, engaged in dialogues with himself.

Billy Name remained holed up in his dark cell for about a year. Then, one spring morning in 1970, the first people to arrive at the Factory were startled to find the door to his room wide open. Inside, they could barely breathe the air, which reeked of thousands of cigarette butts. They found the black walls covered with astrological charts. Tacked to one wall was a note saying, "Andy—I am not here anymore but I am fine. Love, Billy." Warhol was disturbed and puzzled by the mysterious departure, but he never saw or heard from Billy again.[43]

Distressed by Billy's vanishing act, Andy also experienced feelings of free-floating anxiety due to a retrospective of his artworks that was being organized by the Pasadena Art Museum in Southern California. He always had definite ideas about which of his pieces best represented him, and he feared that a conventional retrospective, showing the full range of his work, might mar his reputation. Narrowly focused exhibitions that concentrated on a single subject or image appealed to him the most because they produced a bigger visual wallop. John Coplans, the curator who organized the show, was sensitive to Warhol's concerns and agreed to omit all work made prior to 1962 and, further, to restrict the paintings to soup cans, disasters, flowers, and some of the portraits, including those of Ethel Scull and the Mona Lisa. Stacks of grocery-carton sculptures also went on view. (When some critics later savaged the show for its overly edited selection of works, Coplans was inevitably held accountable.) Warhol, accompanied by Morrissey and others, attended the opening of the exhibition in May 1970. (The show subsequently traveled to the Museum of Contemporary Art in Chicago; the Stedelijk van Abbemuseum in

Eindhoven, The Netherlands; the Musée de la Ville de Paris; the Tate Gallery in London; and finally the Whitney Museum of American Art in New York.)

A couple of days after the show opened in Pasadena, one of the artist's hand-painted works of 1962, the six-foot-high *Big Campbell's Soup Can with Torn Label (Vegetable Beef),* was sold in New York at Parke-Bernet, the city's preeminent auction house (later acquired by Sotheby's), for sixty thousand dollars. Many minds were boggled by the realization that this eight-year-old painting, which few dealers had been willing to display when it was new, had now established a record auction price for a painting by a living American artist. (The picture was bought by Zurich art dealer Bruno Bischofberger and later acquired by that city's Kunsthaus.) Warhol's first-place auction record lasted only until November, when Roy Lichtenstein's depiction of a giant brushstroke, *Big Painting No. 6* (1965), sold for seventy-five thousand dollars.

When *Trash* opened at Cinema II on Manhattan's East Side in October, Holly Woodlawn won rave reviews from both the critics and the public. The performer, according to Canby, "is something to behold, a comic book Mother Courage who fancies herself as Marlene Dietrich but sounds more often like Phil Silvers."[44] Unfortunately, Holly was unable to attend the premiere because he was in jail, charged with forgery and possession of false identification. He had allegedly impersonated the wife of an ambassador to the United Nations and cashed several thousand dollars' worth of bad checks before being apprehended. Holly was taken to the Women's House of Detention in Greenwich Village and put in a cell with a couple of dozen other arrestees. Then, according to Holly, "this big officer woman came in saying, 'All right, lift your dress and pull down your pants.' 'Don't worry, honey,' some girl said, 'they're just looking for dope.' 'Dope?' I said. 'In my *underwear*?' 'Shut up,' the officer woman said to me, 'and pull down your pants.'" Holly obeyed; everyone else screamed, "Get that *man* out of here!" and the next thing he knew, "I was in a paddy wagon on my way to the Tombs." There, Holly languished for thirty days.[45]

Although *Trash* was bringing in substantial profits at the box office, much of them based on Woodlawn's riveting performance, neither Warhol nor Morrissey posted bail for the film's leading "lady."

"Andy just felt she had behaved terribly," Morrissey explained. "He had a puritanical reaction against her behavior and thought she had been so irresponsible. She was running around cashing bad checks to raise money for an unsavory character who was on drugs."[46] Finally, the artist Larry Rivers, outraged by the performer's plight, put up the five hundred dollars' bail and got Holly released.

Holly may have been dragged into jail as an accused forger, but he strutted out a superstar; even one of the prison guards recognized him from *Trash* and complimented his performance. Surrounded by interviewers, Holly made it clear that he was serious about an acting career. "Everybody thinks I want to be in drag for the rest of my life" he said, "but, God, that's not my ambition, to be a drag queen. I want to be an *actor.* I'm not afraid of playing a man; I was *born* a man. And I'm not afraid of being a woman. I love women. Too much is made of gender. I want people to say of me, 'Here is a person who has something to offer besides gender.'"[47]

Andy could often display a shocking indifference to the welfare of his colleagues as well as a niggardly attitude toward salaries. Malanga, after seven years' service with Warhol, was finally earning fifty dollars a week for editing *Interview* and booking films. But he frequently squabbled with Morrissey over the contents of *Interview.* Malanga wanted to publish poetry, which Morrissey opposed. Malanga also had editorial disputes with Pat Hackett, a Barnard College graduate who started working at the Factory as a part-time transcriber, later becoming a full-time employee and the magazine's main proofreader. In the third issue, Malanga surreptitiously listed her on the masthead as "pencil pusher," which sent her screaming to Warhol. "Andy came out of his little office and told me I was fired from the magazine," said Malanga, whose term as co-editor lasted for only the first three issues. Later, Morrissey phased out the film bookings, apparently in the belief that Warhol's early movies harmed the commercial possibilities of the Factory's newer cinematic products. "I was getting so much resistance," Malanga said. "Who needs it?"[48] In November, he left the Factory for good.

With the departures of Name and Malanga, Warhol lost two of his most creative colleagues. He was now flanked at the Factory by his managerial team of Morrissey and Hughes. But the most dramatic change of all occurred in his home life.

Because Andy was frequently away on business for days at a time, he could no longer cope with his ailing mother. Not only was her physical condition worsening, but she was becoming increasingly paranoid and forgetful. Even when she had had her wits about her, she had been so trustful as to let almost anyone into the house if they said they were a friend of Andy's. Now, she sometimes went out and left the front door open. Andy worried that she might get lost and perhaps get hurt. Mrs. Warhola made domestic life particularly difficult for soft-spoken, mild-mannered Jed Johnson. She occasionally made him move her bed to another location in the basement because she was disturbed by imaginary odors emanating from the building next door, which then housed the New York Fertility Institute. Mrs. Warhola was convinced that dead babies were buried in the wall and that she could smell their decomposing bodies. As for Jed's cooking, she accused him of trying to poison her.[49]

After eighteen years of life with Andy in New York, Mrs. Warhola returned to Pittsburgh in the autumn of 1970 and moved into her son John's house. No one ever fully comprehended her reasons for following Andy to New York. Most grandmothers prefer to stay rooted near their married children and their families. Had she needed Andy as much as he needed her? Clearly, she had been a major source of her son's tenacity, shrewdness, resilience, and playful humor, and she had obviously enjoyed her reputation as "Andy Warhol's Mother."

In one of her last interviews before leaving New York, she again expressed the hope that her son would marry. She remarked on "all these beautiful people coming in the house, all these boys," and added, "I wouldn't mind if he would really get engaged and marry one of the boys," because "maybe he would get a little baby, I mean a little Andy." Actually, she envisioned having a hundred little Andys, like the repeated images in the pictures he painted. "I would have all these little Andys, you know, Andys, Andys, Andys, Andy, Andys... wouldn't that be beautiful?" She dreamed about such things at

243. Warhol cowed both his admirers and his detractors by papering the walls of his exhibition at the Whitney Museum of American Art, New York, in April 1971. Photograph by Geoffrey Clements

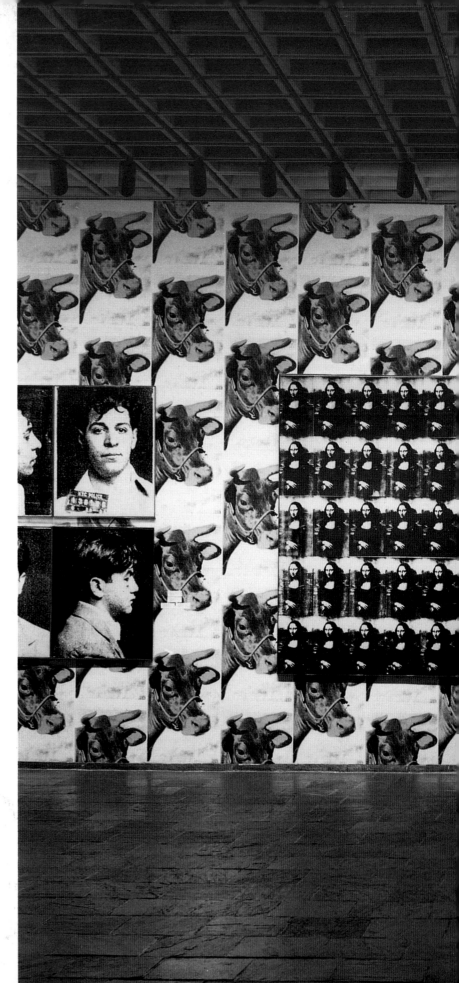

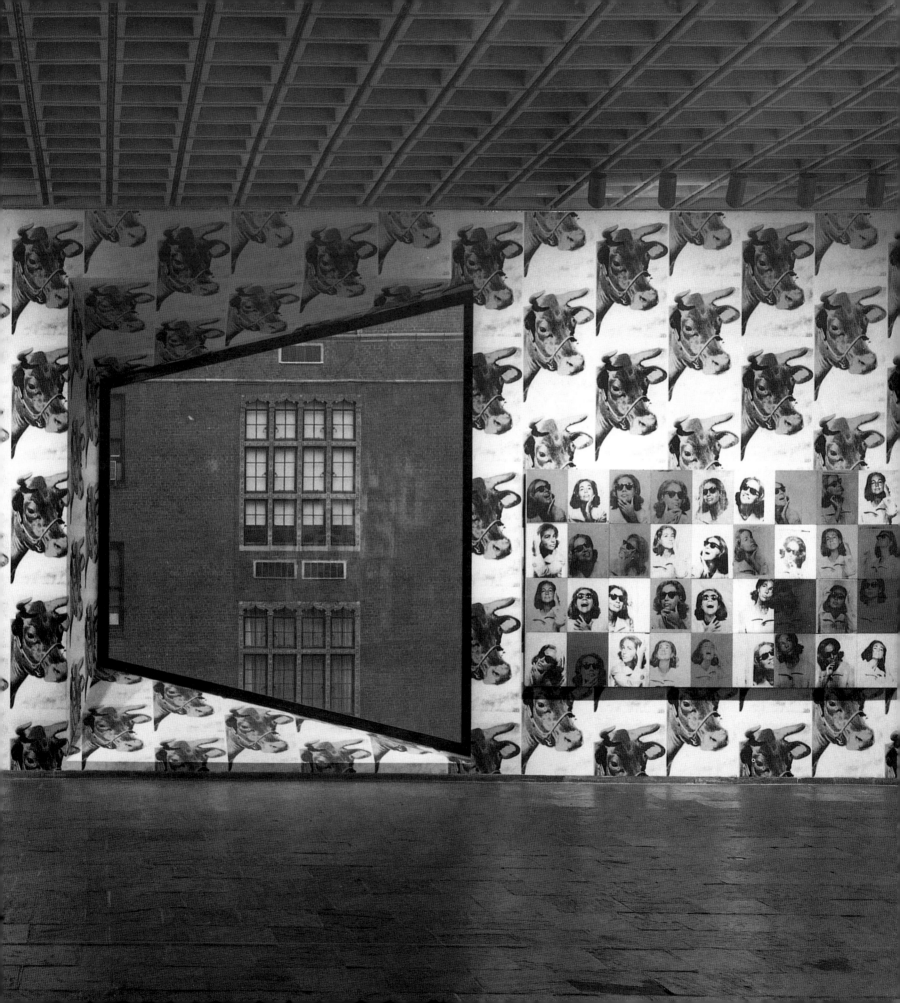

night when she was alone while "he goes out with all the boys and he has so much fun....I love my Andy. Oh, I'm so glad I'm his mother. He's great. That I did that, you know, that's really a creation, don't you think it's a creation to produce Andy Warhol? I, Mrs. Warhol, I sometimes don't believe it that I could do that. But you see all the things he does, the good and the bad and the lousy and the shocking...and the fairies and the girls and the boys and the drugs. It's all here, it's all in him and he pours it out and he pours it out and he gives everything, so that's why he's a great artist."[50]

With his mother out of the way, Warhol was free to travel more extensively. In February 1971, he flew to London to attend the opening of his traveling retrospective at the Tate Gallery. Accompanied by Paul Morrissey, Joe Dallesandro, Jane Forth, Fred Hughes, and Jed Johnson, he proceeded on a junket through West Germany to promote *Trash*. (Earlier, three million Germans had paid to see *Flesh*.) The Warhol troupe attended the February 18 premiere of *Trash*, dubbed in German, at Munich's 1,100-seat Luitpold theater. A Munich newspaper, *Abendzeitung*, bestowed its best film and best star of the year awards on Morrissey and Dallesandro, respectively.

For the Whitney Museum's version of the Pasadena show, which opened on May 1, Andy sought to create a vivid installation by hanging his paintings on walls that were papered with his bright cow heads (plate 243). The result was dazzling, with variously patterned pictures (repeated Mona Lisas, car crashes, and so on) creating optical vibrations when superimposed on unified background pattern (the cows). *New York Times* critic John Canaday, never a fan of Pop art, noted, "The plain, inescapable fact,

which will give pain to his enemies, is that Andy looks better than he has ever looked before. His talent is primarily for display art, and he has never until now—at least not in New York—had such an enormous showcase....Andy Warhol is, among other things, the world's coolest manipulator of borrowed material to induce disturbing responses in viewers less cool than himself."[51]

Barbara Rose, reviewing the show in *New York* magazine, observed, "Merging life and art more closely than any Dadaist or Surrealist could imagine, Andy is the *Zeitgeist* incarnate. The images he leaves will be the permanent record of America in the sixties: mechanical, vulgar, violent, commercial, deadly and destructive." She allowed that some critics saw Warhol "as a Mephistophelian anti-Christ, tempting society into further tawdriness," and that others saw him "as Saint Andy, a lacerated hero." To her, however, "his pageant has always seemed a Passion, his Catholicism a living matter and not a camp."[52]

Shortly before the opening of the Whitney exhibition, the word got around that Warhol was planning to change his name to John Doe. Though just another silly rumor, prompted by a Warholian jest, it was dutifully reported as news. *Time* thought he showed "a depressing lack of originality" in the selection of his new name, but the magazine, as usual, missed Warhol's point.[53] John Doe captured his imagination because it was one of the most famous names in the world, signifying both an unidentifiable individual and Everyman, a figure of basic universality. Warhol admired John Doe's combined anonymity and renown, but he was fully aware, of course, that he could appropriate the name and still be recognized on almost any corner in the Western world.

NOTES

1. Barbara Rose, "In Andy Warhol's Aluminum Foil, We All Have Been Reflected," *New York,* May 31, 1971, p. 56.

2. Interview with Jed Johnson, November 30, 1988.

3. Victor Bockris and Andrew Wylie, "Interview with Joe Dallesandro," *Viva,* June 1974, p. 108.

4. Dotson Rader, "Joe Dallesandro, A Natural Man," *Rolling Stone,* April 15, 1971, p. 31.

5. Interview with Paul Morrissey, December 1, 1970.

6. The Dallesandro/Waldon episode was filmed in the author's Greenwich Village apartment.

7. A. H. Weiler, "The Screen: Paul Morrissey's 'Flesh,'" *The New York Times,* September 27, 1968.

8. Craig Zadan, "Factory Brothers," *After Dark,* December 1970, p. 22.

9. Jonas Mekas, "Movie Journal," *The Village Voice,* January 9, 1969, p. 51.

10. Rex Reed, "Remember My Forgotten Movie," *The New York Times,* February 2, 1969.

11. Leticia Kent, "Andy Warhol: 'I Thought Everyone Was Kidding,'" *The Village Voice,* pp. 37–38.

12. The friend was the author.

13. Andy Warhol, *a* (New York: Grove Press, 1968).

14. "Zzzzzzzz," *Time,* December 27, 1968, p. 63.

15. Andy Warhol and Pat Hackett, *POPism: The Warhol '60s* (New York: Harcourt Brace Jovanovich, 1980), p. 291.

16. The unhappy tenant was the author, who was not keen on the project. "C'mon, David," the artist whined in a fake, plaintive tone, "help me get on my feet again. We'll be there on Saturday at 11:00 A.M."

17. Andy Warhol, *Blue Movie* (New York: Grove Press, 1970), p. 24.

18. Warhol, *Blue Movie,* p. 39.

19. Warhol, *Blue Movie,* p. 23.

20. Viva, "The Superstar and the Heady Years," *New York Woman,* May–June 1987, p. 30.

21. Vincent Canby, "Hollywood Flavors San Francisco Film Festival," *The New York Times,* November 5, 1968.

22. Margia Kramer, *Andy Warhol et al., The FBI File on Andy Warhol* (New York: UnSub Press, 1988), pp. 35–36.

23. Kramer, *FBI File,* pp. 36–37.

24. Howard Smith, "Scenes," *The Village Voice,* January 16, 1969. Solanas denied the accusations. "I never said anything even remotely comparable to any of those things," she told Smith, who interviewed her for his July 25, 1977, *Voice* column.

25. "Actress Gets 3 Years In Warhol Shooting," *Daily News,* June 10, 1969. Solanas never repented. In Howard Smith's "Scenes" column in the August 1, 1977, issue of *The Village Voice,* she was quoted, saying that shooting was "a moral act" and that she believed it "immoral that I missed [Warhol]. I should have done target practice."

26. Warhol and Hackett, *POPism,* p. 279.

27. Much of this account is based on Jane Livingston's essay on the *Rain Machine* in Maurice Tuchman, *A Report on the Art and Technology Program of the Los Angeles County Museum of Art 1967–1971* (Los Angeles County Museum of Art, 1971), pp. 330–37.

28. John Wilcock, *The Autobiography Sex Life of Andy Warhol* (New York: Other Scenes, 1971), n.p.

29. Andrew Sarris, "Films: Westward Ho-Ho with Warhol," *The Village Voice,* May 8, 1969, p. 47.

30. "On the Old Camp Ground," *Time,* May 23, 1969, p. 116.

31. "Audience Shot At Film Show," *Civil Liberties,* February 1970, p. 16.

32. Vincent Canby, "Warhol's Red Hot and 'Blue' Movie," *The New York Times,* August 10, 1969.

33. Al Goldstein, "Dirty Diversion," *Screw,* August 30, 1970, p. 21.

34. Interview with John Wilcock, February 23, 1988.

35. Interview with John Wilcock, February 23, 1988.

36. Interview with John Wilcock, February 23, 1988.

37. Telephone conversation with Andy Warhold, September 17, 1971.

38. Warhol and Hackett, *POPism,* p. 294.

39. Telephone conversation with Andy Warhol, June 4, 1971.

40. "People," *Time,* October 17, 1969, p. 48.

41. Warhol and Hackett, *POPism,* p. 249.

42. Of the 250 sets of *Flowers* portfolios, photographer Patricia Caulfield received twelve as her royalty.

43. Interview with Billy Name, April 4, 1987. After leaving the Factory, Billy Name hitchhiked to Washington, D.C., where, being virtually penniless, he camped out with radical groups and participated in demonstations against the Vietnam war. He then hitchhiked to New Orleans, where he stayed six months, moved on to Boulder, Colorado, and finally to San Francisco, where he became a concrete poet. In 1977, he returned to Poughkeepsie, New York, where he eventually became associate director of the Mid-Hudson Arts and Science Center.

44. Vincent Canby, "Film: Andy Warhol's 'Trash' Arrives," *The New York Times,* October 6, 1970.

45. Guy Flatley, "He Enjoys Being a Girl," *The New York Times,* November 15, 1970.

46. Interview with Paul Morrissey, February 12, 1989.

47. Flatley, "He Enjoys Being a Girl."

48. Interview with Gerard Malanga, December 16, 1989.

49. Interview with Jed Johnson, November 30, 1988.

50. *Andy Warhol, Transcript of David Bailey's ATV Documentary* (London: Bailey Litchfield/Mathews Miller Dunbar Ltd., 1972), n.p.

51. John Canaday, "Art: Huge Andy Warhol Retrospective at Whitney," *The New York Times,* May 1, 1971.

52. Barbara Rose, "In Andy Warhol's Aluminum Foil," pp. 54, 56.

53. "People," *Time,* April 12, 1971, p. 41.

"Andy's basic position on every subject, if he has any, is comical. If you don't have a position, your only refuge is comedy." —*Paul Morrissey*[1]

Warhol seemed to be all over town during the spring of 1971. A few weeks after the opening at the Whitney, the Gotham Book Mart on West 47th Street held an exhibition of his pre-Pop works, which ran from May 26 through June 26. "Andy Warhol, His Early Works 1947 –1959" contained about three hundred items, including blotted-ink drawings for newspaper and magazine ads, gold-leaf pictures, book jackets, greeting cards, rubber-stamp designs, folding screens, hand-colored books, and documentary photographs of Andy in Pittsburgh and during his early years in New York. The exhibition was informative and even fascinating, but Andy, not surprisingly, professed to be embarrassed by the whole thing. He was distressed that the Gotham's owner, Andreas Brown, was attempting to market works that the artist wanted to suppress.

Also during May, a highly stylized comedy titled *Andy Warhol's Pork* opened for a two-week run at La Mama Experimental Theater on East 4th Street in Manhattan. *Pork*'s dialogue was obviously distilled from the artist's taped conversations with Brigid Polk and other cronies. The production was cleverly adapted and directed by Anthony J. Ingrassia, who claimed that Warhol had approached him with a play of twenty-nine acts that would have lasted two hundred hours. Ingrassia boiled down the transcripts to a fast-moving and lusty two-act play that offered a plethora of "good dirty fun." The set combined elements of the Factory, Max's Kansas City, and Brigid Polk's hotel room, and the blackout intervals between scenes were punctuated by the angry wasp-like buzzing of telephone busy signals.

Many of *Pork*'s characters bore scarcely disguised names. Two of the prominent male figures were dubbed Pall and Billy Noname. A garrulous, bitchy blond superstar was named Vulva and played vampishly by a female impersonator in a fright wig. Amanda Pork was a chubby prankster with a voracious appetite for drugs and sex. Like Brigid Polk, Amanda Pork occasionally scampered about topless, but she also cavorted with "the Pepsodent twins," two nude men with pastel-colored genitals. She also assaulted herself with a syringe and masturbated with an egg beater to get attention. The man for whom everyone was performing so outrageously was a deadpan, gray-haired character named B. Marlowe, who, as brilliantly impersonated by Anthony Zanetta, looked and talked

244. *Mao*. 1973. Acrylic and silkscreen ink on canvas, 12 x 10″. Collection Roy and Dorothy Lichtenstein, New York

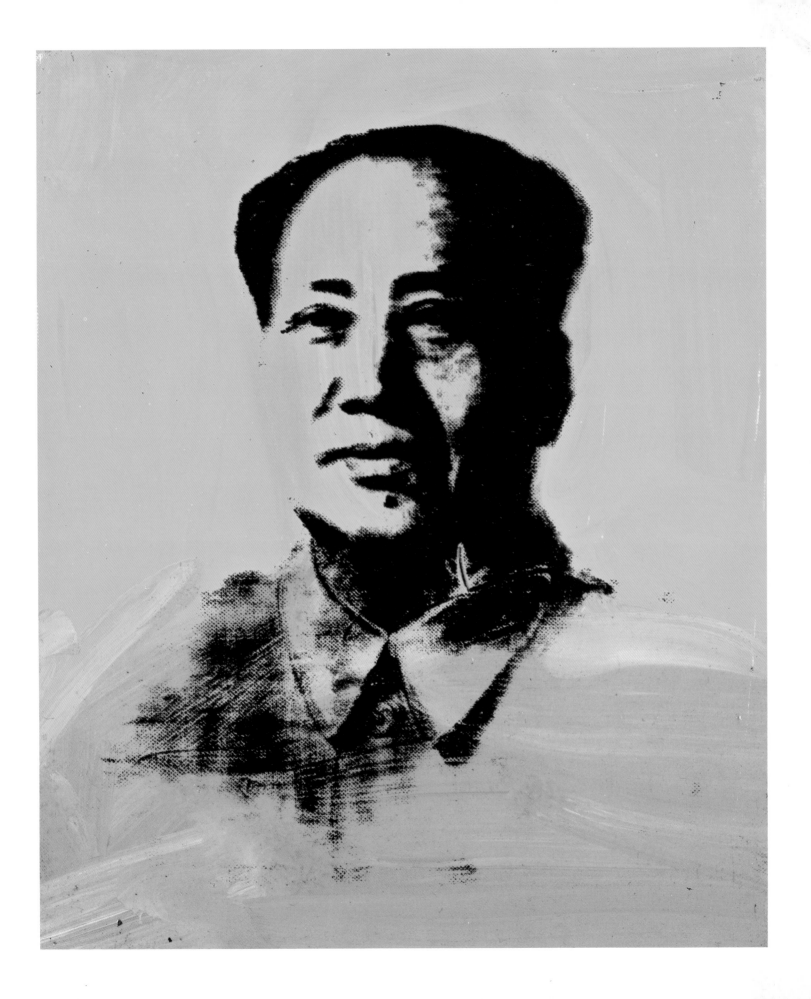

uncannily like Warhol, conveying exactly the right blend of provocation, ennui, and exhaustion. The character's essential passivity was underlined by his inability or unwillingness to rise from an office chair; instead of moving about on his own, he was wheeled around by a pretty boy as he watched and sometimes shot Polaroid photographs of his freaky associates.

B. Marlowe got his voyeuristic kicks by manipulating his narcissistic pals into making fools of themselves. He was, Ingrassia said, "like a kid playing with his dolls." The production went out of its way to alarm the squeamish with its exuberant displays of sexual horseplay and graphic discussions of feces, penises, and pudenda. One of the most outrageous bits of business occurred when a nude Geri Miller, the go-go dancer who had appeared in *Flesh* and *Trash*, turned her nude back to the audience and simulated a douche with water visibly trickling down her bare legs. At the end of the play, Marlowe disconnects the recorder on which he is taping Pork, and says, "Oh, I'm really so tired now." Reviewing the play in the *New York Times,* Grace Glueck said, "Take out the fornication, masturbation, defecation, and prevarication with which *Pork* is larded and you might have a certain similarity to the juvenile gang in *You're A Good Man, Charlie Brown*."[2]

Warhol's marginal involvement with rock music over the years finally paid off in a friendship with Mick Jagger and a commission to design the album cover for the Rolling Stone's *Sticky Fingers* (plate 246). Warhol chose a suggestive image that went right to the heart of the music's primal appeal—a photographic close-up of a man's jeans from waist to thigh. The zipper opened to let viewers peep inside, where they found another photograph of the same body, this time clad only in white jockey shorts. Within two weeks of its release in April, the album sold a half-million copies, and Warhol liked to think that his lewd cover contributed greatly to its success. "You know," he later complained, "that became a number-one album and I only got a little money for that. The next time I do anything, I'm going to try to get a percentage, like a penny on every album sold."[3]

In June, John Lennon and Yoko Ono arrived in New York for an extended stay, and Warhol spent a few days escorting them to his favorite antiques shops and art galleries. Andy's relationship with Yoko was a little strained because he remembered her strident

245. Andy establishes instant rapport with Yoko Ono and John Lennon during the couple's visit to New York in June 1971. Photograph by David Bourdon

attacks on the "homosexual conspiracy" in the New York art world during the 1960s when she was unable to get a reputable gallery to show her conceptual art. As for the former Beatle, Warhol could not look at him without seeing dollar signs. "They must make a million dollars a day!" Warhol exclaimed to a friend. "I'm sure they do. Their records have to make that. Oh, it's just so much fun to have money, isn't it?" He urged his friend to have "a little talk with Yoko" and to persuade her to commission a $40,000 portrait of herself and her husband. "You could just say it's such a great idea. It would link them together. It would be, you know, an heirloom."[4]

Although disappointed that the Lennons did not buy one of his paintings, Warhol maintained an air of friendliness whenever he saw them socially. He described the guests at one party he attended as "all the has-beens—Jonas [Mekas], Yoko, John, me. It

246. Warhol designed a provocative album cover with an actual zipper for the Rolling Stone's 1971 *Sticky Fingers*.

was really funny. And Jackie [Kennedy Onassis]. All the old toys." He didn't dare to hustle a painting to Mrs. Onassis, who apparently never discussed his portraits of her. He thought her "sweet," and once, after dining with her and a group of other people in Chinatown, reported in awe: "The Chinese recognized her. They rushed out of the stores and, blabbing away, followed her down the street. The Chinese don't know me—only white people recognize me—but they really recognized her. It was incredible. Of course, she's very easy to recognize. She's like Marilyn. She has a face that's so distinctive, and she doesn't disguise herself."[5]

Warhol, in his constant search for far-out art ideas, looked to Brigid Polk for inspiration. After an outing with Brigid and Yoko, he reported to a friend that they had "so many great ideas—there is an idea I could really steal from them if I could only make it work. Brigid just wants to buy binoculars like crazy; she thinks that's the new art. And Yoko was talking about the binocular things that they do—looking out of the window or something. But I was just thinking, like, setting up binoculars and painting a window somewhere, in another building. And that would be something that you were the only one that would really know where that art was. Or you pick a pole and

you paint it a bright color and then that's your art. You'd get binoculars to go with it. It'd be a good gallery show. You could just have these binoculars at the back of the room....It also has something to do with the same thing Duchamp was doing [in *Etant donnés*], looking through a box. Sex...in the window....Oh, that would be nutty. That's just the kind of thing you'd want to see with binoculars—some perversion, right? Somebody jerking off. Brigid could be the art. She could stand in the window." He considered installing Brigid in a good apartment and charging twelve people a hundred dollars each month to watch her. "Oh, wouldn't it be great? That *is* great. Oh, it would be fabulous. It's a great idea."[6]

Real estate and money especially preoccupied Warhol that summer, leading to his decision to buy a half-share in a beachfront estate with a large house and twenty acres of grounds in Montauk, a fashionable community at the eastern end of Long Island. Morrissey, who had seen the house first, bought the other half-share with his profits from *Trash*. Around the same time, Warhol was negotiating to trade some of his paintings for an art collector's Philip Johnson–designed house, also on Long Island. That deal fell through when a neighborhood association vetoed the transaction without giving a specific reason; Andy suspected he had been turned down because the neighbors feared he would ruin property values by bringing in his reputed gang of transvestites and drug addicts.

Out in Santa Barbara, Edie Sedgwick, while on probation after a drug bust, was staying at Cottage Hospital, where she was a patient in the psychiatric ward. Between January and June of 1971, she received twenty or more shock treatments. In between, she commandeered the attention of her fellow patients and visitors with embroidered tales of her mistreatment by Warhol, whom she described as "a sadistic faggot."[7] Off the hospital grounds, she made frequent forays for speed, downers, and even heroin, which she bought off junkies, sometimes engaging in sex with the men who supplied her drugs. Her expeditions led to an involvement with a gang of "outlaw bikers" known as the Vikings, and to her participation in a rough life-style that contrasted dramatically with her champagne days as New York's Girl of the Year. Always unhappy about her petite bosom, she finally elected to get cosmetic surgery, receiving silicone breast implants that transformed her modest chest with a pair of cantilevered cones. That spring, she met a twenty-year-old fellow patient, Michael Brett Post, who was making an effort to quit the drug world. There was nothing sexual between them while he was in the hospital. He had seen her go through "a number of guys" and didn't want to become "another statistic on the boards."[8] In July, they married and moved into a Santa Barbara apartment. Edie seemed to be getting her life in order. But when the alarm clock rang on the morning of November 16, Post awoke and thought it odd that his wife was lying in the exact position in which she had fallen asleep. He touched her on the shoulder and discovered that her body was cold. The coroner attributed her death to a barbiturate overdose, made more lethal by alcoholic intoxication. She was only twenty-eight years old.

"She was immediately somebody you really cared about," Warhol told a reporter when he learned of Edie's death. "I thought she was just magic and very imaginative." Although he hadn't seen her for five years, he maintained that she had created "all the styles —right through to the poor-rich look that everyone wears today."[9]

Warhol's ambivalence toward the female sex was never more evident than in his 1971 film *Women in Revolt*, a travesty of the women's liberation movement. An all-star cast of Factory female impersonators—Jackie Curtis, Candy Darling, and Holly Woodlawn —played the leading roles. The plot was basically improvised, with Morrissey offering suggestions for dialogue and story development, but the direction and cinematography were credited to Warhol. (Curtis had agreed to perform in the film only if Warhol was behind the camera.) The production dragged on for nearly a year.

Women in Revolt was calculated to antagonize the women's liberation movement (and perhaps the gay liberation movement as well) by spoofing some of the more extreme positions of radical feminists, many of whom had earned Warhol's contempt by siding with Valerie Solanas. "Valerie doesn't call me anymore, and it's really great," Warhol said in December. "But the funny thing about all this feminist stuff is that they were exposed so quickly. They can't just repeat the same things, so they just make things up. It's all show business. Germaine Greer is on television now, and she would be boring if she didn't do anything new, so she has to come out and

give ridiculous statements because that's what they have to do. Anybody. Like an artist. You can't do the same thing over again. You have to come out with something insane."[10]

According to Morrissey, "Andy is despised by Gay Liberation and the Women's Revolt, whatever it is, because Andy just presents it and doesn't take a position. An artist's obligation is not to take a position ever, just to present. The absence of a position necessitates a comical attitude to make it bearable." Around the Factory, the sex reversal was considered quite amusing. "It's hard for Andy or any of the female impersonators to put down the women's movement," Morrissey said, "because it's a subject that neither Andy nor any of the female impersonators have the vaguest notion about. But the logical extension of what they obviously want is to be men, so why not have men represent them?"[11]

For his part, Warhol admired the diligence with which female impersonators emulated an ideal of movie-star womanhood. "It's hard work," he said, "to look like the complete opposite of what nature made you and then to be an imitation woman of what was only a fantasy woman in the first place."[12]

The film was initially named *P.I.G.S.*—for Politically Involved Girls—but the Factory eventually shied away from this inflammatory title, which sounded too much like a put-down of women's liberation. *Women in Revolt* is a recklessly funny satire with three manic heroines who frantically attempt to escape from gender-defined oppression. Candy Darling played the pretty debutante from Long Island who breaks off an incestuous relationship with her brother, screaming, "You've made me old before my time!"; she later becomes a movie star. Jackie Curtis played an inexperienced young schoolteacher from Bayonne, New Jersey, who finds a lover through an ad in an East Village newspaper; after getting pregnant by a former Mr. America, she goes back home with a baby. Holly Woodlawn plays a high fashion model who, tired of being an abused sex object, turns lesbian and winds up wandering drunkenly on the Bowery.

In an outdoor scene filmed near Washington Irving High School on Irving Place, Jackie and another women's liberationist are heckled by a young hard hat, working in a ditch, as they attempt to hang a poster on a nearby fence. They get even by beating him up

and symbolically raping him—by giving him an enema (this last shot was filmed at the Factory).

Women in Revolt opened at Ciné Malibu on East 59th Street on February 16, 1972. Many critics called it "hilarious" and a "new classic" in absurdist cinema, while conceding that its politics were reactionary, being "the ultimate put-down of women's lib." Warhol, wrote Stuart Byron in the *Village Voice,* "is convinced that women are trapped by biology into certain societal roles. And this viewpoint seems consistent with the fact that the film is cast with transvestites, who, after all, have a stake in keeping alive those very roles which women now wish to shed."[13]

The usually apolitical Warhol displayed a surprising—for him—interest in China during 1971, the year in which the People's Republic replaced Nationalist China in the United Nations General Assembly and Security Council and renewed relations with the United States by inviting an American table tennis team to tour the country. The United States press was filled with stories about the new climate of friendliness in the communist regime and the plans for President Richard Nixon's historic visit to China the following year. "I've been reading so much about China," Warhol said in September. "They're so nutty. They don't believe in creativity. The only picture they ever have is of Mao Zedong. It's great. It looks like a silkscreen."[14]

A couple of months later, he pondered making some portraits of Mao. "Since fashion is art now and Chinese is in fashion, I could make a lot of money. Mao would be really nutty...not to believe in it, it'd just be fashion...but the same portrait you can buy in the poster store. Don't do anything creative, just print it up on canvas."[15] Mao's appeal for Warhol was partly due to the simple fact that his face—displayed in storefronts and on street corners throughout China—was one of the most recognizable faces in the world. But Warhol also relished the fact that, for many Americans, Mao's face symbolized an alien and threatening form of government, which he accurately and perversely predicted would make his portrait more appealing to capitalist collectors in the West. Soon, Warhol was repeating Mao's plump face on canvases, in pencil drawings, in silkscreen prints, and on wallpaper.

Mao would never have tolerated an artist as frivolous as Warhol,

247. *Mao.* 1973. Pencil on paper, 36¼ x 36″. Courtesy Leo Castelli, New York

in that he added some elements of drawing, scribbling black lines alongside the face to help focus attention on it.

At a later date, Warhol would produce a design for wallpaper based on one of his own pencil drawings of Mao's plumlike face repeated in purple on a white background. As with the earlier cows, the Mao wallpaper would serve as a patterned background for the artist's paintings, this time silkscreened portraits of the Chinese leader. The combination of paintings and wallpaper was particularly striking in an exhibition at the Musée Galliera in Paris in February 1974 (plate 248).

Warhol made one of his most impressive silkscreen prints as his contribution to the 1972 presidential election campaign of George McGovern, the North Dakota Democratic Senator. But instead of showing McGovern's face, Warhol portrayed incumbent Republican President Richard Nixon (plate 250). Although the print featured the message "Vote McGovern," it sent out mixed signals. While McGovern supporters could read leprous overtones into the lurid colors Andy chose for Nixon's face, all the president's men could conclude that Warhol was really glamorizing their candidate. (Ben Shahn in 1964 had created an earlier variation on this switch, designing a poster with a drawing of conservative presidential candidate Barry Goldwater, captioned "Vote Lyndon Johnson.") Warhol was simply being true to his aesthetic, selecting Nixon's face over McGovern's on the basis that it was more familiar. The print reportedly earned more than $40,000 for the McGovern campaign.[17]

Another screenprint that exemplifies Warhol's reverse strategies is *Sunset,* also made in 1972. In contrast to the customary goal of making each print in an edition as identical as possible, he deliberately had the colors varied from one impression to the next, creating in effect a Monet-like series of pictures in which the modulated progression of hues suggests distinct moments in the sun's decline. Each one of the 632 prints in the edition is in a perceptibly different set of colors. (The architects Johnson & Burgee used 472 of the prints in the Marquette Inn in Minneapolis, but the prints were removed from the hotel in 1981.)

On the night of July 27, Warhol was among five hundred all-star guests celebrating Mick Jagger's twenty-ninth birthday at a party at

whose humor and irony would have undermined the "revolutionary spirit" of the masses. Artists and intellectuals were especially persecuted during the Cultural Revolution in the late 1960s, being "reeducated" through humiliating physical labor. Professors were assigned to clean toilets in their universities, while artists and musicians were made to build walls and repair roads.[16] The kind of bourgeois consumerism that Warhol portrayed would have landed him in prison.

Warhol based his portraits of Mao (plates 244, 247) on an official photograph of the communist leader. Unlike most of his earlier portraits, he decided to render these in a more painterly style, freely brushing a somewhat expressionist background of colors before silkscreening the image. In a related series of silkscreen prints, Mao's face emerged almost as cosmetic and glamorous as the artist's *Marilyns*. The prints departed from his earlier graphic works

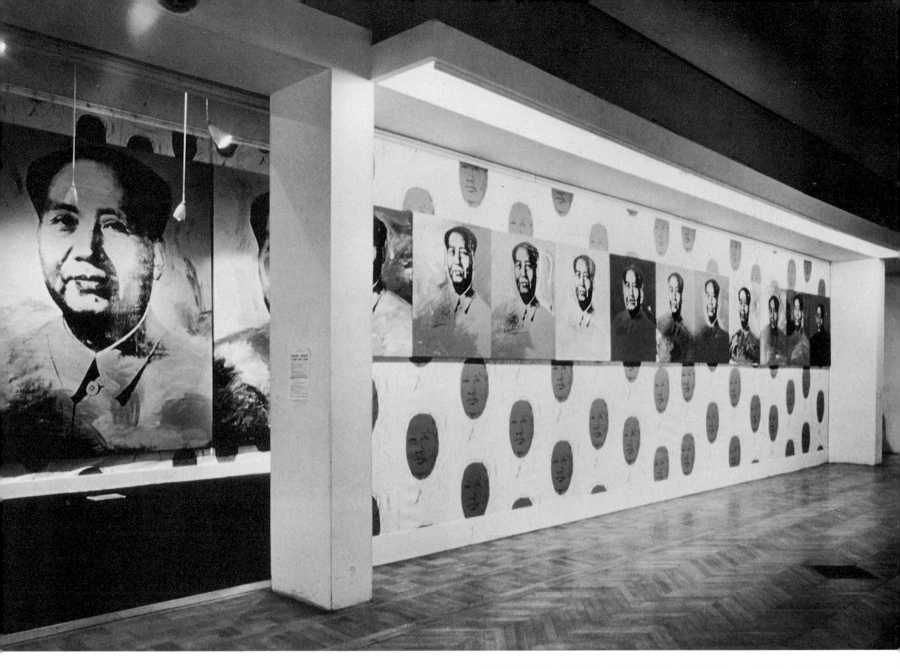

248. Installation view, "Mao," Musée Galliera, Paris, February 23–March 18, 1974

the St. Regis Hotel. Andy determinedly aimed his Polaroid camera at many of the famous faces. Jagger and his wife, Bianca, arrived just before 2:00 A.M. As Count Basie's orchestra played in the background, Geri Miller popped out of the lid of a five-foot cake, nude except for black pasties and a garter on her right leg. She danced, according to the *New York Times*, "with gestures usually reserved for Eighth Avenue pornographic cinemas. Mr. Jagger, at whom the gestures were directed, clapped enthusiastically."[18] This was the type of event and life-style to which Warhol would increasingly devote his time throughout the rest of the 1970s.

Because *Trash* earned a good profit in the domestic and European markets (it reportedly grossed more than one million dollars), Warhol was more than willing to let Morrissey pursue his independence with what was to be the third in the financially successful trilogy of Morrissey-Dallesandro cinematic odes to a young hustler. Morrissey, who once again "wrote," photographed, and directed the new work, titled it *Heat*, and cast his laconic and phlegmatic male star opposite Sylvia Miles, the noted New York actress whose sharp performance in *Midnight Cowboy* had led to an Academy Award nomination for best supporting actress. Andrea

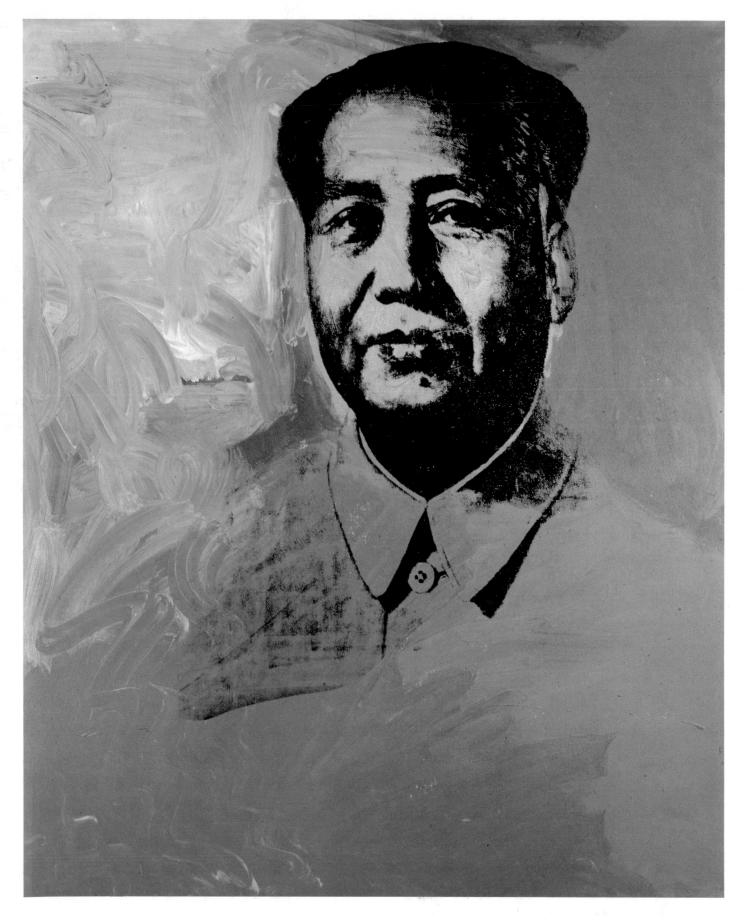

249. *Mao.* 1973. Acrylic and silkscreen ink on canvas, 50 x 42″. Collection Armand Bartos, New York

Feldman, an attractive young Factory starlet who had played an agitated acidhead in *Trash,* was cast as Miles's emotionally confused daughter.

Heat was filmed in two weeks, without a written script, on location in Los Angeles. (Warhol remained in New York.) Most of the action took place in an antiquated Hollywood motel and in an old mansion. Dallesandro plays Joey Davis, a former child television star, attempting to make a Hollywood comeback after a period in the army. He checks into the motel and meets up with a young blond woman called Jessie (Feldman) who lives in a neighboring unit with her infant and her lesbian girlfriend. Jessie's domestic arrangement alarms her mother, a fading actress named Sally Todd (Miles), now reduced to appearing on television game shows. Sally has had four husbands and lives in a thirty-six-room house, the upkeep of which is draining her ("my game show money doesn't keep me in hairspray," she complains). Sally visits the motel, harasses her daughter ("I want you to stay out of dike bars"), and eventually is introduced to Joey.

Before long, both mother and daughter are competing for Joey, crying and posturing like female cats in heat. Sally, who wears only see-through lingerie around the house, latches onto Joey by offering to get him some acting jobs. One day Jessie discovers them in an intimate moment and asks, "What are you up to?" "I'm helping Joey get a screen test," Sally says, pulling up her bra to cover her bare breasts. Later, Sally catches Jessie in a compromising situation with the young man. "She can't even be a good dike!" the mother fumes. Even Sally's ex-husband's current boyfriend gets an opportunity to put the make on Joey. The film ends, not too surprisingly, with Joey abandoning Sally.

Largely owing to its satirical view of Hollywood and Miles's strong performance, *Heat* was invited to film festivals in New York, Cannes, and Venice. At a Los Angeles preview at the Directors Guild in October, Warhol, Miles, and Morrissey hoped to impress tinseltown producers and agents by arriving at the theater in a 1929 Cadillac convertible.

Andrea Feldman was not along for the ride because she had defenestrated herself in New York two months earlier. According to differing stories, all possibly apocryphal, she leaped from a

250. *Vote McGovern.* 1972. Screenprint on paper, edition of 250, 42 x 42″. © Gemini G.E.L., Los Angeles

fourteenth- (or eighteenth-) story window of a relative's apartment on lower Fifth Avenue, clutching a Bible (or rosary) and wearing a pinned note that said, "Happy Birthday Andy." She had earlier demonstrated an unwholesome fixation on Warhol—to the extent that she often called herself Andrea Warhol and stationed herself outside his house at night, much to his annoyance. Her jump did occur on his birthday, but to what extent can her death be related to him? According to Morrissey, "Andrea's problems were entirely with her family and had no connection with Andy."[19]

When *Heat* opened at New York's Festival Theater on West 57th Street on October 6, 1972, it received favorable reviews, which led to its booking in two additional theaters a week later. "Sylvia Miles does a penetrating portrait of the star," Judith Crist wrote in *New York* magazine, "blowzy and fleshy and totally ego-centered, all star and part mother and mostly lust....The most striking performance—in large part non-performance—comes from the late Andrea Feldman as the flat-voiced, freaked-out daughter, a mass of psychotic confusion, infantile and heart-breaking."[20] Miles "looks great even when she looks beat," Vincent Canby noted in the *New York Times,* "and because she's a good actress she automatically works ten times as hard as everyone else to enliven the movie." The film reminded him of an old Our Gang comedy with the kids "getting into mischief and fooling with each other." But where, Canby wanted to know, was Holly Woodlawn, Candy Darling, Jackie Curtis, and Viva? "Have they been junked by the Factory? I surely hope not. Any Warhol-Morrissey film without them is an Our Gang two-reeler without Spanky, Alfalfa, Buckwheat, and sweet little Darla Hood." [21]

With *Heat*, Dallesandro's career peaked. But, as so often happened to those in Warhol's circle, he was not rushed into another tailor-made vehicle but left to languish. Later, he would claim to be ashamed of his involvement with the Warhol-Morrissey films. "I was brought up a very strict Catholic," Dallesandro said. "I believe the movies I've made with Andy Warhol are a sin— *Trash* and *Heat* and *Flesh*. But in New York I would go to confession and the priest would say it was all right, I should go right ahead. It was what I needed to survive and to support my family. That's all the priests care about."[22]

In Pittsburgh, priests were often on Mrs. Warhola's pixilated mind. After a brief stay in her son John's home, she moved in with her son Paul and his family. Three months later, she suffered a stroke and was hospitalized for a month, being in a comatose state part of that time. She was then placed in a nursing home, Wightman Manor, in suburban Squirrel Hill, where she spent her last nineteen months. Following the stroke, her mind slid back forty to sixty years, and she talked mainly of life in the old country and spoke only in her native tongue. According to Paul's wife, Anne, Andy called his mother almost every day and she looked forward to that. But he never saw her after she left New York. Mrs. Warhola died at age eighty on November 28, 1972. Andy, to the dismay of his brothers, did not attend her funeral.[23]

Andy did not mention his mother's death to any of his closest friends. Fred Hughes accidentally found out she had died when he happened to answer a phone call from Andy's brother John. Jed Johnson did not learn of her death until the summer of 1975, when he saw James Warhola, Paul's son, and asked, "How's your grandmother doing?"[24] As late as 1976, when friends asked about his mother, Andy said, "Oh, she's great. But she doesn't get out of bed much."[25]

NOTES

1. Interview with Paul Morrissey, December 1, 1970.

2. Grace Glueck, "'Pork' Is Not The Kosher-est Show in Town," *The New York Times,* May 23, 1971.

3. Telephone conversation with Andy Warhol, June 5, 1971.

4. Telephone conversation with Andy Warhol, June 5, 1971.

5. Telephone conversation with Andy Warhol, April 27, 1972.

6. Telephone conversation with Andy Warhol, June 5, 1971.

7. Jean Stein, *Edie, An American Biography,* edited with George Plimpton (New York: Alfred A. Knopf, 1982), p. 377.

8. Stein, *Edie,* p. 379.

9. Mel Juffe, "Edie, Andy's Star of '65, Is Dead at 28," *New York Post,* November 23, 1971.

10. Telephone conversation with Andy Warhol, December 11, 1971.

11. Interview with Paul Morrissey, December 1, 1970.

12. Andy Warhol, *The Philosophy of Andy Warhol: From A to B and Back Again* (New York: Harcourt Brace Jovanovich, 1975), p. 54.

13. Stuart Byron, "Film: Reactionaries in Radical Drag," *The Village Voice,* March 16, 1972, p. 69.

14. Telephone conversation with Andy Warhol, September 4, 1971.

15. Telephone conversation with Andy Warhol, November 21, 1971.

16. Nien Cheng, *Life and Death in Shanghai* (New York: Grove Press, 1987), p. 187.

17. *Print Collector's Newsletter,* November-December 1972, p. 106.

18. Grace Lichtenstein, "Jagger at 29, Gets a Put On, Turned On Sendoff," *The New York Times,* July 28, 1972.

19. Interview with Paul Morrissey, February 15, 1989.

20. Judith Crist, "Heat" (review), *New York,* October 9, 1972, p.73.

21. Vincent Canby, "Paul Morrissey's 'Heat' Shown at Film Festival," *The New York Times*, October 6, 1972.

22. "Heat," *Oui,* July 1974, p. 130.

23. Interview with James Warhola, November 24, 1988.

24. Interview with Jed Johnson, November 30, 1988. (In 1974, Warhol let the author, who was writing an article on his portraits, help select four paintings of his mother for the cover of the January-February 1975 issue of *Art in America* without mentioning that she had died two years earlier.)

25. Jed Horne, "Andy Warhol Thinks Everybody and Everything Is 'Great' Except His Latest Movie—It's 'Bad,'" *People,* September 27, 1976, p. 75.

"Andy conceived portraits as idealized versions of his sitters. In my case, he always had this conceit that I should have been a movie star, which, no doubt, is why he chose, of all the Polaroids, the most glamorous pose and rendered it in classic Easter egg colors. By using all those powerful colors, all reality is swept away."

—*Brooke Hayward*[1]

251. *Brooke Hayward*. 1973. Acrylic and silkscreen ink on canvas, four panels, each 40 x 40". Collection Brooke Hayward, New York

During the early 1970s, against a turbulent political backdrop that included the fiasco of American involvement in the Vietnam war and the downfall of President Richard Nixon's presidency in the Watergate scandal, a "me" generation sprang to prominence—and Warhol was there to hold up its mirror. Unlike the radicalized protesters of the 1960s who wanted to change all the ills of society, the self-absorbed "me" people sought to improve their bodies and to "get in touch" with their own feelings. They cared passionately about their appearance, health, life-style, and bank accounts. Andy catered to their self-centeredness and inflated pride by offering his services as a portraitist. By the end of the decade, he would be internationally recognized as one of the leading portraitists of his era. Responding to the public's interest in—and his own craving for—celebrity gossip, he revamped *Interview,* expanding its range of subjects. More than ever obsessed with wealth, he attempted—largely successfully—to turn all his art enterprises into big business.

In 1973, Warhol, faced with a rent increase on Union Square West, moved his Factory to its third location, a nearby third-floor loft at 860 Broadway, on the northwest corner of Union Square. The new space was considerably bigger—about twelve thousand square feet—and security was much tighter; visitors stepped off the elevator into a vestibule where they were inspected via videocamera before being buzzed through a locked steel door into a large reception area.

If any style prevailed at the Factory, it was French Art Deco. By 1970, Warhol had already established himself as one of the most active collectors of this geometrized, graceful style of the 1920s and 1930s, and he ultimately played a major role in its revival. In New York, he frequently shopped for decorative objects at antiques shows, where dealers sometimes abandoned their booths to pursue him down an aisle, excitedly informing him that they were holding something exclusively for him—perhaps a batch of "early plastic" bracelets or 1939 World's Fair memorabilia. His trips to Europe always included scouting expeditions for art and antiques. During a visit to Paris in 1969, Warhol, accompanied by Fred Hughes and their art-collecting friends Sandra and Peter M. Brant, paid an enterprising visit to the Puiforcat firm (Jean Puiforcat had been one of Paris's most important silversmiths of the 1920s and

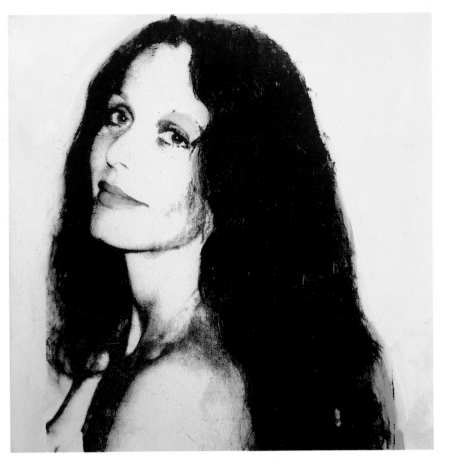
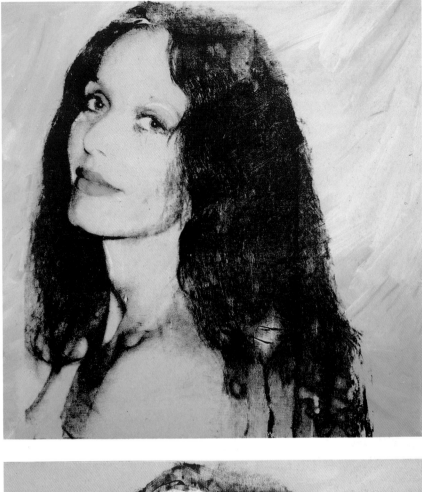
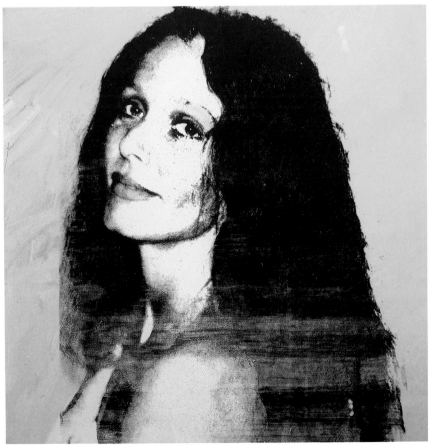
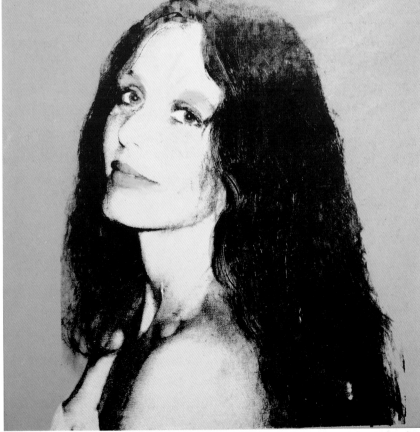

1930s.) There, according to Hughes, they found a dusty old showcase filled with vintage objects in the Art Deco style. They asked if any of the pieces were for sale and succeeded in buying almost every item for little more than its scrap value. The salespeople were apparently incredulous that anyone would want to buy such outmoded works. Warhol loaned many pieces of furniture and decorative objects, including his Puiforcat silver, to the pioneering "Art Deco" exhibition at Finch College Museum of Art in October 1970. Organized by Elayne H. Varian, the show was the first major survey of the style in New York. Most of the objects from Warhol's personal collection were credited in the catalogue to Hughes, because the artist was afraid of attracting attention to his buying habits.

Warhol and Hughes decorated the Factory's handsomely paneled executive office—used mainly for luncheons—with a large oval table veneered in Macassar ebony, along with twelve accompanying chairs, designed by Jacques-Emile Ruhlmann, considered by many to be the best French cabinetmaker since the age of Louis XVI. Most of the furnishings and decorations in this room were also in the Art Deco style, including 1920s posters by Jean Dupas. Andy played down the importance of his collection, denying that he had ever made a shopping trip to Paris and claiming that the table and chairs were just "used furniture"—"stuff we used for a movie [L'Amour] we were making in Paris." The Ruhlmann pieces, he insisted, were "props." "We had them sent back to New York and now we use them as a conference table. We have our little lunch from Brownies [a health-food restaurant] that we get every day right at 16th Street and eat out of paper boxes with people like Bernardo Bertolucci and Sylvia Miles and big producers like Alberto Grimaldi."[2]

The new Factory's ample space enabled Interview to expand its office quarters. Although the magazine reportedly still was not breaking even, its circulation had doubled over the last three years and its advertising pages had tripled. The staff had expanded from three to fifteen, and the fees paid to contributors soared from ten to one hundred dollars. With its March 1973 issue, the publication had forty-eight pages, including eleven pages of ads, and a circulation of about 55,000. Speaking as a publisher, Warhol said, "Our job is to discover new faces, new talent." Asked who read the magazine, he replied, "Our friends. And whoever's on the cover."[3]

Interview became far more visible on city newsstands after the gifted New York painter and poster artist Richard Bernstein began designing its covers in 1972, the year the publication started printing all its covers in color. He quickly developed a glitzy, eye-catching style, basing his distinctive cover paintings on professional photographers' portraits, to which he added expressionist color and occasional collage elements. He devised Interview's logo by writing the word as if it had been scripted in lipstick. Warhol, who was often mistakenly credited with doing Interview's covers, thought Bernstein's faces were "wonderful" because they were "so colorful and he makes everyone look so famous."[4]

Interview's editor throughout most of the 1970s was Bob Colacello, a star-struck, gossipy young man with dark, slicked-back hair, an oily complexion, and a toothy smile. Reared in middle-class Queens, near where his mother sold evening dresses at the Garden City branch of Saks Fifth Avenue, he was fairly typical of the college-educated young people who worked at the Factory in the 1970s. He had started out as a free-lance writer before finding a niche at Warhol's publication, which he helped turn into a gushy celebration of voguish people, but perhaps his greatest talent was for ingratiating himself with superannuated movie queens and the spendthrift wives and daughters of Third World dictators, many of whom he tried to sweet-talk into hiring Warhol to paint their portraits.

Interview assured Warhol's fame beyond the art world—in the considerably larger universe of fashion, entertainment, and society. The magazine also became his vehicle for maintaining his topicality and presence in the mass media. As a publisher, he contributed to the public-relations machinery of celebrity promotion, defining the "now" people and elevating young "nobodies" to month-long prominence. By dispensing attention on a chosen few, whether established celebrities or rising stars, Warhol presented himself as a trend-spotter and tastemaker who determined which people and events were newsworthy, maintaining the illusion that he was constantly aware of new events and personalities. In this way, he kept the rest of the trendy press on edge.

Warhol did not believe in editorial independence; to the contrary, he ceaselessly urged his staff to publish interviews with potential advertisers and portrait clients. In his view, there should have been a more noticeable correlation between who appeared on the cover of the magazine and who commissioned portraits.

Warhol's activities as publisher meshed conveniently with his role as zealous portraitist. Given his facility for stylizing the human face, his fervor for pursuing the rich, and his need to generate a large income, he was better qualified than most American artists of his time to process the faces of the rich and famous for posterity. Wooing prospective clients provided him a pretext for becoming more social than ever, attending as many as three dinner parties in one evening, followed by dutiful visits to various discotheques and nightclubs on the way home. In contrast to his bohemian consorts of the past, he now concentrated his attentions on the wealthy, partying socialites who constituted the glittery jet set—the Beautiful People. He relentlessly stalked the B. P. at dinner parties and clubs, pursuing them in their own habitats, from Sunset Boulevard and Rodeo Drive to Park Avenue, the Champs-Elysées, and the Via Veneto. He was especially keen to find long-term clients whose insatiable vanity would necessitate a new portrait every year. Where, he wondered, were the ladies of fashion who could be persuaded to flaunt their good features and couturier clothes in every room of the house or to document their changing hair styles over the seasons?

When Warhol succeeded in wheedling the rich to commission their portraits, he snapped their pictures with his Polaroid camera, had the prints processed into silkscreens, and turned out a single forty-inch-square painting for twenty-five-thousand dollars; each additional panel cost another five thousand dollars. He attempted to enlist all his dealers, friends, and employees in the quest for new clients, offering them a twenty percent commission. Portraits soon became his main source of income, subsidizing the rent on his new studio, the salaries of his expanding staff, and the ongoing expenses of *Interview*.

Warhol offered his clients an irresistible product: a stylish and flattering portrait by a famous artist who was himself a certified celebrity. Conferring an alluring star presence upon even the most celebrated of faces, he transformed his subjects into glamorous apparitions, presenting their faces as he thought they wanted to be seen and remembered. By filtering his sitters' good features through his silkscreens and exaggerating their vivacity, he enabled them to gain entree to a more mythic and rarefied level of existence. The possession of great wealth and power might do for everyday life, but the commissioning of a portrait by Warhol was a sure indication that the sitter intended to secure posthumous fame as well. Warhol's portraits were not so much realistic documents of contemporary faces as they were designer icons awaiting future devotions.

His intention, of course, was to give as much satisfaction to his clients as society portraitists such as John Singer Sargent and Giovanni Boldini had given to theirs in earlier eras. "I can make ordinary people look good," he said, "but I have trouble making beautiful people look good."[5] The most attractive women, he noted, were the hardest to please: "They're the ones that turn them down. I don't know why, because I work the hardest on them and don't fluff it off as easily."[6]

Art dealers and collectors were among the first to commission their portraits. Irving Blum, not surprisingly, was one of the earliest to see artistic merit in Warhol's glamorized faces. At a cocktail party in Los Angeles in the early 1970s, Blum, who was with his old friend Brooke Hayward, cornered the artist and said, "Andy, hasn't the time come for you to make a portrait of me and Brooke?" Warhol didn't waste a moment in coaxing them into another room so that he could take Polaroids of them. The resulting pictures of Blum (plate 267) pleased the dealer, who saw in them overtones of Humphrey Bogart's romantic tough-guy image. (Blum mounted an exhibition of Warhol's "recent portraits" at his Los Angeles gallery in May 1973.) Hayward expected to like Warhol's paintings of her because she admired his 1970 portraits of her former husband Dennis Hopper (plate 274), thinking they captured what that actor was "all about" at that time in his life. But she was totally unprepared for the ravishing colors Warhol chose for her (plate 251). He accentuated both the ethereal and sensual aspects of her appearance, conveying much of the beauty and radiance she had inherited from her movie-star mother, Margaret Sullavan. The other dealers and collectors who commissioned their portraits during the 1970s could

252. *Hélène Rochas.* 1974. Acrylic and silkscreen ink on canvas, 40 x 40″. Private Collection

253. *Corice Arman.* 1977. Acrylic and silkscreen ink on canvas, 40 x 40″. Collection Corice Arman, New York

fill a museum with their likenesses; they included Leo Castelli (plate 266), Alexandre Iolas, Philip Johnson (plate 263), Ivan Karp (plate 260), Kimiko Powers (plate 254), Ileana Sonnabend (plate 259), Bruno Bischofberger (plate 261), and Thomas Ammann. In most cases, these subjects had known Warhol for a long time and were early enthusiasts of his Pop works.

Warhol's international clientele included entertainment stars, industrialists, fashion designers, and fellow artists. During the 1970s, his subjects included show business personalities such as Liza Minnelli, Paul Anka (plate 256), and Mick Jagger. In the fashion world, Warhol glorified the faces of Yves Saint Laurent (plate 262), Diane von Furstenberg (plate 271), Halston (plate 272), Hélène Rochas (plate 252), and Carolina Herrera (plate 270).

Among politicians and heads of state (commissioned usually not by the subjects but by third parties), he rendered Presidents Gerald Ford and Jimmy Carter (plate 269), German Chancellor Willy Brandt, Massachusetts Senator Ted Kennedy, and Israeli Prime Minister Golda Meir (plate 273). In May 1975, Warhol took the Metroliner to Washington, D.C., to attend a White House dinner hosted by President Ford in honor of the Shah of Iran and the Empress Farah Diba; Andy pulled every string within reach to encourage the sovereign couple to commission their portraits.

Warhol's pursuit of controversial figures such as the Shah of Iran (and, later, Imelda Marcos, the first lady of the Philippines) inevitably raised suspicions about his seemingly amoral attitude in going after clients. Andy seldom expressed specific preferences about the types of people he wanted to paint; family history, social standing, profession, politics, character, morality—none of it mattered as long as the customer had the dough.

Despite Andy's fervent attraction to cash, he enjoyed bartering his portraits. His dealer friends discovered that he sometimes would silkscreen their faces in exchange for other artists' works. A Colorado collector reportedly traded acreage near Aspen for a multipanel portrait. Warhol also found his portraits to be useful in acquiring works of art directly from other artists; among the painters he portrayed were two of his Pop colleagues, Roy Lichtenstein (plate 265) and David Hockney (plate 277). ("I don't really like his work," Warhol said of Hockney; "I don't know why I'm trading."[7])

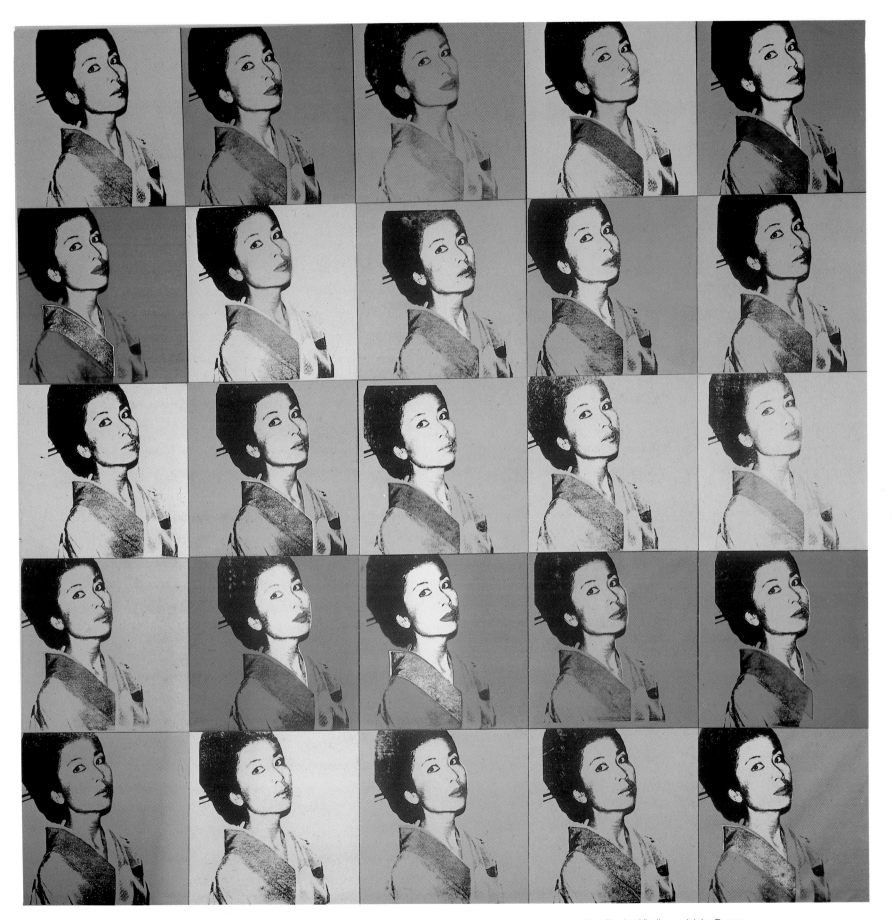

254. *Kimiko Powers*. 1971-72. Acrylic and silkscreen ink on canvas, twenty-five panels, each 40 x 40″. Various owners, nine panels collection Kimiko and John Powers

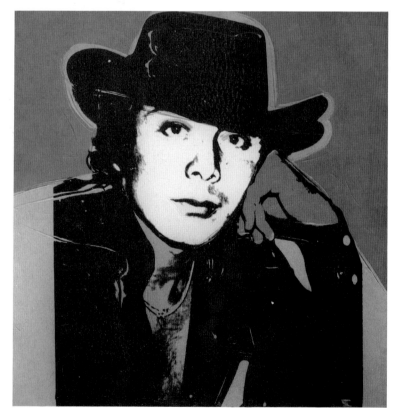

255. *Rudolf Nureyev.* c. 1975. Acrylic and silkscreen ink on canvas, 40 x 40″. The Estate of Andy Warhol

256. *Paul Anka.* 1976. Acrylic and silkscreen ink on canvas, 40 x 40″. Collection Paul Anka

Warhol preferred to base his portraits upon his own photographs, although he was occasionally willing to use preexisting pictures supplied to him by his clients. He generally selected the most complete and informative photograph, usually a full-face or three-quarter-face view. (Profiles, like his portrait of Golda Meir, based on a photograph he did not take, are rare.) Whatever the photographic source, the artist's choice of a deliberately contrasty silkscreen often resulted in a draining away of detailed visual information.

Warhol's portraits of the 1970s display a new interest in painterly painting. In his portraits of the 1960s, he had favored textureless surfaces and monochrome grounds in clear, bright, poster-like hues that linked him coloristically with minimalist painters such as Ellsworth Kelly and Frank Stella. Later, he switched to textured pigments and painterly grounds in modulated hues. About the same time that he abandoned flat paint for expressionistic brushwork, he adopted a new range of offbeat, more cosmetic colors. Some of the later portraits, such as those of Henry Geldzahler (plate 278), Halston, and Erich Marx (plate 275), abound with gestural strokes, suggesting an affectionate parody of the feathery brushstrokes of Willem de Kooning. The showy, if erratic, brushwork mitigated the impersonal and mechanical quality of the subsequent silkscreen process. "When I do the portraits," Warhol told an interviewer, "I sort of half paint them just to give it a style. It's more fun—and it's faster to do. It's faster to be sloppy than it is to be neat."[8]

Another reason for introducing texture was to make the portraits look more "hand-painted," thereby persuading clients that they were getting more of the artist's handcraft for the money. Warhol often added calligraphic flourishes to his paintings by running his extended forefinger through the wet acrylic paint—he wore a rubber glove—to create zigzagged and hatched lines along the contours of his sitters, often scraping through the top layer of color to reveal the underlying hue. His expressionistic finger painting is particularly noticeable in his portraits of Ivan Karp and in posthumous images of his mother (plate 276). (The latter pictures are based on an old snapshot that was obviously taller than it was wide so that the artist, in transferring the image to square panels,

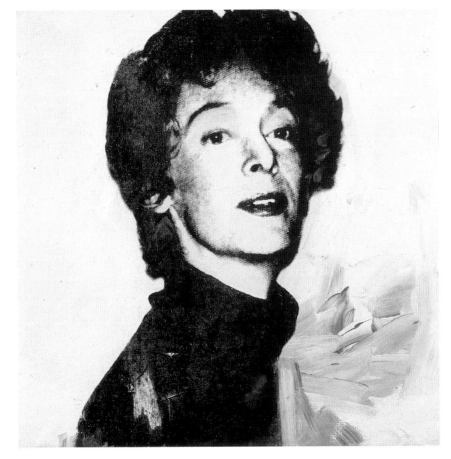

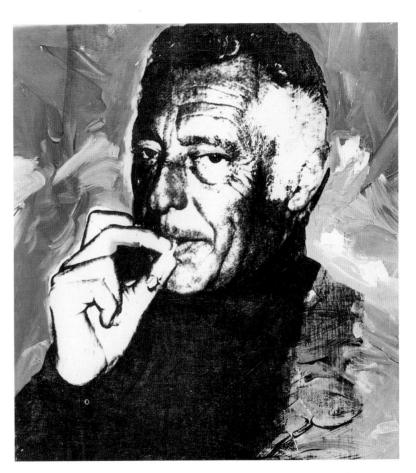

257. *Marella Agnelli.* 1972. Acrylic and silkscreen ink on canvas, 40 x 40″. Collection Dia Art Foundation, New York

258. *Giovanni Agnelli.* 1972. Acrylic and silkscreen ink on canvas, 40 x 40″. Private Collection

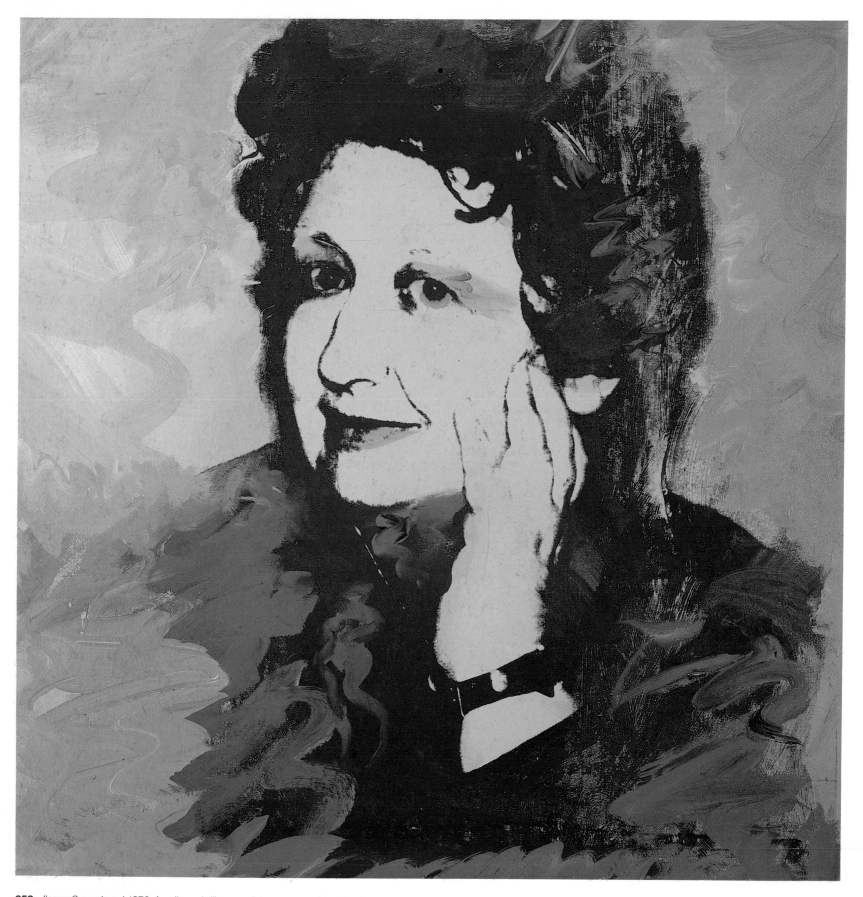

259. *Ileana Sonnabend*. 1973. Acrylic and silkscreen ink on canvas, 40 x 40″. Collection Ileana and Michael Sonnabend, New York

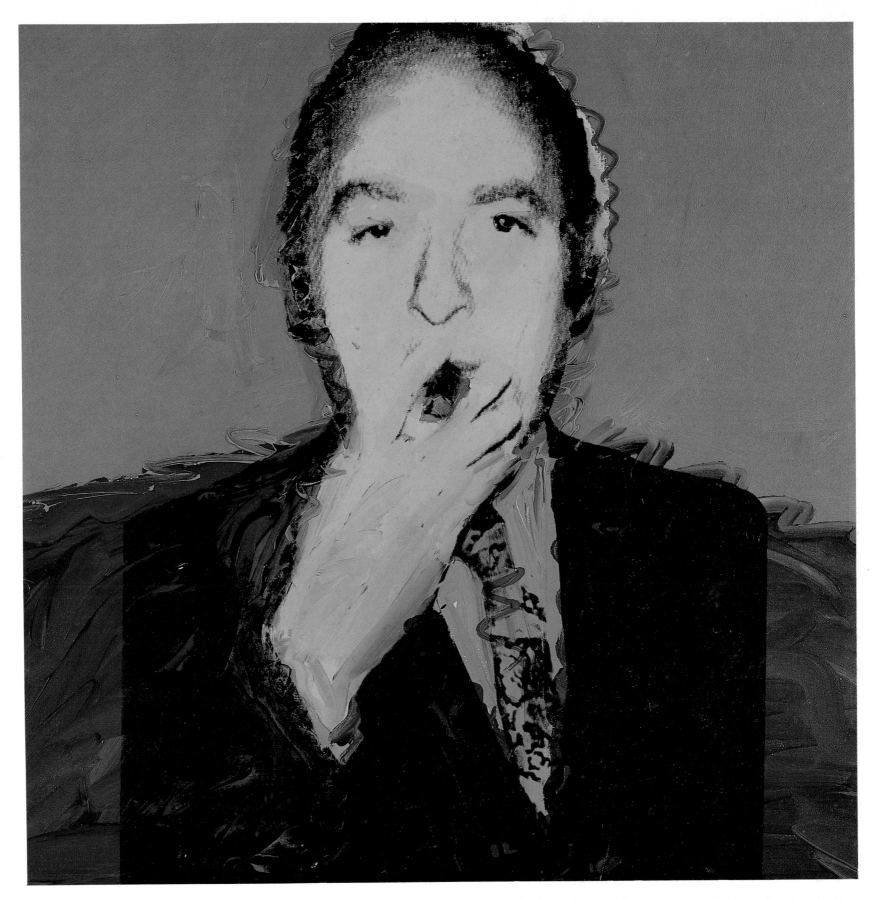

260. *Ivan Karp.* 1974. Acrylic and silkscreen ink on canvas, 40 x 40″. Collection Ivan Karp, New York

261. *Bruno Bischofberger.* 1969. Acrylic and silkscreen ink on canvas, 59¾ x 59¾". Collection Bruno Bischofberger, Zurich

262. *Yves Saint Laurent.* 1974. Acrylic and silkscreen ink on canvas, 40 x 40". Collection Yves Saint Laurent

263. *Philip Johnson.* 1972. Acrylic and silkscreen ink on canvas, nine panels, each 32 x 32″; overall size 96 x 96″. Collection David Whitney

264. *Dorothy Lichtenstein.* 1974. Acrylic and silkscreen ink on canvas, 40 x 40″. Collection Roy and Dorothy Lichtenstein, New York

265. *Roy Lichtenstein.* 1976. Acrylic and silkscreen ink on canvas, 40 x 40″. Collection Roy and Dorothy Lichtenstein, New York

266. *Leo Castelli.* 1975. Acrylic and silkscreen ink on canvas, two panels, each 40 x 40″. Collection Leo Castelli, New York

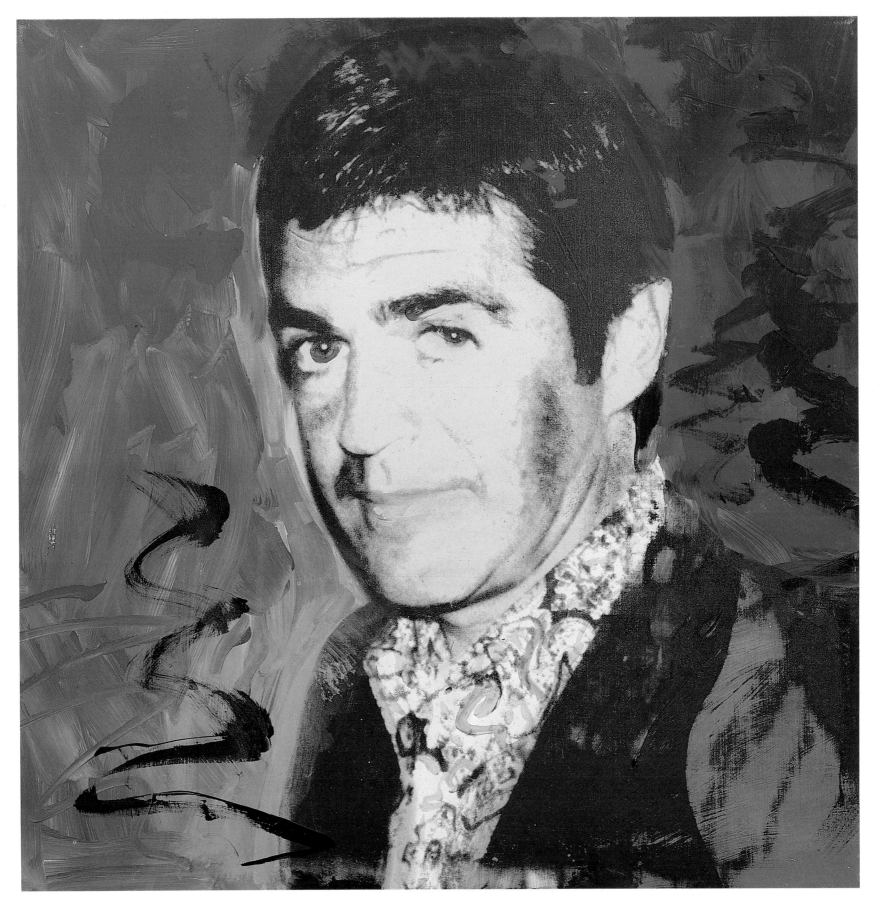

267. *Irving Blum*. 1970. Acrylic and silkscreen on canvas, 40 x 40". Collection Irving Blum, New York

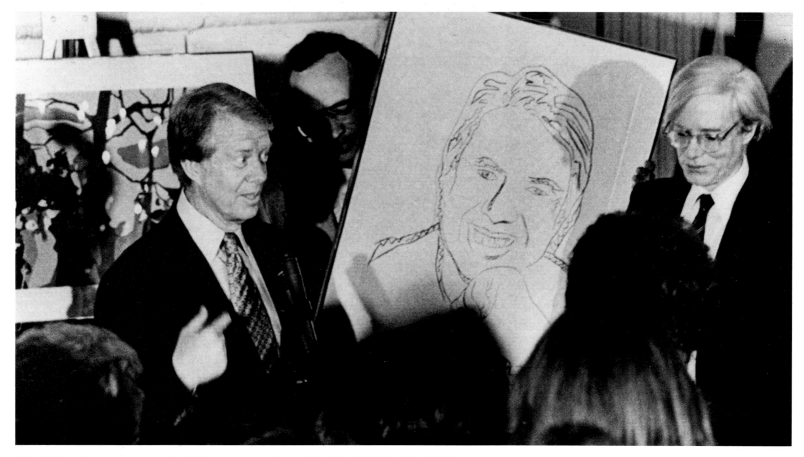

268. Warhol attends a reception at the White House hosted by President Jimmy Carter, June 14, 1977.

was forced to fill in the sides with brushy paint.) While continuing to make expressionistic portraits in the late 1970s, he simultaneously processed some faces—including those of Liza Minnelli, Truman Capote, and Carolina Herrera—in his earlier poster-like style with crisply delineated areas of unmodulated bright color.

One of the characteristics that distinguishes Warhol's portraits from those of most other artists is the larger-than-lifesize face that fills most of the canvas, an aggrandizement that evidently suited the egos of his sitters. Warhol did not aspire to be an accurate cartographer of anyone's physiognomy, so he emphasized the features he considered important. These were always the eyes and the mouth. The eyes tend to be large, lustrous, and luridly embellished with expressionistic eye shadow. The lips are often exaggeratedly sensuous and full because the underlying color area usually exceeds the contours of the photographic lips. In some of his later portraits of women (notably Carolina Herrera and Liza

Minnelli), he separately printed the lips with red enamel to achieve a more precise and vivid effect.

In the mid-1970s, Warhol's customary procedure was to send his chosen Polaroids to Chromacomp, Inc., fine-art printers, where the photographs were converted into half-tone positives of the same size as the final painting. When the half-tone positives were finished, Alexander Heinrici, the Vienna-born vice-president of Chromacomp, brought the acetate sheets to the artist for his approval. Warhol selected the image he wanted and, if necessary, ordered specific retouching. Complexions were cleared up, wrinkles were erased, blemishes disappeared, and sometimes whole ears and noses threatened to vanish. Although he could have ordered silkscreens that offered a wide tonal range of lights and darks, Warhol preferred a contrasty image. In processing a face, he wanted to eliminate most of the middle tones and to keep only the very dark and light ones. After the actual silkscreen was made,

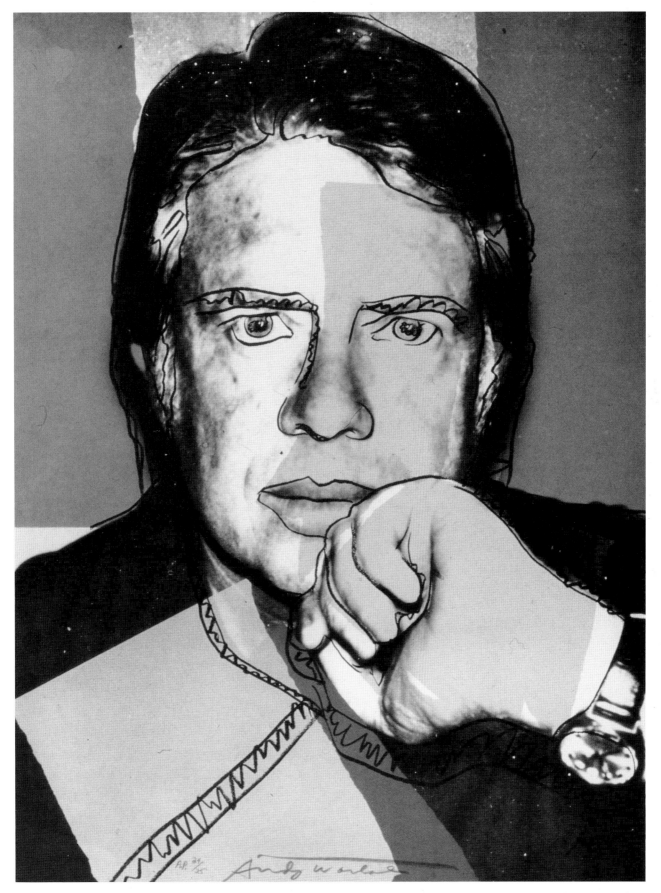

269. *Jimmy Carter I.* 1976. Screenprint, edition of 50, 39¼ x 29½". Courtesy Ronald Feldman Fine Arts, New York

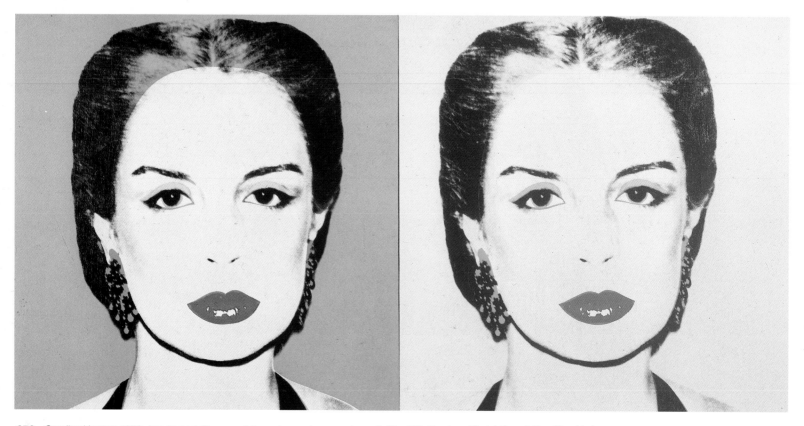

270. *Carolina Herrera.* 1979. Acrylic and silkscreen ink on canvas, two panels, each 40 x 40". Courtesy Dia Art Foundation, New York

Warhol used the acetate sheet as a pattern to trace the approximate features of the face. Then he brushed his colors onto the canvas. Heinrici picked up the painted panels and took them to Chromacomp, where they were screened. "Sometimes," Heinrici said, "he indicates exactly how he wants it. At other times he will say, 'Do it so it looks good.' He gets very upset if it is not what he wanted. You have to listen not only to what he says, but be sensitive enough to understand what he really wants."[9]

Departing from one of portraiture's most traditional ideals, Warhol made little attempt to portray people in character. His silkscreened faces are essentially stylized, cosmetic, skin-deep treatments of surfaces rather than a probing of the individual's personality. Instead of illuminating character, he presented faces as glossy masks. Only art historians with extremely sharp perception —or vivid imaginations—could detect the artist's probes into the mental states of his subjects. Robert Rosenblum, for instance, asserted that Warhol "captured an incredible range of psychological insights among his sitters,"[10] and Charles Stuckey declared that the artist displayed "a remarkable sensitivity to his subjects' personalities," often responding "to the turn of the head or the gesture of a hand, and always to the attentiveness of the eyes."[11] Despite these claims, it remains questionable what importance Warhol placed on knowing his subjects in order to make his portraits. As a maker of commemorative icons, it perhaps did not much matter to him whether his subjects were living or dead. In fact, he sometimes displayed a rather ghoulish eagerness in accepting commissions for posthumous portraits. As knowable personalities, Marilyn Monroe and Mao Zedong, whom he never met, were less remote to him than some of his actual "sitters."

While his career as a portraitist flourished, Warhol met with considerably less success in his film projects. During the early 1970s, he contributed his name and sometimes his talent to several films, all made in France or Italy—and critically panned in the United States. In a Paris-made movie, *L'Amour,* Warhol shared credit as author and director with Paul Morrissey. In this film, Donna Jordan, a dazzling young blonde with a toothy smile, and Jane Forth play a couple of high-school dropouts who go to Paris to make the scene as models and to find rich husbands. There, they meet up with a

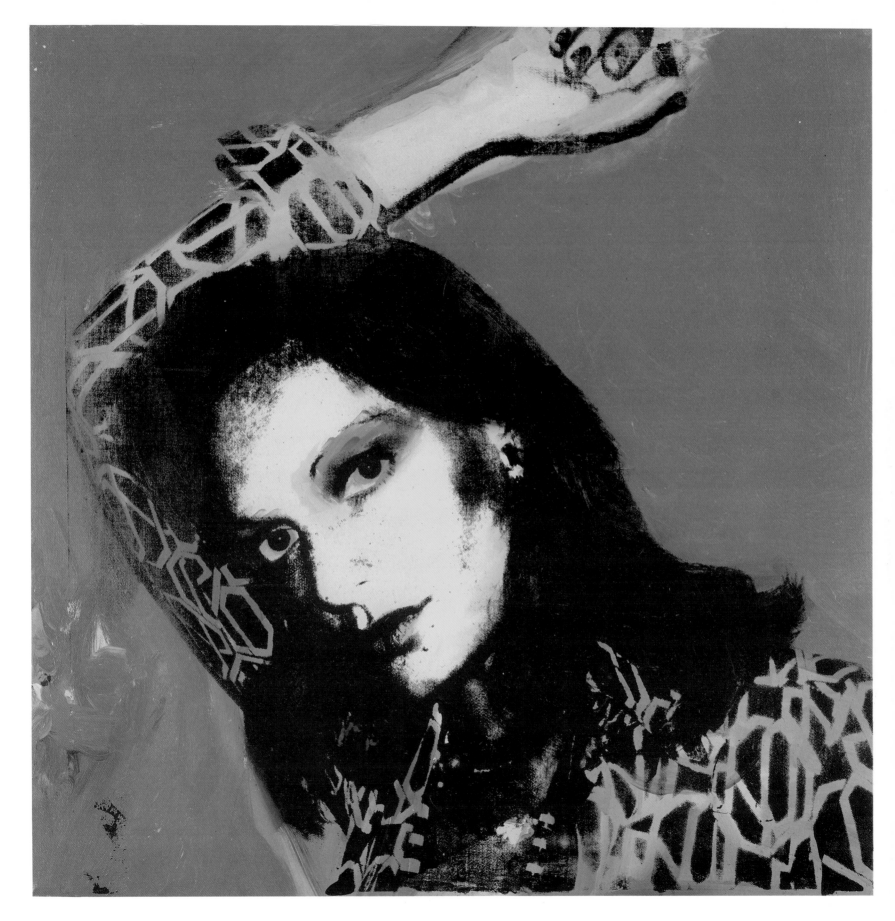

271. *Diane von Furstenberg*. 1974. Acrylic and silkscreen ink on canvas, 40 x 40″. Collection Diane von Furstenberg, New York

272. *Halston*. 1974. Acrylic and silkscreen ink on canvas, 40 x 40″. Collection Halston

273. *Golda Meir*. 1975. Acrylic and silkscreen ink on canvas, 40 x 40″. Virginia Museum of Fine Arts, Richmond. Gift of Sydney and Francis Lewis Foundation

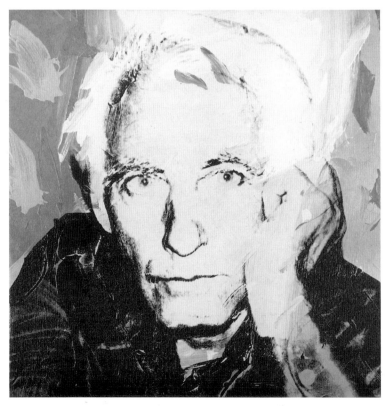

274. *Dennis Hopper*. 1970. Acrylic and silkscreen ink on canvas, 40 x 40″. Private Collection

275. *Erich Marx*. 1978. Acrylic and silkscreen ink on canvas, 40 x 40″. Collection Erich Marx, Berlin

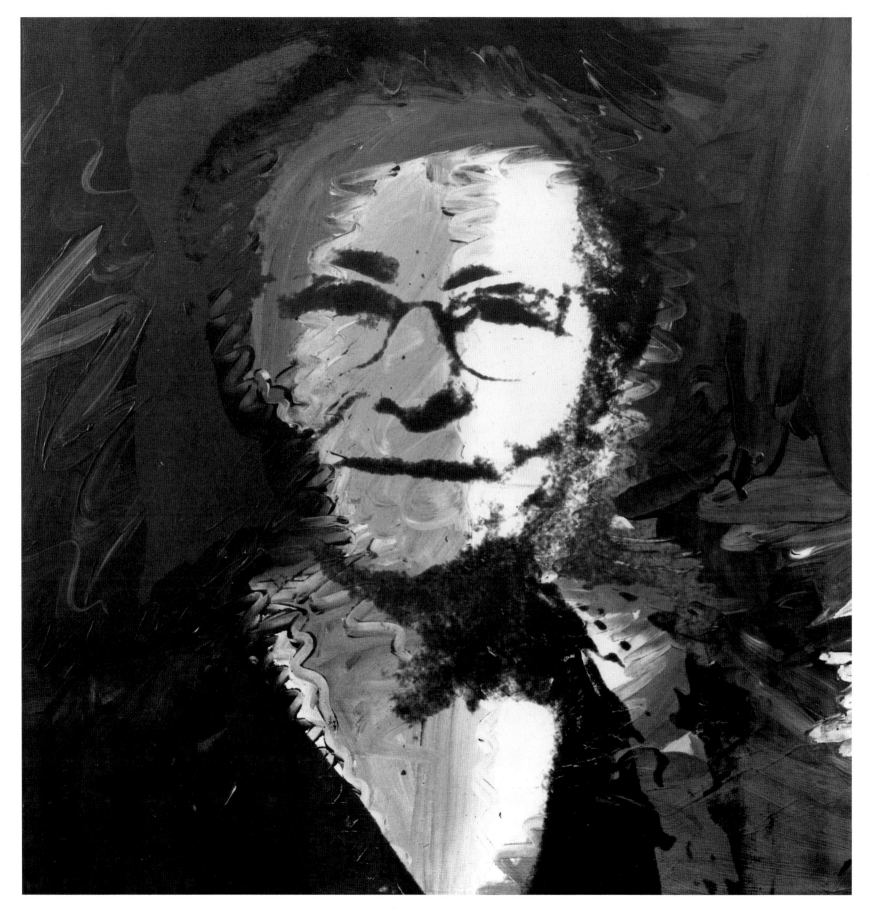

276. *Julia Warhola.* 1974. Acrylic and silkscreen ink on canvas, 40 x 40″. Collection Roy and Dorothy Lichtenstein, New York

344

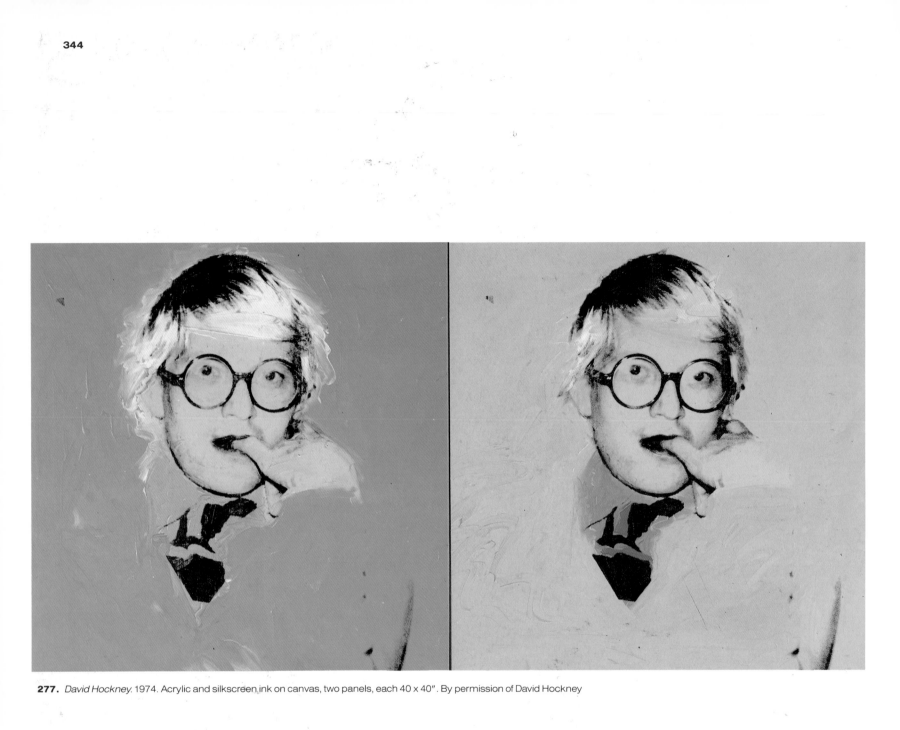

277. *David Hockney.* 1974. Acrylic and silkscreen ink on canvas, two panels, each 40 x 40″. By permission of David Hockney

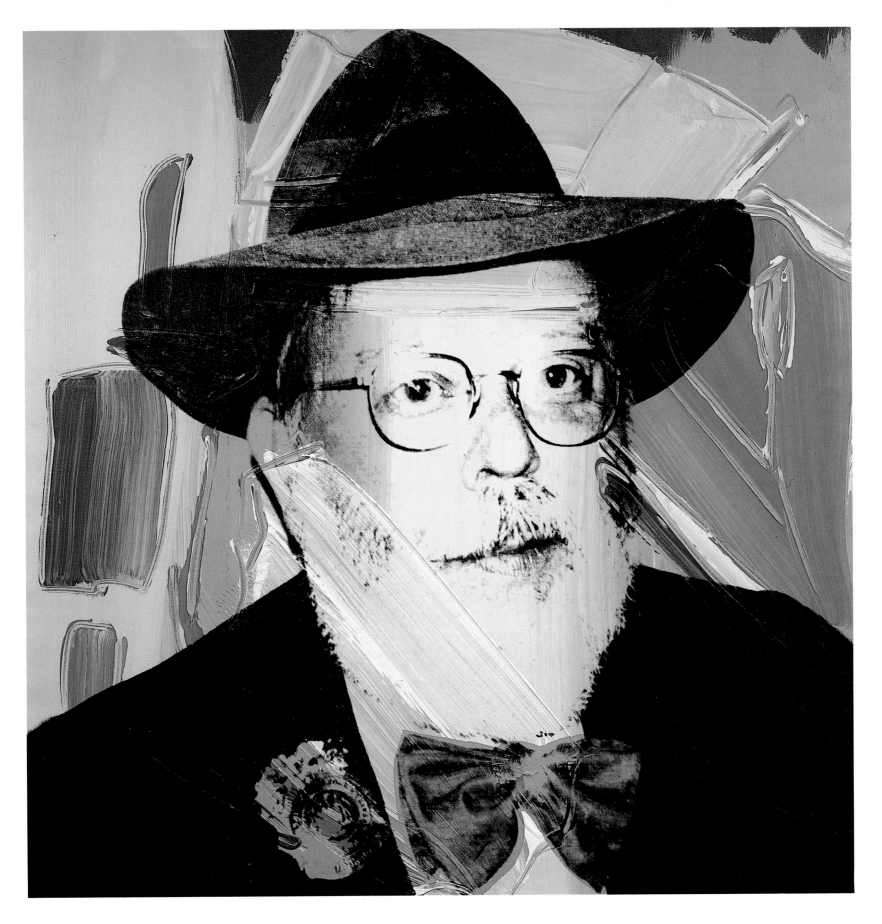

278. *Henry Geldzahler.* 1979. Acrylic and silkscreen ink on canvas, 40 x 40″. Collection Henry Geldzahler, New York

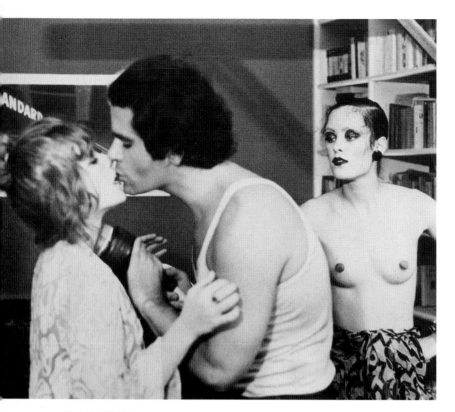

279. Patti D'Arbanville and Max Delys enjoy a moment of passion as Jane Forth looks on in a scene from Warhol's *L'Amour,* filmed in Paris in 1971–72.

rich American playboy, Michael Sklar, who is infatuated with a street hustler, played by Max Delys, a French equivalent of Joe Dallesandro. Michael schemes to marry Donna so he can adopt Max, who tries to seduce Jane, whose only passion is for buying make-up. Jane and Donna celebrate their arrival in Paris by painting their nipples red, and Jane gets to wear black lipstick. When the movie opened in New York in May 1973, critics dismissed it as "total trivia"[12] and "wan," looking "like a high-fashion layout gone a bit looney."[13]

In 1973, Morrissey wrote and directed two horror movies, *Flesh for Frankenstein* and *Blood for Dracula*, in Rome. In the United States, the films were released as *Andy Warhol's Frankenstein* and *Andy Warhol's Dracula*, but, aside from the artist's name in the title, his creative input appears to have been nil. (While in Rome in 1973, Andy played a cameo role in *The Driver's Seat*, a cinematic dud starring Elizabeth Taylor, whom he had recently befriended.) Morrissey's international team of producers evidently thought that their recycling of classic monster stories, spiced up with nudity and

sex, was a sure bet for success. *Frankenstein* was filmed in 3-D at Rome's famous Cinecittà studios, and *Dracula* was done on location in an old mansion. Both films were made, back to back, in only four weeks and starred German actor Udo Kier. *Frankenstein* is the gorier of the two films. It features a decapitation with garden shears and an impalement that illusionistically suspends viscera before viewers' eyes. It also contains both a male and a female monster with a lot of grisly scar tissue. Monique Van Vooren, a slinky blond actress who excelled at impersonating femmes fatales, played the mad scientist's sex-crazed wife-sister, whose lust for the male monster leads to her being literally hugged to death. The film's ample, if not very funny, violence led to its X-rating when it had its premiere in the United States in May 1974. Although one New York critic thought Morrissey handled the sex and nudity as "lightheartedly" as "the buckets of blood that splatter the film,"[14] most of the reviews were disastrous.

While *Frankenstein* was calculated to titillate audiences with gruesome amputations and a disembowelment, *Dracula*, released in 1975, was intended to arouse laughter through a series of scenes centered on regurgitation. (The anemic vampire—Kier—needed to such the blood of virgins; his stomach would not accept the blood of "sullied" women.) The spew of blood and stomach contents in these movies, however, could not disguise the fact that they are rather awful. Warhol's fans who went to the films expecting some sort of artistic revelation were sorely disappointed.

Joe Dallesandro's fans were also frustrated by *Frankenstein* and *Dracula*. Though he received star billing in both pictures, he was not a central figure in either. Even Morrissey, his biggest promoter, had to acknowledge that the roles were "not so good" and that the two films were unsuitable vehicles for the young actor. Dallesandro decided to stay on in Italy, where he was treated like a luminary. While living in Rome during the next seven years, he made more than thirty films. But Dallesandro's career capsized in the late 1970s, following a serious dependency upon alcohol and drugs. In 1981, he moved to Los Angeles, entered a detoxification clinic, joined Alcoholics Anonymous, and worked as a taxicab and limousine driver until he decided it was time to get back into acting. His comeback began with a cameo role as gangster Lucky Luciano

in Francis Ford Coppola's film *The Cotton Club*, in which he was singled out by the critics for high praise.

While Dallesandro had been enjoying the limelight in Italy, a couple of Warhol's brightest stars from earlier years extinguished in New York. One of them was Candy Darling, whose classy work in many independent films and off-Broadway plays—including a major role in Tennessee Williams's *Small Craft Warnings*—had won him a devoted following. In March 1974, Candy gave a courageous and moving performance, evocative of Camille and Violetta, in his room at Columbus Hospital, where he lay dying of cancer and pneumonia; instead of Art Deco plastic bangles, he wore a simple hospital bracelet that read, "Candy Darling, AKA James Slattery." He was still in his twenties when he passed away during the first week of spring. As Candy had once observed, "All the blondes die young."

In May 1975, Eric Emerson, the scintillating star of *Chelsea Girls, Lonesome Cowboys,* and a thousand shenanigans in the back room of Max's Kansas City, was found dead at age thirty-one near the West Side Highway, apparently the victim of a hit-and-run driver. Eric (who, for a period in the early 1970s, had lived with Jane Forth and fathered a son by her) was known as a reckless bicycle rider who paid little attention to traffic as he sped, yodeling, through the canyons of Manhattan. But the bicycle alongside his body was unscratched, leading friends to suspect that perhaps he had overdosed elsewhere and been deposited in the street to simulate an accident. Both Eric and Candy were magic creatures who would linger in many people's minds.

Warhol, still determined to make his mark on Broadway, presented *Man on the Moon*, a musical that opened at the Little Theater on West 44th Street in January 1975. John Phillips, formerly of The Mamas and the Papas, contributed the music and lyrics as well as the book, which revolved around Dr. Bomb, the United States space program, and a plot to explode a bomb on the moon. Morrissey directed the production, which starred Monique Van Vooren. Critics called the show silly and inept, and all agreed that the best part of opening night was the half-hour delay in the rise of the curtain, when the Beautiful People made splashy arrivals.

Because Warhol seldom invested his own money in the

cinematic and theatrical flops to which he lent his name, he suffered no financial losses. He was so single-minded about amassing money that, in 1974, he was able to buy a six-story, Georgian-style town house at 57 East 66th Street for $280,000. (At the time of his purchase, New York City was on the verge of bankruptcy, and the real estate market was severely depressed.) Jed Johnson, Andy's longtime housemate, had been scouting for a more desirable home for about a year when he came across this 1911 structure, which was twenty feet wide and seventy feet deep. Warhol liked the place because of its classical proportions and traditional appearance; he was thrilled by the main staircase (so much wider than the one in his Lexington Avenue house) and the large, open rooms. Architecturally, nothing needed to be changed. Another plus, according to Johnson, was that the house was just around the corner from Madison Avenue—"his favorite shopping promenade." Jed prodded Andy to promise him that he would keep the place tidy.

The move into the new house occurred over an extended period of time. It took months, according to Johnson, just to sort through all the stuff that Warhol had collected over the years and to pack it into cartons. "We began," Johnson said, "by going into the flat files where he kept all his early illustrations from his commercial art days. He tore the old work up and we threw it into jumbo plastic trash bags. We hauled these outside and left them in front of other people's houses down the block and around the corner because he was afraid someone would be curious to know what Andy Warhol was getting rid of in bulk and decide to retrieve it. This was the one and only time I ever saw him throw *anything* away."[15] From Andy's few comments, Jed got the impression that he was "sorry or embarrassed" at having started out as a commercial artist. What Warhol decided to keep was packed up and moved to the top-floor storage rooms of the new house.

Storage containers were becoming increasingly visible in Warhol's daily life. At the Factory, he often drove his colleagues crazy by saving virtually everything, from the canceled stamps on incoming mail to the exhausted batteries in his tape recorder. He deposited most of his mail—all but the bills and the checks—into large cardboard boxes, which, when filled, were sealed and dated

and stacked on steel shelves. Before long, an entire wall of the Factory was lined with neatly stacked containers of miscellaneous memorabilia, eerily evoking the funerary goods that Egyptian pharaohs stashed in their tombs to comfort them in their afterlives.

Warhol thought of the boxes as potentially valuable "time capsules," and he often wondered how to market them. He thought of selling them—unopened and uninspected—to collectors, who might or might not have received an original drawing as well. (The French Nouveau Réaliste Arman had long earlier mastered the artful presentation of commonplace detritus in his *Poubelles*, accumulations of garbage in Plexiglas containers; Warhol, significantly, owned a few of Arman's works.) Andy liked to advise his friends to simplify their lives by boxing up the residue of daily life, dating and locking the containers, and shipping them to a distant storage site. "You should try to keep track of it," he said, "but if you can't and you lose it, that's fine, because it's one less thing to think about, another load off your mind."[16]

Warhol usually showed up at the Factory just in time for lunch, then retreated to his studio in the rear to paint. He generally worked with an assistant, who unrolled the canvas, outlined faces in masking tape, and painted in the flat background colors (like artists in ancient Egypt, Warhol had standard skin colors for his subjects— light for women, dark for men).

One of Warhol's assistants, Ronnie Cutrone, was delegated the task of finding picture sources for a 1974 portfolio of ten silkscreened prints, the *Hand-Colored Flowers* (plate 280), published in an edition of 250. (Andy regarded flowers as a perennially lucrative subject, especially after October 1973, when the Sculls sold one of his large paintings of two blossoms at auction for $135,000.) Cutrone gathered several illustrated books on the art of flower arranging, and Warhol made a selection of images, using them as the basis for freehand drawings, which were then photographically converted into silkscreens.

Unlike the 1970 Flowers screenprints, which consist of ten variations on a single image, the *Hand-Colored Flowers* contain ten

280. *Hand-Colored Flowers.* 1974. Portfolio of 10 silkscreen prints (edition of 250), each 40⅞ x 27¼". Courtesy Ronald Feldman Fine Arts, New York

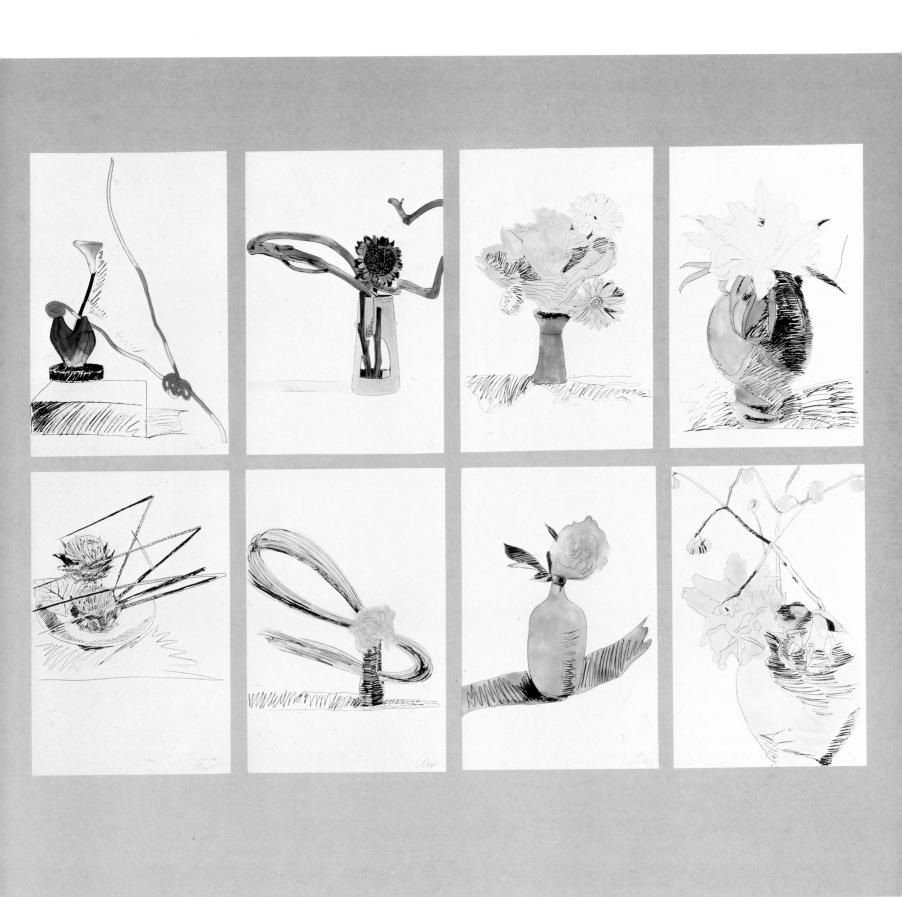

different images. While the earlier floral image appears as flat as a blotter, the blossoms and vases depicted in the newer pictures are three-dimensional, deployed starkly against a comparatively large expanse of white paper. Most of the floral displays are understated, with only a single blossom in the vase, though they are often accessorized by leaves and florist's paraphernalia, such as the piece of angular "driftwood" that accompanies a sunflower. After Warhol's drawings were silkscreened in black, he and his assistants casually filled in the shapes with color. Like so many of the artist's works from the 1950s, the Flowers were brushed with Dr. Martin's aniline watercolor dyes. The prints vary in hue and facture and are among Warhol's most decorative works in the watercolor medium.

Transvestites were another subject with durable appeal for Warhol. Although he surely must have questioned whether much of a market existed for pictures of black female impersonators, he thought it would be amusing to produce a portfolio of ten screenprints, each a different image, archly titled *Ladies and Gentlemen* and published in 1975 in an edition of 250. He assigned a couple of his assistants to cruise the gamier intersections of Greenwich Village late at night to collect the outrageously dressed drag queens, some of whom apparently earned their living as "ladies" of the night. The subjects were easily cajoled into visiting the Factory and posing for Warhol, who paid them a modeling fee. Many of the drag queens crowned themselves with extravagant wigs and obviously fashioned themselves after famous pop singers, ranging from Lena Horne to Diana Ross. In addition to the screenprints, the transvestites also appear in a related series of Warhol's paintings and drawings (see plate 282).

During the same year he portrayed preening transvestites, Warhol also produced screenprints of swaggering Mick Jagger. The result was still another portfolio of ten different images, each based on one of Andy's photographs of the Rolling Stone. The portraits present the bare-shouldered rock star brazenly eyeing the camera, showing off his long hair, pouty lips, and long neck, as if he were vamping for a glamour photographer. Jagger was an ideal subject for Warhol: like Marlon Brando, James Dean, and Elvis Presley, he was not just another pretty face, but sullen, brooding, and turbulent.

In the Jagger screenprints, Warhol incorporated passages of his own drawing, based on the photographs. He had earlier combined his drawing with a photographic image in the Mao screenprints, but the drawing in those portraits had been little more than calligraphic scribbles alongside the head and over the jacket. In contrast to the Maos, the drawn elements in the Jagger portraits actually constitute part of the likeness. The passages of drawing overlap or substitute for the photographic information. In some pictures, the drawn and photographic images are congruent; in others, they are deliberately askew. By embellishing his prints with line drawing, Warhol hoped to enrich and energize them, while also adding a hint of personal touch. His drawn elements were, of course, translated into a silkscreen and printed, thereby enabling him to achieve a handmade look by mechanical means.

In both the *Mick Jagger* and the *Ladies and Gentlemen* screenprints, Warhol incorporated collage-like elements, superimposing the faces on irregular shapes that appear to be torn and overlapping pieces of colored paper. (Like the line drawings, the color patches were actually silkscreened.) The pseudocollage contributes more complexity to the compositions and gives them a determinedly expressive—and sometimes arty—look. The idea of positioning figures against arbitrary blocks of color had at one time been a popular device among art directors, who derived it from artists such as Raoul Dufy, Fernand Léger, and Paul Klee. Warhol himself had juxtaposed his drawing with collage elements in some of his student artworks at Carnegie Tech. He would continue to incorporate collage-like patches of color in most of his prints for the remainder of his career.

Andy's thoughts on art, work, money, and fame were detailed in what is arguably his best book, *The Philosophy of Andy Warhol: From A to B and Back Again*, published in the fall of 1975. The aphoristic text vividly demonstrates his quirky way of thinking. His remarks are conspicuously devoid of any idealism concerning the making of art or its role in society and offer little evidence that he considered painting to be an honorable profession; but he wrote enthusiastically about wealth and success. "Business art is the step that comes after Art," he declared. "I started as a commercial artist, and I want to finish as a business artist.... Being good in business is

281. *Still Life with Book and Camera.* 1975. Pencil on paper, 27 x 40¼". Collection David Bourdon, New York

the most fascinating kind of art...making money is art and working is art and good business is the best art."[17]

Warhol advocated several ideas in his *Philosophy* that he did not practice in his own life. One of them concerned his frequently professed admiration for clutter-free surroundings. "I believe that everyone should live in one big empty space," he wrote. "It can be a small space, as long as it's clean and empty." If people really needed a closet, he advised that it should be in a separate, faraway place: "If you live in New York, your closet should be, at the very least, in New Jersey." He added: "Everything in your closet should have an expiration date on it the way milk and bread and magazines and newspapers do, and once something passes its expiration date, you should throw it out."[18]

The realization of this program, however, did not have a ghost of a chance in Warhol's own household. By this time, he had become an addictive collector who had to go shopping every day. He usually dropped into several shops on his way to work, and, once he got to the Factory, he was always willing to interrupt his work to take

telephone calls from dealers whose merchandise interested him. And there was hardly anything collectible that didn't appeal to Andy, from American Federal furniture to 1950s cookie jars, from Native American baskets and blankets to Russel Wright's streamlined dinner ware.

The rooms of the new house were rapidly filled, often with very impressive examples of art and furniture. Many of the choicest French Art Deco pieces ended up in the sunny front parlor. Here, Andy kept Ruhlmann's sinuously contoured chiffonier, made in an exotic wood—amboyna—with ivory escutcheons. Other masterpieces of Art Deco included Pierre Legrain's pair of console tables with their tops and block feet veneered with *galuchat* (sharkskin), a leather popular in the 1920s, and several of Jean Dunand's superb lacquered vases. Among the contemporary paintings in the parlor were Jasper Johns's six-foot-high *Screen Piece*, Lichtenstein's five-foot-high schematic representation of an oval mirror, as well as his *Sailboats* and *Laughing Cat*, and Cy Twombly's 1967 untitled abstraction with several rows of crayoned

282. *Ladies and Gentlemen*. 1975. Acrylic and silkscreen ink on canvas, 14 x 11″. The Estate of Andy Warhol

scrolls against a gray ground. Typically, Andy chose not to hang any of his own paintings in his home.

While Warhol's Art Deco pieces looked great in the Georgian-style town house, he thought his American country furniture was too drab for its new setting, so he urged Johnson to shop for more appropriate items. Jed, who had never really thought about decorating and was totally without formal training in the field, started scouting furniture for Andy's house, first finding the pieces, then getting Andy's approval to buy them. As a result, Johnson embarked on a very successful career as an interior designer.

Johnson assembled a good collection of American Federal and Empire furniture and created an imposing, almost forbiddingly formal drawing room that was decorated with nineteenth-century European bronze figures and nineteenth-century English and American paintings. The most unusual piece in the room, however, was a twentieth-century eight-legged, Egyptian-style armchair; its back was in the form of a gilt vulture with outspread wings, while the seat rested on a pair of walking lions with gilt masks of Hathor. The large dining room on the ground floor contained mahogany furniture of the Federal period, including an outstanding sideboard attributed to Philadelphia cabinetmaker Joseph Barry and an enormous dining table that, when fully opened, extended more than twelve feet.

In his spacious bedroom on the third floor, Warhol could check his appearance in a huge mahogany-framed cheval mirror, made in about 1815, and fall asleep in a Federal four-poster tester bed. Johnson, whose small bedroom was on the same floor, embellished Andy's retreat with painted ceiling borders and wall patterns that incorporated a frieze of images from antique wallpaper. On the floor above, a guest bedroom contained a handsome suite of rosewood and bird's-eye maple furniture in the American Renaissance style, made in about 1860 by New York City cabinetmaker Gustav Herter.

Although Johnson was constantly urging Warhol to be more selective and to refine his collection, the artist's acquisitiveness was taking him farther and farther away from his ideal of empty space. As Andy had observed in his *Philosophy* book, "Buying is much more American than thinking and I'm as American as they come."[19]

NOTES

1. Interview with Brooke Hayward, March 10, 1989.
2. Interview with Andy Warhol, February 1, 1974.
3. "Noted from the Underground," *New York*, March 5, 1973, p. 63.
4. Richard Bernstein, *Megastar* (New York: Indigo Books, 1984), p. 2. *Megastar* compiles about seventy of Bernstein's *Interview* covers, including those of Cher, Calvin Klein, Bette Midler, and Rod Stewart.
5. Telephone conversation with Andy Warhol, November 12, 1972.
6. Telephone conversation with Andy Warhol, April 13, 1974.
7. Telephone conversation with Andy Warhol, February 9, 1974.
8. Phyllis Tuchman, "Pop!" *Art News*, May 1974, p. 26.
9. Interview with Alexander Heinrici, October 24, 1974.
10. Robert Rosenblum, "Andy Warhol: Court Painter of the 70s," essay in *Andy Warhol: Portraits of the 70s* (New York: Random House in association with the Whitney Museum of American Art, 1979), p. 18.
11. Charles Stuckey, "Andy Warhol's Painted Faces," *Art in America*, May 1980, p. 109.
12. Judith Crist, "Movies," *New York*, May 14, 1973, p. 88.
13. Vincent Canby, "The Screen: 'L'Amour'," *The New York Times*, May 11, 1973.
14. Norma McLain Stoop, "Andy Warhol's Frankenstein," *After Dark*, May 1974, p. 34.
15. Jed Johnson, "Inconspicuous Consumption," *The Andy Warhol Collection/Americana and European and American Paintings, Drawings and Prints*, catalogue to the Sotheby's (New York) sale, April 29 and 30, 1988, n.p.
16. Andy Warhol, *The Philosophy of Andy Warhol: From A to B and Back Again* (New York: Harcourt Brace Jovanovich, 1975), p. 145.
17. Warhol, *Philosophy*, p. 92.
18. Warhol, *Philosophy*, pp. 144–45.
19. Warhol, *Philosophy*, p. 229.

"I never saw him wear a single jewel until one night at Studio 54. I saw a slight bulge under his Brooks Brothers shirt which turned out to be a rather grand emerald necklace."
—Suzie Frankfurt[1]

283. *Still Life (Hammer and Sickle).* 1976. Acrylic and silkscreen ink on canvas, 72 x 86″. Courtesy Leo Castelli Gallery, New York

While his glamorous life style epitomized the privileges of capitalism, Warhol in the late 1970s ironically chose to paint a new subject with ambiguous political overtones—the hammer-and-sickle still lifes (see plate 283), initiated in 1976, the year of his nation's bicentennial. Like the Maos he had painted several years earlier, the tools symbolized a communist nation which the United States traditionally viewed as an adversary. Unlike his paintings of car crashes and other disasters that could happen to virtually anyone, the Maos and the hammers and sickles, which went on view at the Castelli Gallery in January 1977, were calculated to cause a delicious shudder among his patrons, for whom these subjects were emblematic of foreign and unwelcome ways of life. Collectors could hang such images on their walls and believe they had demonstrated bravery and wit in exorcising a troublesome and menacing nemesis of free enterprise.

Warhol was inspired to paint hammers and sickles during a trip to Italy, where he noticed that the symbol of the Soviet Union was among the most typical graffiti on walls. The drawings were so commonplace that they seemed to him almost Pop, having lost their intended meaning through repetition and functioning as decoration instead of political statement. When he returned to New York, he asked Ronnie Cutrone to scout for pictures of the symbol. Cutrone checked out several stores that dealt in communist material, but could not find anything other than the conventional, two-dimensional graphic design—the yellow hammer and sickle that occupy the upper left corner of the red Soviet flag. Stylistically, the flag's tools, which are crossed to signify the united interests of industrial and farm workers, are as flat and emblematic as any Pop icon. But Warhol wanted something different, and he suggested that Cutrone look around for some three-dimensional pictures of hammers and sickles. Cutrone ended up going to the nearby Astro Hardware Center and purchasing a double-headed hammer (more precisely, a mallet) and a sickle, prominently labeled "Champion No. 15/by True Temper." Back at the Factory, he arranged the tools in various compositions and photographed them. In some pictures, the mallet stands upright on its head, while the sickle is propped against a wall. In other pictures, the tools overlap, but not in the X-like shape of the Soviet emblem. Warhol went through Cutrone's

284. *Still Life (Hammer and Sickle).* 1976. Pencil and watercolor on paper, 41¼ x 28⅜". Courtesy Leo Castelli Gallery, New York

photographs and chose the ones he wanted to use as the basis for paintings and drawings.

The hammer-and-sickle paintings are noteworthy in Warhol's repertoire for their harsh, uningratiating color and their dynamic compositions. Several of the paintings are predominantly red and white (the familiar Campbell's Soup color scheme). Displaying a more expressionistic use of paint, he applied the background colors with broad swipes of pigment. Often, the shadows cast by the tools have a presence and prominence that rival the solidity and mass of the objects themselves. One of the best paintings is a large (120 × 160″) close-up of bright red tools, which cast two sets of brilliant orange shadows on a white background. In another, red tools cast black shadows against an orange background.

In a related series of drawings based on the same set of photographs (plate 284), the hammers and sickles are rendered in black pencil and a bright red wash. Warhol's panache is most evident in his treatment of shadows, which are outlined and loosely filled in with swaggering zigzags, suggesting three-dimensional volume while also existing as agitated surface pattern. Because of the absence of other scale indicators, the juncture of horizontal and vertical planes (the floor and wall) suggests a horizon line, making the sweeping curve of the sickle resemble the shape of an Alexander Calder stabile casting long shadows on the landscape. Dramatic shadows—schematically represented in his drawings by slashing strokes—played a major role in Warhol's compositions throughout the 1970s and even became the subject for a large series of paintings.

Some critics, diving deeply for meaning, interpreted the apparent disarray of Warhol's hammers and sickles as an ironic comment upon the Soviet economy. Others thought he was attempting to trivialize a potent symbol by turning it into an element of decoration. But such specific intentions would have been uncharacteristic of him. It is more likely that, once again, he was primarily choosing an already famous subject, loaded with referential overtones.

In the same year of his hammers and sickles, Warhol depicted human heads in their most morbid condition: skulls (see plate 286). Perhaps no more obvious symbol of the transience of life exists than a skull, a traditional subject for memento mori still lifes for several centuries. Death had been among the most persistent of his themes since the *129 Die* painting of 1962, inspiring many of his best pictures, such as the Marilyns, car crashes, and electric chairs.

According to Cutrone, Warhol bought a skull in an antiques shop in Paris. When he returned to New York, he handed the skull to Cutrone and asked him to take some pictures of it. Cutrone shot a number of black-and-white photographs of the skull from various angles, sometimes side-lit to get lengthy shadows. Warhol then went over the contact sheets and selected certain frames for enlargements. These ultimately resulted in a series of paintings, drawings, collages, and prints, with many of the canvases in bright decorator colors that contrast with the usually sobering theme.

Warhol's motivation in painting skulls is not clear. He made the cryptic comment to one interviewer that he was doing "hammers and sickles for communism and skulls for fascism."[2] But his attitude toward these loaded symbols remained as opaque as his reasons for painting Campbell's Soup. Cutrone speculated that Andy might have been thinking of "classical" memento mori paintings, but it is difficult to imagine the artist scrutinizing somber still lifes of skulls by painters such as Cézanne and Picasso and receiving a flash of inspiration that made him want to continue this tradition.[3] Warhol did look carefully at Jasper Johns's *Arrive/Depart* painting of 1963–64, however: Johns had borrowed from him the silkscreen label "Glass —Handle with Care" and incorporated a single impression of it in his picture—along with an image of a human skull. If Johns had painted a skull as a *vanitas* symbol, that would have sufficed to make it a "classical" subject for Warhol.

Curiously, Warhol chose to depict skulls at a time when he was actively pursuing portrait commissions and ostensibly enjoying the materialistic and sybaritic pleasures of life. His friends, however, knew that he was acutely aware of the happenstance nature of sudden death. In the years that followed his shooting, Warhol occasionally expressed the wish that he had died at that time, partly because he "could have gotten the whole thing over with." Life was sometimes more of an ordeal that he ever imagined; the physical pain from his wounds persisted, and he sometimes wanted to simply vanish into thin air. In November 1978, while lunching in a

285. *Torso.* 1977. Acrylic and silkscreen ink on canvas, 50 x 38″. The Estate of Andy Warhol

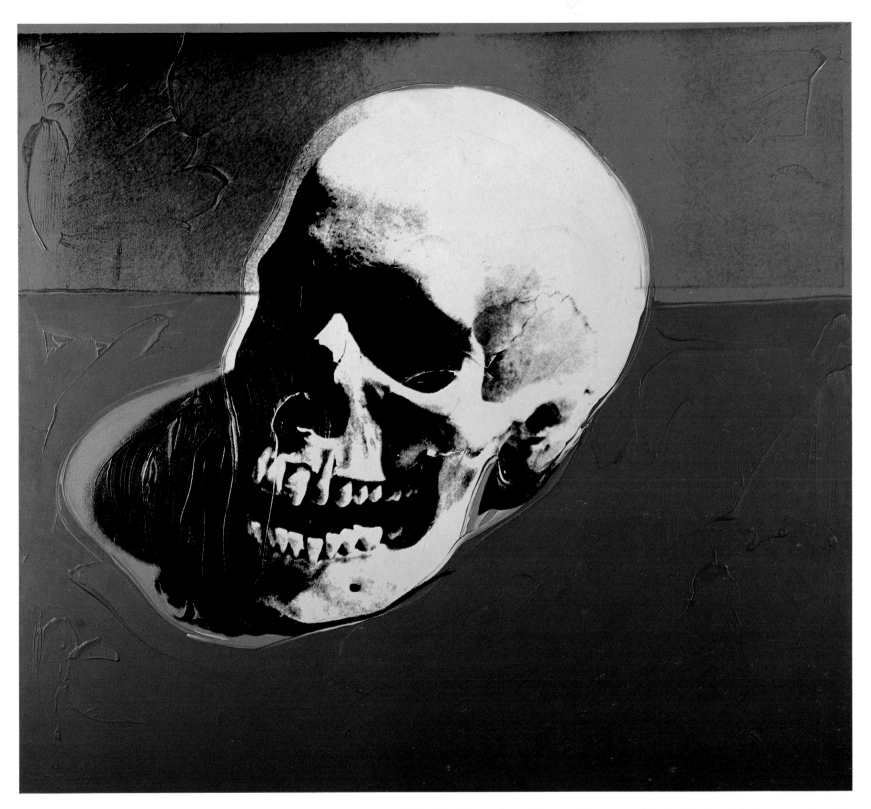

286. *Skull.* 1976. Acrylic and silkscreen ink on canvas, 10 x 11′. Collection Dia Art Foundation, New York

French restaurant with Truman Capote, Warhol would remark out of the blue, "I don't want to live forever, do you?" When one of his associates told him to think of all the things he would miss if he died, the artist responded, "No, you don't miss anything."[4]

While he was still alive, he never missed an opportunity to solicit commissions. If clients didn't want a portrait of themselves or a generic, "Brand X" image of a human skull, Andy tried to talk them into paintings of their companion animals. He painted his own dachsunds, of course, as well as the stuffed Great Dane that stood like a sentinel near the Factory's front door. In the spring of 1976, he had an exhibition of "Animals" at Arno Schefler in New York, followed by a summer show of "Cats and Dogs" at the Mayor Gallery in London. His paintings of cats, though far less whimsical than the creatures in 25 Cats Name[d] Sam and One Blue Pussy, are particularly appealing.

During the summer of 1976, the artist's last film, Andy Warhol's Bad, went into production in the borough of Queens. Its screenplay was by Pat Hackett and George Abagnalo, also employed at the Factory, and its tyro director was Jed Johnson, who previously had helped to edit all the Warhol/Morrissey movies since Lonesome Cowboys. (Morrissey, having amicably split with Warhol, was out in Hollywood, trying to get work as an independent director.) Bad, a union production, cost more than one million dollars, and while most of the money was advanced by others, Warhol and Hughes had to put up substantial collateral.

The most illustrious performer in the film was its star, Carroll Baker. She had not appeared in an American film since Harlow in 1965; afterward, she made many movies in Europe and was regarded as a sex symbol in Italy. Ironically, her career intersected Warhol's cinematic work at key points: her impersonation of Jean Harlow had helped inspire his first sound movie, Harlot, and now her first American film in more than a decade would turn out to be his last. Working with the Factory entourage, however, did not convince the actress that she was back in the mainstream. "You can hardly call making an Andy Warhol movie a 'comeback,'" she noted. "It's more like going to the moon!"[5]

The blond actress, still a beauty at age forty-six, gave a striking, deadpan performance as Mrs. Aiken, a steely and ruthless electrologist ("I can do 650 hairs an hour," she boasts), who works out of her home in Queens. Mrs. Aiken is the breadwinner of the family. Her husband, if he isn't at the neighborhood Off-Track Betting parlor, sits around the house all day, reading his racing form, while her senile mother spends her days sitting by the window, chain-smoking as she dies of lung cancer. Mrs. Aiken's son is in prison, and his dim-witted wife and crying baby squander their lives in front of her television set. In addition to destroying hair roots, Mrs. Aiken runs a crime ring made up of nice-looking but amoral young women who fulfill specific requests for odd jobs, such as amputating someone's finger, destroying a place of business, or killing an autistic baby.

Many of Warhol's pals appear in bit parts, including Brigid Polk, whose manic performance always leaves the audience laughing well into the following scene. She plays a vindictive crackpot who hates a male neighbor so much that she decides the "only way to deal with him is to kill his dog." She tells Mrs. Aiken, "You've got to kill a dog and you've got to do it viciously—it can't die ouchless." When the hit women bungle the job, Brigid goes after the man and his pooch herself, and there isn't a trash can on the street that is immune to her rage.

Bad is a determinedly sick, Grand Guignol comedy with something to offend everyone. The film was rated X because of a scene in which a baby—obviously a doll—is hurled out of a high-rise window. Passersby scream—except for one young mother who angrily tells her crying boy, "That's what I'm going to do to you, if you don't shut up." The movie's "revolting" misogyny upset some viewers, including critic John Simon, who noted that the women are "beastly without exception: cold-blooded killers, lethal psychopaths, murderously vindictive neighbors, infanticidal mothers, or, at the very least, surly, crazed crones and near-cretinous slatterns."[6] But Bad displays sardonic contempt for all its characters, and its fitful wittiness and Punklike high spirits ultimately made it a cult movie.

Shortly before Bad opened at theaters in New York and California the following spring, Warhol was still telling reporters, this time in Los Angeles, "We were hoping we could move out to California. We're just holding our breath that [Bad] is successful so we can come out here" and live "near a studio." He also volunteered

the information that he wanted to make a movie about Jackson Pollock, starring Jack Nicholson, who was allegedly considering it.[7]

In 1977, Warhol produced a series of lushly painted portraits of professional sports stars. It was his second attempt to process faces by category, the first having been the black transvestites in *Ladies and Gentlemen*. The sports project was initiated by Richard Weisman, a New York art collector, investor, and friend of athletes. The ten sports stars chosen for the honor of having their faces glamorized for posterity were boxer Muhammad Ali (plate 288), basketball player Kareem Abdul Jabbar, Pelé the soccer star, jockey Willie Shoemaker (plate 287), tennis ace Chris Evert, figure skater Dorothy Hamill, baseball pitcher Tom Seaver, hockey player Rod Gilbert, football's O. J. Simpson, and golfer Jack Nicklaus. Warhol took all the photographs, usually picturing the athletes with gear that represented their sport, such as a ball, tennis racket, or ice skate. He portrayed about half of the athletes in three-quarter profile, facing to their right. He didn't always match the silkscreened faces to the underlying areas of color, which tended to be in bright pastels, with lots of striated finger painting to blend adjoining hues.

Around the same time that Warhol portrayed the faces of famous athletes, he was painting details of anonymous nude torsos. The close-up views mostly focused on the area between the waist and the upper thighs. Pelvises are often thrust out at angles that suggest dance movements or perhaps aerobic or even amorous exercises. Some of these bodies were female (see plate 285), but the majority were male. The primary connection between the Athletes and Torsos series seems to be that all the subjects were in command of toned muscles and superior physical coordination.

Many of the Torso pictures feature expressionistically applied pigment and finger-painted striations around the edges of the figures. Warhol sometimes repeated the same image with variously colored grounds to form diptychs and triptychs. One five-part painting offers a rear view of a male nude from his upper thighs to the lower back; his legs are spread, his back is arched, and his buttocks muscles are tightened, as if he thrusts his hips forward in an orgasmic-looking gesture. None of the pictures is sexually explicit, but all leave much to the viewer's erotic imagination.

The Torsos extended the artist's long history of documenting the male body's private parts. The series provided some of Warhol's associates with a pretext for picking up attractive young men, who were talked into shedding their clothes so that they might further the cause of art. Appointments were made, the models showed up at the Factory, and Andy the voyeur snapped plenty of Polaroids documenting their torsos, genitals, and buttocks from various angles. He also photographed some of the subjects doing gymnastic headstands, which resulted in upside-down images of the backside.

According to Cutrone, there were "hundreds of photo sessions," which provided "hundreds and hundreds and hundreds of photographs." Cutrone thought it was another example of Warhol's approach to a "classical theme," although he allowed that "the ones that actually got done were mostly cocks and asses and things." To Cutrone, it was a way of "cutting-up the body and getting nice shapes and shadows again."[8] Warhol himself liked to refer to the Torsos as "landscapes."

Some of the models were a great deal more cooperative than others, resulting in a series of erotic pictures, including the portfolio of six silkscreen prints *Sex Parts* of 1978. In some of these very explicit works, based on Warhol's own photographs, one man's hand is shown manipulating the tumescent penis of another man. In other pictures in the series, one man's erect penis is poised as if to penetrate the other man. The screenprints combine elements of the artist's drawing with the photographic image, but they remain a little too raw to rise above coarse erotica. The pencil drawings, however, although based on the same photographic images, display a spare elegance.

A lot of Warhol's erotic energies were getting recharged at this time in a new club that had recently opened in a former CBS studio on West 54th Street. Characterized as the "Oz of discos," Studio 54 surpassed all its competition to become the hottest place in town, famous internationally for its aura of far-outness. The flashy clientele included many rich and trendy Europeans and South Americans, who descended in force on the city, looking for a good time. One of the club's owners, Steve Rubell, made sure that Warhol was on the invitation list for opening night—and the artist immediately became one of Studio 54's most frequent and visible patrons, often bringing

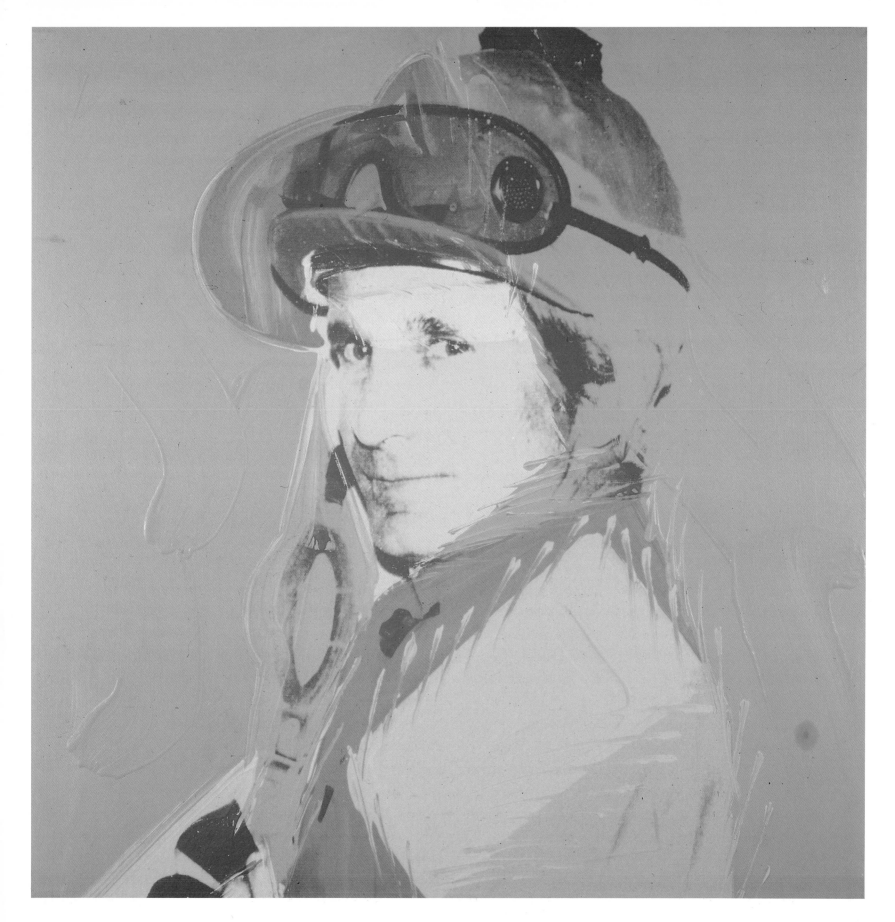

287. *Willie Shoemaker.* 1977. Acrylic and silkscreen ink on canvas, 40 x 40″. Collection Richard Weisman, New York

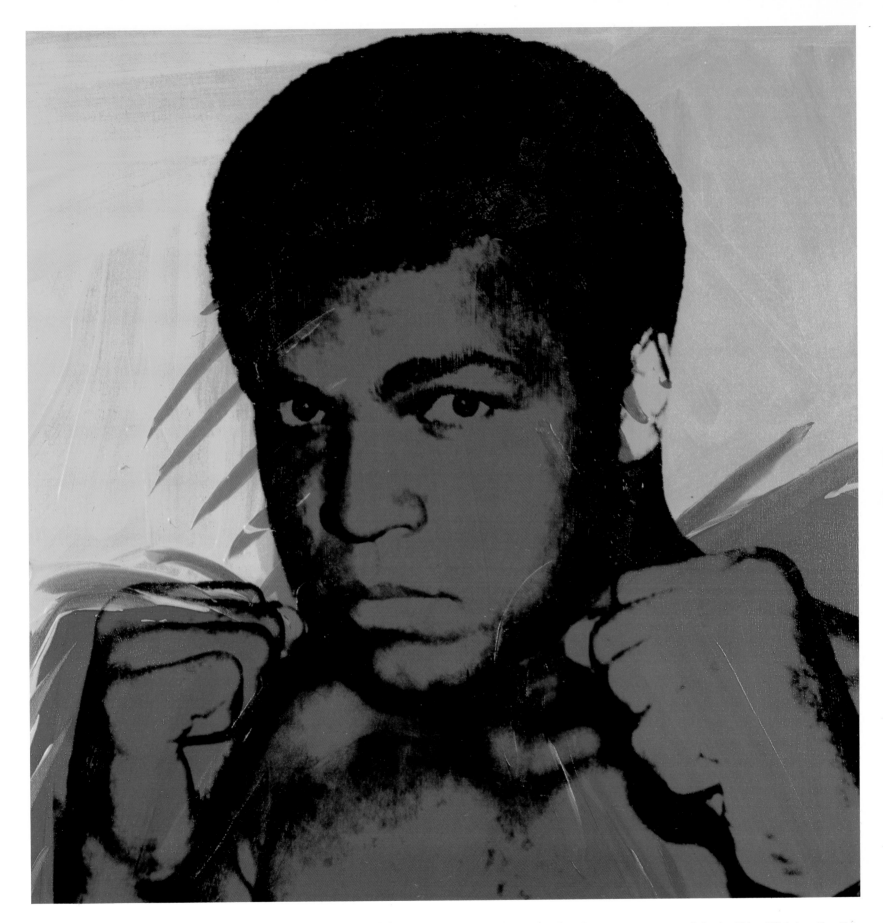

288. *Muhammad Ali.* 1977. Acrylic and silkscreen ink on canvas, 40 x 40″. Collection Richard Weisman, New York

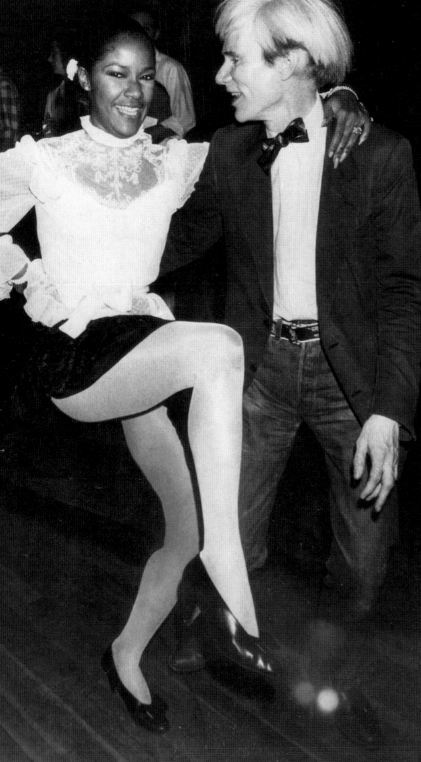

289. Warhol takes to the dance floor at a New York disco with Kim Smith, a college student from Los Angeles, in 1981. AP Laserphoto

other celebrities to the club, thereby contributing to its spiraling status. While throngs of unlucky people remained on the sidewalk, pleading with the doormen for admittance, Andy and his cohorts hobnobbed with the "in" crowd, which included Bianca Jagger, Truman Capote, Liza Minnelli, and Halston.

Andy's association with Studio 54 might have had its counterpart in Toulouse-Lautrec and the Moulin Rouge, except that it resulted in no great art. He took a lot of Polaroid snapshots of famous and pretty faces, but they didn't add up to much artistically. Like everyone else, he was distracted by the outrageous antics all around him. The handsome young waiters (many of them aspiring dancers) sometimes wore only silk basketball shorts, and on at least one occasion—probably a New Year's Eve—only diapers. The scent of marijuana lingered in the balcony, where couples groped in sexual horseplay. Studio 54's very special customers were given access to an exclusive, if somewhat grubby, precinct—a private, carefully guarded, fenced-in basement room next to the boiler, where, according to one observer, "the chic crowd enjoyed New York's most outrageous delights."[9]

Warhol celebrated his fiftieth birthday at a Studio 54 bash. Rubell, knowing how much Andy loved cash, filled up a trash can with eight hundred crumpled dollar bills and dumped them over his head as everyone sang "Happy Birthday." Andy crawled on the floor in his scramble to recover the bills and to stuff them back in the can, which he subsequently deposited as an artifact at the Factory. Six months later, Rubell's picture appeared on the cover of *Interview*.

"At Studio 54, you got very special treatment," Warhol said, "and Steve himself was always running around and personally making sure everything was fabulous."[10] Unfortunately, the action was a little too fabulous for the Internal Revenue Service, which, in December 1978, sent in more than thirty federal agents to seize Studio 54's books. Rubell and a co-owner were indicted and pleaded guilty to about $2.5 million worth of tax evasion. The investigation also uncovered one of the secrets of the club's huge success—not to mention the loyalty of its glamorous and powerful clientele in the worlds of entertainment, politics, and media. Cash-expense records, which the agents came across, listed names of favored customers alongside the dollar amounts spent for cocaine,

"poppers," and other "party favors." The list showed that on August 6, 1978, the disco spent eight hundred dollars for Warhol's birthday party, a figure that in this instance represented cold cash rather than cocaine.

After the existence of the Studio 54 "gift list" was revealed, Warhol said, "No wonder people are afraid to go there now. I mean I don't know anything about the drugs. It was such a fun place. Really great."[11]

Warhol enjoyed Studio 54 not because he was attracted to drugs, but because he was smitten with the place's heady combination of celebrities, rich people, and "pretties." Moreover, he had attained a level of fame that made him, despite his peculiar looks, very attractive to previously unattainable young men. Rupert Jasen Smith, who was then doing most of Warhol's silkscreen printing, reported seeing the artist approached at Studio 54 by "two humpy, well-built numbers," men who "just jumped all over Andy," saying, in effect, "I'll do anything for you, possibly."[12]

But Warhol was not about to bring a stranger—however sexy—home, because he lived in fear of being physically and/or emotionally hurt, whether maliciously or unintentionally. Moreover, he was extremely apprehensive about theft. He had so many artworks and decorative objects stashed away in his house that it was virtually impossible to keep an eye on all of them. For this reason, according to Jed Johnson, Warhol kept most of the rooms locked. "He had a routine," Johnson said. "He'd walk through the house every morning before he left, open the door of each room with a key, peer in, then relock it. Then at night when he came home he would unlock each door, turn the light on, peer in, lock up, and go to bed." He slept on a straw mattress cushioned by wads of bills because, as he explained to Johnson, "you only feel as rich as the money you have in your pocket or under your mattress."[13] By this time, Warhol's collections included American Empire furniture, Indian artifacts, a vast array of jewelry and watches from the 1920s through the 1950s, Fiesta ware, and postwar American cookie jars. He most certainly was not the type of collector who enjoyed displaying his treasures to others.

Nevertheless, in September 1977, Warhol lent about seventy-five items to New York's Museum of American Folk Art, of which he was a member of the Board of Trustees. The exhibition, titled "Folk and Funk, Andy Warhol's Folk Art World," had been guest-cocurated by his friend and collector Sandra Brant. The show contained shop signs (including an oculist's rather surrealistic painted-metal storefront display with large eyes staring through a pair of spectacles), weather vanes, whirligigs, cigar-store Indians, and turn-of-the-century tin boxes painted with product designs for brand-name coffee, tea, and cocoa (which he had owned long before he thought of making grocery-carton sculpture). Although the exhibition offered many insights into the range and consistency of his taste, it was not a critical success. Antiques writer Rita Reif reviewed his collections in the *New York Times* and declared that most of his furniture was "anything but distinguished." Finding few "high-style examples of period designs," she noted that his "Shaker rocker stops a mile short of greatness....The folk art in the show and all of Mr. Warhol's furniture are either plain Jane examples of a style or somewhat forlorn-looking studies."[14] Andy's favorite piece in the show was an eighteenth-century, pale blue door and door frame from a late Georgian mansion. "I like the door best," he said. "You can go in and out of it and still go nowhere."[15] The thought had never occurred to him to patch up and repaint the doorway. "I don't believe in restoration," the artist said. "I really don't. I think things should look just as they are."[16] Conservation of his possessions was among the least of his concerns. "Once Andy bought something, he was on to the next thing—his buying was a conquest, not an adoption," Johnson said.[17]

Seeking to conquer new pockets of the art market, Warhol produced two relatively abstract series of paintings in 1978— the Oxidations and the Shadows. One series revealed his Rumpelstiltskin desire to recycle waste into precious metal, the other displayed his devotion to elusive and even ineffable images. The attractive Oxidation paintings (plate 290) with their freely dribbled and "poured" pigment bear deliberate and perverse resemblances to Abstract Expressionism, particularly when they feature looping lines of blotched pigment that appear to have jetted in from all four sides of the canvas as it lay on the floor. The entire series is in a fairly uniform color scheme of greens and browns on coppery and sometimes golden backgrounds. His taste for metallic,

290. *Oxidation Painting.* 1978. Mixed mediums on copper metallic paint on canvas, 78 x 204¼″. Courtesy Thomas Ammann Fine Art, Zurich

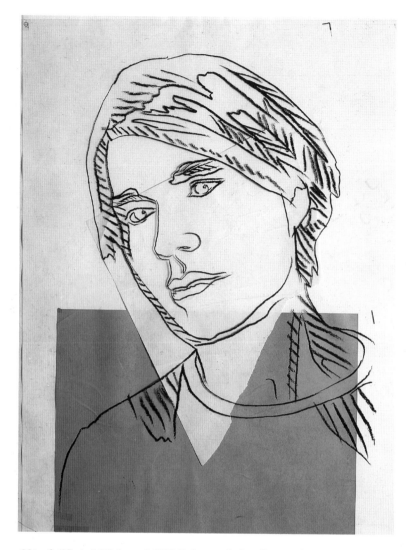

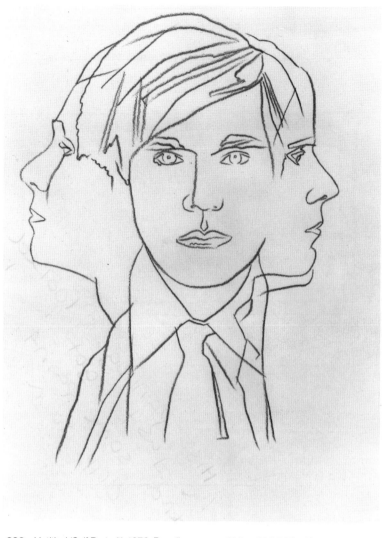

291. *Self-Portrait (Wallpaper).* 1978. Collage and offset film on colored paper, 41½ x 31⅞". Courtesy Thomas Ammann Fine Arts, Zurich

292. *Untitled (Self-Portrait).* 1978. Pencil on paper, 31½ x 23½". The Estate of Andy Warhol

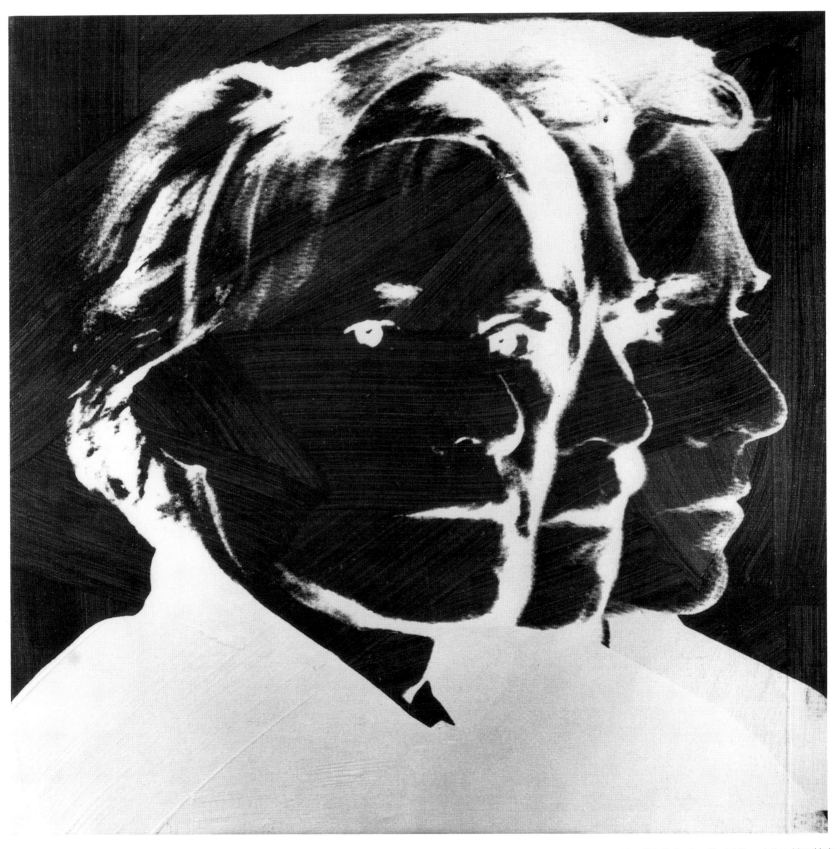

293. *Self-Portrait.* 1978. Acrylic and silkscreen ink on canvas, 40 x 40″. Collection Dia Art Foundation, New York

295

296

glittery surfaces was not at all new, of course, as evidenced by the silver Elvises and gold Marilyn of the 1960s and the Gold Book and Golden Slipper drawings of the 1950s.

What was new in the Oxidation series was the medium—urine. For five or six months, Warhol and Cutrone, occasionally abetted by guests at Factory luncheons, became "living paint brushes." The canvases were spread out on the floor and coated with copper paint, and while the copper paint was still damp, Warhol and his assistants urinated on the canvases. The uric acid and copper sulphate combined to produce the green patina. The oxidation process reportedly continued for the first few years after the paintings were made, but, by November 1986, when many of the paintings were exhibited at the Gagosian Gallery in New York, the coloration was thought to be stable. (The gallery displayed admirable tact in describing the pictures as "mixed media on copper metallic paint on canvas.") It is safe to assume that the artist had only the slightest interest in the chemical process, and was, in fact, far more interested in the alchemical implications, converting bodily fluids into something aesthetic and valuable.

The pictures vary greatly in quality, ranging from opulent, shimmering works evocative of misty Chinese landscapes to obvious parodies of Pollock-type "drip" painting. Some of the least successful are in the artist's modular formats—a triptych and a twelve-part (three-by-four) grid, with a puddled green shape occupying the center of each panel. Among the best paintings in the series are single canvases in exceptionally wide formats, each about seventeen feet wide. Their more intricate spatial complexity is due in part to irregular sets of vertical barlike shapes that provide an

294. Furniture from the Federal period, including a pair of carved and gilded recamiers, adorns the Classical parlor in Warhol's East Side town house, which also contains an early twentieth-century armchair in the Egyptian style.

295. A corner of Warhol's sitting room demonstrates the artist's penchant for Art Deco furniture as well as contemporary art: a Jacques-Emile Ruhlmann chiffonier and two brown velvet armchairs; a cabinet by Pierre Legrain; apricot colored lacquered armchairs and a circular table by Jean Dunand; Roy Lichtenstein's *Laughing Cat*; a Cy Twombly abstraction, and Man Ray's *Peinture Feminine* are but a few of the masterpieces with which Warhol lived.

296. The shelves of Warhol's kitchen hold his massive collection of Fiesta ware, while a small sampling of his cookie jars shares the table with Mickey Mouse and Popeye figures.

297. *Untitled (Boys Kissing)*. 1980. Pencil on paper, 31½ x 23½". Robert Miller Gallery, New York

underlying structure and cadence. The wide canvases also display a greater and richer variety of splatters, splotches, and other marks. One sumptuous gold-flecked canvas even has a radiating star figure in the center.

Shadows (plate 300), produced mainly in December 1978 and January 1979, were as abstract as the Oxidations but even more enigmatic. Shadows particularly appealed to Warhol because they are abstract projections of solid forms. A shadow is perceptibly actual and physical, but at the same time relatively evanescent and insubstantial, with a phantom-like and illusory presence that he found intriguing. Lengthening shadows had been creeping into his work throughout the 1970s.

Warhol based his paintings on Cutrone's photographs of pieces of paperboard arranged to cast shadows. He mopped the canvases with various monochrome ground colors and sent them out to Rupert Jasen Smith for screening. (On December 19, Smith and five assistants printed forty-one Shadows.)[18] The entire series was shown at Heiner Friedrich's gallery in New York's SoHo district from late January to early March 1979. The paintings were hung side-by-side in the gallery to create a wraparound installation (plate 299), with sixty-seven of the paintings in the main gallery and sixteen more in the back room.

Some viewers read into the grainy and ambiguous image an inexplicable play of light in the corner of a room. Others saw a flickering candle flame in the lower left corner. The canvases reminded many viewers of Monet's serial views of Rouen Cathedral, in which architectural forms are dematerialized by progressively lengthening shadows. The repeated image tantalized gallerygoers who looked in vain for something emblematic of contemporary American culture. Nearly everyone agreed that the Shadows retained their stubborn air of impenetrable mystery.

Throughout the 1970s, Warhol continued to produce portfolios of screenprints. In addition to his images of hammers and sickles, skulls, and Sex Parts, he turned out an edition of *Gems* (1978), a set of four pictures, all close-ups of chunky faceted jewels in bright colors (plate 301), reflecting his growing interest in precious stones. He also made a six-screenprint portfolio of *Grapes* (1979), showing clusters of the fruit superimposed on irregular patches of brilliant

298. *Orchid (Yellow)*. 1979. Acrylic and silkscreen ink on canvas, 40 x 40″. Collection Dr. and Mrs. Carlo F. Bilotti, New York

299. *Shadows,* several of the 102 canvases installed at Heiner Friedrich, Inc., 393 West Broadway, New York, January 7–March 10, 1979. Collection Dia Art Foundation, New York. Courtesy the Menil Collection, Houston

300. *Shadows.* 1979. Acrylic and silkscreen ink on canvas, 76 x 52″. Collection Dia Art Foundation, New York. Courtesy the Menil Collection, Houston

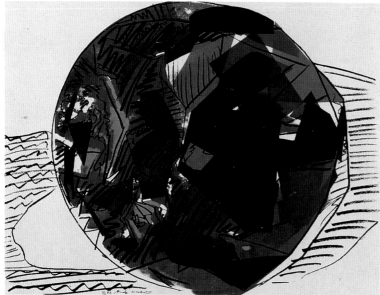

301. *Gems.* 1978. Two screenprints from the portfolio of four (edition of 20), each 30 x 40″. Courtesy Ronald Feldman Fine Arts, Inc., New York

color. In 1977, Warhol made three editions of screenprint portraits of President Jimmy Carter. He was one of five American artists paid ten thousand dollars to create an artwork for a portfolio of "Inaugural Impressions" to be sold for the benefit of the Inaugural Committee. Andy had been unable to attend President Carter's inauguration—he was off in Iran, attending to portrait business with the Shah and the Shabanou—but that June, the artist visited the White House for the opening of the "Inaugural Impressions" exhibition.

In 1979, Warhol published *Andy Warhol's Exposures* with more than 375 of his photographs of personalities from the worlds of film, fashion, rock, sports, and politics. *Exposures* featured such intimate views as Truman Capote at the plastic surgeon's office and Liza Minnelli stepping out of the shower; Bianca Jagger was captured for posterity shaving her armpit. The snapshots were accompanied by Warhol's gossipy text, relating dramatic moments in Western culture, such as the time Rudolf Nureyev, not wanting to be photographed, ripped up Andy's Polaroids and threw them in his face; when the artist tried to pick up the pieces, the dancer stepped on his hand. (Andy found the confrontation "exciting.") The regular book sold for $19.95; an autographed silver edition went for $100; and a gold edition of one thousand copies with gilt-edged pages, a twenty-two-karat cover imprint, and signature was available for $500.

Warhol's role as "court painter" to the international jet set was confirmed by the Whitney Museum of American Art, which mounted an exhibition, "Andy Warhol: Portraits of the 70s," in November 1979. Andy's longtime friend David Whitney (who was not related to the museum's founding family) masterminded the stylish installation, which contained paired portraits, arranged in checkerboard fashion in three parallel rows. Altogether, there were two portraits each of fifty-six subjects from the worlds of art, business, politics, entertainment, and fashion. The faces on view included those of Truman Capote, Diane von Furstenberg, Henry Geldzahler, Halston, Roy Lichtenstein, Golda Meir, Liza Minnelli, Yves Saint Laurent, Giovanni and Marella Agnelli, Mick Jagger, Michael Heizer, Leo Castelli, David Hockney, and Hélène Rochas. A separate area contained three portraits of Mao, each larger than fourteen by eleven feet, and eight portraits of the artist's mother.

Robert Rosenblum, professor of fine arts at New York University, wrote the catalogue essay, in which he declared that Warhol was "resurrecting from near extinction" the "visual crackle, glitter, and chic" of traditional grand-style portraiture. He noted admiringly that Warhol had become "a celebrity among celebrities" and attributed the artist's success to his fusion of "the commonplace facts of photography" with "the artful fictions of a painter's retouchings," calling it a "suitable formula for the recording of those wealthy and glamorous people whose faces seem perpetually illuminated by the afterimage of a flashbulb." In Rosenblum's view, Warhol's portraits added up to "a Human Comedy for our time."[19]

But critics with an egalitarian ax to grind were not amused by Warhol's portraits of the rich and famous. In fact, the show generated a surprising amount of hostility, much of it focused on the artist's "decorator colors" and his relentless pandering to the cultural pretensions of his sitters. Even sympathetic critics, such as Peter Schjeldahl, were made uneasy by Warhol's "passionate avarice, fame-love, and workaholism."[20]

Andy, of course, was not fazed by his detractors. He remained secure in the knowledge that he had omitted his clients' blemishes and given them the portraits by which many of them would be remembered.

NOTES

1. Suzie Frankfurt, "A Friendship," *The Andy Warhol Collection/Jewelry and Watches,* catalogue to the Sotheby's (New York) sale, April 27, 1988, n.p.
2. Glenn O'Brien, "Andy Warhol: Interview," *High Times,* August 1977, p. 22.
3. Interview with Ronnie Cutrone, February 4, 1988.
4. "Truman Capote, interviewed by Andy Warhol and Bob Colacello," *Interview,* January 1978, p. 31.
5. Clarke Taylor, "Movies: Andy Warhol in Mainstream with 'Bad'," *Los Angeles Times,* August 1, 1976.
6. John Simon, "Movies," *New York,* May 23, 1977, p. 85.
7. Barbara Isenberg, "Andy Warhol Busy Being…Andy Warhol," *Los Angeles Times,* February 24, 1977.
8. Patrick S. Smith, *Andy Warhol's Art and Films* (Ann Arbor, Mich.: UMI Research Press, 1986, 1981), p. 281.
9. Henry Post, "The Rise and Fall of Studio 54," *New York,* November 12, 1978, pp. 46–50.
10. Andy Warhol and Pat Hackett, *Andy Warhol's Party Book* (New York: Crown Publishers, 1987), p. 34.
11. Post, "Studio 54," pp. 46–50.
12. Smith, *Warhol's Art and Films,* p. 474.
13. Steven M. L. Aronson, "Possession Obsession," *House & Garden,* December 1987, p. 194.
14. Rita Reif, "Warhol the Collector: A Taste for the Commonplace," *The New York Times,* September 22, 1977.
15. Judy Klemesrud, "A Party for Warhol's 'Folk and Funk,'" *The New York Times,* September 20, 1977.
16. Reif, "Warhol the Collector."
17. Aronson, "Possession Obsession," p. 196.
18. Smith, *Warhol's Art and Films,* p. 472.
19. Robert Rosenblum, "Andy Warhol: Court Painter to the 70s," essay in *Andy Warhol: Portraits of the 70s,* edited by David Whitney (New York: Random House in association with the Whitney Museum of American Art, 1979), pp. 9, 14, 15, 18.
20. Peter Schjeldahl, "Warhol and Class Content," *Art in America,* May 1980, p. 117.

Interviewer:

Is there any question that you...?

Warhol: **No.**

Interviewer:

...have not been asked...?

Warhol: **No.**

Interviewer:

...that you think is important?

Warhol: **No.**[1]

302. *Four Multicolored Marilyns (Reversal Series),* 1979/86. Acrylic and silkscreen ink on canvas, 36¼ x 27¾". Private Collection

Throughout the 1970s, most of Warhol's public continued to straitjacket him as an artist of the 1960s who had outlived his period of aesthetic importance. He, too, tended to view the 1970s as a relatively uneventful and lusterless decade, but he had never let up in his efforts to reelectrify viewers with one more jolt, whether it be a portrait of Mao Zedong or a urine-stained canvas. As the 1980s approached, he took a retrospective look at his own career and reshuffled some of his most famous Pop images in order to come up with a couple of new series of surprisingly good and fresh-looking paintings. While concentrating on his art, he also took advantage of his reputation as the "pope" of Pop to write a gossipy memoir of the 1960s. Warhol even augmented his fame by continuing to level aesthetic hierarchies: he went to Hollywood to play himself in a cameo role on the popular television show *The Love Boat*, and he went to Milan to show his updated versions of Leonardo da Vinci's *Last Supper*.

Warhol's next two series of paintings, the Reversals and the Retrospectives, both initiated in 1979, brought his Pop career full circle by enabling him to reuse all his "trademarked" motifs in novel contexts. His Reversals recapitulate his portraits of famous faces—from Marilyn and the Mona Lisa to Mao and the wallpaper cow—but with the tonal values reversed. As if the spectator were looking at photographic negatives, highlighted faces have gone dark while former shadows now rush forward in electric hues. Sometimes this results in extravagantly melodramatic images. The reversed Marilyns, especially, have a lurid, otherworldly glow, as if illuminated by infernal footlights (plate 302).

While the Reversals repeat a single image in rows, Warhol scattered several different subjects across the surfaces of his Retrospectives (plate 304). These paintings offer a sort of souvenir assortment of Warholian themes, from soup cans and corn flakes cartons to Marilyn and Mao, with violent car crashes and electric chairs juxtaposed with bucolic flowers and cows. The casually arrayed images are sometimes overlapped or screened in reverse. The meaning or significance of these pictures is greatly enhanced by the viewer's awareness that all the images exemplify famous milestones in the artist's career.

In summarizing his most familiar motifs, Warhol once again

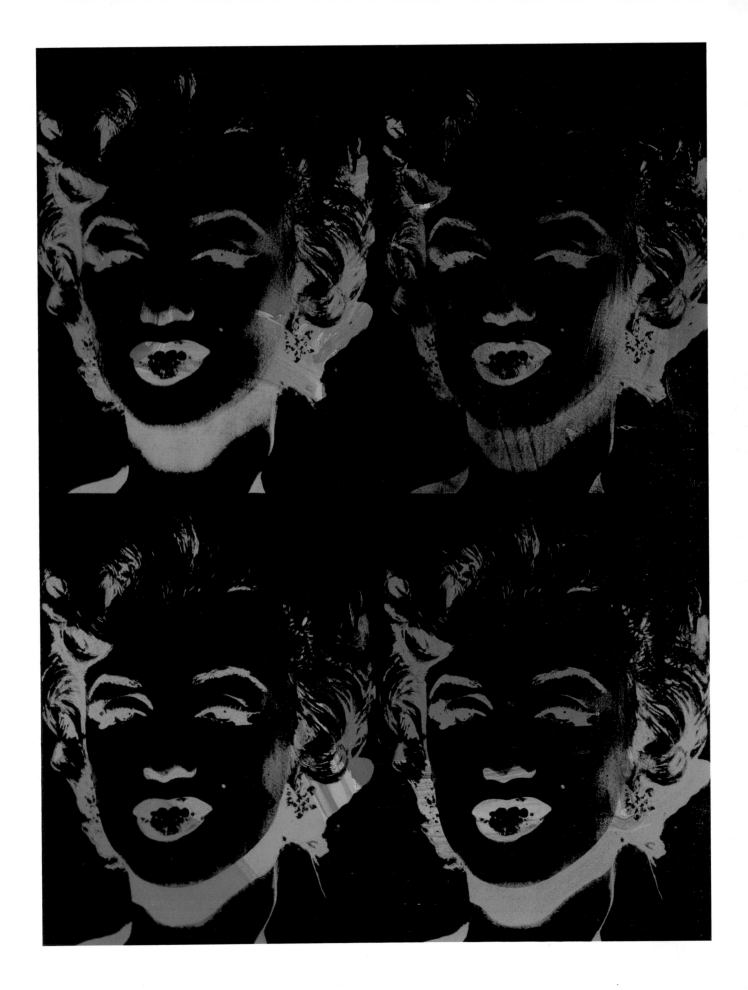

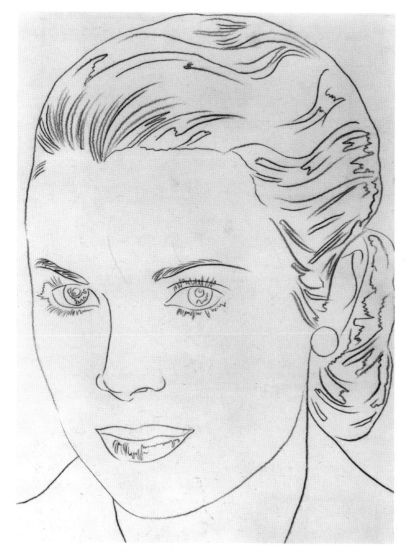

303. *Grace Kelly.* 1984. Pencil on paper, 31 1/2 x 23 1/2". Courtesy Robert Miller Gallery, New York

took a cue from Jasper Johns, who continually reused familiar themes—the American flag, the light bulb, and so on—to generate new compositions. Very likely, Warhol also had in mind Marcel Duchamp's *La Boîte en Valise*, that artist's limited-edition "portable museum," which surveyed all his most important artworks in the form of miniature replicas, photographs, and reproductions. (Warhol owned two copies of *La Boîte en Valise*, one from the 1941 first edition and another from a late 1950s edition.)

By ransacking his own past to produce the Reversals and Retrospectives, Warhol revealed himself to be one of the shrewdest of the new wave of post-modernists. While modernism had been an ideal that survived throughout most of the 1960s, continuing its self-conscious search for new forms of expression, post-modernism, which gained currency in the "pluralist" 1970s, reflected an ironic attitude toward all aesthetic camps and displayed an indifference to traditional hierarchies of "high" and "low" art. With his Retrospectives, Warhol clearly shunned modernism's consistency and continuity, preferring instead to make a pastiche of his former subjects, which he now arbitrarily juxtaposed as if to contradict their earlier significance.

Warhol's post-modernist attitude is particularly discernible in his paintings and prints of shoes and dollar signs. Instead of isolating a single shoe against a plain ground as he had done in the 1950s, Warhol jumbled several kinds of ladies' shoes in exuberantly disordered compositions that he arranged, photographed, and had silkscreened in 1980 (plate 305). Selecting only one shoe of each type, he carefully positioned them to show some in profile and some from above, all choreographed to convey a sense of clutter. Like his earlier Golden Slippers, the later shoe pictures display Warhol's persistent attraction to glittery surfaces: these literally shimmer, because they were sprinkled with diamond dust—a powdery by-product in the manufacture of industrial diamonds. Starting in 1979, Warhol added a layer of diamond dust to many of his paintings and prints.

With his series of Dollar Sign paintings and prints, created in 1981, Warhol once again displayed his unflagging interest in money. He had handpainted dollar signs copied from newspaper ads for some of his earliest Pop pictures of television sets, water heaters,

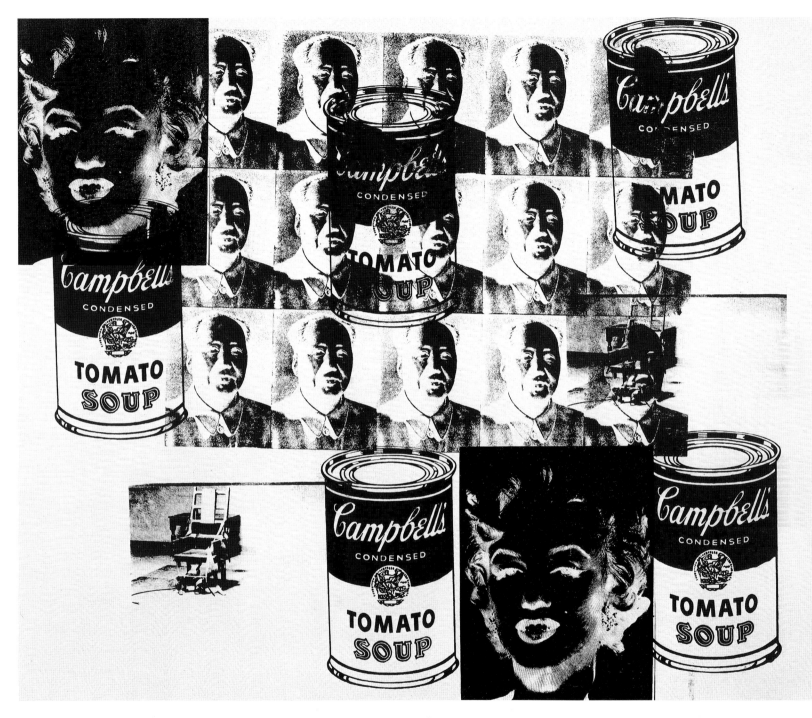

304. *Black-and-White Retrospective.* 1979. Acrylic and silkscreen ink on canvas, 49 x 61″. Courtesy Galerie Bruno Bischofberger, Zurich

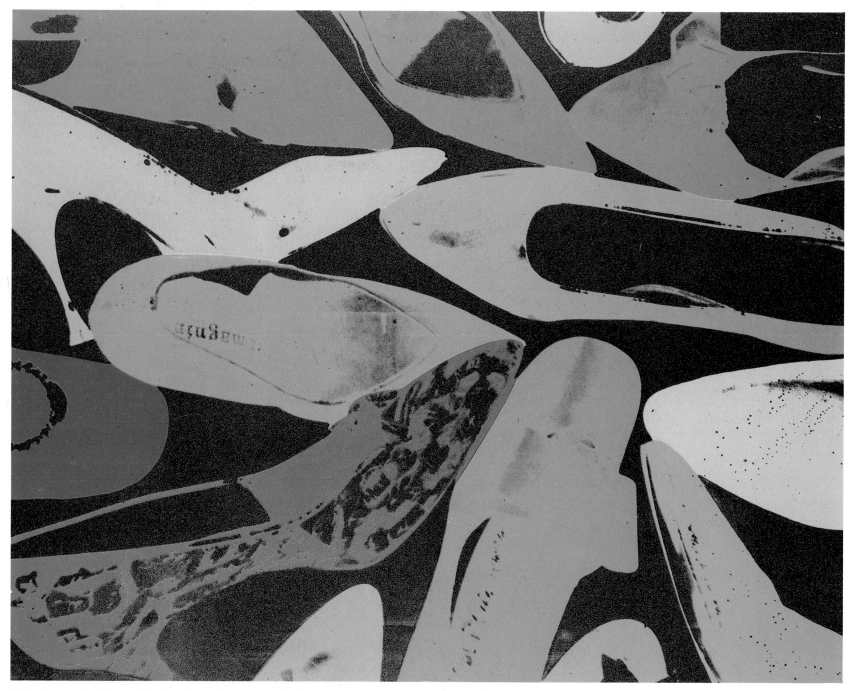

305. *Diamond Dust Shoes.* 1980. Acrylic and silkscreen ink with diamond dust on canvas, 70 x 78″. The Estate of Andy Warhol

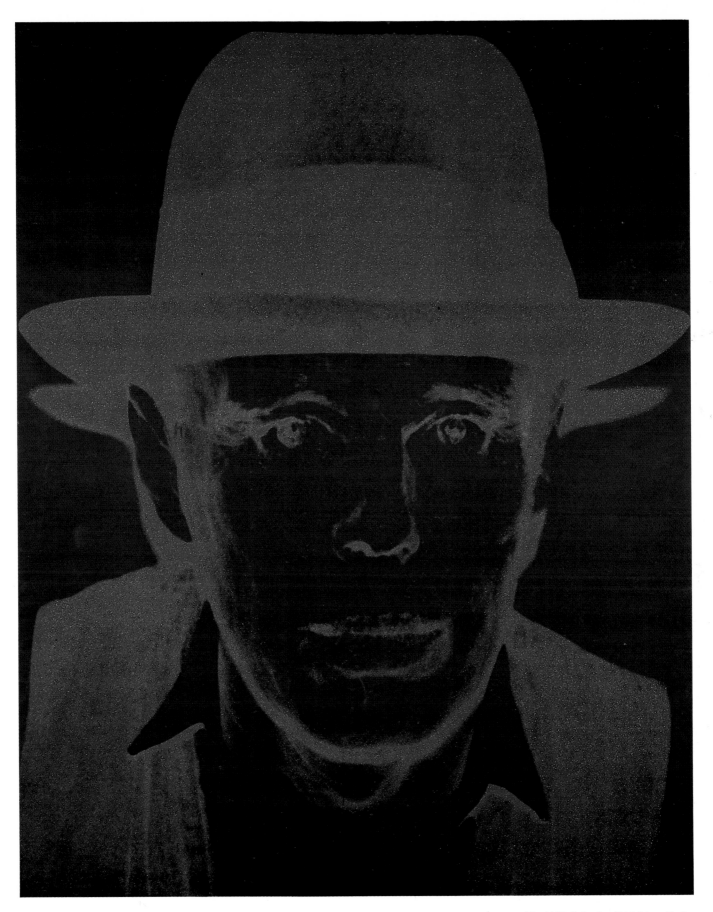

306. *Joseph Beuys.* 1980. Acrylic, silkscreen ink, and diamond dust on canvas, 100 x 100″. Collection Erich Marx, Berlin

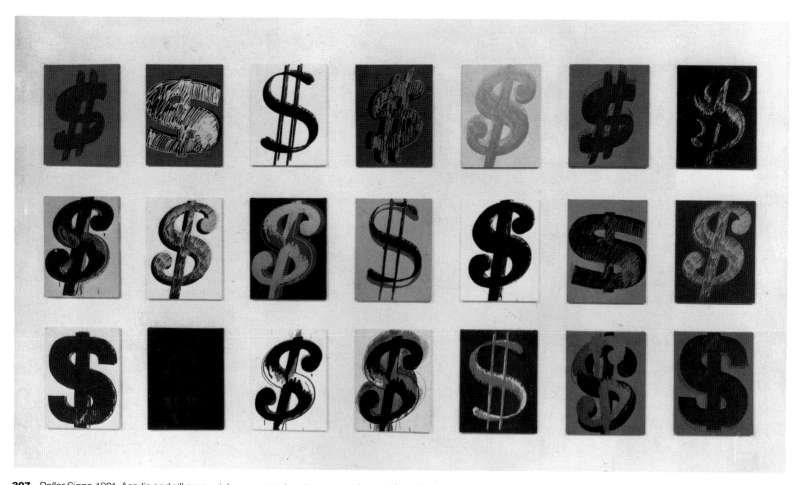

307. *Dollar Signs.* 1981. Acrylic and silkscreen ink on canvas, twenty-one panels, each 20 x 16". Courtesy Leo Castelli Gallery, New York

and storm windows, all with their prices prominently displayed alongside them. The new *Dollar Signs* (plate 307) were silkscreened, but based on his own drawings. He printed them singly on small canvases or casually regimented them in rows on larger canvases. When they were shown at the Castelli Gallery in January 1982, they appeared as prophetic emblems of the huge amounts of money that would pour into the art world during the following years. Warhol's *Dollar Signs* are brazen, perhaps even insolent reminders that pictures by brand-name artists are metaphors for money, a situation that never troubled him. As he declared in his *Philosophy* book, "I like money on the wall. Say you were going to buy a $200,000 painting. I think you should take that money, tie it up, and hang it on the wall. Then when someone visited you, the first thing they would see is the money on the wall."[2]

Warhol's zeal for money prompted him to target a certain sector of the art-collecting public. In 1980, he produced a series of paintings and a portfolio of screenprints entitled *Ten Portraits of Jews of the Twentieth Century.* The ten prints portray actress Sarah Bernhardt, American jurist Louis Brandeis, philosopher Martin Buber, physicist Albert Einstein (plate 308), psychoanalyst Sigmund Freud, composer George Gershwin, novelist Franz Kafka, Hollywood's Marx Brothers, Israeli Prime Minister Golda Meir, and American writer Gertrude Stein. Certainly, it took a lot of nerve on his part to include portraits of Bernhardt and Stein, both of whom had been portrayed on numerous occasions by the leading artists of their eras. Because he was portraying people who were no longer alive, Warhol necessarily had to use preexisting publicity and archival photographs. He subjected those found images to his

customary cropping, his characteristic flourishes of draftsmanship, and his collage-like blocks of color. While his glitzy, highly stylized treatment was appropriate for portraits of socialites and show-business celebrities, its suitability for relatively austere thinkers such as Buber, Freud, and Kafka was perhaps questionable.

Warhol made his selection of famous Jews with the assistance of Ronald Feldman, whose New York gallery initiated many of the artist's print portfolios during the 1980s. To promote the project, Feldman helped organize an exhibition of the paintings from the series at New York's Jewish Museum. The show ran from September 17, 1980, through January 4, 1981, and inspired critic Hilton Kramer to begin his jeremiad in the *New York Times*: "To the many afflictions suffered by the Jewish people in the course of their long history, the new Andy Warhol show at the Jewish Museum cannot be said to make a significant addition. True, the show is vulgar. It reeks of commercialism, and its contribution to art is nil."[3]

In the same year that Warhol created posthumous images of Einstein, who fled Nazi Germany, he made a series of portraits of West Germany's most famous living artist, Joseph Beuys (plate 306). Though Beuys's art is formally and thematically quite different from Warhol's, the two artists were frequently linked by critics who perceived them as possessing an almost alchemical ability to transform ordinary objects into valuable artworks. The two artists were never close friends but they displayed an elaborate and wily respect for each other. They met "officially" in Düsseldorf—in Hans Mayer's gallery—on May 18, 1979. "For those who witnessed the two approaching each other across the polished granite floor," an American writer reported, "the moment had all the ceremonial aura of two rival popes meeting in Avignon."[4] Warhol typically recorded the event in snapshots of Beuys's gauntly poetic face that would soon materialize in a number of striking portraits. In a portfolio of three screenprints, produced in 1980, Warhol presented Beuys in black on black, black on white, and black on red, the latter two printed as negative images and flecked with glittery diamond dust. By reversing the lights and the darks, Warhol conveyed some of the elusive character of the mystifying German artist.

After processing faces of famous Jews and Joseph Beuys, both projects done on assignment, Warhol was ready and willing to

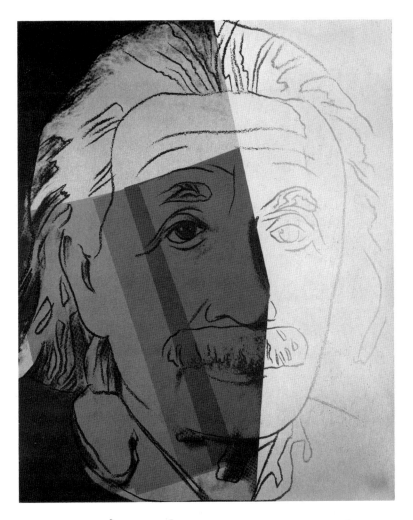

308. *Albert Einstein,* from the portfolio *Ten Portraits of Jews of the Twentieth Century* (edition of 200), 1980. Screenprint, 40 x 32″. Courtesy Ronald Feldman Fine Arts, Inc., New York

produce portraits for just about any special interest audience. In the years to come, he would design screenprints celebrating historic leaders (Alexander the Great, Frederick the Great, Lenin), cultural giants (Goethe, Beethoven), movie stars (Jane Fonda, Ingrid Bergman, Grace Kelly), contemporary female monarchs (Elizabeth II of the United Kingdom, Margrethe II of Denmark, Beatrix of the Netherlands, Ntombi Twala of Swaziland), and a Canadian hockey star (Wayne Gretsky).

In addition to creating stylized portraits of real people, both living and dead, Warhol produced a 1981 portfolio of screenprints showing the faces of ten different archetypal or allegorical figures, mainly derived from movies, cartoons, and radio and television

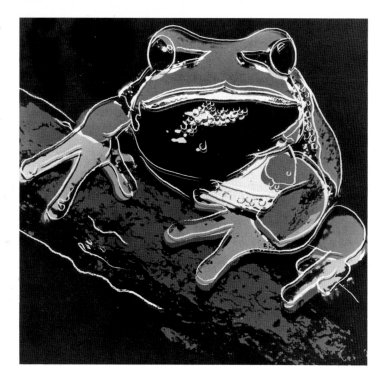

309. *Pine Barrens Tree Frog,* from the portfolio *Endangered Species* (edition of 150), 1983. Screenprint, 38 x 38″. Courtesy Ronald Feldman Fine Arts, Inc., New York

310. *Whooping Crane.* 1986. Screenprint, 14 x 11″, made for the book *Vanishing Animals* by Kurt Benirschke, published by Springer-Verlag

sources. The fictional characters are Santa Claus, Uncle Sam, Superman, Mickey Mouse, The Star (Greta Garbo costumed as Mata Hari), Howdy Doody, Dracula, The Witch (based on Margaret Hamilton's terrifying interpretation of the Wicked Witch of the West in *The Wizard of Oz*), Mammy (inspired by Hattie McDaniel's classic performance as Scarlett O'Hara's domineering slave in *Gone with the Wind*), and the Shadow. (Superman and Dracula, of course, had already appeared in Warhol's pictures in the early 1960s.) When possible, Warhol took the photographs himself, usually hiring costumed models to impersonate the characters.

Warhol himself impersonated the Shadow (plate 312), a fictional character who knew "what evil lurks in the hearts of men" as he went about solving crimes in a popular radio mystery show of the 1930s and 1940s. While not a great self-portrait, it nevertheless presents two sides of Andy's enigmatic character: the mousy voyeur and the wizard who plays tricks with shadows.

A couple of years later, Warhol demonstrated once again that his fervor for faces extended beyond the human race. Having drawn and painted so many cats and dogs over the years, he now turned his attention to more threatened members of the animal kingdom, producing in 1983 a portfolio of ten different *Endangered Species* (plate 309). Warhol based all the images on other photographers' pictures, to which he added his characteristic, deliberately off-register line drawings. He spruced up some of the animals by giving them bright new colors: the gray African elephant became pink, while the black rhino came out blue.

While consolidating his reputation as a versatile portraitist of living, dead, mythic, and animal faces, Warhol also seized the opportunity to establish himself as a cultural historian, publishing *POPism: The Warhol '60s*, his memoir of "the Pop phenomenon in New York." He produced the book in 1980 in collaboration with Pat Hackett, who did most of the writing, basing the text on her interviews with Andy's friends and colleagues. As a result, it was often their recollections rather than Warhol's that ended up in print. Despite the embroidered anecdotes, distortions, and incorrect dates supplied by the interviewees, the book does succeed in illuminating the character of the man and capturing the frenetic excitement of the period.

Warhol's crowded social life compensated for a new void in his private life, caused by Jed Johnson's surprising departure in January 1980. Having lived with Andy for twelve years, Johnson was eager to step out of the artist's shadow and to make a dramatic change in his own life by moving into a West Side apartment by himself. Over the years, Johnson had edited several of the Warhol-Morrissey movies, directed *Bad,* and found and decorated the artist's present town house. He had been a salaried employee throughout that time. Now, having lined up a number of clients whom he initially met through Warhol, Johnson intended to pursue a new career in interior design. Andy interpreted Jed's action as a personal rejection, of course, and felt betrayed, although he reacted in his typically cool and aloof way. After Jed moved out, Andy never once telephoned him but was unable to shut him out of his life entirely because Johnson claimed joint custody of Warhol's two shorthaired dachshunds. Jed kept a key to Andy's house and took Archie and Amos on weekends, when Warhol's maids were off.[5]

Warhol continued to snoop into the love lives of his friends and colleagues, relentlessly interrogating them about their affairs. He wanted to hear about every crush and heartbreak in the greatest detail. According to one of his new friends, Maura Moynihan, a writer-actress-*Interview* cover girl, "he liked to hold hands with boys and sometimes he'd try to kiss one of my male friends in the back of a taxi, but I always felt that he preferred to have his affairs vicariously through the girls he knew."[6] Warhol still nurtured the fantasy that rich girls enjoy the best of all possible worlds because they do not have to work and they supposedly never fail to attract gentlemen callers. If he were going to be reincarnated, he hoped it would as an heiress.

A year after Jed's departure, Warhol met Jon Gould, a twenty-seven-year old executive with Paramount Pictures, where he was a vice-president in charge of marketing and distribution. An extremely personable young man—tall, slim, athletic, with dark eyes and a flashy smile—Gould aspired to become a producer. Andy found him very appealing, not least because of his Paramount connection. Warhol's eyes lit up when he realized Gould might be his ticket to Hollywood.

Warhol campaigned for about a year and a half to get Gould to move in with him, refusing to believe that a twenty-five-years'

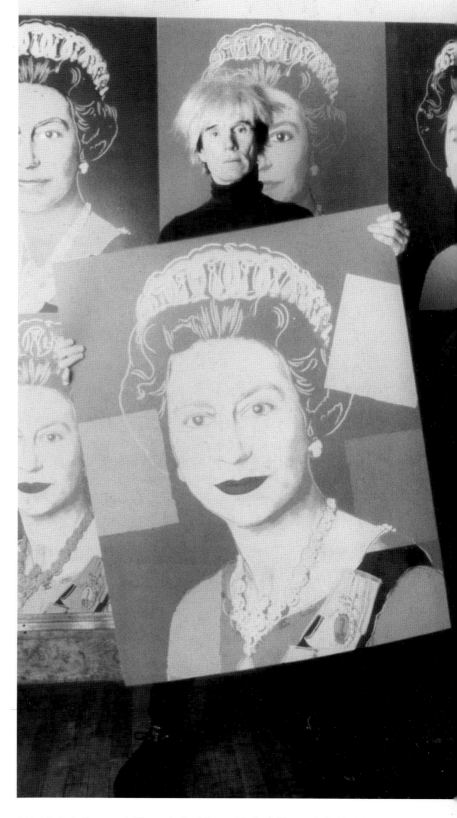

311. Warhol with several of the portraits of Queen Elizabeth II he made for his series of Reigning Queens, 1985. Photograph by Derek Hudson

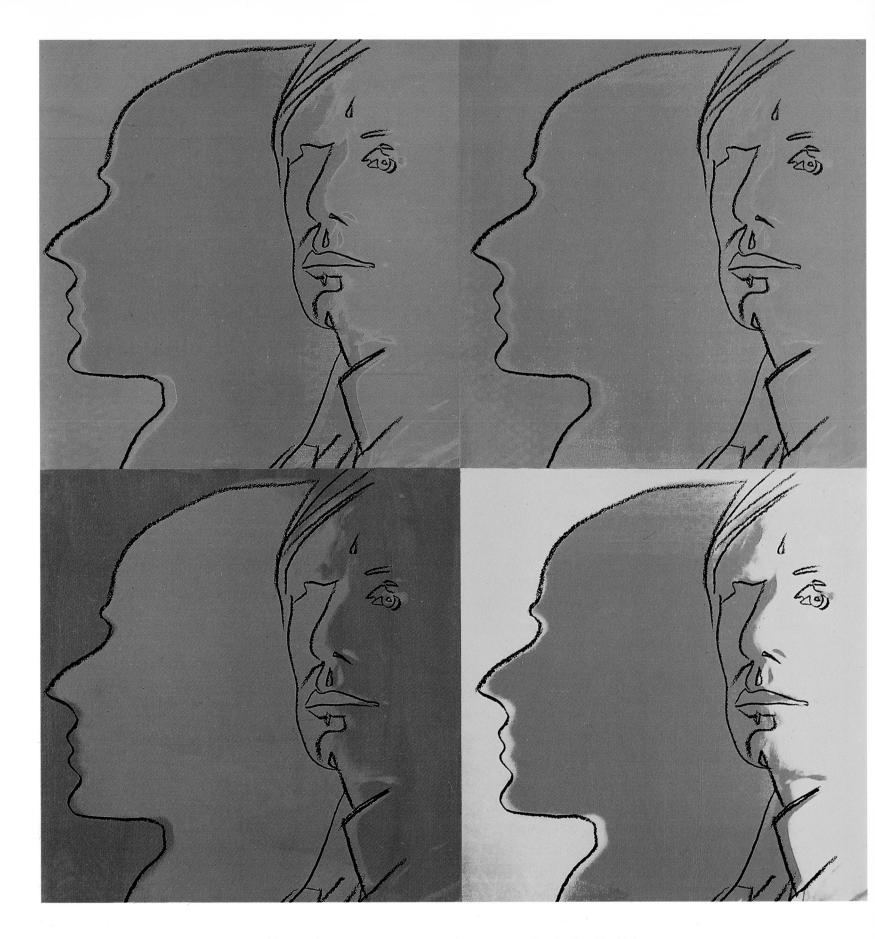

312. *Self-Portrait (With Shadow).* 1981. Acrylic and silkscreen ink on canvas, 60 x 60″. Courtesy Ronald Feldman Fine Arts, Inc., New York

difference in their ages hindered a potential relationship. But Gould
valued his independence (as well as his reputation) and did not want
to be perceived as Andy's "boy date." Nevertheless, the two of
them saw each other frequently and often went out together,
accompanied by their mutual friends photojournalist Christopher
Makos and artist Peter Wise. To celebrate Gould's and Wise's
nearby birthdays in May 1981, Warhol hired a helicopter and treated
the group to an aerial tour of Manhattan. Shortly after Christmas that
year, the foursome made the first of several weeklong ski trips to
Aspen, Colorado.

Makos, who worked as a freelancer for *Interview,* regarded
himself as Warhol's "official" personal photographer and usually
accompanied the artist on all his trips to Europe. In 1982, he, Andy,
and Fred Hughes traveled to Hong Kong as the guests of a rich
industrialist who had commissioned Warhol to paint portraits of
England's Prince Charles and the Princess of Wales for the opening
of a new club, which catered to the international jet set. (It was
Warhol's second visit to that city, the first having occurred during his
1956 trip around the world.) After the festivities in Hong Kong,
Warhol's host offered him and his party a free trip to Beijing. There,
they saw all the classic tourist sites, from the Gate of Heavenly Peace
to the Forbidden City, and even made a day trip to the Great Wall.
But Andy did not want to visit the Mao Zedong Mausoleum in
Tiananmen Square. If any of the Chinese people he met were aware
of his portraits of Mao, no one mentioned them. To the Chinese,
Warhol was just another American tourist.

Back in New York, Warhol finally prevailed on Gould to move
into the guest room that Johnson had so meticulously decorated on
the floor above Andy's bedroom. But Gould did not want to receive
mail at Warhol's address, so almost immediately, Warhol helped the
young man buy a co-operative apartment in the fashionable Hotel
des Artistes at 67th Street and Central Park West. The West Side co-
op served primarily as Gould's official mailing address. With Gould,
Warhol did something he had seldom done before—take vacations.
They went to Palm Beach, Florida, a couple of times, and once
spent a week with Makos and Wise on the island of St. Martin. On
the beach at Montauk, while visiting Halston (who had rented
Warhol's house for the summer), Gould wore a double strand of

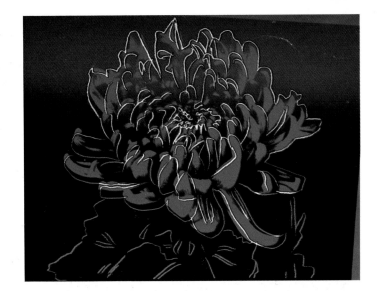

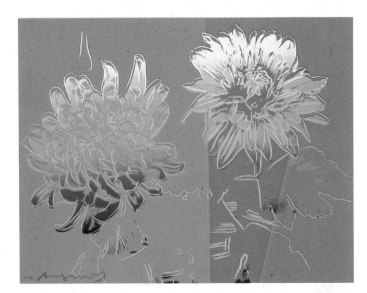

313. *Kiku.* 1983. Portfolio of three screenprints (edition of 300), each 19⅝ x 26″.
Courtesy Ronald Feldman Fine Arts, Inc., New York

314. Sandro Chia beneath two-panel portrait of himself (c. 1983, acrylic and silkscreen ink on canvas, each 40 x 40″). Photograph by Thomas Hoepker, *Stern* magazine

Bulgari pearls—a gift from Andy—swagged over his bare chest.

No one had ever found life with Andy easy, and Gould was no exception. In addition to the artist's eccentricities, Gould had to put up with Jed Johnson's unannounced weekend visits to pick up and return Archie and Amos. It was disconcerting, to say the least, that Andy's former housemate still had keys to the place and could let himself in at will. Moreover, the two dogs never accepted Gould, always barking furiously at his approach. As a result, Gould seldom slept in Andy's bed, claiming that the dogs broke wind in his face.

Through Gould, Warhol developed an interest in the supposed healing powers of crystals, which some so-called New Age people believe have the ability to magnify psychic energy. Andy, who had always been interested in gems, started to make regular visits to a couple of "crystal doctors," who apparently prescribed and sold to him beneficial pieces of quartz. He spent a lot of money on the crystals and regretted that some he wanted were too expensive. A few of his friends attributed his interest to a streak of mysticism, while others thought he was primarily fascinated by quackery. In any case, Warhol actually wore crystals around his neck, carried some in his pocket, and kept others on the bedroom dresser at home. He frequently mentioned his belief in crystal vibrations that somehow energized him. Makos recalled that Andy also wore "this ugly thing around his neck, a plastic mood pendant that he would never let me photograph because I was so cynical and made fun of it all the time. It was a really cheap thing with some kind of gel inside that changed color where you touched it and told you what mood you were in."[7] Warhol was not at all embarrassed about his crystals. When Maura Moynihan asked him about his interest, he said, "I was always jealous of girls because they live longer, and now I know why —crystals. Diamonds really are a girl's best friend."[8]

Warhol and Gould brought along their crystals when they took their annual post-Christmas ski holiday in Aspen, where they shared a rented house with Makos and Wise. "I knew we had reached new heights of oddness," Makos said, "when I came downstairs one cold morning and there was Andy boiling water for his oatmeal—with crystals in the water. I asked him why and he said because the crystals were releasing energy into the water, thus making the oatmeal more energized."[9]

315. *Keith Haring and Juan DuBose.* c. 1983. Acrylic and silkscreen ink on canvas, 40 x 40″. The Estate of Andy Warhol

316. *Portrait of Francesco Clemente.* c. 1985. Acrylic and silkscreen ink on canvas, 40 x 40″. Courtesy Sperone Westwater, New York

By this time, Warhol had already energized a new generation of artists who had grown up believing that prominence in the mass media was a fact of art life. Far from regarding him with suspicion because of his ties to commercial art and his flair for publicity, they perceived him as a role model. No longer would teenagers have to apologize to their parents for wanting to pursue an art career rather than a supposedly more secure future in medicine, engineering, or business administration. Warhol was proof positive that art could be lucrative. In the eyes of many artists who emerged in the late 1970s and early 1980s, Warhol was an almost legendary figure whose oracular statements inspired careful study. Two groups of emerging painters were particularly attracted to him—the "graffiti" artists, who included Keith Haring, Kenny Scharf, and Jean-Michel Basquiat, and the Neo-Expressionists, who included Francesco Clemente, Sandro Chia, and Julian Schnabel. Warhol became friendly with all of the aforementioned artists and eventually exchanged his

portraits of them for examples of their own artworks.

Warhol was particularly intrigued by Basquiat, a rebellious young artist of Haitian and Puerto Rican descent who was born in 1960, the year of Andy's first Pop paintings. Basquiat had first attracted public notice in the late 1970s, when he inscribed graffiti, which he signed "SAMO," throughout New York City's subway stations. He eventually developed contacts with other graffiti artists and began to emerge as a gifted and salable painter around 1981. Basquiat idolized Warhol, and managed to insinuate himself into Andy's personal life through Paige Powell, an athletic, pert, and enterprising young woman from Portland, Oregon, who was director of advertising and promotion at *Interview.*

"We sort of shared the same boyfriend," Powell said later, describing her and Warhol's relationship with Basquiat. Although she was savvy in the ways of magazine promotion, nothing in her white, middle-class, Catholic background had prepared her for

dealing with either artist. She had become Basquiat's girlfriend after organizing a show of his work in her apartment on West 81st Street. "We just hit it off. Andy wanted to trade art with Jean-Michel but was terrified of him. Andy had never done anything social with him. Then, Bruno Bischofberger, the Swiss dealer, had Jean-Michel come to lunch at the office in 1982." Shortly afterward, Powell saw Basquiat lurking outside the Factory, waiting for Warhol to come in. "Already I could tell there were going to be problems because he was too focused on Andy."[10]

Basquiat courted Powell for about six months before she agreed to go out with him. "I had had no experience with drug addicts," she said, "but he really cleaned up his act. He was a very romantic person who made the sweetest little gestures. Once, he showed up with an elaborate ice cream cone with about nine different scoops and he was always bringing me presents back from Europe. The way he did it was really sweet and innocent." Basquiat had his own place on Crosby Street in SoHo, but he started living in Powell's apartment. One day she came home and found the whole place strewn with books and magazine articles on Warhol. "He'd go over each statement and ask me questions about it. He did little drawings of Andy. I figured it out later: I was his link to Andy; I was sort of like the medium."[11]

"Jean-Michel wanted to get as close to Andy as possible," said Powell. "He was bisexual in his earlier years, which I was unaware of." But Warhol's interest in the young man was strictly that of an older mentor who wanted to coach a protégé. The two began exercising together at the Factory and on one occasion, in 1983, Warhol took Basquiat along on a brief business trip to Europe. "All these doors were suddenly open to Jean-Michel," Powell said. "Andy was taking him to Yves Saint Laurent's dinner parties." In New York, Basquiat displayed a tendency to disappear for days at a time, which greatly upset Powell. "But then he would come back to me and we'd get back together. He was all about finding magic and he wanted to be involved with all the glamour, and then he was really overwhelmed by it."[12]

In the fall of 1983, Basquiat moved into a two-story building that Warhol owned on Great Jones. The rent was four thousand dollars a month. "He felt he could afford it," Powell said, "because he was

doing pretty well. But he was nervous about it, too. He had never paid that much for rent before." In any case, he was not always prompt in paying, partly because he was extravagant with money and also because he had developed a $1,000 a week cocaine habit. Andy, who continued to dine out with Basquiat, constantly lectured him to spend less money on trips and clothes and to get off drugs altogether.

Andy's crystal ball failed to alert him that his relationship with Jon Gould was coming apart. Gould's career evidently meant more to him than did Warhol. He made many extended business trips to Los Angeles, often staying for a month at a time. He even found himself a house there so that he could be closer to Paramount's studios. Finally, he was spending more time in California than in New York—and did not give Andy a key to his house. "Andy became very bitter about Jon," Makos said, "because he had thought he could have a professional working relationship with someone working at Paramount Pictures. He had invested so much time, money, and effort into having a relationship again, and it just collapsed in front of his own eyes. I think he became very disenchanted."[13]

Realizing that he had failed once again in his attempt to crash Hollywood, Warhol concentrated with renewed energy on his lucrative careers as painter, portraitist, and magazine publisher. In 1984, he paid $1.2 million for a five-story midtown building, a former Consolidated Edison power plant, and moved all his business enterprises into it—the first time he had owned his Factory space. Its location, ironically, was only a couple of blocks west of the old "duplex" apartment at 242 Lexington Avenue that he had shared with his mother in the 1950s. Though the new Factory's roofline was noticeably lower than those of most of its neighbors (the Empire State Building was only one block to the west), the building was substantially larger than a passerby might suspect; it was T-shaped in plan, with entrances and facades on 32nd and 33rd streets as well as Madison Avenue. The Factory's move from Union Square to 33rd Street took place over a six-month period, with most of the transporting being done on weekends. The eclectic, but often exotic decor (stuffed animals, nineteenth-century busts, antique furniture) and the businesslike manner of the well-groomed staff subtly

317. *Rorschach Test.* 1984. Acrylic on canvas, two panels , each 10 x 8′. Courtesy Leo Castelli Gallery, New York

announced that the odd, eccentric-looking quarters were those of an art magnate. Receptionists answered the telephones with, "Warhol Studio," not "Warhol Factory."

Warhol usually did not arrive at the studio until about 2:30 P.M. (On most weekdays, before heading downtown, he made a fifteen-minute visit to St. Vincent Ferrer Church on Lexington Avenue at 66th Street; on Sundays, he attended mass, sitting in the rearmost pew.) Then he zipped in and out of several antiques shops to inspect newly arrived wares, usually passing out copies of *Interview* as he made his rounds. Upon arriving at the Factory, he would groan, "Oh, we have so many portraits to do, so much work," but he seldom accomplished much. Many days, there was so much routine

business to attend to at the Factory that he could only find time to paint on weekends. He took to calling himself "a Saturday–Sunday painter."

Among the first works that he created in his huge new studio were a series of so-called Rorschach paintings (plate 317), inspired by the inkblots that Swiss psychiatrist Hermann Rorschach had devised shortly after World War I for psychological testing. In these paintings, the smallest of which is one-hundred by eighty inches, Warhol essentially returned—though on a much larger scale—to his old blotted-line technique. But instead of blotting ink on paper, he now blotted paint on canvas. After unrolling a canvas on the floor, he poured black pigment (Liquitex) in an abstract configuration on one

half, then pressed the other half over it to repeat the image and end up with a symmetrical design.

Warhol improvised his own compositions, unaware that he simply could have copied Rorschach's standard set of ten inkblot designs. (Rorschach's *Psychodiagnostik* is a "form interpretation" test, used by doctors to assess their patients' perceptions and conceptions.) He had thought—mistakenly—that the idea was to have the patient make the drawing, as well as interpret it: "I thought that when you go to places like hospitals, they tell you to draw and make Rorschach tests. I wish I'd known there was a set."[14] While the Rorschach series adds a novel dimension to Warhol's oeuvre, they also contribute a witty footnote to the history of stain painting, as pioneered by artists such as Helen Frankenthaler and Morris Louis.

In the same year that Warhol painted his Rorschachs, he also produced dozens of paintings in collaboration with Basquiat and Clemente, then solely with Basquiat. Warhol's contribution to these works consisted primarily of handpainted corporate logos and newspaper headlines to which Basquiat added his typical primitivistic drawings of faces and silhouetted figures. In *Alba's Breakfast* (plate 319), a three-way collaboration with Basquiat and Clemente (whose wife Alba inspired the title), Warhol contributed the image of a washing machine and the General Electric logo. In other pictures, Warhol painted Paramount Pictures' mountain-peak logo, an image that emerged in his art during his relationship with Gould.

A group of the Warhol-Basquiat pictures were exhibited at the Shafrazi Gallery in New York in September 1985 (plate 320), but only one work was sold and the show was panned, with one critic dismissing Basquiat as an "art-world mascot." Warhol was accustomed to devastating reviews, but the younger artist was wounded by the criticism and immediately severed his ties to Andy.

Warhol continued to create artworks specifically for certain markets. His public was skeptical about much of the work he created in the 1970s and 1980s because it was so blatantly commercial. Like a true post-modernist, he gave equal weight to advertising images as to those from art history. He went so far as to claim to buy magazines for their ads and to prefer television commercials to the program being shown. Warhol viewed

318. Jean-Michel Basquiat. *Dos Cabezas.* 1982. Acrylic on canvas, 60½ x 61″. Private Collection

319. Jean-Michel Basquiat, Francesco Clemente, and Andy Warhol. *Alba's Breakfast.* 1984. Mixed mediums on paper mounted on canvas, 46½ x 59¾″. Courtesy Galerie Bruno Bischofberger, Zurich

320. Jean-Michel Basquiat and Warhol collaborated for the exhibition "Warhol, Basquiat Paintings" at the Tony Shafrazi Gallery in New York, September 14–October 19, 1985.

321. *Campbell's Soup Mix (Chicken Noodle).* 1985. Acrylic and silkscreen ink on canvas, 71¼ x 59⅞". Private Collection, New York

advertising as an artistic expression of his times; he watched it in much the same way as he went to museums. Certainly he had no qualms about making advertising art. In 1985 he produced a portfolio of ten screenprints, *Ads,* in which he combined his own choice of colors and typically off-register line drawing with "classic" advertising images for famous products, including Life Savers, Chanel No. 5, and the Volkswagen beetle.

Many of Warhol's late projects were commissions to glamorize manufactured products. As in the old days when art directors had told him what images to draw, he now painted whatever the clients asked for, whether it be Scandinavian vodka, French mineral water, or West German automobiles. Some critics thought his career had gone full circle, beginning with and returning to advertising art. But Warhol brazenly disagreed: "I was always a commercial artist." He denied that he had ever made a transformation from commercial to "real" artist. "When I started out, art was going down the drain. The people who used to do magazine illustrations and the covers were being replaced by photographers. And when they started using photographers, I started to show my work with galleries."[15]

In 1985, the Campbell Soup Company hired Warhol for an undisclosed sum to produce a series of paintings of the company's dry soup mixes, the motive being to boost sales for that line of products. (While Campbell's still dominated the canned-soup market, it held a much smaller share of the dry soup mix market.) According to a Campbell's executive, the company approached Warhol because of "his overwhelming identification with the can." "We figured since we did so well without him, then maybe we could do as well in the dry soup business if we *did* ask him." Andy made the new batch of paintings a little more "artistic" than their counterparts of the early 1960s by adding silkscreened line drawings that haloed the contours in bright, contrasting colors (plate 321). In addition to the canvases, he also produced some boxlike sculptures, stretching silkscreened canvases over wood frames to replicate large packages of Campbell's Soup mix. With his earlier Campbell's Soup paintings, Warhol had shocked viewers by enshrining a commonplace product in a high-art context. More than two decades later, his new soup box paintings and sculptures were instantly perceived as legitimate and even somewhat bland art

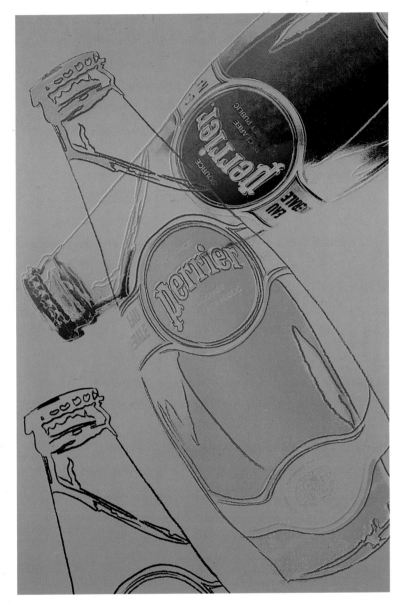

322. *Perrier.* 1984. Acrylic and silkscreen ink on canvas, 30 x 20″. Private Collection, New York

objects. Among the many Warhol fans who were dismayed by his lucrative alliance with industry was Irving Blum, who called the new soup paintings "purely promotional" for Campbell's. But Warhol, too, Blum had to admit, had become a commodity, as famous as the soup he was promoting. "It's all become commerce for him."[16]

Dealer Hans Mayer brought Warhol together with the Daimler-Benz automobile company in West Germany in 1986 to discuss ways of commemorating the centennial of the invention of the automobile. The conservative auto maker provided the artist with some photographic materials and he proceeded to make paintings of the company's 1970 experimental model with its sleek fiberglass body and doors that open vertically, resembling bat wings (plate 323). The firm's board of directors was sufficiently impressed to commission the artist to make a series of automotive portraits, beginning with an 1886 motor carriage, and continuing through a 1937 grand prix racing car (plate 324) and a 1954 coupe. The project was to have encompassed one hundred years of automotive history based on the Mercedes-Benz line, using illustrations of twenty different vehicles. Warhol completed his stylized interpretations of the first eight cars in early January 1987. He produced thirty-five paintings of Mercedes-Benz cars and many related drawings.

Warhol viewed himself as a marketable commodity; he became a celebrity model, registered with an agency, and endorsed products. His photograph appeared in many ads, including those of securities firms and hi-fi manufacturers. Warhol was also intended to be available by proxy, in the form of a robot. Broadway producer Lewis Allen arranged for the construction of a lifelike, computerized Andy Warhol robot, whose face and hands were taken from molds of the artist's body. Allen said the robot would be programmed to speak and answer questions on stage in a production called "Andy Warhol Overexposed: A No-Man Show," and that it later might have a career as a commercial spokesman. The robot promised to fulfill Andy's long-standing dream to be replaced by a machine.

Warhol also became a regular sight on television. He developed his own cable television show, "Andy Warhol's Fifteen Minutes," a series on which he interviewed voguish guests such as David

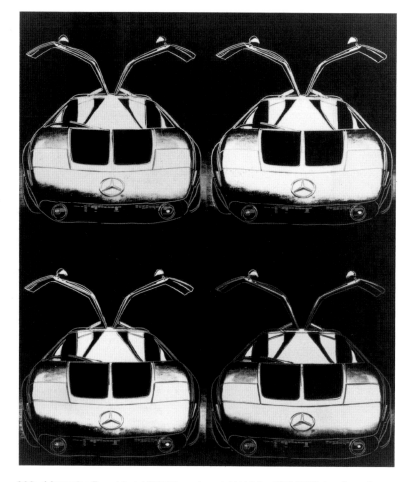

323. *Mercedes-Benz Model C 111 Experimental Vehicle, 1970.* 1986. Acrylic and silkscreen ink on canvas, 60⅛ x 50⅜". Collection Daimler-Benz AG

Hockney and fashion magazine editor Diana Vreeland. He was hired to do television bits for the popular, late-night variety show *Saturday Night Live.* In one memorable, videotaped appearance, Warhol's head fell off his body, rolled on the floor, and said, "Have a nice time at the parties."

Through Douglas S. Cramer, an art collector and network television producer, Warhol was invited to play himself in an episode of the comedy series *The Love Boat;* he filmed the segment in Hollywood in March 1985 (the installment was first aired October 12, 1985). While in Los Angeles, he attended a *Love Boat* party, held at the Beverly Hilton Hotel, marking the appearance of the show's one-thousandth guest star—Lana Turner. Andy shared a table with several celebrities, including two of his subjects from the 1960s,

324. *Mercedes-Benz W 125 Grand Prix Car, 1937.* 1986. Acrylic and silkscreen ink on canvas, 40¼ x 60⅛″. Collection Daimler-Benz AG

Ginger Rogers and Troy Donahue. Andy was called to the stage to join a line of stars surrounding the show's producers, Aaron Spelling and Cramer. For Andy, it was a dream come true to share a stage with 1940s luminaries such as Alexis Smith, June Allyson, Mary Martin, Carol Channing, Ginger, and Lana, amid hundreds of falling balloons.

By this time, virtually every glamour puss in the movie, television, and pop music worlds was aware of Andy's reputation for enshrining faces for posterity. Lana Turner, Joan Collins, and Diana Ross joined his growing list of subjects. Meanwhile, his prices rose:

the portraits now cost thirty thousand dollars for one panel and twenty thousand dollars for each additional panel. Warhol returned to a more poster-type style, preferring areas of flat color to areas of expressionist brush work. In some of his "fantasy" portraits, such as those of singer Grace Jones (plate 325), he silkscreened the eyes separately in a color that contrasted with the rest of the face, which might be blue and topped with pink or purple hair.

Warhol's celebrity contributed to the spiraling increase in his resale prices. In 1985, one of his paintings established a new record high, $165,000 paid for *S & H Green Stamps.* That price was

325. *Grace Jones.* 1986. Acrylic and silkscreen ink on canvas, 40 x 40". The Estate of Andy Warhol

326. *Jerry Hall.* 1984. Acrylic and silkscreen ink on canvas, 40 x 40". The Estate of Andy Warhol

surpassed three times during the course of New York auction sales in November 1986. A painting from the Scull collection, *200 One Dollar Bills,* sold at Sotheby's for $385,000. *Campbell's Soup Can with Can Opener* was sold for $264,000 and *Triple Elvis* sold for $203,500. (But Warhol's prices were not unduly high. That same month, Jasper Johns's *Out the Window* sold for $3.63 million and James Rosenquist's epic *F-111* sold for $2.09 million.)

Interview was also flourishing financially. In 1986, it sold on newsstands for $2.50 and its circulation was about 170,000. Richard Bernstein's eye-catching covers (plate 327) were always easy to identify because of his romanticized treatment of faces, rendered in dreamy, cosmetic colors. Andy himself usually interviewed the cover subject, assisted by one or more of his staffers. The publication was fat with fashion ads. In 1986, both the April and September issues contained 306 pages. "Andy," said Paige Powell, "wanted *Interview* to be all ads. Even as the magazine was being printed, he'd say, "Oh, Paige, can't we get one more ad in?"[17]

In 1986, Warhol made still another foray into "pure" abstraction with a series of Camouflage paintings, based on standard designs used by the United States armed forces. He modeled his four-color pattern upon a swatch of camouflage netting purchased at an army and navy store on Fifth Avenue, tracing the interlocking shapes and ordering three silkscreens. He did not need a fourth silkscreen because he first gave the canvas an allover coat of the lightest color, printing the other three, darker colors over it. In addition to the nature-mimicking shades of green, brown, and gray that appear in actual camouflage, Warhol also used many bright colors, such as reds and pinks. He proceeded to make a number of large paintings consisting only of camouflage patterns. Compared to many of the "color" and "pattern" paintings that serious abstractionists had produced in the 1960s and 1970s, Warhol's Camouflage series appears relatively bland and unadventurous.

But used in combination with figurative imagery, particularly portraits, the camouflage pattern contributes a strong and energetic structural element that both complements and contradicts the photographic information that is superimposed on it. After Beuys's death at age sixty-four in January 1986, Warhol made a memorial portrait of him, reusing the same photograph that had figured in his

327. Richard Bernstein's covers for *Interview* became ever more glamorous in the 1980s as the magazine itself became a showcase for photographers such as Bruce Weber and Robert Mapplethorpe.

1980 portraits, but this time printing it on a camouflage ground. The result is an unusually poignant tribute to an extremely complex and highly regarded colleague.

Warhol also used the camouflage pattern in various color schemes as the background for his next—and last—series of self-portraits, made in 1986. These large paintings, more than six feet square, are startling, rather horrific close-ups of the artist's starkly isolated face. Shocks of hair shoot up and outward in various directions, almost suggesting that the head is suspended from above. The face is gaunt and fissured by the jigsaw-like pieces of camouflage. The watchful eyes stare blankly at the viewer and the slightly parted lips betray no emotion. Warhol produced a related series of self-portraits, using the same photograph but printing it on monochrome grounds; though visually striking, these one-color canvases are less compelling and certainly less chilling than the camouflage versions. When the self-portraits were shown at the Anthony d'Offay Gallery in London in July and August, 1986, many viewers were deeply moved. Some spectators interpreted the pictures as memento mori, an unblinking, unsentimental view of a hurriedly approaching mortality. Others perceived them as a metaphor for the multiplicity of ways in which the artist was perceived; everyone saw different parts of the Warholian puzzle. The mirror of his age lurked behind a scrim so complicated that it was difficult to comprehend any of its elements.

Warhol's visage by this time was, of course, almost totally invented: the hair belonged to one of dozens of wigs, the skin had been dermatologically transformed and constantly tautened through the use of astringents, and the sunken cheeks had been smoothed out with collagen injections. (Contrary to rumors, Warhol never had a facelift; his fear of the surgeon's scalpel made him forego that treatment.) Despite the artificiality of his appearance, the face was still reconcilable with that of the clear-eyed teenager who had drawn an earnest self-portrait in his high-school art class. The forty-odd years between that early pencil drawing and the last self-portraits had certainly heightened his awareness of human vanity and prepared him to contemplate his own mortality. Though he did his best to suppress morbid thoughts, references to death and disaster continued to sidle into his art. In two of his last drawings,

328. Warhol was among the many celebrities to guest star in *The Love Boat,* one of the most popular American television series of the decade. He is seen here with Ted Lange, who played the ship's bartender. The episode was filmed in March 1985.

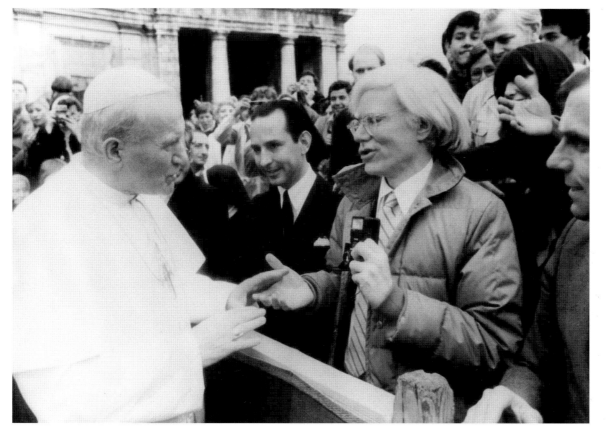

both dated 1986, he copied dire religious messages: "Repent and sin no more!" and "Heaven and hell are just one breath away!"

Many of the extraordinary personages who played key roles in the Warhol drama exited the stage during the 1980s, their final departures often accelerated by drug addiction or a new and terrifying epidemic known as AIDS (acquired immune deficiency syndrome). Two of Andy's heroes from the 1950s were among the first to go: Cecil Beaton, a prolific photographer to the end (having survived a debilitating stroke in 1974), passed away in January 1980, four days after his seventy-sixth birthday; Truman Capote, his body ravaged by years of drug and alcohol intoxication, expired in August 1984, one month before his sixtieth birthday. Eleanor Ward, who became a private dealer after closing her gallery in 1970, died at age seventy-five during January 1984. Out on Long Island, Ted Carey, Andy's longtime gallerygoing and shopping companion, died at age fifty-three of an AIDS-related illness in August 1985, a week before the opening of his first and only exhibition of

faux naif paintings, shown at an East Hampton gallery. One of Warhol's early enthusiasts, Robert C. Scull, the taxi tycoon who had assembled a world-renowned collection of Pop and Minimal art (and determinedly fought to keep it in a bitter divorce battle with his ex-wife Ethel), died at age seventy on New Year's Day, 1986; his fatal diabetes was reportedly complicated by unprescribed drug use.

A few more of Andy's superstars plunged into permanent blackout in the 1980s. Tom Baker, while celebrating his birthday in September 1982, unwittingly shot himself up with a lethal dose of cocaine and heroin. Jackie Curtis died at age thirty-eight of a drug overdose in May 1985. Ingrid Superstar, following a clouded history of alleged prostitution and drug dealing, disappeared from her home in Kingston, New York, in December 1986 and was never seen again.

None of Andy's friends and colleagues was missed on quite so global a scale as John Lennon, whose music, wit, and dedication to peace endeared him to millions; on December 8, 1980, the forty-

330. *Self-Portrait.* 1986. Photograph by computer creation. Courtesy Amiga World

year-old ex-Beatle was gunned down outside his New York apartment building by a crazed assassin with a .38 revolver. A few weeks later, on Christmas morning, the trim but bloodied body of Gregory Battcock, the effervescent art professor, critic, and columnist who had performed in Warhol's *Horse* and other early movies, was found on the balcony of his tenth-floor condominium apartment in San Juan, Puerto Rico; the forty-three-year-old bon vivant, noted for his risky habit of picking up rough trade, had been

stabbed 102 times. In May 1983, a heart attack (complicated, friends said, by a cocaine problem) took the life of Mickey Ruskin, the fifty-year-old, art-loving saloonkeeper whose Max's Kansas City established him as the Texas Guinan-Toots Shor of his generation. Alice Neel, perhaps Warhol's least merciful portraitist, died at age eighty-four in 1984. Mario Amaya, the dapper, sophisticated magazine editor and museum director who had survived Valerie Solanas's bullets, succumbed at age fifty-two to AIDS-related ailments in June 1986.

Three months later, AIDS also claimed the life of Jon Gould, who died at age thirty-three of cryptococcal meningitis in Los Angeles. A year earlier, during the fall of 1985, he had made a pilgrimage to Nepal, evidently with the hope of finding a way to allay the disease; shortly after his return to Hollywood, Paramount Pictures rewarded him for his eight years' service to the company by elevating him to independent producer with his own production unit. Although Andy's colleagues at the Factory attempted to keep him in the dark about Gould's condition, what news filtered through surely must have sparked his anxieties about his own health; no matter how much he tried to put it out of mind, he had to realize that the deadly AIDS virus had been incubating in the body of the young man whose bed he had shared.

Warhol became extremely health conscious. He consulted with nutritionists and took vitamins several times a day. He engaged a personal trainer to come to the Factory several days a week, and the regular workouts left him in excellent physical condition with good muscle tone and plenty of energy. After a long period of being too thin, his weight was satisfactory, hovering in the upper 120 pounds. He devoted a lot of attention to his skin, discussing facials and beauty tips as well as weight control with dowagers and models. He sometimes sounded like a beautician who knew all the tricks of the trade. Makos noticed that Warhol always traveled with a bag of cosmetics, skin creams, and astringents and that the first thing he did upon entering his hotel room was to lay out all his beauty products in front of a mirror and give himself a facial treatment. But Andy avoided his personal physician, whom he had not visited professionally for years, preferring to go to a chiropractor who practiced holistic medicine.

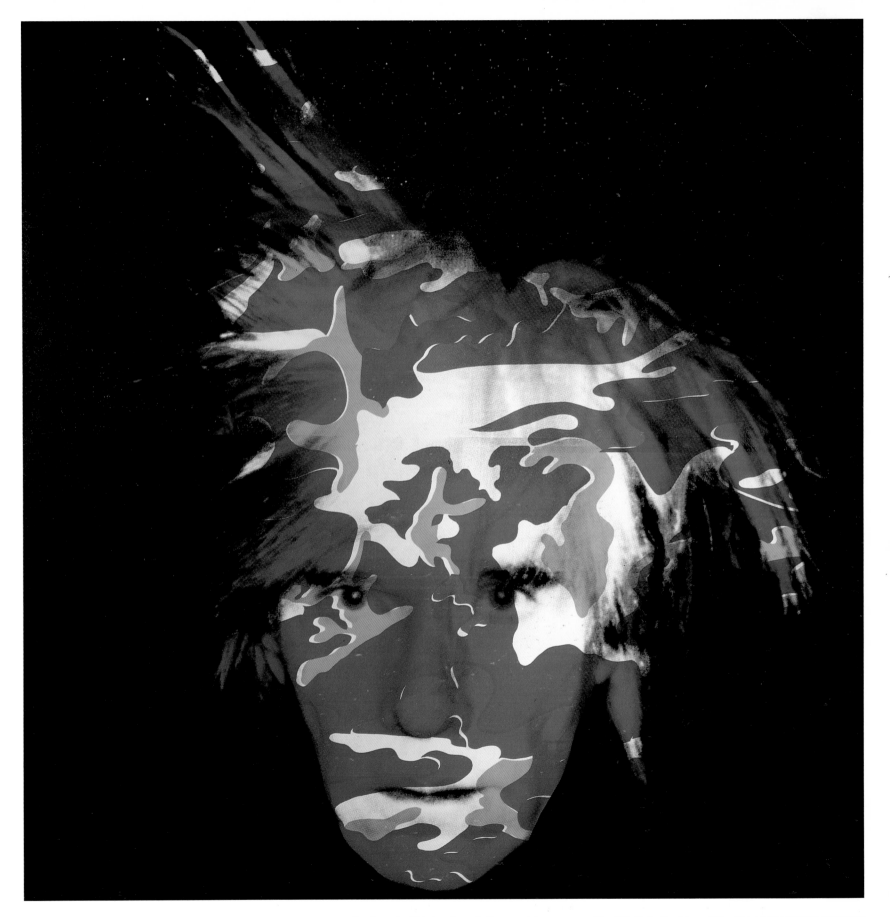

331. *Self-Portrait*. 1986. Acrylic and silkscreen ink on canvas, 80 x 80". Collection Mr. and Mrs. Robert Rosenblum, New York

By day, in front of other people, he often made a show—even in fancy restaurants—of consuming only steamed vegetables and herbal tea. But before retiring at night, in the privacy of his room, he could devour almost half a box of Godiva chocolates and wash them down with repeated drafts of brandy. He also took Valiums to help put him to sleep. "The kind of days that Andy had," Makos said, "were so highstrung and so keyed up that you'd have to be a devout yoga kind of person to be able to unwind yourself. He was like a perpetual motion machine; once this thing started winding up, there was no way to unwind."[18]

In addition to taking care of himself, Warhol made efforts to assist the unfortunate. Paige Powell knew that Andy desired a more meaningful way to spend holidays, so she took him along on those days to the Church of the Heavenly Rest, an Episcopal house of worship on East 90th Street, where they helped serve dinner to needy people. The first time they tried it was on Christmas Day in 1985, and they enjoyed it so much that they returned on other holidays. On Easter 1986, Warhol, accompanied by Powell, designer Stephen Sprouse, and Wilfredo Rosado, an editorial assistant at *Interview*, returned to the church to help serve dinner to homeless people. Warhol poured coffee, tied up the garbage bags, and carried them outside. When a mother and her children came in too late for dinner, Andy went into the kitchen and found aluminum foil with which he wrapped up the extra cupcakes to give to them to take home. "That was the first time I ever saw him in an environment where no one knew who he was," Rosado said, "and he just loved it."[19]

Early in 1986, Warhol's first New York dealer, Alexandre Iolas, who had closed his Manhattan gallery and settled permanently in Europe, commissioned Andy to make some works based on Leonardo da Vinci's *Last Supper*. Iolas offered to show the works in a Milan gallery, right across the street from the refectory of the church of Santa Maria delle Grazie, which houses the famous Renaissance wall painting. Warhol found the project extremely appealing for several reasons. Perhaps the most obvious was that he felt comfortable with the subject of food, a recurrent theme in his art from *Wild Raspberries* and Campbell's Soup through a 1979 series of screenprints of grapes, peaches, and other fruits. To an artist who

frequently fretted that he had "so many mouths to feed" and who enjoyed serving dinner to needy people (and even throwing bread crumbs to the pigeons on Park Avenue), the opportunity to update Leonardo's dining scene was pretty irresistible. Moreover, Andy was not intimidated by Leonardo, having paraphrased his portrait of Mona Lisa many years earlier, as well as a landscape detail from *The Annunciation*, which Warhol recycled in several paintings and screenprints in 1984. (Leonardo's *Annunciation* was one of three pictures that each prompted a 1984 portfolio of Warhol screenprints, titled *Details of Renaissance Paintings*; the other two works were Sandro Botticelli's *Birth of Venus* (see plate 336) and Paolo Uccello's *St. George and the Dragon*.)

The hard part for Warhol was finding a usable source upon which to base his paintings. Art-book reproductions were generally too dark. Sharp-focus photographs revealed that very little remained of Leonardo's original pigment and that what remained of the badly decomposed wall painting was largely the invention of past restorers. Consequently, he decided to work from kitsch, secondary sources. They included a white plastic maquette of the *Last Supper* that was reportedly found in a gas station on the New Jersey Turnpike, a published line drawing based on the composition, and a large, Italian-made Capo-di-Monte bisque figural group that was found in a midtown shop.

Warhol made both hand-painted and silkscreened versions of Leonardo's composition (plates 334, 335). In the hand-painted pictures, he once again—after an interval of about a quarter of a century—let the paint from his brush drip down the canvas, an effect he liked, although he also whined that "it looks like my old stuff." In some of the silkscreened paintings, he repeated Leonardo's composition in grids as many as sixty times. He silkscreened some Last Suppers on camouflage grounds and he produced several pictures that offered details of Jesus superimposed on overlapping colored rectangles. Although he liked both the hand-painted and the silkscreened versions, he chose to show only the latter in Milan.

Warhol flew to Milan to attend the January 22, 1987, opening of his Last Supper exhibition. The show attracted an enormous crowd of about three thousand people, many of them temporarily blinded

by the glare of television lights that accompanied the crews trying to film Leonardo's pale follower. Spectators were invited to first take a look at the actual *Last Supper,* then undergoing still another stage of restoration, then cross the Corso Magenta to view Warhol's interpretations, hung in another refectory-gallery in the Palazzo delle Stelline. At the extravagant dinner party afterward, Warhol, flanked by Fred Hughes and Makos, was engulfed by wealthy Milanese and a large contingent of jet setters who had flown in for the occasion. Throughout the evening, Andy received greetings from and exchanged gossip with a stream of fans and well-wishers. But he was not feeling well so he made an early evening of it and returned to his hotel before midnight.

Back in New York during the first week of February, Warhol felt a sharp pain in his stomach after dining with friends at Nippon, an East Side Japanese restaurant; instead of staying out for the rest of the evening, he went home early. He experienced several days of intermittent discomfort during the following week. Evidently, Warhol was aware that his gallbladder might be causing the acute pain (a gallbladder condition had been first diagnosed in 1973), but he continued to postpone a visit to his physician, preferring instead to seek treatment from a West Side chiropractor, Linda Li of the Li Chiropractic Healing Arts Clinic. After his session with her, he experienced such agony that he spent most of the weekend in bed.

On Saturday, February 14, Warhol complained about his abdominal pain to his dermatologist, Dr. Linda Burke, telling her that Linda Li had "mashed" his gallbladder during a massage. "He said Linda did shiatsu that involved really mashing his gallbladder. That's how he put it," said Dr. Burke, who described the massage as a "very detrimental thing to do." In her view, "A professional person would not have done it."[20] Dr. Burke, who at an earlier date had smoothed the artist's facial wrinkles with collagen injections, suggested he see his internist. At Dr. Burke's urging, Warhol went that same day for a sonogram—an image made by sound waves—which showed that Warhol's gallbladder was enlarged.

That Monday, Warhol did not go to work and canceled his appointments with his exercise trainer for the entire week. The following night he still didn't feel well, but showed up, as scheduled, to model some designer clothes at Tunnel, a West Side disco. While waiting in a cold dressing room to go out and model, Andy made a show of being more concerned about installing new batteries in his camera than about his physical pain, but his suffering showed on his face. He managed, however, to get through the show. Afterward, he rushed back to his dressing room and begged his companions to get him out of there quickly.

On Wednesday, February 18, Warhol finally sought treatment from his longtime physician, Dr. Denton S. Cox, an internist and friend who had not seen Andy professionally for several years. He told Dr. Cox he had felt ill for three or four weeks. A second sonogram revealed that Warhol's gallbladder was severely infected, inflamed, and filled with fluid. His doctor warned him that the organ was in danger of becoming gangrenous and advised immediate surgery. But Warhol resisted because of his dread of hospitals and surgeons. In *POPism*, he had written: "It was scary to think that you could lose your life if you were taken to the wrong hospital or if you happened to get the wrong doctor at the right hospital."[21]

When the doctors convinced him there was no time to try alternative treatments, Warhol agreed to enter New York Hospital on Friday. But up to the minute he checked in, he continued to insist, "Oh, I'm not going to make it." And the more his doctors tried to reassure him, the more times he would say, "Oh no, I'm not." No one —except, of course, the patient—expected the operation to be anything other than routine.

Warhol checked into New York Hospital on Friday, February 20. He was escorted there by Ken Leland, a tall, well-mannered young man who had only been working for the artist since the previous October. Leland was the latest in a line of "walkers," whose simple-sounding but arduous job it was to accompany Warhol on his daily rounds, hailing taxis, carrying shopping bags, and serving as a "gofer" and bodyguard. Most walkers did not last very long, and Warhol had initially feared that Leland, whom he met through Makos, was too new to New York and so naive that he would need a walker of his own in order to survive the city streets. Along the way, Leland asked Warhol if he was scared, and the artist replied no, he was not. But Leland thought he looked a "little bit worried."

At the hospital, Warhol registered under an assumed name, Bob Robert, and said he did not want visitors. He also inquired if any

big stars were on the premises and appeared both disappointed and flattered at being told, "you're the biggest." In fact, he was noticed by several people, who could be heard commenting to others, "That's Andy Warhol." They took the elevator to his private room on the twelfth floor of Baker Pavilion, and immediately turned on the television set. Leland went out to fetch some reading material and brought back an assortment of newspapers and periodicals (*National Enquirer, TV Guide*, the *Post* and the *News*), and a couple of show-business biographies (*Dreamgirl*, by one of the Supremes, and *His Way*, about Frank Sinatra). He also bought some flowers for the room, which elicited from his boss a faintly annoyed "What did you do that for?" Then they settled down to watch *Divorce Court*. "He was complaining that he was cold," Leland recalled later,

"because he had these white pajamas on and he really didn't look like Andy. So I put his black leather jacket around him." A nurse took some blood from him and hooked him up to a bag of clear liquid, which soon ran out. "Andy," Leland asked, "are you thirsty, because your bag's empty." "Oh yeah," Warhol said, "why don't you ask the nurse about that?" Leland notified the nurses, who "gave him another bag." Then Warhol gave Leland money to take a taxi home.[22]

Warhol's surgery was performed on Saturday, February 21, between 8:45 A.M. and 12:10 P.M. The operation went smoothly, and the gallbladder—which proved to be gangrenous—was removed. He remained in stable condition as he spent three hours in a recovery room. At 3:45 P.M. he was taken to his own room. There, he was placed under the personal care of a private nurse who had

332. *The Big C 699.* Announcement of exhibition at the Leo Castelli Gallery, New York, June 20–July 31, 1987.

been hired as a precaution on the recommendation of Dr. Cox, but selected by the hospital from a registry. Warhol was examined during the afternoon and again in the early evening by a senior attending physician, who noted nothing unusual. Alert and in good spirits, Andy watched television and, around 9:30 P.M., telephoned his housekeepers.

But at some point after midnight, Warhol's condition took a surprising turn for the worse. No one really knows what happened during the next four or five hours. According to later reports, the hospital's medical and nursing staffs neglected to look in on him periodically and to monitor his intravenous fluid intake and urinary output. No one adequately supervised the private-duty nurse, whose incomplete notes failed to record the patient's blood

pressure, pulse rate, and other vital signs, as well as his dosages of morphine and other medications. As a result, Warhol's overhydration went unnoticed.

At 5:45 A.M., the private duty nurse, who later maintained she had been reading her Bible in Warhol's room, noticed that her patient had turned blue—he was cyanotic due to insufficient oxygen in his blood, and his pulse was feeble. Unable to waken him, she contacted the floor nurse, who in turn summoned an emergency cardiac team. They tried to resuscitate him but had difficulty inserting a tube in his windpipe because rigor mortis was already setting in. The team worked for close to an hour but all attempts to revive him failed. Warhol was pronounced dead at 6:31 A.M. on February 22, 1987.

333. *Raphael I.* 1985. Acrylic on canvas, 13′1¼″ x 9′8″. The Estate of Andy Warhol

334. *Untitled (The Last Supper).* 1986. Acrylic on paper, 31½ x 23½″. Private Collection. Courtesy Robert Miller Gallery, New York

335. *Christ and the Bread.* 1986. Acrylic on canvas, 9′9″ x 19′4½″. The Estate of Andy Warhol

336. *Botticelli's Venus.* 1984. Acrylic and silkscreen ink on canvas, 48 x 72″. The Estate of Andy Warhol

NOTES

1. Patrick S. Smith, *Andy Warhol's Art and Films* (Ann Arbor, Mich.: UMI Research Press, 1986, 1981), p. 519.
2. Andy Warhol, *The Philosophy of Andy Warhol: From A to B and Back Again* (New York: Harcourt Brace Jovanovich, 1975), pp. 133–34.
3. Hilton Kramer, "Art: Warhol Show at Jewish Museum," *The New York Times,* September 19, 1980.
4. David Galloway, "Beuys and Warhol: Aftershocks," *Art in America,* July 1988, p. 121.
5. Interview with Jed Johnson, November 30, 1988.
6. Maura Moynihan, "The Cover Girl and the Prosperous Years," *New York Woman,* May–June 1987, p. 32.
7. Interview with Christopher Makos, January 26, 1989.
8. Moynihan, "The Cover Girl," p. 32.
9. Interview with Christopher Makos, January 26, 1989.
10. Interview with Paige Powell, March 8, 1989.
11. Interview with Paige Powell, March 8, 1989.
12. Interview with Paige Powell, March 8, 1989.
13. Interview with Christopher Makos, January 26, 1989.
14. Robert Nickas, "Andy Warhol's *Rorschach Test,*" *Arts Magazine,* October 1986, p. 28.
15. Paul Taylor, "Andy Warhol" (interview), *Flash Art,* April 1987, pp. 40–44.
16. Dick Polman, "But Is It Art?," *The Philadelphia Inquirer,* November 2, 1985.
17. Interview with Paige Powell, March 8, 1989.
18. Interview with Christopher Makos, January 26, 1989.
19. Beauregard Houston-Montgomery, compiler, "Andy Warhol Remembered: An Impressionist Canvas," *Details,* May 1987, p. 75.
20. Tim McDarrah, "Docs Lash Chiropractor Over Warhol Massage," *New York Post,* March 2, 1987.
21. Andy Warhol and Pat Hackett, *POPism: The Warhol '60s* (New York: Harcourt Brace Jovanovich, 1980), p. 187.
22. Houston-Montgomery, "Warhol Remembered," p. 75.

EPILOGUE

None of Andy's friends slept late that Sunday morning. Many were awakened by ringing telephones that carried the shocking news of his death. Those who knew him best, aware of his incredible willpower and stamina, had always assumed that he would outlive them. His demise was a lead item in television newscasts and front-page headlines. The New York *Daily News* bannered: "POP ART'S KING DIES."

Warhol's will, dated March 11, 1982, and witnessed by Ronnie Cutrone, named Fred Hughes executor of the estate and bequeathed to him $250,000, as well as the discretionary power to give "up to" $250,000 to each of the artist's two brothers. The primary beneficiary of the estate—whose total value was estimated by *New York* magazine between $75 and $100 million—was the Andy Warhol Foundation for the Visual Arts, possibly the wealthiest charity ever created by an American artist.

Paul and John Warhola accompanied their younger brother's body to Pittsburgh for burial. At the Thomas P. Kunsak Funeral Home, the artist was attired in a black cashmere suit and—perhaps for the first time—a correctly knotted paisley tie. The solid-bronze casket with gold-plated rails was left open for viewing. The funeral mass was held on February 26, 1987, at Holy Ghost Byzantine Catholic Church (John's parish church) on the working-class North Side of town, followed by burial near his parents' graves in St. John the Baptist Catholic Cemetery-Byzantine Rite in suburban Bethel Park. About ninety mourners, mostly relatives and Factory coworkers, attended the service. Paige Powell tossed the February and March 1987 issues of *Interview* into the open grave before the casket was lowered.

On April 1, a memorial mass was held at St. Patrick's Cathedral in Manhattan. More than two thousand people attended, representing virtually every phase of Warhol's life, from family members, art dealers, and fellow artists to stars of his underground films, fashion designers, and pop singers. Mourners such as Jane Holzer, Dominique de Menil, Liza Minnelli, and Jean-Michel Basquiat—each with her or his unique slant on Andy—sat as if oblivious to each other in adjoining pews as they listened intently for words of consolation. Brigid Berlin, looking like the society matron her parents had always wanted her to be, read passages from scripture, a dramatic contrast to her not-so-spiritual telephone monologues in *Chelsea Girls*. Yoko Ono reminisced about Andy's kindness to her fatherless son—and the artist's expressed eagerness to paint a new portrait of the boy each year. Art historian John Richardson eulogized Warhol as a "saintly simpleton" and "as the quintessential artist of his time and place—the artist who held the most revealing mirror up to his generation." The mass was followed by lunch for five hundred at the Diamond Horseshoe. Among many striking outfits, none was more Pop than Gerard Malanga's: he wore a white T-shirt silkscreened with a front page of the *New York Post,* headlined "ANDY WARHOL DEAD AT 58."

As Warhol's friends mourned him, the confusion surrounding his death mounted. Statistically, he was something of an oddity, being among the two-tenths of one percent of patients under the age of sixty who die while hospitalized after routine gallbladder surgery in New York State. The autopsy confirmed that there had been no complications during the operation. New York City's chief medical examiner, Dr. Elliott Gross, declared that Warhol had died of "cardiac arrhythmia"—an irregular heartbeat—"of undetermined origin."

In March, New York Hospital announced that its own study showed that the private nurse, a woman named Min Chou, should have summoned help more than an hour before she did. The hospital had "questions" concerning Chou's overall performance (though previously she had been a staff nurse there for eleven years) and asserted that it did not intend to have her work there again.

A month later, the New York State Health Department issued a ten-page report that accused Warhol's private nurse of "failing to communicate with the physician immediately" when the trouble started. The report faulted not only the private nurse, but also

Dr. Cox, Warhol's personal physician, and the hospital's medical and nursing staffs. It enumerated a score of shortcomings in Warhol's treatment, including failure to perform proper work-up tests before the surgery, administration of a drug to which he might have had an allergic reaction, allowing him to become overhydrated, and repeated negligence in noting his chart accurately. A hospital physician had given strict instructions regarding the patient's fluid input and urine output, but the suction device that should have permitted a reduction of fluids was not functioning, and the only entry of output recorded was made by Chou at 6:45 P.M. on the evening before Warhol's death. The nursing staff monitored neither Warhol nor his private nurse: in fact, the only time a floor nurse went into Warhol's room between midnight and 5:45 A.M. was to summon Chou to answer a 1:00 A.M. phone call from the chief surgical resident. State investigators went so far as to suggest that the few notes entered on Warhol's chart after midnight were actually made after his death.[1]

New York Hospital countered with a thirty-five page response to all the charges made by the State Health Department, claiming that it had supplied "thorough and appropriate" care to the artist.

Dr. Gross asked the Manhattan district attorney to determine whether a full-scale criminal investigation was justified. In August, the district attorney's office declared there was "insufficient evidence" to bring charges over Warhol's care, but noted that "poor medical records" were kept in the hours before his death. "It is not now possible," Manhattan District Attorney Robert M. Morgenthau wrote, "to determine whether more careful and vigilant nursing care would have detected the fatal arrhythmia in time to have prevented Warhol's death because his heart rhythm was not being electronically monitored when the fatal arrhythmia occurred."[2]

During the first week of December, New York Hospital President Dr. David B. Skinner asserted that Warhol had received "clearly first-class medical care. We're sorry that he died. But those things happen when you have a severely gangrenous gall-bladder."[3] A

week later, Warhol's estate filed a malpractice and wrongful death suit, seeking an unspecified amount of money from New York Hospital and eleven doctors and nurses. Estate lawyer Edward Hayes alleged that physicians and nurses failed "to properly and safely administer and monitor fluids intravenously given" to Warhol, "resulting in a fatally excessive overhydration."[4]

In the months following Warhol's death, several of the people who had played key roles in his life also made their departures. In June 1987, Alexandre Iolas, the elegant *danseur* who had given Warhol his first and last gallery shows, took his final curtain call, ironically at New York Hospital; he was eighty years old, and the cause of death was undisclosed. In April 1988, Valerie Solanas, the would-be assassin who dropped out of sight after shooting Warhol, died of bronchial pneumonia and emphysema in San Francisco; she was fifty-two years old. In July 1988, Nico fell off a bicycle on the Spanish island of Ibiza, where she had been vacationing, and succumbed a few hours later to a cerebral hemorrhage; she was forty-nine years old. In August 1988, Jean-Michel Basquiat passed away in his sleep at age twenty-seven, his death attributed to an overdose of heroin. Ondine, the amphetamine-driven hero of *a* and the demonic "pope" of *Chelsea Girls,* suffered the cirrhotic consequences of a lengthy dependence on drugs and drink, and his intense theatrical presence and mellifluous, cello-like voice had gradually faded from downtown theater stages. In failing health, he moved into his mother's home in Queens, where he spent his last years before his organs finally gave out on him in April 1989.

Meanwhile, Hughes was busily, but prudently liquidating the estate's assets. One of his first acts was to hire a couple of curators to inventory the artist's personal effects. Warhol's twenty-seven-room town house was glutted with the purchases of many years of bargain hunting and thousands of shopping expeditions. For the past several years, Warhol had managed to keep only a few rooms free of clutter. Every other space was piled high with his purchases, many of them still unpacked in the shopping bags or cartons in

which he had brought them home. The dining room was almost impossible to enter. Its long table overflowed with a vast amount of acquisitions, including a treasury of Native American material—from Navajo blankets and jewelry to Pima and Pomo basquetry and Kwakiutl painted-wood masks. Even the staircase was crowded with objects. Closets contained everything from Picassos to Miss Piggy memorabilia. Loose gems turned up in all sorts of unexpected places, and fine jewelry was found stashed in the cornice over his four-poster bed. The quality was wildly uneven—from one-of-a-kind Art Deco treasures to flea-market kitsch. The sheer quantity of his possessions prompted comparisons with William Randolph Hearst, the Hearstian accumulation of warehoused objects in *Citizen Kane,* and the tomb of King Tut.

Hughes chose to auction Warhol's various collections through Sotheby's, because that firm's New York exhibition space was large enough to display everything at once, something that no one, not even Warhol, had ever seen. More than two dozen people spent several months compiling a catalogue of some ten thousand items, including 210 Bakelite bracelets, 1,659 pieces of Russel Wright pottery, and 175 cookie jars.

The ten-day auction, which took place from April 23 through May 3, 1988, attracted throngs of sightseers as well as hopeful collectors. The crowds peaked on Sunday, April 24, when approximately ten thousand people, many from as far away as the West Coast and Europe, elbowed their way through the exhibition, which sprawled over three floors and out to the curb, where Warhol's 1974 Rolls-Royce, also to be sold, was parked. Even opened bottles of Andy's half-used cologne—his Shalimar, Tzigane, and Dans la Nuit—were on view, destined to be knocked down to the highest bidder.

Sotheby's grouped the items into more than 3,400 lots, divided into six categories. But the auction house's estimates did not take the artist's celebrity and mystique into account. As a result, the estimates were only realistic at the high end of the scale; souvenir hunters and curiosity-seekers were willing to pay large premiums in order to purchase a piece of Andy. All but the Native American segment brought at least double the auction house's estimates.

The Art Nouveau and Art Deco material brought in $5.3 million,

setting a record that type of sale. The oval Ruhlmann table on which so many Factory lunches had been served went for $79,750. Warhol's shopping forays in Paris paid off when a Puiforcat silver tureen brought $55,000 and that same maker's tea and coffee set fetched $44,600. A European dealer picked up the Legrain consoles for $418,000, setting a record price for that designer's work. Warhol's early-twentieth-century Egyptian revival armchair went for $170,500. Among his antique American furniture, a Joseph Barry sideboard, once cluttered with the artist's unopened packages, brought $104,500, a record price for that type of piece.

Warhol's spotty collection of contemporary art went for a total of $2.8 million. More than half of this sum was generated by only two pictures—Cy Twombly's abstraction, which sold for the record price of $990,000, and Jasper Johns's *Screen Piece*, which made $660,000. Roy Lichtenstein's *Sailboats* sold for $605,000, and his cartoon-style painting *Laughing Cat* went for $319,000. Johns's light bulb drawing, which Andy had purchased for less than $500, brought $242,000.

Likenesses of Warhol did especially well. David Hockney's colored-pencil portrait, estimated at $60,000–$80,000, fetched a record price of $330,000. Basquiat's double portrait of himself and Warhol, predicted to bring $10,000–$15,000, went for $99,000.

The folk art and memorabilia also brought good prices. Warhol's Punch figure sold for $77,000. His cast iron and tin occulist's sign brought $34,100, a record for a tin sign.

For many people, the items most closely identified with Andy's sensibility were his cookie jars, often in the whimsical form of animals, and mostly produced in the 1940s and 1950s. Andy had seldom if ever paid more than $25 apiece for his cookie jars. Sotheby's grouped he cookie jars in lots of two to five, estimated to sell for between $75 and $250. But the collection triggered intense bidding wars and each lot actually sold for between $1,980 and $23,100. A single buyer purchased thirty-five of the thirty-nine lots, paying a total of $198,605. Altogether, Andy's cookie jars brought in $247,830—nearly as much as he had paid for his Georgian-style town house. (The house itself was put on the market for $6 million.)

The grand total of the ten-day Warhol auction was $25,333,368. Incredibly, that was not all. In June, the Warhol Foundation's

curators, while clearing out a storeroom in the house, removed a lower drawer from a file cabinet and discovered that its false bottom concealed still another cache of unmounted gems, designer jewelry, and watches, many of them stuffed in paper or plastic bags. The 273 items included 72 loose diamonds, dozens of sapphires, a 300-carat carved emerald, 20 diamond solitaire engagement rings, 93 wrist and pocket watches, and an assortment of gold jewelry. These items were auctioned on December 4, 1988, and brought in an additional $1.64 million.

After Warhol's death, the prices of his own artwork climbed dramatically. In May 1987, *White Car Crash Nineteen Times* sold at Christie's in New York for $660,000, a new auction record for the artist. That sum was surpassed a year later, when *210 Coca-Cola Bottles* was sold at Sotheby's in New York for $1.43 million. Then, in November 1988, *Marilyn Monroe Twenty Times* sold at Sotheby's for $3.96 million. Warhol's *Shot Red Marilyn,* a forty-inch-square canvas of 1964, established a still higher record when it was sold for $4.07 million at Christie's in New York in May 1989.

That same month, the Warhol estate sold *Interview* to Brant Publications, Inc., which publishes *Art in America* and *Antiques* magazines. *Interview*'s new owners, Peter and Sandra Brant, who had briefly invested in the magazine some fifteen years earlier, reportedly paid about $10 million.

New York's major contemporary art museums competed to honor the artist with posthumous exhibitions. The Whitney Museum of American Art, a longtime favorite of Warhol's because it had mounted two shows of his work (in 1971 and 1979), and The Museum of Modern Art, which had displayed little interest in his painting, now vied to assemble a major retrospective. Despite a cordial relationship with the Whitney, Hughes chose to cooperate with the Modern because it had the contacts and the know-how to circulate an exhibition internationally. The Whitney settled for a retrospective of sixteen Warhol films that were screened there between April 26 and June 5, 1988. From September 30 through November 27, 1988, The Solomon R. Guggenheim Museum hosted a traveling exhibition of the artist's Mercedes-Benz series, organized by the Kunsthalle in Tübingen, West Germany, and supported by a grant from the automobile company. The Museum

of Modern Art retrospective, which opened on February 6 and continued through May 2, 1989, offered only a smattering of Warhol's pre- and post-Pop works but constituted an excellent survey of his art of the 1960s, particularly the silkscreened paintings made between 1962 and 1967. Almost simultaneously, the Grey Art Gallery & Study Center of New York University presented a comprehensive view of the artist's pre-Pop work, assembling a lighthearted but scholarly survey of his early art, commercial illustrations, promotional books, newspaper and magazine ads, among many other items in a delightful show that ran from March 14 through April 29, 1989. Between his museum shows, the auction sales, and his spiraling prices, it seemed Warhol's fifteen minutes would never end. To cap it all, stories began to circulate that Andy was still alive.

Bizarre rumors maintained that Warhol was living in relative anonymity under the name Stephen Paul Miller in upstate New York. According to an account published in the January 4, 1989, issue of the Dutch journal *De Groene Amsterdammer,* Andy, though still working in the fields of design and communications, was virtually unrecognizable because he wore an "ordinary" man's wig. Other stories placed him in the vicinity of the Adirondacks, where his total baldness enabled him to circulate unnoticed. Still other rumors located him in the Soviet Union (perhaps because of his Lenin portraits) or Germany (where reports circulated that he was actually Jewish). It did not escape the attention of the artist's fanatic followers that his final series of paintings, the Last Suppers, might have prophesied his move into another plane of existence.

Warhol's rumored life-after-death is only a macabre embellishment to a personal history that already brims with implausible developments. In the annals of cultural history, he is sure to live on as a rather chimerical personage who played a highly visible and controversial role in American life for three decades. By reiterating Campbell's Soup cans and Coca-Cola bottles and hitching his wagon to stars such as Marilyn Monroe and Elvis Presley, he succeeded in making himself a mythic figure and cultural emblem of his times.

More than just a colorful character, however, Warhol—as the posthumous museum shows confirmed—was also a gifted artist

whose best work promises to be extremely durable. Bucking the prevailing trend of painterly abstraction, he injected new freshness and vitality in some of the most traditional categories of painting—portraits, still lifes, and genre. By looking to the mass media for inspiration, he vastly expanded the range of subject matter now available to painting by introducing a wealth of topical and seemingly ephemeral material, ranging from newspaper front pages, display ads, and comic strips to news photographs and publicity stills. He became in the process a pictorial chronicler of American society, depicting many of the faces, products, and events that exemplified his era. It is conceivable, of course, that the documentary, newsreel-like quality of his paintings will work against him in the future. The resonance of his subjects might fade. There may even come a day when Marilyn Monroe, Elvis Presley, and Jacqueline Kennedy Onassis cease to monopolize public attention. But in addition to his adaptation of painting into a form of reportage, Warhol also pioneered a couple of formal innovations that ought to assure his importance in art history.

The first of Warhol's innovations concerns his unique use of repetition—his reiteration of representational images to create seemingly abstract grids. His grid compositions enabled him to "abstract" his ready-made pictorial subjects and make them comply with the formal requirements of a "flat" painting style. His second major formal innovation was the use of the silkscreen printing process to apply pigment to canvas, yielding the impersonal appearance of mechanical reproduction and suggesting that the image had been straightforwardly transposed without any mediation of the artist's psyche. It took some of his audience a long time to perceive his personality and quirky artistry in the off-register colors and imperfectly screened images.

Despite the novelty of his mass-culture subjects, grid compositions, and quasimechanical technique, Warhol's art persists in fascinating viewers primarily because of his complex and ultimately enigmatic sensibility. Equally adept at playing the simpleton and the charlatan, expressing feelings that were astonishingly naive or incredibly sophisticated, he unfailingly presented himself as a mass of contradictions. Throughout all his work, a cheerful, folkloric strain meshes with a determinedly modern, mechanistic idealism. While he seemingly distanced himself from his subjects by imprinting them through stencils or silkscreens, he did so in a primitivistic manner that made them look affectionately hand-made and individuated. This particular combination of naive-versus-sophisticated attitudes was also reflected in his twin passions for folk art and Art Deco.

If Warhol's work proves to be truly durable, it necessarily will be reevaluated and may have to communicate new and possibly contradictory meanings to succeeding generations. Tomorrow's audiences might see a more distinct, less elusive Warhol, but the inimitable combination of naïveté and guile that so intrigued his fans during his lifetime surely will continue to tantalize. Future viewers may peer into the Warholian mirror and see a radically different artist than his contemporaries did; but however altered their perspective, they will still find that he presented a crystal-clear reflection of the world as he perceived and interpreted it.

NOTES

1. M. A. Farber and Lawrence K. Altman, "A Great Hospital in Crisis," *The New York Times Magazine,* January 24, 1988, pp. 18–21 and ff.
2. Kirk Johnson, "No Criminal Charges Brought by Inquiry On Death of Warhol," *The New York Times,* August 1, 1987.
3. Ellis Henican, "State Planning to Discipline Hospital in Warhol Death," *Newsday,* December 3, 1987.
4. "Estate of Warhol Sues Hospital and Doctors," *The New York Times,* December 11, 1987.

SELECTED BIBLIOGRAPHY

The sources cited here represent a selection of the wealth of material devoted to Andy Warhol. Entries in the section "By the Artist" are listed chronologically; all others are in alphabetical order.

By the Artist

Vanderbilt, Amy. *The Amy Vanderbilt Complete Book of Etiquette*. Garden City, N.Y.: Doubleday, 1952. Illustrations by Warhol, Fred McCarroll, and Mary Suzuki.

A Is an Alphabet. "By Corkie [Ralph T. Ward] and Andy [Warhol]." New York: 1953. Illustrations by Warhol; text by Ward.

Love Is a Pink Cake. "By Corkie [Ralph T. Ward] and Andy [Warhol]." New York: 1953. Illustrations by Warhol; text by Ward.

25 Cats Name[d] Sam and One Blue Pussy. New York: c.1955. Illustrations by Warhol; text by Charles Lisanby. Reprinted New York: Panache Press at Random House, 1987.

A la Recherche du Shoe Perdu. New York: 1955. Illustrations by Warhol; poems by Ralph Pomeroy.

A Gold Book. New York: 1957. Illustrations by Warhol.

In the Bottom of My Garden. New York: c. 1958. Illustrations by Warhol.

Wild Raspberries. New York: 1959. Illustrations by Warhol; recipes by Suzie Frankfurt.

Aspen. December 1966. Magazine in box format designed by Warhol and David Dalton; includes texts by Ron Tavel, Gerard Malanga, John Wilcock, and Jonas Mekas, as well as an underground movie flip book of Warhol's *Kiss*.

Andy Warhol's Index (Book). New York: Random House, 1967. Includes photographs by Nat Finkelstein and Billy Name.

Screen Tests: A Diary. New York: Kulchur Press, 1967. By Warhol and Gerard Malanga.

A: A Novel. New York: Grove Press, 1968. Warhol's transcripts of tape-recorded conversations with Ondine.

Blue Movie. New York: Grove Press, 1970. Transcript of the complete dialogue of the film with more than 100 photographs.

The Philosophy of Andy Warhol: From A to B and Back Again. New York: Harcourt Brace Jovanovich, 1975. Text by Warhol.

Andy Warhol's Exposures. New York: Andy Warhol Books/Grosset & Dunlap, 1979. Photographs by Warhol; text by Warhol and Bob Colacello.

POPism: The Warhol '60s. New York: Harcourt Brace Jovanovich, 1980. Reprinted New York: Harper & Row, 1983. Text by Warhol and Pat Hackett.

Andy Warhol's Children's Book. Küsnacht/Zurich: Bruno Bischofberger, 1983.

America. New York: Harper & Row, 1985. Text and photographs by Warhol.

Benirschke, Kurt. *Vanishing Animals*. New York: Springer-Verlag, 1986. Art by Warhol.

Andy Warhol's Party Book. New York: Crown, 1988. Text and photographs by Warhol and Pat Hackett.

The Andy Warhol Diaries. New York: Warner Books, 1989. Edited by Pat Hackett.

About the Artist
Books and Catalogues

Andy Warhol. Berlin: Deutsche Gesellschaft für Bildende Kunst e.V. (Kunstverein Berlin) and the Nationalgalerie, 1969. Foreword by Werner Haftmann and Eberhard Roters.

Andy Warhol: Arbeiten/Works, 1962–1986. Salzburg: Galerie Thaddaeus Ropac, 1987.

Includes essays by Anton Gugg, William Milié, and Stuart Morgan and reminiscences by Glenn O'Brien, David Hockney, Leo Castelli, and Dennis Hopper.

Andy Warhol: Death and Disasters. Houston: Menil Collection and Houston Fine Arts Press, 1988. Includes essays by Neil Printz and Remo Guidieri.

Andy Warhol: Guns, Knives, Crosses. Madrid: Galería Fernando Vijande, 1982. Includes an interview by Rodrigo Vijande and Alfred Nadaff, initially published in *El País*, February 7, 1981.

The Andy Warhol Collection: Sold for the Benefit of the Andy Warhol Foundation for the Visual Arts. New York: Sotheby's, 1988. 6 vols.

Andy Warhol in the 1980s. Ridgefield, Conn.: Aldrich Museum of Contemporary Art, 1983.

Andy Warhol in Venice. Milan: Mazzotta, 1988. Introductions by Carlo Monzino and Leo Castelli; texts by Pier Paolo Pasolini and Lola Bonora.

Andy Warhol Photographs. New York: Robert Miller Gallery, 1986. Essay by Stephen Koch.

Andy Warhol: Portrait Screenprints, 1965–80. London: Arts Council of Great Britain, 1981. Essay by Suzi Gablik.

Andy Warhol—The Thirteen Most Wanted Men. Paris: Galerie Ileana Sonnabend, 1967. Essay by Otto Hahn.

Bailey, David. *Andy Warhol: Transcript of David Bailey's ATV Documentary*. London: Bailey Litchfield/Mathews Miller Dunbar, 1972. Reprinted Paris: Giraudin Import Disques, 1973. Includes interviews with Warhol, his mother, and his colleagues.

Barthes, Roland. *Wilhelm von Gloeden: Interventi di Joseph Beuys, Michelangelo Pistoletto, Andy Warhol*. Naples: Amelio, 1978.

Bastian, Heiner. *Joseph Beuys, Robert Rauschenberg, Cy Twombly, Andy Warhol: Sammlung Marx*. Munich: Prestel-Verlag, 1982. Second edition, Berlin: Arkadien Verlag, 1983.

Billeter, Erika, editor. *Andy Warhol: Ein Buch zur Ausstellung 1978 im Kunsthaus Zurich*. Zurich: Kunsthaus, 1978. Includes essays by David Bourdon, John Coplans, Hans Heinz Holz, Jonas Mekas, Barbara Rose, Helmut Salzinger, and Wolfgang Siano as well as a filmography and a bibliography of interviews.

Bonuomo, Michele, editor. *Vesuvius by Warhol*. Naples: Electa Napoli, 1985. Includes texts by Giuseppe Galasso, Nicola Spinosa, Angele Tecce, Francesco Durante, and Bonuomo.

Bowman, Russell. *Warhol/Beuys/Polke*. Milwaukee: Milwaukee Art Museum, 1987. Includes essay by Linda L. Cathcart.

Brant, Sandra, and Elissa Cullman. *Andy Warhol's "Folk and Funk."* New York: Museum of American Folk Art, 1977.

Brest, Jorge Romero. *Andy Warhol*. Buenos Aires: Galería Rubbers. 1965.

Brown, Andreas, compiler. *Andy Warhol: His Early Works, 1947–1959*. New York: Gotham Book Mart Gallery, 1971.

Collaborations: Jean-Michel Basquiat, Francesco Clemente, Andy Warhol. Küsnacht/Zurich: Edition Galerie Bruno Bischofberger, 1984.

Coplans, John. *Andy Warhol*. Greenwich, Conn.: New York Graphic Society, 1970. Essays by Coplans, Calvin Tomkins, and Jonas Mekas, with filmography.

Crone, Rainer. *Andy Warhol*. New York: Praeger, 1970. Includes a catalogue raisonné and comprehensive bibliography.

———. *Andy Warhol: A Picture Show by the Artist*. New York: Rizzoli, 1987. Translation

and elaboration of *Andy Warhol: Das zeichnerische Werk, 1942–1975*. Stuttgart: Württembergischer Kunstverein, 1976. Includes reprints of *Love Is a Pink Cake, 25 Cats Name[d] Sam and One Blue Pussy, A Is an Alphabet, In the Bottom of My Garden, A Gold Book*, and the illustrations for *A la Recherche du Shoe Perdu* and *Wild Raspberries*.

——— . *Das bildnerische Werk Andy Warhols*. Berlin: Kommissionsvertrieb Wasmuth, 1976. Includes a comprehensive bibliography.

Crone, Rainer, and Winifred Wiegand. *Die revolutionäre Ästhetik Andy Warhols*. Darmstadt: Melzer Verlag, 1972.

De Salvo, Donna M., editor. *Success Is a Job in New York: The Early Art and Business of Andy Warhol*. New York: Grey Art Gallery & Study Center, New York University (and Pittsburgh: The Carnegie Museum of Art), 1989. Texts by De Salvo, Ellen Lupton [and] J. Abbott Miller, and Trevor Fairbrother.

Dolezal, George J. *Andy Warhol: Schweizer Portraits*. Thun: Kunstsammlung der Stadt Thun, 1982.

Feldman, Frayda, and Jorg Schellmann, editors. *Andy Warhol Prints: A Catalogue Raisonné*. New York: Ronald Feldman Fine Arts, Editions Schellmann, and Abbeville Press, 1985. Introduction by Henry Geldzahler; essay by Roberta Bernstein.

Finkelstein, Nat. *Andy Warhol: "Oh this is fabulous."* Rotterdam: Bébert Editions, 1989.

Geldzahler, Henry. *Andy Warhol*. Bogotá: Galería Fernando Quintana, 1988.

——— . *Andy Warhol: A Memorial*. Bridgehampton, N.Y.: Dia Art Foundation, 1987.

Gidal, Peter. *Andy Warhol: Films and Paintings*. London: Studio Vista, New York: Dutton, 1971.

Green, Samuel Adams. *Andy Warhol*. Philadelphia: Institute of Contemporary Art, University of Pennsylvania, 1965.

Haenlein, Carl. *Andy Warhol: Bilder 1961 bis 1981*. Hannover: Kestner-Gesellschaft, 1981.

Hahn, Otto. *Andy Warhol*. Paris: Galerie Ileana Sonnabend, 1965.

——— . *Warhol*. Paris: Fernand Hazan Editeur, 1972.

Hanhardt, John G., and Jon Gartenberg. *The Films of Andy Warhol: An Introduction*. New York: Whitney Museum of American Art, 1988.

Koch, Stephen. *Stargazer: Andy Warhol's World and His Films*. New York: Praeger, 1973. Second edition, New York: M. Boyars, 1985.

Kornbluth, Jesse. *Pre-Pop Warhol*. New York: Panache Press at Random House, 1988. Introduction by Tina S. Fredericks.

Kramer, Margia. *Andy Warhol et al.: The FBI File on Andy Warhol*. New York: UnSub Press, 1988.

Kulturmann, Udo. *Andy Warhols Blumen*. Essen: Galerie M. E. Thelen, 1965.

Lenin by Warhol. Munich: Galerie Bernd Klüser, 1987. Includes essays by Katharina Hegewisch and Achille Bonito Oliva.

Licht, Ira. *Andy Warhol: Ten Portraits of Jews of the Twentieth Century*. Coral Gables, Fla.: Lowe Art Museum, University of Miami, 1980.

Makos, Christopher. *Warhol: A Personal Photographic Memoir*. London: W. H. Allen, New York: New American Library, 1988. Foreword by Henry Geldzahler; introduction by Glenn Albin.

McShine, Kynaston, editor. *Andy Warhol: A Retrospective*. New York: The Museum of Modern Art, 1989. Introduction by McShine, with essays by Robert Rosenblum, Benjamin H. D. Buchloh, and Marco Livingstone.

Morphet, Richard. *Warhol*. London: Tate Gallery, 1971.

Ostrow, Stephen E. *Raid the Icebox I with Andy Warhol: An Exhibition Selected from the Storage Vaults of the Museum of Art, Rhode Island School of Design*. Providence: Museum of Art, Rhode Island School of Design, 1969. Includes essays by Daniel Robbins and David Bourdon.

Pacquement, Alfred. *Andy Warhol*. Paris: Musée d'Art Moderne de la Ville de Paris, 1971. Preface by Gilbert Brownstone.

Pasolini, Pier Paolo. *Warhol*. Milan: Luciano Anselmino, 1976.

Ratcliff, Carter. *Andy Warhol*. New York: Abbeville Press, 1983.

Remembering Andy: Warhol's Recent Works. Tokyo: Galerie Watari, 1987.

Salzmann, Siegfried. *Kultstar—Warhol—Starkult*. Duisburg: Horst E. Visser Verlag, 1972.

Schrage, Dieter. *Warhol '80: Serie Reversal*. Vienna: Museum Moderner Kunst, Museum des 20. Jahrhunderts, 1981. Text by Dieter Ronte.

Serrano, Eduardo. *Andy Warhol*. Bogotá: Museo de Arte Moderno, 1974.

Smith, Patrick S. *Andy Warhol's Art and Films*. Ann Arbor, Mich.: UMI Research Press, 1986.

——— . *Warhol: Conversations About the Artist*. Ann Arbor, Mich.: UMI Research Press, 1988.

Solomon, Alan. *Andy Warhol*. Boston: Institute of Contemporary Art, 1966.

Spies, Werner. *Andy Warhol Cars: Die letzten Bilder*. Tübingen: Kunsthalle, 1988.

Vester, Karl-Egon, editor. *Andy Warhol*. Hamburg: Verlag Michael Kellner, 1988. Includes inteview by Eva Windmoller.

Warhol, Andy, Kasper König, Pontus Hultén, and Olle Granath, editors. *Andy Warhol*. Stockholm: Moderna Museet, 1968. Documentary photographs by Billy Name and Stephen Shore.

Warhol. Paris: Ileana Sonnabend, 1964. Essays by Jean-Jacques Lebel, Alain Jouffroy, and John Ashbery.

Warhol: Campbell's Soup Boxes. Van Nuys, Calif.: Martin Lawrence Limited Editions, 1986. Introduction by Martin S. Blinder; essay by Michael Kohn; interview by Blinder and Kohn.

Warhol: Il Cenacolo. Milan: Mondadori, 1987.

Warhol Maos: Zehn Bildnisse von Mao Tse-Tung. Basel: Kunstmuseum Basel, 1972.

Warhol Shadows. Houston: Menil Foundation, 1987. Essay by Walter Hopps.

Warhol verso De Chirico. New York: Marisa del Re Gallery, 1985. Includes essay by Claudio Bruni Sakraischik and interview by Achille Bonito Oliva.

Whitney, David. *Johns, Stella, Warhol: Works in Series*. Corpus Christi, Tex.: Art Museum of South Texas, 1972.

Whitney, David, editor. *Andy Warhol: Portraits of the 70s*. New York: Random House in association with the Whitney Museum of American Art, 1979. Includes essay by Robert Rosenblum.

Wilcock, John. *The Autobiography & Sex Life of Andy Warhol*. New York: Other Scenes, 1971. Interviews.

Wünsche, Hermann. *Andy Warhol: Das graphische Werk, 1962–1980*. N.p., n.d. Catalogue raisonné with essays by Gerd Tuchel and Carl Vogel.

Newspaper and Periodical Articles

"Andy Warhol, 1928–87: A Collage of Appreciations from the Artist's Colleagues, Critics and Friends." *Art in America*, May 1987, pp. 137–43. Contributions by Peter Schjeldahl, Philip Pearlstein, Lawrence Alloway, David Bourdon, Scott Burton, Kenneth E. Silver, Larry Rivers, John Coplans, Charles F. Stuckey, and Martin Filler.

Antin, David. "Warhol: The Silver Tenement." *Art News*, Summer 1966, pp. 47–49, 58–59.

Artstudio. Spring 1988. Special Warhol number with contributions by Jean Baudrillard, Stephen Koch, Gabriel Bauret, Luc Lang, Eric Valentin, Bruno Paradis, Thomas Crow, Michel Bourel, Démosthènes Davvetas, Ann Hindry, and Bernard Marcadé.

Battcock, Gregory. "Andy Warhol: New Predictions for Art." *Arts Magazine,* May 1974, pp. 34–37.

——— . "An Art Your Mother Could Understand." *Art & Artists,* February 1971, pp. 12–13.

Berg, Gretchen. "Nothing to Lose/Interview with Andy Warhol." *Cahiers du Cinema in English,* May 1967, pp. 38–43.

Bergin, Paul. "Andy Warhol: The Artist as Machine." *Art Journal,* Summer 1967, pp. 359–63.

Betsch, Carolyn. "Catalogue Raisonné of Warhol's Gestures." *Art in America,* May–June 1971, p. 47.

Blinderman, Barry. "Andy Warhol." *Arts Magazine,* February 1981, p. 15.

——— . "Modern 'Myths': An Interview with Andy Warhol." *Arts Magazine,* October 1981, pp. 144–47.

Bourdon, David. "Andy Warhol and the Society Icon." *Art in America,* January–February 1975, pp. 42–45.

——— . "Stacking the Deco." *New York,* November 11, 1974, pp. 64, 66.

——— . "Warhol as Filmmaker." *Art in America,* May–June 1971, pp. 48–53.

Brenson, Michael. "Looking Back at Warhol, Stars, Super-Heroes and All." *The New York Times,* February 3, 1989.

Chanan, Michael. "Pasolini and Warhol: The Calculating and the Nonchalant." *Art International,* April 20, 1970, pp. 25–27.

Cipnic, Dennis J. "Andy Warhol: Iconography." *Sight and Sound,* Summer 1972, pp. 158–61.

"Collaboration Andy Warhol." *Parkett,* no. 12, 1987, pp. 34–103. Contributions by Stuart Morgan, Glenn O'Brien, Remo Guidieri, and Robert Becker.

Collins, Bradford R. "The Metaphysical Nosejob: The Remaking of Warhola, 1960–1968." *Arts Magazine,* February 1988, pp. 47–55.

Coplans, John. "Andy Warhol and Elvis Presley." *Studio International,* February 1971, pp. 49–56.

Crow, Thomas. "Saturday Disasters: Trace and Reference in Early Warhol." *Art in America,* May 1987, pp. 128–36. Discussion in October 1987, p. 21.

Danto, Arthur C. "Who Was Andy Warhol?" *Art News,* May 1987, pp. 128–32.

Deitch, Jeffrey. "The Warhol Product." *Art in America,* May 1980, pp. 9, 11, 13.

Fairbrother, Trevor J. "Warhol Meets Sargent at Whitney." *Arts Magazine,* February 1987, pp. 64–71. Interview.

Finch, Christopher. "Warhol Stroke Poussin." *Art & Artists,* February 1967, pp. 8–11.

Galloway, David. "Beuys and Warhol: Aftershocks." *Art in America,* July 1988, pp. 113–23.

Gardner, Paul. "Gee, What's Happened to Andy Warhol?" *Art News,* November 1980, pp. 72–77.

Geelhaar, Christian. "Zeit im Schaffen von Andy Warhol." *Pantheon,* October/December 1974, pp. 390–98.

Geldzahler, Henry. "Andy Warhol." *Art International,* April 25, 1964, pp. 34–35.

Glaser, Bruce. "Oldenburg, Lichtenstein, Warhol: A Discussion." *Artforum,* February 1966, pp. 20–24. Reprinted in *Roy Lichtenstein,* edited by John Coplans (New York: Praeger, 1972). Transcript of a radio broadcast that took place in June 1964.

Grossberger, Lew. "Arts and Crafts with Andy Warhol." *New York,* November 12, 1979, pp. 53–58, 60.

Grundberg, Andy. "Photography View: Warhol Sews a Subversive Pattern in Black and White." *The New York Times,* January 11, 1987.

Hickox, Fayette. "Le Nouvel Atelier d'Andy Warhol." *Connaissance des Arts,* February 1987, pp. 108–14.

Houston-Montgomery, Beauregard, compiler. "Andy Warhol Remembered: An Impressionist Canvas." *Details,* May 1987, pp. 71–75.

Johnson, Ellen H. "The Image Duplicators—Lichtenstein, Rauschenberg, and Warhol." *Canadian Art,* January 1966, pp. 12–29.

Kagan, Andrew. "Most Wanted Men: Andy Warhol and the Anti-Culture of Punk." *Arts Magazine,* September 1978, pp. 119–21.

Kent, Letitia. "Andy Warhol, Movieman: 'It's Hard to Be Your Own Script.'" *Vogue,* March 1970, pp. 167, 204. Interview.

Kozloff, Max. "Andy Warhol and Ad Reinhardt: The Great Accepter and the Great Demurrer." *Studio International,* March 1971, pp. 113–17.

Kroll, Jack. "The Most Famous Artist." *Newsweek,* March 9, 1987, pp. 64–66.

——— . "Raggedy Andy." *Newsweek,* September 15, 1975, pp. 67, 69.

Kuspit, Donald. "Andy's Feelings." *Artscribe International,* Summer 1987, pp. 32–35.

Larson, Kay. "Art: Death and Menace." *New York,* April 21, 1986, pp. 89–90.

——— . "Art: Everybody's Andy." *New York,* February 20, 1989, pp. 77–78.

Leff, Leonard. "Warhol's 'Pork.'" *Art in America,* January 1972, pp. 112–13.

Leider, Philip. "Saint Andy: Some Notes on an Artist Who, for a Large Section of a Younger Generation, Can Do No Wrong." *Artforum,* February 1965, pp. 26–28.

Lester, Elenore. "What Has Andy Warhol's Gang Been Up To?" *Eye,* August 1968, pp. 38–43, 94–95.

Lurie, David. "Andy Warhol/'Disaster Paintings.'" *Arts Magazine,* Summer 1986, pp. 117–18.

Malanga, Gerard. "Andy Warhol: Interviewed by Gerard Malanga." *Kulchur,* Winter 1964/65, pp. 37–39.

——— . "A Conversation with Andy Warhol." *Print Collector's Newsletter,* January–February 1971, pp. 125–27.

——— . "My Favorite Superstar: Notes on My Epic, 'Chelsea Girls.'" *Arts Magazine,* February 1967, p. 26. Interview.

Masheck, Joseph. "Warhol as Illustrator: Early Manipulations of the Mundane." *Art in America,* May–June 1971, pp. 54–59.

McGill, Douglas C. "Andy Warhol, Pop Artist, Dies." *The New York Times,* February 23, 1987.

McGuigan, Cathleen. "The Selling of Andy Warhol." *Newsweek,* April 18, 1988, pp. 60–64.

Mead, Taylor, and David Bourdon. "The Factory Decades: An Interview." *Boss 5,* 1979, pp. 19–43.

Mekas, Jonas. "Movie Journal." *The Village Voice,* September 29, 1966. On *Chelsea Girls.*

Meyer, Jean-Claude. "Andy Warhol et l'arrêt du monde." *XXe Siècle,* December 1973, pp. 61, 83–87.

Morrissey, Paul, and Derek Hill. "Andy Warhol as a Film-maker: A Discussion." *Studio International,* February 1971, pp. 57–61.

Mussman, Toby. "The Chelsea Girls." *Film Culture,* Summer 1967, pp. 41–44.

Nickas, Robert. "Andy Warhol's *Rorschach Test.*" *Arts Magazine,* October 1986, pp. 28–29. Interview.

O'Doherty, Brian. "Narcissus in Hades." *Art & Artists,* February 1967, pp. 13–15.

Perreault, John. "Andy Warhol, This Is Your Life." *Art News,* May 1970, pp. 52–53, 79–80. Reply by John Coplans in September 1970, p. 6.

Pluchard, François. "Andy Warhol." *Connaissance des Arts,* April 1976, pp. 36–41.

Pomeroy, Ralph. "An Interview with Andy Warhol. June 1970." *Afterimage,* Fall 1970, pp. 34–39.

——— . "The Importance of Being Andy Andy Andy Andy Andy." *Art & Artists,* February 1971, pp. 14–19.

Rainer, Yvonne. "Don't Give the Game Away." *Arts Magazine,* April 1967, pp. 44–47.

Ratcliff, Carter. "Andy Warhol: Inflation Artist." *Artforum,* March 1985, pp. 68–75.

——— . "Starlust: Andy's Photos." *Art in America,* May 1980, pp. 120–22.

Restany, Pierre. "Andy Warhol: A Mauve-Tinged Platinum Wig." *Cimaise,* June/August 1987, pp. 69–72.

Richardson, John. "The Secret Warhol." *Vanity Fair,* July 1987, pp. 64–75, 124–27.

Rose, Barbara. "Art: In Andy Warhol's Aluminum Foil, We All Have Been Reflected." *New York,* May 31, 1971, pp. 54–56.

Rubin, David S. "Andy Warhol." *Arts Magazine,* December 1978, p. 10.

Russell, John. "The Season of Andy Warhol: The Artist as Persistent Presence." *The New York Times,* April 11, 1988.

"Saint Andrew." *Newsweek.* December 7, 1964, pp. 100–103A.

Sarris, Andrew. "Films: The Chelsea Girls." *The Village Voice,* December 15, 1966, p. 33.

Schjeldahl, Peter. "Warhol and Class Content." *Art in America,* May 1980, pp. 112–19.

"Soup's On." *Arts Magazine,* May–June 1965, pp. 16–18.

Stanton, Suzy. "Warhol at Bennington." *College Art Journal,* Summer 1963, pp. 237–38.

Steiner, Reinhard A. "Die Frage nach der Person: Zum Realitätscharakter von Andy Warhols Bildern." *Pantheon,* April/June 1984, pp. 151–57.

Stoller, James. "Beyond Cinema: Notes on Some Films by Andy Warhol." *Film Quarterly,* Fall 1966, pp. 35–38.

Stuckey, Charles F. "Andy Warhol's Painted Faces." *Art in America,* May 1980, pp. 102–11.

Swenson, G. R. "What Is Pop Art?: Answers from 8 Painters, Part I." *Art News,* November 1963, pp. 24–27, 60–63.

Taylor, Paul. "Andy Warhol: The Last Interview." *Flash Art* (International Edition), April 1987, pp. 40–44.

Tillim, Sidney. "Andy Warhol." *Arts Magazine,* September 1964, p. 62.

Tuchman, Phyllis. "Pop!: Interviews with George Segal, Andy Warhol, Roy Lichtenstein, James Rosenquist, and Robert Indiana." *Art News,* May 1974, pp. 24–29.

Vaughan, Roger. "Superpop or A Night at the Factory." *New York Herald Tribune,* August 8, 1965, pp. 7–9.

Wallis, Brian. "Absolute Warhol." *Art in America,* March 1989, pp. 25, 27, 29, 31.

Weaver, Neal. "The Warhol Phenomenon: Trying to Understand It." *After Dark,* January 1969, pp. 23–30.

Weinraub, Bernard. "Andy Warhol's Mother." *Esquire,* November 1966, pp. 99, 101, 158.

Wilson, William. "Andy-Mania Is Alive and Well in New York." *Los Angeles Times,* February 6, 1989.

——— . "'Prince of Boredom': The Repetitions and Passivities of Andy Warhol." *Art & Artists,* March 1968, pp. 12–15.

The Artist in Context

Alloway, Lawrence. *American Pop Art.* New York: Collier Books in association with the Whitney Museum of American Art, 1974.

——— . *The Photographic Image.* New York: The Solomon R. Guggenheim Museum, 1966.

——— . *Six Painters and the Object.* New York: The Solomon R. Guggenheim Museum, 1963.

Amaya, Mario. *Pop Art...and After.* New York: Viking, 1966.

Amerikansk pop-konst. Stockholm: Moderna Museet, 1964. Includes texts by Alan R. Solomon and Billy Kluver and an essay on Warhol by Henry Geldzahler.

Battcock, Gregory, editor. *The New American Cinema.* New York: Dutton, 1967.

——— . *The New Art.* New York: Dutton, 1966. Revised edition, 1973.

Boatto, Alberto. *Pop Art in USA.* Milan: Lerici, 1967. Revised edition: *Pop Art* (Milan: Editori Laterza, 1983).

Bockris, Victor, and Gerard Malanga. *Up-Tight: The Velvet Underground Story.* New York: Quill, 1983.

Calas, Nicolas, and Elena Calas. *Icons and Images of the Sixties.* New York: Dutton, 1971.

Codognato, Attilio, editor. *Pop Art: Evoluzione di una generazione.* Milan: Electa, 1980. With contributions by Roland Barthes, Achille Bonito Oliva, David Bourdon, Germano Celant, and David Shapiro.

Compton, Michael, *Pop Art.* London: Hamlyn, 1970.

Coplans, John. *Pop Art USA.* Oakland, Calif.: Oakland Art Museum, 1963.

——— . *Serial Imagery.* Pasadena, Calif.: Pasadena Art Museum, 1968.

Core, Philip. *The Original Eye: Arbiters of Twentieth-Century Taste.* Englewood Cliffs, N.J.: Prentice-Hall, 1984.

Finch, Christopher. *Pop Art: Object and Image.* London: Studio Vista; New York: Dutton, 1968.

Geldzahler, Henry. *New York Painting and Sculpture, 1940–1970.* New York: Dutton in association with The Metropolitan Museum of Art, 1969.

——— . *Pop Art, 1955–70.* Sydney: International Cultural Corporation of Australia Limited, 1985.

Haskell, Barbara. *Blam!: The Explosion of Pop, Minimalism, and Performance, 1958–1964.* New York: Whitney Museum of American Art in association with W. W. Norton, 1984.

Lipman, Jean, and Richard Marshall. *Art About Art.* New York: Dutton in association with the Whitney Museum of American Art, 1978.

Lippard, Lucy R. *Pop Art.* New York: Praeger, 1966. Includes essays by Lawrence Alloway, Nancy Marmer, and Nicolas Calas.

New York: The New Art Scene. Photographs by Ugo Mulas; text by Alan Solomon. New York: Holt Rinehart Winston, 1967.

Pierre, José. *Pop Art: An Illustration Dictionary.* London: Methuen, 1977.

Renan, Sheldon. *An Introduction to the American Underground Film.* New York: Dutton, 1967.

Rose, Barbara. *American Painting: The Twentieth Century.* Geneva: Skira, 1969.

Rublowsky, John. *Pop Art.* New York: Basic Books, 1965. Photographs by Ken Heyman.

Russell, John, and Suzi Gablik. *Pop Art Redefined.* New York: Praeger, 1969. Includes reprint of G. R. Swenson's interview with Warhol, originally published in *Art News* in November 1963; due to an error, the last eight paragraphs are actually from Swenson's interview with Tom Wesselmann, initially printed in *Art News* in February 1964.

Sandler, Irving. *American Art of the 1960s.* New York: Harper & Row, 1988.

Solomon, Alan. *New York: The Second Breakthrough, 1959–1964.* Irvine: University of California, 1969.

Stein, Jean, with George Plimpton, editors. *Edie: An American Biography.* New York: Alfred A. Knopf, 1982.

Tomkins, Calvin. *The Scene: Reports on Post-Modern Art.* New York: Viking, 1976. Includes essay on Warhol.

The Tremaine Collection: 20th Century Masters. Hartford, Conn.: Wadsworth Atheneum, 1984.

Tyler, Parker. *Sex Psyche Etcetera in the Film.* Baltimore: Pelican Books, 1971.

——— . *Underground Film: A Critical History.* New York: Grove Press, 1969.

Ultra Violet [Isabelle Dufresne]. *Famous for 15 Minutes: My Years with Andy Warhol.* New York: Harcourt Brace Jovanovich, 1988.

Warhola, Julia. *Holy Cats by Andy Warhol's Mother.* [New York: Printed by Seymour Berlin, c. 1957]. Reprinted in New York: Panache Press at Random House, 1987.

Wilson, Simon. *Pop.* London: Thames & Hudson, 1974.

ACKNOWLEDGMENTS

The generous cooperation of the following individuals helped make this book possible:

Andy Warhol's friends and colleagues, including George Abagnalo, Lawrence Alloway, Betty Asher, Richard Bernstein, Irving Blum, Stephen Bruce, Leo Castelli, Ronnie Cutrone, Betty Lou Davis, John P. Dodd, Suzie Frankfurt, Henry Geldzahler, John Giorno, Nathan Gluck, Samuel Adams Green, Pat Hackett, Brooke Hayward, Frederick W. Hughes, Robert Indiana, Jed Johnson, Ivan C. Karp, Leonard Kessler, George Klauber, Billy Klüver, Ken Leland, Charles Lisanby, Christopher Makos, Gerard Malanga, Taylor Mead, Allen Midgette, Paul Morrissey, Billy Name, Ondine, Peter Palazzo, Philip Pearlstein, Paige Powell, Jay Shriver, Allan Stone, Ronald Tavel, Ultra Violet, John Wilcock, Carlton Willers, and Peter Wise.

The artist's relatives, including Anne and Paul Warhola, John Warhola, Paul C. Warhola, Jr., and James Warhola.

Photographer Fred W. McDarrah, my old colleague on the *Village Voice*, for his zeal in documenting the Warholian scene.

Those intrepid friends of mine who volunteered to read portions of the manuscript in early draft form and contributed ideas and editorial guidance, including Alexandra Anderson, Marion Asnes, Elizabeth C. Baker, Krisanne Baker, James Collins, Trevor Fairbrother, Robert Heide, Les Levine, Bob Nickas, John Quinn, and Barbara Rose.

Andy Warhol had a profound influence on my life and my way of thinking, and I feel privileged to have enjoyed his friendship and moral support over the years. He gave me his permission to embark on this book during the summer of 1986, and I deeply regret that he did not live to see its completion.

D.B.

PHOTOGRAPH CREDITS

The author and publishers would like to thank the individuals, galleries, and institutions who so kindly loaned their photographs and/or their consent to the publication of works by Warhol. Wherever the attribution is not included in the caption, or wherever the copyright is significantly supplied, the listing follows below. All references are to plate numbers.

Courtesy Thomas Ammann Fine Arts, Zurich: 75, 95, 96, 133, 254, 290, 297; Courtesy Paul Anka: 256; Arteaga Studio, Saint Louis: 92; Courtesy Art Museum, Princeton: 168; Associated Press/Wide World Photos: 239, 289; Courtesy Galerie Bruno Bischofberger, Zurich: 134, 261, 302 (with Waddington Galleries, London), 304, 319 (Beth Phillips); Courtesy BlumHelman Gallery: 267; David Bourdon: 175, 245; Courtesy Cavan Butler, Tradhart Ltd., Slough, England: 277; Courtesy Leo Castelli Gallery, New York: 86, 104, 106, 121, 138, 143, 248, 249, 283, 307, 332 (Rudolph Burckhardt: 130, 144, 162, 167, 173, 177, 205), (Bevan Davis: 284), (eeva-inkeri: 85), (Bruce Jones: 247), (Eric Pollitzer: 108, 124, 136, 149, 169), (Pollitzer, Strong & Meyer: 99), (Walter Russell: 65), (Shunk-Kender: 127, 141), (Dorothy Zeidman: 317, 333); Geoffrey Clements, New York: 117, 119, 147, 155, 235, 243; Computer Creation, Amiga World: 330; © 1949 Conde Nast Publications, Inc.: 17, 18, 19; Courtesy Merce Cunningham Dance Foundation, New York: 203; Walter Daran, New York: 220; Courtesy Dia Art Foundation, New York: 76, 137 (Noel Allum), 257, 270, 286 (Noel Allum); Courtesy d'Offay Gallery, London: 331; Susan Eisenstein, Los Angeles: 97; Courtesy Robert Nickas and David Koepp: 206; Courtesy Ronald Feldman Fine Arts, Inc., New York: 3, 301, 308, 309, 310, 313 (D. James Dee); © 1987 Carl Fischer. All rights reserved: 240; © Germini G.E.L., Los Angeles: 250; Courtesy Solomon R. Guggenheim Museum, New York: 323, 324; Courtesy O.K. Harris Gallery, New York (D. James Dee: 260, 269, 280); Thomas Hoepker, New York: 314; Jacob and Schulze, Berlin: 109; Bill Jacobson Studio, New York: 251; Courtesy Sidney Janis Gallery, New York (Pollitzer, Strong & Meyer: 129); Joseph Klima, Jr., Detroit: 170; Courtesy Billy Klüver: 199; Fred W. McDarrah © 1964: 160, © 1965: 187, © 1966: 194, 195, 197, 198, 200, 201, © 1967: 215, 216, © 1969: 214, © 1972: 161, 165, 171; R. McKeever, New York: 91, 100, 163, 244, 264, 265, 276; Christopher Makos, New York: 2; Archives Malanga, New York: 164, 174, 180, 181, 182, 196, 224; Courtesy Menil Collection, Houston: 66, 69, 72, 74, 83, 293, 299 (Jon Abbott), 300 (Paul Hester); Duane Michals, New York: 60; Courtesy Robert Miller Gallery, New York: 71, 334 (Zindman/Fremont); Paul Morrisey, New York: 193; John Naar, New York, © 1965, 1988: 179; Otto Nelson, New York: 16, 21, 49, 50, 51, 59, 60, 61, 62, 190; Courtesy New York Post: 231 (Boxer and Engel); Courtesy New York Times: 1 (Jack Manning), 268 (Paul Hosefros); Niggemeyer, Berlin: 43, 275; Courtesy Michael Ochs Archives, Venice, California: 246; Courtesy Outline Press Syndicate, Inc.: 311 (Derek Hudson); Philip Pearlstein, New York: 9, 20; Philip Pocock, New York: 13, 14, 15, 31, 34, 35, 36, 37, 38, 39, 40, 44, 52–53, 54, 327; Courtesy Dr. Erika Pohl-Ströher, Darmstadt: 111 (Will Haustadt); Eric Pollitzer, New York: 145, 263; Pollitzer, Strong & Meyer, New York: 272, 278; John D. Schiff, New York: 157; Courtesy Tony Shafrazi Gallery, New York: 320 (Ivan Dalla Tana); Stephen Shore, New York: 202, 204, 306; Harry Shunk, New York: 183, 184, 185, 186, 253, 274; Sotheby's © 1987: 103, 140, 294, 295, 296, 318; Courtesy Sperone Westwater Gallery, New York: 316 (Zindman/Fremont); Eric Sutherland, Minneapolis: 166; Charles Uht, New York: 123; Courtesy James Warhola, Rhinebeck, New York: 4, 5, 7, 10, 11, 12, 22, 26, 27, 47, 48, 230; Courtesy Warhol Foundation, New York: 87, 188, 211, 225, 226, 227, 228, 229, 236, 237, 238, 252, 255 (Phillips/Schwab), 262, 279, 282 (Phillips/Schwab), 285, 305, 312 (Phillips/Schwab), 315, 325 (Phillips/Schwab), 326, 328, 329, 335, 336 (Phillips/Schwab); Including Factory Fotos: 172 (Billy Linich), 189, 209, 210 (Billy Name), 213, 214 (Billy Name), 218, 219, 222, 223; Courtesy David Whitney Gallery, New York: 242; Zindman/Fremont, New York: 291, 297, 303

INDEX